Imaging Culture

Imaging Culture

Photography in Mali, West Africa

Candace M. Keller

INDIANA UNIVERSITY PRESS

This book is a publication of

Indiana University Press
Office of Scholarly Publishing
Herman B Wells Library 350
1320 East 10th Street
Bloomington, Indiana 47405 USA

iupress.org

Cover. Tijani Sitou, *See My Henna*, 1983. High-resolution digital scan of original 6 × 6 cm negative. Courtesy Tijani Sitou Estate © Tijani Sitou. [Plate 9].
Cover / Book Jacket Author Portrait. Photo of Candace M. Keller by G. L. Kohuth, Michigan State University.

Manufactured in the United States of America

Second printing 2022

Library of Congress Cataloging-in-Publication Data

Names: Keller, Candace M., author.
Title: Imaging culture : photography in Mali, West Africa / Candace M. Keller.
Other titles: African expressive cultures.
Description: Bloomington, Indiana : Indiana University Press, 2021. | Series: African expressive cultures | Includes bibliographical references and index.
Identifiers: LCCN 2020055099 (print) | LCCN 2020055100 (ebook) | ISBN 9780253025579 (paperback) | ISBN 9780253057204 (ebook)
Subjects: LCSH: Photography—Mali—History. | Photography—Social aspects—Mali.
Classification: LCC TR119.M34 K45 2021 (print) | LCC TR119.M34 (ebook) | DDC 770.96623—dc23
LC record available at https://lccn.loc.gov/2020055099
LC ebook record available at https://lccn.loc.gov/2020055100

*This book is dedicated to all professional photographers
who worked in Mali and have passed on.*

*It especially honors Malick Sidibé and
my papa, Robert N. Moses.*

*Although neither lived to see this publication,
it would not exist without their support.*

CONTENTS

Plates follow page 392

Acknowledgments

Research for this project would not have been possible without support from Fulbright-Hays (2003–4), the British Library (2011–13), the National Endowment for the Humanities (2014–17), the US Embassy in Bamako (2003–17), Indiana University (2002–5), and Michigan State University (MSU; 2009–17). I am particularly grateful for the Humanities and Arts Research Program (HARP) production grant from MSU, which helped fund the high-quality paper, color illustrations, and image permissions for this book.

The expert vision of Dee Mortensen and her wonderful team at Indiana University Press, including Sarah Jacobi and Ashante Thomas, and the editorial magic of Leigh McLennon and the staff at Amnet, greatly improved this publication. I thank you all, along with the members of the board, for your patience and perseverance in support of this book over the long haul—including the three years it took to obtain image permissions.

Since 2002, when my research in Mali began, a great number of individuals and institutions have enabled this project in a variety of ways that warrant acknowledgement.

First, I thank everyone in Mali, France, and the United States who participated in interviews and discussions related to this project. In particular, I am indebted to Brehima Sidibé, Malick Sitou, Youssouf Sakaly, Amadou Baba Cissé, and Bakary Sidibé, whose expertise and insights have proven invaluable. Also in Mali, I am grateful for the support and perspectives of Cheick Oumar Mara at the Direction Nationale du Patrimoine Culturel (National Directorate of Cultural Heritage), Timothée Saye at the Archives Nationales (National Archives) in Kuluba, Youssouf Traoré at the Institut Nationale des Arts (National Art Institute), Nouhoum Samaké at the Agence Malienne de Press et de Publicité (Malian Agency of Press and Publicity), Moussa Diaby at the Ministère

de l'Éducation Nationale du Mali (Malian Ministry of National Education), Samuel Sidibé at the Musée National (National Museum), Moussa Konaté and Tidiane Sangaré at the Maison Africaine de la Photographie (African House of Photography), Anatol Sangaré at the Commissariat de Police (Police Station) in Bamako, and Minister of Culture N'Diaye Ramatoulaye Diallo.

Special thanks go to the Public Affairs Office staff, particularly Stephen Kochuba and his team, Leanne Cannon, William Bellis, Emma Moros, and Ambassador Paul A. Folmsbee at the US Embassy in Bamako for their support of this research and the Archive of Malian Photography (AMP).

I am also especially grateful to Amadou Sôw, Bocar Bocoum, Oudya and Sidiki Sidibé, Dada and Ladji Traoré, Tata Sidibé, Iyouba Samaké, Youssouf Doumbia, the *grins* of Daoudabugu and Bagadadji, Bouba Sôw, Lamine Traoré, Abdoulaye Diakité, Abdoulaye Sillah, Gaoussou Mariko, Adama and Sory Kouyaté, Moussa Kalapo, Massaran Diancoumba, Marta Carrascosa, Karim Saad, Jean Harman, Whitney Floyd, Dahamane Mahamane, Yaya Sékou, Baba Keïta, Kassim Koné, Cheickna Touré, Allison Meserve, Paul and Marie Davis, Igo Diarra, Yoby Guindo, and Cheick Oumar Tounkara. Above all, for their hospitality, friendship, and dedication, I am most deeply indebted to the Sidibé, Sitou, Sakaly, and Traoré families. *Aw ni baaraji, alla k'aw sara.*

The knowledge and experience of over one hundred professional photographers in Mali has informed and enriched this work—the most constant of whom, serving as a source of eternal wisdom and inspiration, has been Malick Sidibé. *Alla k'a dayoro sumaya, ka hine a ma.*

Archival research in France was expedited by the expert guidance of the staff at the Centre des Archives d'Outre-Mer (Center of Overseas Archives) in Aix-en-Provence and at the Bibliothèque Nationale (National Library) in Paris. Most engaging and informative has been my long-term correspondence with Gérard Guillat-Guignard, who has generously shared his archives, private publications, recollections, humor, and perspectives on his time in Mali (then Soudan Français) and afterward, including his November 2004 visit with Malick Sidibé in Biarritz, France. *Merci de partager généreusement votre temps, votre énergie, et vos souvenirs.*

The years of concentrated study, passion, and perseverance that resulted in this book were enriched by the sustained enthusiasm, support, and expertise of several mentors and peers who have become friends and confidents. From Indiana University, I extend my sincere gratitude to Heather Maxwell, Aaron Steele, Elizabeth Perrill, Laura Smith, Eileen Fry, Julie Simic, Diane Reilly, Betty Jo Irvine, Samuel Obeng,

George Brooks, John Hanson, Sarah Lea Burns, Janet Kennedy, Marion Frank-Wilson, and Teri Sowell. Special appreciation goes to the last, my life guru, in San Diego, who facilitated my entrée into African art as well as my marriage to the wonderful and amazing Ryan Claytor.

At MSU, I am indebted to the College of Arts and Letters, especially Dean Chris Long, and to the Residential College in the Arts and Humanities and Dean Stephen Esquith for supporting and valuing my research. I am also grateful for my colleagues in the Department of Art, Art History, and Design, particularly my mentor, Susan Bandes. In addition, I thank the fabulous team at Matrix: The Center for Digital Humanities and Social Sciences, especially Catherine Foley, Mike Green, Alicia Sheill, Kayla Van Dyke, Ethan Watrall, Scott Pennington, and Dean Rehberger. I also extend my gratitude to the fantastic staff at the MSU Museum, including Theresa Goforth, Lynne Swanson, and Marsha MacDowell, and at the Eli and Edythe Broad Art Museum, especially Steven Bridges, for their enthusiastic support. I am grateful to the MSU Main Library and Peter Limb, Joe Lauer, Jessica Martin, and Terrie Wilson for their expertise, generosity, and unwavering support. In addition, I appreciate the support of colleagues Rocio Quispe-Agnoli, Safoi Babana-Hampton, Kurt Dewhurst, and everyone at the Alliance for African Partnership and the African Studies Center, especially Jamie Monson, David Wiley, John Beck, John Metzler, and David Robinson. I would also like to thank my students—graduate and undergraduate, past and present—for their engagement, curiosity, and willingness to teach and learn in reciprocity.

I am grateful for the encouragement and advice of Africanist colleagues Barbara Blackmun, Tavy Aherne, Monica Blackmun Visonà, Peri Klemm, Kassim Koné, Joanna Grabski, Karen Tranberg Hansen, Victoria Rovine, Stephen Wooten, Allison Moore, Antawan Byrd, and Olabisi Silva as well as that of photo historian Geoffrey Batchen. For their comments and suggestions on this and related projects, I thank Elizabeth Cameron, Rowland Abiodun, Liam Buckley, John Peffer, Christraud Geary, Tobias Wendl, Érika Nimis, Susan Gagliardi, Giulia Paoletti and especially Patrick McNaughton, Diane Pelrine, Maria Grosz-Ngate, Zoë Strother, and Barbara Hoffman.

This publication has benefited as well from technical training, support, and facilities provided by Jeffrey Wölin, Jordan Tate, Osamu James Nakagawa, Patricio Chavez, Eileen Mandell, Alex Nichols, Heïda Shoemaker, Malick Sidibé, Adama Kouyaté, Malick Sitou, and Matrix.

Images are critical to the success of this book. Therefore, I extend my gratitude to every individual and institution who granted image permissions. I am particularly grateful for the collaboration and generosity of photographers and their families in Mali who provided permissions and

am equally indebted to Amadou Baba Cissé and Youssouf Sakaly, who helped me procure them.

I would also like to take this opportunity to thank my excellent teachers and mentors: Malick Sidibé, Malick Sitou, Brehima Sidibé, Youssouf Sakaly, Amadou Baba Cissé, Teri Sowell, Janet Kennedy, Sarah Lea Burns, Barbara Blackmun, Roy Sieber, Diane Pelrine, and Patrick McNaughton. To the last, thank you for believing in me with patience and dedication. Your passion and brilliance remain sources of inspiration, and your guidance will always be appreciated. Malick, Brehima, Youssouf, and Amadou, I have learned so much from you and am blessed by your kindness, integrity, and trust.

Finally, I extend my profound gratitude to my family, whose support has remained essential and steadfast. Bobby Moses and Coco Logan, thank you for your creative input and inspiration and for paving the way in Michigan. We are fortunate to have you near. Donna and Marshall Claytor, I will always welcome your sage advice and feel proud to be your daughter-in-law. Uncle Zia and Annie Yazdani, thank you for adopting the Moses-Claytor clan and for all your support over the years. I am forever grateful to Robert and Mae Moses for their eternal love and patience and to Jon and Yvonne Faulkner for catching me when I fall and lifting me back up again. Nana and Papa, Mom and Jon, your tireless support and unwavering faith have been my foundation. Your strength, generosity, and wisdom remain my compass. You are my angels and guiding light. Ryan, your consummate optimism, fantastic sense of humor, infinite trust, tireless patience, love, and genuine partnership are the greatest gifts, as are your efforts to help me eat my elephant while you nosh on your own. Thanks for taking this journey with me. After all these years, we remain better together. Owen, you are my heart, joy, and greatest purpose. You bring sunshine every day and never cease to amaze me. You have taught me so much. I love you to the end of the universe and back, forever and always. I am so proud to be your mommy.

Last but not least, hats off to all who focus their energy toward making the world a better place. Specifically, I thank Jimmy Carter, Mister Rogers, Al Gore, Kim Claytor, and Malick Sidibé for exemplifying the power of change that one person can make.

Imaging Culture

Introduction

IT IS SAID THAT A photograph is worth a thousand words. But which and whose words remain open questions, as meaning is never constant and is informed by boundless interpretations. Perhaps Roland Barthes said it best: "Such is the photograph: it cannot *say* what it lets us see" (Barthes 1981, 100). Contrary to the notion that pictures hold universal power, therefore, a photograph can be read and understood in a variety of ways, provoking multiple possible connotations that bear unequal weight (Sontag [1973] 1977, 109). Mediated by individuals—creators and viewers—its message is unfixed, fluctuating through time, space, and social contexts. Addressing cultural nuance in the production and reception of photographs, Olu Oguibe argued, "Though the science of photography is universal, photography itself is nevertheless culture-specific, defined and supported by varying cosmologies and the different technologies of survival that they occasion or demand" (Oguibe 2002, 15). Tied to cultural logic, photographs constitute a powerful component of visual language and virtual knowledge, informing much of what one knows and how one perceives the world, which is critical for cross-cultural (mis) understanding.

For over twenty years, black-and-white portrait photographs from West Africa have captured the imagination of international audiences. Recontextualized as fine art in numerous exhibitions on nearly every continent and featured in a large corpus of catalogs, popular journals, and fashion magazines, perhaps the most publicly revered and emulated are images produced from the 1950s to the 1970s by Malian photographers

Seydou Keïta and Malick Sidibé. However, when this commercial photography from Africa was first introduced to international communities, it was interpreted within a Western art historical canon, informed by Western aesthetic perceptions and intellectual frameworks. Such privilege was exemplified during the 1993 festival of photography in Arles, France, where Seydou Keïta's oeuvre was first honored and presented to an overseas audience as contemporary art.[1] Projected in an outdoor amphitheater in the dark of night to the musical accompaniment of Mama Sissoko's electric guitar, Keïta's portraits appeared one by one, in pairs, or in groups of three, according to featured studio props (The Chair, The Purse, The Radio) and perceived social categories (Mothers, Fathers, Professionals, Dandies, and Playboys). Removed from Keïta's archival system, which was organized by date and formal genre,[2] this framework was selected by the exhibition's curator, Françoise Huguier, à la German photographer August Sander's ethnographic study *People of the Twentieth Century* from the 1910s and 1920s (Hamidou Maïga 1993).[3] Ever since, published accounts often align Keïta's portraits (fig. I.1) with those of Sander (fig. I.2) based on their formal qualities and typological organization (Als 1997, 72; Enwezor 2010, 32; Denver Art Museum 2013).

August Sander is most known for his "comprehensive photographic index" of German people during the early twentieth century, which consists of hundreds of images he solicited and classified into seven categories according to his subjects' profession and social class (The Farmer, The Skilled Tradesman, The Woman, Classes and Professions, The Artists, The City, and The Last People).[4] The Getty Center explains that Sander's "images are thus representations of types, as he intended them to be, rather than portraits of individuals."[5] Designed for commercial publication, they were meant to be experienced collectively by European audiences in the form of books and museum exhibitions.

As a professional portraitist in the Malian capital of Bamako from the 1940s to the 1960s (fig. I.3), Keïta strove to present his clientele as they wished to be seen, according to particular cultural values and aesthetic tastes. Although he provided material aids to facilitate such performances, he never categorized his subjects accordingly. He did not conceive of his creative engagement as ethnographic and therefore did not organize individuals according to social "types." At the service of his patrons, he did not set out to encapsulate a time, place, or community for commercial publication and presentation in international art contexts as a form of cultural achievement or social commentary (Storr 1997, 27). Although his images may function this way in global markets today, it is important to note that this was never the original intent of Keïta or his subjects but was a foreign perspective the photographer later embraced.

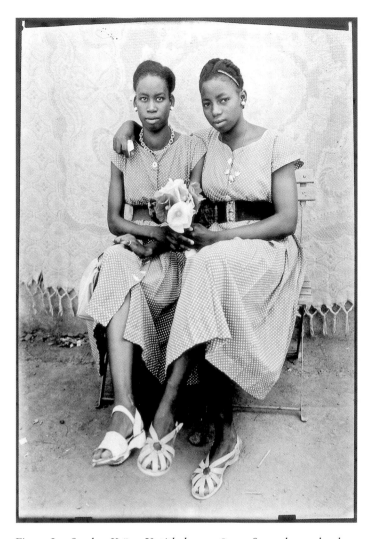

Figure I.1. Seydou Keïta, *Untitled*, c.1948–54. Secondary school
students wearing the uniform of the College de Jeunes Filles
Marius Moutet in Bamako. Gelatin silver print, 23 × 19 inches.
Courtesy CAAC—The Pigozzi Collection. © Seydou Keïta/
SKPEAC.

In terms of content, local cultural significance, time period, audience,
function, and intended meaning, Sander's project is quite unique from
Keïta's. This effectively reduces the comparison to formal elements, which
empowers Western viewers to assign meaning to Keïta's images from their
own cultural knowledge and experience and overlooks Keïta's unique aes-
thetic strategies and artistic contributions to photographic practice in the
twentieth century. As a result, Keïta's archive has been assimilated within
a Western interpretive framework and art historical canon. Thereby, little
is revealed about Keïta's visual language, working relationships, aesthetic

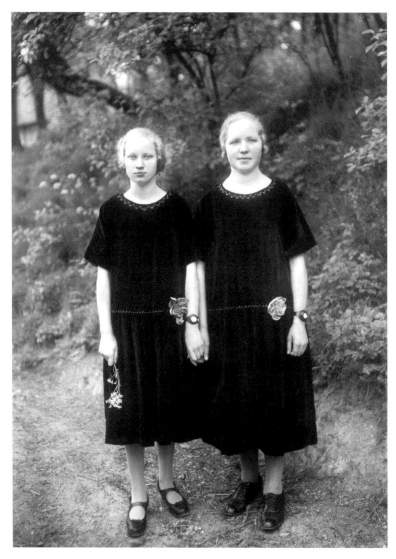

Figure I.2. August Sander, *Country Girls*, 1925. © 2016 Die Photographische Sammlung / SK Siftung Kultur—August Sander Archiv, Cologne / ARS, NY.

proclivities, goals, subjects, or the specific cultural contexts in which his images were created. Instead, the formal qualities and archetypal categories of Sander's project inform Western conceptualizations of Keïta's images. Thus, Western logic is privileged over Malian narratives and creativity. By and large, such culturally biased introductions of photography from Africa have overshadowed the popularization of particular African perspectives, histories, aesthetic systems, and intellectual frameworks among global audiences.

Addressing this practice, African art critics Okwui Enwezor and Octavio Zaya stated, "Too often, many Western critics, curators, and

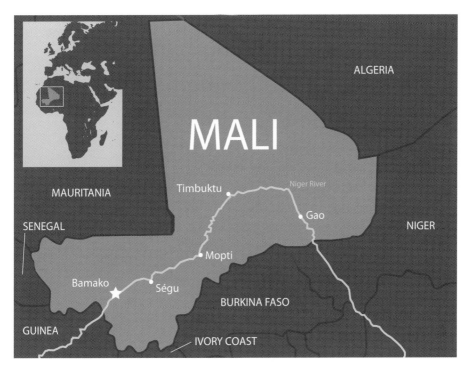

Figure I.3. Austin Thompson-Truchan, Map of Mali, 2019. Courtesy Matrix, Michigan State University.

scholars, instructed and trained within the theoretical frame of Western photography, seem predisposed to applying their presuppositions to non-European photographers or artists, thus ignoring or dismissing specific socio-cultural situations and ideological conditions that inform artistic practice in other regions of the world" (Enwezor and Zaya 1996, 31). Seeking to decenter the Eurocentric canon and destabilize its predominant understanding of photographic production, this book is invested in local practices, perspectives, histories, and innovations and participates in the current movement toward global histories of photography (Pinney 1997, 2008; Pinney and Peterson 2003; Wendl and DuPlessis 1998; Wendl and Apagya 2002; Saint-Léon and Fall 1998; Poole 2003; Behrend 2003, 2013; Golia 2009; Strassler 2010; Haney 2010). Recognized as a transcultural medium, this analysis explores the ways in which photography has been "continuously shaped, reshaped, and transformed" by photographers and patrons in Mali "in order to fit the local fabric of imaging and imagining" (Wendl 2001, 78). Thus, the title *Imaging Culture* holds twofold significance—referencing *both* the culture of photographic imaging *and* culture as imagined and imaged in photographs produced in Mali during the twentieth and twenty-first centuries.

Beyond black-and-white portraiture from the 1950s to 1970s, which has recently been popularized in international markets, the practice of photography in Mali has spanned the twentieth century, extending to the present day. For nearly a century, it has undergone multiple transitions under the control of professional commercial and state photographers who have engaged various genres of the medium to serve unique audiences and intents. This is the larger story of photography in Mali as it has been practiced in its many manifestations in intimate connection with local culture, social politics, and aesthetic values as well as transcultural trends.

Photography traveled to present-day Mali during the 1880s in the service of French imperialist expansion and capitalist venture. Wielded by French military officers and later colonial administrators, missionaries, and expatriate studio photographers, the medium was intended to record people, places, customs, and developments in the Haut-Sénégal et Niger and the French Sudan, as Mali was alternatively known, to justify the government's civilizing mission. By the late 1930s, an African market for photography had developed in the colony as the technology was exploited by urban African elite and later by the middle classes to empower and mobilize these populations, mediating colonial occupation, national liberation, socialism, military dictatorship, and democracy. In the hands of African patrons and professional photographers—who maintained a monopoly over the medium until the 1980s—photography became a powerful visual means of self-expression, exploration, and social agency.

Due to its capacity to serve simultaneously as creative commodity and social document, photography became a critical constituent in twentieth-century cultural imaging of Malian and French West African modernities and collective memories. Although practiced by itinerant photographers throughout the rural landscape, photography particularly suited the needs of the steadily growing population of young urban Africans. As a result, since the 1930s, professional studio practices have developed according to the desires and tastes of these communities in Bamako and smaller cities such as Ségu and Mopti. They have also been informed by transformations in available photographic technology determined by fluctuating political and economic policies. Thus, the story of photography in Mali is also one of urbanization and the development of an urban-based French West African modernity. Over the years, civil servants, religious and political leaders, merchants, and eventually the general populace chronicled their activities in commissioned portrait, identification, and documentary photography. Among urban populations during twentieth century, photography became a potent means to attain social capital, perpetuate or challenge cultural trends and values, inform popular memory, and affect social change.

Because photography was originally imported from Europe and has become predominantly an urban phenomenon, its practice traverses ethnic and cultural categories. Reflecting diversity in Mali's general population, the photographers and their clientele are multiethnic and transcultural, including Fulani, Bamana, Senufo, Wasulu-Fulani, Bobo, Soninké, Songhai, Malinké, Maninka, Sarakolé/Marka, and Jokoramé communities as well as Yorùbá, Asante, and other émigrés.[6] Therefore, this study does not focus on a single culture group.[7] Nor does it assume the conception of "Malian" photography, which presumes human stasis with regard to national borders. Rather, it discusses historical practices of photography *in* Mali, particularly those driven by and for African communities.

Like other forms of popular visual culture and mass media, photography has been integral in Mali to processes of world making, identity construction, and individuals' sense of connection to and participation within a larger community, whether local, national, regional, or global (Anderson [1983] 2006). This is particularly true in the context of portraiture, where authentic and imagined aspects of one's identity are performed and then shared with intimates both near and far (Eicher and Sumberg 1995; Firstenberg 2001; Mustafa 2002; Rovine 2009).

These realities highlight the power of photography. Due to its simultaneously subjective and indexical nature (the result of light reflecting off the depicted body directly onto the film as a visual record), the medium has the unique capacity to augment or supplant individual and collective memory and survey, empower, and mobilize populations (Sontag [1973] 1977; Barthes 1981; Sekula 1986; Tagg 1993; Batchen 1999). Among these are the faculty to represent oneself and the "other," to experiment with disparate versions of the self, and to visually communicate unique or shared moral and aesthetic values, which have remained paramount in Mali since the colonial era.

This book is organized into two parts. Part 1 lays the historical foundation. Chapters 1 and 2 examine transitions in photographic practices in the country from the late nineteenth to the late twentieth century that responded to specific technological developments, sociopolitical movements, and popular trends. The story begins by introducing early developments of photography in the territory. These were closely tied to state power and its processes of urbanization under the auspices of the French colonial government. This was particularly true in the capital city of Bamako, which remains the nexus of photographic production in the country today.

The first chapter considers the development of photography within the context of urbanization, colonialism, and the cultural revolution that fostered a sense of nationalism and French West African modernity

beginning in the 1920s and flourishing after the 1940s. Alongside language and other vernacular social media, such as newspapers, radio, and cinema, photography has been a critical constituent in the construction of French West African, Malian, and Bamakois identities and a shared sense of community and collective memory.

Covering the first half of the historical survey, chapter 1 centers on the era of late colonialism and the early stages of urban-based anticolonial movements. Supporting personal accounts, interviews, and archival research, Albert Memmi's treatise on late French colonialism in northern Africa provides the theoretical context for understanding the complex and ambiguous relationship among "colonizer" and "colonized" during this period and the decades that shortly followed (Memmi [1965] 1991). This ambivalence informed the practice of both commercial and government-sanctioned professional photography, as evident in remnant photographic archives.

Chapter 2 extends the chronology, centering on the peak era of professional black-and-white studio and public reportage practices. That era witnessed broad sociopolitical and pop-cultural movements that spanned periods of national liberation, socialism, and military dictatorship. The chapter closes with the introduction of color photography and commercial processing laboratories, which incited a decline in professional patronage in the 1980s, closely followed by the dawning of a new democratic era and the development of an overseas market for African photography in the early 1990s. (Biographical summaries of African, European, and Lebanese photographers who have worked in Mali since the twentieth century are provided in the digital appendix: https://amp.matrix.msu.edu/biographies.php)

Building on the historical foundation, part 2 concentrates on the social significance of photography in Mali. This includes the cultural value of photographers and their unique inventions, the capacity of visual images to convey local aesthetic ideas, and the secular as well as metaphysical power photographs have in Malian communities. Part 2 thus offers the analytical heart and intellectual depth of the book—bearing its title, *Imaging Culture*—and comprises chapters 3 through 7. This portion of the book centers on portrait photography created both in and outside the studio—a genre in which individuals' identities are explored, trends are disseminated, and values are preserved and challenged. Particular focus rests on the kinds of identities and relationships people have sought to capture on film over time and how photographers have been able to invent strategies that visually communicate them.

Chapter 3 posits photographers and their clients as active agents in the construction of identity, social memory, and sense of community—as integral to the creation and dissemination of culture and processes of

transculturation. To understand these dynamics within Malian contexts, portrait photography is considered in this and subsequent chapters in terms of *fadenya* and *badenya*, principal concepts derived from indigenous theories of social action that are intimately bounded to aesthetic values. Although these concepts arise from Mande cultural practice exchanged transculturally over centuries,[8] they have become multicultural and remain significant for indigenous and immigrant communities—among women and men, youths and seniors—within and beyond Mali's borders. As such, they are part of what Mali's former first lady Adama Bâ Konaré referred to as a "common denominator" among all cultural groups in Mali: "characteristics and values that are internalized and shared" (A. B. Konaré 2000, 15).

Derived from the most commonly spoken Malian language, Bamanankan, fadenya and badenya encompass critical notions of identity, agency, personhood, and community. In this socially prevalent theoretical system, the intrinsic relationships among individual and societal values, concepts of social organization, cultural fluctuation and stability, and aesthetic preference are articulated. Thus, these concepts are applied within this analysis to address specific sociocultural conditions and ideological beliefs that inform the artistic practices of photographers. Chapter 3 therefore illustrates how the principles of fadenya and badenya guide photographers' business tactics, social networks, compositional strategies, and aesthetic and moral considerations. Moreover, it describes the ways in which this worldview informs the subject, visual composition, and meaning of portrait photographs. It is engaged in Malian contexts during moments of photographic creation as well as interpretation among individuals of various cultures, genders, and generations. This chapter thus facilitates an appreciation of the social significance of photography and its creators within the visual cultural dialogue of Mali.

Pushing these ideas further, chapter 4 analyzes the social roles professional photographers have occupied in their communities while introducing their individual artistic innovations. Due to the imported, urban nature of the profession, photographers, like tailors and chauffeurs, are not subject to caste or ethnic restrictions. Until the 1990s, professional photography was generally open only to young men from all walks of life in Mali with access to requisite resources and training. Maintaining a monopoly over the medium until the development of lay photography in the 1980s, these men served as visual historians, artists, entertainers, and storytellers, leading some to characterize their status as "visual griots."

Delving deeper into the artistry of these photographers, chapter 4 reveals a variety of technical processes, such as camera operations, darkroom practices, and material preferences, that reveal professional

photographers' esoteric knowledge and expertise. This chapter highlights their resourcefulness and capacity for invention and identifies the compositional and technological strategies unique practitioners have developed to address climactic and resource challenges while meeting the needs and desires of their clientele.

Chapter 5 highlights the role of aesthetics in these processes, illustrating how photographers and clients incorporate concepts such as *jɛya* (clarity, whiteness, and formal perspicuity) and *dìbi* (darkness, obscurity, and ambiguity) in portrait photographs to emphasize ideas associated with fadenya and badenya, and explains how terms such as *nyì* (goodness) and *di* (tastiness) are employed to evaluate them. Since the emotional, philosophical, and cognitive associations of these aesthetic phenomena cut to the heart of human experience and intuition, this chapter closes with an analysis of the ways they can be appreciated cross-culturally.

Furthering many of the ideas previously put forth, chapter 6 investigates the metaphysical efficacy of photographic imagery among Muslim and animist communities in Mali. Locally conceptualized as *ja*, meaning "shadow," "reflection," "representation," "double," or "photograph" in Bamanankan, the indexical nature of photography operates on an immaterial and physical plane that informs the strategic methods of its production, dissemination, and preservation. As among Mourides in neighboring Senegal, portrait photographs can be used in Mali to heal, protect, and act on behalf of an individual (Roberts and Roberts 2003, 2008). Therefore, like other personal by-products, many individuals in both rural and urban areas consider portraits deeply personal, ambiguous objects that can at once empower the beholder and render vulnerable the depicted. This chapter engages these metaphysical capacities of photographic practice in Mali from its introduction by the French in the late nineteenth century to the present day.

Mindful of the spiritual significance of portraiture, chapter 7 addresses ethical concerns regarding the ownership and authorship of photographers' archives as they move from local to international contexts, including continued methods of their collection and dissemination in the global art market. It also considers repercussions this new market has realized for various populations, including well-established photographers, their apprentices, and their families; young practitioners, their contemporary networks, and professional opportunities; and the depicted subjects and their relatives in Mali and overseas. This chapter considers the global impact on the present-day canon and the archives of photographers who remain along its periphery, as well as the steps archival custodians and their partners have taken to protect the artistic legacy and cultural heritage of their collections. Concluding this book, chapter 7 thus presents an overview of the local climate, opportunities, and challenges faced by

photographers today, particularly in Bamako, after the development of the African photography biennial (*Rencontres Africaines de la photographie*) in 1994.

Research for this project was conducted in Mali between 2002 and 2017, with support from Fulbright-Hays, the British Library, the National Endowment for the Humanities, Indiana University, and Michigan State University. Primary sources include personal interviews with over one hundred photographers, clients, dealers, collectors, curators, apprentices, artists, and scholars as well as archival collections in Mali, France, and the United States.

I began this project in Mali by locating the eldest living professional practitioners in Bamako—the nexus of photography in the country. Their knowledge and experience have been particularly invaluable because several important first- and second-generation photographers, such as Seydou Keïta, Abdourahmane Sakaly, and Mountaga Dembélé, had already passed by the time I arrived. To develop a more comprehensive understanding of photographers' exchanges, I gradually followed their professional relationships and social networks. This brought me from Bamako to Buguni, Ségu, Mopti, Timbuktu, Gao (fig. I.3), and back, until I eventually arrived at the youngest generation of practitioners in the capital city. This approach illustrated the flow of material and ideas among them, revealing connections among urban and rural social practices, continuities between traditional and contemporary cultural productions, and transcultural fluencies among various communities in Mali. By extension, the practice highlighted the medium's integration with long-standing forms of creative expression in Mali, such as *Yokoro* (a children's theatrical performance [fig. I.4]) and other religious practices surrounding the Muslim holidays of Ramadan and Tabaski (fig. I.5).

Although more than eighty photographers are discussed within this account and dozens more are referenced, only a fraction of these are its predominant focus. Due to individual photographers' disparate local and global impact, as well as their (or their family's) availability and interest in this project and our particular relationship, along with other practical factors, this analysis concentrates on a few central artists. Namely, these are Amadou Baba Cissé, Diango Cissé, Mamadou Cissé, Malim Coulibaly, Mountaga Dembélé, Seydou Keïta, Ousmane Keïta, Baru Koné, Moumouni Koné, Adama Kouyaté, Hamidou Maïga, Abdourahmane Sakaly, Tijani Sitou, and especially Malick Sidibé, with whom I worked most closely.

To best appreciate the unique artistry and working practices of individual photographers, my research in Mali has largely consisted of participant-observation methods, during which I accompanied photographers on documentary assignments, frequented their studios, and

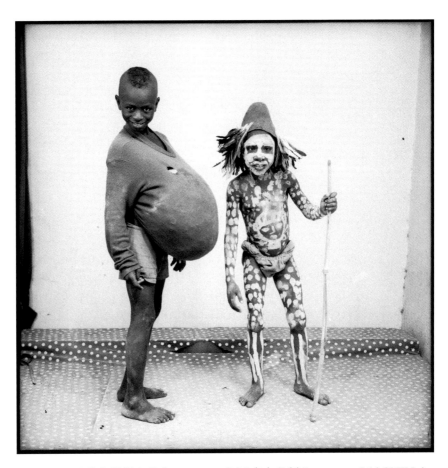

Figure I.4. Malick Sidibé, *Yokoro*, 1970. © Malick Sidibé, courtesy MAGNIN-A gallery, Paris.

apprenticed in darkroom techniques with professionals such as Malick Sidibé, Malick Sitou, and Adama Kouyaté. To support these studies, a great deal of time and energy have been spent conducting tape-recorded and transcribed interviews in Bamanankan and French with numerous photographers, clients, teachers, scholars, governmental employees, and political figures. Whenever possible, formal interviews have been supplemented with continuing dialogue in the form of in-person discussions, phone conversations, and personal communications via post and email with individuals such as Malick Sitou, Malick Sidibé, Moussa Sitou, Brehima Sidibé, Bakary Sidibé, Dada and Ladji Traoré, Youssouf Sakaly, Amadou Baba Cissé, and Moussa Konaté. Admittedly, the majority of interviewees and consultants have been men—predominantly, male photographers. As a result, my understanding of photography in Mali reflects this gender and professional bias.

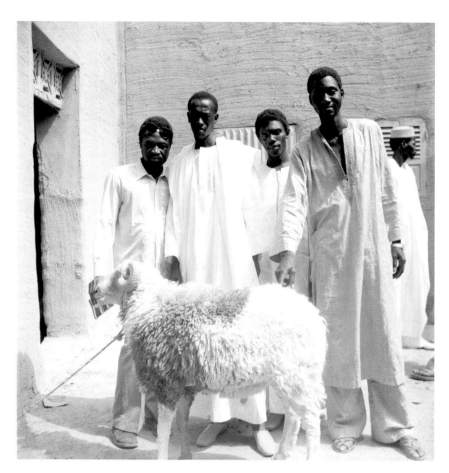

Figure I.5. Tijani Sitou, *Tabaski Ram*, c. 1970s. High-resolution digital scan of original 6 × 6 cm negative. Courtesy Tijani Sitou Estate © Tijani Sitou.

My interpretations have also been informed by casual daily discussions with clients, framers, lab technicians, students, instructors, neighbors, families, women, and children as well as my observations. These have been augmented by archival research undertaken in Bamako and Mopti, which included photographers' negative and print media collections as well as holdings in the National Library, the National Art Institute, and the National Archives at Kuluba. To enhance this research, I also consulted annals housed in France at the Center of Overseas (Colonial) Archives in Aix-en-Provence and at the National Library in Paris.

To gain greater understanding of photography's local and global histories in Mali since the early 1990s, I conducted interviews with contemporary African art collectors, gallery owners, museum directors, designers, stylists, critics, curators, scholars, and representatives of funding institutions in Bamako, Paris, and New York. These included Alioune

Bâ, agnès b., Igo Lassana Diarra, Denis Gardarin, Kadar Keïta, Sean Kelly, Andreas Kokkino, Max Osterweis, Samuel Sidibé, Claude Simard, Svend Erik Sokkelund, Amadou Chab Touré, André Magnin, Marta Carrascosa, Moussa Konaté, C. Angelo Micheli, and Simon Njami.

As evident in the acknowledgments, this book has also benefited from my discussions with scholars of African photography and Mande history, art, and culture as well as other Africanists and professional photographers from neighboring West African countries, such as Philip Kwame Apagya and J. D. 'Okhai Ojeikere.

The foreign terms incorporated within this discussion consist primarily of French and Bamanankan—the two most widely spoken trade languages in Mali. To facilitate comprehension in English, most French titles have been translated. To best reflect intended meaning for anglophone audiences, these English translations are not literal.[9] Titles that lose important cultural significance when converted to English, such as Tirailleurs Sénégalais, Office du Niger, and Foyer du Soudan, have not been translated. Where titles and phrases are given in these foreign languages, subsequent English translations are provided in parentheses. All Bamanankan terms, save for the proper names of individuals, are denoted using the Bamanankan rather than the French spelling (Kuluba, instead of Koulouba). Unable to utilize the Bamanankan orthography software programs generously provided by ethnomusicologist Heather Maxwell and linguist Moussa Diaby at the Ministry of National Education in Bamako, letters of the Roman alphabet have been combined ("ny" or "ng") and accent marks have been used (ò) to simulate the three absent Bamanankan characters and their phonetic pronunciations. This follows the tradition established by a number of Mande scholars (Bird and Kendall 1980; Brink 1980, 2001; McNaughton 1988, 2001, 2008; Arnoldi 1995, 2001; Hoffman 1995; Frank 1998; Hale 1998; Rovine 2001; Colleyn 2001). To remain consistent, as Bamanankan spellings vary in extant literature, I have followed the orthography provided by Bailleul (2000a and 2000b).

While substantial, this remains an incomplete and imperfect overview of photographic practice in Mali. Additional research may fill some of the historical gaps and address persistent questions. In the present circumstances, I have made every attempt to be as thorough and accurate as possible.

Notes

1. The initial exhibition of Keïta's work overseas was *Africa Explores* (1991) in New York. However, at that time, the photographs were not attributed to Keïta (see Vogel 1991, 160–61).

2. Keïta largely filed his archives according to formal categories, such as standing or bust portraits, with the exception of group portraits, which he organized into couples, family, and friends (S. Keïta 2011, unpaginated). This system varies greatly from the social archetypes and studio prop themes employed by Huguier in 1993, which more closely align with Sander's ethnographic catalog.

3. On stage, receiving credit for Keïta's "discovery," were French photographers Françoise Huguier and Bernard Descamps (Hamadou Maïga 1993). Both photojournalists for l'Agence Vu, in the early 1990s, Huguier and Descamps began working with Malian photographers Alioune Bâ and Diango Cissé before becoming acquainted with Malick Sidibé and eventually Seydou Keïta (Mercier 2006, 12).

4. From the online exhibition abstract published by the Metropolitan Museum (2004) in New York City for the exhibition *August Sander: People of the Twentieth Century, A Photographic Portrait of Germany*, May 25–September 19, 2004.

5. From the online exhibition abstract published by the Getty Museum (2008) Los Angeles for the exhibition *August Sander: People of the Twentieth Century*, May 6–September 14, 2008. Some subjects essentially functioned as actors or at least were used by Sander to exemplify several unique categories (Batchen 2015).

6. Although Mali's present populations also include Bozo, Tuareg/Tamachek, Somono, Wolof, Hausa, and other culture groups, I am not aware of professional photographers in the country who claim these heritages. Thus I have not listed them in the body of the text.

7. Jean-Loup Amselle and others have demonstrated that "ethnic" categories in Africa have often been the result of colonial constructs (Amselle 1998). Therefore, in these contexts, the term *ethnicity* is not always appropriate. Instead, Africanist scholarship often employs *culture group*, as I do in this book.

8. Mande (sometimes called Manding or Mandingue) is a collection of varied communities (such as Bamana and Malinké) that share linguistic, cultural, religious, and sociopolitical foundations and occupy vast territories across western Africa, including much of Mali (Zobel 1996, 45; Conrad 2006, 73). These groups recognize a common ancestry that dates to the Mali Empire of the thirteenth century and share a "system of commonly held beliefs—a philosophy, ideology, or cosmology" (Bird and Kendall 1980, 13). The Mande heartland, called Manden, is located in present-day southern Mali and northeastern Guinea between the Sankarani and Milo Rivers (Colleyn 2001, 245; Houis 1959, 38–41; Conrad 2006, 73).

9. Due to cultural nuance, translations reflect my subjective choices, and I accept responsibility for any errors they may contain.

I. Development of Photography in Mali

1

Photography and Urbanization
(1890–1940s)

SHORTLY AFTER FRENCH SCIENTIST LOUIS-FRANÇOIS Arago introduced photography to the world in 1839, the technology traveled around the globe in the hands of explorers, artists, missionaries, and military personnel. The product of nineteenth-century European industrialization, capitalism, and nationalist zeal, it readily became an important tool for imperialist expansion. It was precisely in this context, nearly fifty years later, that the French brought photography to present-day Mali.

Prior to this, France had developed trading relations along the West African coast by the eighteenth century. Moving further inland, French explorers traveled the Niger River and led expeditions to the medieval cities of Timbuktu and Jenné (see fig. I.3) in the early nineteenth century (Monti 1987, 1; Denyer 1978, 3). At this time, illustration was used to document the land's monuments and topographical details as well as its flora, fauna, and human populations.[1] By the late nineteenth century, military exploits began to overshadow those of artist-explorers, traders, and other small-scale traveling parties, marking the genesis of French colonial expansion in the region. Given photography's unparalleled indexical accuracy and, by extension, its capacity to serve as scientific record, it was quickly put to use in service of these missions.[2]

In landlocked Upper Senegal (as present-day Mali was known from 1880–90), photography's presence dates to the 1880s, when the medium was systematically used in military expeditions.[3] Among the most important were those led by Lieutenant-Colonel Gustave Borgnis-Desbordes (1880–83) and Captain Joseph Simon Gallièni (1886–88). Charged with

exploring and gaining control of the upper Senegal and Niger Rivers, including all trading centers established along their banks, such as Ségu and Bamako, they gathered information and produced photographic records for the French Geographical Society (Pakenham 1991, 164; Duclos 1992, 15).[4] The first of these voyages just preceded the Berlin Conference of 1884–85 and the Treaty of Berlin, which determined that European coastal territories on African land could be freely extended inland. Subsequent legislation expedited colonial expansion throughout the continent in a race among European powers—such as France, England, Germany, and Belgium—known as the "Scramble for Africa." The result was the partitioning of Africa into geopolitical borders that closely align with those extant today. In Mali (named the French Sudan in 1890), this process was largely completed just eight years later, after Colonel Louis Archinard gained control of the territory's major centers (Méniaud 1931, 14; Imperato 2008, xxix, 18).

From the 1880s onward, photography was put to use in widespread service of French colonial projects in western Africa while providing commercial opportunities for resident entrepreneurs. By the turn of the century, postcard photographs from the continent were widely distributed in Europe and overseas European territories, primarily by European editors, publishers, and administrators (David 1999).[5] Most feature photographs taken by Europeans. Some, however, recontextualize portraiture and documentary images taken by African photographers based largely in coastal West Africa (Geary 1991, 2017; Paoletti 2015; Anderson and Aronson 2017). Regardless of who took the picture, or in what context, the popularization of these images among European audiences in the early twentieth century served to justify colonialism. Numerous examples depict anonymous individuals representing cultural "types" (fig. 1.1), several of whom are scantily clad and pictured in rural settings, removed from imported commodities and technologies (Prochaska 1991, 44–45).[6] Others provide evidence of colonial domination and "progress" in terms of *la mission civilisatrice*,[7] France's goal to render "primitive" Africans as "civilized" moderns, in part through the development of local infrastructure (fig. 1.2).[8]

Among these were photographic images of the Upper Senegal and Middle Niger (Mali from 1904–20) and its inhabitants, thanks to the work of French photographer-editors based in West Africa, such as François-Edmond Fortier (David 1978, 5). Between 1905 and 1906, Fortier, who was based in Dakar, Senegal, traveled through the Upper Senegal and Middle Niger, photographing colonial construction projects as well as scenic views and indigenous "types" (figs. 1.1 and 1.2).[9] Along with lantern slides and newspaper, magazine, and journal reproductions,

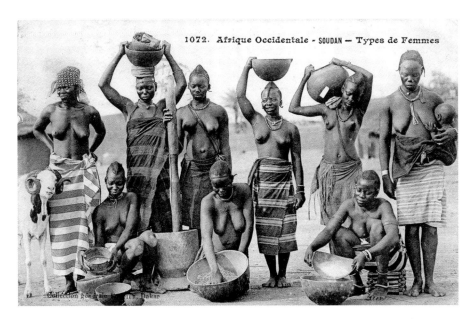

Figure 1.1. Francois-Edmund Fortier, *West Africa—French Sudan—Types of Women*, Postcard 1072, Dakar, c. 1905–6. Courtesy S. Richemond, Association Images et Mémoires.

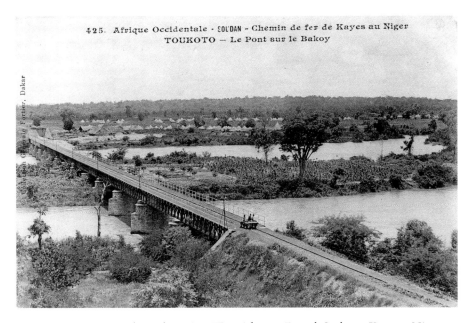

Figure 1.2. Francois-Edmund Fortier, *West Africa—French Sudan—Kayes—Niger Railway TOUKOTO—Bakoy Bridge*, Postcard 425, Dakar, c. 1905–6. Courtesy S. Richemond, Association Images et Mémoires.

postcards were among the most common means of transmitting visual information.[10] Many of those produced in Africa and disseminated in Europe helped cement culturally biased, largely imagined Western notions of Africa and Africans as exotic, primitive, isolated, and decidedly not modern—justifying the colonial project to citizens back home (Landau and Kaspin 2002, 157).[11] Such photographs, and the text that frames them, do not objectively record reality as much as they "signify and construct it" (Wells 2001, 69).

While photography remained the prerogative of French soldiers, administrators, missionaries, and businessmen in the Upper Senegal from the 1880s to 1920s, professional studios operated by African photographers were established as early as the 1860s in the coastal regions of West Africa, including present-day Senegal, Sierra Leone, Liberia, and Ghana, serving local African and European commissions. Photographers of this time, whether European or African, were members of a relatively elite class of citizens who could afford the requisite time and equipment to expertly engage the chemical and material processes of the medium.

Although amateur or "snapshot" photography became viable in Europe and the United States shortly after the invention of the Kodak camera in 1888, it was not until nearly a century later that the phenomenon occurred in West Africa among Africans (David 1978, 11; Coe and Gates 1977, 21–22). Rather, for much of the twentieth century, photography in Mali remained the purview of urban professionals, and, as such, its histories must be considered alongside the development of the nation's cities.

The largest, which was designated the capital in 1908 and has remained the site of the greatest volume of photographic production in present-day Mali, is Bamako, followed by Ségu and Mopti (see fig. I.3). Bamako began as a fairly small riverine merchant center, established as late as the seventeenth century by Diamoussa Dian Niâré and Bamba Kong (Villien-Rossi 1963, 380).[12] When Scottish physician Mungo Park arrived there in 1805, it had become a commercial town of about 6,000 inhabitants whose market featured salt, gold, slaves, spices, kola nuts, and livestock (Imperato 2008, 32–33, 235–36).[13] During subsequent decades, its population dwindled to some 2,500 inhabitants within an expanse of about twenty hectometer blocks when Borgnis-Desbordes and his battalion arrived there on February 7, 1883, and immediately began to construct a military fort.[14]

By the 1890s, the French had effectively achieved control over all of present-day Mali after Archinard captured Jenné and Mopti in 1893 and conquered Samory Touré in 1898.[15] Guided by commercial interests, military campaigns gradually gave way to development projects in the domains of infrastructure, education, monetary capitalization, and the

import-export trade. Long-standing practices of taxation,[16] military conscription,[17] and forced labor continued,[18] with the first and last perpetually increasing to facilitate the construction of roads, railroads, bridges, administrative buildings, schools, and hospitals. These practices steadily brought migrant populations from rural areas and neighboring territories to the nascent city of Bamako, where they searched for the means to pay annual levies, avoid forced labor, and work in some capacity for the colonial administration (Gorer 1970, 103). Such migrations helped form the urban community that would, within a few decades, develop an African market for photography. In fact, it was around this time that Bakary Keïta, the grandfather of renowned photographer Seydou Keïta, moved to Bamako to help his father pay administrative taxes in his native village.[19]

In 1903, Borgnis-Desbordes's fort was dismantled, and administrative buildings were erected on Kuluba, the prominent hill overlooking the town and the Niger River, where the presidential palace and colonial archives remain today. By October 1904, the Dakar–Niger railway opened in Bamako, the same month that French West Africa and the Upper Senegal and Middle Niger (present-day Mali) were created.[20] Expediting Bamako's growth in population, commercial trade, and urbanization, the railroad later provided the city with important access to seaports, such as those of Dakar and Abidjan. To facilitate trade and communications within the territory, by 1905, a chamber of commerce was instituted in the city, a telephone line was put in place between Bamako and Kati, and the Bank of West Africa was created, which printed bills for use in French West African trading houses (Meillassoux 1968, 8; Konaré and Konaré 1981, 97, 100).

Thus, by May 25, 1908, when Bamako became the capital of Upper Senegal and Middle Niger, it had already experienced rapid transformations in population growth and the development of infrastructure, education, and entertainment, predominantly designed to serve French populations in the city. During the decade that followed, such developments were accelerated, and the capital's population nearly doubled, from 6,000 to 8,735 in 1915 and reaching 15,596 in 1926 (Villien-Rossi 1963, 381; Bleneau and la Cognata 1972, 26–42; Meillassoux 1968, 9).[21] This expanse was due in part to the practices of partial and, later, full military conscription and forced labor, compounded by the drought and famine that struck the region around 1911,[22] then by the advent of World War I (1914–18), which brought people from all over the territory to the capital city.[23]

Arguably, World War I and World War II had the greatest impact on the growth of Bamako's population and urban development before independence. The French West African army—Tirailleurs Sénégalais—and

its policy of conscription drew men and eventually their families to the city, where a military base was located near Kuluba in Kati. It also brought men from neighboring French West African territories, such as Senegal, to Bamako, resulting in the development of new immigrant neighborhoods such as Wolofobugu, or "Wolof Town," created by Wolof troops in the Tirailleurs Sénégalais (Villien-Rossi 1963, 390; Meillassoux 1968, 8–9). In addition, returning soldiers often settled in Bamako, which presented one of the the greatest local opportunities for civil service and military employment (I. Samaké 2005).

Soldiers were among the first French West Africans to travel en masse to Europe, where they directly experienced European culture (Echenberg 1991, 140). When they returned, many "gravitated to the larger towns . . . where they had greater access to imported consumer goods and privileges."[24] In Europe, they were exposed to European lifestyles and trained in various industrial trades, such as auto and aviation mechanics and, eventually, engineering, chauffeuring, and photography, thereby gaining access to the requisite materials and knowledge to pursue these fields back home.[25]

During the 1910s and 1920s, Bamako's population continued to grow, reaching twenty thousand by 1931 (Villien-Rossi 1963). Paving the way for studio practices and other cosmopolitan activities, various amenities were introduced in the city around the same period. These included utilities, such as electricity and water (1925–35), as well as transcultural venues, such as movie theaters (1910), a printing house (1910), a post office (1914), a telegraph and radio station (1924), several major roadways (1926), a submersible bridge (1926), and a soccer stadium (1928 [Konaré and Konaré 1981, 117–18]). Most of these facilitated communication and the mobility of goods, people, and ideas between urban centers.

By 1920 a community of African urban elite, known in French as *évolués*, was present in Bamako for the first time.[26] Many had attended primary schools such as the École des fils de Chefs,[27] originally designed to assimilate chiefs' sons to French knowledge systems and ideologies, and related institutions such as the École William Ponty in neighboring Senegal.[28] Several had also served in the Tirailleurs Sénégalais. Closely associated with colonial figures and their cultural lifestyles from this period on, these individuals held new urban-based professional positions as primary school teachers, assistant doctors, policemen, and law clerks (Foltz 1965, 20–21).[29] This was the case for Seydou Keïta's grandfather, Bakary Keïta, who worked as an assistant to the high court justice in Bamako during the 1920s (Magnin 1997, 285).[30] Naturally, the family members of these men, including women and children, shared their elite status, which was rendered visually evident through their adoption of

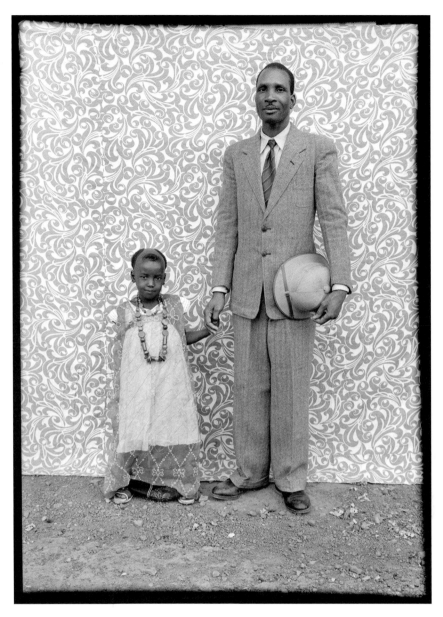

Figure 1.3. Seydou Keïta, *Untitled*, c. 1953–57. Gelatin silver print, 23 × 19 inches. Courtesy CAAC—The Pigozzi Collection. © Seydou Keïta/SKPEAC.

Western cosmopolitan attire and symbols of colonial power such as pith helmets and, for men, military uniforms (figs. 1.3 and 1.4). The same was the case for the possession of new modes of transportation, including the bicycle and, later, the scooter and automobile, which individuals were sure to document in their portraits during the subsequent two decades (figs. 1.5–1.7).

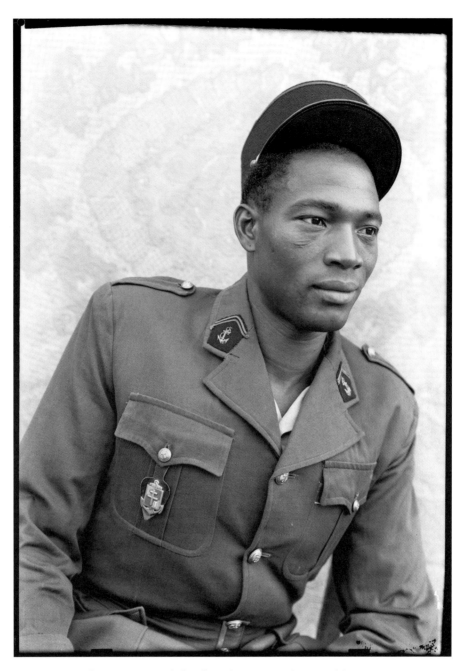

Figure 1.4. Seydou Keïta, *Untitled* (colonial marines infantry soldier), c. 1948–54.
Gelatin silver print, 23 × 19 inches. Courtesy CAAC—The Pigozzi Collection. ©
Seydou Keita/SKPEAC.

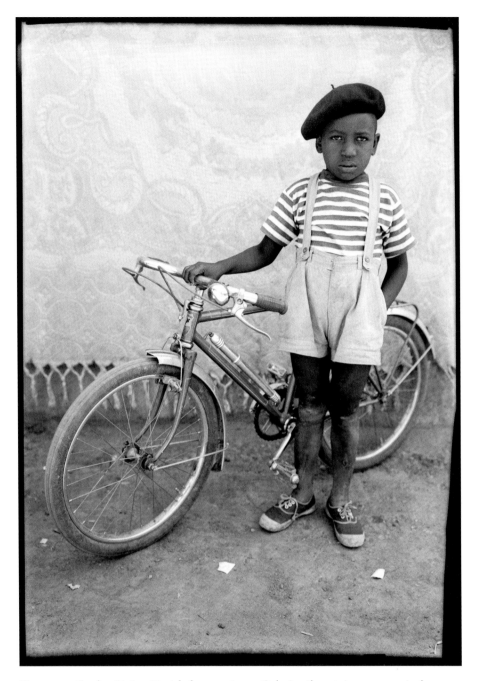

Figure 1.5. Seydou Keïta, *Untitled*, c. 1948–54. Gelatin silver print, 23 × 19 inches.
Courtesy CAAC—The Pigozzi Collection. © Seydou Keïta/SKPEAC.

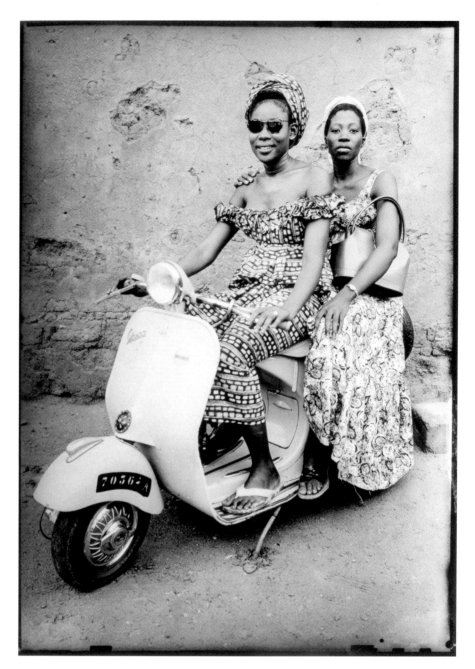

Figure 1.6. Seydou Keïta, *Untitled*, c. 1948–54. Gelatin silver print, 23 × 19 inches. Courtesy CAAC—The Pigozzi Collection. © Seydou Keïta/SKPEAC.

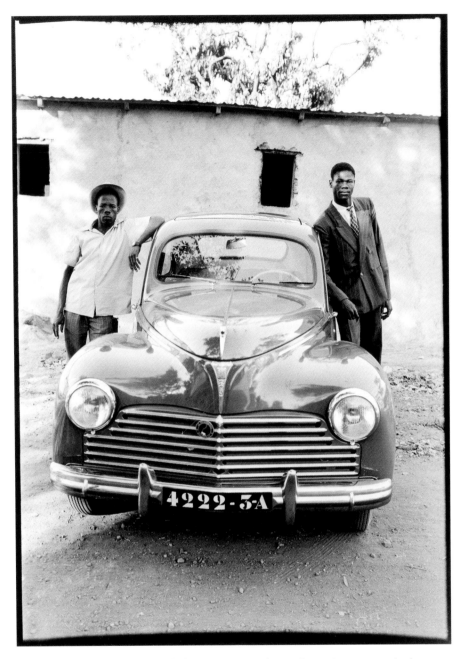

Figure 1.7. Seydou Keïta, *Untitled*, c. 1952–55. Gelatin silver print, 23 × 19 inches. Courtesy CAAC—The Pigozzi Collection. © Seydou Keïta/SKPEAC.

Beyond accessing imported materials and obtaining urban-centered professions, at this time, Bamakois elites began attending new social events. Among these were high-society dances and cinematic presentations at establishments such as Cinéma Mahl, which regularly screened French and American feature films—important transcultural media that were regularly referenced in local portraiture during subsequent decades.[31]

The urban environment offered many other benefits as well. In addition to the opportunity to access cash currency and other aforementioned amenities, for some it was a haven in which to escape agricultural and infrastructural forced labor (Little 1957, 580).[32] Moreover, new urban-centered professions not based on caste or ethnicity, such as tailoring, chauffeuring, and photography, were being developed in the territory between 1910 and 1930 (M. Sidibé 2005).[33] This represented a significant shift from customary rural practices, in which social status and career options were primarily determined by birthright. Alternately, this new context presented young men with the chance to more freely choose their profession—a privilege formerly open only to hunters—and break somewhat free of village-life constraints and familial obligations. About this situation, Bakary Sidibé attested that "the caste system and ethnicity does not hold the same power in urban areas. . . . In the city, people who are not blacksmiths can make pots and blacksmiths can be businessmen (Bakary Sidibé 2005).[34] Photographer Sidiki Sidibé stressed this point, stating that in cities, "you can try to do what you like" (S. Sidibé 2005).

Most who pursued these new fields were family members of the earliest generations of resident soldiers and government employees in the capital, who sought work in the developing urban locale. Iyouba Samaké explains, "During colonialism people were guards, policemen, or gendarmes working for the government [who were] obliged to come to cities. Families depended on them. Most had to find other work. That is why most photographers and tailors were related to those colonial officers. As families grew, the others had to find work in the young cities. Some think that they are more important than their ethnicity or caste, so they find work outside of those confines" (I. Samaké 2005). But it is important to recognize that the pursuit of these trades was not always by choice. Iyouba Samaké opined that people come to urban centers "looking for fortune [they] can't find in a village. Most of the time blacksmiths don't change their job because their work is needed here. [However] if a farmer comes to the city to find fortune, to try to find work here, they will have to do whatever type of job they can find to survive" (I. Samaké 2005).

The presence of colonial photographers increased during the 1920s and 1930s, just preceding the advent of a local African market for photography. In addition to producing postcards and "scenes and types" photographs, these men now accompanied motorized expeditions, aerial survey projects, and research experiments.[35] They worked for the colonial police, as in the case of French photographers Andréef (1920s and 1930s) and Vanetti (1930s to 1950s),[36] and participated in ethnographic studies and art-collecting missions, including one famously undertaken by Marcel Griaule and Michel Leiris, for French institutions.[37] Working alongside these men were the first recorded African photographers in Mali, such as André Touré (b. 1911), who worked as a photographic assistant during the missions of Georges Gizycki in 1928.[38]

According to historian Érika Nimis, the 1920s saw the earliest examples of portrait photography in the capital—created by French photographers such as Merle (Nimis 1998c, 14). This era also witnessed an influx of Lebanese Christians into francophone African cities, such as Bamako, Ségu, and Mopti, after France assumed political control of Lebanon in 1920. Many, such as Emile Zeydan in Mopti and Marcasan Jr. in Ségu, operated commercial businesses and became important figures in local markets and histories of photography (Elder 1997, 65–66).

Beyond new trades, French West African cities also offered their young inhabitants increased mobility as well as an environment that championed youth and, eventually, young people's capacity to hold social and political leadership positions (Little 1957, 580). In other words, the urban environment introduced new needs, resources, interests, networks, professional opportunities, and governmental power structures. In terms of the last, these contexts brought a reversal of village-based systems, which typically grant governing seats and related power to elders in accordance with communal values and established generational hierarchies. In the years following, this political hierarchy would be inverted in urban centers, such as Bamako, by first-generation évolués and their offspring.

As this discussion has shown, from the 1880s through the 1920s, photography in present-day Mali remained the prerogative of French colonials and Lebanese immigrants, whose presence was most strongly felt in urban capitals such as Bamako. The genres of photography the former produced in the region at the time continued in the imperialist vein. In these images, Malians are largely depicted as examples of ethnic or cultural "types." At times, those represented were the ones who worked most closely with the colonial administrators as interpreters, guides, assistants (often pejoratively referred to as "house boys"), and members of the Tirailleurs Sénégalais.[39] Thus, the photographic illustration of

social realities in Mali was, up to this point, predominantly the work of French and Lebanese photographers and of other Europeans who traveled throughout the territory for institutions like National Geographic and religious missions. But photography was not yet a local African phenomenon and had not yet developed local consumers, professional creators, or style. Rather, these developments began during the 1930s and 1940s.

In the first three decades of the twentieth century, most Africans in the French Sudan (Mali) first encountered photography within the context of colonial research or while taking identification photos for the French administration and its army. In addition to an increase in military conscription, the 1930s witnessed several ethnographic and scientific research expeditions in the region. Perhaps the most renowned and influential of these were undertaken by French anthropologist Marcel Griaule. In 1931, the same year the International Colonial Exhibition was held in Paris, Griaule, Leiris, and others embarked on an "ethnographic reconnaissance" mission between Dakar and Djibouti. Their task was to acquire "artifacts" from present-day Senegal and Mali for the Ethnographic Museum at the Trocadéro Palace (created in 1878), directed by Georges-Henri Rivière in Paris. Between May 31 and August 4, 1931, the entourage collected some nine hundred objects for the museum and took about five hundred photographs of rural West African lands, people, and artworks.[40]

During 1932 and 1933, another French mission, led by Charles Roux in the French Sudan, was designed to research the viability of producing vegetal fuel and crossing the Sahara by motorcar under the theme "motorization of Africa." Two years later, in 1935, eight hundred photographs and photographic negatives from that project were displayed at the Sudanese exhibition in Paris.[41] On view in galleries on the Champs Elysées and in the Grand Palais, these rural images were designed to let Parisians "get to know" the French Sudan, the Sahara desert, and their inhabitants through a French lens (*L'Économiste Soudanais* 1935c).

The 1930s also introduced popular African photographic production and consumption in Mali. However, access to photography at this early stage was largely determined by one's physical and social relationship to the French colonial community in urban centers such as Bamako (Nimis 1996, 13). As a result, unlike most colonial imagery of Africans in the territory, the majority of local African photographic commissions came from the urban middle and upper classes and were concentrated in the domain of portraiture.[42] These images were designed to depict a person's idealized identity, highlighting real or desired social status, modernity, and cosmopolitanism (figs. 1.6–1.8).

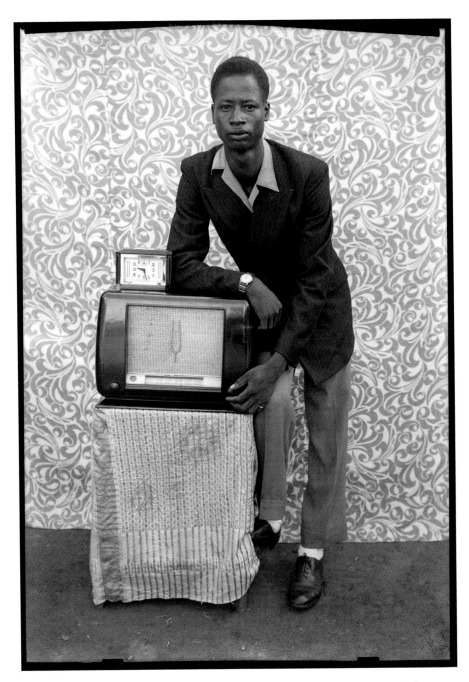

Figure 1.8. Seydou Keïta, *Untitled*, c. 1953–57. Gelatin silver print, 23 × 19 inches. Courtesy CAAC—The Pigozzi Collection. © Seydou Keïta/SKPEAC.

Early African photographers were presented with several ways to become acquainted with the medium. Some, such as Adama Kouyaté, obtained their materials from French soldiers and civil servants departing for Europe, who sold their equipment to African buyers on (A. Kouyaté 2004a). Others, such as Mountaga Dembélé and Mamadou Cissé, were able to purchase equipment or procure training through their service in the colonial army (B. D. Kouyaté 2004). Still other men, such as Seydou Keïta, received their first materials from relatives who traversed the territory on business, traveling between cities, or via commercial prize give-aways, as was the case for Baru Koné (Magnin 1998, 9; B. Koné 2004).

Many of these early African photographers claim to have been self-taught, learning photography through trial and error without assistance.[43] However, some acquired their knowledge of photographic processes while apprenticed to slightly older, more seasoned African photographers. For example, Seydou Keïta learned from Mountaga Dembélé, Mamadou Cissé from Guinean photographer Robert Bangoura, Mamadou Kanté (known as "Papa") from Kélétigi Touré, and Moumouni Koné from Youssouf Traoré. Likewise, several were able to obtain knowledge by observing the practices of, and conversations among, African colleagues and established European photographers. Most, such as Félix Diallo, Salif Camara, and Bogoba Coulibaly, benefited from the advice of French and Lebanese photographers. Diallo learned at the Kita mission, while the others were mentored by commercial practitioners Pierre Garnier and Roland La Salle (Nimis 1998c, 73; A. Kouyaté 2004a; Elder 1997, 13).

During the same period that Griaule first conducted research in the region, another French researcher-photographer, Captain Jules Garnier, was sent to study botany and herbal medicine in the French Sudan.[44] Over the three years he was stationed in Bamako (1931–34), the botanist befriended several of the young city's African inhabitants and taught a few of them, such as Baru Koné and Mountaga Dembélé, some aspects of photography (B. Koné 2004). However, it was his son, Pierre Garnier, who went on to become the most influential French photographer in Bamako during the 1930s and 1940s. Locally respected for studio portraiture and identification imagery, Garnier also produced postcard photographs depicting French colonial architectural and cultural "progress" in the capital from the 1930s to the 1950s (Nimis 1998c, 24).

In 1935, a year after his father's untimely passing,[45] Pierre Garnier and his mother opened a photography studio and supply store called Photo-Hall Soudanais in the heart of the capital city.[46] It readily became the nexus of local photography and provided products as well as

processed and developed film for European and African populations. It also served as a networking center for aspiring African photographers. For example, employed (and often trained) at the establishment were Baru Koné, Nabi Doumbia, Bogoba Coulibaly, Seydou Keïta, Félix Diallo, and Adama Kouyaté.

Early photographers came to the field with diverse social, economic, and professional experiences. Kélétigi Touré was an uneducated itinerant and studio photographer who entered the trade as a teenager during the 1930s (Monreal and Oliva 1997, 36–45). Youssouf Traoré, one of Mali's first professional photographers, was an illiterate mason who started practicing itinerant photography in the region of Buguni before opening his studio in the Dravéla neighborhood of Bamako (Nimis 1998c). Also in Buguni, Adama Kouyaté trained in leatherwork and shoe repair before entering the photography profession (A. Kouyaté 2004a). Likewise, Baru Koné was a "jack of all trades"—a plumber, electrician, blacksmith, and farmer—before he became a photographer (B. Koné 2004), and Seydou Keïta was trained as a carpenter (Magnin 1997, 16). Niether of these men had attended school, and both were illiterate. On the other hand, Nabi Doumbia (and likely his brother Bakary) and Bogoba Coulibaly were educated—Coulibaly at a primary school in Ségu and Doumbia at the École Normale in Kati where he "specialized in agricultural work" (Elder 1997, 89–93). Likewise, Samba Bâ, Mountaga Dembélé, and, later, Mamadou Keïta worked as primary school teachers, both before and while practicing photography (Nimis 1998c, 29–30). Dembélé also served in the Tirailleurs Sénégalais as a mechanic and electrician during World War II (Elder 1997, 74; Michetti-Prod'Hom 2003, 30–33). Although not all were initially elite or even urban, each was a young male with an entrepreneurial spirit that enabled engagement in a relatively recent and largely unfamiliar enterprise, and all (eventually) settled in an urban locale yet remained fairly mobile.[47]

Resulting from the manner in which their materials were obtained, African photographers during these decades worked with equipment and technologies similar to those of nineteenth-century colonial photographers. Their cameras were generally large-format wooden box versions (thirteen by eighteen inches), commonly known as view cameras (fig. 1.9a and fig. 1.9b), that were often secondhand and defective. Baru Koné described the process: "I used to take photos using a [view camera]. I would measure the distance . . . two meters [or] three meters, just the way that I wanted. Then I arranged the person for the photo . . . put my head in the box, and took the picture" (B. Koné 2004).

In contrast to photography today, this technology was relatively slow and required exposure times of several seconds. Like rigid Victorian

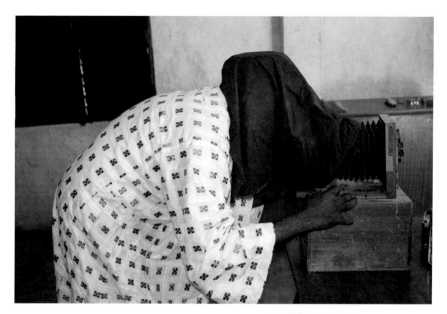

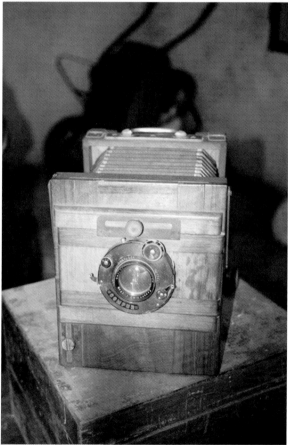

Figures 1.9a and 1.9b. Adama Kouyaté with his view camera. Photos by author, Ségu, 2004.

portraits, people tend to look "frozen" in some of these early images due to the long exposure times. Thus, it is important to keep in mind that the formal postures and reserved expressions in early French Sudanese portraits resulted from several variables, including available technology and aesthetic influences. The latter includes Victorian photography, which affected portrait photography across the globe as well as local methods of representing esteemed individuals (Mack 1991, 64). For example, many authors consider the frontally seated, hands-on-knees posture prevalent in early African-produced photographic portraiture indicative of the influence of colonial photography. However, as Sprague and Geary have argued, the practice probably results from long-standing means of depicting enthroned African leaders and other prominent figures (Sprague 1978, 52–59; Geary 1997, 409; for examples, see Colleyn 2001, 161; Phillips 1999, 412).[48] Alternatively, particular visual aids or props pictured in these images, such as the table stand, pillar, painted scenic backdrop, and floral arrangement, likely derive from Victorian portrait practices (fig. 1.10).

Climactic conditions in the French Sudan (dust, powerful sunlight, and high temperatures) required photographers to creatively adapt the technology to their environment in accordance with accessible resources. This was true during these early phases, when available chemicals and related materials were less sensitive—taking longer to develop and print—and were prepared by the photographer himself. It remained so as the technology evolved and presented new challenges over the course of the century (B. Koné 2004). Through the years, each photographer had to invent a new way of confronting the same obstacles, which resulted in individuated end products as well as many artistic trade secrets.

Unlike some of the first French studio photographers in Bamako, whose establishments were indoors—using available electricity and flash technology—and incorporated a darkroom laboratory, early African portrait and identification photographers in the capital operated plein air, or outdoor, studios. Most often they worked out of their domestic courtyards or in those of their clients. Likewise, their darkroom facilities were usually in a room at home, often the photographer's bedroom. This was the case in other areas of western Africa as well, as Nigerian photographer J. D. 'Okhai Ojeikere explained: "Call it a 'studio' if you want. It was simply where I could be found. I took photographs in a small passageway of the house, without a flash or electric lighting" (Magnin 2000, 40–41). Malian photographer Baru Koné similarly stated, "Everyone used to work at home [at that time]. . . . We had no studio. It was outside" (B. Koné 2004).

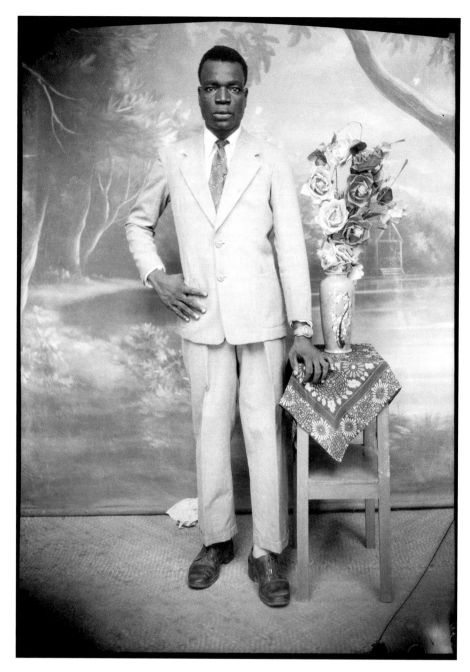

Figure 1.10. Seydou Keïta, *Untitled*, c. 1948–54. Gelatin silver print, 23 × 19 inches. Courtesy CAAC—The Pigozzi Collection. © Seydou Keïta/SKPEAC.

Without electricity, early photographers worked with natural sunlight to create their photographic negatives and prints. Most cameras at this time featured large-format, dry-plate glass negatives that allowed the photographer to print through the glass directly onto the paper. For example, Seydou Keïta explained that his thirteen-by-eighteen-inch view camera, which he purchased from Pierre Garnier, "had a chassis for the prints, so I made all of my prints directly on 13x18 inch paper . . . I didn't need [an] enlarger" (Elder 1997, 72). At the time, direct printing was possible with either large-format glass plate or gelatin-coated paper negatives, which, due to their size (nine-by-fourteen, thirteen-by-eighteen, and eighteen-by-twenty-four-inch formats), did not require the use of artificial light or an enlarger. Baru Koné (2004) described the process of direct printing outdoors, "First, you lay the paper on a flat surface. Then, place the negative on top [of it]. This is how we used to print from the sun. It would take two to three minutes at most." Koné also explained that photographs printed by the sun were sepia toned while those made by artificial light and an enlarger were black and white.

Employing similar technology in neighboring Nigeria, Stephen Sprague reported that photographers used mirrors to redirect concentrated sunlight for indoor printing before the local accessibility of electricity (Sprague 1978, 52–59). In present-day Mali, Moussa Diarra resorted to similar tactics to make his prints at home in Buguni (M. Diarra 2004). Unlike resident French and Lebanese photographers of the day, most African photographers in Bamako and smaller cities along the Niger River did not own an enlarger at this time (M. Sidibé 2003). Access to one usually required collaboration with or solicitation of those who owned such valuable equipment. For example, on occasion, photographers throughout the region commissioned Pierre Garnier to print enlargements.[49] In Mopti around the same time, African photographers such as Hassan Traoré solicited Lebanese photographer Rahael Moukarzel (purportedly the first photographer in Mopti) for the use of his enlarger to print their photographs (Malick Sitou 2004). However, in Bamako, Baru Koné and Mountaga Dembélé were two of a few African photographers to possess enlargers at this early stage. A talented blacksmith, Koné personally manufactured his enlarger out of recycled metal in Bamako (B. Koné 2004). Dembélé ordered his Impérateur enlarger while in France with the military after World War II and finally received it in Bamako in 1947 (Nimis 1998c, 31–33). By 1948, Seydou Keïta employed Dembélé's device to make his prints (Magnin 1997, 9, 11).[50]

Photographers also invented ways to generate light at night, when they had more free time for printing. Like photographers in Nigeria during the twentieth century, who used motorbikes for this purpose,

African photographers in the French Sudan employed bicycle "dynamos" and kerosene lamps to make prints at home in the city and while away in rural villages. As Seydou Keïta stated, "Every so often I had to go up country to take photos for identification cards. Because there wasn't any electricity, I put together a contraption that I could take with me and use to make my photos anywhere. I took a metal petrol barrel and made a hole in it with a slide and fitted a piece of red-painted glass which acted as a filter. Inside was the kerosene lamp which allowed me to develop my prints. This is how I printed my work in the villages" (Magnin 1997, 11). Mountaga Dembélé recounts printing in a similar manner, "I used the Petromax [lamp] in order to make prints at night. . . . Depending on the light, sometimes one exposed for 2 seconds, 1 second, it could even go up to six seconds. . . . Even with the dynamo of my bicycle . . . I was able to make enlargements, prints, everything. I took it to Timbuktu, to Gao, everywhere" (Elder 1997, 76).

Although photography was practiced in Bamako and other areas of the French Sudan during the 1930s, the preeminence it enjoyed during its golden age did not truly begin until the late 1940s. The delay likely resulted from combined economic, social, and governmental factors. In the 1930s, Bamako's population grew at a fairly slow pace, from 20,000 in 1931 to 21,391 in 1936 (Bleneau and Cognata 1972, 26–42; Villien-Rossi 1963, 381). At this time much of the world, including Africa, had been significantly affected by the economic crisis known as the Great Depression. In the French Sudan, a decrease in cash-crop prices and exports resulted in increased unemployment. The situation worsened as taxation levies escalated in the territory throughout the decade. In order to pay obligatory tariffs and subsist during this period of severe poverty, some rural inhabitants moved to the cities. However, as evidenced by Bamako's slow population growth during these years, many more were recruited—or resigned—to work for newly instated grand-scale rural agricultural programs, such as the Office du Niger, designed to boost cotton, tea, peanut, tobacco, and rice cash-crop markets in the French Sudan.[51] Ultimately, though, many of these workers, including women and children, toiled for little or no pay as forced laborers (Lydon 2000, 61–71).[52] Others, approximately thirty to forty thousand at this time, migrated seasonally to Senegal and the Ivory Coast seeking agricultural work (Foltz 1965, 46).

Despite the Great Depression, the capital continued to undergo visual, cultural, and infrastructural changes throughout the decade to perpetuate *la mission civilisatrice* and highlight colonial progress. For example, the year that Jules Garnier arrived in Bamako (1931), a leprosy hospital and research institution opened in the city (Imperato 2008, 158).[53] In May of that year, in celebration of colonial conquest of the territory and

subsequent French political authority, several roads were named after early French colonial administrators and explorers: Rue de Tretinian, General Brière de l'Isle, Avenue Maréchal Gallièni, and Avenue Ballay. To honor African soldiers who fought in the French forces in World War I, another street was christened Rue Tirailleurs Sénégalais.

In 1932, when Baru Koné's father began working for the colonial police, the School of Sudanese Artisans was founded by Le Gall, professor at the Paris School of Applied Arts, in the center of the capital (B. Koné 2004; A. O. Konaré and A. B. Konaré 1981, 122).[54] Photographers Malick Sidibé and Diango Cissé studied visual arts at the institution prior to their respective professional careers in the 1950s and 1970s.

In 1936, Governor Alfassa launched a plan to construct and preserve monuments in Bamako that above all exalted the "pacification and civilization" efforts of French colonization (Barry 2003, 17). Two years later, the Grand Hôtel du Niger (also known simply as Le Grand Hôtel) was operational in the capital (L'Economiste Soudanais 1938, 1),[55] and two elementary schools, the Republic Square School and the Rural School of Bamako, were respectively renamed after the former head of education (Jean-Louis Monod) and the former mayor (Benoit Debonne).[56] Continuing the colonial project, the annual Bamako Fair, held in February the following year, exhibited numerous French appliances and technological advances.[57]

During the 1930s, infrastructure and transportation were improved in the territory, particularly for the European population, and agricultural campaigns were underway. For instance, in 1932, the aforementioned irrigation scheme, Office du Niger, was created northeast of Ségu in the Niger River delta. In 1936, a year after a thermoelectric plant was installed in the Markala-Ségu area, a telephone service was organized in the French Sudan (Bulletin de l'Afrique Noire 1973, 14). In 1938, Air France introduced a Dakar–Bamako line, and Air Afrique regularly advertised flights between Bamako and Marseilles (L'Économiste Soudanais 1938, 1).

The year 1936 was also important politically; it marked the formation of the Popular Front socialist government in France, whose ideals resonated with many in the growing évolué community in Bamako. It cited its aim as "the defense of all the oppressed without distinction of race" and promised to make the colonial system "more humane" (Lydon 2000, 63). Marius Moutet became the first socialist minister of the colonies, and Marcel Jules de Coppet was appointed the governor-general of French West Africa. The latter created the SFIO (French Section of the International Worker) socialist party in French West Africa and wrote legislation that legalized labor unions and the organization of African elite as means to political emancipation and an end to the indigénat policy

of forced labor in the French African colonies. He was also the first in his position to observe the Muslim holidays of Ramadan (*'id al fitr*) and Tabaski (*'id al-adha*) in the territory and the first to invite African students to the colonial palace (Lydon 2000, 63).

In the 1930s, évolués—the educated elite—continued to represent a relatively small percentage of the total population. Estimates suggest only 3 percent of school-age children attended primary school at this time, and decidedly fewer went on to pursue a secondary education. Of those, several attended the federal William-Ponty School near Dakar, Senegal, which trained teachers, civil servants, and assistant doctors, although the institution granted a mere two thousand degrees between 1918 and 1945. Nevertheless, individuals of this minority sect eventually became highly influential and played primary leadership roles in the fight for independence. Members of this community, along with French sympathizers, created the Sudanese Popular Front in Bamako, followed by the Association of Sudanese Scholars (later renamed Foyer du Soudan) in 1937 (Foltz 1965, 20–21, 119–24). The latter evolved into an extremely active organization from which sprung most of the earliest political parties in the territory after World War II (Imperato 2008, 27). Already evident among these individuals were undercurrents of nationalism and pan-Africanism—sociopolitical movements that would later ignite in the mid-1940s and thrive during the 1950s and 1960s (Cohen 1971, 197).

To manage the anticolonial dimension of this population and thwart its primary agents, the colonial administration created the infamous Kidal prison in the 1930s. Located in the Sahara desert at Kidal, this facility has been known as "the worst" in the country for decades (B. Sidibé 2004). Its communal holding cell, exposed to the elements and harsh midday sun, was equipped with low entranceways (that had to be humiliatingly crawled through) and lacked basic amenities. Until it was closed by Alpha Oumar Konaré in December of 1997, the penal institution was used predominantly to house political prisoners (Imperato 2008, 178–79).

With similar impetus, the Laval Decree, passed in 1934, instituted an elevated, comprehensive policy of surveillance in the French colonies. According to Nimis, after this legislation was instated, the production and dissemination of film was strictly regulated throughout French West Africa. In other words, at this time photography remained under tight surveillance, conceived as technology in the service of colonial interests (Nimis 1996, 22; I. Samaké 2004). This conservative plan came on the heels of the system of censorship and scrutiny, in place two years prior, that deemed postal services subject to inspection three times per year and required individuals to procure authorization from the administrator in chief of the colonies to posses a radio or camera.[58]

From this period until independence in 1960, Africans who were able to access photographic materials, particularly those trained by French practitioners such as Garnier, were thus subjected to restrictive measures. Malick Sidibé recalled, "During the colonial period . . . it was not all that easy for a white boss to show his African employee how to use a camera. . . . [Many] Africans who were employed by [French] photographers were not even able to have a camera in their hands!" (M. Sidibé 2004).[59] Due in part to this colonial policy and, as Tanya Elder rightly suggests, to strategic practices designed to ensure the commercial monopoly of French photographers, the training of African apprentices was confined to one or two (but not all) aspects of the photographic process. In other words, one might have learned how to compose a picture, *or* how to develop, *or* how to print, *or* how to retouch negatives, but not all of these. African assistants often were denied knowledge of film development in these early years. For example, according to Mountaga Dembélé, "Garnier worked alone in [his] darkroom . . . [and thus] controlled the development of the film."[60] For several years he kept that part of the process hidden from his African assistants and out of their reach, thereby safeguarding his professional monopoly and market demand (Elder 1997, 71).

Needless to say, the tactic worked. Many African photographers in and outside the capital had no choice but to send their film to to be developed by Garnier because they lacked the requisite knowledge of the technical process. In fact, Elder concludes that it was not until after European and Lebanese photographers recognized that they could increase their profits by selling darkroom materials to local African photographers that African photographers were "able to become autonomous practitioners" (Elder 1997, 72). Certainly, this transition also resulted from a transformation of colonial policies on the control and surveillance of photographic equipment and technology, which became less stringent in the early 1940s. Testament to this shift, in 1942, Nabi Doumbia became the first African photographer employed at the Sûreté Soudan, or French Sudan Police (Nimis 1996, 18). In addition, other independent professional photographers, such as Baru Koné, took politically oriented photographs during this era (B. Koné 2004). Some were commissioned by incipient African leaders while others, like Adama Kouyaté, created such imagery out of personal interest or due to their active participation in the African-driven sociopolitical movements of the day (A. Kouyaté 2004a).[61]

More comprehensively, and especially on a sociopolitical level, the second half of the 1940s was a period of heightened change that marked the beginning of the march toward independence. From this period onward, social activism became more pronounced and widespread.[62] In fact, photographer Adama Kouyaté refers to the period between 1946

and 1968 as "militant" (A. Kouyaté 2004a, 2004b). Mass protests were held, driven by popular disdain for restrictive and abusive colonial programs such as the *corvée*, *indigénat*, military conscription, escalating taxation, and lack of legal rights and political representation, not to mention the demoralizing treatment of the Tirailleurs Sénégalais by de Gaulle's government after World War II.[63] In addition, between 1944 and 1945, panregional French West African labor unions such as the trade labor union of Sudan (URSS) were established, and special interest groups, such as the Foyer du Soudan,[64] were formed, leading to the early stages of political party movements throughout the territory (Foltz 1965, 21, 49; Imperato 2008, 123).[65] Perhaps the most publicized revolts were those of the Tirailleurs Sénégalais at barracks near Thiaroye, Senegal, in 1944. The repercussions were felt far and wide.[66] These events catalyzed major reforms in French West African social and political policies between 1945 and 1960 (Echenberg 1991, 105; Cohen 1971, 200). For instance, they helped incite the 1945 Brazzaville conference, which resulted in the laws of Houphouët-Biogny (abolished forced labor in the French colonies)[67] and Lamine Gueye (established French citizenship for all former French "subjects") in 1946[68] and the articulation of a new constitution (Constitution of the French Union) that same year (Lee 1986, 81).[69] With citizenship and the creation of the French Union came previously denied electoral privileges. The first elections were held in the fall of 1946.[70]

Although progress was being made toward greater equality—witnessing the emergence and influence of young, talented, educated African leaders such as Modibo Keïta,[71] Mamadou Konaté,[72] Mamadou Sangaré,[73] Fily Dabo Sissoko,[74] and Makan Macoumba Diabaté[75]—the quest for equal human rights remained a constant struggle. Many if not all of these prominent African figures were regularly monitored, relocated, fined, restrained, and incarcerated by the French colonial government.[76] Popular religious figures, such as Cheikh Hamallah, were afforded similar treatment by the French administration.[77] Battling the growing Islamization of the day, the government arrested Hamallah and exiled him to Algeria in 1941, where he died in 1943 (Konaré and Konaré 1981, 125, 127–28; Triaud 2010, 836).[78]

It was within this context that the golden age of black-and-white photography in Mali truly began. This was due in part to the vast numbers of Tirailleurs Sénégalais returning home after World War II (first to Bamako, where many remained and thus contributed to the city's rapid population growth to circa seventy thousand in 1948 compared with thirty-seven thousand in 1945). It was also incited by 1946 legislation that rendered all African inhabitants of French West Africa as French citizens, resulting in

new requirements for identification photographs (Echenberg 1991, 112; Meillasoux 1968, 12).[79] Affected by this boom, several first-generation[80] African photographers in Mali, such as Mountaga Dembélé, Kélétigi Touré, Sadio Diakité, Youssouf Traoré, Nabi Doumbia, Bogoba Coulibaly, Baru Koné, Moumouni Koné, Adama Kouyaté, Mamadou Cissé,[81] and Seydou Keïta, had successful careers by the early 1950s.[82] Malick Sidibé recalls that by 1952 Keïta was "already famous [and] rich. He even had a car" (M. Sidibé 2003; Lamunière 2001b, 55). Bâ Tièkòrò Keïta, Seydou's uncle, corroborates Sidibé's testimony: "It wasn't long before [Seydou Keïta] was taking care of most of his father's family's expenses and even those of my family. He bought the millet, rice, and other things, and paid the electricity bill and all the taxes. He did this from 1939, at the beginning of WWII, and continued until his father's death twenty years later" (Magnin 1997, 17). Even Keïta himself admitted, "I made a good living from photography and even bought a Peugeot 203 in 1952 or 1953 and then a Simca Versailles around 1955" (Magnin 1997, 11).

Throughout French West African territory during the 1940s and 1950s, "studios sprang up everywhere, ranging from sheds to elaborate commercial buildings" (Geary 1997, 408).[83] At this time, electricity began to reach more towns and a greater number of Bamako neighborhoods, although studios operated by African photographers were not electrified in the city until after the late 1950s.[84] Along with the Bamako's first taxi in 1942, these improvements were part of Governor Emile Louveau's plan to make the capital a "beautiful metropolis" (Magnin 1997, 285–86; Konaré and Konaré 1981, 127–28). In the early 1940s, this included numerous construction projects: the School of Public Works, the Modern College of Young Girls, and four new neighborhoods. Additionally, in 1948, the Vincent Auriol Bridge (commonly called "the Old Bridge") was inaugurated in Bamako. By 1960, it would finally allow traffic to cross the river between the northeastern (older) and southwestern (newer) sections of the city (Konaré and Konaré 1981, 61).

In spite of this growth, however, the photographic community remained relatively small in the French Sudan, where, according to Adama Kouyaté, everyone "knew each other." In particular, Kouyaté said he "met all of the early photographers at [Pierre] Garnier's lab: Toumani Diakité, Bakary Diarra, Mountaga Dembélé, Samba Bâ, Boundiala Doumbia, Youssouf Traoré, and Roland la Salle" (A. Kouyaté 2004a). Similarly, Moumouni Koné said he knew "Mountaga Dembélé and Seydou Keïta [because they] were in the same neighborhood . . . and all [of them] used to collaborate [and] exchange materials" (M. Koné 2004).

These early practitioners were often itinerant or studio photographers. The latter were commonly tied to elite members of the city.[85]

Although they produced work in myriad genres—documentary (*report-age* in French), advertising, landscapes, and so forth—they predominantly engaged in the production of identification photos and portraiture.[86] In fact, at this time, having an identification portrait made was most people's first experience with the medium. For example, Iyouba Samaké made his first visit to a photography studio in 1947 in order to commission an ID photo for work (I. Samaké 2004).[87] Citing the significance of identification photographs, Baru Koné recalls that during this period, "Nothing [went] without photography. It was very important at the time" (B. Koné 2004).

Still reserved mainly for the elite and middle-class segments of the population,[88] photographs during this period remained relatively expensive. It cost circa 150 francs for identification pictures and 300 francs for portrait and postcard photographs (compared, in 1948, to 10 francs for three eggs, 20 francs for a pair of pigeons, and 600 francs for an entire sheep; B. Koné 2004; Konaré and Konaré 1981, 140).[89] Yet, for those who could afford the luxury, visiting a photographer's studio became a favorite event. In fact, according to Seydou Keïta, from the 1940s to the 1970s, clientele would form lines that often encircled his studio space (Magnin 1997, 9). This was particularly true during the evening, when people had more free time and climactic temperatures decreased. Saturdays and Thursdays were the busiest occasions (considered auspicious days on which weddings are held), along with holidays, such as Ramadan and Tabaski, and market days (M. Sidibé 2004).[90] As Keïta described this phenomenon, "There was always a crowd around my studio and I was working all of the time. All the elite in Bamako came to be photographed by me: government workers, shop owners, politicians. Everyone passed through my studio at one time or another. Some days, especially Saturdays, there were hundreds of people" (Magnin 1997, 9). Similarly, describing studio business two decades later, Malick Sidibé recounted, "The busiest period at my studio was always towards the end of Ramadan. People saved up and bought brand new clothes for the festival . . . and had themselves photographed in their new clothes" (Magnin 1998, 38). The trend continued for several more decades, as illustrated in the photographic archives of photographers, such as Sidibé in Bamako and Tijani Sitou in Mopti, which house portraits of individuals with their sacred Tabaski sheep from the 1960s and 1970s, respectively (see fig. I.5).

The tastes, popular trends, sociopolitical affiliations, and religious associations of this demographic, as well as the aforementioned social, cultural, and political changes of the age, were visually evident in their photographic images. Today, however, only a small number of photographic negatives and prints from the 1940s remain or are publically

accessible. Original prints held in family collections, and those retained or sold by frame maker Cheickna Touré, are among the best visual sources from this period (see Chapoutot 2016). Most negatives from this time have been lost to flooding, fire, decay, and the colonial practice of burning negatives, both annually and upon exodus of the country (Guillat-Guignard 2016). As a result, most of the earliest remaining examples date to the 1950s and, as such, are discussed in the following chapter.

Notes

1. Known as "scenes and types," this genre is exemplified in Abdon-Eugène Mage's (1868) *Voyage dans le Soudan Occidental*.

2. It should be noted that in African coastal areas at this time, documentary photography was accompanied by portraiture. By the 1860s, for example, there were practicing African itinerant and studio photographers in Freetown, Sierra Leone, serving local urban elite (Viditz-Ward 1999, 36). This was not so in the Upper Senegal during the 1880s.

3. In 1861, the French minister of war decreed that every army brigade contain at least one photographer (Marien 2002, 86).

4. Gallièni's last expedition (1887–88) photographed local scenery and the construction of roads, bridges, railways, and forts in the environs of the Niger River and Kayes for the French Geographical Society (Duclos 1992, 15). This focus continued through the turn of the twentieth century, when French colonial artillery captain Eugene Lenfant was sent to explore the Niger River and took over three hundred photographs (Vassalo 2003, 121).

5. According to Amadou Malick Guissé, the earliest postcards of Bamako, which depict *tamtam* music and dance festivals, date to 1898 (Guissé 2010, 8–10).

6. For examples dating to the early twentieth century, see Centre des Archives d'Outre-Mer, FM, DFC, XXXIX, MEMOIRES/194, ICO 30FI/17. To review samples of Fortier's postcards, consult the Centre Edmond Fortier website (n.d.).

7. France's assimilation policy, *la mission civilisatrice*, attempted to conform Africans to French culture. French citizenship, however, was not extended to most Africans in francophone territories until 1946 (Foltz 1965, 10; Mustafa 2002, 175).

8. Several images from 1881 to 1948, which depict the construction of forts, railways, roads, bridges, dams, monuments, and administrative buildings, are housed in the Centre des Archives d'Outre-Mer under FM, DFC, XXXIX, MEMOIRES/194, ICO 30FI/12.

9. Among the specialties Fortier advertised on his business card were "collections of views and indigenous types" (Prochaska 1991, 44). Philippe David credits these themes and an emphasis on African exoticism to "local [European] editors" such as Fortier, a prolific photographer-editor based in Dakar from 1900–10 (David 1978, 10–11).

10. The invention of halftone printing in the 1880s enabled photographs to be reproduced in books, magazines, and newspapers (Roberts and Roberts 1988, 10 and 14; Marien 2002, 167).

11. Certainly photographers, officials, scientists, editors, publishers, authors, explorers, missionaries, vendors, and consumers coauthor the meaning and function of these images as they move through time and space. Christraud Geary has argued that many African subjects also exercised some degree of agency regarding the content and appearance of their image in colonial photographs. Thus, it is possible that the perception and significance of these photographs among Africans and even the photographers who pictured them varied drastically from that popularized via the selection and distribution processes of the commercial and colonial administrative systems (Geary 2001).

12. Rock paintings from the Paleolithic era (c. 8,000–5,000 BCE), discovered by Françs Zeltner in caves under Point G on Kuluba in Bamako in 1911, suggest the area was once occupied by nomadic groups that originated from the eastern Sahara desert (Villien-Rossi 1963, 379; Becchetti-Laure 1990, 31; Barry 2003, 143). However, most accounts date Bamako's origin to the seventeenth century (Villien-Rossi 1963, 380; Becchetti-Laure 1990, 32; Archives Nationales du Mali, *Repertoire Fonds Anciens 1855–1954*, ID 33-3, "Borgnis-Desbordes," 11–14; Meillassoux 1968, 4, 6–9; Magnin 1997, 282). Three related families—Niâré, Touré, and Dravé—provided the town with its earliest neighborhoods (Niâréla, Touréla [currently Bagadadji], and Dravéla), which were accompanied by the neighborhood of Bozo fishermen (Bozola).

13. While Imperato holds conflicting dates for this history in his 1977 and 2008 editions, 1805 seems accurate given that Mungo Park traveled from Bamako to Sansanding and "left Sansanding on 17 November 1805" (Imperato 2008, 236).

14. To reach the Niger River at Bamako and establish a military fort, Borgnis-Desbordes undertook three separate expeditions (1880–81, 1881–82, and 1882–83). During his first mission, Borgnis-Desbordes established a depot in Kayes, occupied the territory up to Kita, and researched the construction of telegraphic lines to be used by military personnel. Bamako was the objective of his second expedition, but it became impossible to send troops up the Senegal River due to a plague of yellow fever. During his final expedition to Bamako, he left Kita, and, on February 7, 1883, construction began on the fort in Bamako, primarily by European workers, auxiliary African workers recruited from Senegal, and Chinese laborers, using stones extracted from Kuluba and wood cut from along the Oyako River. It was completed April 19, 1883, and Borgnis-Desbordes left Bamako the following week, on April 27, 1883 (Archives Nationales du Mali, *Repertoire Fonds Anciens 1855–1954*, ID 33-3, 17, 19, 20–23; Centre des Archives d'Outre-Mer, 14 MIOM/2275, 15G/24).

15. Samory Touré (c. 1830–1900), born in present-day Guinea, was a powerful Muslim cleric, local chief, and *almamy* (prayer leader) who established a large state in the nineteenth century that spanned much of today's Ivory Coast, Guinea, Burkina Faso, and southern Mali (Imperato 1989, 33).

16. According to Malian scholar Youssouf Tata Cissé, taxation has existed in the territory at least since the seventeenth century, preexisting French colonialism (Magnin 1997, 283). However, the colonial "head tax," or "capitation," that Africans were required to pay in cash, and "prestation,"

a local tax to finance road maintenance payable either through labor or a designated monetary sum, regularly resulted in forced labor known as the *corvée* (Foltz 1965, 32; Gorer 1970, 102; Imperato 2008, 118–19).

17. Before 1857, when Louis Faidherbe created the Tirailleurs Sénégalais, West African members of the French military were often slaves, captives, or other lower-class individuals involuntarily sold into military servitude (J. Thompson 1990, 423). Following a period of increasing recruitment, in 1912 Governor-General William Morleau-Ponty enacted a law calling for the partial conscription of Tirailleurs Sénégalais soldiers, which produced 170,000 Africans during World War I (Echenberg 1991, 25). This conscription law of February 7, 1912, rendered annual interwar levies for Tirailleurs Sénégalais membership averaging 12,000 men for all of French West Africa, which later led to full conscription in the form of an annual draft with the passing of the conscription law of 1919 (Mann 2000, 8; Echenberg 1991, 29, 49).

18. Like taxation and military conscription, forced labor was most directly the jurisdiction of village and *canton* chiefs, who were required by the colonial administration "to provide manpower for public works construction, especially roads. [These] workers were not compensated and were often forced to work against their will" (Imperato 2008, 118–19; Foltz 1965, 13). Generally speaking, all public works projects at this time were the result of unpaid labor (Gorer 1970, 105–7). Although these practices were widespread, Africans did not passively accept them. Many relocated to growing urban centers in avoidance, and others revolted (Imperato 2008, 40; Echenberg 1991, 38, 41; Mann 2000, 8).

19. According to Tièkòrò Keïta (Seydou Keïta's uncle), Bakary Keïta relocated to Bamako sometime between 1888 and 1890 and worked there as a tailor until about 1920, when he was appointed assistant to the high court justice (Magnin 1997, 15, 284–85).

20. According to Foltz, "it was not until the reforms of 1902–1905 that the federation became an administrative and political reality. . . . The crucial step was [the creation] of [the 1904] constitution for French West Africa (A.O.F.) which gave the governor-general the power to raise money for the federal government by taxing the imports and exports of the individual territories. . . the interior land was established as a vast colony bearing the name Haut-Sénégal-Niger . . . with its capital in Bamako" (Foltz 1965, 16–17).

21. Meillassoux's numbers are lower than those of the other authors: six thousand in 1907 and seven thousand in 1912 (Meillassoux 1968, 9).

22. From 1911 to 1914, the Upper Senegal and Middle Niger experienced a devastating drought, and the victims numbered between 250,000 and 300,000 (Konaré and Konaré 1981, 103–5). This circumstance brought rural farmers and herders from the northern regions to areas in the South as well as to urban areas such as Bamako.

23. According to Gregory Mann, "approximately 160,000 West African troops [Tirailleurs Sénégalais] served in [World War I], and roughly 30,000 of them were killed. They were used almost entirely as combat troops" (Mann 2000, 7). Myron Echenberg's numbers are slightly higher: Spanning five years of combat during World War I, "French West Africa furnished 170,891 men . . . [with] 30,000 killed in action" (Echenberg 1991, 25, 46).

24. Echenberg argues that veterans, in urban settings, often adopted "French tastes in dress and food. . . . Tobacco and alcohol were also products that had their appeal among ex-servicemen" (Echenberg 1991, 140). Corroborating this account, Baru Koné recalled that "all the military guys smoked" in Kati, where he lived with his brother-in-law Jean Ambourazine, a soldier who led Koné to photography in the 1930s (B. Koné 2004).

25. This was true after World War I but became more pronounced after World War II and the French wars in Indochina during the 1950s (Echenberg 1991, 104, 113). Mann notes, "In the 1950s West African soldiers acquired much more advanced technical skills than had their fathers' and grandfathers' generations. They were, for example, allowed to serve as mechanics, drivers, and photographers; each of these activities gave them skills valuable in civilian life" (Mann 2000, 9). Not surprisingly, then, conscription into Tirailleurs Sénégalais service, and relationships with colonial administrators and military personnel, were the primary vehicles through which many early African photographers in present-day Mali became familiar with the medium.

26. At its origin, the term *évolué* (an "advanced," "broad-minded," or "evolved" person) reflects a pejorative, racist slant informed by Western bias. Ultimately, it suggests that African urban elite—who assimilated French culture and are literate—are more culturally advanced or "civilized" than their village-based and illiterate relatives. This book does not intend to perpetuate such negative implications. Rather, in this context, the term infers the particular social status, education, literacy, cosmopolitanism, and cultural tastes of the urban elite in Bamako, without requiring the frequent reiteration of these associative adjectives.

27. In 1903, teachers were sent to Bamako to recruit the sons of chiefs (young men of the traditional elite) to attend the École des fils des Chefs in Kayes. In 1915, the school was transferred to Bamako under the name L'École professionnelle centrale et des fils des chefs, which later became the École primaire supérieure et d'apprentissage in 1923, the Lycée Terrasson de Fougères in 1950, and the Lycée Askia Mohamed in 1961. In addition, primary schools existed in the city around the turn of the century. By the end of 1905, for example, Jean-Louis Manod had created an elementary school for boys in Bamako that, in 1906, had an enrollment of twenty-six students. According to archival records, there were 282 students attending French schools in Bamako by 1912 (Echenberg 1991, 18; Konaré and Konaré 1981, 110; Archives Nationales du Mali, *Repertoire Fonds Recents*, book 2, *1918–1960*, 2D-138/1, letter sent May 22, 1930, from Kuluba to the governor of the Colonies).

28. The École William Ponty, located near Dakar, Senegal, granted some two thousand degrees between 1918 and 1945 and was responsible for training numerous West African teachers, civil servants, and assistant doctors (Foltz 1965, 21; Echenberg 1991, 116). Fily Dabo Sissoko graduated from the school in 1918, as did fellow future political leaders Modibo Keïta, Mamadou Konaté, and Léopold Sédar Senghor, to name a few (Imperato 2008, 169, 186, 272).

29. In 1932, for example, Iyouba Samaké's father went from being in the Tirailleur Sénégalais to serving as a policeman in the capital city (I. Samaké

2005). The colonial police department, Service special de la sûreté (the Sûreté Nationale after independence), was officially created in the territory in 1925 (Konaré and Konaré 1981, 117). In Bamako, the service employed French photographers Vanetti and Andréef and, later, Malian photographers Nabi Doumbia and Seydou Keïta.

30. According to his son, Tièmòkò, Bakary Keïta did not look favorably on his appointment, and when he initially refused the position "on moral grounds," he was jailed. He was finally persuaded to accept the post by several of his notable friends, such as the father of future political leader Mamadou Konaté. Keïta's story thus illustrates the intimate nature of the évolué community in Bamako at the time and suggests that migrating to the capital and holding such positions of prestige were not always the result of choice and, therefore, may not reflect these individuals' values or ideals.

31. At least two cinemas were in business during this period in Bamako: one operated by a man named Mahl and his wife (which was frequented by local African populations as well as Europeans) and another smaller cinema run by Debove at the train station called Buffet de la Gare, which was patronized only by Europeans. Both were commanded by the Société des Cinémas Maurice in Dakar, which furnished them with French and American films. Monitored by the Sûreté (police) in Bamako, films for African audiences were often censored and designed for social education. According to a colonial report dated January 24, 1938, Cinéma Mahl held six hundred seats and offered three showings per week while the Buffet de la Gare contained only fifty places and projected films four times per week. This report states that about five hundred "locals" attended the viewings each month. The cost for Cinéma Mahl was two to five francs per seat. Buffet de la Gare's prices were more expensive (Archives Nationale du Mali, *Repertoire Fonds Recents*, book 2, *1918–1960*, ID-62, "Cinéma 1932–1936"). Iyouba Samaké recalls that "Soudan Ciné [Soudan Cinéma] belonged to Mr. Mahl" and was also called "Cinéma Mahl." To see a film there during the 1940s "cost *tama* (1 franc) to sit on a wooden bench, 2 francs to sit on a chair, and 3 francs to sit in an armchair (for the French only)" (I. Samaké 2004). Mr. Mahl was also the proprietor of Bamako's first printing house, the Gazette.

32. During the 1920s, however, urban laborers also struggled. Several labor strikes, like the one held by the Thiess-Niger railway line workers in 1925, took place all over the territory (Gorer 1970, 107). Such resistance catalyzed a policy of heightened "surveillance" among the French colonial government from 1924–40. As a result, administrators closely monitored population migrations, the possibility of indigenous revolts, and political, religious, and social climates with an eye on key "agents," such as Modibo Keïta (beginning in the 1940s) and other future African leaders (Archives Nationales du Mali, *Repertoire Fonds Recents 1855–1954*, book 2, *1918–1960*, 2D-138/1).

33. Internationally renowned photographer Malick Sidibé (2005) explained, "Photography is European, so there is no caste attached." That said, Sidibé generally believed many professions in the city remained casted. However, he admitted that ethnic- and caste-based restrictions and taboos had been altered by "globalization" (M. Sidibé 2004).

34. In Mali, and many parts of West Africa, pottery is the prerogative of blacksmith women. Thus, by saying that "people who are not blacksmiths can

make pots," Sidibé illustrates that some caste-based trade monopolies have been transformed in cities.

35. For example, the French automotive company Citroën organized missions across the Sahara in 1922 and 1923 and a trans-African trip that took place in 1933. These events were photographed and published in an album and are currently housed in the Centre des Archives d'Outre-Mer, catalogued under We223 (Duclos 1992, 16). Likewise, a photographic mission in the Bani and Macine valleys from 1926–28, led by Captain Denoid, Lieutenant Gaillard, and Sergeant Maxime Pfeifer, resulted in aerial survey photographs of Sansanding and local textile production in Ségu (Archives Nationales du Mali, *Repertoire Fonds Anciens 1855–1954*, ID-19).

36. Pierre Garnier reports that French photographers Andréef and Vanetti worked for the colonial police taking pictures for the Service special de la sûreté, which became the Sûreté Nationale, or the National Security and Police, after independence (Nimis 1998, 16).

37. In addition to those carried out by Griaule and associates during and after the 1930s, ethnographic projects were undertaken in Mali by organizations such as *National Geographic* magazine, which sent John Oliver to make photographic and cinematographic records throughout French West Africa in June 1927 (Archives Nationales du Mali, *Repertoire Fonds Anciens 1855–1954*, ID-2).

38. Archives Nationales du Mali, *Repertoire de Dossiers de Personnes, Fonds Recent Serie 1C 1918–1960 (1989)*, 1C5.17, Gizycki Georges, operateur de la photographie (1928–31).

39. For example, an obituary describes Mamdou Sall (born in Senegal around 1852), who worked as an interpreter "beginning in 1881 with Colonel Borgnis-Desbordes" and participated in many missions, such as that of "Archinard in Jenne and Bandiagara," and ended his administrative career in 1936. He died September 14, 1944, at the age of ninety-two (*Journal Officiel du Soudan Français* 1944, 70).

40. Among the company's possessions were several medium-format twin lens reflex cameras, two Renault trucks, firearms, and ammunitions (Archives Nationales du Mali, *Repertoire Fonds Anciens 1855–1954*, ID-70, "Mission Griaule, 1930–1935").

41. The exhibition was titled "Annual motorisation coloniale" (*L'Économiste Soudanais* 1935a). Also that year, Griaule and Germaine Dieterlen completed a subsequent "Sahara-Sudan" ethnographic mission (Konaré and Konaré 1981, 123).

42. Documentary photography, particularly identification photos, was commissioned at this time alongside portraiture and became even more important with changing citizenship laws in the 1940s. However, portraiture predominates photographers' archives from the early decades (1940s and 1950s) and extant scholarship on them. During these early years, photography was a luxury, costing fifty to one hundred francs on average—which, to provide some perspective, equated to a family's sustenance for two or more days (Elder 1997, 81).

43. Seydou Keïta described his experience in an interview with Magnin: "I hadn't any training at all. . . . I watched [Pierre Garnier] and that way I learned to develop and print myself. I have to admit, however, that Mountaga

[Dembélé] also gave me a lot of advice" (Magnin 1997, 9). Malick Sidibé also claimed to have been "self-taught" in these domains: "I am not sure how long it took me to become proficient in the darkroom. It takes place over time. I can't say. No one taught me the lab [darkroom processes]. I taught myself. I had to learn when [Gérard Guillat-Guignard] left [Photo Service in 1958]. There was no one else to do it" (M. Sidibé 2004).

44. Captain Garnier, working for the colonial administration, attended and assisted army reserve meetings in Bamako, opened the city's first pharmacy, and wrote an unpublished manuscript on photography (Nimis 1996, 77). According to Baru Koné, Garnier and his son used to grow local medicinal plants along the Sankarani River and sent them to Paris, where they were fabricated into pharmaceuticals such as Novocain, which was made in Bamako from the roots of the *sinjan* plant (B. Koné 2004).

45. Captain Garnier died Sunday, September 9, 1934, at Point G hospital in Bamako (Centre des Archives d'Outre-Mer, 14 MIOM/2275, 15G/24).

46. Photo-Hall Soudanais was more than a photo shop. According to an advertisement Mrs. Garnier posted in *L'Économiste Soudanais* (October 20, 1935), the store sold French delicacies alongside photographic materials and accessories for musical instruments.

47. Dembélé traveled throughout the country as a teacher, taking photographs wherever he was stationed. Koné made reportage, portrait, and identification photographs along railway routes from Bamako. Kélétigi Touré worked as an itinerant photographer in Mali and Senegal before opening his studio in Kayes (Nimis 1998b).

48. Rowland Abiodun has also convincingly argued for the relationship between this posture and long-standing *àkó* sculptural portraits among Yorùbá in Nigeria, which represent the depicted as a respectable member of adult society with all ten fingers displayed (Abiodun 2013).

49. Adama Kouyaté explained that he "met all of the early photographers at Garnier's lab . . . [as] he was the only one with an enlarger" (A. Kouyaté 2004a).

50. Today, Dembélé's enlarger belongs to the nascent archival collection of the African House of Photography (MAP) in Bamako (Moussa Konaté 2004).

51. The Office du Niger agricultural and irrigation scheme was created on January 5, 1932 (Konaré and Konaré 1981, 122), and was engineered and directed by E. L. Bélime (Lydon 2000, 69 and 71).

52. Ghislaine Lydon writes that the Office du Niger, "which claimed to be a social oeuvre, was in fact exploitation on a massive scale reminiscent of slavery. . . . [The] indirect practice of forced labor . . . [also] fell upon women and children. This unrecorded 'free labor' was . . . largely taken for granted" (Lydon 2000, 71). Claude Meillassoux corroborates her argument, reporting that "in the early thirties, forced-labor recruitment was intensified in order to contribute to the project of the Office du Niger" (Meillassoux 1968, 10).

53. Several photographs illustrating the institution's façade and some of its patients are housed at the Centre des Archives d'Outre-Mer in Aix-en-Provence, France, under FM, DFC, XXXIX, MEMOIRES/194, dossier 117; 14 MIOM/2283 15G/5b; 14 MIOM/2275 15G/24; ICO, 30 FI/10; ICO, 30FI/12; CO, 30FI/14; and ICO, 30FI/17.

54. While Alpha Oumar and Adama Bâ Konaré record the school's opening in 1932, three other sources have it as 1933 (Becchetti-Laure 1990, 36; Institut National des Arts 1981, 3; and Gaudio 1998, 208). In 1936, the school underwent renovations inspired by Le Gall's visit to the Artisinat in Côte d'Ivoire which was directed by Heuzy (Becchetti-Laure 1990, 36). In 1938, the same Le Gall founded Art et Travail, whose members included prominent politically active figures, such as Modibo Keïta, who encouraged their colleagues to criticize the colonial government within their pursuits (Imperato 2008, 20).

55. This date conflicts with that provided by the Konarés, who hold that the Grand Hôtel du Niger was inaugurated some fourteen years later on February 2, 1952 (Konaré and Konaré 1981, 144).

56. Archives Nationales du Mali, *Repertoire Fonds Recents 1855–1954*, book 2, *1918–1960*, IG-221, "Schools in Bamako 1938."

57. At La Foire de Bamako, on February 19, 1939, France presented a Matford four-door, five-seat car for 46,900 francs; a Griffon bicycle; an RCA-Victor battery-operated radio-phone; farming equipment; weekly service to Dakar by Air France; trucks presented by Vezia, Renault, and Peyrissac; an Underwood typewriter; motorcycles by Peyrissac; an Explorateur tent and camping materials exhibited by Cauvin-Yvose; and Singer sewing machines. The Office du Niger presented a hybrid cotton called "Buddy" and several rice varieties, which it distributed for free to fairgoers (*L'Économiste* 1939, 1).

58. Archives Nationales du Mali, *Repertoire Fonds Recents 1855–1954*, book 2, *1918–1960*, ID-62, "Cinéma 1932–36," and J-9, "Relevés des Postes Radio Electroniques 1935." This practice was part of a larger system of surveillance, which included the monitoring of population migrations, preparing for the possibility of indigenous revolts, and tracking political, religious, and social climates, with an eye on key agents. Understanding the affective power of visual media, the government censored all cinematic productions, particularly those exhibited to indigenous audiences. In 1936, for example, Europeans were shown comedies, violent films, and "comic actors of color." Malians were shown *The Three Musketeers* and *Old Yeller*, which were considered more "innocent" and well-suited for children. The censorship process was overseen by M. Court, chief of the service of the sûreté (police department) in Bamako. In that year, no less than fifty-two movies were censored before they were released to their respective theaters: Buffet de la Gare, Soudan Cinéma, M. Petit, and Mahl (Archives Nationales du Mali, *Repertoire Fonds Recents 1855–1954*, book 2, *1918–1960*, ID-62).

59. In an interview in 2004, Sidibé denounced the restrictive measures French photographers used to control photographic technology and information during the colonial era as "selfish" and the French photographers as "egoist Europeans [who] at the time wouldn't let Malians touch the camera or teach them much about the darkroom" (M. Sidibé 2004).

60. Dembélé reported that Garnier monopolized film development in his shop while his Malian assistants, Adama Kouyaté and Tiaman Samaké, were in charge of the prints (Elder 1997, 71). Seydou Keïta supported Dembélé's account: "I watched [Garnier] work and that way I learned to develop and print myself" (Magnin 1997, 66).

61. Adama Kouyaté was involved in the movement for political independence and even worked as a chauffeur for Mamadou Konaté (one of the leading activists at the time) during his political campaign with Union Soudanaise-Ressemblement Démocratique Africain (US-RDA) in 1955 (A. Kouyaté 2004b).

62. Numerous strikes, revolts, and uprisings took place in the territory during the 1940s and 1950s (Konaré and Konaré 1981, 14, 147; Echenberg 1991, 149; Centre des Archives d'Outre-Mer 14MIOM/2275, 15G/24, 2, Report, 9; and *Barakela* 1954, 11).

63. More than two hundred thousand black Africans served in the French forces during World War II alone. After fighting in the front lines for the French during World War I and World War II (and many imprisoned in German POW camps such as Fronts-Stalags, including Léopold Sédar Senghor), toward the close of World War II, de Gaulle's administration released its Tirailleurs Sénégalais members from their service as part of the "so-called 'whitening' (*blanchissement*) of the Free French Forces" (Echenberg 1991, 87–88, 97–98; Mann 2000, 8). For an excellent account of this history, see Echenberg 1991.

64. The Foyer du Soudan was formed in 1944 by graduates of the École William Ponty (Dakar) as an "outgrowth" of the Association des Lettrés in Bamako. It brought together the city's educated elite and future political leaders and was instrumental to the formation of political parties in the territory, which began around 1945 (Imperato 2008, 123).

65. Describing this situation, Echenberg states that a "common aspiration among trade unionists, civil servants, and veterans [at the time] was an end to colonial discrimination, with gradual if not immediate implementation of equal treatment under the law for metropolitan and overseas citizens" (Echenberg 1991, 105, 149).

66. Frustrated by "unequal and inferior treatment" at the end of the war by the French government ("whitening" of the military, poor payment policies, and a colonial system that did not appreciate the sacrifices of African servicemen), some 1,280 African soldiers revolted on December 1, 1944, at Thiaroye near Dakar. Thirty-five Africans were killed during the uprising. Directly afterward, French officials paraded Thiaroye prisoners through the streets of Dakar. This news quickly spread, even to African soldiers stationed in France. According to Echenberg, "Thiaroye became an important political symbol of colonial oppression and [the Rassemblement Démocratique Africain organized] a public pilgrimage to the cemetery at Thiaroye where the fallen soldiers were buried" (Echenberg 1991, 101, 103–4, 169). See Ousmane Sembéné's film *Le Camp de Thiaroye* (1988) for a reenactment of these events.

67. The Houphouët-Biogny law was passed April 11, 1946. It was named after Félix Houphouët-Biogny, an African doctor, chief, and farmer, who became the founding head of the interterritorial political party Rassemblement Démocratique Africain (RDA) after 1946 (Foltz 1965, 56; Imperato 1977b, 86). In spite of this legislation, several accounts suggest that the practice of forced labor continued in the territory well into the 1950s, sparking public outcry by prominent activists such as Modibo Keïta and Mamadou Konaté (Centre des Archives d'Outre-Mer, 14MIOM/2272, 15G/16, and 14MIOM/2283, 15G/56).

68. This law was adopted May 7, 1946 (*L'Essor* 1952a; Meillassoux 1968, 12). There were actually two Lamine Gueye laws: The first, adopted May 7, 1946, "granted immediate citizenship to all peoples of the colonial territories" (Foltz 1965, 58). However, they did not officially become citizens until June 2 in a ceremony held at the National Assembly (Konaré and Konaré 1981, 132). The second, adopted June 30, 1950, extended "family allotments and other fringe benefits to African as well as European governmental employees" (Foltz 1965, 58).

69. This constitution went into effect in October 1946 (Konaré and Konaré 1981, 132; *L'Essor* 1952a; and Robinson 1958, 314). It extended citizenship to all inhabitants of French overseas territories, granting them representation in French parliament and the new consultative Assembly of the French Union (Robinson 1958, 314 and 316).

70. However, in the November 1946 elections, all the candidates for the Union Économique et Sociale (UES) and the Union Franco-Africaine (UFA), for example, were French, and the number of counted votes was minimal. Interestingly, photographer Pierre Garnier was a candidate, yet he did not receive any votes (Archives Nationales du Mali, *Repertoire Fonds Recents 1855–1954*, book 2, *1918–1960*, 7-D-90/2 "elections au conseil general").

71. Modibo Keïta was a graduate of the École William Ponty, a teacher, and a highly influential political activist who eventually became Mali's first president in 1960.

72. Mamadou Konaté was the leading figure of the US-RDA and a prominent political activist whose popularity would likely have rendered him Mali's first president if he had not died from hepatitis in 1956 (Imperato 2008, 186).

73. Mamadou Sangaré was the first *gérant* (manager), director of publication, and editor of *L'Essor*, the daily newsletter originally circulated by the Union Soudanais (later, the US-RDA) in present-day Mali (Konaré and Konaré 1981, 140; and Centre des Archives d'Outre-Mer, 14MIOM/2275, 15G/24).

74. A canton chief of Niamba (1933), teacher at the École Regionale in Bafoulabe, and uncle of photographer Diango Cissé, Fily Dabo Sissoko was one of the key political figures present at the National Assembly conferences throughout the 1950s. He was the leader of the Parti Progressiste Soudanais (PSP), which was created in Bamako in 1945 (de Benoist 1998, 9; Konaré and Konaré 1981, 131; Imperato 2008, 239–40, 272–73; and *L'Union* 1959b).

75. Originally from Senegal, Makan Macoumba Diabaté (along with Mamby Sidibé) founded the Association des Lettrés du Soudan in Bamako, which later became the Foyer du Soudan. According to Imperato (1977b, 70), "He was one of the first Africans in the Sudan, occupying a key position, to attack the colonial government." Later, Diabaté served as a government official during Modibo Keïta's administration in the 1960s and was a "well-known business agent" (Nimis 1996, 21). He was also an important figure for several photographers, including Baru Koné, Nabi Doumbia, and Bakary Doumbia. Koné moved his practice to Diabaté's house because he had electricity. There, Koné took Malick Sidibé's first ID photo in the early 1950s (B. Koné 2004).

76. Although Modibo Keïta was originally exalted as a teacher with "an excellent reputation" by the colonial officials, he was incarcerated several times in 1947 alone for speaking out against forced labor practices that continued in Sikasso under the canton chief and Administrator Rocher. Because of his political activism, from 1946 onward the administration accused him of being a communist, transferred him from Sikasso to organize nomadic schools in a remote region near Timbuktu, and determined he was "a dangerous agitator" and their "number one enemy." As such, they placed him under regular surveillance and relocated, fined, and imprisoned him. Likewise, in 1950, Mamadou Sangaré was repeatedly fined and arrested by the colonial administration for "public injuries" to colonial officials, such as de Coppet and Maurice Méker (Centre des Archives d'Outre-Mer, 14MIOM/2275, 15G/24, "Reseignements: Incident de Sikasso—Affaire Modibo Keïta, February 1947," and 14MIOM/2283, 15G/56, "Chapter 2: Political parties," 14). (Incidentally, Méker was the French administrator who, two years later, recognized Malick Sidibé's talent for drawing while he was a student in Buguni and referred him to the governor of the French Sudan, Emile Louveau, who eventually helped him enroll at the École des Artisans Soudanais in Bamako.) It should be noted that this policy of censorship was not reserved for Africans, although theirs was the most severe. At times, for example, French journalists were detained for speaking out against the colonial administration in French West Africa (*L'Essor* 1951).

77. Headquartered in Nioro during the colonial era, Cheikh Hamallah was an influential Muslim leader of the Sufi movement sometimes called Hamallism or "eleven-bead Tijaniyya" in West Africa. His name variously appears as Ahmed Hamallah (Hanretta 2008, 478), Sidi Ahmad Hamahullah ibn Muhammad (Ryan 2000, 217), and Ahmédou Hamahoullah (Alioune Traoré 1983, 57).

78. During the 1940s, Cheikh Hamallah experienced great popularity (in part due to his opposition to French colonialism); several madrasas (Islamic schools) were opened across the city; and many individuals, such as photographer Baru Koné, converted to Islam. Furthermore, in November of 1948, construction began on the "great [Friday] mosque" in Bamako. According to the Konarés, that year marked the first time the population contained "more Muslims than animists": 1,706,135 Muslims, 1,439,057 animists, and 15,257 Christians (Konaré and Konaré 1981, 125, 127–28, 140; B. Koné 2004).

79. During the colonial era, the French government required Malians to carry identification cards as a means to monitor individuals' migrations from rural to urban locales within and between territories (Elder 1997, 172; Saint-Cyr 1999, 19). ID photos were also used to supervise military personnel. As an army photographer, Mamadou Cissé worked with French and African photographers making identification photos for the military throughout francophone West Africa. However, since it was not until 1940 that all adult French citizens were required by law to carry a photo ID, and the "indigenous people of the colonies" were not granted French citizenship until six years later, ID photos did not become mandatory until 1946 (Elder 1997, 73, 172; Y. T. Cissé 1995, 3).

80. Admittedly, dividing photographers and their involvement in the histories of photography in Mali into generations is somewhat arbitrary and flawed. However, it provides a helpful means to understand the changing styles and contexts of photographic practices over the decades.

81. Mamadou Cissé resides somewhere between first- and second-generation photographers in Mali. However, because he began his career during the late 1940s, I have decided to group him with the first generation.

82. During an interview in Bamako, Adama Kouyaté added a man named Boundiala Doumbia to this list (A. Kouyaté 2004a). So-called first-generation photographers in Mali are generally considered to be those whose photographic careers began before or during the 1940s. Typically, these photographers worked in black-and-white technology; used second-hand, large-format (commonly eight-by-thirteen-centimeter) view cameras and glass-plate negatives; operated outdoor studios that employed sunlight as opposed to electricity to take and print photographs; used direct printing methods (as most did not own or have easy access to an enlarger); and often initially became familiar with the medium by employing smaller Kodak Brownie box cameras for amateur and reportage photographs. For more specific information concerning the careers of these men, refer to their individual biographical entries in the digital appendix: https://amp.matrix.msu.edu /biographies.php.

83. In many ways, French West Africa communities experienced a unique but somewhat shared reality, particularly in terms of sociopolitical climates, urbanization processes, pop-cultural trends and developments, style and appearance of portrait photography, and, to a lesser extent, French colonial policies.

84. However, many African neighborhoods in Bamako were still without water and electricity in 1948 (Centre des Archives d'Outre-Mer, 14MIOM/2275, 15G/24,).

85. For example, Seydou Keïta descended from elite stock. His grandfather worked as a magistrate's assistant for the high court in Bamako and was close to many notables, such as the father of Mamadou Konaté (B. Koné 2004).

86. Reportage, or documentary, photography includes photographs made for the governmental administration and police—for example, of accidents, construction projects, and mug shots of accused criminals as well as unsolicited images the photographers took for themselves recording public performances, diplomatic visitors, and other events. The term is also locally applied to photographs taken on commission outside studio walls at parties, dances, and other celebrations.

87. Iyouba Samaké could not recall the name of the studio he visited at this time. However, he said it was a "Malian photographer's studio" and he was sent there by his boss (I. Samaké 2004).

88. "The population" here signifies Bamakois as well as urban-based West African traders, businessmen, soldiers, officials, students, and kinfolk who passed through the capital during their intercity travels. These individuals were the bulk of photographers' clientele. However, rural migrants certainly had their pictures taken in the city, and inversely, Bamako-based photographers traveled to rural areas to make identification and portrait

photographs. Some, such as Baru Koné, even made a regular practice of serving customers in small towns along the railway line (B. Koné 2004).

89. Seydou Keïta provides more specific details: In the 1940s, he said, the price was 25 francs for six-by-nine prints, 100 francs for nine-by-twelve, and 150 francs for thirteen-by-eighteen, and, in the 1950s, it was 300 francs per "card" for daylight pictures and 400 francs for "studio lights" (S. Keïta 2011, unpaginated).

90. Corroborating Sidibé's account, his cousin Brehima stated, "There are a lot of marriage celebrations in Mali and [other] Muslim countries in general the month before Ramadan" (B. Sidibé 2006). Thus, this period was eventful for professional photographers. September 22, 1960—Independence Day— became another busy occasion for professional photographers' businesses (Malick Sitou 2004). More recently, brides often don their white wedding attire and commission color portraits in the gardens of national monuments in Bamako on Sundays. Malian musicians Amadou and Mariam sing a song called "Dimanche à Bamako" ("Sunday in Bamako") describing this popular practice.

2

Heyday of Black and White (1950s–1980s)

AFTER A LOCAL PHOTOGRAPHIC MARKET was established in the French Sudan, black-and-white photography reached its peak in the period from the 1950s to the 1980s. In the form of portraiture, identification, and reportage images, it witnessed broad sociopolitical and pop-cultural movements that spanned periods of national liberation, socialism, and military dictatorship. Encompassing three generations of loosely grouped photographers and their clientele, its popularity initially arose from the medium's ability to cater to the new needs of young urbanites and, more broadly, the civic requirements of citizens in rural and urban locales in the decade that ushered in national independence.

Toward National Liberation and Socialism: 1950s–1968

The 1950s was a decade of increased political activism. In line with civil rights movements across the globe from this time onward, young évolués and ascending leaders utilized new venues—such as Radio-Dakar, Radio-Brazzaville, and Voice of America;[1] the daily publications *L'Essor*,[2] *Réveil*,[3] and *Vérité*;[4] and movie theaters Cinéma Rex and Cinéma Vox[5]—to debate colonial politics, advocate self-governance, and draw inspiration from those engaged in similar struggles across the continent and overseas.

In the French Sudan, this dialogue distilled into a heated battle between two primary ideological positions and their affiliate political parties: the African Democratic Rally (Rassemblement Démocratique

Africain; RDA), the anticolonial, socialist organization led by liberation-ist évolués across French West Africa, such as future president Modibo Keïta, and the Sudanese Progressive Party (PSP), the French-supported, prodemocratic, capitalist party headed by canton chiefs, such as Fily Dabo Sissoko. Given their prominence, the leaders of these political parties became popular icons, even trendsetters. For example, in 1952, a style known as "Fily Dabo" was in vogue in the French Sudan alongside Senegalese fashions imported from Dakar (A. O. Konaré and A. B. Konaré 1981, 147; *L'Essor* 1952d). This aesthetic bent reveals popular support among évolués in the capital for PSP and its philosophy of Négritude (championed in neighboring Senegal by leaders such as Léopold Sédar Senghor) in the early part of the decade. By 1956, however, public alliance had rapidly shifted toward the socialist, pan-African perspectives of the RDA.

Such passionate political views were visually expressed in portraiture. For example, a photograph taken by Seydou Keïta toward the end of the decade (fig. 2.1) depicts a woman proudly supporting the RDA (Y. T. Cissé 1997, 277).[6] Featuring a centrally located purse boldly ornamented with the initials "V-RDA"—short for "vive" or "long live" the RDA—the woman's anticolonial stance and support for national independence are given visual prominence. Similar sentiments are conveyed in the portrait of a Sarakolé family taken by Malick Sidibé in Bamako in 1962, two years after independence (fig. 2.2). In this image, factory-printed cloth featuring an illustrated portrait of Sékou Touré (the staunchly anticolonial RDA leader who became the first president of neighboring Guinea in 1958) is donned by the central figure to publicly proclaim her political proclivity and preserve the moment on film. Her companions are similarly attired in factory-printed cloth to advertise their support for the president and a local governor. In like fashion, Hamadou Bocoum's archives picture two girls, in Mopti around 1960, sporting identical dresses that feature an official portrait of Mali's first president, Modibo Keïta, presumably to profess their shared nationalist pride and commemorate the moment for family and friends (Elder 1997, photo 1.22).

Although many youths from the 1940s to 1960 were actively challenging the colonial government, some continued to support the regime. Both appropriated symbols associated with French culture and authority as a means to claim a particular privileged status. For example, pith helmets were commonly worn by African civil servants and other men employed by the colonial administration, as well as their family members, to announce their social capital. By extension, the pith helmet is a common feature in the archives of Seydou Keïta and his contemporaries (see

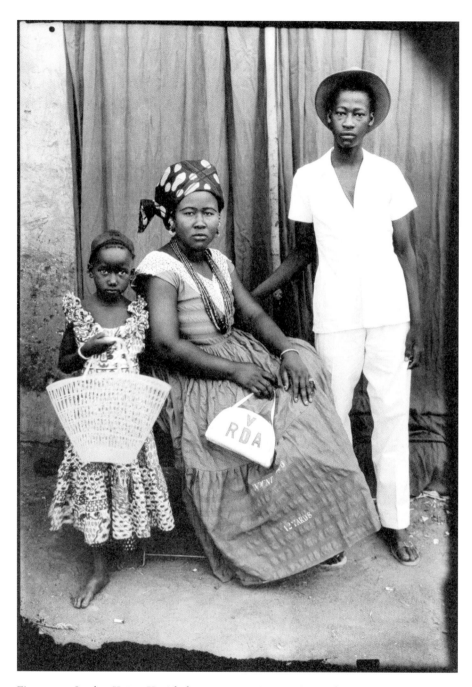

Figure 2.1. Seydou Keïta, *Untitled*, c. 1954–60. ("V-RDA" on the woman's purse stands for "Vive le Rassemblement Démocratique Africaine," or "Long Live the RDA," the anticolonial socialist party of Mali's first president, Modibo Keïta.) Gelatin silver print, 23 × 19 inches. Courtesy CAAC—The Pigozzi Collection. © Seydou Keïta/SKPEAC.

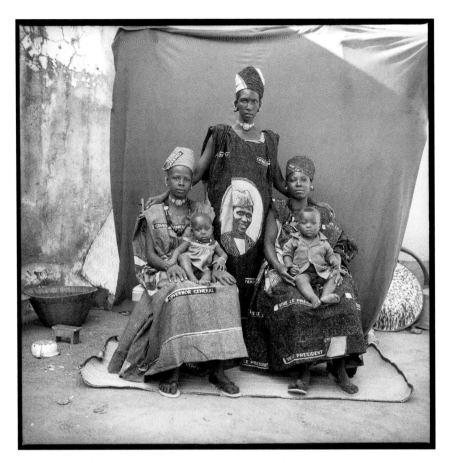

Figure 2.2. Malick Sidibé, *Sarakole Family at the Bamako Mission*, 1962.
© Malick Sidibé, courtesy MAGNIN-A gallery, Paris.

fig. 1.3). Likewise, military uniforms—donned by gendarmes and Tirail-leurs Sénégalais troops of the French Armed Forces—publicly advertised the heightened social and political status of their hosts throughout French West Africa in the 1940s and 1950s (see fig. 1.4). By the 1950s, being a member of the Tirailleurs Sénégalais (which was initially a lower-class, conscripted position) had become entirely voluntary. At this time, it was viewed as a desirable way in which one could acquire "advanced technical skills" by serving, for example, as a mechanic, driver, or photographer, thus attaining a position of social prestige and respect (Mann 2000, 9). As these symbols represented valued aspects of self-identity, these men typically appeared at the studio so attired. In a slightly less direct manner among the African intellectual elite and those who emulated them, men sported European suits and women donned secondary school uniforms in their portraits to convey their affluence and sophisticated transcultural

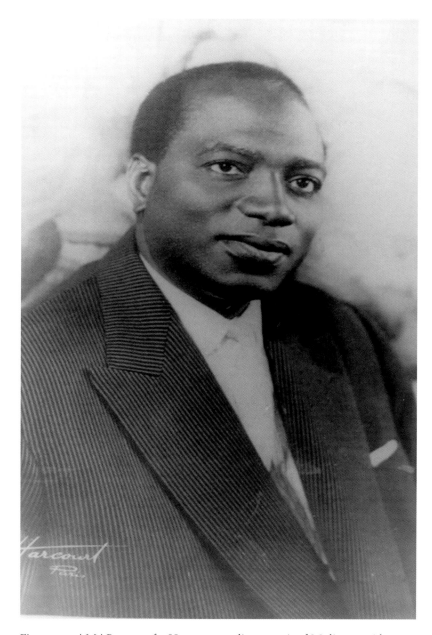

Figure 2.3. AMAP, copy of a Harcourt studio portrait of Malian president Modibo Keïta, 1960. Reprinted by Nouhoum Samaké for author, Bamako, 2004.

tastes (see fig. I.1). Comprising the majority of photographers' clientele during much of the colonial era, their likenesses predominate the remnant archives of first- and second-generation photographers. Indeed, even those who were staunchly anticolonial adorned themselves in Western cosmopolitan fashions to convey their modern sensibilities and sophisticated urban style (fig. 2.3).[7]

Imported commodities and modes of transportation remained important symbols of one's modern experience in the French Sudan from this era onward, particularly among urban dwellers (see figs. 1.6–1.8). Speaking on this issue, Malick Sidibé explained, "During decolonization and towards the end of the fifties, radio sets, bicycles and mopeds were not in general use but were luxuries. The young originals of the distant villages wanted to show those who remained behind everything they possessed and how modern they had become" (Knape 2003, 78–79). In other words, individuals sought new representations of themselves that evoked affluence, success, and education, suggesting coveted access to particular economic, political, and social opportunities afforded to a select few during this era. By incorporating these commodities within their portraits, they expressed actual as well as desired class differentiation among Bamakois and other French West Africans, particularly regarding access to Western material culture. Astutely addressing the social leverage these objects denoted, Sidibé opined, "The mere fact that [an item] came from the West gave the wearer a certain kind of power, a kind of power that kids are looking for. Grown men too, I suppose" (Lamunière 2001b, 55).

The symbolic prestige Western commodities conveyed in portraiture was so desirable for clients that those materials became staples in the studios of photographers who could afford them. Remarking on this phenomenon, Keïta stated, "I had several European suits available in my studio including straight ties, bow-ties, breast-pocket handkerchiefs, shirts, hats, and even a beret. . . . I also had accessories available for them: watches, fountain pens, watch-chains, plastic flowers, a radio, a telephone, a scooter, a bicycle, and an alarm clock. A lot of people liked to be photographed with this kind of thing" (Magnin 1997, 12).

Appropriating cosmopolitan objects in portraiture also provided a counternarrative to colonial depictions of Africans as ethnographic "types." Created by and for Africans in the French Sudan, portrait photographs that depict individuals wearing imported clothing alongside modern technological devices and pop-cultural commodities counter prevalent portrayals of Africans in Western contexts, which regularly stereotype them as rural, primitive, exotic, and often sexualized, as seen at this time in French-owned studio Photo Service (see Keller 2008, 517, 640; Guillat-Guignard 2016). In effect, such imagery provided urban Africans in the French Sudan with a more desirable and empowering image of themselves as cosmopolitan, informed, and successful. By extension, it granted them a certain degree of control over their cultural and personal memory—the significance of which during the late colonial era can hardly be overstated.

Of course, products from Europe and the United States were not the only emblems of modernity or enviable social position in the French Sudan at that time. Regionally inspired fashions and accessories held equally symbolic weight in the portraits of middle- and upper-class women. Portrayed fashions include dyed skin, locally crafted gold and silver jewelry, elaborate hairstyles, and tailored attire made from locally woven, factory-printed, and embroidered cloth (fig. 2.4 and plate 1). For example, Seydou Keïta relayed, "What was important was that their jewels appear in the photos . . . some *grandes dames* used elaborate make-up [or dye] around their mouths. All of these details, external signs of wealth, beauty and elegance, were of great importance. These women were very conscious of that. They also liked to show off their hands and slender fingers that were a sign of high social standing" (Magnin 1997, 12). In line with Keïta's account, Malick Sidibé offered, "Women who wanted to show off their wealth came to be photographed with their bracelets, necklaces and watches. . . . They would come several times because fashions were always changing. Mainly hairdos and braids" (Magnin 1998, 40).

To highlight these features in portrait photographs, some women would have them tinted—particularly fingernails (red), jewelry (yellow/gold), and head wraps (green)—by hand colorists such as Cheickna Touré, who was also a popular frame maker in the 1950s through 1980s (see Chapoutot 2016, 55, 59, 64; C. Touré 2009; S. Keïta 2011, unpaginated). Among the most revered modern fashions for women in Bamako were urban ensembles imported from neighboring Senegal and referred to as "Senegalese chic." At least one boutique, Comptoire Moderne de Bozola, offered the coveted feminine styles of Dakar to women of means in the capital city during the 1950s (*L'Essor* 1952e).

In similar fashion, numerous men and women arrived at the studio wearing expensive, high-quality, embroidered *boubous* (fig. 2.5). Blacksmiths and hunters proudly donned locally produced, power-laden shirts and posed with fine handcrafted rifles (*màrìfaw*) to advertise their affluence as well as their efficacy and accomplishments in the wilderness (fig. 2.6). Thus, in the portraits of this and subsequent eras, traditional and contemporary, rural and urban, and indigenous and foreign elements comfortably coexist in the modern transcultural experience. Attesting to the mutual currency of each, these elements often appear side by side within a single image (plate 2).

Since the 1940s and 1950s, then, individuals in present-day Mali have used portraiture to visually express, emphasize, and memorialize important accomplishments over their lifetime, such as marriage and baptisms, as well as valued aspects of their personal identities, including their political affiliation, socioeconomic status, cultural heritage, religious

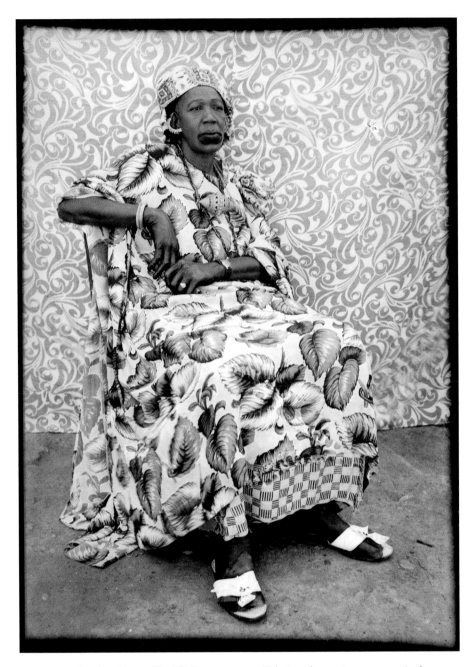

Figure 2.4. Seydou Keïta, *Untitled*, c. 1953–57. Gelatin silver print, 23 × 19 inches.
Courtesy CAAC—The Pigozzi Collection. © Seydou Keïta/SKPEAC.

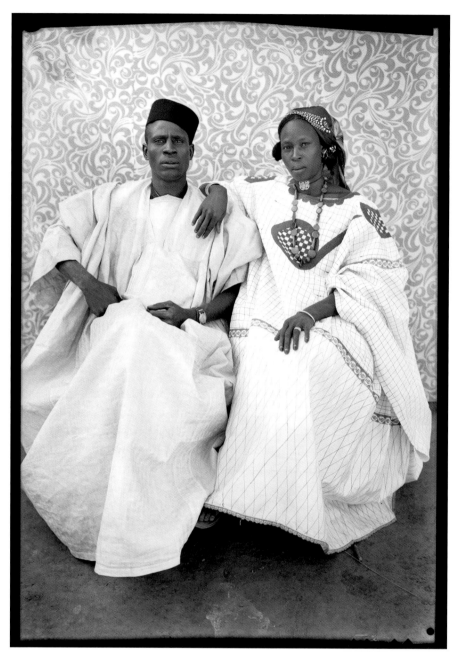

Figure 2.5. Seydou Keïta, *Untitled*, c. 1953–57. Gelatin silver print, 23 × 19 inches. Courtesy CAAC—The Pigozzi Collection. © Seydou Keïta/SKPEAC.

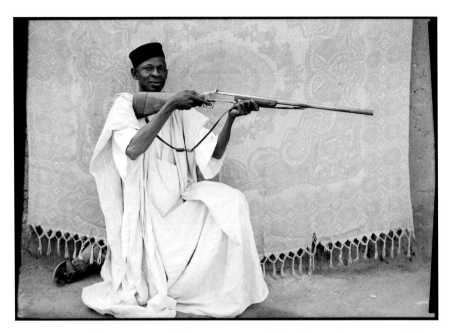

Figure 2.6. Seydou Keïta, *Untitled*, c. 1948–54. Gelatin silver print, 23 × 19 inches. Courtesy CAAC—The Pigozzi Collection. © Seydou Keïta/SKPEAC.

association, and profession. Most often these ideas are conveyed through attire and the incorporation of material aids, or props. For example, to record sitters' professional activities, photographers would travel to their clients' places of labor (fig. 2.7) or patrons would arrive at the studio accompanied by materials associated with their trade in order to have their portrait made (fig. 2.8). Photographers, too, have often captured themselves in their studios and reception rooms, surrounded by photographic paraphernalia, to document this significant aspect of their lives (fig. 2.9). Time and again, the profession that dominates photographers' archives is that of the tailor. As a relatively recent urban enterprise deeply rooted in identity formation and expression, and preoccupied with the latest fashions and popular trends, tailors share a symbiotic social and commercial relationship with photographers. Most practically, photographs have served as primary sources of advertisement for tailors, who display images of their designs in albums and on boards in front of their establishments. Likewise, their clients don newly tailored outfits for professional portraits. Therefore, tailors' boutiques and photographers' studios are often located next to one another.[8]

Through personal adornment and the inclusion of specific commodities, patrons communicate and preserve their cultural heritage in portraiture. Hairstyle, dress, scarification, and henna- or indigo-dyed skin are readily identifiable cultural symbols. In a photograph by Seydou

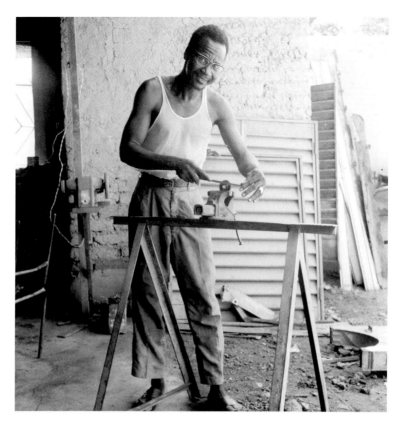

Figure 2.7. Tijani Sitou, *Carpenter*, c. 1970s. High-resolution digital scan of original 6 × 6 cm negative. Courtesy Tijani Sitou Estate © Tijani Sitou.

Keïta (fig. 2.10), for instance, a young man's Mossi identity is discernible by his facial scarification (Y. T. Cissé 1997, 277). Likewise, Fulani and Wolof women often dye the area just beneath their bottom lip with indigo (figs. 2.4 and 2.8), thereby publicly expressing their cultural heritage while accentuating their beauty. Foreign commodities have also been acculturated in Mali, as with portable radios and boom boxes in the 1960s and 1970s (plate 2), with particular brands associated with specific culture groups.[9]

Portraiture can highlight religious persuasion as well. Donning recognizably Tuareg attire and jewelry and posing with "tea ceremony" paraphernalia (fig. 2.11), a woman (pictured on the right) in a portrait by Keïta at once communicates her cultural heritage and her Muslim faith (Y. T. Cissé 1997, 274).[10] This aspect of personal identity is evident in numerous photographs that together illustrate the escalating presence of Islam in the French Sudan during the 1940s and 1950s.[11] Sufism, often described as the inner, mystical dimension of Islam, allows for the merging

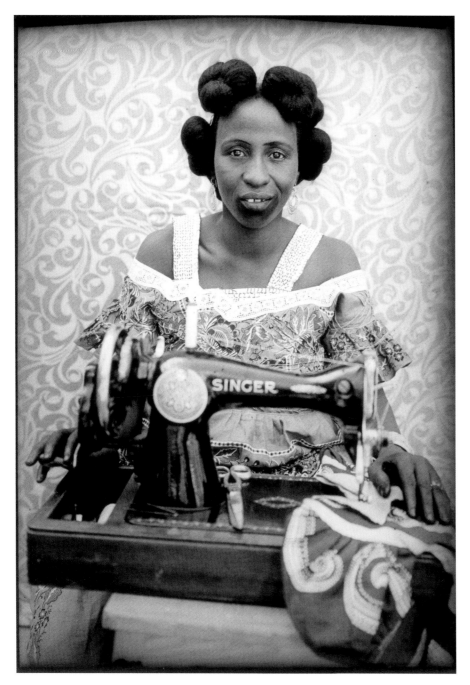

Figure 2.8. Seydou Keïta, *Untitled*, c. 1953–57. Gelatin silver print, 23 × 19 inches. Courtesy CAAC—The Pigozzi Collection. © Seydou Keïta/SKPEAC.

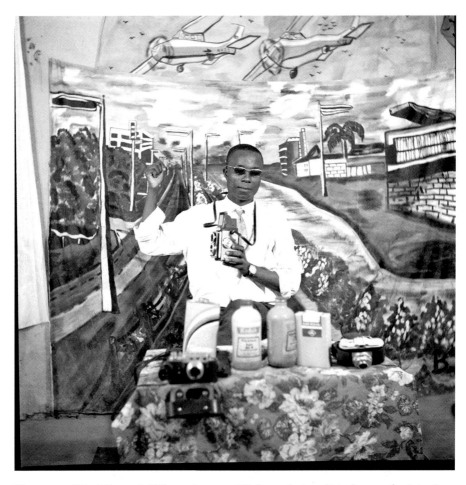

Figure 2.9. Tijani Sitou, *Self-Portrait*, 1971. High-resolution digital scan of original 6 × 6 cm negative. Courtesy Tijani Sitou Estate © Tijani Sitou.

of local animist practices and Muslim beliefs and has been prevalent in the region since the thirteenth century. However, during the twentieth century, with financial support from several nations in the Middle East, a new Islamization was implemented in urban centers. For example, by 1950, several *madrasas* (Islamic schools) had opened throughout the territory.[12] In June that year, the centrally located Chérif Arafan Haidara Mosque was inaugurated in Bamako, and, three years later, the popular film *Aure de l'Islam* averaged "1,460 spectators per show[ing]" in Bamako.[13] In fact, informed by the desires of their clientele and their own religious persuasion, some photographers, such as Mamadou Cissé, specialized in religious photography. During this period, Cissé developed a genre of photo collage in which he arranged portraits of local Muslim

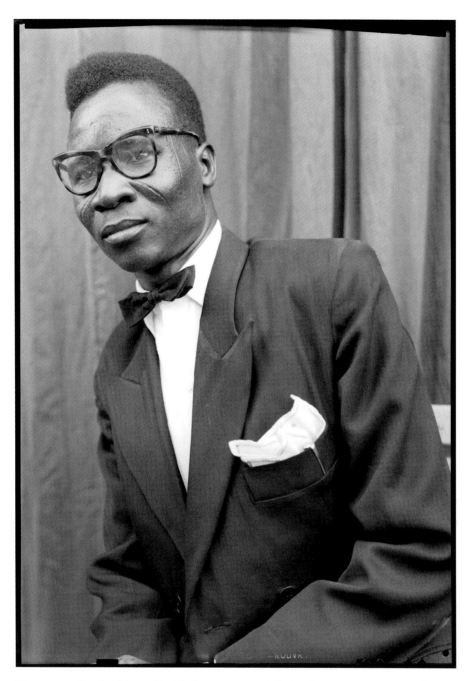

Figure 2.10. Seydou Keïta, *Untitled*, c. 1952–55. Gelatin silver print, 23 × 19 inches.
Courtesy CAAC—The Pigozzi Collection. © Seydou Keïta/SKPEAC.

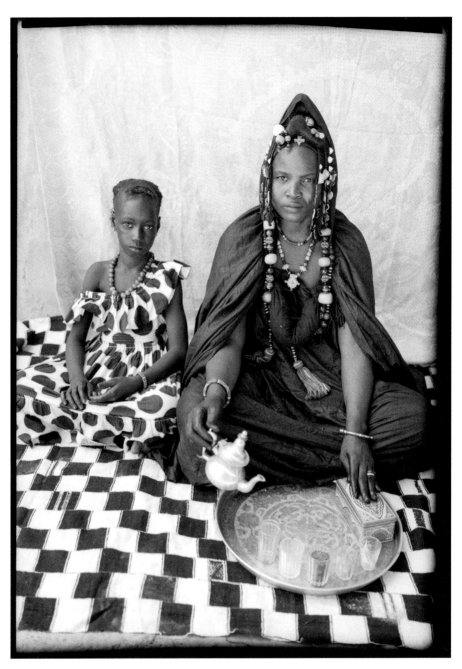

Figure 2.11. Seydou Keïta, *Untitled*, c. 1948–54. Gelatin silver print, 23 × 19 inches. Courtesy CAAC—The Pigozzi Collection. © Seydou Keïta/SKPEAC.

leaders interspersed with Arabic text to honor the men and promote their teachings (O. Cissé 2004).

During the 1950s, alongside first-generation practitioners, a "second generation" of photographers was on the rise.[14] In Bamako, this includes Malick Sidibé, Mamadou Berthé, Oumar Siby, Abdourahmane Sakaly, Malim Coulibaly, and Ousmane Keïta (who also worked in Ségu). Elsewhere, there was Félix Diallo in Kita;[15] Mahaman Awani, known as "Juppau," and Azeem Lawal in Gao; Hussein and Hassan Traoré,[16] Hamadou Bocoum, and Bassirou Sanni in Mopti; Moussa Diarra in Buguni; Soungalo Malé in Sikasso; and Hamidou Maïga in Timbuktu.[17] Those based in Bamako were commonly more educated than their predecessors. Some, such as Malick Sidibé (and later Diango Cissé and Youssouf Sogodogo), were trained as fine artists, obtaining their education at the capital's Western-driven art center—the influential House of Sudanese Artisans (the National Art Institute since 1964)—before they entered the field of commercial photography (D. Cissé 2004; Sogodogo 2004).[18] In fact, it was while he was enrolled in the jewelry program at the institution that Malick Sidibé had his first ID photo taken by Baru Koné (fig. 2.12). Furthermore, his affiliation with the program eventually led Sidibé to work in the photographic studio of Frenchman Gérard Guillat-Guignard in 1955, which became his gateway into the profession (M. Sidibé 2003; B. Koné 2004).

Like their forerunners, second-generation photographers continued to practice a wide variety of photographic genres, including identification photography, documentary and politically oriented pictures (often created for the police and affiliate agencies), advertising images (primarily for tailors, politicians, and musicians), landscape photographs, and studio portraiture—all using black-and-white technology. For example, in addition to commissioned portraiture and reportage photographs, over the years Malick Sidibé took photos of daily life in his rural hometown of Soloba. These include a fishing ceremony in 1957, corn and tobacco harvests, women transporting firewood, a soccer player dressed in a bullhorn costume, famous *donsongoni* (hunter's harp) player Tumani Koné in 1976, and other images Sidibé took for his personal collection (fig. 2.13). Sidibé also admitted taking several photographs of politicians, such as Modibo Keïta, and other socialist leaders as well as images of Pionniers, architectural buildings, and Youth Week events for his personal use (fig. 2.14).[19] Although he was not officially commissioned to do so, he said this practice was permitted at the time (M. Sidibé 2003).

Figure 2.12. Baru Koné, identification photo of Malick Sidibé, c. 1953. Copy of original photo by author, with permission from Malick Sidibé, Bamako, 2004.

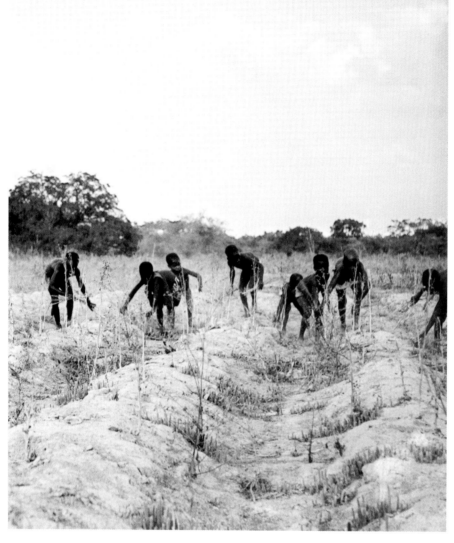

Figure 2.13. Malick Sidibé, *Soloba, Farmers* (detail), 1980. © Malick Sidibé, courtesy MAGNIN-A gallery, Paris.

Rather than the large wooden view cameras employed by their predecessors, most second-generation photographers worked with medium-format twin lens reflex (TLR) cameras, such as the Rolleiflex.[20] Their smaller, readily portable equipment and faster technology was more conducive to work outside the studio, capturing people in motion. Due to these practical advantages and the sociopolitical trends of the day, reportage photography began to steadily increase over the years, although it did not replace the market for studio portraiture. Today, many

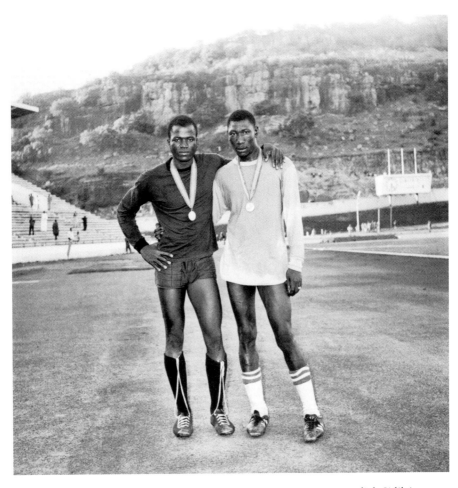

Figure 2.14. Malick Sidibé, *Youth Week, 7th Final Cup*, 1968. © Malick Sidibé, courtesy MAGNIN-A gallery, Paris.

photographers' archives, such as those of Malick Sidibé, Abdourahmane Sakaly, and Mamadou Cissé, contain multiple negatives of lively social events that regularly appear more candid than the studio portraits of first-generation photographers. Perhaps due to the overwhelming emphasis on youth, even studio portraits made by second-generation photographers generally have a more playful air about them (fig. 2.15), although this is not always the case. Malick Sidibé summarized this transition:

> Seydou Keita was very well known and I have understood that he was a great portraitist. But he started in the forties while I started in the [fifties and] sixties. It was no longer the thing to have one's photograph taken by Seydou.[21] His clientele was better off. The people were older, more posed, wearing traditional costume or expensively dressed. My clientele was of a different generation. . . . My clientele was less orderly. Profound changes had taken place. (Knape 2003, 78)

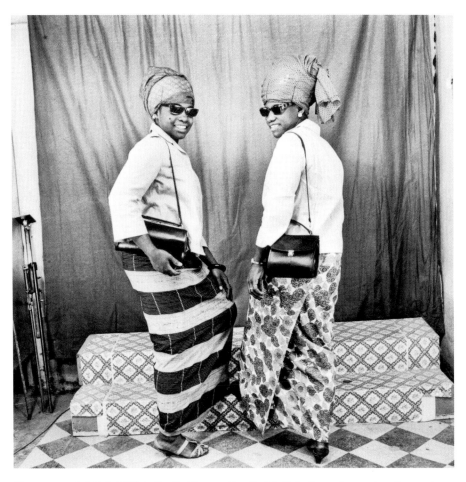

Figure 2.15. Malick Sidibé, *Kadia Traore, Studio Malick, Bamako, 13 janvier, 1969*
(*Vues de dos* series), 1969. © Malick Sidibé, courtesy MAGNIN-A gallery, Paris.

Although many photographers of the second generation were born in
urban settings (such as Bamako or Ségu), a few came to the capital from
rural areas as single young men initially residing with members of their
extended kin—often uncles—who had already established themselves in
the city.[22] Malick Sidibé described the shock he experienced on arriving
in Bamako in 1952: "I was lost. There was inspection, cars, airplanes,
[and] new sounds" (M. Sidibé 2003). Like their predecessors, these
young men were still largely tied to French colonial institutions and es-
tablishments, and they often trained with French photographers.[23] Some,
such as Félix Diallo, relied on Pierre Garnier and his store, Photo-Hall
Soudanais, to acquire the majority of their materials and experience as
well as to process their film and enlargements. Others, such as Malick
Sidibé and Mamadou Berthé, worked under Gérard Guillat-Guignard

at Photo Service or depended on his business to produce their images. Addressing the social politics of that era, Malick Sidibé explained in an interview, "Gerard gradually allowed me to work in the laboratory and finally to take photos of my own—although only of African customers, since Europeans would not have wanted to be photographed by an African" (Njami and M. Sidibé 2002, 95).[24] For photographers in Ségu during this time, such as Salif Camara, Ousmane Keïta, and Malim Coulibaly, Roland La Salle and his Studio Étoile played a similar role.

It is important to note that all these Frenchmen served the colonial administration in some capacity. However, most who arrived in Bamako after Garnier, such as Guillat-Guignard and Thierry, were directly employed by the government to take documentary photographs of military and political figures and their social events. Such events mainly took place at the administrative capital, Kuluba, and at the Grand Hotel, which later housed the new US Embassy in 1961 (Keeley 1991).[25] This practice suggests a social and political divide among opportunities granted to French and African photographers in the capital during the late colonial period. However, like Nabi Doumbia, who was employed by the colonial government in 1942, at least one African photographer in Bamako, Abdourahmane Sakaly, was regularly hired by the administration after 1956 to document "big receptions and high society parties" at the Grand Hotel alongside these Frenchmen.[26] According to Malick Sidibé, Guillat-Guignard (a.k.a. "Gé-Gé le Pélicule") and Sakaly were rivals at these venues and once even "came to blows, using their flashes to try to blind each other" (Magnin 1998, 36; M. Sidibé 2003).[27] Contrary to Sidibé's experience at Photo Service, Sakaly's position indicates a degree of fluidity among European and African populations and the relative accessibility some African photographers enjoyed at this time.

Beyond apprenticeship, first- and second-generation African photographers in the French Sudan typically were reliant on French establishments to obtain requisite photographic supplies. During this era in Bamako, La Croix du Sud undoubtedly was the most frequented, along with Photo-Hall Soudanais, Photo Service, and Optique Photo.[28] For example, from the 1930s until the 1950s, when Garnier left Mali, Seydou Keïta purchased all his supplies at Photo-Hall Soudanais, which "sold film and Kodak and Lamunière paper" (Magnin 1997, 10). Moumouni Koné and Malim Coulibaly bought their materials at La Croix du Sud (M. Koné 2004; M. Coulibaly 2004).[29]

Nevertheless, in the French Sudan during the late 1950s, African photographers' reliance on French photographers decreased as they gradually

procured the latter's African clientele and started opening their own businesses. This transition transpired largely around the time French photographers were leaving the country, often for political reasons. Photographer Adama Kouyaté opined that "Pierre Garnier left for Guinea and the Ivory Coast in 1953 because Mali was preparing for Independence" and, as a result, "his assistants were then on their own" (A. Kouyaté 2004a).[30] Likewise, Malick Sidibé did not open his own business, Studio Malick, until 1962—well after Guillat-Guignard left for Nouméa, New Caledonia, to work as the "photographer of the High Commissioner of the [French colonial] government" in 1958 (Aren 2001, H; M. Sidibé 2003; Guillat-Guignard 2016).[31]

In the 1960s, most second-generation photographers went on to operate indoor studios. Their studio interiors, like those of French photographers, were typically organized into three distinct areas: the reception area, where business transactions took place; the studio; and the darkroom/storage space.[32] Their facades often featured a glass case (plate 3) that was used to advertise the latest and most popular trends in portraiture or to shame patrons who had yet to pay for their images into completing the transaction (Malick Sitou 2004). Some exceptional establishments also provided electricity, thanks in part to the Bamako-Dar-Salam thermoelectric plant that opened in 1953.[33] For instance, Malick Sidibé stated that his studio "worked well between 6pm and midnight because people appreciated the electric lighting which was rare in Bamako" (Knape 2003, 78, 80). Others, like Malim Coulibaly, Ousmane Keïta, and Mamadou Cissé, went to work for the governmental press (known as the Information Commissionership from 1958 to 1961), particularly in the decade after independence, when it was renamed the National Information Agency of Mali, or ANIM. These photographers took reportage and portrait photographs from the institution's indoor, electrified studios, which were located in various cities such as Bamako, Kayes, Ségu, Mopti, Gao, and Sikasso (M. Coulibaly 2004; O. Keïta 2004).[34]

Like their clients, first- and second generation-practitioners were relatively young and regularly active in popular cultural, political, and consumer trends. Typically, these reflected a concern for sociopolitical independence as well as the tastes of upper- and middle-class Bamakois and other urban West Africans, which were contemporaneously captured in their photographs. As a cosmopolitan metropolis accommodating local and visiting multicultural populations, it should be noted that not all those who commissioned photographs from photographers in Bamako during this time were Bamakois. Seydou

Keïta explained this reality: "Bamako was at that time a city of about 100,000 people. It was a major crossroads then and had a really good atmosphere. People from the Ivory Coast, Burkina Faso, and . . . Niger all stopped in Bamako on their way to Dakar My studio was in a good place. A lot of people getting off the train came to see me to have their photograph taken on the way to visit the zoo. That's why I was so well known in the other West African countries" (Magnin 1997, 10). Nor were they all elite members of society, as is often claimed by individuals such as Seydou Keïta, who stated, "My clients were elite . . . functionaries and diplomats" ("Un malien aux états-unis" 1996). Rather, as noted by Manthia Diawara, many clients belonged to the middle classes (businessmen and civil servants), and some chose to reflect this aspect of their identity by posing with personal possessions in their portraits. Others sought to emulate elite styles and claim higher social standing through the use of props supplied by the photographer (Diawara 2003b, 10). Employing material aids, these patrons were able to emulate the fashion trends of celebrities and members of wealthier classes in portraiture. In the archives of first-generation photographers, such as Seydou Keïta, during the 1950s, perhaps the most common of these are photographs in which young men portray themselves as French dandies known as *zazous* (Magnin 1997, 275).[35] This elegant style was popular among schoolteachers who admired the poetry of French symbolists, such as Stéphane Mallarmé (plate 4), and dressed in their sophisticated, dapper fashion (Diawara 1999, 241; Lamunière 2001b, 38).[36] Attesting to the prevalence of the trend, Youssouf Doumbia claimed that at this time there was even a young men's club (or *grin*) named Zazous that was started by Ousmane Soumano in Bamako (Y. Doumbia 2004).[37] According to Malick Sidibé, Zazous members were "high class young adults who had lived in Paris or visited Europe. They were taxi drivers, businessmen, [and] managers. . . . They were gentlemen, *kamalenbaw* [playboys], who wore particular haircuts, ties, vests, [and] loafers (M. Sidibé 2003). Similarly, Doumbia described them as, "a group from St. Germain-des-Prés . . . a market intersection along Boulevard St. Germain in Paris. They were businessmen and civil servants in the 1950s" (Y. Doumbia 2004). Young women also presented themselves in this refined manner and, along with their male counterparts, were often pictured holding a flower to highlight their elegant style (fig. 2.16). An important facet of the experience of these young évolués is that they were educated, which was visually articulated by their attire and accessories, such as books and spectacles (figs. 2.17–2.18; see also fig. I.1).[38]

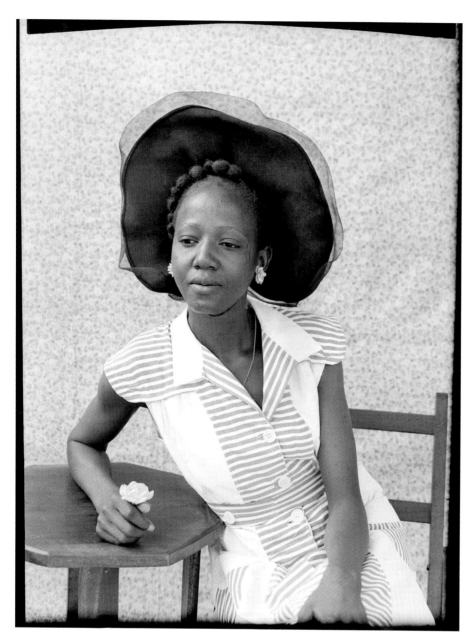

Figure 2.16. Seydou Keïta, *Untitled*, c. 1958–59. Gelatin silver print, 23 × 19 inches.
Courtesy CAAC—The Pigozzi Collection. © Seydou Keïta/SKPEAC.

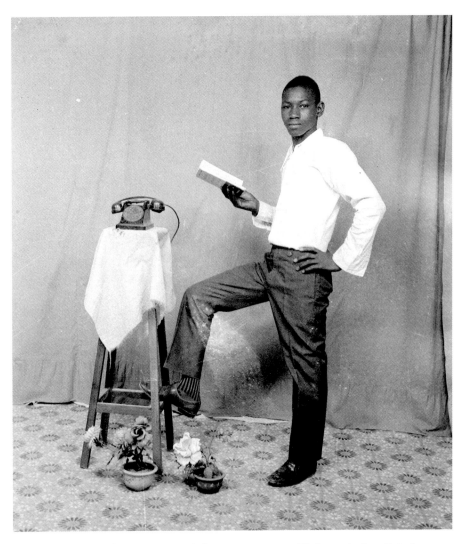

Figure 2.17. Mamadou Cissé, *Untitled*, c. 1950s–1960s. High-resolution digital scan of original 6 × 6 cm negative. Courtesy Mamadou Cissé Estate © Mamadou Cissé.

But appearances can be deceiving: At first inspection, a young man appears to have been artfully photographed in his everyday likeness by Seydou Keïta during the 1950s (fig. 2.18). However, when compared with another of Keïta's portraits (plate 4), the man's portrayal of a *desired*—rather than *lived*—zazous identity becomes apparent in the recognition of studio-provided materials, such as the eyeglasses, tie, watch, handkerchief, and fountain pen that are identical in both images. Friends and family members residing in Bamako would likely have been privy to whether or not studio props were used in portraits to create a desired self-image. However, relatives in rural villages, pen pals in France,

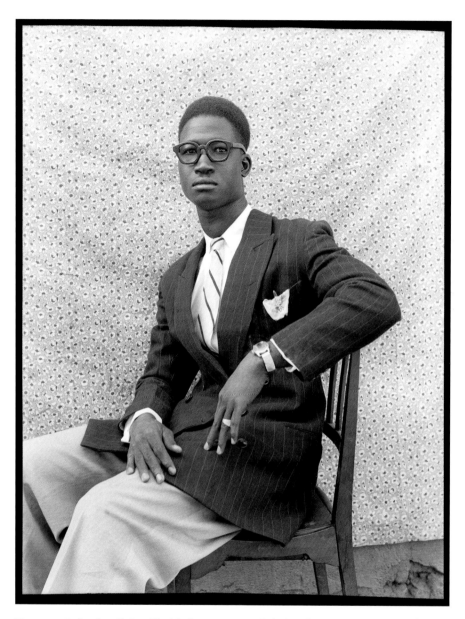

Figure 2.18. Seydou Keïta, *Untitled*, c. 1958–59. Gelatin silver print, 23 × 19 inches. Courtesy CAAC—The Pigozzi Collection. © Seydou Keïta/SKPEAC.

and foreigners would not and might presume the accuracy or authenticity of an image. Composing idealized portraits grants those images the authoritative power to speak through a perceived reality as "truth" and to serve as a form of "proof" for future generations. As a result, portrait photography was and is a powerful tool for identity construction and its dissemination, enabling individuals to create desirable self-images and augment their personal reputations in certain social circles.

In this capacity, as Susan Sontag and Roland Barthes noted, photographs accommodate a lack of trust in human sensory capacities to *know* and mental faculties to *remember* details (Sontag [1973] 1977, 163–65; Barthes 1981, 84–91). For example, Barthes stated that the photograph's "force is nonetheless superior to everything the human mind can or can have conceived to assure us of reality" (Barthes 1981, 87). Although rarely a conscious phenomenon, photographs and related visual media, such as television and film, form the primary vehicles by which one becomes familiar with, or "knows," national and international cultural and political icons from decades past as well as current celebrities, whom ordinary citizens rarely encounter in person. In this regard, Nimis stresses the importance of photography as a guardian of cultural and personal memory (Nimis 1998c, 59). Although one may be inclined to view these as merely Western attitudes, photographs operate similarly in Mali and neighboring countries. Highlighting this situation, Ghanaian photographer Joseph K. Davie commented, "If you don't photograph yourself, you die forever. Nobody remembers you, nobody knows you" (Wendl and DuPlessis 1998). Urban Malians feel similarly about the capacity of photographs to retain information over periods of time with greater accuracy than the human mind and oral accounts alone. As a result, photographs serve as memory reminders, bolsters, and even substitutes.[39] In this vein, one photographs with the hopes that the moments captured will not fade from individual or collective memory. Through these images, one is able to visually and mentally revisit moments from the past and delight in their details. Previously experienced emotions and feelings may be rekindled. Uncannily, photographs enable one to confront former versions of oneself and scrutinize the minutia of one's past physical likeness, which would otherwise be impossible. In general, however, photographs serve as memory markers, preserved to remind us of past times, places, experiences, and people.

As evidence of an individual's existence, photographic portraits are also a means to "know" someone who is no longer living. This capacity was among the most important for Bakary Sidibé (2005), who stressed that "photographs have the power to remind you of someone far away, who is dead." For many people, photographs are the *only* way they can visually *know* and *identify* these individuals (Sontag [1973] 1977, 165). Azeem Lawal clearly stated this point: "If I never met you, with your picture, I can know you" (A. Lawal 2004). This is particularly true in the case of ancestral portraits that feature deceased grandparents or great-grandparents. Retaining such images in family archives promotes a sense of cohesion and continuity between older and younger generations. It is also a way to commemorate those persons—to honor and prolong their visual presence in the collective memory of the living. As such,

photographic portraits come to represent them as personal surrogates. Illustrating their importance are instances in which Malians visit studios to have portraits of deceased elders or siblings reprinted years later from negatives retained in studio archives. In the twenty-first century, for example, Malians who have immigrated to Europe or the United States as well as those who reside locally regularly arrive at Studio Malick to request such prints. During my year-long residency, I witnessed more than forty of these commissions. It is a testament to Sidibé's archival system that immediately, or within a day or two, he was able to locate the negatives in question and reprint them. Today, this work is undertaken by his son Karim.

In some cases, when negatives are not available, clients commission photographers to photograph old, frail images with the hope of prolonging their lifespan for future generations. For similar purposes, individuals sometimes solicit portraits of themselves holding an old or damaged photograph. These practices reiterate the importance of photographs as memory devices. They also indicate that, contrary to the notion that photographs are permanent records, they, too, have a finite existence. As vulnerable, fragile objects, they fade, wither, crease, tear, and deform with time (Sontag [1973] 1977, 4). In this regard, Barthes described the photograph as "mortal: like a living organism . . . attacked by light, by humidity, it fades, weakens, vanishes" (Barthes 1981, 93). Such archival challenges are especially pertinent in Mali, where temperatures exceed 120 degrees Fahrenheit during the hot season, air conditioning and other forms of climate control are prohibitively expensive for most citizens, and dust is pervasive, particularly during the Harmattan season when powerful winds blow desert sands southward toward the capital. In light of these circumstances, it is telling, yet not surprising, that professional photographers in Mali cite durability as a primary factor informing their general preference for black-and-white film (D. Sitou 2004; M. Diarra 2004; Magnin and M. Sidibé 2003, 80).

Portraits preserve aspects of personal identity as well as sociohistorical events and changes in cultural trends and styles over time. This renders them particularly important today in cultural, historical, and ethnographic studies, as evident in numerous photographic archives maintained by museums and academic institutions across the globe. Therefore, as Wells observed, "popular photography is increasingly used as social-historical evidence. Personal albums, and other materials, are viewed as a form of visual anthropology" (Wells 2001, 53). In this vein, Magnin stated, "The thousands of prints that Keïta took form an outstanding record" of Malian society during the 1950s and 1960s (Magnin 1997, 8). Thus, photographic images can be retroactively powerful as

documentary evidence of a particular time and place. In *their day*, however, by capturing current trends and styles, portrait photographs held an influential capacity facilitated by their reproductive quality, rapid dispersal, and mobility. On display in front of photographers' studios, or passed from person to person, photographic images readily disseminated trends and knowledge great distances, which expedited their popularization during the 1950s in the French Sudan.

Among urban trends, such as zazous, boxing had become popular throughout Africa by the 1950s. Around that time, photographer Baru Koné was an active participant in the neighborhood boxing associations of Bagadadji and Niaréla in Bamako (B. Koné 2004). On this topic, Koné remarked, "Before . . . the 1940s, boxing became popular. It was brought from Senegal and France. People liked it. Bercure was the first Malian boxer. . . . In Bagadadji, [Baladji] Cissé [Mamadou Cissé's brother] was the president of the boxing association. . . . [Even I] was strong at the time [from doing blacksmith work] and was good at boxing. One knock and you were on the floor!" (B. Koné 2004).[40] Reflecting the sport's popularity, many portraits of African men in the French Sudan from this period portray them as boxers (fig. 2.19), assuming aggressive stances and at times donning iconographic silk shorts or boxing gloves, whether captured in the boxing ring or in the photographer's studio (M. Sidibé 2003). Soccer was also popular by the 1950s in the French Sudan. As a result, studio archives are replete with images of men posing with a soccer ball or trophy to convey their love of the game and record their success (fig. 2.20).

By the 1940s, another favored urban phenomenon was the cinema. Writing in the 1960s, Claude Meillassoux stated that, in Bamako, "the attraction of the movies is so strong, especially for the youth, that some boys, after earning their daily fifty francs at the market carrying baskets for European ladies, attend every night. Seeing the same show several times in a row is not uncommon. Married men of the petty bourgeoisie go to the movies on Saturday night with boy and girl friends, but usually without their wives. . . . There is always a crowd of young men at the doors of the movie house, standing and chatting loudly during the entire performance. It is a common meeting place" (Meillassoux 1968, 88). Most individuals of these generations whom I interviewed in Bamako said they frequented the cinema in their youth—spending a good part of their salary or allowance on the entertainment—on Saturday evenings and Sunday matinees and in some cases daily. For example, Baru Koné remembered going to see silent pictures when he was twelve years old at Soudan Cinéma in Bamako-Kura (B. Koné 2004).[41] In his younger years, Malick Sidibé went to the cinema "once a week," and Youssouf

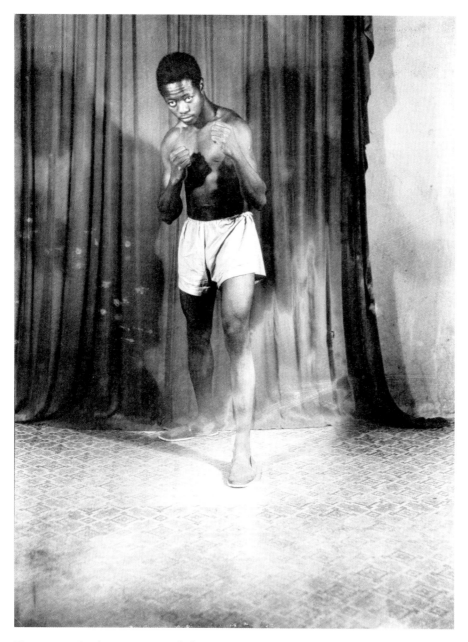

Figure 2.19. Seydou Keïta, *Untitled*, c. 1954–60. Gelatin silver print, 23 × 19 inches. Courtesy CAAC—The Pigozzi Collection. © Seydou Keïta/SKPEAC.

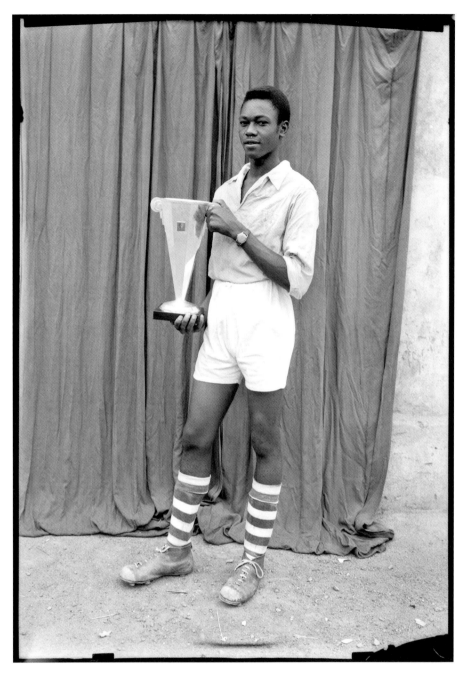

Figure 2.20. Seydou Keïta, *Untitled*, c. 1954–60. Gelatin silver print, 23 × 19 inches.
Courtesy CAAC—The Pigozzi Collection. © Seydou Keïta/SKPEAC.

Doumbia recalled going "to the movies every evening [for] 50–100 francs" (M. Sidibé 2003; Y. Doumbia 2004). The latter frequented Cinéma Vox and Cinéma Río, near Studio Malick, in the Bagadadji neighborhood of Bamako.

It is clear that young men comprised most of the cinemas' patronage, and written accounts tend to focus on their movie preferences. As a result, little has been reported on the tastes of women. However, in an article in *Elle* magazine, Malick Sidibé stated that "girls would wear flared skirts like [Bridget] Bardot 'The Liberated' in *And God Created Woman*, in their souvenir [portraits]," suggesting they appreciated depictions of sexy, independent women and emulated their associated fashions (M. Sidibé 2003, 214–16). However, most portraits from this era retained in photographers' archives depict women in the more conservative, long, flowing dresses and skirts à la Audrey Hepburn and Natalie Wood (fig. 2.21) that were called "grand Dakar" in Bamako, indicating a connection to Senegalese fashions of the time (Y. T. Cissé 1997, 273–75).[42]

Several men with whom I spoke cited "cowboy" or "Western" films among their favorites (B. Koné 2004; I. Samaké 2004; Y. Doumbia 2004). As Doumbia stated, "There wasn't a bad film at that time. There were gangster films and cowboy films, and it was those that we were interested in at first. I always preferred Westerns . . . American Westerns like John Wayne and Gary Cooper. . . . At the time there were Italian [Spaghetti] Westerns also, like *Django* [Clint Eastwood], [that] were in vogue" (Y. Doumbia 2004). Similarly, Malian musician Panka Dembélé commented on the Western trend in Bamako: "The cowboy style went well with fringed jackets, jeans and boots. We didn't have T.V., so films were our main source of inspiration" (Magnin 1998, 170). Their recollections are corroborated by colonial documents housed at the Center of Overseas Archives in Aix-en-Provence, France, which record that in 1945, "the African public [preferred] American productions, in particular 'cowboy' films."[43] For his part, Baru Koné said he most enjoyed "all action and detective films" (B. Koné 2004). The photographs of Seydou Keïta's and Malick Sidibé's clientele suggest he was not alone in this regard. Their archives contain several examples of young men emulating heroic protagonists from Westerns (fig. 2.22) and spy films (fig. 2.23), which were first introduced to Malian audiences at Bamako's earliest movie theaters, such as Cinéma Vox, Cinéma Rex, and Soudan Cinéma (Lamunière 2001b, 39).[44] Malick Sidibé recalled, "Some young people even copied the clothes and dances of actors they discovered at the movies in Bamako. You didn't see such things in villages in the country" (Magnin 1998, 37). A popular example was Eddie Constantine, an American actor who played Lemmy Caution, Federal Agent Number One, in a series of French detective films

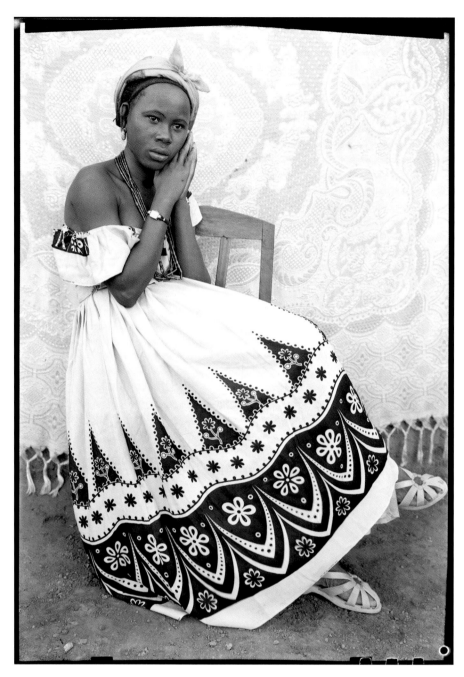

Figure 2.21. Seydou Keïta, *Untitled*, c. 1948–54. Gelatin silver print, 23 × 19 inches. Courtesy CAAC—The Pigozzi Collection. © Seydou Keïta/SKPEAC.

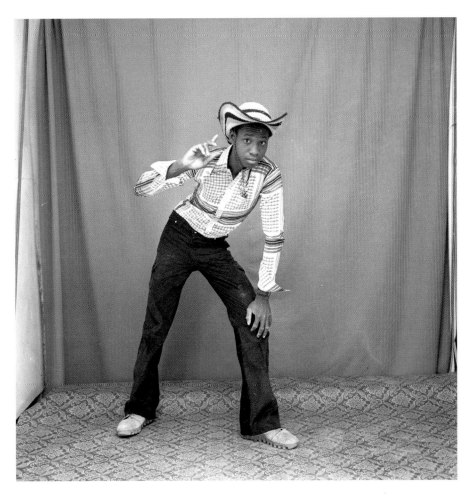

Figure 2.22. Malick Sidibé, *Look At My Beautiful Hat*, c. 1969. © Malick Sidibé, courtesy MAGNIN-A gallery, Paris.

from the 1950s and 1960s (Magnin 1998, 37; Y. Doumbia 2004). Depictions of these "tough guys" assuming strong postures and donning cool expressions, adorned with brimmed hats and loafers and often smoking tobacco pipes or cigarettes, are prevalent in the careers of both artists, which span the three decades from the 1950s through the 1970s. James Dean was another fashionable icon emulated by young men in Bamako, particularly members of the "Dean's Boys Club." According to Meillassoux, "These young men showed great admiration for the American movie star, dressed in blue jeans and fancy shirts with plunging necklines, walked with hunched shoulders, and had their hair cut so as to look like their idol" (Meillassoux 1968, 131).

During this period, Craven A, Camel, Job, Gauloise, and Mélia were the most popular cigarette brands in Bamako (B. Koné 2004; *Marchés*

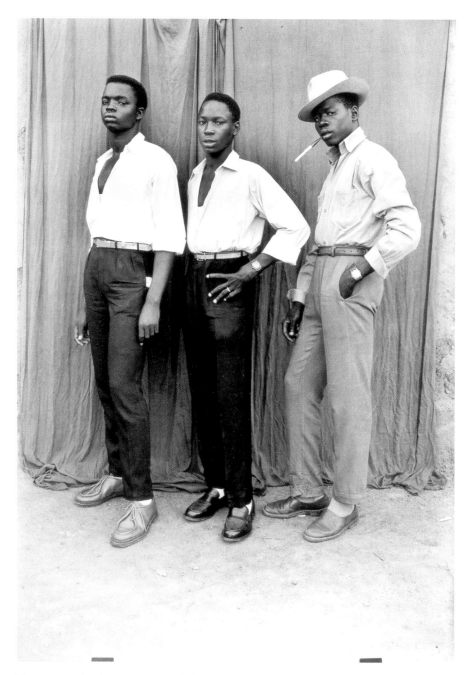

Figure 2.23. Seydou Keïta, *Untitled*, c. 1952–55. Gelatin silver print, 23 × 19 inches. Courtesy CAAC—The Pigozzi Collection. © Seydou Keïta/SKPEAC.

Tropicaux et Méditerranéen 1966). Mélia, a French commodity, was the most appreciated during the 1940s through independence in 1960. Like elsewhere in the world, the practice of smoking cigarettes grew increasingly familiar in Bamako after World War I and World War II, and it was popularized by members of the Tirailleurs Sénégalais. Baru Koné stressed, "All the military guys smoked" (B. Koné 2004). Even he picked up smoking from his brother-in-law, Jean Ambourazine, who was a soldier from Martinique stationed in Bamako. Beyond conveying the stylish demeanor and masculine bravado these young men desired, Elder argued that "the cigarette became a symbol of independence and membership in the adult world" in part because, for most youth, "smoking was prohibited at home" (Elder 1997, 108). Expressing an elevated sense of modern autonomy, by the following decade, young women are also pictured with cigarettes (fig. 2.24). Thus, over the years, the cigarette has remained a symbol of contemporary sensibilities and youth culture in Mali and, as a result, has been incorporated into photographic portraits. Speaking about the cigarette's importance for Bamako fashions in the 1960s, Diawara explained, "The elegance of Paris's style was also marked by a pack of 'Craven A' cigarettes. . . . With [a] Craven A cigarette and tailored shirt [a man could look] like the actors from the Italian photonovellas" (Diawara 2003b, 8). In fact, even nonsmokers purchased or borrowed cigarettes as props. Discussing one of his photographs (fig. 2.25), Malick Sidibé stated, "The *balafon* players were not really smokers, but they wanted their photo taken with cigarettes. Most people used chew or snuff at the time, but they wanted the 'cool' European playboy touch" (M. Sidibé 2003). The habit also presented certain opportunities, particularly in the way of mail-order prize giveaways. This advantage was appreciated by photographer Baru Koné, who at a young age collected discarded cigarette cards around the military camp at Kati (near Bamako) to obtain his first camera (B. Koné 2004).

Another imported commodity consumed and championed by young men in particular during the 1950s and 1960s in Bamako was alcohol. Alongside La Gazelle, a popular clear ginger ale made by the Sudan Brewery, whiskey and beer were regularly featured at neighborhood youth parties and dances (Y. Doumbia 2004; Elder 1997, 95, 108; Meillassoux 1968, 137). However, alcohol remains a contested commodity; several Muslim religious and political leaders since this period have sought to curtail its sale and consumption.[45] As a result, alcoholic beverages, like cigarettes, were an important element of and symbol for the emancipation activities of young people during this era and were associated with personal independence, modernity, and self-indulgence.

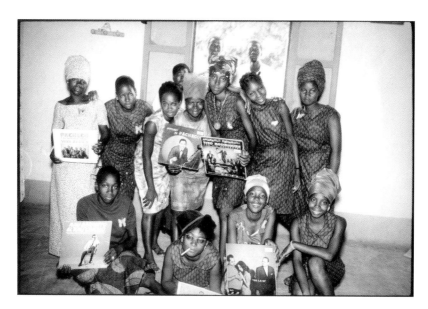

Figure 2.24. Studio Malick, *Record Lovers*, 1966. © Malick Sidibé, courtesy MAGNIN-A gallery, Paris.

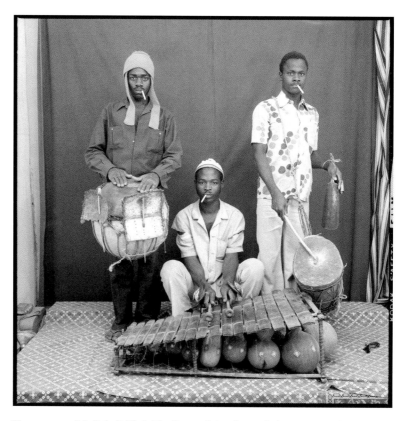

Figure 2.25. Malick Sidibé, *Traditional Studio Balafon Music of Mali*, 1966. © Malick Sidibé, courtesy MAGNIN-A gallery, Paris.

According to Iyouba Samaké, "modern dancing" began in Bamako in the 1940s. However, at that time, dances were accompanied by accordion music rather than an orchestra, which became more prevalent in the following decade.[46] During that period, Samaké stated that there were few record players and radio was little known because the colonial officials "did not want [Africans] to be informed about news from France during World War II."[47] However, Samaké recalls that he and his friends "would borrow record players from rich people on special occasions," and he remembers that at the time "typical music was called bekin (Cuban, salsa music)" (I. Samaké 2004). The Konarés report that, around 1942, the bara ("box") dance was popular (A. O. Konaré and A. B. Konaré 1981, 128). By the early 1950s, balls, or group dances, were regularly held by various neighborhood youth organizations and political or labor unions (*L'Essor* 1952b, 1955b).[48] In 1953, the same year the Sudan Museum was inaugurated in Bamako, the first "club," Bourbon, was created in the capital's Medina-Kura neighborhood (Becchetti-Laure 1990, 62). Its members, students recently home from France for summer vacation, introduced the bee bop dance. According to Meillassoux, bee bop became "[an] essential element of culture" for the city's elite. He also reported that, three years later, the Triana club—to which Malick Sidibé and his friends, such as Youssouf Doumbia, belonged—was created in Bamako-Kura and modeled on the Bourbon (Meillassoux 1968, 131).[49] Doumbia described the atmosphere: "Our neighborhood [Bamako-Kura] . . . was a melting pot . . . there were Senegalese, Guineans, Malians, there was everyone. . . . It was the center of Bamako. There was the Bar Coumba, the Bar Mali . . . everything. Above all, our [Triana club] nightly base was Bar Mali" (Y. Doumbia 2004).[50]

Contrary to the Zazous and Bourbon clubs, Triana's membership consisted of modern, middle-class young men who had not yet been to France. Par Doumbia's account, music at these "dance parties" (which he and fellow members also called "surprise parties" or "Cheb Jen parties") was provided by a Tepaz record player from the United States.[51] Popular dances from the 1950s and 1960s, he recalled, were the twist, the Madison, the jerk, the pachanga, and the goumbé, which was from the Ivory Coast (Y. Doumbia 2004; A. O. Konaré and A. B. Konaré 1981, 147).[52] Panka Dembélé, a musician in Mali during these decades, listed similar trends: "We played the beguine, the rumba, the tango, the waltz, blues, the bolero, swing, and, later on, in 1960, the twist arrived, along with the jerk, rock, and Louis Armstrong's jazz music and John Lee Hooker's blues" (Magnin 1998, 168–69).[53] However, as Malian musical sensation Boubacar Traoré ("Kar Kar") explained, although they

shared the same name, many of these dances merged imported and local styles, becoming transcultural modern creations in Bamako: "The twist was very successful, the whole world was moving to that music. Then the jerk arrived. The Mali twist and the European twist were different, but people danced them the same anyway. I wrote the songs myself. I sang them in French and [Bamanankan]. It was me who invented all that, we didn't copy anything! In Mali, we had a lot of different music, a lot of rhythms, plenty of art. I could mix two kinds of Malian music, and the result was the twist. That doesn't mean it was the European twist" (Magnin 1998, 181). Panka Dembélé concurred, "We added the African system to it, our spice! Young people didn't dance exactly like in Europe, they altered their dances by inventing gestures and moves" (Magnin 1998, 170).[54]

Abdourahmane Sakaly (and his assistants) and competitors such as Malick Sidibé at Photo Service regularly photographed their peers (figs. 2.26–2.27) at these dance parties during the late 1950s and early 1960s (M. Sidibé 2003). On this topic, Youssouf Doumbia stated, "At the time, photographers were invited to make souvenirs . . . at our surprise parties, our 'Cheb Jen,' that is to say when we danced in the night or during the day. It was Malick [Sidibé] who took our photographs. . . . I knew other photographers, [such as Abdourahmane] Sakaly, but I preferred Malick because of our friendship and because he was excellent. Malick is very strong in reportage. . . . There is a difference between others and him" (Y. Doumbia 2004). Malick Sidibé described the scene: "I moved about, always looking for the best position, I was always on the look-out for a photo opportunity, a light-hearted moment, an original attitude, or some guy who was really funny. . . . I had my table reserved where I could put my gear. . . . Some people would ask me to photograph them to have a souvenir, others would go off into the bushes and call me to take them with my flash while they were kissing in the dark. I would use up to six 36-shot films for a single surprise party" (Magnin 1998, 37). Sidibé continued, "Only the boys bought the photos, and they'd give them to the girls as a souvenir" (Magnin 1998, 39). In fact, male chivalry and female dependency were large parts of these social interactions. Meillassoux's research highlights numerous occasions in which the young men were required to pay the clubs' membership dues and the entrance fees for the balls or dance parties on behalf of their female partners, in addition to their own (Meillassoux 1968, 134–42). Thus, the young men who belonged to these institutions and participated in their events were clearly not from the lower classes.

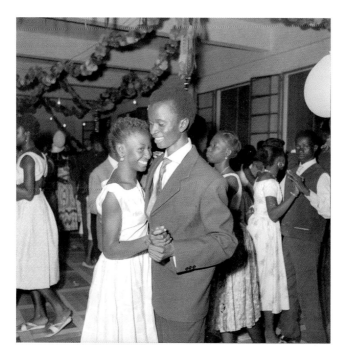

Figure 2.26. Abdourahmane Sakaly, *Untitled*, June 1959.
High-resolution digital scan of original 6 × 6 cm negative.
Courtesy Abdourahmane Sakaly Estate and the Archive of
Malian Photography (AMP). © Abdourahmane Sakaly.

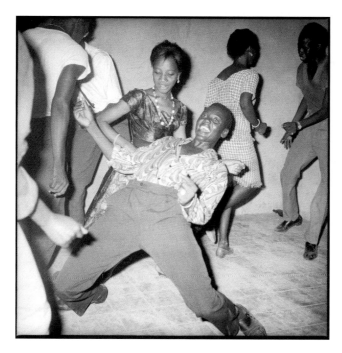

Figure 2.27. Malick Sidibé, *Look at Me!*, 1962. © Malick
Sidibé, courtesy MAGNIN-A gallery, Paris.

Although the photographic community, in Bamako specifically and in the French Sudan more generally, remained rather intimate in the 1950s, competition was nevertheless present. Thus, each photographer developed strategies to attract business and stand apart from his competitors. To this end, Seydou Keïta sent two of his apprentices, Malamine Doumbia and Birama Fané, to advertise his images and collect clients at the train depot nearby. Keïta explained, "They used to go to the railway station with samples of my work looking for customers and I gave them a percentage of the final price" (Magnin 1997, 10). Like other photographers at the time, Keïta also developed a rubber stamp to imprint his name on the back of his prints in order to bring in business by word of mouth. Emphasizing the success of this practice, Keïta related, "Everyone passed through my studio at one time or another. . . . Everyone knew about me. I had a rubber stamp—'Photo KEITA SEYDOU'—that everyone wanted on their prints" (Magnin 1997, 10). Similarly, Malick Sidibé decorated his prints with a serrated edge to personalize his creations and appeal to Photo Service patrons and, later, those at Studio Malick. He stated, "I noticed that clients liked them like that. Some would buy up to ten to twenty photos" (Magnin 1998, 39).

With similar impetus, most photographers used iconic backdrops as a recognizable signature for their work. For Seydou Keïta, it was decorative floral and arabesque patterned cloth, and Malick Sidibé has used vertically striped backdrops—of which two have been the most employed due to their continued efficacy today (Magnin 1997, 12; M. Sidibé 2005). Those who utilized painted scenic backdrops regularly changed them to keep abreast of fluctuating trends, ensuring their appeal for clientele (Malick Sitou 2004; M. Sidibé 2003, 2005; A. Kouyaté 2004b).[55] Circa 1950, Seydou Keïta featured a lush lakeside setting for évolué portraits (see fig. 1.10). In the 1970s, Malick Sidibé provided a "villa" backdrop painted by a "Wolof painter" (fig. 2.28) so patrons could have their portraits taken in the setting of a modern domestic courtyard (M. Sidibé 2003, 2005).[56] In Mopti, Hamadou Bocoum supplied his clients with a scenic backdrop depicting the Bani River and local fishing boats—an "important source of wealth in the region" (Elder 1997, 112). Finally, since the 1950s, Abdourahmane Sakaly used at least three painted scenes—a mosque, an ocean view, and an idyllic mountainside—in his studio to maintain the interest of his clientele.

Of course, studio props were another tactic regularly used to draw patrons in, as were the aforementioned glass cases that adorned studio facades to advertise their most recent work. In addition, many, like Seydou Keïta, used to hang samples of their work along their studio walls as advertisement and inspiration (Magnin 1997, 11). In some cases, the

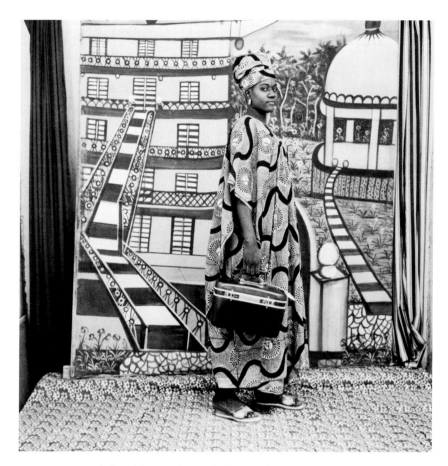

Figure 2.28. Malick Sidibé, *Studio Malick, Bamako, 13 mai 1977*, 1977. © Malick Sidibé, courtesy MAGNIN-A gallery, Paris.

strategy backfired. Malick Sidibé stated, "Some [clients] ordered prints and then didn't buy them because the most important thing for them was for their photos to be on view. So I took the precaution of asking for an advance" (Magnin 1998, 39).

To encourage the return of their patrons (and their friends and family) to the studio to have duplicates or reprints made of their images, most photographers retained systematically organized archives—in some cases over several decades. This practice has proven lucrative. For example, Keïta said of his customers, "They came back often and asked me for prints, so I kept all my negatives" (Magnin 1997, 10).

Finally, for those who could afford it, electricity was another amenity customers appreciated, and it ultimately boosted sales. In 1962, Malick Sidibé hoisted a neon sign above his studio entrance to draw attention to his shop. Sidibé described the scene: "It was very lively in front of my studio. I had put up a six-by-three-foot sign that read 'Studio Malick' in

neon. It was the only place on the street that was lit up outside. It brought me a lot of publicity but cost me a lot too" (M. Sidibé 2003; Knape 2003, 78; Lamunière 2001b, 27).

It is important to note here that with the greater prevalence and viability of electricity in the capital during the late 1950s and early 1960s, photography transformed from a daytime practice to one that thrived during the evenings, when patrons had more free time and temperatures cooled. Although studios remained open during the day, primarily to take identification photos, this time typically saw fewer clientele and therefore allowed for lunchtime siestas and extended "tea time" visits with family and friends, usually from the proprietors' and assistants' grins.

In another sound business tactic, Sidibé deliberately christened his enterprise Studio Malick—the local spelling of his first name—to separate himself from foreign photographers. Sidibé explained, "I chose the name Studio Malick because people knew me as Malick and because Malick is a Malian name, distinct from French photographers and [Abdourahmane] Sakaly," who was from Senegal (M. Sidibé 2003).

Alongside French practitioners, some of the popular African photographers in the territory from the 1930s onward were not native to the French Sudan. For example, according to Seydou Keïta, Boundiala Kouyaté (1920s–1950s) was among the oldest and most well-known photographers in Bamako (Nimis 1998c, 33). However, he was not from Mali but rather neighboring Guinea. Likewise, another Guinean, Robert Bangoura, was a well-patronized photographer in Mopti who taught Mamadou Cissé the art of photography at the close of the 1940s (O. Cissé 2004). Furthermore, perhaps the most popular reportage photographer in the capital during the 1950s, Abdourahmane Sakaly, was Senegalese born of Moroccan heritage (Sakaly 2010). I draw attention to this reality now to complicate any notion of photography in Mali as solely "Malian." Rather, it is the product of a multicultural, multilingual population with transnational practitioners who share French West African experiences, pan-African ideals, and global tastes. By the 1950s, and increasingly after independence, several anglophone West Africans (largely Yorùbá from Nigeria and Asante from Ghana) came to Mali to practice photography professionally. In so doing, they introduced new techniques and styles of photography as well as new ethnic-based neighborhoods in Mopti, Gao, Ségu, and Bamako, which will be discussed in greater depth in the context of the 1970s.[57]

Several important events between 1956 and 1960 directly led to the nation's independence from France and several sociopolitical shifts that significantly affected the practice and content of photography. In 1956, a major stepping stone toward independence—the *loi-cadre*—was passed,

which expedited the decentralization of political power in French West Africa (Foltz 1965, 73–74). That same year, on November 18, Modibo Keïta was elected vice president of the territorial assembly in the French Sudan and mayor of Bamako (A. O. Konaré and A. B. Konaré 1981, 150; Uwechue 1996, 340). It was also an important year for Keïta's political party, the RDA, which, for the first time, overwhelmingly triumphed in the 1956 general elections. By extension, that year marked the beginning of Modibo Keïta's march toward the presidency as he assumed the leadership of the French Sudanese branch of the RDA (US-RDA) after the untimely passing of its former head, Mamadou Konaté (Foltz 1965, 68; A. O. Konaré and A. B. Konaré 1981, 149).

At this time, dramatic political transitions were taking place throughout western Africa in anglophone as well as francophone territories. In the year that followed, 1957, the Gold Coast attained its independence from Great Britain. Under the leadership of its first president, Kwame Nkrumah, it appropriated the name Ghana (after the legendary empire that dominated the region from the eighth to twelfth centuries) to reclaim its proud heritage and promote nationalist morale. In the French Sudan, the same year saw the inception of Radio Soudan, which was instrumental, along with *L'Essor*, in disseminating RDA propaganda to the masses in the environs of Bamako (Lake 1993, 64; M. Sidibé 2003). Given the great sociopolitical import of radio broadcasts in Bamako during the 1950s and 1960s—as a venue for disseminating information and propagating ideas—radios in portraits were emblematic of individual agency and sociopolitical engagement as well as personal wealth and status (see fig. 1.8).

That year, Malick Sidibé began repairing cameras—a trade for which he became internationally—as well as locally—renowned (Magnin 1998, 40). As he recounted,

> I sent my first professional camera, a six-by-six Senflex, to France for repairs, but it would have cost three thousand CFA [an acronym for the French West African currency, Communauté Financière Africaine] and would have taken two months, so I asked them to return it . . . and I taught myself how to repair the camera. My brother, in Soloba, was an electrical handyman, so I learned some things from him. In 1956, there was an army photographer [in Bamako] who knew how to repair cameras. . . . He [also] helped. I took the camera apart, understood it, and then I could fix it. . . . In 1960, the photographer left and I did the rest of the repairs. (M. Sidibé 2003)

Although his decision was initially based on personal financial circumstances, this move ultimately marked another separation from French monopolization of photographic processes and a significant measure toward African independence and self-sufficiency in the French Sudan.

Subsequent years witnessed perhaps the greatest political strides in French West Africa leading up to 1960. In 1958, shortly after Charles de Gaulle was elected president of France, neighboring Guinea achieved its independence from French rule under Sékou Touré and, with Kwame Nkrumah, formed the short-lived Ghana-Guinea Union. Later, the French Sudan experienced internal political autonomy as the Sudanese Republic and afterward as the Mali Federation, which initially incorporated present-day Mali, Senegal, Burkina Faso, Benin, and the Ivory Coast (Foltz 1965, 89, 95–99, 104). Additionally, in 1958, African doctor Mamadou El Béchir Gologo was appointed assistant director of informational services for what is now AMAP. Gologo was the first non-Frenchman to hold the position, which was significant for the institution's African photographers: Malim Coulibaly and Ousmane Keïta (Gologo 2004; M. Coulibaly 2004; O. Keïta 2004).

The first Black African Youth Festival in Bamako, an event that expressed the popular sentiments of the day, including the drive toward pan-Africanism, African unity, the emancipation of youth, and political independence, was held that year (A. O. Konaré and A. B. Konaré 1981, 156; Becchetti-Laure 1990, 119). The festival, coupled with similar events, such as the Bamako soccer team's win at the French West African (AOF) Cup the same year, helped create an atmosphere, or *ambiance*, of "national consciousness" in the French Sudan (Foltz 1965, 124; *L'Essor* 1958). Indeed, from this period through the early 1960s, *ambiance* became *the* descriptive noun used to summarize the emancipatory, celebrative, nationalist fervor of youth-driven activities in the capital.[58] For example, Malick Sidibé recounted, "As a photographer I have been able to show [the] mad ambiance [of] this period so rich in revolutions that threw our traditions into disarray" (Knape 2003, 79). Not surprisingly, then, many Europeans, like Gérard Guillat-Guignard, began leaving the country this year as the reality of its political liberation quickly approached and the French administration presented opportunities elsewhere (Aren 2001, H; Guillat-Guignard 2016).

By 1958, Bamako supported a population of more than one hundred thousand inhabitants and contained nine neighborhoods (*L'Essor* 1952c, 4; Villien-Rossi 1963, 381). Youssouf Doumbia explained, "During the époque there was . . . Bamako-Kura, Niaréla, Bozola, Bagadadji, Medina-Kura, Dravéla, Wolofobugu, Dravéla-Bolibana, and Wolofobugu-Bolibana. Everyone knew each other and there was an ambiance between us" (Y. Doumbia 2004). To support the ever-expanding, active urban population, taxi services were augmented at this time. Doumbia recollected, "The first taxis were around 1949. . . . They became popular around 1958 and after independence. In 1958 there was a French brand by the name of 'Versailles'[59] that was installed in the [French] Sudan. It

was the 'Versailles' brand that Seydou Keïta had. [Thus,] people bought 'Versailles' cars and used them as taxis" (Y. Doumbia 2004). Like photography, this mode of transportation remained the prerogative of the middle and upper classes during this period, with the price of petroleum products rivaling photographic prints as luxury items.[60] Nevertheless, both industries continued to boom, and from 1959 to 1964, the local market of photography and cinema products (particularly photo paper) rose sharply (importing from 105,000 CFA to 250,000 CFA in 1964), with the French Sudan supporting the highest numbers in francophone West Africa. For example, by 1963, Mali had imported 27,500 CFA worth of darkroom materials, which was more than any other francophone African country, including the Ivory Coast (21,700 CFA) and Senegal (11,700 CFA). Thus, despite photography's relatively late genesis in the capital, by this time in French West Africa, Bamako had already become its most prolific center (*Marchés Tropicaux et Méditerranéen* 1966, 333). This suggests the city was a hub for photography in Africa well before it was chosen as the site for the *Rencontres* African photography biennial in 1994.

In January 1959, the African Federation Party was created, and Modibo Keïta was elected its president (Uweche 1996, 341; *L'Union* 1959a). Shortly thereafter, the federation named itself the Mali Federation and adopted its own constitution. Like Ghana before it, the appropriation of *Mali* was a deliberate attempt by the federation's leaders to align themselves with the illustrious Mali Empire (thirteenth through fifteenth centuries), paying homage to the region's great heritage and bolstering African pride among its citizens (Foltz 1965, 99, 104, 112).

That same year, the Gabriel Touré Hospital was opened in Bamako, and the city hosted the International Congress of Black Writers and Artists (A. O. Konaré and A. B. Konaré 1981, 156; *L'Union* 1959a). Expressing the convictions of the general population in French West Africa, the event heavily critiqued the "white racism Africans [had] endured" under colonialism and championed the empowering ideas of African unity and pan-Africanism (*L'Union* 1959a).[61] Around the same time, the National Youth Union of the Mali Federation (Union Nationale de la Jeunesse du Mali, UNJM) was founded, marking the beginning of many nationalist organizations that would emerge in the 1960s (A. O. Konaré and A. B. Konaré 1981, 158).

The 1960s

By the time the Mali Federation gained its independence from France on June 20, 1960, only Senegal and Mali remained members (Uweche 1996, 341). The union was short-lived, however. The federation was

dissolved by Senegal in August of that year due to conflicting ideologies and the competition waged between Léopold Sédar Senghor and Modibo Keïta—each vying for the primary leadership position. Culminating the Dakar meeting, which was riddled with dramatic events, Modibo Keïta and his entourage were "sent back home to Bamako by special sealed train on the morning of August 22, 1960" (Foltz 1965, 178, 181–82).

Shortly after Senegal declared itself an independent nation, Mali became an independent republic on September 22, 1960, during an "Extraordinary Congress" called by the US-RDA in Bamako. At that moment, the National Assembly and the Popular Militia were created under Modibo Keïta (A. O. Konaré and A. B. Konaré 1981, 163; Foltz 1965, 184; Imperato 2008, 204–5).[62] Mali cut off diplomatic relations with Senegal for three years after the rift and shut down the Bamako–Dakar railway at the border until 1963 when, "under the influence of the newly-formed Organization for African Unity [OAU], Senghor and Keïta met at the Senegal-Mali border in an emotional embrace to reopen the railroad and usher in a new era of cooperation between two independent states" (Foltz 1965; see also Lee 1986, 88; 183–84; Clark 2000, 252).

For many, independence gave rise to a period replete with optimism, celebration, and national pride. Like most nascent republics, the new government encouraged nationalist sentiments by renaming public institutions with national titles, such as Radio Mali,[63] Air Mali, Mali Energy, and the National Army of Mali (Lake 1993, 64; A. O. Konaré and A. B. Konaré 1981, 163–64);[64] by rechristening landmarks, roads, and other public structures built during the colonial era with the names of prominent African leaders, such as the Askia Mohammed High School;[65] by employing rhetoric charged with then popular notions of African unity, equality, and modernity; and most powerfully by invoking and promoting the cultural traditions and legendary histories of the territory's past. Nationalism was also encouraged by the single-party system. Meillassoux explained, "Every man and woman over eighteen [had to], in theory, join the [US-RDA], buy a membership card, and attend the general assemblies" (Meillassoux 1968, 70).

Initially, this policy nurtured a sort of unification among the civilian masses. The government and its people generally embraced socialist ideologies and practices as a welcome reprieve from the inequities and abuses experienced under the capitalist-imperialist policies of French colonialism and championed above all the ideals of African unity and pan-Africanism (Diawara 2003b, 14). Young segments of the population most actively propagated such ideals. They were the majority in urban locales like Bamako and tended to be more progressive in their ideas and worldly in their experiences.

Photographs taken by Malick Sidibé, his assistants, and his contemporaries captured the Panglossian fervor and exuberant atmosphere of the independence era, featuring young people from various social classes celebrating their newly achieved freedoms, often in the context of parties and dances hosted by neighborhood clubs or grins (fig. 2.27). Malick Sidibé described his images: "A lot of my pictures are of young people enjoying life. They are optimistic and happy-go-lucky. . . . When I first started taking pictures I would go around Bamako when Afro-Cuban music had just reached Africa. The music really liberated the young people, and I was able to catch that liberation on film" (Henry 2001, 4). The recently acquired freedoms for youth extended well beyond the political realm into the domains of popular culture and gender relations. Sidibé explained, "I started in the 60s. The young people were very insouciant [and] didn't worry about anything, just enjoying themselves. . . . In the 60s, the movies and music changed a lot in Mali. With the blues and then tango, the boys and girls had an opportunity to dance together. . . . Before that, the girls were like a precious jewel nobody could touch" (Burton 2004, 20–23).

Neighborhood parties were typically staged by clubs or grins in homes and residential streets in Bamako. According to Malick Sidibé, Rue Pachanga was the "busiest" locale for such events, and Panka Dembélé recalls organizing dances on lots owned by "Commandant Mory and Mister Daouda" in his neighborhood (M. Sidibé 2004; Magnin 1998, 168). "Dust dances" were held on vacant dirt plots around town. Thus these parties covered a wide range of informal and formal affairs, with the latter often orchestrated in celebration of graduations, birthdays, and weddings and to commemorate national independence. As Malick Sidibé described the practice, "To make things more serious . . . clubs saved up for big celebration parties like Independence Day parties . . . [for which] personal invitations called 'pleases' or 's'il vous plaîts' [were sent out]" (Magnin 1998, 169). As with all youth-guided activities, the dance, music, and fashion trends exposed at these events were continually in flux. Along with Western styles, the twist, and other modes practiced since the late 1950s, Sidibé recalled a popular dance in Bamako at the time was the locally inspired *nyogomen*, or "camel walk" (M. Sidibé 2003). Like this grassroots trend, several vogue elements of the era expressed Afrocentric values and popular sentiments tied to civil rights and liberation movements. For example, two trendsetting hairstyles for men in the 1960s were the Ghanaian and the Nkrumah, respectively named after the first independent West African nation and its esteemed leader (Elder 1997, 110; Magnin 1998, 169–70). Similarly, common nicknames revered international "freedom fighters" such as Sékou Touré, Patrice Lamumba, Kwame N'Krumah, Mao Tse-Tung, Martin Luther King Jr., Ernesto

Ché Guevara, Muhammed Ali, and Mahatma Ghandi (Diawara 2003a, 174). Other aliases functioned as local shorthand for regional and global pop-cultural icons and historical figures, including Modibo (Van Morrison), Adama (Nostradamus), and Django (Clint Eastwood), as evident in the name of third-generation photographer Diango Cissé (Malick Sitou and D. Traoré 2004).

Above all, fashions among Bamakois in the 1960s were driven by popular music and cinema, with the former effectively publicized on Voice of America. Youssouf Doumbia stated, "Every morning at 6 a.m. I listened to . . . Voice of America, which was animated by George Collinet. . . . Every Wednesday they released a new record. When I heard the record, I immediately ordered it on Thursday morning, and the following Monday [two weeks later] I received the disk in my mailbox. [Voice of America] were the ones who made pachanga . . . the twist and James Brown . . . popular in Mali" (Y. Doumbia 2004). Of these, James Brown's style inspired many fashion trends (fig. 2.29). Malian film scholar Manthia Diawara recalls that these included "tight turtleneck shirts with buttons or a zipper, which the local tailors made from looking at the pictures on album covers. The same tailors in Bamako also made the 'James Brown' style of shorter, above-the-ankle bell-bottom pants, which were thought to enhance one's ability to dance the Jerk or the Mashed Potato" (Diawara 2003b, 14). Diawara added that, in the 1960s, "everybody had to have a flowered shirt to feel part of the youth culture, not only in Bamako, but also in Paris, London, and Amsterdam," connecting youth in Bamako with those elsewhere around the world (Diawara 2003b, 8). Emphasizing the contemporaneous, cosmopolitan nature of the era's fashions in Bamako, which challenged prevalent Western perceptions of Africans, Malick Sidibé exclaimed, "Look at my photos of that time, and nobody could say we were behind the times!" (Magnin 1998, 180).

In addition to providing entertainment, dance parties facilitated long-term intimate connections among friends and romantic partners. As Sidibé stated, "Most young people met at those dances and got married" (Magnin 1998, 169). In turn, secular wedding celebrations often concluded, as in the West, with dancing festivities.[66] Meillassoux's account from the early 1960s describes this phenomenon in Bamako: "The most sumptuous artistic shows offered in the streets by a Bamako association are undoubtedly the marriage celebrations of *Ambiance*" (Meillassoux 1968, 107).

Diawara surmises that "party" photographs from the independence era indicate a new social preference for reportage photography over studio portraiture in the 1960s: "The change in power from a colonial system to an independent state brought about a profound transformation in

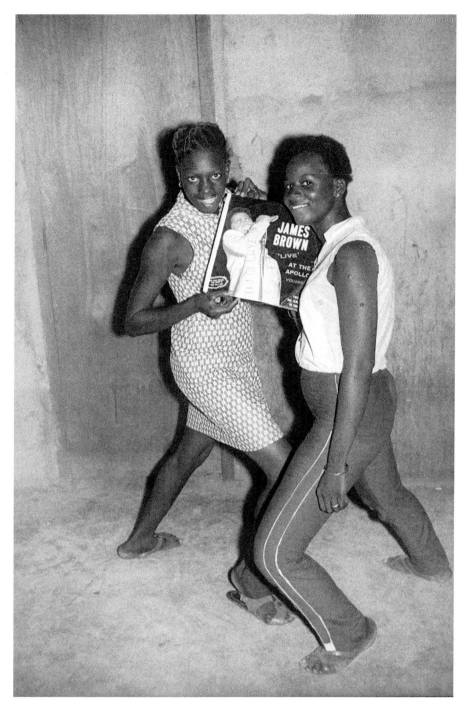

Figure 2.29. Studio Malick, *James Brown Fans*, 1965. © Malick Sidibé, courtesy MAGNIN-A gallery, Paris.

people's sense of aesthetics in photography. . . . To be photographed in a studio was associated with being fake and a powerless pretender. . . . In other words, studio photography was seen as unreal, whereas realism had become the criterion for defining the new aesthetics of Bamakois photography. . . . Photographers therefore had to come out of the studio and follow the action wherever it was taking place" (Diawara 2003b, 10).

Although the appearance and emotive quality of portraiture continued to change, reflecting the contemporary values, interests, and energy of the young clientele, Diawara's position is not entirely accurate. First, studio portraiture remained popular well into the 1970s, even among youth. Second, there are a number of reasons why reportage or "party" photos had already become a popular phenomenon during the 1950s, including advances in camera technology and changing social practices that catalyzed the development of new business strategies. Certainly reportage was an enterprise dominated by youth. As Baru Koné more definitively articulated, "Kids did reportage [while] older people did studio work." In other words, since the 1960s, younger photographers have more readily engaged in reportage photography, typically relegating older practitioners to studio and identification portraiture. In his own case, Koné said that by the time of the Trois Caimans (Three Crocodiles) nightclub, which was located near the old bridge in Bamako during the 1960s, he stopped making reportage photographs because he was too old (B. Koné 2004).[67]

In fact, this generational divide provides the general impetus for well-established photographers to hire young apprentices. More than the need for assistance with work overload, photographers regularly employ male assistants of the same generation as their predominant clientele (young people commission more photographs than do elders) to help keep their business afloat. On this topic, Moumouni Koné stated that "photography is tied to generation" and determined that he had markedly fewer clients as an older photographer "because young people go to young photographers" (M. Koné 2004). Similar impetus exists in other areas of western Africa, even beyond reportage contexts, as explained by internationally renowned Ghanaian photographer Philip Kwame Apagya: "As I get older I think more about giving up my studio. One of the reasons is that women especially prefer to go to young photographers. With people the same age they can joke and have fun, whereas they must show respect for an older person" (Wendl and Apagya 2002, 48).

In Mali, due to the kind of activities young people engage in at parties, dances, and nightclubs (i.e., intimate male-female interaction and alcohol consumption), which are often deemed inappropriate by older segments of the population, young people patronize reportage photographers of their same generation, correctly presuming they will be more sympathetic to

their interests. Malick Sidibé explained, "It's not appropriate for an old person to attend the parties of young people. Kids don't want old people to know what they are doing" (M. Sidibé 2003). Therefore, in the studio industry, commonly the young, unmarried apprentice photographer shoulders reportage work while the more seasoned professional remains at the studio, composing portrait and identification photographs and carrying out or overseeing all darkroom processes, particularly printing. Several photographers I interviewed opined that the generational divide begins with marriage. After marriage, one is considered an elder and therefore must hire an unmarried apprentice to assume the studio's reportage commissions (M. Sidibé 2003; Sidiki Sidibé 2003; Malick Sitou 2004).

This reality brings to light an important and regularly overlooked aspect of photographic practices in Mali specifically and in West Africa more generally: namely, the work of apprentices in the archives of professional studios. Case in point is an image of a couple kissing at a house party during the 1970s featured in Magnin's catalogue of Seydou Keïta's photographs (Magnin 1997, 269). For all the reasons formerly put forth, it is not possible that Keïta (who was married, in his fifties, and employed at the police department) took that photograph. The same point could be argued concerning a number of images published under the name of several prominent photographers working in Mali and elsewhere in western Africa since the 1940s. By drawing attention to this reality, I do not wish to take anything away from these men—namely Keïta in this instance—or their families. After all, professional photographers are considered to be the rightful owners of the negatives produced by their studio "workshop," which in this way operates similarly to those of European Renaissance artists and many international artists today. Rather, I address this point to highlight the important role apprentices have played throughout the history of photography in Mali as an important element of sound business tactics, maintaining the social relevance of studio enterprises across multiple generations. This tradition, which began as early as the 1940s, continues today and, as such, is addressed again in subsequent chapters.

During the 1960s and 1970s, studio portraiture did not wane in Mali but instead remained common among youth and other segments of the population. In studio settings, individuals continued to incorporate props to convey their (idealized) identity, as evidenced in the archives of Malick Sidibé in Bamako (fig. 2.30), Tijani Sitou in Mopti (figs. 2.31–2.32), and their colleagues. Thus, contrary to Diawara's argument, the aesthetic transmutation of photography at this time was not necessarily informed by a heightened appreciation for "realism" (which Diawara aligns with reportage imagery) or a distaste for falsehood (affiliated, in Diawara's

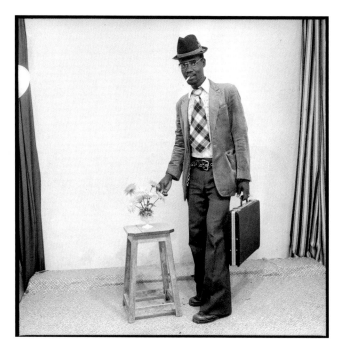

Figure 2.30. Malick Sidibé, *After the Studio, Voyage to France*, c. 1960s. © Malick Sidibé, courtesy MAGNIN-A gallery, Paris.

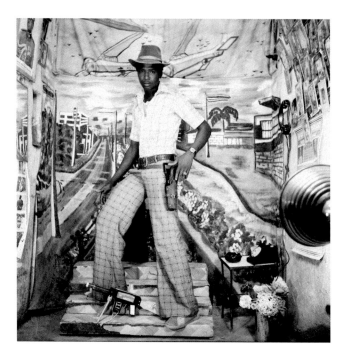

Figure 2.31. Tijani Sitou, *I Am Pecos*, 1976. High-resolution digital scan of original 6 × 6 cm negative. Courtesy Tijani Sitou Estate © Tijani Sitou.

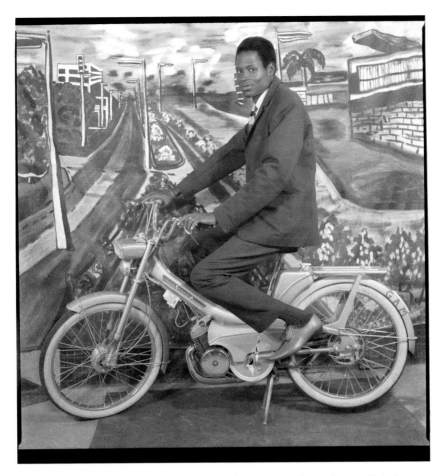

Figure 2.32. Tijani Sitou, *Good-Bye Friends*, 1976. High-resolution digital scan of original 6 × 6 cm negative. Courtesy Tijani Sitou Estate © Tijani Sitou.

model, with portraiture) but, rather, by a preference for the visual expression of the era's emotive, kinetic energy. Malick Sidibé explained, "I've always felt the need to bring some life into my photos. Even in my studio photos, I was interested in movement" (Njami and M. Sidibé 2002, 95). To convey this sense of energetic motion, photographers developed and employed various compositional strategies in studio as well as reportage contexts, which will be disclosed in chapters 3 and 4. In fact, despite his international renown for "party" pictures, according to Sidibé, "The best portraits are [made] in the studio" (M. Sidibé 2004).

Although clients continued to solicit studio portraits well after independence, the personalities they assumed in their images transformed somewhat during the dynamic period of the 1960s. Relatively aggressive characters in popular culture, such as Lemmy Caution and the boxer, continued to be emulated in portraiture during the 1960s (fig. 2.33).

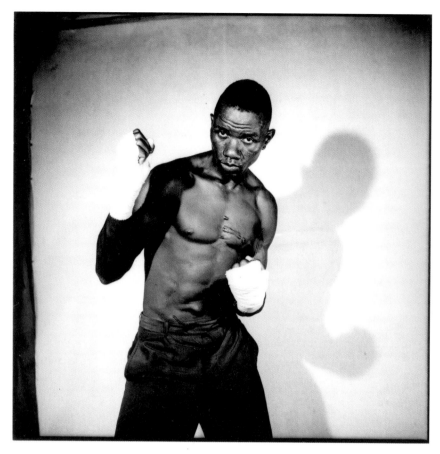

Figure 2.33. Malick Sidibé, *Boxer*, 1966. © Malick Sidibé, courtesy MAGNIN-A gallery, Paris.

However, the more reserved dandies inspired by Mallarmé fell out of fashion, no longer resonating with the active spirit of the younger generation. In place of the zazous, a new fashionable persona emerged—the *Yé-Yé*—who flaunted stylish trends associated with the popular musical genres of the day performed by the Beatles, Johnny Hallyday, and James Brown (fig. 2.15).[68]

In addition to capturing prevailing trends in their portrait and reportage work, first- and second-generation photographers during this period also documented many sociopolitical changes and cultural events that transpired throughout the country. For example, Abdourahmane Sakaly, Mamadou Cissé, and photographers at the institution that would become ANIM in 1961, such as Malim Coulibaly and Ousmane Keïta, made numerous images documenting the visits of foreign dignitaries and other political events,[69] as well as cultural celebrations, such as the annual

National Youth Week festivities, that transpired around the country after 1962 (O. Keïta 2004; M. Coulibaly 2004; A. B. Cissé 2005; M. Sidibé 2004).[70] They also documented the construction of newly erected monuments and architectural buildings. Several of these images appeared in *L'Essor*, *L'Observateur*, and international francophone journals such as *Industries et Travaux d'Outremer* and *Afrique*, as did photographs illustrating the implementation of social projects, such as Modibo Keïta's Operation Taxi program (see fig. 2.35 further below), Pionnier events, and voting practices. Other photographers, such as Malick Sidibé, also took photographs of those occasions along with images featuring President Keïta and other socialist leaders.[71]

From this era onward, many of the country's professional photographers participated in national competitions held in the governmental palace at Kuluba to determine the official presidential portraits of Modibo Keïta and his successors (O. Keïta 2004). These heavily duplicated images appeared in nearly all governmental, and some commercial, offices. They were also featured in *L'Essor* and other newspapers, in parades, and on factory-printed textiles. According to photographer Siriman Dembélé, every president before Amadou Toumani Touré (ATT) held one of these competitions (S. Dembélé 2004). In his account, ten of the prospective participants were selected to compete. The contest took place on a designated day during which each photographer was granted fifteen minutes to take four to seven portraits. The president would stand in a large room and the photographers would take turns photographing him. A few days later, they would return with their portraits and present them to a jury that would determine the winner. Dembélé participated in both Moussa Traoré's and Alpha Oumar Konaré's portrait competitions, yet he did not say who won either of these.[72] However, Bakary Sidibé later attested that Dembélé had created "official" portraits for Moussa Traoré in 1984 when he was "promoted to general in the army and commander of the whole National Defense Forces and did the same thing for Alpha Oumar Konaré in April 1992" (Bakary Sidibé 2006). Ousmane Keïta said he made "official" portraits of Modibo Keïta, Moussa Traoré, and Alpha Oumar Konaré as the "chief of the Photography Section of AMAP" (O. Keïta 2004). One of the most reproduced portraits of Modibo Keïta was created at the Harcourt studio in Paris (fig. 2.3)—a symbol of French elite status known for glamorous celebrity photos since the 1930s and 1940s. Regardless of the context in which these photographs were created, officially sanctioned presidential portraits functioned as self-promoting displays of power, and their frequent repetition has rendered them iconic—immediately identifiable, culturally loaded—images.

Nationalization also facilitated a greater need for identification photographs. In the words of photographer Mahaman Awani in Gao, "everyone needed ID photos" in Mali after 1960 (Awani 2004). As with many countries, these national forms of accreditation constitute an integral part of citizenship and the regulation of civil liberties, such as voting, traveling, working, attending school, or getting married (Boyer 1992, 42; Elder 1997, 171–72). Identification cards were similarly required by Mali's newly independent neighbors, such as the Ivory Coast, where Abidjan photographer Dorris Haron Kasco reports, "After independence the need for identification pictures increased, as passports and identity cards were being issued" (Kasco 2002, 57). Due to governmental stipulations, identification photography remained a major staple of studio photographers' businesses until recently, when digital versions have begun to be issued directly by the national police for official documents such as passports and visas.

Independence brought about innumerable changes, including urban population growth, which in Bamako rapidly expanded from circa 100,000 in 1958 to around 150,000 in 1963 (Villien-Rossi 1963, 381; Meillassoux 1968, 3; Magnin 1997, 10). Youssouf Doumbia explained, "With time, more people started coming from [rural areas] with different mentalities . . . and it changed the dynamic" (Y. Doumbia 2004). In some areas, the proliferation was in part due to the "evacuation" of French military bases from villages, such as Guelelenekoroni in the Wasulu region of southwestern Mali, where Malick Sidibé's cousin Bakary Sidibé was raised.[73] According to the latter, when the military left, so too "went the villagers' medical treatments for seasonal illnesses" (Bakary Sidibé 2004). This, coupled with the quest for improved economic opportunities, led some citizens to head for the cities. To combat this "rural exodus," the government developed the Quinquennial Plan, a five-year program (1961–65) designed to modernize and develop the rural economy in the domains of "transitional industry, mining research, education, health, transportation and the development of a national conscience." As part of this plan, with financial support from the USSR, China, and Czechoslovakia, the Office du Niger was nationalized, and related "agricultural schemes," including Operation Rice, Operation Cotton, and Operation Peanuts, were implemented, thus shaping Malian agriculture today (A. O. Konaré and A. B. Konaré 1981, 167; Imperato 1977b, 84; Clark 2000, 256).

The military's retreat does not imply that French involvement in the developing nation ceased to exist, however. In fact, in 1962, the Cultural Service of the French Mission of Cooperation and Cultural Promotion was created, supporting research by French scholars on the topic of local

culture (Becchetti-Laure 1990, 95). One such project concerned research on oral traditions among Dogon communities in the Bandiagara region of Mali "in collaboration with [French anthropologists] Germaine Dieterlen [and] Jean Rouche and . . . Malian historian Youssouf Tata Cissé," whose publications on Bamana culture and the history of Bamako remain important today (Y. Cissé 1973).

Within two years of independence, the population experienced several new shifts that would impact their individual and communal lives for decades to come: In 1961, the Malian Bank (BMCD) was created, and all but one French financial institution was forced out of the country, in an attempt to nationalize the economy (A. O. Konaré and A. B. Konaré 1981, 168, 171; Hazard 1969, 3). That same year, the influential nationalist youth organization Pionniers du Mali was formed. During the decades that followed, all children in Mali (eight to eighteen years of age) were required to participate in the Pionniers as part of a governmentally sanctioned scheme to socialize the nation's youth in accordance with party policies and propaganda (Meillassoux 1968, 67, 71; A. O. Konaré and A. B. Konaré 1981, 161, 165).[74]

On a more personal level, in 1962, the year Malick Sidibé opened Studio Malick, Seydou Keïta was coerced into governmental employment as a photographer for the National Security (fig. 2.34),[75] where he took mug shots of accused criminals and prisoners at police headquarters downtown.[76] As early as the 1860s, photographs of convicts became fairly common in Western contexts and were appreciated for their capacity to serve as evidence, record, or proof (Sekula 1986, 5; Marien 2002, 73; Tagg 1993, 66–68, 95). Under the control of national police forces, the practice became increasingly professionalized and standardized in the 1880s and 1890s. The man accredited with inventing the mug shot, as it is commonly known, is Alphonse Bertillon (1853–1914), director of the Identification Bureau of the Paris Prefecture of Police (Sekula 1986, 3, 17, 18, 25; Marien 2002, 224; Elder 1997, 172). His archival system paired descriptive information with a photographic portrait on a single indexical card.[77] Bertillon's method was widely proliferated in the late nineteenth and early twentieth centuries and contributed to the "internationalization and standardization of police methods" (Sekula 1986, 34). This system was practiced by the French colonial administration in Mali.

After independence, the Malian government inherited a kindred procedure in which prisoners are photographed according to a set of standardized criteria. These mug shots contain a frontal bust portrait with a neutral background and prominently feature a signboard, hung around the neck of the individual, that includes name, birth date, and date and

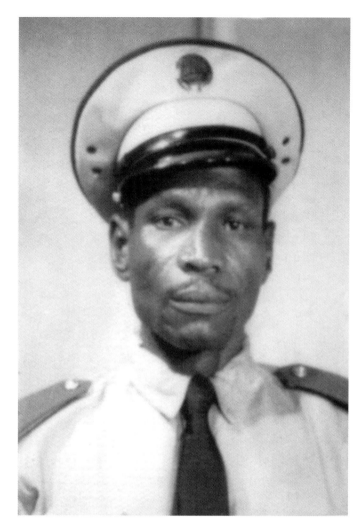

Figure 2.34. Portrait of Seydou Keïta wearing his police uniform during his service at the National Security in Bamako (taken sometime between 1962 and 1977), framed and on display in his son's establishment, Studio Seydou Keïta. Photo by author with permission from Baba Keïta, Bamako, 2010.

location of arrest. Seydou Keïta created this genre of photography for the Sûreté Nationale during the 1960s and 1970s. Of his coerced employment, Keïta stated,

> In 1962, just after independence, the government was socialist and everyone was expected to work for the new state of Mali. Issa Traoré, a childhood friend, the head of the Malian police, who was called 'the man with the Datsun,' came to look for me. He told me: 'Seydou, close your studio; the government needs a photographer.' . . . Oumar Boré, the director general of Malian security, was more considerate. He told me, 'Seydou, you can work in your studio, but only after office hours.' . . . But in 1963 they put pressure on me to close down my studio completely" (Magnin 1997, 13).

Those employed under Modibo Keïta's regime were forbidden to work in the private sector. Thus, at this time, Keïta's personal enterprise was handed over to his brother Lacina, son "Gomez," and assistants Abdoulaye and Mouris until he retired from his appointment in 1977 (B. Keïta 2010). According to police director Anatol Sangaré and former police official Ibrahim Doumbia, no examples of photographs taken by Seydou Keïta for the National Security during this period remain (Y. Doumbia 2005; A. Sangaré 2005). They insist such documents were destroyed, along with other official archives, in fires set at police headquarters in central Bamako during the riots of the March 1991 coup d'état.[78]

Between 1961 and 1962, a number of governmental creations were "officially" established that continue to function today, sometimes under a different name. Several of these were state enterprises formed during the Sixth Congress of the US-RDA. Most significant for photographers were the Malian Office of Cinematography (OCINAM) and the National Information Agency of Mali (ANIM). The former oversees the creation of educational, governmental, artistic, and commercial film and video productions in the country. Today it goes by the National Center of Cinematographic Production (CNPC) and employed photographer Harouna Racine Keïta until his death in 2020. The latter, presently known as the Malian Agency of Press and Publicity (AMAP), has been the primary workplace for photographers Malim Coulibaly, Ousmane Keïta, Oumar Siby, Mamadou Cissé, and Nouhoum Samaké.

During this time, drastic changes in national economic policies affected all markets, including photography, with wide-ranging repercussions. In 1962, Modibo Keïta withdrew Mali from the CFA (French African franc) zone and instituted a national currency—the Malian franc—which soon proved economically disastrous. Due to its inconvertibility, the new franc was "worthless outside the country" (Clark 2000, 256). As a result, imports grew scarce in the nation, which vitalized

smuggling and boosted the black market. Simultaneously, exports were diminished, inciting further stagnation of commercial agriculture in Mali (Snyder 1969, 18–19). Iyouba Samaké explained, "Going through the government food system, I couldn't get more than thirty kilograms [of grains]. How could I live that way? I was forced to go downtown and buy from traders [illegally]" (I. Samaké 2005).

All this, coupled with the government's ever-increasing reliance on loans, caused inflation and, according to Francis Snyder, "unregulated market prices of consumer goods [which] rose 88 percent between 1962–63 and early 1967" (Snyder 1969, 19). The financial and practical hardship that resulted from this act was readily felt at all levels of society and led frustrated businessmen and traders to hold protest demonstrations in Bamako on July 20, 1962. This ended tragically with 2 persons killed and 250 arrested, including three PSP leaders—Fily Dabo Sissoko, Hamadoun Dicko, and Kasim Touré—who were charged with treason and sentenced to death (I. Samaké 2004; Imperato 1977b, 39–41; A. O. Konaré and A. B. Konaré 1981, 171; Snyder 1969, 18). On October 8, 1962, their judgments were commuted to life in prison in Kidal. However, on August 3, 1964, the year Modibo Keïta was reelected,[79] the government "announced that the three had been killed in an ambush in the [region] of Kidal while being transported to Bouressa," implying they had been trying to escape amid the Tuareg rebellions underway in the area at the time (Imperato 2008, 87–88).[80] The general population widely doubted this explanation, and most people believe the prisoners were executed on Modibo Keïta's orders.[81]

In spite of the national recession, those in prominent social positions benefited most from Keïta's socialist program. Governmental employees and the military enjoyed "relatively early retirement from government service on good pensions, generous leave, and free healthcare and educational benefits for dependents" (Imperato 1991, 26). For much of the 1960s, the president's close relations with communist nations enabled political figures, governmental employees, students, technicians, photographers, and other civil servants to travel to the Eastern Bloc for training and education.[82] During this time, ANIM photographers Oumar (Diallo) Siby and Malim Coulibaly were sent to East Germany to learn various photographic processes. Papa Kanté went to Moscow for pharmaceutical training, where Guinean colleague Fasiné Ponkura introduced him to photography. Siriman Dembélé traveled to Bausher, Poland, and Mamadou Wellé Diallo trained in Bulgaria (M. Coulibaly 2004; P. Kanté 2004; S. Dembélé 2004; Nimis 1998c, 31, 61; Elder 1997, 73–74).

Furthermore, although western European commodities grew increasingly scarce in Mali during this time, those produced in communist

nations were widely available. As a result, Félix Diallo was able to acquire a Soviet Krokus enlarger. Elder argues that the presence of such materials in Mali was in part due to the fact that "students could not convert the Ruble when they left Russia [which] led to a focused investment in the technologies they considered to give them the best returns" back in Mali (Elder 1997, 84). One such commodity, which became ubiquitous during this period in Bamako, was the Zenit camera. Hamidou Traoré explained Malick Sidibé's involvement in this history: "I bought [my Zenit] from Malick, always with Malick. There were students who came from [the Soviet Union and East] Germany, who sold it to him. . . . Always people came to sell him things like that . . . they sold it for a profit" (Elder 1997, 84). Testament to Traoré's account, Harouna Racine Keïta admitted to having received his first camera, a Zenit, from Malick Sidibé (H. R. Keïta 2004).

Of all professional photographers in Mali at this time, it is unsurprising that those who received the most support were employed at ANIM. Thanks to funds and aid provided by East Germany, Poland, Yugoslavia, the USSR, and China, the institution's photographic department was well stocked and well trained (Elder 1997, 87, 89).[83] As Malim Coulibaly stated, "During the time of Modibo Keïta, you couldn't find a lot, but a lot was given to us [at ANIM], so we had no problem with materials. With Modibo, socialist countries gave [photographic] materials for free. [For instance] Yugoslavia gave [ANIM] an enlarger [and a] projector" (M. Coulibaly 2004). His colleague Ousmane Keïta concurred: "We never lacked products in the lab. We worked with the same products the entire time" (O. Keïta 2004).

Under the socialist regime in 1964, the year the House of Sudanese Artisans transformed into the National Art Institute (INA) and enrolled Diango Cissé, commercial photographers who were not affiliated with governmental institutions experienced difficulty obtaining requisite materials (Gaudio 1998, 208; D. Cissé 2004). Depending on their particular circumstances, photographers responded to the dearth of supplies in a variety of ways: Some emigrated elsewhere (even if temporarily), as in the case of Adama Kouyaté, and some traveled regularly, like Hamidou Maïga.[84] Others established trade networks with mobile relatives and friends (such as traveling businessmen and truck drivers) as well as colleagues who had relocated to neighboring countries, as did Abdourahmane Sakaly (photographer H. Maïga 2004; A. Kouyaté 2004a).[85] Most, however, suffered economic and professional hardship. For example, Adama Kouyaté recalled that "times were hard for photographers. Materials were difficult to find [and] everything became expensive" (A. Kouyaté 2004a).

The material strife extended into other areas of social life and had an impact on all markets as well as youth culture, which continued to pursue Western trends and commodities. As consumer products, particularly imported items, gradually depleted during this era, individual citizens invented ways to access them. Youssouf Doumbia, no longer able to purchase records in Bamako as the "main emcee" for Triana parties in the capital, solicited "childhood friends" who worked as flight attendants to smuggle them in from France. This way, he acquired music from a variety of artists: "Pachanga, Ray Bareto, Tito Pointe, Alfredito Bladez, Aragon, Chubby Checker, Elvis Presley, Otis Redding, Ray Charles, [and] James Brown" (Y. Doumbia 2004). Although locally fabricated items, such as Djoliba cigarettes, were available, people took similar covert measures to obtain coveted commodities, such as Western-style cosmopolitan attire and foreign-made cigarettes.[86] Baru Koné explained that, at the time, La Croix du Sud "sold all cigarette brands, even smuggled ones from Ghana, Nigeria, Guinea, and the Ivory Coast" (B. Koné 2004).

Beyond luxury items, the stifled market affected the realm of daily sustenance, which had a greater impact on the population at large. Rations were placed on food staples, such as millet, rice, and sugar. Youssouf Doumbia explained:

> Around 1963, the population was hungry, and to have five kilograms of grains tomorrow you had to stand out in front of one of the cooperative stores today around six o'clock in the evening. That is to say that each neighborhood had a cooperative store. . . . Some days you were unable to get anything and had to try the following day. . . . Imagine a situation in which the population regularly purchased their books freely at the market, and in a single blow, for their daily needs to be met, they have to stand in line from six o'clock in the afternoon until eight o'clock in the morning just to have five kilograms of rice. (Y. Doumbia 2004)

Malick Sidibé added, "It was a very somber period. Some areas couldn't sell grains. . . . In every neighborhood there was a big rice cooker, [a] community kitchen, and food was provided by the government, but it was less than people were used to" (M. Sidibé 2004). To stock these cooperative stores and kitchens, Keïta's regime devised a department of state known as Action Rurale, which was conceived to help rural farmers collectivize privately owned land and communally till the fields, creating so-called "collective farms" or "common fields" (Hazard 1969, 4–6; Rawson 2000, 271).

This situation worsened during Modibo Keïta's cultural revolution, which began full force in 1967 (Imperato 2008, 74–75). Like his socialist neighbor, Sékou Touré—who oversaw large-scale "arrests,

executions and prison deaths" in Guinea from 1964 to 1984—Keïta subjected citizens to increasingly repressive measures from 1967 until his fall from power via coup d'état at the close of 1968 (Uwechue 1996, 755). His stern reaction was incited in part by popular dissent to the Franco-Malian agreement, in which Keïta joined the Malian franc with French currency and devalued the former by 50 percent (Bennett 1975, 258; Snyder 1969, 19). On August 22, 1967, Keïta announced over Radio Mali his immediate plan to launch what he termed an "Active Revolution" in which he dissolved the National Political Bureau and handed its power over to the National Committee of the Defense of the Revolution (CNDR; A. O. Konaré and A. B. Konaré 1981, 183). The CNDR had been created in March the previous year after the coup that toppled fellow socialist leader Kwame N'Krumah in Ghana on February 23, 1966 (A. O. Konaré and A. B. Konaré 1981, 179–80; Rawson 2000, 271).

At this time, several radical positions were taken. First, Keïta and his administration denounced moderate functionaries, such as author-historian and diplomat Amadou Hampaté Bâ, who was removed from office and chose to remain in the Ivory Coast (where he was formerly Malian ambassador) until after the coup of 1968 (Imperato 2008, 28). Such policies were enacted in part through the institution of Operation Taxi and Operation Villa, which were purportedly designed to expose the (antisocialist) corruption and greed of government ministers and dignitaries (fig. 2.35).[87] During Operation Taxi, Francis Snyder reports, "Militiamen rounded up [168] private vehicles allegedly used as sources of illegal profits [privately-owned commercial taxis] by government and party employees and impounded them in the Bamako sports stadium until the owners could be [publicly] identified and exposed [over Radio Mali]" (Snyder 1969, 20; Imperato 2008, 233). Similarly, Operation Villa commissioners scrutinized the ownership of real estate that allegedly had been illicitly acquired by government employees. According to Snyder, in the end, nearly two hundred individuals, including "Hamaciré N'Douré and [Amadou] Hampaté Bâ [both ambassadors], and the political secretary of the [US-RDA], Idrissa Diarra," were sacked and publicly denounced. Illustrating the degree of pressure leveled at the population during this era, Snyder reports that repeated announcements on Radio Mali postulated, "'What have you done for the active revolution today?' and 'What kind of traitor are you?'" (Snyder 1969, 20).

The second and most volatile act of Keïta's "Active Revolution" was the revitalization of the Popular Militia, which was unleashed on the populace to quell dissidence, expose corruption, and cleanse the administration.[88] In reality, however, the Popular Militia readily became

Figure 2.35. Ousmane Keïta for AMAP, *Operation Taxi*, 1963–64. Reprinted by Nouhoum Samaké for author, Bamako, 2004.

an abusive force that was sanctioned by the government. By the end, its members regularly administered rampant arrests and corporal punishment, harassing citizens and military personnel alike (Hazard 1969, 10; Snyder 1969, 22; Uwechue 1996, 342; Imperato 2008, 74–75, 170). Youssouf Doumbia explained, "The 'brigade of vigilance' did not only occur at night . . . the militia used to go to the market during the day . . . and affected everyone: the butchers, the poultry sellers. [The militia] would take their merchandise from them and leave" (Y. Doumbia 2004). Doumbia also recounted some of his own experiences: "During the time of Modibo Keïta the police followed me because they felt I was responsible for the delinquency of minors [for supplying alcohol at neighborhood parties], which was against socialism, and they wanted to imprison me" (Y. Doumbia 2004).

Again, describing events that transpired during a party he held for his niece, Doumbia stated, "My record player and records were confiscated because the Popular Militia detected that we were having a dance. Otherwise, we would have danced peacefully, without problems" (Y. Doumbia 2004). Before long, the abuses of power committed by the Popular Militia were cast far and wide and included the confiscation of foodstuffs from rural farms, the detention of individuals without a trial, and torture (Bingen 2000a, 246; Imperato 2008, 10). Concerning this situation, Malick Sidibé recounted, "The system itself was bad. There was no justice at all. Some were even sentenced to death without judgment" (M. Sidibé 2003).

In a Malian newspaper article, for example, a man named Bakary Koné disclosed having been "tortured" for criticizing the "regime of Modibo Keïta in front of some police" ("Political Persecutions in Mali" 1996). Bakary Sidibé summarized the atmosphere of the day:

> People were getting fed up with socialism. The Popular Militia was treating people badly and people were getting poorer and poorer. The country was not developing. For food, Modibo Keïta was planning communal kitchens like in China. . . . There was no money, no clothes, no freedom, no enjoyment. People had to hide business. It was forbidden to be a private businessman. [The government] started grouping people into communes of workers: "Farming Communes," "Fishing Communes," etc. They tried to send people to China and the Soviet Union for training in these activities. Sometimes there was a curfew from 8 p.m.–5 a.m. Some of the opposition was killed. Some died in jail. Some were taken to Kidal for their opinions, for example. Kidal [was] the worst prison in Mali. (Bakary Sidibé 2004)

The *reality* of these hardships is submerged, and in a way subverted, in the portrait and reportage photographs made during this era (fig. 2.36).

However, these images regularly captured the indignant attitudes of young men and women who were frustrated by restrictive governmental policies and acted defiantly against them.[89] Sidibé's photographs, and those of his apprentices, for example, represent the rebellious attitudes and activities that defied the mandates of Keïta's socialist regime, continuing to a lesser degree throughout Traoré's rule (1970s and 1980s), when parties and dances were venues for young men and women to express their individuality and experience contested social interaction. Manthia Diawara recalled, "In Bamako, curfews were set and youths caught wearing miniskirts, tight skirts, bell-bottom pants, and Afro hairdos were sent to reeducation camps. Their heads were shaved and they were forced to wear traditional clothes. The situation did not get any better for the youth after the military takeover in 1968" (Diawara 2003a, 171).[90] Youssouf Doumbia explained:

> If you put on a tie, they would say that you are a capitalist, a colonialist. . . . If you were caught walking down the street with your girlfriend, and she was wearing a [short] skirt, not only would they tear the skirt, but they would take you both to their militia camp and beat you and let you return home with the possibility that you will be punished again if they see you together under the same conditions. That was the strategy they used to change the youths' mentality, to keep them underdeveloped. . . . The people in the photographs had to hide. They also had to hide that they were having a party. (Y. Doumbia 2004)[91]

Doumbia elucidated the means they employed to do so: "To throw a Cheb Jen party, one shared only the day and the time of the party (for

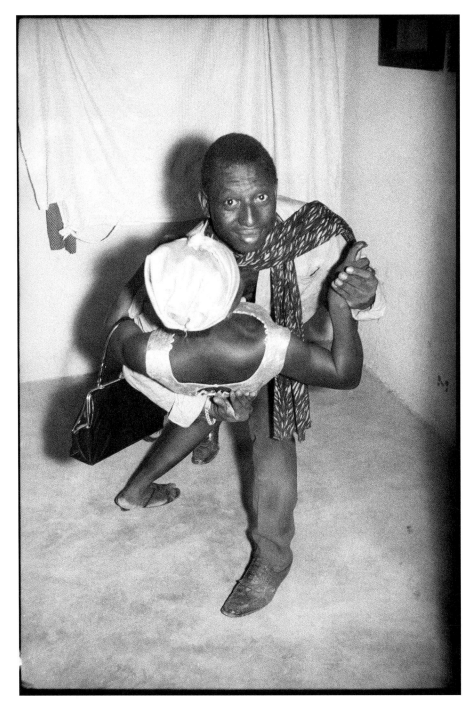

Figure 2.36. Studio Malick, *Couple of Dancers of the Beatles Club of Bagadadji*, 1966. © Malick Sidibé, courtesy MAGNIN-A gallery, Paris.

example, Saturday night). On Wednesday, each participant paid five hundred francs. Thursday, this sum was given to the girls, who would prepare the food. At the same time, the boys would be gathered at a house near the [Central Market]. [In other words,] we split up, used word of mouth, and did not tell our parents the truth about where we were going" (Y. Doumbia 2004).

Like their clientele, young photographers who documented these incriminating occasions, such as those employed at Studio Malick, equally participated in what were essentially dissident, covert events. Sidibé underscored the reprieve the festivities granted Bamakois youths in the repressive atmosphere: "Keïta created factories and curfews—all was controlled and forced. Young people could feel free at the parties because they were not free the rest of the time" (M. Sidibé 2004).

Although images in Sidibé's archive that were taken after 1964 resemble those created during the independence era and are often discussed as such in extant literature, it is important to recognize that these photographs no longer capture a celebratory atmosphere of youth rallying behind their newly independent government. Rather, they depict recalcitrant young men and women enjoying themselves and their forbidden freedoms, which have been surreptitiously attained.[92]

By 1968, the nation and its government were in a state of turmoil, as evidenced by the dismantling of the National Assembly on January 16 of that year. Furthermore, its citizens had been estranged from the administration due to its repressive measures and the abuses of power exercised by the Popular Militia. Their feeling of alienation was coupled with widespread fear and paranoia, which were propagated by the depraved comportment of authorities as well as by unofficial reports, for example, that Keïta was planning to kill off older segments of the population, particularly in rural villages.[93] Army support waned due to rumors that the regime had plans to disband and replace it with the Popular Militia (Snyder 1969, 20–22; Imperato 2008, 69–70, 170; Uwechue 1996, 342). This level of civil and military unrest rendered Mali ripe for a new revolution, and that is exactly what it got in the form of a coup d'état.

On the morning of November 19, 1968, a select faction of Malian army officers formed the Military Committee of National Liberation (CMLN),[94] immobilized the Popular Militia,[95] detained a small number of dissident colleagues,[96] closed down the airport, and cut major communication lines, with the intent to overthrow the government (Snyder 1969, 21; A. O. Konaré and A. B. Konaré 1981, 184). Shortly thereafter, military troops stopped President Keïta in the region of Kulikoro and took him into custody (Imperato 2008, 171).[97] Within hours, the majority of CNDR members and former government ministers (including Mamadou

El Béchir Gologo at ANIM) were arrested.[98] Citizens heard this message broadcast over Radio Mali: "The hour of liberation has come. The regime of Modibo Keïta and his lackeys has fallen" (Snyder 1969, 21). The announcement was followed by the music of renowned Malian *griot* Bazoumana Sissoko,[99] which has become a powerful national symbol played during every important political event and Malian holiday since 1960. The next day, massive demonstrations in support of the military coup formed in the streets of Bamako. Youssouf Doumbia asserted, "The coup liberated everyone. That is to say that people cried 'Liberty' and broke tree branches in the street [to show their joy of the event]" (Y. Doumbia 2004).[100] Although the participants condemned Keïta, they more fervently shouted, "Down with the militia!" (Imperato 2008, 69–70). After the coup, the former freedom fighter and socialist president was sent to the Kidal prison, where he was detained until two months before his death on May 16, 1977, at the age of sixty-two (Uwechue 1996, 342; A. O. Konaré and A. B. Konaré 1981, 184). On November 22, 1968, just three days after the coup, the CMLN created a provisional government headed by Yoro Diakité. The former administration was restructured, leaving approximately 60 percent of its personnel intact (Bennett 1975, 251).

In the context of Africa at large, Mali's coup seems to have followed an expansive trend during the decade in which numerous national rebellions felled former independence leaders: Togo (January 1963), Congo-Brazzaville (August 1963), Dahomey (October 1963), Ghana (February 1966), Central African Republic (mid-1966), and present-day Burkina Faso (mid-1966; Lee 1986, 86). Clearly, in spite of the greatest hopes and intentions, independence brought new and many struggles. To be fair, a number of these were inherited from past colonialism and unabated cultural, political, and economic imperialism. Nevertheless, some Malians, such as Malick Sidibé, look back on the 1960s and find they preferred colonialism: "Things were good during the colonial period—physically, if not morally. During Modibo Keïta's regime there was a crisis" (M. Sidibé 2004).[101] Sharing the sentiments of most Bamakois who reflect on Keïta's socialist era, Youssouf Doumbia declared, "Liberty is not without its price!" (Y. Doumbia 2004).

Moussa Traoré's Regime: 1968–91

As it turns out, Doumbia's statement rang true a second time. Immediately following the coup of 1968, a police state was organized and run by Captain Tiékoro Bagayogo, chief of security, with informers monitoring youth and educators, who were among the most hostile to military rule (*France Eurafrique* 1971, 9; Nampa-Reuters 2002, 1). Although the coup

did bring about several initial improvements (reintroducing semi–free trade markets, attempting reparations with France, and employing rhetoric that implied a move toward democracy), the population was confronted with numerous new hardships during what over time became an oppressive twenty-two-year military dictatorship (*France Eurafrique* 1971, 7). This nascent government took form on September 19, 1969, when Moussa Traoré replaced Yoro Diakité as the president of Mali and the CMLN (Bennett 1975, 253; *L'Essor* 1969; Nampa-Reuters 2002, 1).

At the start of 1969, some positive changes were evident. Commerce was revitalized and city shops were restocked with necessities, such as oil, flour, soap, rice, and sugar (Comite 1970, 17; *Marchés Tropicaux et Méditerranéen* 1969a, 415). Bakary Sidibé recounted some of the improvements: "Moussa Traoré ended Modibo Keïta's system. Stores were full of food, business improved, there was access to health care [and] more girls could go to school" (Bakary Sidibé 2004). Malick Sidibé concurred, "Moussa Traoré opened commerce. More was freed with him" (M. Sidibé 2004). Thus it was to some extent a period of optimism. Speaking contemporaneously, John Hazard anticipated, for example, that "foreign investors will be invited to enter the country. . . . Private trade will be permitted to flourish. Perhaps the Lebanese will even find it advantageous to return as taxes are reduced on their activities as merchants" (Hazard 1969, 14). For the most part, these predictions materialized. As a case in point, business was improved during this time for most commercial photographers, who had an easier time obtaining the requisite materials. Because of this, Adama Kouyaté described this period as "favorable; [providing] more money and a busier studio" (A. Kouyaté 2004a). Conversely, those at ANIM suffered from a comparative lack of supplies (O. Keïta 2004). Malim Coulibaly, a photographer employed by the agency, explained, "With Moussa, we had to buy [photo supplies] at the market . . . [and therefore] everything was more expensive" (M. Coulibaly 2004).

By 1969, other visible changes and future development projects were underway as well. Like its predecessors, the CMLN began renaming streets and architectural structures to publicly announce its authority and eradicate that of the former regime (*Marchés Tropicaux et Méditerranéen* 1969b, 558). In addition, plans were put in place that year to construct a new international airport fourteen kilometers outside Bamako in Senou (where it currently resides) with the aid of European funds, and this was later realized on December 29, 1975 (*Industries et Travaux d'Outremer* 1969, 43–44; Imperato 1977b, 10).

Amid these transitions, some practices that had been instituted by the former regime, such as the Pionniers, were retained (M. Sidibé 2004).

As a result, in terms of social liberties, many things were slow to change, and youth continued to feel under attack by the government. Thus, as life grew increasingly more expensive, and in many ways more repressive, population unrest soon became evident. Addressing the recession in 1971, a journalist for *France Eurafrique* wrote, "In three years the cost of living has risen twenty-two to twenty-three percent . . . [and] salaries remain blocked since 1958. Last year, 2,000 young teachers, with their bachelor's degrees, walked around Bamako and other towns without finding employment" (*France Eurafrique* 1971, 8). This inflation affected professional photographers as well. One individual did not open his studio in the 1970s because of exorbitant taxes (40,500 francs annually), which he could not afford, and he did not want to risk going to jail.[102] Diawara cites additional reasons for the outrage: "Even though the former regime was castigated for taking people's freedom away, for being worse than the colonizer in its destruction of African traditions, and for being against free enterprise, the soldiers who replaced the militia continued to patrol the streets of Bamako in search of rebellious and alienated youth" (Diawara 2003b, 12). His perspective was echoed by that of another citizen, who professed, "Students went on strike many times during Moussa's period. There were curfews in both Modibo Keïta's and Moussa Traoré's time. The curfew was worse in Moussa Traoré's time. He wouldn't let people do what they wanted, as people were in unrest."[103]

Illustrating some of these common grievances, several student strikes were held between April 17 and 21, 1969, in Bamako and again in March 1971 (A. O. Konaré and A. B. Konaré 1981, 187, 192). Moreover, an alleged coup d'état attempt was uncovered by Chief of Security Tiékoro Bagayogo, and thirty-three military personnel were arrested, including Captain Diby Sillas Diarra, governor of the region of Mopti (Bennett 1975, 252–53). In the following year, members of the Malian Labor Party were detained and "accused of participating in a secret society against the president" (A. O. Konaré and A. B. Konaré 1981, 188). The year after that, the National Workers' Union of Mali was disestablished by Moussa Traoré, and its members were incarcerated for two months after its officers organized an unauthorized meeting in January 1971 (Bennett 1975, 261). Furthermore, that year, a second alleged coup, purportedly orchestrated by Yoro Diakité and Malick Diallo for March 9, 1971, was intercepted, and in 1972 the two military men were sentenced to life imprisonment at hard labor (Imperato 2008, 52, 79–80; A. O. Konaré and A. B. Konaré 1981, 191, 199).

Governmental photographers were among those affected by the new leadership and its paranoid policies. For example, akin to Modibo Keïta's

cra, once Moussa Traoré's regime appointed Youssouf Traoré as the director of ANIM, the institution's photographers were pressured to discontinue any private practices in which they were engaged, including operating commercial studios, if they wished to remain employed by the government.[104] During Youssouf Traoré's tenure at ANIM (approximately 1969 to 1977), it remained the institution's policy that its personnel must not engage in privately owned photographic practices. For this reason, many photographers walked away from or were forced out of the agency during this period.[105]

Amid these transformations, a "third generation" of professional photographers emerged between the mid-1960s and the late 1970s, including Diango Cissé, Siriman Dembélé, Mamadou Wellé Diallo, Amadou Fané, Harouna Racine Keïta, Mamadou "Papa" Kanté, Sidiki Sidibé[106] and his apprentice Issa Sidibé, Karim Sangaré, Youssouf Sogodogo, Abdoulaye Traoré, Alitiny "Lito" Traoré, and Baba Traoré, among others.[107] For the first time, most of these practitioners were introduced to the medium or trained by African rather than Western photographers. In fact, many had been apprenticed to second-generation photographers (Elder 1997, 36), such as Malick Sidibé—who, for example, trained three and assisted several of the aforementioned professionals.[108]

Like their forerunners, third-generation photographers worked with medium-format cameras, such as the Rolleiflex, and black-and-white film. Later, by the mid-1970s, they began using 35-millimeter cameras and color film, much like their ambulant and amateur counterparts. Following the path of their older colleagues, they also took pictures of National Youth Week festivities and other sociopolitical events; reportage photos of weddings, parties, and picnics along the Niger River (figs. 2.37); studio portraits; documentary photos of accidents for the police department and insurance companies; class pictures for elementary schools; tourist postcards (fig. 2.38); and "art" photographs (fig. 2.39). That last genre was typically the domain of those who had attended the National Art Institute, such as Diango Cissé and Youssouf Sogodogo, or art institutions abroad, as Harouna Racine Keïta did in France, before entering the photography profession (H. R. Keïta 2004).

Most of these professionals were born in the city. However, several, including Tijani Sitou[109] and his son Rachid, Moustaphe Akee, Bernard "Ben" Koudemedo, Azeem Oladejo Lawal,[110] and Alhaji Hamid Glaniye, came from neighboring West African countries (predominantly Nigeria and Ghana). Thus, the late 1960s and early 1970s brought more foreign African business and photographers into Mali, who introduced new

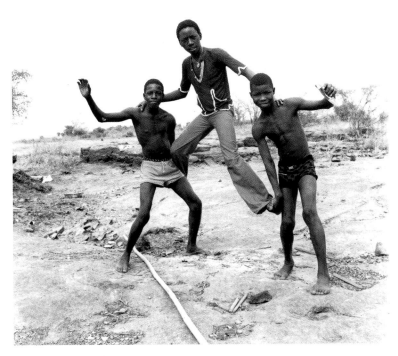

Figure 2.37. Studio Malick, *At the Shore of the Niger River*, 1976.
© Malick Sidibé, courtesy MAGNIN-A gallery, Paris.

TOMBOUCTOU

Figure 2.38. Diango Cissé, *Timbuktu—Minaret of the Djinguereber
Mosque, Al-galoum Entrance, and Door to the Governor's Office*,
2000. Postcard 70.1. Made in CEE Diango Cissé. Collection of author.

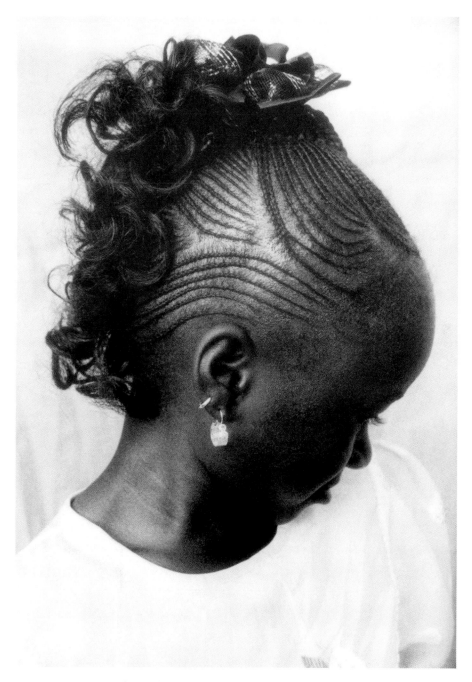

Figure 2.39. Youssouf Sogodogo, *Untitled* (*Hairstyle* series), c. 1970s–1990s.
© Youssouf Sogodogo.

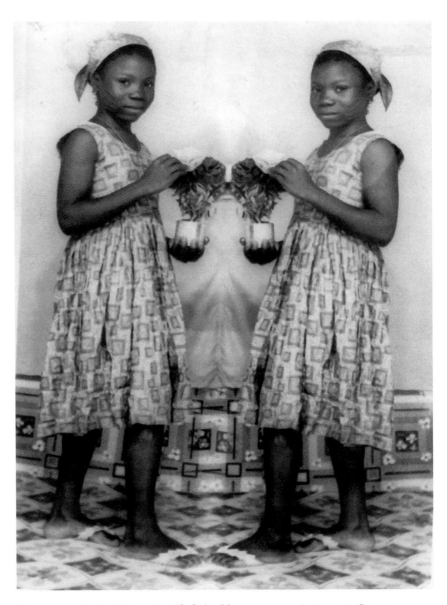

Figure 2.40. Rachid Sitou, *Untitled* (double-exposure print), 1978. Courtesy Tijani Sitou Estate © Tijani Sitou.

photographic styles and practices (fig. 2.40), such as double-exposure prints (Elder 1007, 86; Malick Sitou 2004). More often, however, these men were trained in the medium by local practitioners, and their practices catered to the nation's domestic clientele. As a result, the significance, style, appearance, and use of their photographs are predominantly local. These émigrés settled and opened studios in Mopti, Gao, Ségu, and, to a lesser degree, Bamako. Many, such as Tijani Sitou, became quite famous and had highly successful careers.

As their communities and markets expanded, third-generation photographers typically purchased their materials from a variety of commercial vendors rather than from one primary boutique, as was common among the first two generations. Furthermore, more and more of the available products came from Nigeria because its commodities were less expensive than those imported from Europe and the United States (A. B. Cissé 2005; Elder 1997, 86). For example, Jean Bignat, a shop owner and former photo supplier in Mopti, complained that photographers have had to "resort to buying materials from Nigeria, which are not as good, just to get prices that are low enough for people to afford. That is why I stopped selling photo products [such as] Kodak materials from France" (Bignat 2004).

During the 1970s, alongside social, cultural, and political reportage, black-and-white portrait photography remained fashionable. However, the stylish characters it depicted transitioned with the times. Now replacing the Yé-Yé was the more generic kamalenba (playboy), who incorporated a variety of trends into his ensemble, ultimately striving to cultivate a unique aura of chic desirability. Exhibiting the latest fashions in their portraits, these young trendsetters often appear aloof to the camera (fig. 2.41) or directly engage it (fig. 2.42). Directed by photographers such as Malick Sidibé and Tijani Sitou, they assume strong, dynamic postures and cool expressions, usually partially obscured behind opaque sunglasses.

Trends that had begun in the period of late colonialism and grew after independence, such as soccer and boxing, continued (figs. 2.33 and 2.43). In fact, one of the most internationally renowned boxing matches—the "Rumble in the Jungle" between Mohammed Ali and George Foreman—took place in Zaïre in 1974; it was a hot topic in Mali and was discussed in the local newspaper, L'Essor. In addition, karate became popular at this time, inspired by cinematic portrayals of champion martial artists (fig. 2.44). Local newspaper postings attest that karate films were among the most common in urban cinemas. Chief among them were those starring Bruce Lee, such as They Call Me Bruce Lee; Fury of the Dragon (a.k.a. Return of the Dragon); and Bruce Lee, The Tiger of Manchuria.[111]

"Spaghetti Westerns" were also highly appreciated at the time. As a result, many young men continued to emulate cowboys in their portraits (fig. 2.31). To assist clients' portrayal of these popular characters, photographers continued to supply their studios with a variety of props, such as hats, toy guns, clothing items, and other accessories.

In portraiture, women's appropriation of international pop-cultural icons and changing fashion trends is not as readily evident as men's

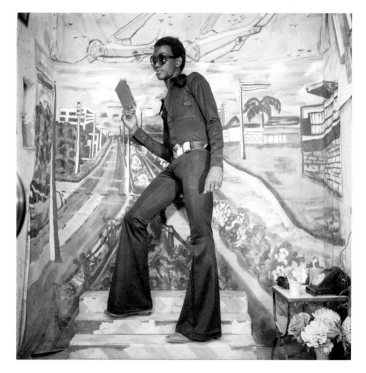

Figure 2.41. Tijani Sitou, *I Am Educated*, 1977. High-resolution digital scan of original 6 × 6 cm negative. Courtesy Tijani Sitou Estate © Tijani Sitou.

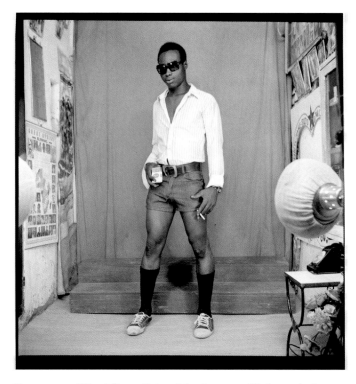

Figure 2.42. Tijani Sitou, *I Am Adonis*, 1977. High-resolution digital scan of original 6 × 6 cm negative. Courtesy Tijani Sitou Estate © Tijani Sitou.

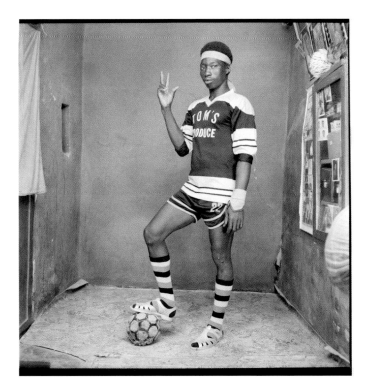

Figure 2.43. Tijani Sitou, *Pele of Mopti*, 1983. High-resolution digital scan of original 6 × 6 cm negative. Courtesy Tijani Sitou Estate © Tijani Sitou.

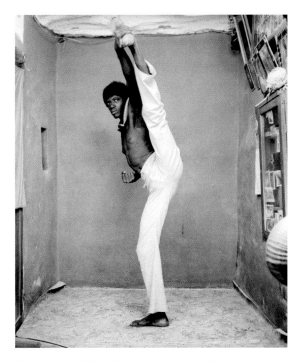

Figure 2.44. Tijani Sitou, *I Am Bruce Lee*, c. 1980s. High-resolution digital scan of original 6 × 6 cm negative. Courtesy Tijani Sitou Estate © Tijani Sitou.

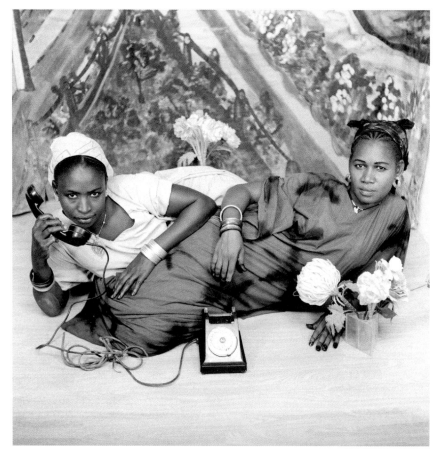

Figure 2.45. Tijani Sitou, *Hello! Hello!*, 1978. High-resolution digital scan of original 6 × 6 cm negative. Courtesy Tijani Sitou Estate © Tijani Sitou.

during this period. Young women continued to wear short skirts and, like their male counterparts, increasingly donned bell-bottom pants and platform shoes. Alternatively, women's hairstyles tirelessly fluctuated, perhaps more forcibly than men's, following local and global trends that often provided impetus for new portrait commissions.

Material aids such as the telephone became increasingly popular in portraiture to indicate one's modern material desires, rather than one's lived experiences (figs 2.45). Although some members of the upper and middle classes in Bamako had telephone service at home by the late 1970s, for most citizens the telephone remained an unobtainable luxury until after 1992.[112] Rather, most of the population relied on telegrams and telegraphs for long-distance communication.

During the late 1970s, the boom box rapidly became localized (plate 2). Whether in Bamako, Mopti, Ségu, or elsewhere, it was regularly incorporated in portrait photographs to convey one's economic status,

modern lifestyle, and cultural heritage (B. Sidibé 2004). More apparent in Mali than in the United States during the early years of its inception (as cassette technology gradually replaced record albums), boom boxes depicted in portraits from this era were the clients' own property. Popular music in urban Mali at this time was imported from Zaïre (Democratic Republic of the Congo), Cuba, Jamaica, Brazil, and the United States in the form of "soul, funk, and disco" (*EuropeOutremer* 1978, 20, 36).

Also made explicit in portraiture is the ever-increasing interest in literacy and education (figs. 2.41 and 2.46). Both male and female clients posed with books, often in the act of reading, visually reinforcing those values and claiming them as part of their personal identity and experience (Bleneau and La Cognata 1972, 56).[113]

Generally speaking, youth were still the majority of studio photographers' clientele during this period, and they continued to follow local musical and fashion trends, along with the trends of global youth culture, which required photographers and their apprentices to remain abreast of the latest fads.

Like the prior generations, youth commissioned studio and reportage photographs for a variety of reasons. Photographs predominantly served as souvenirs or mementos to commemorate important events, rites of passage, and relationships as well as powerful markers of one's identity—whether idealized or factual, personal or social, public or private. Photographs were and continue to be shared with family and friends, mailed to pen pals abroad, preserved in albums, and displayed at home in various wood or painted glass picture frames. Thus, although they were often created using medium-format cameras, which produce square negatives, they were cropped in the darkroom and printed as standardized three-by-five, four-by-six, five-by-seven, and eight-by-ten-inch formats to suit the dimensions of manufactured photo albums and locally fabricated frames. Malick Sidibé explained, "People rarely asked me for large formats. They preferred [three-by-five-inch] photos because they could put them in their personal albums, [frames], or send them by mail to their friends" (Magnin 1998, 39).

As a result, business relationships often developed between professional photographers and frame makers. For example, over the years, Sidibé worked with Cheickna Touré, a frame maker and photo colorist based in the Bamako neighborhood of Bagadadji since 1953, not far from Studio Malick (Malick Sitou 2006; M. Sidibé, D. Sidibé, and S. Sidibé 2009; C. Touré 2009). From the 1950s to the present, Touré has worked closely with many photographers in Bamako, and his painted glass frames have been featured in recent exhibitions of Sidibé's photographs lent by the Jack Shainman gallery in New York City (Simard 2006; Keller 2008).

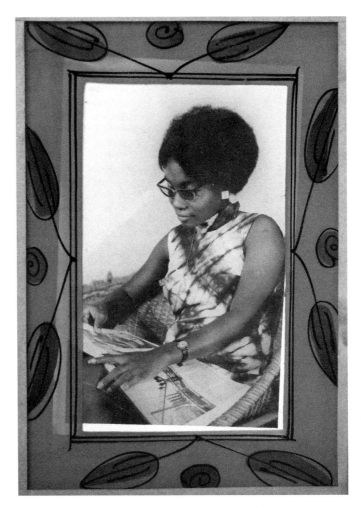

Figure 2.46. Malick Sidibé, untitled portrait of a woman, c. 1970s. Painted glass frame by Cheickna Touré. Photo by author of a reprinted image being prepared for an exhibition at Jack Shainman Gallery in New York, Bamako, 2004. Original photo © Malick Sidibé, courtesy Malick Sidibé and MAGNIN-A gallery, Paris.

Due to these networks, Touré has accumulated one of the most impressive and historically significant archives of original prints in all of Mali.[114] His collection of photos obtained as gifts or never reclaimed by patrons includes photographs by Seydou Keïta, Malick Sidibé, Baru Koné, Samba Bâ, Mountaga Dembélé, Mamadou Cissé, Abdourahmane Sakaly, and other Bamakois photographers. The images include portraits that depict political leaders and local celebrities as well as other subjects and photographic genres, such as the funeral of Mamadou Konaté in 1956 (C. Touré 2009; Sakaly 2016; Byrd 2015, 2016).

In 1972, Bamako's population was around 320,000, compared to 161,300 in 1966, and incorporated an annual influx of around 30,000 seasonal laborers (*barani*) from rural Malian towns, such as Nioro, between January and April (Imperato 1977b, 10–11; Bleneau and La Cognata 1972, 36, 41; Meillassoux 1968, 96). These migrant workers, in need of identification cards, contributed to the steady seasonal revenue of professional urban photographers in cities such as Mopti and Bamako. While the expansion of the capital's population appears impressive, and indeed it was, it is important to keep in mind that in the early 1970s, 90 percent of the country's total population remained concentrated in rural areas (Elder 1997, 129). This was particularly critical during the catastrophic droughts that affected the entire Sahara region of western Africa between 1972 and 1974 (*EuropeOutremer* 1978, 12).

Although the droughts most directly affected the northern Sahel and desert regions of Mali, the indirect repercussions were experienced by nearly all the nation's inhabitants as well as those of its immediate neighbors (Clark 2000, 257; Derrick 1977, 560). It is difficult to encapsulate the scope of this calamity. However, statistics suggest that "in 1972 it was estimated that forty percent of the food harvest had been lost . . . [and] by mid-1973, Mali had lost forty percent of its cattle, which [approximated] five million" (Derrick 1977, 559; Bennett 1975, 259). This resulted in the initial inundation of the market with inexpensive meat, followed by its scarcity coupled with inflated prices, which affected rural and urban citizens alike. Furthermore, it forced thousands to seek shelter in refugee camps in Gao and around the periphery of local cities, particularly the capital (Derrick 1977, 544; Kapuściński 2002, 43). In addition, a large number of Malian laborers headed to neighboring Ivory Coast and Ghana (Derrick 1977, 541). Others participated in a mass exodus to Algeria, Mauritania, Libya, and Burkina Faso (Humphreys and Mohamed 2003, 17; Derrick 1977, 562). This eventually led to border conflicts between Burkina Faso and Mali in which several lives were lost (Imperato 2008, 44). In 1975, an agreement was finally reached between the two nations with mediation from Guinean president Sékou Touré.

During the drought era, cities were flooded by refugees searching for some form of income or relief through international donations, which were more readily distributed in urban locales. In some cases, girls had been sent to the city to help lessen the subsistence burden on their rural-based family and to look for new ways to acquire cash currency. Alongside "crop failures, exhaustion of water supplies [and] loss of livestock," Jonathan Derrick identified the "drying up of cash income" as a significant effect of the droughts in village contexts (Derrick 1977, 548, 560; Grosz-Ngaté 1986, 94).

Collectively, these population movements expedited rural depletion and hyperurbanization. The loss in agricultural and livestock production simultaneously challenged cities' available resources and incited market inflation (Kapuściński 2002, 43). In sum, Derrick proclaimed that the "drought was an economic disaster for millions. It was in fact the worst natural disaster in the area since a similar drought in 1911–14" (Derrick 1977, 537). Therefore, it attracted the attention of international news media. Several institutions (such as National Geographic) publicized the event in photographs that depict emaciated Tuareg families barely subsisting in refugee camps (Englebert 1974, 562–63). More devastating than the financial repercussions, of course, was the shocking number of lives lost. According to Imperato, approximately "100,000 people died throughout the six-country region during the drought" (Imperato 2008, 97–98).

Just as annual precipitation rates began to normalize in the North, and the devastation of the droughts started to subside, more social turbulence arose in Bamako. In 1974, the year construction commenced on the Grand Mosque in the capital city, several citizens were arrested on June 18 for having accused the government of holding false elections (A. O. Konaré and A. B. Konaré 1981, 199; Bennett 1975, 265). Two years later, more men were incarcerated and charged with conspiracy to overthrow the government in a coup d'état, with twelve of the accused military members condemned to death on June 10, 1977 (A. O. Konaré and A. B. Konaré 1981, 204, 207). On November 19, 1976—the anniversary of the coup that toppled Keïta's socialist regime—Moussa Traoré and his administration "stopped the voting" and created the Democratic Union of Malian People (UDPM) in response to criticism of the government's lack of democracy.[115] Without much structural change, however, "democracy" in the context of Traoré's repressive and paranoiac military dictatorship was merely rhetorical. In subsequent years, members of the disgruntled population participated in several protests and faced further punitive actions.

It was during this era that color technology first entered the photography market in Bamako. However, it was not yet a viable option as the

country lacked color processing labs. Printing color film required mailing it to companies such as Photo Rush in France—a process that regularly left clients waiting for up to a month to receive their orders (Knape 2003, 80; Malick Sitou 2004). Similarly, although they were invented in 1947, Polaroid cameras and instant film were introduced in Mali around this time (Marien 2002, 315). In Bamako, Michael Thuillier at La Croix du Sud reportedly was the exclusive distributor of Polaroid products (Thuillier 2007). Until recently, the technology had been utilized primarily for ID photos. Today, digital photography is gradually taking its place in the domain of official identification documentation, such as passports and visas.[116]

In the late 1970s, along with the importation of new technologies, the nation made strides in the areas of infrastructure, culture, commerce, tourism, and transportation. For instance, by 1977, Mali hosted seven hundred miles of paved roads with plans to build several more (Imperato 1977b, 10). To facilitate future tourism, the Hôtel de l'Amitié, which features seventeen floors and 185 rooms (one of the tallest structures in Bamako today), was open for business in the city during October of that year and has remained an important reportage venue for professional photographers to date (A. O. Konaré and A. B. Konaré 1981, 207; "Tourism in Mali" 1970, 49). In addition, in 1977 ANIM transformed into its current body, the Malian Agency of Press and Publicity (AMAP), with Oumar [Diallo] Siby directing the photography department (M. Coulibaly 2004). Furthermore, the National Cinematographic Agency, where photographer Harouna Racine Keïta was gainfully employed until 2020, assumed its current appellation in December 1977. Finally, another artistic project, a photography exhibition held at the House of Retired War Veterans (Tirailleurs Sénégalais), was realized during this year (A. O. Konaré and A. B. Konaré 1981, 207; L'Essor 1977).[117]

In the same year, Seydou Keïta retired from the Sûreté Nationale due in part to frustration with the administration's policies. With little recourse, he started working as an auto mechanic. In an interview with Michelle Lamunière, Keïta explained:

> By 1977 . . . I had a misunderstanding with some of the military people, and I decided that I was tired of the job. They agreed to let me take retirement, and when I got home, the first thing I checked was my darkroom. I couldn't believe it. All the equipment, the cameras, the tripods, everything except the enlarger and the three projectors—which were too heavy for them to carry—had been stolen. With those few exceptions they stole everything, right down to the trash cans. I didn't know what to do; I was completely wiped out and I couldn't take pictures anymore. (Lamunière 2001b, 48)

Like the preceding years, 1977 also saw many public uprisings. As before, most of these were civilian and took the form of student protests. However, one of the largest demonstrations of 1977 was held at Modibo Keïta's funeral, which, in spite of everything, was well attended and included many protestors who used the opportunity to criticize Traoré's regime for remaining politically oppressive (Wolpin 1980, 288). Unabatedly, even in the subsequent decade, each of these uprisings was followed by arrests and often deaths.

The following year, 1978, saw several important national cultural and artistic developments. The Cultural Palace, which seats some three thousand people and today is one of the many *Rencontres* photography biennial venues, began construction in the neighborhood of Badalabugu with aid from North Korea and was opened to the public by 1983 (A. O. Konaré and A. B. Konaré 1981, 208; Becchetti-Laure 1990, 80). Malian cinematographer Souleyman Cissé won a prize for his film *Baara* (*Work*) at the Festival pan-Africain du cinema et de la television de Ouagadougou (FESPACO), and went on to attain four more awards by the end of the year (A. O. Konaré and A. B. Konaré 1981, 211). Around this time, Moussa Traoré appointed scholar and future Malian president Alpha Oumar Konaré as minister of culture—a position from which he later resigned in protest (Boyer 1992, 40).

Conversely, 1978 was a year of continued civil unrest and incarcerations. The most infamous of these was the arrest of CMLN members Kissima Doukara (former minister of defense and minister of state), Karim Dembélé (former minister of transport, telecommunications and tourism), and former chief of security Tiékoro Bagayogo, along with thirty others accused of treason (A. O. Konaré and A. B. Konaré 1981, 208; Imperato 2008, 29–30, 77, 94–96). The cover of the March 8, 1978, issue of *L'Essor* featured images of them with "their heads bagged [wearing] slates around their neck with their name and age" that were the talk of the town for many months in Bamako.[118] The shocking public display served equally as a warning to remaining officials and citizens *and* as damning, shameful images of the accused.

In the service of governmental sovereignty, the social potency of criminal portraiture in Mali is informed by the concept of *màlo*. Variously translated as "shame" and "social constraint," anthropologist James Brink has more accurately defined màlo as "a condition of being 'controlled by another's eyes' . . . authority . . . or social position" (Brink 1980, 419; 1982, 426). Thus, as strategies of social control, mug shots are intended to incite màlo in one's interior and communal worlds. This dynamic is intensified when such images are made public and become the talk of the town.

During their "economic trial," which transpired in March 1979 and included sentencing for Joseph Mara (former minister of justice), who had been detained just two months prior, Doukara was condemned to death while Mara received twenty years at hard labor, Dembélé received ten, and Bagayogo was sentenced to five (A. O. Konaré and A. B. Konaré 1981, 211). Over the course of the next few years, most of the former CMLN members disappeared or died of mysterious and controversial means in governmental custody.

On April 12, 1979, several former RDA officers from the Keïta era were charged with the "offense of the president," "creation of a secret organization," and "possession of arms of war without authorization" (A. O. Konaré and A. B. Konaré 1981, 213). In October of that year, two of the accused, Mamadou El Béchir Gologo and Idrissa Diakité, received a prison term of four years each (Gologo 2004). This occurred after more student demonstrations on January 29, 1979, and the general/presidential elections on June 19, 1979, during which Moussa Traoré "stood unopposed and received 99.9% of the vote" (Wolpin 1980, 289).

On a more positive note, 1979–82 witnessed construction on the new architectural structure for the National Museum, which was designed by Frenchmen Jean-Loup Pivin and P. Martin Saint-Léon and under the directorship of Claude Daniel Ardouin, at its current location along the base of Kuluba.[119] Today, the museum serves as the focal point of the *Rencontres* biennial's exhibitions and opening and closing ceremonies. In 1979, the "first African disco film," *Dance My Love*, was screened in the capital's movie theaters (*L'Essor* 1979b). In step with global trends, disco and reggae culture were growing in popularity in urban Mali, as reflected in the era's portraiture (A. O. Konaré and A. B. Konaré 1981, 214; see Keller 2008, 554).

Two years later, Malian cinema drew international attention a second time with CNPC's first feature-length film, *A Banna* ("It Is Finished"), which won a prize at the seventh FESPACO in Burkina Faso (A. O. Konaré and A. B. Konaré 1981, 215, 217). In fact, the 1980s brought about many new building and cultural projects, with several emphasizing the arts. For example, *La Festama* (The Festival of Malian Arts) biennial was instituted in Bamako in 1982 by the National Association of Artists the same year that the Sahel Museum opened in Gao (Becchetti-Laure 1990, 75, 125).

Since the early 1980s, in the interest of preserving Mali's cultural heritage, the Sahel Museum and the National Museum in Bamako have hired and trained professional photographers in their audiovisual departments, including Alioune Bâ, Youssouf Sogodogo, Aboubakrine Diarra, and Sokona Diabaté.[120] As archivists, they document, conserve, and restore

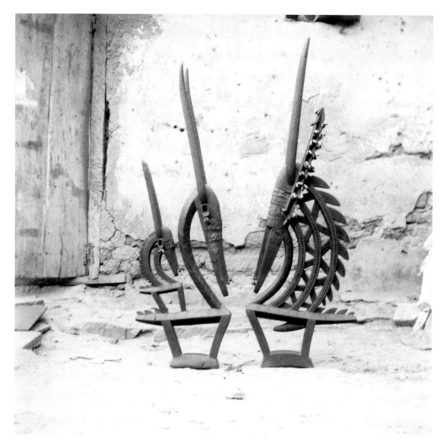

Figure 2.47. Moumouni Koné, *Untitled* (CiWara masks), Bamako, c. 1970s. High-resolution digital scan of original 6 × 6 cm negative. Courtesy Koné Family © Moumouni Koné.

pieces in the collection and videotape and photograph museum events. Of his own volition, Sogodogo took several pictures of women's hairstyles, which he conceived as structurally beautiful representations of local cultural heritage, during his tenure at the Sahel Museum (fig. 2.39). Like his colleague J. D. 'Okhai Ojeikere in Nigeria, Sogodogo is best known for this series of images in the international art market today.

With similar concern for posterity, individuals and communities have hired photographers to document their valued possessions, which often include sculpted artworks (fig. 2.47).[121] In such cases, people strive to preserve the appearance of their objects, particularly if the works are brand new, decaying, or about to be sold.[122]

The French Cultural Center (CCF) was also inaugurated in 1982. Over the years, it has made strides in improving its image among the local population thanks to the efforts of Georges Jourdin and its numerous

directors (Becchetti-Laure 1990, 99). Today, as the Institute Français, the establishment operates one of the most active theaters, galleries, and libraries in the capital, frequented by Malians and expatriates alike. It also sponsors numerous cultural and artistic projects around the country in the domains of theater, music, dance, and visual art, including photography exhibitions that have been affiliated with the *Rencontres* biennial and Helvetas (now the Center for Photographic Training, CFP).[123]

In the following year, the former minister of culture, Alpha Oumar Konaré, created Jamana, a cultural cooperative that sponsored festivals, conferences, workshops, and art programs in the country (Boyer 1992, 40; Clark 2000, 257; Becchetti-Laure 1990, 86–89). By 1989, the association had introduced the first independent printing and publishing company in Bamako as well as a private radio station and art gallery (Becchetti-Laure 1990, 114; Boyer 1992, 40).[124] Each of these creations reflects a large undercurrent at the time toward free enterprise and democracy. However, for the most part, local news and cultural production remained in the hands of the government in the form of *L'Essor*, CNPC, and the new telecommunications and television company Office de Radioduffusion-Télévision du Mali (ORTM). The ORTM, initially funded in part by Muammar al-Qaddafi (Khadafi) in Libya under the name Radiodiffusion-Télévision Malienne in 1983, was a color television company that broadcasted thirty-seven hours a week (Lake 1993, 60).[125] Malick Sidibé explained, "It was Khadafi who brought television to Mali. . . . Khadafi financed it and the Germans constructed it. The programs were always in French [and] there was only one channel: TéléMali (which is now ORTM)" (M. Sidibé 2003).

Finally, illustrating the Islamic reformism in the nation, particularly in Bamako, a massive Islamic Cultural Center was opened in the capital in 1987 and funded by Libya and the United Arab Emirates. The center is located in the Dar-es-Salam neighborhood of the city and features a school with sixteen classrooms, a library, an auditorium, an athletics field, and a mosque (Gaudio 1998, 213). It is part of what Malick Sidibé described as "an influx of Middle Eastern Islamic influence . . . in the 1980s [via] NGOs, schools, money, etc." The intense Islamization is evident in conservative Middle Eastern Islamic attire worn by men and women from this period onward. However, like many Bamakois who find this recently introduced Islamic practice too rigid, Sidibé opined, "It is freer here [than in the Middle East]. There is a blending of tradition and Islam" (M. Sidibé 2003). As astute businessmen, and often Muslims themselves, photographers catered to this focus by incorporating backdrops featuring mosque façades and central views of Mecca in their studios (figs. 2.48 and 2.49).

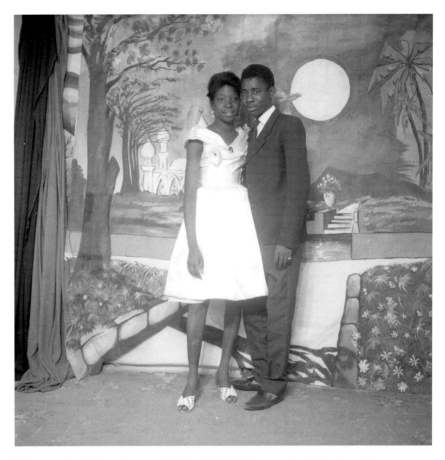

Figure 2.48. Abdourahmane Sakaly, *Untitled* (mosque backdrop), 1963.
High-resolution digital scan of original 6 × 6 cm negative. Courtesy
Abdourahmane Sakaly Estate and the Archive of Malian Photography (AMP).
© Abdourahmane Sakaly.

Like Keïta decades earlier, they also provided props, such as prayer cos-
tumes and accessories for their clientele (plate 5). In Mopti, for example,
Tijani Sitou supplied customers with an ensemble he purchased in Saudi
Arabia during his hajj, or pilgrimage to Mecca (Malick Sitou 2004).

Other urban trends that youth, and particularly kamalenbaw, emu-
lated in portraiture during this era were inspired by popular rock and
rap music, television, and music videos. In step with the United States,
Europe, and elsewhere in the world, break dancing and its affiliated attire
was popular and regularly depicted in portraits of young people. Like-
wise, Michael Jackson, particularly his video "Thriller," was all the rage
(fig. 2.50). Markets in Bamako, Mopti, and other cities offered T-shirts
with his image and logos for sale, and some young men assumed his
dance postures while having their pictures taken in professional studios
(Malick Sitou 2006).

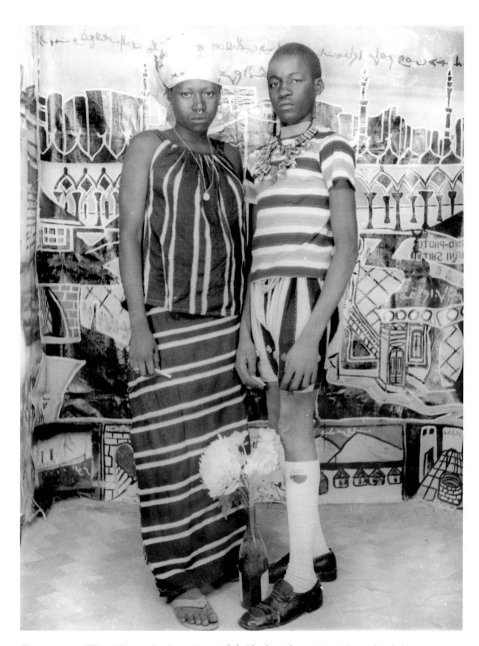

Figure 2.49. Tijani Sitou, *In Our Beautiful Clothes* (featuring Mecca backdrop painted by Sidi Cissé), 1975. High-resolution digital scan of original 6 × 6 cm negative. Courtesy Tijani Sitou Estate © Tijani Sitou.

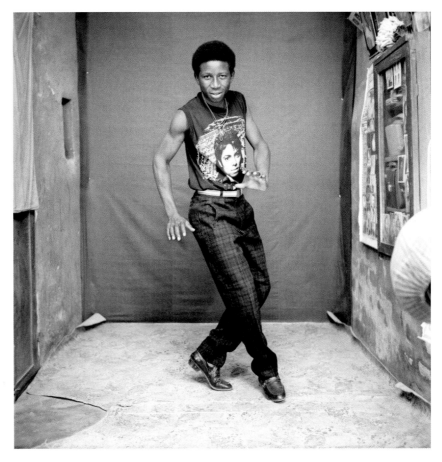

Figure 2.50. Tijani Sitou, *Thriller*, 1984. High-resolution digital scan of original 6 × 6 cm negative. Courtesy Tijani Sitou Estate © Tijani Sitou.

Amid these developments were more public protests, particularly in the 1980s. Among the largest were the student and teacher demonstrations in 1979–80, sparked partially by long delays in salary disbursements that were considered evidence of a corrupt administration (Imperato 1991, 26; A. O. Konaré and A. B. Konaré 1981, 214). Members of the military suffered similar hardships by regularly enduring weeks of work without payment (Clark 2000, 257). According to one informant, "Moussa Traoré received a lot of aid from the US, Canada, Europe, Japan and Arab countries, but none trickled down to the population. . . . Roads, schools, water, offices, telephone were all in bad condition. . . . No salaries were paid on time. They were three months behind. Everyone bought on credit."[126]

Many of those who participated in these marches were incarcerated. The most famous prisoner, student leader Abdoul Karim Camara, known as Cabral, "died under torture" at a military detention facility in Bamako

on March 17, 1980 ("Political Persecutions in Mali" 1996; A. O. Konaré and A. B. Konaré 1981, 214).[127] Twelve days later, his collaborators were freed, and classes resumed a mere two days afterward. For his efforts and inspiration, Cabral was memorialized in a monument erected in the Lafiabugu neighborhood of the capital in 1996, after the fall of Traoré's regime (Barry 2003, 166). In addition, an equipment room at one of the city's few private radio stations, Radio Kayira, was named the Cabral Booth in his honor (Lake 1993, 87). Later in the year, another coup d'état plot purportedly was uncovered, and several men were arrested, including Aladji Djiré, Sékou Sanogo, and Abdoul Karim Sissoko, who each received death sentences during their trial on March 11, 1981 (A. O. Konaré and A. B. Konaré 1981, 214). In this context, Raymond Gastil unsurprisingly ranked Mali among the "least free" of world nations in terms of political and civil liberties (Wolpin 1980, 288).

Thus, civil unrest and governmental suspicion abounded from the late 1970s to the 1980s. This was a critical period for the photographic market in Mali as well. With the advent of color technology, which eventually became viable, as well as the enclave of amateur and ambulant photographers who emerged within this atmosphere, the golden age of black-and-white photography began its sharp decline. This introduced a strain on the studio industry that unfortunately proved insurmountable for many proprietors.

The End of the Golden Age of Black and White: 1980–91

During the 1980s, studio businesses started to falter in Malian cities, and nowhere more so than Bamako. Malick Sidibé declared, "In the 1980s, times were hard for us. It was hard to feed ourselves from photography. . . . From 1985 color began to dominate. . . . Black-and-white photography was a definite loser" (M. Sidibé 2004; Knape 2003, 80).[128] Central to their demise was the lower cost and greater convenience of color technology, the advent of commercial laboratories (Photo Kola in 1982 and Tokyo Color in 1984), and the influx of amateur "street" photographers. Street photographers, free from the burden of rent, electricity, and taxation, could undersell studio prices by more than 30 percent, posing a lasting challenge to studio establishments (Nimis 1998c, 95).[129] Expressing frustration over this issue, Amadou Baba Cissé stated, "Ambulent photographers take photos at whatever price. The professionals can't do that." He continued, "Amateurs can do accidents, but should leave the portraits and reportage to professionals" (A. B. Cissé 2005). In addition, as Elder pointed out, "the popularity of color rendered black and white products increasingly expensive, with fewer retailers willing

to supply those goods" (Elder 1997, 85). Compounding the situation further, video was introduced shortly thereafter and became popular in the 1980s. Ever since, like elsewhere in the world, it has become the most valued means of recording important personal events, such as baptisms and weddings (Malick Sitou 2004).

Some second- and third-generation studios persevered, however, including those of Malick Sidibé (Bamako), Tijani Sitou (Mopti), Adama Kouyaté (Ségu), Azeem Lawal (Gao), and Papa Kanté (Bamako). These men adapted to the new market by taking on young apprentices, often their sons, to carry out reportage commissions in color film and video. By the next decade, the former could be processed at one of a growing number of photo laboratories around the capital, such as Photo Royale (1985), Arc-en-Ciel (circa 1991), Express Photo (1993), Lion Photo (now Sun Color, 1993), Photo Kyassou (1993), and Korean Photo (1995). Some of these companies are owned and operated by Malians. However, most proprietors are from South Korea, Japan, or elsewhere in Asia. Of these, the majority of photographers prefer the quality and service at Tokyo Color, although it is relatively expensive. For example, Fousseini Sidibé, son of Malick, opined, "Tokyo Color is the best [lab] in all of Bamako because they treat each photograph carefully and print fewer mistakes. The others just run it through the machine" (F. Sidibé 2004).[130] Because of this, the establishment has become, particularly for "amateur" and reportage practitioners, a local hub where photographers meet, share knowledge, and learn about the medium and the market in a manner akin to first-generation professionals at Photo-Hall Soudanais in the 1940s and 1950s. Others patronize neighborhood labs out of convenience or process their film at less expensive laboratories, such as Korean Photo and Sun Color.

In addition to weddings, birthday parties, baptisms, sporting events, and social organizations, reportage venues, following the times, have gradually expanded to include dance clubs, which grew in number during the 1980s and 1990s and remain popular among youth today. In fact, wedding parties now customarily hold dinner celebrations and receptions at these locations (Malick Sitou 2006). Due to this popularity, a few amateur and professional photographers currently specialize in club and nightlife pictures (Soumaré 2003; Elder 1997, 212). Many among the former also travel door-to-door to take portraits of people at home, returning a few days later with their finished color prints.

This is the atmosphere in which most fourth-generation photographers—both professionals and amateurs—entered the trade. In Bamako, this group includes Abdoulaye Baby, Amadou Baba Cissé, Mamadou Konaté, Amadou Keïta, Fousseini Sidibé, Dahirou Traoré,

Emmanuel Bakary Daou, Drissa Diakité, Oumar Cissé, Aly Maïga, Hamadou Ombitombé, Baba Keïta, Adama Kanté, Abdoulaye Kanté, Amadou Sow, Harandane Dicko, Nouhoum Samaké, Adama Bemba, Awa Fofana, Fatoumata Diabaté, and Ouassa Sangaré, among many others. Elsewhere, for example, are Ousmane Juittey and Jafa Maïga in Ségu and Ibrahim Sitou, Malick Sitou, and Ali Bocoum in Mopti.[131]

Several of the aforementioned are considered professionals who own or are employed within a studio environment, and most have been trained in darkroom processes. A fair percentage, including Baba Keïta, Fousseini Sidibé, Adama Kanté, Ali Bocoum, Oumar Cissé, and Ibrahim Sitou, consists of children of first-, second-, and third-generation photographers. Many have been educated at art schools such as the National Art Institute, which today offers courses in photography taught by Youssouf Traoré, and have participated in photography workshops and programs such as those at Helvetas (now CFP). Several have been involved in the *Rencontres* biennial. A few have studied photography or worked in studios abroad, typically in Europe. Moreover, a new demographic—women—has entered the scene, enabled in part by programs offered by institutions such as Promo-Femme and the Conservatoire in Bamako.[132] However, there are greater numbers of practicing photographers who are not familiar with the art of developing and printing film. Due to this, and because they often do not own or operate a studio, professional photographers consider them "amateurs," even though they make their living through photographic work (M. Sidibé 2004; A. Kouyaté 2004a; P. Kanté 2004; Malick Sitou 2004; Elder 1997, 229). For example, Malick Sidibé opined, "They are not artists [professionals], the ones who take color photos to the lab. For me they are not artists. They make only snapshots. They do it aimlessly, they don't arrange the subject well. . . . After taking a photo you should go into the darkroom to develop and print from the enlarger. . . . In the darkroom you invent, create, ameliorate, beautify a photo with materials and techniques that we have in the darkroom. You modify some images. Then you become a real artist" (M. Sidibé 2004). Similarly, Malick Sitou explained, "There are many [trade] secrets in the darkroom. That's why they say that a photographer who doesn't know the darkroom knows nothing" (Malick Sitou 2004). Thus, during the past twenty years, the field in Mali has broadened immensely to include a variety of people with unique backgrounds, interests, abilities, and experience, ranging from amateur to fine art photographers.

Numerous changes have transpired within studio spaces as well. Most obviously, they have become significantly smaller over the years, losing a room or two to landlords who transform them into apartments for their children (M. Sidibé 2004; Keller and Sitou 2007).[133] In addition, due to

the advent of color, studio backdrops and props have grown increasingly prefabricated, with most studios since the 1980s retaining some sort of exotic, commercially printed Western garden or nature view as a scenic backdrop for clientele. To help established professionals endure the color/amateur onslaught, the National Group of Professional Photographers of Mali (GNPPM) was created in Bamako between 1987 and 1988, around the time of Abdourahmane Sakaly's passing. Malick Sidibé described the organization, of which he was president and finally honorary president up to the time of his death in 2016: "GNPPM was created in 1987. It was initially only open to professional photographers with studios. But since 1993 it has been open to everyone, even amateurs. It provides education, information, support, critique, problem solving, loans, etc." (M. Sidibé 2003).

One of its primary goals, which photographers dismiss as unsuccessful and impossible to implement, is the institution of standardized pricing. Today, nearly every studio displays a GNPPM pricing guide on the wall of their reception room that, for instance, lists four black-and-white identification pictures as 1,500 CFA and the color equivalent as 2,500 CFA. However, the photographers unanimously maintain this attempt has proven futile as spontaneous deals are regularly made for a variety of reasons, including special relationships and desperate financial circumstances (A. B. Cissé 2005; M. Sidibé 2005). Amadou Baba Cissé explained, "GNPPM has a fixed price (1,000 CFA for identification photos and 1,500 CFA for three portraits) that is never respected" (A. B. Cissé 2005). Similarly, Sidiki Sidibé opined, "There is the GNPPM, but photography is poorly organized. . . . Everyone has their own price. The ambulant photographers are the ones who made it unorganized. They sabotage the price. If someone says there is a fixed price in Mali, they lied. It is not regulated. It is not organized" (S. Sidibé 2005). According to Elder, transient photographers also complain about the absence of an enforced, fixed price. About this situation, Sabana Aikie extrapolated, "It is a question of crisis in clients. . . . The price that is agreed upon is 750 [CFA] but there may be clients who may tell you that they don't have enough money. Well, you could give them a discount of 50 francs, or you could even take the photograph for 600 francs, then they would take it" (Elder 1997, 165).

Nevertheless, the GNPPM is the largest organization of its kind, and it is nationwide, with its headquarters in Bamako. It also features honorary officers in smaller cities such as Ségu (Abdoulaye Konaté), Mopti, and Gao (Azeem Lawal). For a variety of reasons, some photographers have formed more intimate, locally concentrated associations such as Djaw (Ja), Ja Ton (Image Association), Ja ni Yelen (Light and Shadow), Farafina

Foto (African Photo), Nayé-Nayé (Pinhole Camera, meaning "light" in Dogon), Cameramen (Videographers), the National Photographic Artists' Group of Mali (GNAPM), Kita Professional and Amateur Photographers' Association (APPAK), and Djabuguso (Image House).[134] There is also the photographers' labor union, Syndicat des Professionnels des Métiers de l'Image du Mali (SYNAPROMIM; Dembélé 2009). Like the GNPPM, several of these groups sponsor photography workshops and artistic collaborations, exhibition projects, social and professional support, and additional forms of education (M. Sidibé 2004; Lamunière 2001b, 58; Vroegindewey 2013). Guided by their professional networks, particular interests, and primary concerns, photographers often belong to more than one of these organizations.

In light of the challenging color market, some photographers found or continued to engage in supplementary means to subsist amid waning business. For example, camera repair has been a saving grace for Studio Malick. Until the mid-2000s, Malick Sidibé spent many days out in front of the studio repairing cameras. Today, his son Karim continues this practice. They have engaged this task on commission or in preparation to sell (or pass along free of charge) equipment to aspiring and established photographers alike (Knape 2003, 80). Others permanently or temporarily gave up their studios for governmental work, changed their careers entirely, settled for early retirement, or moved away, as in the case of Sadio Diakité and Sidiki Sidibé, who left Mali to practice photography and other vocations in various parts of West Africa during this period (Njami and Boudon 2001; S. Sidibé 2004). In the 1980s, AMAP provided a welcome reprieve for some, such as Ousmane Keïta, who closed his studio circa 1984–85 and returned to work for the institution until he retired in 1994 (O. Keïta 2004).

Those who persisted, such as Malick Sidibé, Adama Kouyaté, and Tijani Sitou, continued to toil at their studios through the 1990s, when African photography caught the attention of Western collectors, dealers, and curators and thereby gained much recognition in the international art world. Malick Sidibé's namesake and adoptive son, Malick Sitou, described Sidibé's situation: "In 1985, things got really tough, but he was patient. He didn't change his job. Then he became internationally recognized in 1994 and by 1999 things were going well" (Malick Sitou 2004). This particular history began around 1991, which was also an important year sociopolitically, riddled with mass civilian demonstrations that, with support from the military, ultimately led to the end of Traoré's twenty-two-year reign (Imperato 1991, 24).

Frustrated with Traoré's administration, students, teachers, laborers, women, and others took to the streets in March 1991 and set fire to a

number of governmental structures and looted stores. In turn, in one case, national troops blocked all exits and set a shopping complex ablaze, killing more than sixty-five people. Several tens and perhaps even hundreds of civilians were killed or wounded in the uprisings of March 22–23 (Clark 2000, 258). Evidence of these events is housed at the photography department of AMAP in the form of a CD-ROM.[135] In the chaotic footage, rioters flood the streets of Bamako, buildings are burned and gutted, and hospitals teem with wounded patients. A witness described the scene and its impetus: "[At the end of Moussa Traoré's regime there were] high taxes and low income. They would arrest you at home if you didn't pay. There were riots and killings on the Avenue de l'Independence. Old women marched naked for several days. Many people died in March 1991. . . . There were burning tires, shooting, looting . . . a lot of people were at the hospital. There were hundreds of victims."[136]

In response, Traoré declared a state of emergency, sealed the borders, shut down the airports, and instated a dusk-to-dawn curfew across the nation.[137] One photographer described his experience of the repercussions of these events and his proximity to them. He said that the police "came to the studio three times and shot tear gas" in a punitive measure.[138] On March 24, a committee of opposition leaders, headed by Alpha Oumar Konaré, convened in the capital and demanded Traoré's resignation, an end to the state of emergency and national curfew, the dissolution of the one-party National Assembly, and the drafting of a new constitution, which was approved January 12 the following year. An interim government was established by Amadou Toumani Touré, and Traoré was imprisoned and later placed under house arrest in the capital, where he remained until his death on September 12, 2020. Presidential elections were held a few months later, and Alpha Oumar Konaré was inaugurated into office June 8, 1992. Grateful for the change in leadership, one Malian exclaimed, "For us, it is thanks to youths—to the youth movements—that Moussa Traoré fell."[139] Similarly appreciative, another individual explained, "Democracy during the Alpha Oumar Konaré period was better than [with Moussa] Traoré. . . . Traoré said that he had democracy, but there was not really democracy until Konaré's time."[140] Another individual agreed: "In 1991, change was obligatory. With only one party, there is no democracy. Multipartism is better."[141] Thus, since 1991, Malians arguably have enjoyed greater personal liberties, a marginally improved economy, and greater political democracy.[142]

The year 1991 also witnessed the *Africa Explores: 20th Century African Art* exhibition at the Center for African Art (now the New Africa Center) and the New Museum in New York City, curated by Susan Vogel. In this exhibition, Vogel controversially displayed seven black-and-white

portrait photographs she had collected in Mali during the 1970s and attributed them to an "unknown" artist.[143] Three of those images are featured in the exhibition's catalog, again attributed to an "unknown photographer," and one is reproduced on the cover (Vogel 1991, 160–61).

The transcultural movement and repurposing of these objects is reminiscent of the recontextualization of nineteenth-century African portraiture within colonial publications, such as postcards, by European editors, publishers, and administrators. Geared toward Western audiences, commercial portraits representing cosmopolitan Africans became photographs of anonymous cultural "types" from an exotic continent, interpreted within Western visual and conceptual paradigms. For many years, the photographers' identities and contributions were obscured until recent scholarship brought them to light, complicating global understanding of photographic production in coastal West Africa from 1857 to the 1930s (Viditz-Ward 1985, 1987, (1998) 1999; Haney 2010, 2014; Gore 2013, 2015; Gbadegesin 2014; Schneider 2014; Hickling 2014; Crooks 2015; Evans 2015; Paoletti 2015; Geary 2017; Anderson and Aronson 2017). While both scenarios were somewhat facilitated by African as well as Western agents, such practices raise ethical questions regarding authorship and ownership that will be addressed in chapter 7.

Africa Explores famously brought André Magnin—art critic and former curator of Jean Pigozzi's contemporary African art collection—to Bamako in 1992 (Magnin 2004). Armed with the exhibition catalogue and assistance from French photographers François Huguier and Bernard Descamps, Magnin was able to identify the artist as Seydou Keïta and, in the process, became familiar with the work of Keïta's compatriot Malick Sidibé. Keïta described the occasion:

> One morning while I was working on the engine of my motorcycle, three people showed up at my place. It was André Magnin with a woman named Françoise Huguier, and [Bernard Descamps]. They told me they wanted to talk to a photographer named Seydou. Apparently they thought I was a mechanic! I tried to assure them that I was indeed Seydou Keïta the photographer, but they didn't believe me! . . . I took them into the house where my boxes were kept, and told them each to grab one and have a look at what was inside. The boxes were the kinds that you usually use to store paper, but these were full of my negatives. Well, they just couldn't believe it! That's when it all began, in 1993. That's when it really started, and it just grew from there. Since then, I've been around quite a bit. (Lamunière 2001b, 49)

This voyage thus helped set the wheels in motion for numerous exhibitions and publications of Malian and African photography that have been created over the past twenty years. All of these, in turn, have

ultimately shaped the international art world's conceptual and visual understanding, and aesthetic expectations, of these images (i.e., large-scale, square-formatted, full-frame, black-and-white, titled, portrait and reportage photos of now largely anonymous subjects).[144] This reality is not lost on photographers and archival proprietors in Mali. With hopes to participate in this market, Malick Sitou, son of Tijani Sitou and adoptive son of Malick Sidibé, requested square, full-frame prints of his father's original negatives and posthumously titled the images in preparation for an exhibition held at the Indiana University Art Museum in the spring of 2007.

Additional repercussions include Bamako's designation as the capital of photography in Africa with the institution of the *Rencontres de la Photographie Africaine* (*African Photography Meetings*) biennial—the continent's first festival of African photography—in 1994. Photographs by Seydou Keïta and Malick Sidibé, among others, were featured in this exhibition, which was inaugurated with an address by then president, scholar, and former minister of culture Alpha Oumar Konaré. In a small exhibition affiliated with the festival's second opening in 1996, portrait photographs by Tijani Sitou were on display in Ségu alongside those of two of his colleagues, Hamadou Bocoum (in Mopti) and Adama Kouyaté (in Ségu; Mesplé 1996a, 8; Malick Sitou 2004). To date, the biennial has occurred twelve times,[145] with each rendition incorporating more international photography (it is no longer confined to African photography) and less of that produced in Mali itself, which is a common grievance among the country's professional photographers (Njami 2003; Carrascosa 2004). Nevertheless, despite its many faults, it was this festival, and its organizing bodies and funding partners (such as Afrique en Création, today Association Français d'Action Artistique [AFAA]; Fonds National d'Art Contemporain [FNAC]; and Revue Noire), that initially introduced young Malians to foreign modes of photography in the 1990s. It was also one of the first to locally recognize the work of commercial photographers in Mali as "art." Finally, it provided a new venue in which photographers from all over the continent, and eventually the world, could engage in artistic and social dialogue, exchange ideas, network, and travel to other parts of the globe.

As mentioned, some fourth- and fifth-generation photographers in Mali have become self-proclaimed "fine art" photographers, inspired by the *Rencontres* and workshops held at or sponsored by the National Art Institute, Helvetas (now the CFP), the (now defunct) Seydou Keïta Foundation, the National Museum, the National Conservatory, the French Cultural Center (Institute Français since 2010), photographers' collectives such as Djabuguso, and professional Malian photographers like

Malick Sidibé (M. Sidibé 2005; O. Cissé 2004; A. B. Cissé 2005). Most, but certainly not all, of these artists work in black and white—the genre presently relegated to artistry—although color is growing increasingly acceptable and digital photography has become more viable since 2008. A few of these photographers have been invited to Europe to participate in photographic exchange programs, residencies, and workshops sponsored by Western institutions such as Helvetas (now CFP).

Additionally, since the inception of the *Rencontres* biennial, a museum and center for photography (the African House of Photography) has been planned for the capital. It remains unclear where and when it might become a reality. Until April 2018, the project was directed by Moussa Konaté, who headed the *Rencontres* office, in the relatively new Bamako neighborhood ACI 2000 (M. Sidibé 2004, 2005; Moussa Konaté 2004, 2009; A. B. Cissé 2005, 2009). Today, Tidiane Sangaré holds this position. While it has begun to develop a collection of historically significant photographic materials (such as Dembélé's Imperateur enlarger and the low-resolution collection of images and metadata from the Archive of Malian Photography), it does not yet function as a museum.

Thus, as this brief discussion has shown, the histories of photography in Mali since 1991 are as complex, multivalent, fluid, and integrated as those that came before. Yet they operate within a markedly different context—namely, the international art market. Because of this, their stories will be revisited in chapter 7, which serves as a much smaller, proverbial bookend to part 1 of this book.

Notes

1. Europeans in Bamako during the 1940s regularly listened to Radio-Dakar, Radio-Brazzaville, and the Voice of America. By the 1950s, upper-class, educated, urban Africans in the capital were tuning in; a few years later, when Radio-Soudan was created in 1957–58, they were speaking out (Lake 1993, 64; M. Sidibé 2003; Centre des Archives d'Outre-Mer, 14MIOM/2275, 15G/24, Telegram-Letter, February 17, 1940, 10).

2. On October 17, 1949, the Rassemblement Démocratique Africaine (RDA), with the Tribune des Jeunes, began printing a daily newsletter in Bamako entitled *L'Essor* under the direction of Mamadou Sangaré. By 1950, *L'Essor* was printing three hundred issues per day. With independence in 1960, *L'Essor* became the country's only national daily newspaper and served as the mouthpiece of the US-RDA until 1968 (Echenberg 1991, 163; A. O. Konaré and A. B. Konaré 1981, 140; Imperato 1977b, 119).

3. Published in Dakar, *Réveil* was a weekly journal propagating African unity and liberation that was popular among Africans in French West Africa during the colonial era (Centre des Archives d'Outre-Mer, 14MIOM/2275,

15G/24, October 24, 1949, report "Chapter 1: State of the Spirit of the Populations," 7).

4. By 1950, the Parti Progressiste Soudanais (PSP) had launched its daily publication, *Vérité* (Centre des Archives d'Outre-Mer, 14MIOM/2283, 15G/56, "Chapter 2: Political Parties," unpaginated).

5. According to colonial documents, Cinéma Vox and Cinéma Rex were the two movie theaters in the capital during the 1950s most frequented by Africans (Centre des Archives d'Outre-Mer, March 19, 1953, Chapter 1, Report "Aure d'Islam," 11). Cinemas were also semipublic locales that political parties (particularly the RDA and the PSP) utilized for conferences, meetings, and lectures. Throughout the decade, most *L'Essor* and *Vérité* issues feature an advertisement on the back page calling for all members and like-minded Bamakois to attend their upcoming meetings at local theaters (Centre des Archives d'Outre-Mer, 14MIOM/2275, 15G/24, Soudan Service de la Sûreté, "rapport Mensuel, Etat d'Esprit des Populations," May 1947, #3497, 2).

6. As with many of Keïta's images, the exact date of this photograph is unknown. However, it is generally dated between the late 1950s and early 1960s as determined by the backdrop and outdoor setting.

7. For a self-reflective examination of the complexities and ambiguities with which French colonial subjects experienced the cultural practices, opportunities, and ideologies presented by French colonialism in northern and western Africa at this time, see Memmi ([1965] 1991).

8. For example, some of Malick Sidibé's closest friends and regular customers were tailors, such as Youssouf Doumbia and Youssouf Saker. The latter came by Studio Malick on December 8, 2003, and spoke with me about their relationship (M. Sidibé and Saker 2003).

9. According to Malick Sitou, Malick Sidibé, and Sidiki Sidibé, particular brands (such as JVC, Trident, Sony, and Panasonic) were generally preferred by people of different ethnicities based on loudness, durability, and size. Thus, they could be used to visually indicate or interpret an individual's cultural heritage (Malick Sitou 2004; M. Sidibé 2005; and S. Sidibé 2005).

10. In many areas of western Africa, tea drinking is an important social event. In Mali, it occurs on numerous occasions over the course of the day among most adult citizens, particularly men. In these contexts, Chinese green tea typically is brewed over small charcoal fires, flavored with spearmint and sugar, and served in small glasses passed around a group of participants. Over the course of a visit, conversation, or business transaction, three rounds are customarily served. The amount of mint and tea usually remains the same for the three rounds yet sugar is added each round, rendering each cup sweeter. Social decorum dictates guests are served first, and a lower-status member of the host's brood (by age, gender, or profession) typically does the brewing and serving, thereby regularly reinforcing social hierarchies.

11. See, e.g., Pigozzi and Magnin (2011, plates 07088, 01056, 02404).

12. Centre des Archives d'Outre-Mer, 14MIOM/2275, 15G/24, Telegram-Letter, Dakar, February 17, 1940, from the governor-general to the governor of the French Sudan at Kuluba, marked "confidential," signed by Louveau, 12–13.

13. This number sounds excessive, although it was recorded in a 1953 official report: Centre des Archives d'Outre-Mer, 14MIOM/2283, 15G/56, "Chapter 2: Political Parties" and "Chapter 4," and Centre des Archives d'Outre-Mer, 14MIOM/2275, 15G/24, Folder 2, "March 19, 1953," 11.

14. Generally speaking, second-generation photographers began their careers between the 1950s and 1960s and often apprenticed to first-generation photographers or remaining French photographers or received an art education at the Maison des Artisans Soudanais (today the Institut National des Arts) in Bamako.

15. Having learned photography in the 1940s, it could be argued that Félix Diallo's career more closely aligns with those of first-generation photographers in Bamako, particularly since he worked as an assistant to Pierre Garnier at Photo-Hall Soudanais during the 1950s. However, because he began working as a photographer in 1952 and is closer in age to second-generation photographers, I discuss his career among that group.

16. In this general history, Hussein and Hassan Traoré reside somewhere between first- and second-generation photographers. However, I include them here because they opened their studio—purportedly the first in Mopti—during the 1950s.

17. Consult the digital appendix (https://amp.matrix.msu.edu/biographies .php) for more information on specific photographers.

18. The Maison des Artisans Soudanais began as the École Artisanale du Soudan in 1933 and was transformed into the Institut National des Arts in 1964 (Gaudio 1998, 208; Becchetti-Laure 1990, 37).

19. Les Pionners du Mali was a government-sanctioned national youth association established under Modibo Keïta in 1961.

20. See RolleiClub (n.d.). According to Ernst Wildi, twin lens reflex cameras existed before 1900, "but the [TLR] was really born in 1929 with the appearance of Rolleiflex . . . [which] . . . went on to become one of the most successful makes of all time" (Wildi 1987, 8). Although this camera remains favored among professional photographers in Mali and is commonly found in their archival collections, it did not predominate there until the 1950s and 1960s (O. Keïta 2004). It should be noted here that first-generation photographers, such as Keïta and Kouyaté (who received his Rolleiflex from Garnier before he left Mali), also worked with TLR cameras from the 1950s through the 1970s, if their careers extended that long (A. Kouyaté 2004a). However, several photographers of the first and second generations in Mali actually began experimenting with photography using "amateur" cameras, such as the Kodak Brownie.

21. By the time Sidibé opened his studio in 1962, Keïta had ceased working as a portrait photographer, having accepted a position taking mug shots of prisoners for the National Security downtown.

22. Born and raised in Soloba, Malick Sidibé first resided with his paternal uncle Dioumé Sidibé in Bamako. Similarly, Malim Coulibaly (who was originally from Sokolo) initially stayed at the home of his brother Sory while in the capital city. In fact, for most photographers—no matter the generation—relatives typically played a key role in initializing their careers, and the family members who seem to have made the biggest impact

(providing room and board, supplies, and professional contacts) have overwhelmingly been uncles. Consult the digital appendix (https://amp .matrix.msu.edu/biographies.php) to appreciate this trend.

23. Three exemplary exceptions are Mamadou Cissé, occupying a place somewhere between first- and second-generation photographers, who began learning photography at the age of nineteen from Guinean photographer Robert Bangoura in Mopti around 1949; Mahaman Awani, who started learning photography from his friend Idrissa Keïta in Gao circa 1955; and Hamidou Maïga, who learned photography from an unnamed Ghanaian photographer as well as an unnamed soldier in Mopti and sent his negatives to be printed by twin brothers Hussein and Hassan Traoré in the same city. While in Bamako, however, Maïga obtained his materials from La Croix du Sud and later Studio Malick (O. Cissé 2004; M. Coulibaly 2004; Awani 2004; and photographer H. Maïga 2004).

24. Guillat-Guignard contested this view in 2016, stating that Sidibé and his colleague Mamadou Berthé took identification and reportage photos while he took all the portraits for Photo Service (Guillat-Guignard 2016). His recollection, too, is complicated by a photograph he mailed to Studio Malick in December 2003 that suggests his African assistants, such as Mamadou Berthé, sometimes took portrait photographs of Westerners (see Keller 2008, 517). Likewise, a photo in Seydou Keïta's archive, which depicts a white woman in local dress, attests that—while rare—some African photographers had taken photographs of Europeans in the French Sudan by the 1950s (Pigozzi and Magnin 2011, plate 03827).

25. Illustrating the close connection between the colonial government and the photo community in Bamako, French photographer Vanetti first worked for the Soudan Sûreté (later the National Security) in the capital and went on to acquire Photo-Hall Soudanais after Garnier left the country in 1954 (Nimis 1998c, 26; M. Sidibé 2003).

26. While Nimis claims Sakaly had a monopoly on "official reportage" and trained photographers "at the Information" (Nimis 1998c, 34), none of the photographers I interviewed (save for his former employee Baru Koné) agreed that Sakaly had a monopoly on the practice. Furthermore, Malim Coulibaly and Ousmane Keïta, who worked for several decades at the National Information Agency of Mali (ANIM) and the Information Commissionership before that (1958–61), staunchly disagree that Sakaly trained photographers at the governmental press. In fact, Coulibaly claims to have occupied that role himself (O. Keïta 2004; M. Coulibaly 2004).

27. Guillat-Guignard also took "a lot of photos of the train station Cherek et Bouquet and Garage Visiage in 1952 to 1955 in Kati" along with pictures of "highway, railway, [and] building construction" (M. Sidibé 2003).

28. In Ségu and Mopti during this era, Lebanese photographers occupied important roles similar to those of French photographers in Bamako: supplying photographic materials, processing film and enlargements, and imparting practical knowledge of photography to African practitioners (Elder 1997, 66; Malick Sitou and Bocoum 2004).

29. In the following decade, many of these establishments were acquired by Lebanese, and later African, businessmen and businesswomen. For example, Assad Jean Bittar managed Photo Service and purchased the business circa

1962. He later liquidated the company, and Abdourahmane Sakaly acquired all of its materials in 1970 (Nimis 1996, 30). La Croix du Sud was sold to Express Photo, which was headed by Malians in 1993.

30. In fact, after leaving Bamako, Garnier subsequently traveled to Senegal, Guinea, Ivory Coast, and back to Mali, filling various posts for the French government in French West Africa before returning to France in 1965. Thus, unlike most French inhabitants of Bamako during this period (who did leave because of Mali's independence in 1960), it seems that Garnier left under different, yet still political, circumstances.

31. By 1962, when Sidibé opened Studio Malick and ceased his employment at Photo Service, the latter had undergone management by several French and Lebanese individuals (M. Sidibé 2003).

32. For the most part, due to its practicality, studios in Mali continue to be thus arranged today. However, as rent and other fees continue to escalate, and as landlords seek to use their real estate in new and diverse ways, some of these older studios have been drastically reduced in size over the years.

33. *Bulletin de l'Afrique Noire* 1973, 14778. In addition, according to Iyouba Samaké, "The first electrical company Energy de l'A.O.F. [Energy of French West Africa] based in Sanfils opened in 1951 . . . and after independence it became E.D.M. [Energy du Mali] in 1961" (I. Samaké 2004). Soon thereafter, most of the territory's cities were becoming electrified: a thermoelectric plant opened in Gao in 1952, another started operation in Markala in 1951 to generate electricity in the Ségu region, and another was begun in Mopti in 1958 (*Bulletin de l'Afrique Noire* 1973, 14778; Elder 1997, 83).

34. According to Elder, "A.N.I.M. state owned studios were also open to the public. [Working at these studios] 'after hours' [ANIM photographers] could earn . . . extra income [of] up to 12–15,000 Malian francs per day" (Elder 1997, 89). Malim Coulibaly, who was employed at these studios as a photographer and trained most of their staff as the head of the photography department from 1960–70, stated that "ANIM opened studios all over Mali. . . . The first was Bamako." He went on to say that Abdoulaye Traoré, called "Berlin," worked at the studio in Bamako while Boubacar Sidibé, known as "Mensi," worked at the ANIM studio in Kayes. Abdoulaye Camara, nicknamed "Blocus," worked at the one in Gao, Mamadou Soumaré was employed at the studio in Mopti, and Abdou Talata continues to work at the studio in Sikasso (M. Coulibaly 2004).

35. According to Meillassoux, *zazou* was the "name given in the forties to male adolescents in France, who distinguished themselves by their long hair, long coat, and narrow pants" (Meillassoux 1968, 129). In Bamako in the 1940s and 1950s, young men who wore cosmopolitan suits with ties, fountain pens, polished shoes, handkerchiefs, fedora hats, and often spectacles were known as zazous (A. O. Konaré and A. B. Konaré 1981, 143).

36. Etienne Stéphane Mallarmé (1842–98) was a French symbolist poet and teacher whose works center on themes of love, beauty, charm, heroicism, eroticism, humor, and the idealism of youth, expressed with a refined faculty for ambiguity and layered meaning. Among his most appreciated poems are "L'Après-midi d'un faune" and "Hérodiade" (Lloyd 1984, 1–12, 14, 19, 23, 25; Lloyd 1999, 122–28; and Takeda 2000, 4, 7, 51–53, 57, 63, 90).

37. According to Magnin, *grin* derives from "the name of the French satiric poet Pierre Gringore (1475–1538). . . . In the 1920s and 1930s, under the colonial regime, newspapers were banned and African intellectuals in West Africa held formal meetings called grin where they discussed how to deal with colonial policies. This term is still used today and remains popular" (Magnin 1998, 36). Malick Sidibé defines grins as "youth clubs with a name. [In grins] youths drink tea, trade newspapers, [and] talk politics. Today they are different. . . . It's just for entertainment now. In the past they were helpful networks, like fraternities" (M. Sidibé 2003).

38. In fact, this period marked a drastic increase in education across French West Africa, which steadily escalated through the 1960s. According to Foltz, "in 1929–30 there were two French West Africans registered in French universities. Twenty years later, there were 165 and by 1954–55, there were 684, with another 200 following university-level courses in Dakar" (Foltz 1965, 70–71). Furthermore, *Marchés Tropicaux et Méditerranéen* reported that "the importation of glasses" in French West Africa increased "from 61 CFA in 1960 to 100 CFA in 1964" because "literacy is increasing" (*Marchés Tropicaux et Méditerranéen* 1966, 336).

39. As superficially focused records, however, they do not *replace* memory, as Sontag and Barthes have argued, but function as future triggers or expediters of memory and all the sensual, intellectual, and emotional information it recalls and, in essence, reexperiences (Sontag [1973] 1977; Barthes 1981).

40. Malick Sidibé corroborated Koné's account, stating that Baladji Cissé was a famous boxer in the French Sudan during this era and was "head of the boxing association in Mali" (M. Sidibé 2003). His triumphant boxing match in Bamako on October 7, 1956, is recorded in *Grandes Dates du Mali* (A. O. Konaré and A. B. Konaré 1981, 150).

41. Koné said that he attended the movie theater every day when he was younger, costing him a *tama* (a coin worth fifty francs) each visit (B. Koné 2004). Similarly, Iyouba Samaké recalled regularly going to the movies with three or more male friends, even though his father did not approve and assumed it would make him "a bandit." He said, "it used to cost 50 francs to sit on a wooden bench, 100 francs to sit in a chair, and 150 francs to sit in an armchair, which was reserved for French only" (I. Samaké 2004).

42. Regrettably, I enjoyed less access to women of this generation than men due in part to my foreign status and age. The women with whom I have regularly interacted are generally younger. In the future, I hope to work more closely with this population to shed more light on their particular perspectives.

43. Centre des Archives d'Outre-Mer, 14MIOM/2275, 15G/24, Telegram-Letter, February 17, 1940, 10. (It remains unclear why the letter is dated 1940 when the information it contains concerns events that took place in 1945.) More comprehensively, it reads: "Films preferred by the metropolitan public are French films; the African public prefers American productions, in particular 'cowboy' films, in which the movement supplements the difficulties of dialogue comprehension." (Tellingly, the French colonial administrator who authored the report did not consider Africans in Bamako "metropolitan.")

44. According to Meillassoux, the first cinema to open in Bamako was Cinéma Normandy in 1910 (Meillassoux 1968, 87–88). Silent films were shown inside Hôtel de la Gare (also called Buffet de la Gare) during, and prior to, the 1940s (I. Samaké 2004). By the 1940s, le Mal, le Rex, and le Vox cinemas exhibited French, American, and Arabic films. Soudan Cinéma (often referred to as Soudan Ciné), the fifth French movie theater to open in the capital, was popular by the 1950s, when cinematic productions began incorporating local languages, such as Bamanankan (M. Sidibé 2003; S. Sidibé 2003; Meillassoux 1968, 87–88). A colonial report from 1953 admits that films in Senegal and Mali were censored in part because "a lot of functionaries belong[ed] to the U.S.-R.D.A." (Centre des Archives d'Outre-Mer, 14 MIOM/2275, 15G/24, Chapter 1, March 19, 1953, 10). As previously mentioned, it is important to keep in mind that movie theaters were not only sites of entertainment but were also regularly used in the 1940s and 1950s by nascent political parties and labor unions as venues of contesting colonialism.

45. An article in *Vérité* requests "better control of imports such as alcohol and raising the price of alcohol selling permits" (*Vérité* 1958, 1). A few years later, Meillassoux reported, "Consumption of liquor, mostly whiskey, has increased considerably—indeed, to the point of worrying the government about religious principles and the foreign trade balance. Restrictions have been put on the import of liquors, and prices have been raised" (Meillassoux 1968, 137).

46. Youssouf Doumbia recalled that orchestras disappeared in 1958. Thereafter, "records and DJs" were all that was available for "modern dances" (Y. Doumbia 2004).

47. Radio Soudan began broadcasting in Bamako in 1956 (*L'Union* 1958c). However, according to Youssouf Doumbia, "One listened more to Voice of America because [at that time] Radio Soudan played only griot songs" (Y. Doumbia 2004). In fact, the famous griot Bazoumana Sissoko made his first musical recordings at Radio Soudan in 1958 (A. O. Konaré and A. B. Konaré 1981, 157).

48. The popularity of these events extended well into the 1960s when, in 1963, Meillassoux reported, "Balls have become a favorite entertainment for the emancipated youths. Several ballrooms exist in town, and public buildings—such as the Maison des Combatants, Maison des Pionniers, or Maison du Parti—are occasionally rented for the purpose" (Meillassoux 1968, 8).

49. According to Doumbia, Triana was created by Drissa Sidibé, who was better known as Androuse. Unlike Meillassoux, Doumbia holds that "the first tea clubs, the first grin [and] the first dance club was the Triana Club of Bamako-Kura." Later, in the same interview, he stated, "Surprise parties began around 1956–57 and . . . we created Triana in 1956." By 1958, several of these clubs, including Triana, Florina, Las Vegas, and Aragon, were formed in Bamako's nine neighborhoods (Y. Doumbia 2004).

50. To be clear, Doumbia stated that parties sponsored by Club Triana were held "in the middle of the street; [not] in a building. [They] were in front of Amadou Wara's house. . . . Women from the neighborhood [would do the

cooking]. . . . Brasserie du Soudan provided all of the drinks" (Y. Doumbia 2004).

51. *Cheb Jen* is the Wolof term for "fat rice," a famous Senegalese cuisine. For Cheb Jen dances, between one hundred and five hundred francs were collected from each participant beginning on Wednesday, and the dances would be held Saturday night. Records were purchased from a Lebanese store called l'Olympia near La Croix du Sud (Y. Doumbia 2004).

52. Meillassoux mentions this trend, calling it "Gube" (Meillassoux 1968, 116–25).

53. Meillassoux cites similar popular musical genres of the 1960s: "A few songs come from traditional folklore, some as old as the fourteenth century. Most, however, are inspired by modern music, and phrases of Charleston, rumba, samba, mambo, conga, and cha-cha can be detected" (Meillassoux 1968, 126). Testament to the importance of these trends in Malian history, they have been included in the Konarés' chronology of the "Great Dates of Mali" (A. O. Konaré and A. B. Konaré 1981).

54. Meillassoux's account contradicts those of Traoré and Dembélé: "The steps are even more directly inspired by Western dances than is the music" (Meillassoux 1968, 126).

55. More recently, studios in Bamako, Ségu, and Mopti, for example, continue to incorporate these backdrops alongside commercially manufactured Western landscapes.

56. Nimis argues that these hand-painted, greyscale scenic backdrops have been introduced throughout western Africa since the 1950s by Yorùbá photographers from Nigeria (Nimis 2005, 2013).

57. Nimis presented an overview of the pervasiveness of Yorùbá photographers in West Africa, including those who practiced photography in Mali (2005). In a less extensive project, Elder shed some light on the role of Ghanaian photographers in Ségu and Bamako (1997). Once more research has been conducted on the histories of photographic practice in other African national and cultural contexts, one hopes the relationships between photographic production and photographers' networks in the region will be better understood.

58. Youssouf Doumbia described the *époque*, stating: "There was a total ambiance among people" (Y. Doumbia 2004). Similarly, Malick Sidibé recalled, "In the clubs it was precisely the ambiance, the movement and the gaiety that I wanted to capture. I was there, I only had to look. . . . I followed the young people in their . . . delight" (Knape 2003, 78). The term was also used by Panka Dembélé to describe the dancing scene in the early 1960s: "At the beginning of every dance we'd play our number 'Kalikato,' starting it with 'Ambiance! Ambiance!,' which people knew . . . by heart" (Magnin 1998, 170). Meillassoux noted: "Ambiance was a fashionable word in the sixties . . . it was . . . the name of the *jeli-to* ["bard association"], of a Malian hit tune, and of a fashionable native loin cloth" (Meillassoux 1968, 107, 136).

59. Simca produced the Versailles model at this time, which Keïta owned. However, his most cited and photographed vehicle, which was used as a taxi in Bamako, was the Peugeot 203.

60. In 1958, for example, gas cost 37.19 CFA (Lee 1986, 114) per liter, oil was 25 CFA per liter, and a liter of diesel fuel cost 32 CFA (A. O. Konaré

and A. B. Konaré 1981, 157–58). These figures can be compared to the price of photographs at the time, which were typically 300 CFA for "day" photographs and 400 CFA for "night" photographs due to the cost of electricity (Elder 1997, 94). However, Malick Sidibé's prices were lower: 100–150 CFA for a nine-by-thirteen-centimeter matte print, and the same size glossy print was 150–200 CFA (Magnin 1998, 39).

61. For example, Iyouba Samaké, who experienced French colonialism in Mali, plainly stated: "Colonialism *manyi dɛ!* [Colonialism was really bad!]" (I. Samaké 2004).

62. According to Imperato, the Popular Militia was "an armed auxiliary of the Union Soudanaise-RDA, originally formed September 1960 to enforce party discipline. It was reactivated in August 1967 during the cultural revolution [of Modibo Keïta], when its numbers were enlarged and its functions expanded" (Imperato 2008, 240).

63. With independence, Radio Soudan was transformed in 1960 into Radio Mali, which had enough range to serve the areas in and around Bamako (Lake 1993, 64). The station was particularly significant for Malian musicians in the 1960s, and it popularized their songs using technology that could eventually be sold commercially (Magnin 1998, 181). By the following decade, the programming and reach of the station had grown: Broadcasts, in French with local language news segments, reached most of West Africa (Imperato 1989, 99).

64. According to the Konarés, Keïta's government created the Armée Nationale du Mali on October 1, 1960 (A. O. Konaré and A. B. Konaré 1981, 163). However, an article featured in *L'Independant* in 1996 dates the inception of the institution to 1961 ("Great Diplomatic Dates of Mali" 1996, 3). Either way, it is interesting to note that it was formed *after* the Popular Militia of the RDA. For more on the creation of the national army, see Mann (2000, 10).

65. On December 15, 1961, the Lycée Terrasson de Fougères became the Lycée Askia Mohammed, after the famous leader of the great Songhai Empire of the fourteenth through sixteenth centuries. Likewise, the Frederic Assomption stadium was renamed Quizzin Coulibaly at this time, and William Ponty Avenue was renamed Avenue Liberté (A. O. Konaré and A. B. Konaré 1981, 143, 168). The same occurred to several other major thoroughfares and institutions in the city. For example, in 1962, as "part of a cultural development and national identity" project, the Musée du Soudan became the National Museum (Musée National) and was affiliated with the Institut des Sciences Humaines (Becchetti-Laure 1990, 62–63).

66. In Mali, each couple customarily participates in two wedding celebrations: a religious ceremony and a secular, legal proceeding. During the latter, which takes place at the mayor's office, the attire is akin to Western weddings, with the bride in a formal white gown, and the event includes a celebratory procession of vehicles as well as a reception afterward. Today, the wedding party and guests travel to a local dance club to continue the celebration into the night.

67. Malick Sidibé described retiring from reportage in the 1976 because that was when "the clubs started to break up" (Magnin 1998, 40). In fact, his assistants, such as Sidiki Sidibé, Shaka Sidibé, and Baba Traoré, had already

assumed most of the reportage commissions in the 1960s, taking pictures of young men and women at neighborhood parties and picnics along the Niger River (M. Sidibé 2004; S. Sidibé 2003; B. Traoré 2004).

68. According to Jay Schwartz (2002), *Yé-Yé* is a French term for the "popular musical movement of the 1960s. 'Ye Ye' music (or 'Yeh Yeh' or 'Ya Ya') [was] perky [and] youthful. [Its] major stars [were]: Françoise Hardy, Sylvie Vartan, France Gall, [and] Serge Gainsbourg." In Mali, the Konarés equate Yé-Yé with the Twist (A. O. Konaré and A. B. Konaré 1981, 172).

69. The Commissariat de l'Information, which was instituted during the colonial era, became the Agence National de l'Information du Mali (ANIM) on August 3, 1961 (A. O. Konaré and A. B. Konaré 1981, 167; M. Coulibaly 2004). From this time on, ANIM has served as *the* "national press agency of Mali," issuing official press releases (although today it is known as AMAP). In the early 1960s, according to Imperato, it also produced "a daily news program for Radio Mali called 'Journal Parlé'" (Imperato 1977b, 14).

70. In the 1960s, Meillassoux described the atmosphere of National Youth Week (Semaine Nationale de la Jeunesse), which was held in each of Mali's six regions and in every major city; incorporated various cultural events, such as music, theater, dance, and sports; and was originally designed as a week of competitive events for Pionniers from around the country (Meillassoux 1968, 71–74, 88).

71. Sidibé said he worked with almost all the musicians involved with the National Youth Week festivals every year since 1962 (M. Sidibé 2004).

72. Of his competitors, Dembélé remembers Ousmane Keïta, Sina Keïta from Tokyo Color, Dahirou Traoré of studio Diamant Noire, Cissé (whom he recalls was Guinean), and a Japanese photographer from Tokyo Color (S. Dembélé 2004).

73. According to the Konarés, the French military began evacuating its bases on January 20, 1961, which is corroborated by Bakary Sidibé, who stated that the French military left his village of Guelelenekoroni in 1961 (A. O. Konaré and A. B. Konaré 1981, 164; Bakary Sidibé 2004).

74. Meillassoux states, for example, "Youth associations and their memberships [were] taken over by the national organization of the Pionniers. Membership is compulsory for all young people of both sexes between the ages of eight and eighteen (Meillassoux 1968, 71–72).

75. The National Security, in France, is a division of the Interior Ministry "heading all police forces except the gendarmerie and the Paris Prefecture de Police" (Cousin et al. 2000, 411). In Mali, it is the National Police, headquartered in central Bamako (M. Sidibé 2004; Brehima Sidibé 2006; and Malick Sitou 2004). The Sûreté Soudan was instituted in the colonial territory prior to 1925 (A. O. Konaré and A. B. Konaré 1981, 117).

76. Malick Sidibé explained, "Seydou Keïta stopped doing photography in 1962 to work for the Sûreté" (Njami and M. Sidibé 2002, 94). Reiterating Sidibé's statement, Baru Koné said that in the 1960s, "Seydou Keïta was busy taking police photographs of prisoners. . . . He didn't take pictures of political leaders" (B. Koné 2004). In 2004, Mountaga Dembélé's relative, Bouya Dembélé Kouyaté, provided a variation of Keïta's story: "Police were in need of a photographer to take pictures of prisoners before sending them

to jail. So Maurice Keïta, a close friend of Mountaga's, came to [Mountaga] and [Mountaga] proposed to send Seydou Keïta to work for the police. [Afterward] Keïta began taking pictures for the police and worked there until his retirement" (B. D. Kouyaté 2004).

77. In Bertillon's system, portrait photographs were composed according to "neutral" standards such as a set focal length, consistent lighting, and a fixed distance (Sekula 1986, 18–30).

78. In the 1990s, Seydou Keïta presumed the negatives he had taken for the National Security were in the official archives in Bamako (Magnin 1997, 13). In 1997, Magnin added that the "pictures from that period are governmental property and therefore inaccessible" (Magnin 1997, 8). Reliant on the accounts of Sangaré and Doumbia and without physical evidence of any kind, it is difficult to assess whether the images have been permanently destroyed or are temporarily inaccessible.

79. Although Keïta was reelected in 1964, it is difficult to surmise whether or not it was forced on the population. For instance, Malick Sidibé stated, "During the time of Modibo [Keïta], people voted by force by the power of the RDA" (M. Sidibé 2003).

80. Modibo Keïta's treatment of Tuareg citizens during the rebellions of 1962 to 1964 has been criticized for repressing "the uprising by sacking the Kidal region, poisoning wells [and] killing an estimated 1,000 Tuaregs" (Humphreys and Mohamed 2003, 17). (Since 1894, Tuareg populations have held several "uprisings" in the territory, primarily seeking greater administrative support, resource allocations, and the right to form an independent state of Azawad.)

81. Iyouba Samaké explained, "Fily Dabo Sissoko, Hamadoun Dicko, and Kasim [Touré] were against the Malian franc and organized a demonstration at the French Embassy. At this time, they were arrested. Many people were arrested, but they were the main three. They were sent to Kidal prison. They died there. They were killed. [The government] lied to the people, but the truth was [eventually] leaked" (I. Samaké 2004).

82. Travel and training were part of a larger socializing program that sought to persuade the young population and its leaders to adhere to Marxist principles and policies (Hazard 1969, 6).

83. Communist nations provided the country with financial support in other avenues as well. For example, construction began on June 12, 1963, on a new omnisport stadium in Bamako with aid from the Soviet Union and China. Likewise, in 1966–67, the Chinese built a new cinema in Bamako named Babemba after Babemba Traoré, the last king of the Kénédougou kingdom (1893–98) who committed suicide rather than endure capture as the French laid siege to his capital Sikasso in 1898 (A. O. Konaré and A. B. Konaré 1981, 172). Communist nations also brought their art and cultural projects to the city. In December 1964, an exhibition of Bulgarian "art photography" was held in Bamako, for example. Additionally, in 1966, Air Mali was financially and technically assisted by the USSR and other Eastern Bloc countries as well as France, and all of the airline's pilots were "Russian" (*Marchés Tropicaux et Méditerranéen* 1966, 335, 439).

84. Due to the difficult market, in 1965 Adama Kouyaté left Ségu, where he had been working as a professional photographer, for Bamako. Experiencing

similar hardships, he quit the capital for the Ivory Coast in 1966. He did not return to Mali until 1969, after the fall of Modibo Keïta (A. Kouyaté 2004b).

85. Abdourahmane Sakaly and Adama Kouyaté forged an arrangement during this period in which Kouyaté supplied Sakaly with photographic paper from Ouagadougou, Burkina Faso, and in return Sakaly sent money to Kouyaté's mother in Buguni (A. Kouyaté 2004b).

86. Djoliba ("Niger River") cigarettes began production in Mali in 1965. Among the earliest Malian brands were Djoliba, Gemme, and Liberté (A. O. Konaré and A. B. Konaré 1981, 179).

87. Those implicated include Salif N'Diaye (secretary of state in charge of energy and industries), Abdoulaye Sangare (secretary-general of the Scientific Research Council), and Moussa Drame (former minister of national education and chief of the Cabinet of the Minister of Justice and Labor) as well as Hamacire N'Doure (in Brussels) and Amadou Hampate Bâ, former ambassador in the Ivory Coast (*Bulletin de l'Afrique Noire* 1967, 9845).

88. The Popular Militia was created in 1960 as an armed auxiliary to the US-RDA, to enforce the party's ideological position, and, according to Uwechue, to "occupy unemployed youth in the capital" (Uwechue 1996, 342). However, it did not become active on a grand social scale until 1967. Diawara shed more light on this history: "In Mali, the socialist government created a militia in the mid-1960s to monitor the behavior of people in conformity with the teachings of socialism. This militia was aimed not only at abolishing traditional chiefs and other tribal customs, but also correcting the youths' habitus" (Diawara 2003b, 11).

89. Diawara similarly stated, "In Sidibé's photographs one can see the turbulence of youth and the generational conflict that characterized the 1960s" (Diawara 2003b, 9). However, the "turbulence" was also due to restrictive political policies. As briefly illustrated, in the last years of his presidency, Modibo Keïta endorsed unpopular socialist programs inspired by those in the Soviet Union, Yugoslavia, Poland, East Germany, and China. Young people resisted many of these, including punitive restrictions placed on the commercial market and violence the population endured at the hands of the Popular Militia (A. O. Konaré and A. B. Konaré 1981, 163, 183; M. Sidibé 2003, 2004; I. Samaké 2004, 2005; Y. Doumbia 2004; and Bakary Sidibé 2004).

90. Youssouf Doumbia's account reinforces Diawara's experience: "After the coup [1968], the activities of youths restarted, but in a more reserved fashion. We were still not free under Moussa Traoré like we were with colonialism" (Y. Doumbia 2004). Similarly, Iyouba Samaké reported, "There were curfews in both Modibo Keïta's and Moussa Traoré's time. The curfew was worse in Moussa's time. He wouldn't let people do what they wanted, as people were in [a state of] unrest" (I. Samaké 2005).

91. Doumbia continued, "It was on the way home that they could stop the girls [who were wearing] a dress or a skirt. . . . We had no freedom at all and we had to hide for pleasure" (Y. Doumbia 2004). Panka Dembélé extrapolated, "[Girls] wore billowing skirts or pumps with short dresses, which the militia had banned. In the street they would hide their miniskirts under big boubous [long robes]. If a girl was caught wearing a short skirt, the [militia] might tear it off her and make her pay a fine" (Magnin 1998, 169;

Elder 1997, 110). While young people were pressured by religious, political, and parental authorities to steer clear of Western fashions, youth associations made them requisite for membership (Meillassoux 1968, 132, 134; Diawara 2003b, 15). Thus, participating in these festivities and their related cultural practices was part of *belonging* to a certain desirable and exclusive social class—thereby cultivating a vogue identity—just as it was part of claiming one's independence by *resisting* and *challenging* a variety of authoritative bodies.

92. The youth acted against governmental laws and policies by organizing and attending parties and dances at night, thereby violating curfew, and by continuing to purchase records, turntables, alcohol, and Western clothing from merchants working illegally in Mali or by smuggling these consumer goods into the country by other means. Thus, although they may not appear so, these acts were irreverent—defiant toward governmental and parental authority—rather than merely entertaining (I. Samaké 2004, 2005; Y. Doumbia 2004; and Meillassoux 1968, 137).

93. The mass execution of elders was especially feared in the Wasulu region of southwestern Mali, where the Sidibé family originated (M. Sidibé 2003).

94. The coup was driven by fourteen military officers who formed the CMLN: Moussa Traoré, Yoro Diakité, Baba Diarra, Youssouf Traoré, Filifing Sissoko, Tiékoro (also spelled Cékoro) Bagayogo, Joseph Mara, Mamadou Sanogo, Kissima Doukara, Moussa Koné, Karim Dembélé, Malick Diallo, Charles Samba Sissoko, and Mamadou Sissoko (Imperato 1977b, 30).

95. According to Snyder, "the Milice Populaire was assembled, ostensibly to prepare a welcome for President Keïta, who was returning from the annual economic conference at Mopti aboard the river boat General Soumaré. Their weapons were seized and their leaders arrested" (Snyder 1969, 21).

96. Snyder reports that on this date, "Eight officers who opposed the scheme, including Chief of Staff Traoré, were arrested" (Snyder 1969, 21).

97. In the preceding days, the president had toured the country, stopping at Timbuktu and Mopti, where he had attended the city's eighth economic conference. He was taken into military police custody during the coup d'état on November 19, 1968 (*L'Essor* 1968a). I have confronted various accounts of his arrest, the details of which vary somewhat. According to Imperato, "Keita was returning to Koulikoro from Mopti on the *General Soumaré* river steamer. As he drove by car to Bamako, he was arrested on the outskirts of Koulikoro" (Imperato 2008, 171).

98. Mamadou El Béchir Gologo was imprisoned in Kidal for three years (Gologo 2004).

99. *Griot* is a French term that translates in English as *bard* and in Bamanankan as *jeli*.

100. Iyouba Samaké similarly commented, "[The coup] brought freedom—freedom from socialism. Socialism was not freedom at all" (I. Samaké 2005).

101. In a previous interview, Sidibé shared similar points of view:

> Colonialism was positive for Africa. . . . During the colonial period medicine was free. . . . We listened to traditional music every night. . . There were parties. . . . There was Radio-Dakar and then Radio

Soudan. . . . [People] learned a lot. . . . People were aware of what they were doing. . . . It was more positive than negative. People were always at work, profiting from colonialism's systems for developing the country technologically [and] financially. . . . Politically, people were serious, not chaotic. The white government was doing everything by its own will [which brought] progress. . . . The colonials made good decisions in the interest of the entire country. . . . Independence brought a lot of problems. There were no qualified, good leaders. . . . Socialism was a bad experience for Mali. (M. Sidibé 2003)

Undoubtedly, Sidibé's position has been strongly informed by his personal experience of colonialism as a middle- to upper-class urban youth.

102. Specific information has been omitted to protect the identity of the unnamed person.

103. Specific information has been omitted to protect the identity of the unnamed person.

104. Specific information has been omitted to protect the identity of the unnamed person.

105. Specific information has been omitted to protect the identity of the unnamed person.

106. Admittedly, to some degree, the division of professional photographers by "generation" is somewhat arbitrary, with a few practitioners on the cusp of these categories. For instance, Sidiki Sidibé began learning photography as an apprentice to his cousin Malick Sidibé around 1960. However, as he was Sidibé's assistant and did not open his own studio in Bamako until 1970, I have placed him in this chronological overview among third-generation photographers.

107. Akin to that of Sidiki Sidibé, Baba Traoré's career in photography does not readily align with those of either second- or third-generation photographers. However, due to the fact that, like Sidiki, Traoré worked as an apprentice under Malick Sidibé until 1970 and did not open his own studio in Bamako until 1971, I have placed him here among the third generation.

108. For example, Malick Sidibé trained Harouna Racine Keïta in "lab work," gave Keïta his first camera, a Soviet Zenit, in 1974, and developed his film with identification photos (H. R. Keïta 2004). Of the men mentioned in this paragraph, Sidibé also mentored Baba Traoré and Sidiki Sidibé and had an immeasurable impact on the photography careers of many third- and fourth-generation photographers after them.

109. Tijani Sitou, due to his age (born in 1932), is to some degree more aligned with second-generation photographers. Yet he began learning photography in the late 1960s under Mahaman Awani in Gao and Malick Sidibé in Bamako and did not open his own studio in Mopti until 1971. Thus, I have decided to place him among the third generation.

110. Like Sitou, Lawal's career sits somewhere between second- and third-generation photographers. He was born in 1948, started learning photography in 1964 in Niger, and opened his studio in Gao in 1969. Due to his age, particularly in regard to that of his colleagues in Gao, such as Mahaman Awani, I have decided to place him among third-generation photographers in this historical overview.

111. *L'Essor* (1978) and IMDb.com (n.d.). In this issue of *L'Essor* alone, seven of the twelve existing movie theaters were showing karate films, most of which starred Bruce Lee.

112. Domestic telephone service did not become more widespread until the late 1970s, and the more commonly used *cabines telefoniques* (public telephone services) did not become available until after 1992.

113. For example, in 1971 there were five times the number of baccalaureates earned in Mali than in 1963, and the number of baccalaureates nearly doubled from 1970 to 1971 (Bleneau and La Cognata 1972, 56). Furthermore, more than 200,000 Malians were enrolled in school in 1970. Of those, 196,000 attended primary school. Approximately 2,000 frequented "secondary teaching schools," greater than 1,000 studied at professional institutions, 570 attended technical schools, and 867 studied abroad (200 in the Soviet Union). Finally, advertisements in the journal *Africa* featured cigarettes and "Teachers" brand Scotch Whiskey ("Tourism in Mali" 1970, 73, 76).

114. Touré would not allow his collection to be photographed when I visited him in 2009. (I hoped the archive would remain in Mali and eventually become accessible to the public at a national institution, so I did not consider purchasing any of the original prints.) Over the years, some prints from his collection have been sold to André Magnin and others, such as Antawan Byrd (Byrd 2016; Chapoutot 2016).

115. Specific information has been omitted to protect the identity of the unnamed person quoted here. Similar information is given in A. B. Konaré and A. O. Konaré (1981, 204).

116. According to an anonymous photographer, "national police have begun to take photos now with digital cameras . . . printing passport photos and I.D. cards on computers" thanks to the United States Agency for International Development. This individual, for example, finds it difficult to accept this new development, adding: "No one can live like this. I spend all day without clients. I buy materials on credit in the morning and must pay [for them] in the evening." Specific information has been omitted here in order to protect the identity of the unnamed person.

117. The exhibition, which was free and open to the public, was on display from April 14–19, 1977, and it featured daily evening film projections. Unfortunately, I have not been able to ascertain the type of photographic images that were on display, who made them, or who sponsored the exhibition.

118. For their protection, the identity of this person has been omitted.

119. According to the Konarés, construction began on the museum on November 23, 1979 (A. O. Konaré and A. B. Konaré 1981, 214). However, Becchetti-Laure cites 1981 as the year the building project commenced. Jean-Loup Pivin was also the architect of the current French Cultural Center in Bamako, which was inaugurated on March 8, 1982 (Becchetti-Laure 1990, 68, 99). The museum was renovated and enlarged by Jean-Loup Pivin, Moustapha Soumaré, Bruneau Airaud, and Renaud Caen in 2000 and was later reinaugurated on October 11, 2003 (Barry 2003, 105).

120. Bâ was the first photo-laboratory technician in the audiovisual department of the National Museum. Until his recent passing, he was the head of the photographic lab. Sogodogo bears the title of conservator, Diabaté that of

archivist, and Diarra the head of the audiovisual department (Sogodogo 2004; Alioune Bâ 2004; Aboubakrine Diarra 2004; Vroegindewey 2013).

121. The archives of Moumouni Koné house several of these images.

122. In the past, and continuing to some degree today, sculptural arts were gifted, traded, or sold by individuals, families, and village associations to researchers, collectors, and dealers. Presenting a recent alternative, projects such as Culture Bank (created by former Peace Corps volunteer Todd Crosby), which are designed to retain cultural and familial heritage in the wake of capitalism in Mali, collect indigenous artworks from individuals and families and house them in small-town "museums" in exchange for small loans. Once the loan is paid off, the family or individual may repossess the item or take out a new loan (Crosby 2004).

123. Helvetas is a Swiss foundation that has sponsored art workshops and exchange programs in Africa since the 1990s. Today, the Helvetas office in Mali has been nationalized under the new title CFP (Cadre de Promotion pour la Formation en Photographie).

124. Becchetti-Laure refers to the La Galerie Jamana equally as Atelier Jamana, which she claims was created in 1989 (Becchetti-Laure 1990, 114). Other authors cite its existence as early as 1986 (Boyer 1992, 40).

125. According to René Lake, Moussa Traoré made efforts to keep telecommunications like the national press governmentally regulated and "instituted a law that ordained that 'the monopoly of telecommunications granted to the O.P.T. (General Post and telecommunications Office) applies to private radioelectricity" as well (Lake 1993, 60).

126. Anonymity has been used here to protect the quoted person. This account was echoed by that of another individual, who similarly stated: "At the beginning [Traoré's regime] was good but it ended badly. . . . [People endured] three months of work [with] one month paid. It was hard times for people. Corruption eventually mounted and people grew tired of it."

127. Abdoul Karim Camara was a fourth-year philosophy student at L'École Normale Supériure in Bamako and the secretary general of the Malian student's and teacher's union, l'UNEEM (l'Union Nationale des Elèves et Etudiantes du Mali; see A. O. Konaré and A. B. Konaré 1981, 214; Barry 2003, 166).

128. Elsewhere, Sidibé stated that between 1986 and 1990, he started to have fewer clients and "no longer exhibited photos in the lit window [case]" (M. Sidibé 2004).

129. At African Photo studio, Amadou Baba Cissé stated that he and his two colleagues pay 120,000 CFA per year in taxes and 15,000 CFA each month for electricity (A. B. Cissé 2005). Drissa Diakité explained that he used to charge 500 CFA per color photo and now, "to be more competitive," he charges 250 CFA (Diakité 2004).

130. I should add here that because the Sidibé family finds Tokyo Color "the best" and considers the developing process more important than that of printing, they have most "of their color film developed at Tokyo Color." However, they sometimes elect to have it printed at less expensive establishments, such as Korean Photo, which is closer to their business, Studio Malick (F. Sidibé 2004).

131. Today, Ibrahim Sitou is located in the Central African Republic and Malick Sitou is in the United States.

132. For example, three of the previously listed fourth-generation photographers, Awa Fofana, Fatoumata Diabaté, and Ouassa Sangaré, are women. Furthermore, the current archivist at the National Museum in Bamako is female professional photographer Sokona Diabaté (Vroegindewey 2013). I should also mention here that another young female (amateur) photographer, Rokia Traoré, whom I met in the streets of Bamako in 2004, learned photography in high school during a competition held by the French Cultural Center (R. Traoré 2004). For more on the institutional vision and history of Promo-Femme, see Moore (2008).

133. This has been the case, for example, with Tijani Sitou in Mopti and Malick Sidibé in Bamako, whose studios were downsized to one or two small rooms in the early 2000s (Malick Sitou 2004; M. Sidibé 2003).

134. Unlike the other aforementioned associations, Nayé-Nayé is more of an outreach photographic workshop project funded by Oscura de France and instructed by several professional photographers in Mali—namely Malick Sidibé (until 2009) and Amadou Baba Cissé, among others. About this organization, Sidibé has said, "It's great for children, even the ones who live in the bush or on the prairies, because anyone can do it, and you end up with fantastic images. I have two instructors working with me to train the kids . . . kids who aren't working, kids who are in school, even handicapped kids" (Lamunière 2001b, 58).

135. Nouhoum Samaké, head of the photography department at AMAP in 2004, allowed me to view the CD-ROM. However, I was not able to duplicate it. Thus, I am unable to illustrate images from it here.

136. For their protection, I have chosen to keep the identity of this individual anonymous.

137. For their protection, I have chosen to keep the identity of this individual anonymous.

138. For their protection, I have chosen to keep the identity of this individual anonymous.

139. For their protection, I have chosen to keep the identity of this individual anonymous.

140. For their protection, I have chosen to keep the identity of this individual anonymous.

141. For their protection, I have chosen to keep the identity of this individual anonymous.

142. However, according to some Malians and scholars, such as Mamadou El Béchir Gologo, the 1991 coup did not bring positive transformations. For example, in 2004, Gologo stated, "The coup of 1991 was bad, too. All believed that Alpha Oumar Konaré would make change, but he didn't do anything" (Gologo 2004). Such critical positions, which question the legitimacy of Mali's democracy, have recently come to the fore again with the coup that ousted President ATT in March 2012 (following Tuareg rebellions that resurfaced in the north toward the end of 2011 fueled, in part, by the fall of Khadafi in nearby Libya).

143. Vogel has since been vehemently criticized for this act in reviews in *African Arts* (Oguibe 1993; Pellizzi 1993). She defended herself in an interview

(Bigham 1999, 62) and made similar arguments to support her 1991 decision at the 2006 conference held at the University of California, Santa Cruz, in a paper titled "Poor Housekeeping" (Vogel 2006).

144. Vogel was the first to exhibit photographs from Mali as enlarged prints (larger than originally commissioned). However, Pigozzi and others, such as the Sean Kelly and Gagosian galleries, initiated the trend for monumental enlargements of Keïta's images. Magnin was the first to publicize titled photographs of Sidibé's work while Keïta's portraits have generally remained untitled.

145. The most recent edition, titled *Streams of Consciousness: A Concatenation of Dividuals*, was held November 30, 2019–January 31, 2020.

II. Imaging Culture

3

Photography as Social Agency

SINCE THE 1930S, PHOTOGRAPHERS AND clients in present-day Mali have collaborated on the construction of self-identity, social memory, and local conceptions of modernity. Through the creation of portraiture and reportage imagery, their engagement with the medium has been integral to the development and dissemination of contemporary cultural values and processes of transculturation. New ideas and practices have been shared via the production and exchange of images, and those already established have been reinforced or challenged, inspiring visual dialogue across social strata for generations. To understand these dynamics within an appreciation of the local significance, meaning, and aesthetic intents of photographic images produced in Mali during the twentieth and twenty-first centuries, photography is considered here in terms of *fadenya* and *badenya*, principal concepts derived from indigenous theories of social action that are intimately bounded to local aesthetic values.[1]

Fadenya and Badenya: Social Theory and Cultural Logic

As with all theories and philosophical concepts, badenya and fadenya encompass a complex web of meanings that can be understood in a variety of ways, dependent on context and interpreter. Derived from the practice and cultural concept of polygamy, *badenya* literally translates as "mother-child-ness," an idea that refers to the camaraderie, loyalty, and respect among children who have the same mother and father (Bailleul 2000a, 20). This notion emanates from *sinjiya*, the bond that is

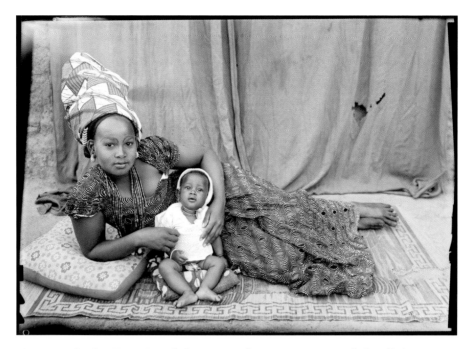

Figure 3.1. Seydou Keïta, *Untitled* (portrait of a woman wearing cloth called "my cowife's evil eye"), c. 1954–60. Gelatin silver print, 23 × 19 inches. Courtesy CAAC—The Pigozzi Collection. Seydou Keïta/SKPEAC.

formed between siblings who share the same breast milk, which signifies a strong physical connection as well as one that is emotional, psychological, and even spiritual (M. Sidibé 2004). *Fadenya* is translated as "father-child-ness," a concept that refers to the competition, rivalry, and jealousy that often occurs among siblings who share a father but have different mothers (Bailleul 2000a, 119). It describes the competition among cowives for a husband's resources and affection, which carries with it similar dynamics among their offspring (M. Sidibé 2004; K. Sidibé 2004; C. Keïta 1996, 98; A. B. Konaré 2000, 19).[2] This idea is addressed in cloth called *n sinεmuso nyε-jugu*, or "my cowife's evil eye" (fig. 3.1),[3] and *n tε siran n sinεmuso nyε*, meaning, "I'm not afraid of my cowife" (fig. 3.2), worn by women in portrait photographs taken by Seydou Keïta (Y. T. Cissé 1997, 273–75).[4]

Within the context of society at large, fadenya and badenya help illuminate the fluidity of power, mutual affectability, and dialectic tension existing between individuals and social groups. To this end, Martha Kendall and Charles Bird discuss fadenya and badenya as a social theory of inertia in which fadenya is associated with "centrifugal forces of social disequilibrium: envy, jealousy, competition, self-promotion—anything tending to spin the actor out of his established social field." Alternately,

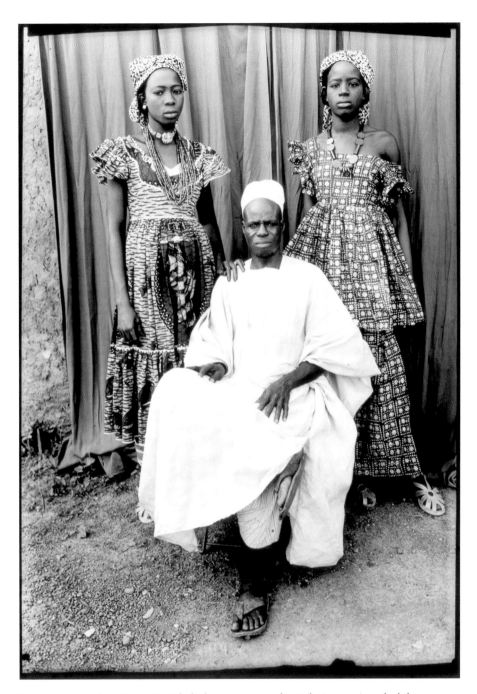

Figure 3.2. Seydou Keïta, *Untitled* (the woman on the right is wearing cloth known as "I am not afraid of my cowife"), c. 1952–55. Gelatin silver print, 23 × 19 inches. Courtesy CAAC—The Pigozzi Collection. © Seydou Keïta/SKPEAC.

badenya is aligned with "the centripetal forces of society: submission to authority, stability, cooperation, those qualities which pull the individual back into the social mass" (Bird and Kendall 1980, 15). Essentially, fadenya is understood as individual competitiveness and the struggle to build one's identity and reputation—traits often associated with youth.[5] Although potentially divisive, these characteristics can harbor fundamentally positive and necessary social benefits. In the words of Malick Sidibé, "Fadenya came to put heart into [people], to motivate [people]. That is good fadenya. That brings work [and] progress. On the negative side of fadenya, there is selfishness and egoism" (M. Sidibé 2004). His colleagues Adama Kouyaté and Abdoulaye Kanté concur: "The true definition of fadenya is competition, in the bad sense. [However,] fadenya [can be] a good thing. It elicits motivation and change" (A. Kouyaté 2004b). In Kanté's words, "Fadenya brings revitalization [to the community]. It is good. It allows men to advance. Without competition, there is no development. . . . On the bad side, competition often leads to hate" (Abdoulaye Kanté 2004). Inversely, badenya is interpreted as communal cohesion, societal obligation, and the quest for social stability, harmony, and prosperity. Adama Kouyaté explained, "Badenya is communion, union" (A. Kouyaté 2004). Papa Kanté's son, Abdoulaye, described badenya as "very important; [representing] the good side of society" (Abdoulaye Kanté 2004). Ideally beneficial and supportive, when unchecked these qualities can promote stagnation and stifle individual creativity. Recapitulated by Sidibé, "Badenya is real [unity and] fraternity. [But] badenya is also restraint" (M. Sidibé 2004).

Thus, in this system both concepts and their respective qualities are needed for all parties to excel: The society depends on individuals to invoke change and challenge stagnation. Individuals rely on the structure and stability of the community to provide support and validation—*the* enabling factors for their success in life. Understood in this way, fadenya and badenya comprise a theoretical model of social action developed to interpret and understand social tensions and relations of power exercised via individual and communal agency.[6]

As such, fadenya and badenya speak to Western theories of social action, such as Georg Simmel's conception of conflict and Anthony Giddens's notion of structuration and praxis (Simmel 1955, 13–21, 54–72). For Giddens, structuration is a theory of action that explores "complex agency," or the "power relations of autonomy and dependence," that exist between individuals and society. In other words, structuration recognizes the "mutual dependence of structure and agency" in human social life. Giddens explains, "Structure [in this sense] is regarded as rules and resources recursively implicated in social reproduction: institutionalized

features of social systems that have structural properties [such] that relationships are stabilized across time and space. . . . Agency refers to an individual's power to act. . . . [Because] all social actors, no matter how lowly, have some degree of penetration of the social forms which oppress them, agency implies power" (Giddens [1979] 1990, 69–73, 85–95; 1984, xxi–xxxi). Giddens describes praxis as the production and reproduction of social systems through the repeated actions of individuals (Giddens [1979] 1990, 4–5; 1984, xxi–xxxi).

Like structuration and praxis, fadenya and badenya address complex agency and interdependence among individuals and social institutions. Furthermore, these dynamics and their associated ideals are constantly reproduced and manifested in individuals' mundane interactions. In this vein, Adama Kouyaté has said, "Fadenya and badenya is the daily life of Mali. It is our patrimony" (A. Kouyaté 2004b). Beyond the scope of Western theories, the aptness of fadenya and badenya to studies of photography in Mali is twofold: First, the concepts are endemic, arising from the same contexts as the photographs and their subjects, and are applied within local discussions of photographic processes and content. Second, derived from Mande cultural logic, these ideas directly engage Mande aesthetics. This elusive and complex category, rife with nuance, is intimately bounded to and informs the arts in Mali, including photography. Therefore, an appreciation of fadenya and badenya is critical in order to understand the social significance of photographic production in Mali since the mid-twentieth century.

Before embarking on an analysis of the visual expressions of fadenya and badenya in photographic imagery and their relevance for understanding photographers' networks and professional dynamics, however, it is helpful to first discuss their significance in the broader contexts of social relationships and notions of personhood, or *mogoya*, among multicultural populations in present-day Mali (Jansen and Zobel 1996, 98–99).

Fadenya

According to Mande ideology, as Bird and Kendall have stated, every individual is born with a reputation largely determined by that of one's father "and by extension that of patrilineage" (Bird and Kendall 1980, 14). To be successful in life, each person is expected to live up to or surpass that reputation and develop a unique name (*togo*) and admired individual identity (Johnson 1999, 16; Jansen and Zobel 1996, 99). As a result, a Mande proverb articulates *I fa y'i faden folo*, meaning "Your father is your first rival" (Bird and Kendall 1980, 14). Alternately, another proverb states *Bee k'i fa ya baara ke*, "All should do their father's work" (Hoffman

2000, 59). In this regard, Malick Sidibé explained, "Some people think that it is ungrateful to be competitive with your father but, generally speaking, people want to surpass their father or at least do as well as he" (M. Sidibé 2004). Thus, one foundational basis of self-identity, in addition to sibling rivalry, is competition with one's parent. This is generally the expectation for father-son relations. Particularly in cities, though, daughters may also strive to surpass their father's accomplishments. Competition between mothers and daughters, however, is not as socially condoned or expected as father-son rivalry in part because relations with one's mother—regardless of the child's gender—are conceptualized in terms of badenya more than fadenya. Malick Sidibé explained, "Badenya is more associated with the mother and fadenya is more associated with the father. In Africa, children think more of the mother than of the father. There is more jealousy with the father than with the mother" (M. Sidibé 2004).

The following verse reiterates the expectation of father-son rivalry:

I fa yelenna jiri min ka n'i ma se k'a yelen,
("If your father climbs a tree that you cannot climb,")
i ka fini bo k'i sigi a jukoro.
("take off your shirt and rest against the tree's trunk.")
Mogo temen tow n'u ba miir'i yelen to la don
("People passing by will either think that you are about to climb it")
o ba miir'i jiri na de.
("or that you have just gotten down.") (Malick Sitou 2004)

Malick Sidibé cited Malick Sitou, son of photographer Tijani Sitou, as an example of this productive aspect of fadenya, stating, "He is jealous. He has fadenya. He wants to be [a successful photographer] like his father" (M. Sidibé 2004). This competition serves several purposes. Among the most important is the inspiration for individual accomplishment and communal progress. For instance, Sidibé admitted he would be "happy" if his sons excelled beyond his success and had "the courage" to achieve renown in photography. However, illustrating a sense of fadenya competition among some of his colleagues and their descendants, Sidibé also said he would not be happy if someone else's son "passed [him] by" (M. Sidibé 2004). Father-son rivalry informs photographers' mentoring practices as well. Several photographers have solicited colleagues to train their sons in the medium in the hopes that such training will be more productive, objective, and fair than it might be under their own tutelage. Sidibé explained:

In this type of thing, the father [being the teacher] doesn't have a lot of patience with his son. If he misbehaves a little bit, the father can get nervous. But with someone else it is better, because the person won't

get as annoyed as the father. That is why I think it is better for my kids to learn from others. . . . [My son] Fousseini used to go to Papa Kanté's studio. He encouraged him and printed photos for him. . . . Even Siriman Dembélé came here to teach [my son] Mody how to develop film. (M. Sidibé 2004)

By extension, this form of rivalry is manifested in generational competition, in which youth struggle to assert themselves and prove their capacities have surpassed those of their elders. Today, this is made explicit in the vernacular of young men who refer to Bamako (which is commonly translated as "the back or spine of the crocodile" in Bamanankan) as *Bamada*, meaning "the mouth of the crocodile" (Malick Sitou 2004). Drawing this distinction, they conceptualize themselves operating within the more perilous position of the crocodile's mouth while their forefathers merely rested on the reptile's back. Through this equation, therefore, young men suggest they are stronger, braver, and better equipped to face challenges and take risks than men of their parents' generation. In the words of Malick Sitou, *Fadenya de don!*—"That's fadenya!" Such conflicts of interest inform the practice of photography in Mali as well. As the previous chapter has shown, it is due to this generational divide that established photographers hire young apprentice-assistants to assume the reportage dimension of their businesses after they themselves have gotten married or are no longer of the same generation as the young people who dominate that dimension of their clientele.

Fadenya can exist within and across generations among relatives, spouses, and neighbors. With regard to the last, Sidibé shared, "You would like to be like your neighbors. If they are rich, you would like to be rich too. If he is hard working, you would also like to be hard working. You don't want to depend on him. That is fadenya. All that your age-mates do, you want to do the same thing. That is fadenya" (M. Sidibé 2004). Such competition informs the commission of photographic portraiture, which simultaneously functions as a venue for the enactment of cultural belonging and as evidence of one's unique social capital, whether real or imagined.

Although an individual's reputation or name (togo) is typically conceived in terms of the father and fadenya, in fact it derives from both parents. Arguably the matrilineage is most significant because it is from this relationship that an individual inherits his or her destiny (*dakan*). Malick Sitou explained, "In Africa, we all believe that if a child is successful or not depends on the character and behavior of the mother" (M. Sidibé and Malick Sitou 2004). Cheick Oumar Mara expressed a similar faith, citing two phrases: *Bɛɛ b'i ba bolo*, meaning "Everyone is in their mother's hand," which implies each person's welfare, character, and

success depend on the behavior of their mother; and *I bor'i ba ko la ka bin*, "You fell from your mother's back," suggesting you are not a good person (Mara 2004). Disclosing the relevance of this conception in his personal life, Malick Sidibé stated, "People say that what I have achieved today is due to my mom," which is an opinion Sidibé shares (M. Sidibé and Malick Sitou 2004). Over the years, he has made recurrent references to sacrifices his mother endured that he feels directly facilitated the success of his photographic career. David Conrad's account of Mande heroism sheds light on Sidibé's belief: "[It is a] popular notion that a hero receives his power from his mother, and that both mother and son must endure various humiliating and painful ordeals on the road to eventual glory" (Conrad 2006, 86).

For Sidibé, photography was always his destiny, as foreseen in a dream his mother had while he was away at school in Buguni at around the age of nine in which her bedroom was decorated—from ceiling to floor—with his images. Sidibé originally assumed her vision referenced his hand-drawn illustrations (fig. 3.3) since he was already a talented artist in his youth. Later in life, though, he was confident that it foresaw his photographs (M. Sidibé 2004). Thus, his mother had realized his destiny when he was just a child. Scholars of Malian art and culture, such as Adama Bâ Konaré and Barbara Hoffman, have made similar observations.[7] Konaré holds that although an individual's last name (*jamu*) is provided by the father, "the blessing and mystical force" of the person derives from the mother (A. B. Konaré 2000, 19). Hoffman, who studies the professional lives of *jeliw* (oral historians, bards, or griots), similarly reports that one's spiritual efficacy is "inherited from the matriline" (Hoffman 1995, 59).

Generally speaking, whether derived from one's mother or father, and by extension one's ancestors, concern for self-identity and social reputation is associated with fadenya. Historically, this preoccupation has been publicly upheld and entertained by jeliw, who continue to occupy an important position in society today (Johnson 1999, 21; Conrad 2006, 84–85). For example, John Johnson explains, "At the center of fa-denya and ba-denya action is the struggle between the authority structure of the group status quo and the search for power by the individual seeking to make a name for himself both in the oral annals of the bard, and in the modern world of realpolitik" (Johnson 1999, 21). In modern cities, such fadenya impulses have similarly characterized the profession of photography and the solicitation of its most predominant genre: portraiture.

During the twentieth century, as illustrated in part 1, the developing urban environment presented new personal freedoms, enabling individuals to pursue recently introduced trades, such as tailoring and

Figure 3.3. Malick Sidibé, untitled illustration, c. 1940s (when Sidibé was in grade school). Photo of original artwork by author with permission from Malick Sidibé, Bamako, 2003. © Malick Sidibé.

photography. Photographers themselves, particularly at the onset of their careers, have typically been young men engaged in fadenya endeavors. They are generally courageous and adventurous—traits necessary to embark on a relatively new and largely unknown profession. The most accomplished have had an acute aesthetic sensibility and have been occupied with the latest trends, fashions, and communal values. To ensure success among their competitors, they have needed to be shrewd businessmen: inventing unique styles and techniques of photography that, in turn, have helped them build their professional reputations.

Tending toward fadenya pursuits and personalities, it is not surprising, then, that cities, such as Bamako, Ségu, and Mopti became centers for portrait photography—the genre most aptly suited for the visual construction of identities. Within this category, perhaps the personal and visual expression of selfhood is most apparent in individual portraiture, which intentionally conveys important aspects of one's identity, such as one's profession (see figs. 2.7–2.8), political consciousness (see figs. 2.1–2.2), and real or desired socioeconomic status (see fig. 1.8), as well as other personal achievements such as one's "success . . . in school examinations or professional promotions and appointments" (Meillassoux 1968, 138).

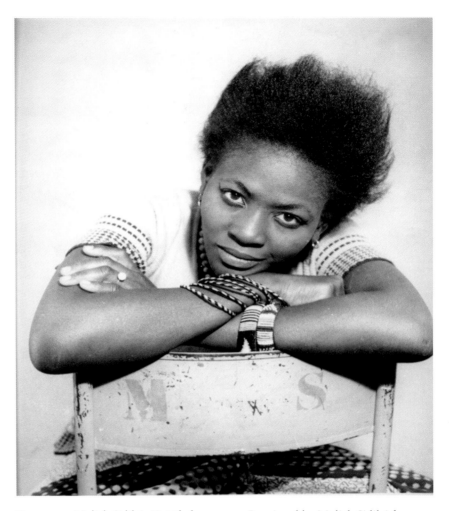

Figure 3.4. Malick Sidibé, *Untitled*, c. 1970s. Reprinted by Malick Sidibé for author, Bamako, 2004. © Malick Sidibé.

One's attributes often are indicated through the incorporation of material aids or props, whether studio provided or patron owned. In this vein, several professional photographers, including Malick Sidibé, explained that "large radios" or boom boxes (plate 2) show strength, underscoring one's social capital (M. Sidibé 2005). According to Malick Sitou (2004), as explained in chapter 2, ethnic identity and cultural rivalry can also be proclaimed through the possession of various radio brands, such as JVC, Panasonic, and Trident, which are favored differently by unique culture groups based on qualities of durability, loudness, size, and battery lifespan.

Fadenya is most blatantly expressed, however, in portraits of youth (fig. 3.4)—in particular, those of *kamalenbaw* "playboys" (see fig. 2.42).

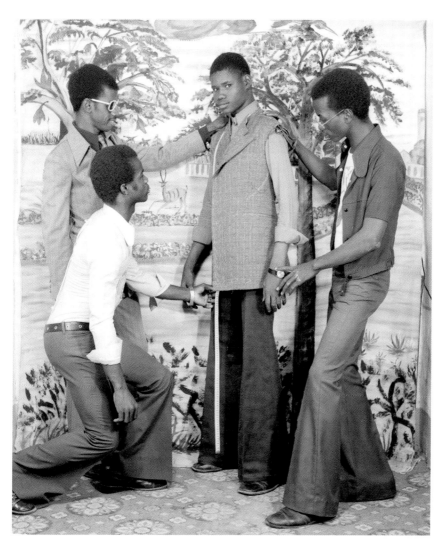

Figure 3.5. Hamidou Maïga, *Tailoring Scene*, 1973. Gelatin silver print, 12 × 16 inches. © Hamidou Maïga, courtesy the artist and Jack Bell Gallery, London.

Highlighting one's independent character and personal style, these images are informed by the will to be desired and envied, as enacted by a group of young men in a portrait by Hamidou Maïga (fig. 3.5). To enhance this aura, kamalenbaw are typically pictured with accessories that suggest a rebellious attitude, such as cigarettes, sunglasses, and youth-liberating rock 'n' roll and rhythm and blues music (fig. 3.6). Moreover, the pictured youth, assuming dynamic postures and cool expressions, regularly appear aloof to the camera (see fig. 2.15) or directly engage it (see fig. 2.33).

These individuals have also personified fadenya-oriented popular fictional and real-life characters who embodied fortitude, displayed an

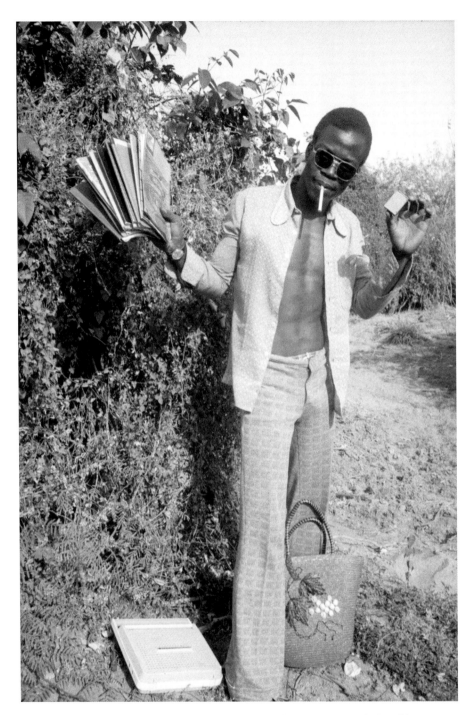

Figure 3.6. Malick Sidibé, *All Alone Beside the Bushes*, 1975. © Malick Sidibé, courtesy MAGNIN-A gallery, Paris.

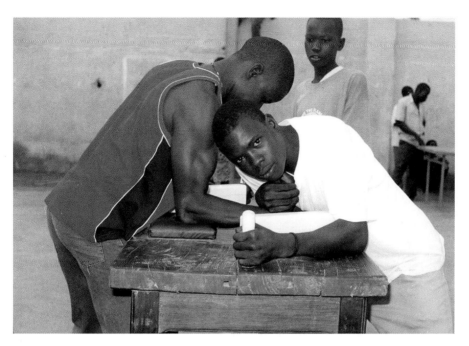

Figure 3.7. Ibrahim Sitou, Gros Bras competition, c. 1990s. Reprinted by Ibrahim Sitou for author, Mopti, 2004. © Ibrahim Sitou.

identifiably unique style, and were respected for their stark individuality. Often using studio props, for example, they have portrayed themselves as heroic protagonists in spy films (see fig. 2.23), Spaghetti Westerns (see fig. 2.31), and martial arts movies (see fig. 2.44) or mimicked international icons such as The Beatles, James Brown, Jimi Hendrix, and Michael Jackson (see fig. 2.50). Expressing their corporal strength and capacities—literally illustrating fadenya rivalry and competition—they have commissioned images of themselves in the act of boxing, karate, and arm wrestling (fig. 3.7).

Young women also have expressed fadenya attitudes in their portraits through the incorporation of rebellious symbols, such as cigarettes, and controversial, even forbidden, attire in the form of miniskirts (see figs. 2.24 and 2.29). With a commercial bent, popular female singers known as *Mali Konow* (Birds of Mali), such as Oumou Sangaré and Babani Koné, solicit studio and concert portraits to perfect and aggrandize their public image and to promote upcoming performances and album releases (figs. 3.8a and 3.8b).

At times, the desire to express one's enviable social status has extended beyond visual representations to the commercial transaction of portraiture itself. Malick Sidibé recounted an anecdote involving a Sarakolé customer who requested a receipt to (falsely) indicate that he paid

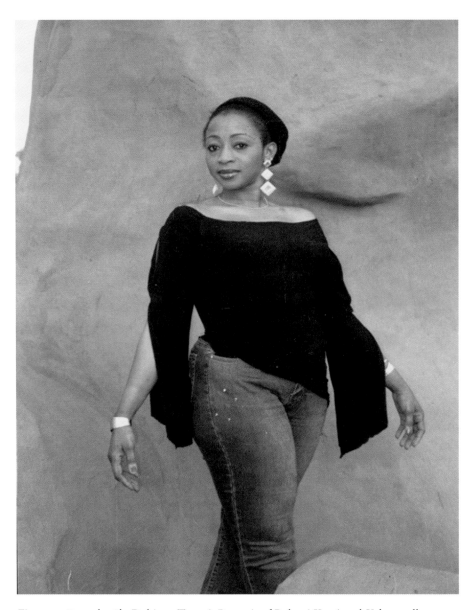

Figures 3.8a and 3.8b. Dahirou Traoré, Portrait of Babani Koné and *Yelema* album cover, 2004. Collection of C. M. Keller. © Dahirou Traoré.

a higher price than his companions as means to (fictitiously) evince his elevated socioeconomic standing. Revealing the charade, Sidibé explained, "It is not really what [he] paid, but because the receipt shows that [he] paid more, [he] claims more power. It is [a form of] competition" (M. Sidibé 2005).

In fact, a wide variety of situations and circumstances are regularly interpreted by Malian citizens in terms of fadenya and badenya, attesting

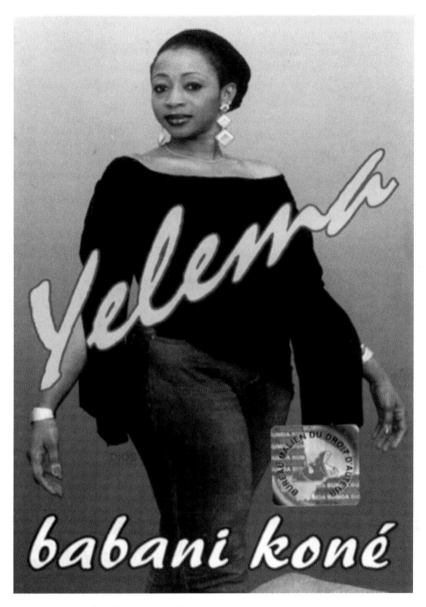

Yelema

babani koné

Figures 3.8a and 3.8b (*continued*)

to the pervasiveness of the concepts and their interconnectivity in social communication and cultural production. Speaking on the varied contexts in which fadenya is enacted and conceived, Sidibé explained that fadenya "even [exists] between nations. You are supposed to work together, but when you decide that you are *faden* you never work together or collaborate because, if fadenya should come, there will be jealousy and competition. If fadenya comes, [badenya] becomes destroyed and chaotic"

Photography as Social Agency | 193

(M. Sidibé 2004). For example, the disintegration of the Mali Federation (due in large part to the lack of accord between Léopold Senghor and Modibo Keïta, who each vied for the predominant leadership position) was perceived by most Malians as "fadenya ruining badenya" (M. Sidibé 2004; M. Sidibé, K. Sidibé, and Malick Sitou 2004; I. Samaké 2005). Iyouba Samaké similarly discussed Moussa Traoré's execution of his former colleagues, Tiékoro Bagayogo and Kisiman Dounkara, as an extreme example of fadenya literally "killing" badenya (I. Samaké 2005). Sidibé explained that in such cases fadenya arose "because of power or position . . . someone wants to be the leader and have control." By contrast, Sidibé continued, "There is no rivalry, no war in badenya. [Rather,] you would like to work together . . . for peace" (M. Sidibé 2004).

The Sidibé and Sitou families explained that fadenya also exists among spouses once children enter the picture. As Malick Sidibé explained, usually "the husband gets fadenya against the wife [because] kids love the mother more, naturally, and the father feels jealous. He feels like he has provided more, so he should get more" (M. Sidibé 2004). In family compounds this is partially caused by and results in the practice of presenting gifts to one's mother in private while one's father receives gifts in public. According to Sidibé, this makes "the father start to think that the wife gets more." Such power dynamics affected Sidibé's own childhood experience. After the death of his father, his uncle became the head of the family, and similar fadenya-inspired tensions arose. In light of this, Sidibé was careful to hide the gifts he gave to his mother from his uncle to circumvent the power of the latter to confiscate them (M. Sidibé 2004).

"There are other [examples of] fadenya that exist in work and at the workplace," Sidibé explained in 2004. For instance, among photographers in Mali, fadenya is present in numerous contexts in a variety of fashions.[8] Some have been previously addressed in chapter 2 with regard to business competition: professional studio versus ambulant and amateur photographers since the 1980s; the rivalry publicly expressed in reportage contexts between Sakaly and Guillat-Guignard during the 1950s; and Studio Malick named to distinguish Sidibé as a Malian among French photographers and Sakaly (who was from Senegal) in Bamako.[9] Fadenya is prevalent in the tension between native and foreign African photographers in Mali. Elder has reported, for example, that "without the support of a home community, an outsider would have a harder time breaking ground. . . . [Tijani] Sitou told how he was pulled off of a truck by local Malian photographers who claimed that only local photographers were allowed to take the 'bush' taxi to the rural villages. He also described a situation when he left his studio once to get something to eat and when he returned he found that his lens had been broken. [About this situation,

Sitou said,] 'That's what they tended to do [to foreigners] in Gao'" (Elder 1997, 91). Similarly, Adama Kouyaté identified fadenya in the "racist attitudes" and "fierce competition" he experienced as an immigrant photographer in neighboring Burkina Faso and the Ivory Coast (Elder 1997, 91; see also A. Kouyaté 2004b).

However, more often fadenya is less conspicuously engaged by photographers in the area of trade secrets, characterized by Malick Sitou (2004) as *doniya dogolen*, or "hidden knowledge." Such expertise is cultivated and jealously guarded to ensure one's unique product, thereby carving out a niche for the photographer in the competitive market. Trade secrets themselves encapsulate a broad range of inventive artistic strategies and business tactics. The majority of these are carried out in the darkroom—the most coveted and potent domain of the practice—described by Sitou (2004) as "the room where all of the secrets are; where the most important things are kept." Examples of this specialized knowledge include the use of specific photographic products, particularly those unavailable in local markets, and technical practices (employed during the composition, developing, or printing processes) personally invented or learned privately from colleagues.[10]

Photographers do not share all their trade secrets with their apprentices, and apprentices do not share everything they have learned (from various avenues) with their mentors. Moreover, each practitioner utilizes unique methods to secure the obscurity of their secrets. For example, Sitou writes his darkroom notes in Yorùbá and Arabic "to ensure that no one else can read them" (Malick Sitou 2004). Several photographers, such as Malick Sidibé, Papa Kanté, Tijani Sitou, and Amadou Fané, have resigned to work only with their children as apprentice-assistants since the 1980s. About this prerogative, Malick Sidibé opined, "Photography is better within a family. When things are handed over, it will still be within the family. [However,] if you take an apprentice or employee from outside the family, because it is just commercial, he will leave you and establish himself somewhere else" (M. Sidibé 2003). Sidibé's explanation continued:

All the ones that I have trained [who are not members of my immediate family] have gone and I remain alone. Yeah, that's how it ends. . . . Sidiki, my first apprentice, when he got married he left. . . . [Amadou] Fané left me too. . . . Now I am alone. I remain alone. That is why I say that photography should remain in the [immediate] family. . . . I know that if I taught one of my brothers' kids, when he grows up he will just keep the money for himself and not share it with my family. But if someone like [my sons] Fousseini, Karim, or [Mody] could learn the art well, then when I am no longer alive they will share the money with

their brothers and not keep it for themselves alone . . . But even among siblings there is fadenya. (M. Sidibé 2004)[11]

By extension, fadenya, or the awareness thereof, has guided the behavior of photographers as well as the nature of their relationships. For example, Sidibé described his relationship with Seydou Keïta in terms of local conceptions of fadenya: "Here in Africa, there is a strong distrust of competition. . . . I am the younger photographer, and if I started showing up at [Keïta's] studio and then later on his business started to flounder, or the jobs stopped coming in, he might well think: 'That young guy put a spell on me!' That's what always kept me from going over to his studio" (Lamunière 2001b, 28).

Fadenya in competitive business relations has inspired the vernacular phrase *faden kene* (fadenya field), often used by Bamanankan speakers to refer to the marketplace—one domain of socially sanctioned fadenya (Malick Sitou 2005, 2008). Of all West African locales, the market is among the most socially, economically, physically, and spiritually competitive.[12] In Mali, it is conceived as a challenging space loaded with ambiguity, trickery, falsehoods, altercations, and opportunities. To succeed requires courage, strength, intellect, gumption, and skill, which are ideal properties associated with fadenya.

Faden kene is also used to describe the venture of overseas travel. In general, young people travel abroad to prove to themselves and their family, neighbors, and friends that they can be successful. They leave home with the desire to do something new, to grow, "to be better than people at home" (Malick Sitou 2005, 2008). Malick Sitou, who has been residing and working in the United States for the past few years, described the expectations of such a voyage:

> It is a challenge to those who go abroad and to those left behind. At first, the people at home don't take it seriously. They just assume it's a fun thing. Up to a year, they forget about the person. They think maybe they will never see them again. But once the person sends money back home [or returns home with money, foreign commodities, and skills], they start to prove themselves and the people back home start to feel the fadenya. This act is a symbol of their success in a foreign culture, which suggests that they are strong, courageous, capable, and serious. (Malick Sitou 2008)

Thus, faden kene helps explain the social capital and esteem among Bamakois of Zazous and Bourbon members, évolués, and soldiers returning from overseas during the 1940s and 1950s, informing their portrayals in portraiture (see figs. 1.5 and 2.3). In other words, their cosmopolitan experience and modern activities were imbued with traditional significance

and symbolism. Neither entirely new nor unprecedented, they aligned with established cultural values, expectations, and achievements. Their opportunities and experiences abroad brought benefits to which their peers aspired. In the process, they helped "modernize" their communities. Alluding to contemporary contexts, Sitou continued, "Most people who go abroad don't succeed. They end up in jail, they can't find a good job, or they can't get a visa or a Green Card, so they can't return home. Not everyone is successful abroad. This way, you find out what kind of person they are. Those who can send money home, and get a visa to return home to help out, are successful and bring success to their family. Those who stay and never return, or don't send money home, are considered weak (*fugaru*) and selfish. That is the real negative fadenya" (Malick Sitou 2008).[13]

Malick Sidibé explained that a fugaru is conceptualized in terms of the negative aspect of fadenya:

> Today, well, fadenya has become a problem. But, normally, when [fadenya] comes like that everybody will be hard working. That is to say, you sometimes hear *faden sago*. . . . Someone who does nothing or has become nothing is called faden sago. *Fadensagoya* is the state of being the will of the enemy. But if it is pure fadenya, there will be motivation to work hard, like . . . your neighbors, like other human beings. That is good fadenya. You can't sit down like that, you've got to work! If all of your enemies are working, if you are healthy, you also must work. That brings the will to work. If you don't, they will tell you, "you are faden sago," [which] means you are at the mercy of others. (M. Sidibé 2004)

Malick Sitou's case, on the contrary, is quite positive, exhibiting the productive aspect of fadenya. He regularly sends money to family members in Mali and Niger and is in the process of building three homes in West Africa (one for his mother in Sakí, Nigeria). He also sent his mother to Saudi Arabia to complete the hajj in 2008 and purchased rice fields and several cattle near Mopti. Moreover, he has achieved US citizenship, which enables him to return home regularly to promote these projects (Malick Sitou 2008, 2018). Finally, after completing his undergraduate degrees in computer science and cultural anthropology and his MA in international relations, he plans to resettle in Bamako to develop a professional enterprise. Bird and Kendall describe this successful practice as heroic fadenya, arguing that "the figures preserved in history are those who broke with traditions of their village, severed the bonds of badenya, traveled to foreign lands searching for special powers and material rewards, but just as important, they are also the ones who returned to the villages and elevated them to higher stations" (Bird and Kendall 1980, 22).

Post-1990s, Keïta and Sidibé exemplified such heroic success in faden kene, traveling abroad to attend exhibition openings and (in Sidibé's case) to participate as artists-in-residence at colleges and universities overseas, resulting in international renown. For example, after the global acclaim Sidibé received after the first *Rencontres* biennial in 1994, including the Hasselblad Foundation International Award in Photography (2003), the Venice Biennale's Golden Lion Lifetime Achievement Award (2007), the International Center for Photography accolade in New York City (2008), and the PhotoEspaña Baume and Mercier Award (2009), his national celebrity was exponentially raised, earning him the national gold medal in 2010. In the twenty-first century, Sidibé made several television and radio appearances for ORTM, Radio Mali, and Radio Klédu in Bamako. He also served as a central spokesman at the Malian National Assembly, alongside the minister of culture and the Malian director of the *Rencontres* festival. There, Sidibé advocated national support and funding for photographic institutions such as the proposed African House of Photography (MAP) as well as future photography workshops and educational programs for youths (M. Sidibé 2004). Beyond this, he occupied several local leadership positions in which he strove to realize improvements, alleviate conflicts, and promote badenya relations among colleagues and compatriots, as evident in his role as president (and later honorary president) of the national photographers' association (GNPPM).[14]

Illustrating the complex, fluid, and at times contradictory nature of social theories and ideological perspectives, which are informed by human experience, interpretation, and agency, Sidibé admitted it is also possible to have fadenya relations with *baden* siblings (those who share the same mother and father).[15] Turning the common presupposition on its ear, he explained, "It is usually the younger brother who is jealous of the older one. The elder brother always has pity for the younger brother. . . . It is common. It happens everywhere" (M. Sidibé 2004).

Sidibé illustrated his point by citing examples from personal relationships with family members, which would not be appropriate to recount here. He also referenced the biblical example of Cain and Abel, positing, "Has fadenya not existed among the two children of Adam? God showed Cain his favor, so Abel killed his brother Cain out of jealousy. A lot of badenya brothers misunderstand each other. Badenya gets spoiled between them" (M. Sidibé 2004). He interpreted the founding of Rome in terms of fadenya as well: "Consider how Rome was created: The fight between Romulus and Remus; and [in the end] Romulus won the battle. [But] they are twins! They have the same mother (badenya). [As you can see,] fadenya has [existed] since the dawn of time. It is in all societies" (M. Sidibé 2004).

Sidibé recognized fadenya among baden is "opposite from the normal understanding," although he insisted that it does happen and can exist among monogamous nuclear families as well as within polygamous households (M. Sidibé 2004). Both Sidibé and Sitou explained that the conflict results from sinjiya and the fact that "not all people are created equal" (M. Sidibé and Sitou 2004). Sitou elucidated, "When we are all breastfed from the same mom, we can't conceive of the difference, the inequality between us. . . . How can [one] be richer, more successful, or more beautiful? We can't understand (M. Sidibé and Malick Sitou 2004). Because of this reality, Sidibé admitted that sometimes "children of rivals love each other more than children of the same mother," *Sinanmuso denw be nyogon fe ka tɛmɛ muso kelen denw kan* (M. Sidibé 2004).

Badenya

Although it is widely recognized that both badenya and fadenya are necessary for all parties to excel in social life, in this system badenya is generally favored. In the words of Malick Sidibé, *Badenya ka fisa fadenya ye*, or "Badenya is better than fadenya" (M. Sidibé 2004). His son, Karim, added, "In badenya, no one envies you, even if you are better. But they would like to share in what you have. When there is success in a fadenya household, other people don't share in it. They are jealous and want to make *juju* [against you]" (M. Sidibé and K. Sidibé 2004). As a result, people in Mali have developed a variety of strategies designed to encourage badenya while circumventing the negative repercussions of fadenya.[16] For example, Karim Sidibé cited the practice his Sarakolé (Soninke)[17] neighbors have instituted within their households to deter the negative impact of fadenya in polygamous homes. According to Sidibé,

> in a Sarakolé family, the first wife gives her child to the second wife . . . six months [after its birth], and the second wife gives her child to the third wife, and the third wife gives her child to the first [wife]. The success goes to the [woman in charge of raising] the child, not the birth mother. That is what determines [a mother's] character and identity. If you raise a child well, it shows that you have good intentions. Failure to do so is humiliation (*maloya*). So there are more layers of love and intimacy in Sarakolé families. Fadenya was not meant for destructive effects. That is why Sarakolé thought that raising each other's children would improve the situation and increase badenya, while lessoning fadenya and favoritism. (K. Sidibé 2004)

One of the oldest and most enduring practices developed to promote badenya and curtail the negative repercussions of fadenya in Mali is *senankunya*, or the "joking relationship."[18] It is designed to ensure

camaraderie between people of disparate castes, ethnicities, and families (*jamuw*) as well as among in-laws and extended family members (Camara, n.d., 1–8; A. B. Konaré 2000, 22; M. Sidibé 2004; Conrad 2006, 91). According to oral history, senankunya originated from early communal migrations as a means to mediate relationships among native and foreign populations in a manner that supports cooperation and harmony (Brooks 1989, 23–40; Camara, n.d., 3–4). For example, it is a bond or pact formed between people who operate in socially interdependent relationships yet hold potentially conflicting agendas and perspectives in order to render them symbiotic. This is evident in the case of Fulani herders and Bamana farmers: Herders require land on which their livestock may graze; in return, animal waste fertilizes farmers' crops. However, these groups also compete for scarce resources, such as land and water, particularly during the dry season and periods of sustained drought. Thus, a "joking relationship" (senankunya)—in which insults are wittily cast from both sides—has been customarily established between these groups to locate common ground and facilitate understanding in order to better work together.[19] In short, senankunya is a form of intellectually stimulating and entertaining diplomacy, and, as Camara argues, it is a wise way to create friendships (Camara, n.d., 7). Such relationships exist today among blacksmith families (such as Kanté and Doumbia) and Fulani (including Cissé and Bâ) or "Wasulu Fulani" (Sidibé) families, for example, and are regularly enacted among photographers, assistants, and clientele.

Camara explains that senankunya (which he spells *sanankunya*) etymologically derives from *sanan*, which means "hunk" or "chunk" (in reference to hardened food attached to the interior base of a cooking pot), and *kunya*, meaning "endurance" and "stoicism." These concepts elicit the harsh treatment the *sanan* suffers as it is scorched, scraped from the pan, pounded, and recooked numerous times, which is metaphorically akin to the lifecycle of an individual, replete with successes and failures. Therefore, the practice of senankunya reminds people of the importance of enduring criticism and hardship with forbearance and courage yet remaining willing to learn from others while altering one's behavior to become an ideal, moral, cooperative person. Through joking relations, "each partner learns something about his own ancestors from the other partner" (M. Sidibé 2004). As a result, people recognize that daily teasing is more informative and productive than "everyday fighting" (Camara, n.d., 3–8). Thus, Malians are proud of the senankunya tradition and reference it regularly in casual discussions.

Another tradition, regularly employed by Africans in Mali to promote and reflect badenya between individuals and their respective families, is *togoma* (namesake) relations. For example, photographer Tijani Sitou

named his first Malian-born son Malick after Sidibé to honor Sidibé and express his profound appreciation for the support, advice, and friendship Sidibé had given him since shortly after Sitou arrived in Mali during the late 1960s (M. Sidibé 2004; Malick Sitou 2004). Togoma relationships such as this are typically understood as serious familial bonds sustained throughout the lifetime of one or both individuals.[20] As Malick's son Karim Sidibé explained, "There is no fadenya among namesakes, but there is badenya, because it is a product of love" (K. Sidibé 2004). Malick Sidibé continued, "If there should be fadenya among togomaw; it would be chaotic. That should never happen. Rivalry should never exist between togomaw. The responsibility falls on the older one always" (M. Sidibé 2004). After the passing of his father in 1999, Malick Sitou has been absorbed into the Sidibé family as an adoptive son of sorts. While in Bamako, Sitou resides at the Sidibé compound in Daoudabugu and has often apprenticed in studio, darkroom, and reportage work at Studio Malick. Like Sidibé's children, Sitou accompanied Sidibé abroad, where he served as his interpreter, assistant, and familial companion during his participation in exhibitions, such as *African Art Now* (Houston 2005), in the United States. Nimis reports that Abdourahmane Sakaly similarly named his son Naby after his photographic mentor in Bamako, Nabi Doumbia, as a sign of respect and friendship (Nimis 1998c, 86).[21]

According to Karim Sidibé, togoma relationships can also be formed between father and son, or grandfather and grandson, as a way to emphasize badenya in polygamous households. For example, Malick Sidibé's third son, Mody, has been nicknamed *N'fa* (My Father) by the Sidibé family. The pseudonym, which refers to his namesake—the father of Sidibé's second wife—is regularly used by relatives, friends, and neighbors. As such, it deliberately connects the son of Sidibé's first wife with the father of his second wife to encourage badenya among *faden* (Malick Sitou 2015). Related examples exist among other photographers' families in which sons are given nicknames that reference their father, such as the cases of "Papa" Kanté and "Baba" Keïta (Seydou Keïta's son) in Bamako. Although Karim Sidibé discussed this practice in terms of badenya, it can also be interpreted in relation to the expectation and drive of father-son rivalry (as stimulus for individual reputation and identity), which is considered a productive aspect of fadenya (K. Sidibé 2004).

With similar impetus, attempts have been made to secure badenya relationships among political leaders and nations. Before it was destroyed by the fadenya rivalry between Modibo Keïta and Léopold Sédar Senghor, the Mali Federation was intentionally organized to encourage cooperative, unifying badenya relations between member countries in the era leading up to political independence (M. Sidibé 2004; Foltz 1965, 87,

191).[22] This was true when it initially incorporated Mali, Burkina Faso, Dahomey, Ivory Coast, and Senegal and later when only Mali and Senegal remained (A. B. Konaré and A. O. Konaré 1981, 155; Foltz 1965, 95). The failure of the Mali Federation to achieve badenya was lamented by Modibo Keïta in a speech given in Liberia in 1960: "The mystical force of African unity is not yet strong enough to bring [its] states together" (Foltz 1965, 179). Panterritorial political organizations (such as the African Democratic Rally, RDA, which emerged in the mid-1940s and continued after independence) also were conceived as platforms for badenya, committed to the "goal of African unity" (Gologo 2004; Foltz 1965, 67, 78, 51). In fact, during this period, the quest for African unity was reiterated time and again in political speeches, party ideologies, labor unions, and notions of pan-Africanism. As a case in point, Modibo Keïta asked his delegates to swear thrice publicly "to defend everywhere the Mali Federation, to become tireless pilgrims and preachers of political unity and to accept the ultimate sacrifice for the realization of African unity" (Foltz 1965, 51, 67, 102, 126, 131, 179, 197, 198, 200). Likewise, most Malians, such as Malick Sidibé, viewed the Organization for African Unity, which was formed in Addis Ababa in 1963, as a significant attempt to ensure badenya relations among African nations, although they admit it has been largely unsuccessful (M. Sidibé 2004; M. Coulibaly 2004). Hope for real badenya ties among the continent's nations was rekindled for a brief period after the organization was renamed the African Union in 2003 (M. Coulibaly 2004).

In terms of socioeconomic politics, socialism was initially conceived as a collaborative, unifying (badenya) answer to the abusive, self-serving (fadenya) policies of French colonial capitalism. Addressing the Malian equation of imperialist capitalism with negative fadenya, for example, Foltz has written, "The Sudanese mince no words about ridding themselves of individualism and individualists, considered among the most dangerous legacies of European occupation" (Foltz 1965, 209). Reiterating this point in terms of today's Malian economy—one legacy of French colonialism—Malick Sidibé opined, "The way that humanity is moving, money has spoiled badenya, because each person wants to be an individual and wants to have money alone. . . . That is the ruin of badenya" (M. Sidibé 2004).

Skeptical of this cultural appropriation during the 1950s, Modibo Keïta stated in a public address, "Everyone . . . is agreed in recognizing that the traditional solidarity [badenya] which plunges its roots deep in the African soil, is in danger of crumbling slowly, but surely." He continued, "After independence the [US-RDA] party will have to be doubly careful to break down the divisive structures that colonialism

Plates

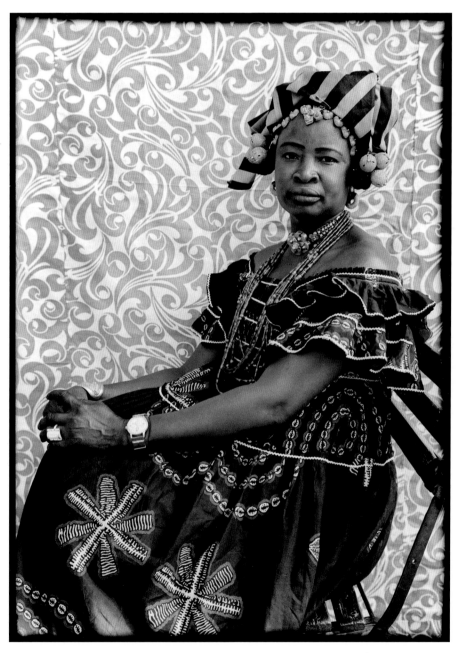

Plate 1. Seydou Keïta, *Untitled*, c.1953–57. Gelatin silver print, 23 × 19 inches. Courtesy CAAC—The Pigozzi Collection. © Seydou Keïta/SKPEAC.

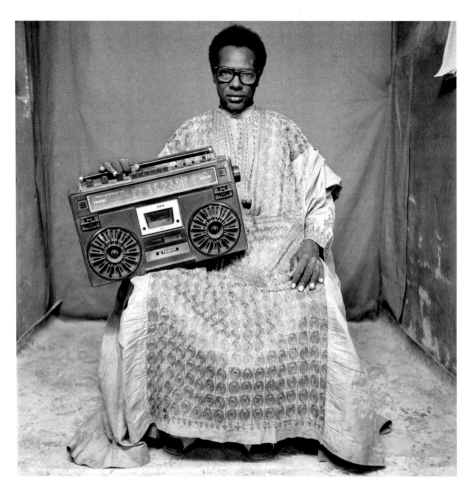

Plate 2. Tijani Sitou, *My Embroidered Boubou and Pretty Radio*, c. 1978. High-resolution digital scan of original 6 × 6 cm negative. Courtesy Tijani Sitou Estate © Tijani Sitou.

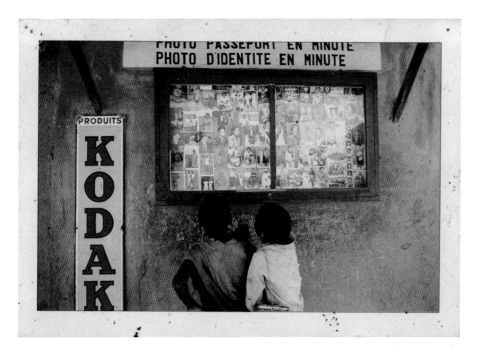

Plate 3. Façade of Tijani Sitou's studio, Photo Kodak, in Mopti. Photo by J. M. Lerat. Postcard 4074. Paris: Editions HOA-QUI, Diffusion Sacko Moussa BP2756, Bamako, c. 1980s. Collection of C. M. Keller.

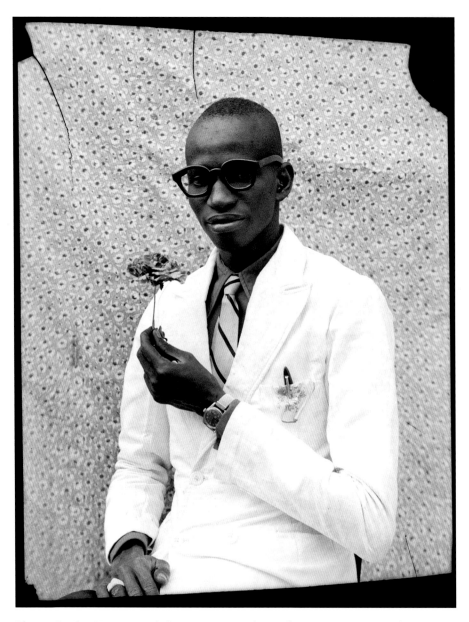

Plate 4. Seydou Keïta, *Untitled*, c. 1958–59. Gelatin silver print, 23 × 19 inches.
Courtesy CAAC—The Pigozzi Collection. © Seydou Keïta/SKPEAC.

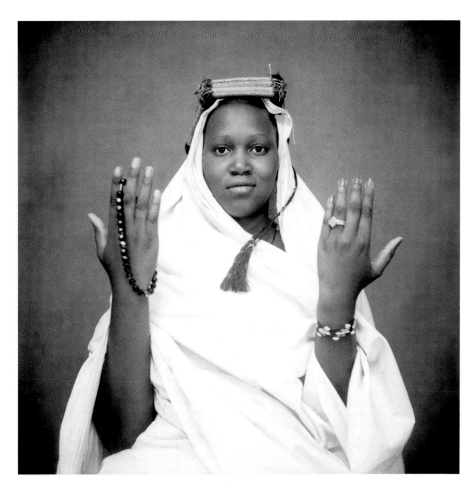

Plate 5. Tijani Sitou, *God Is Great*, 1980. High-resolution digital scan of original 6 × 6 cm negative. Courtesy Tijani Sitou Estate © Tijani Sitou.

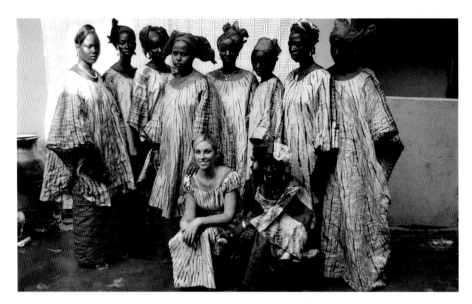

Plate 6. Members of the Sidibé family and C. M. Keller wearing a "uniform" indicating an affiliation with Malick Sidibé and each other during the wedding of Karim Sidibé at Malick Sidibé's home in Daoudabugu, 2004. Photograph by Malick Sitou. Collection of C. M. Keller.

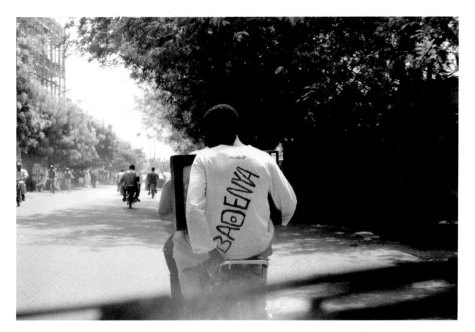

Plate 7. Man riding on the back of a motorbike, wearing a hand-painted "badenya" shirt, near Studio Malick in the Bagadadji neighborhood of Bamako, 2003. Photo by author.

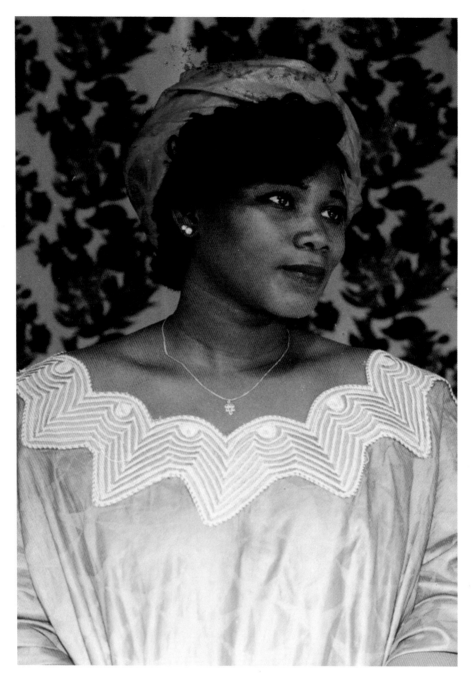

Plate 8. Drissa Diakité, reddened portrait print, 1995. Reprinted by Drissa Diakité for author in Bamako, 2004.

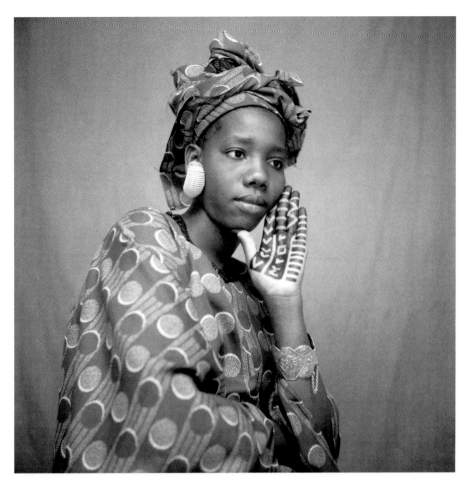

Plate 9. Tijani Sitou, *See My Henna*, 1983. High-resolution digital scan of original 6 × 6 cm negative. Courtesy Tijani Sitou Estate © Tijani Sitou.

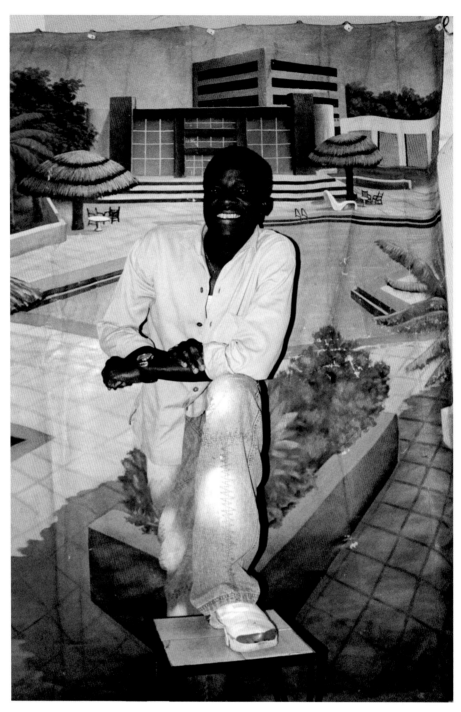

Plate 10. Portrait of Ibrahim Sitou in front of painted cloth backdrop at Photo Kodak, Mopti, 2004. Photo by author.

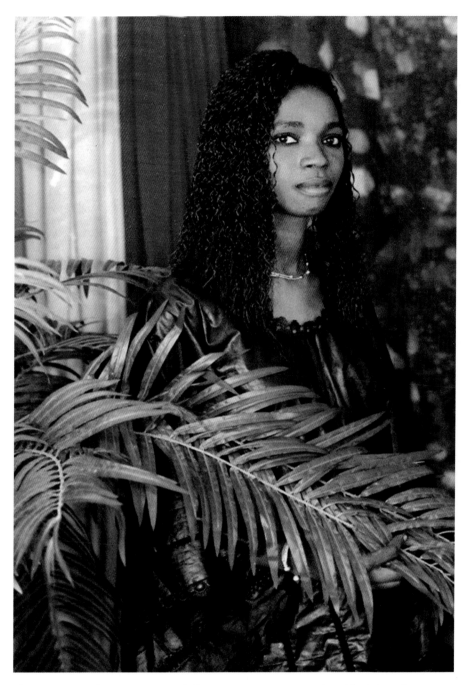

Plate 11. Mamadou Konaté, untitled portrait, c. 1990s. Reprinted by Mamadou Konaté for author, Bamako, 2004. © Mamadou Konaté.

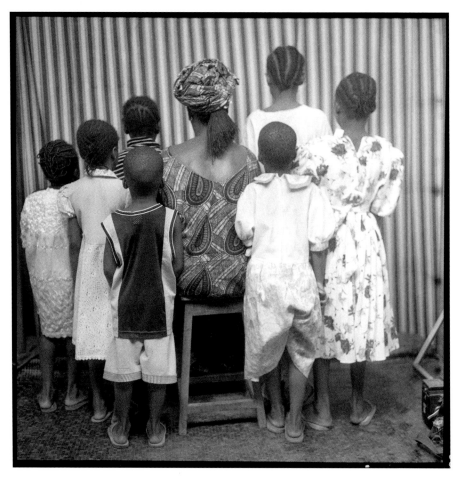

Plate 12. Malick Sidibé, *Large Family from Behind* (*Vue de dos* series), 2000.
© Malick Sidibé, courtesy MAGNIN-A gallery, Paris.

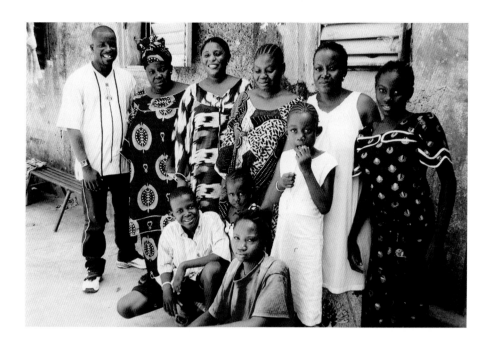

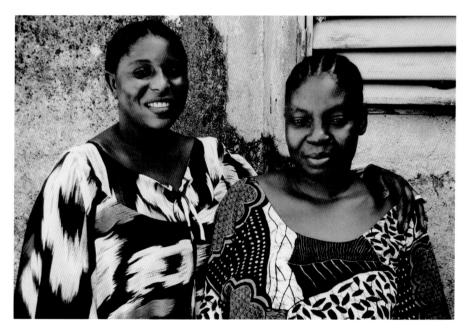

Plates 13a and 13b. *Top*: Doumbé Diallo (*center, looking downward*) and family with Malick Sitou (*far left*) and Oudya Sidibé (*left of Doumbe*) at the Diallo home. *Bottom*: Oudya Sidibé (*left*) and Doumbé Diallo (*right*) at the Diallo home. Photos by author, Bamako, 2004.

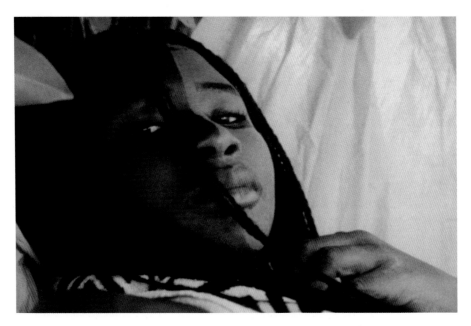

Plate 14. Emmanuel Bakary Daou, *Photo Nature* (*Bogolan de San* series), c. 2000. Postcard 4 (St.-Hilaire-de-Riez: Michaell Tessier). Collection of C. M. Keller. Courtesy Emmanuel Bakary Daou.

Plate 15. Mamadou Konaté, *Les Nouvelles*, c. 1990s. Courtesy and © Mamadou Konaté.

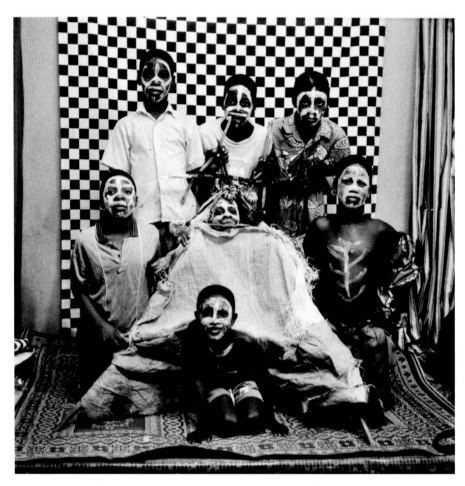

Plate 16. Malick Sidibé, *Yokoro*, 1967. © Malick Sidibé, courtesy MAGNIN-A gallery, Paris.

has implanted on African soil" (Foltz 1965, 126). His party's answer to this legacy was socialism, which was perceived by many as "solidarity, camaraderie, communally cohesive badenya" (Gologo 2004). Indeed, the RDA's ideological perspective and propagandistic vocabulary were replete with terms such as *comrade* and *brother*. Although some of its officers, such as Mamadou El Béchir Gologo, believe "socialism worked" (Gologo 2004), regrettably for most Malians, it proved to be as self-serving to those in power and arguably more abusive to the populous as French imperial capitalism.

On a more intimate scale, the long-standing tradition of unifying individuals across ethnic, caste, and class lines into association groups (*tonw*) inspired professional photographers to create the National Group of Professional Photographers of Mali (GNPPM) around 1987 to encourage badenya relations among its members in light of rampant competition (M. Sidibé 2003).[23] Although it was initially developed as means for professional photographers to have a collective voice and reach consensus on a standardized pricing system designed to be competitive with prices charged by ambulant and amateur photographers, it soon became a fraternal organization that offered support on a variety of levels. For example, when one of its members passes away, the collective typically pools together some funds to gift to the deceased member's family. This was the case with the passing of Abdourahmane Sakaly and Mamadou Cissé (M. Sidibé 2004; A. B. Cissé 2003; S. Sidibé 2003). GNPPM members have also offered photography workshops to help aspiring practitioners get their start in the field. However, Malick Sidibé, the organization's acting president until 2004, complained that it has not been particularly successful recently as "everyone is involved with their own lives now" (M. Sidibé 2003).

The GNPPM and similar photographers' organizations are by no means the only examples of badenya in Mali's photographic community. Just as there are numerous cases of fadenya among photographers, there are several instances of badenya as well. Photographers visit one another's studios to share materials, borrow equipment, give advice, learn from each other, and at times lend or donate money for support (M. Sidibé 2003; Elder 1997, 163, 167). For example, fourth-generation photographer Abdoulaye Kanté (2004) stated, "Friends also help. They give money and fix problems. That is badenya."[24] Photographers also train each other's children in the medium, particularly in darkroom processes, as previously discussed in the case of Papa Kanté and Malick Sidibé's son Fousseini and Siriman Dembélé and Sidibé's son Mody. Furthermore, over the years, many have developed intimate friendships, like the ones that formed between Malick Sidibé and Tijani Sitou and between

Abdourahmane Sakaly and Nabi Doumbia. Photographer Thomas Daou (2004), for instance, spoke of his close relationship with colleague Diango Cissé, who he says he "loves" a great deal. Adama Kouyaté (2004b) explained, "There is badenya between me and Malick Sidibé. All is given; all is open. It is [a relationship of] support without question." Malick Sidibé shared that he was also close with Mamadou Cissé and used to visit him before his passing in 2003. That is one reason Sidibé worked diligently, as the association's head, to get GNPPM members to collectively offer a sum of money to Cissé's family as a sign of peer tribute and neighborly assistance (M. Sidibé 2003; S. Sidibé 2003).

In the present day, when several African photographers meet, work together, and exchange ideas and stories at international exhibitions and biennials, these relationships extend beyond national boundaries. For example, during the past twenty years, Malick Sidibé formed friendships with J. D. 'Okhai Ojeikere (Nigeria), Philip Kwame Apagya (Ghana), and other photographers and contemporary artists from all over Africa who work in various media. In regard to this relationship, Apagya stated in an interview with Tobias Wendl, "I have always admired Malick Sidibé and Samuel Fosso's photographs. I have met both of them and we are good friends. For Malick Sidibé, I am a son or nephew, and Samuel Fosso and I are more like brothers or colleagues sharing the same fate" (Wendl and Apagya 2002, 48). In fact, it was in these contexts that compatriots Malick Sidibé and Seydou Keïta truly became friends rather late in their careers, although they had known each other for several years and began developing a "casual friendship" when Keïta would visit Studio Malick to have his cameras repaired (M. Sidibé 2004; Lamunière 2001b, 28). Strong bonds have also been cemented between Sidibé and Western photographers, such as Guy Hersant, who attended the wedding of Sidibé's son Karim in Bamako in 2004.

Alongside professional organizations, village-based or hometown associations have been formed among compatriots from the same town to provide community outreach and development projects, financial support, and new opportunities to the rural community (Meillassoux 1968, 62, 162–63; Malick Sitou 2004).[25] For example, an association of people from Soloba, the Wasulu town in southwestern Mali where Malick Sidibé was born, gathers monthly at Sidibé's compound in Bamako in order to discuss recent village affairs, mediate conflicts and solve problems, offer financial and material assistance, and administer forthcoming projects, such as the construction and repair of roads and schools and the sponsoring of festivals and ceremonial events (M. Sidibé 2004; Brehima Sidibé 2006).[26] In this way, urban and rural inhabitants, relatives, and neighbors

remain engaged in the life and activities of the village with both charitable and vested interests.

A panregional—in fact global—organization named Sakí Parapo (Sakí United) continues to flourish in cities throughout western Africa and much of the world to accomplish similar goals for the town of Sakí, Nigeria, where Tijani Sitou was born. Today, Sitou's son, Malick, is actively involved in the Yorùbá organization, which has branches in Connecticut and Pennsylvania, for example, as means to support the village and its members—most of whom reside abroad (Malick Sitou 2004). In addition to the aforementioned activities, the provisions afforded to members of this group include a specific form of financial and social security (Malick Sitou 2004; Meillassoux 1968, 74, 87, 145, 162–63). Within the organization, friends, relatives, and neighbors often unite to create a stable and efficient self-administered savings-and-loan program. Generally speaking, each member of the unit contributes a preestablished amount of their weekly salary to a communal account, which is withdrawn every three months in its entirety by a different member in cyclical fashion. This practice has enabled individual members to purchase livestock back home, repair family compounds, send intimates to school, and build homes for oneself and others in the village and elsewhere. In fact, this support system partially enabled Sitou's success abroad by facilitating his individual and communal achievements in the faden kene (Malick Sitou 2008). As such, it provides communal support for the town while meeting the individual needs of its members. Several such institutions exist in Mali, some with large memberships. As in the case of Sakí Parapo, they often extend beyond national and continental boundaries, rendering them powerful unifying social organizations.

Urban voluntary and professional organizations, such as Sakí Parapo and GNPPM, have been inspired by the long-standing practice of village associations known in Bamanankan as tonw.[27] These include Jo and Ntomo (initiation and educational societies that assist children's transformation into adulthood), CiWara (agricultural association), kamalen ton (youth association), donsow ton (hunters' association), and more secretive, powerful associations known among Bamana, for example, as kòmò, kònò, and gwan.[28] Tonw have also informed the creation of urban "clubs" and neighborhood collectives, or grins, which were discussed in chapter 2.[29]

In cities such as Bamako, Mopti, and Ségu, each of these association groups has informed the practice of portrait photography in Mali. For example, along with their fadenya individuality, clients have wanted to portray and record their badenya alliances, which exist in intimate circles across ethnic, class, gender, cultural, and national boundaries. For

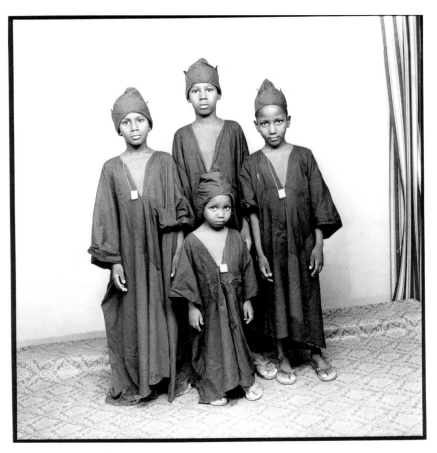

Figure 3.9. Malick Sidibé, *The Newly Circumcised*, 1983. © Malick Sidibé, courtesy MAGNIN-A gallery, Paris.

instance, as individuals mature and enter association groups, they form new badenya relationships (Colleyn 2001, 244). In an image by Malick Sidibé (fig. 3.9), young boys communicate and record that they have completed the first phase of their initiation into the Jo society (M. Sidibé 2003).[30] In this association, both boys and girls are guided through the process of becoming young men and women, which includes circumcision and indoctrination into societal values of responsible adult behavior (Imperato 1994, 58–60; Ezra 2001, 131–34). This alliance is made visible through the identical robed attire, Bamada (crocodile mouth) caps, and amulets the boys wear.

In urban neighborhoods, grins function similarly as association groups. In these clubs, to which both young men and woman may belong, men gather daily at the grin room or other common locales to drink tea, discuss politics, watch television, or play games (Magnin 1998, 36; Meillassoux 1968, 131). In the 1960s and 1970s, Manthia Diawara reports,

""Most Grins . . . had a shortwave radio which received BBC Radio, the Voice of America, and Radio France International. . . . [Some] had the local newspaper, *L'Essor*, and occasionally one could find French papers like *Le Monde* and magazines like *Paris-Match* and *Salut les Copains*, from which they removed the posters of the Beatles of Liverpool, Jimi Hendrix and James Brown to put on the wall (Diawara 2003a, 173). According to Malick Sidibé, "In the past grins were helpful networks. We used to help each other with exams and school. They were true, serious friendships—solid badenya relationships—tying people together for life" (M. Sidibé 2003). In a related statement, Diawara commented, "The youths at the Grins also saw themselves as rebels against traditional societies. . . . They thought of themselves as open-minded and tolerant toward each other, regardless of ethnic and class origin" (Diawara 2003a, 174). The archives of most professional photographers include numerous group portraits commissioned by these grins, usually incorporating a written sign proclaiming their collective name (fig. 3.10). Grins remain ubiquitous in Malian neighborhoods as evident by the numerous renditions of their names painted along the walls of public and private buildings in cities such as Bamako, Ségu, and Mopti. From the 1950s until his passing in 2016, Malick Sidibé belonged to a grin called Tirianna whose members continued to meet at his studio into the twenty-first century (M. Sidibé 2003). Simultaneously, to the left of the studio entrance, the grin of his son Mody, known as Kalla City, continues to congregate daily.[31]

Likewise, to illustrate their intimate badenya relationships, women and men in Bamako and smaller Malian cities regularly commission portraits of themselves dressed in "uniforms"—outfits tailored from the same cloth (fig. 3.11). Relatives also wear "uniforms" in portraits to visually proclaim kinship ties. In the contexts of social ceremonies, such as weddings, women adorn "uniforms" (plate 6) to publicly profess their badenya allegiance to either the patrilineage or matrilineage of the bride or groom and to friendship as well as family connections (M. Sidibé 2004; Malick Sitou 2004; O. Sidibé 2004; Elder 1997, 109; Little 1957, 590).

Similarly, the Sidibé family commissioned Comatex to create a textile featuring a portrait of Malick Sidibé to be worn as a "uniform" by friends and family (M. Sidibé and Sitou 2004). In celebration of the Hasselblad, which Sidibé was awarded in 2003, a festival was held in his honor in Soloba, his hometown in the Wasulu region of southwestern Mali.[32] Family members and friends who attended donned the "uniform," publicly professing their relationship to and alliance with Malick Sidibé and each other. Preserved on film (Drissa Diakité and Fousseni Sidibé were the photographers), both in portraiture and video recordings, images of the

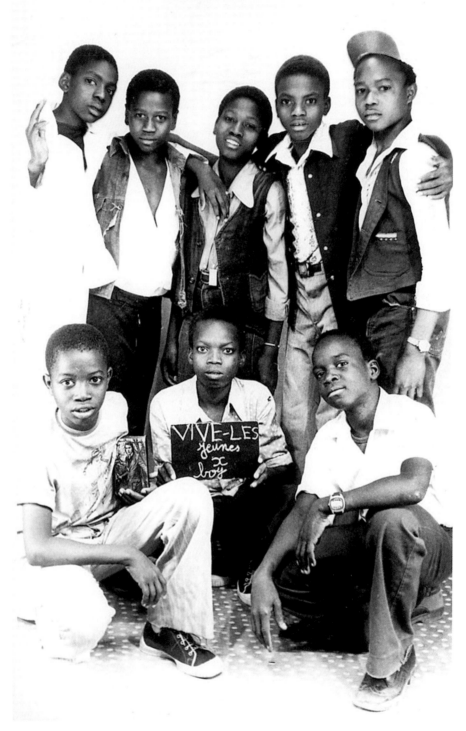

Figure 3.10. Sidiki Sidibé, *Untitled* (Grin X, "young boy"), 1972. Reprinted by Sidiki Sidibé for author, Bamako, 2004. © Sidiki Sidibé.

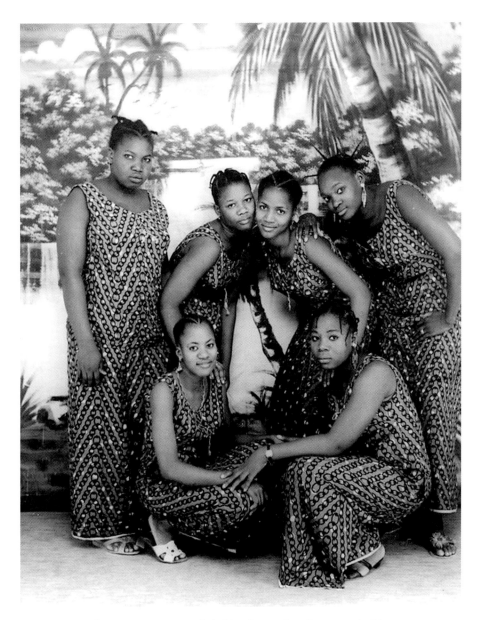

Figure 3.11. Adama Kouyaté, *Untitled* (friends wearing the same cloth), c. 1970s.
Reprinted by Adama Kouyaté for author, Ségu, 2004. © Adama Kouyaté.

event communicate and record the strong badenya affiliation and partner-
ship between these individuals (O. Sidibé 2005).

As Sidibé's photographs indicate, members of clubs or grins also
wear identical outfits to proclaim fraternal ties (fig. 3.12). With related
purpose, women from rural areas travel together to urban markets,
purchase like undergarments, and capture their camaraderie and expe-
rience on film (Malick Sitou 2004; Elder 1997, 110).[33] Finally, during

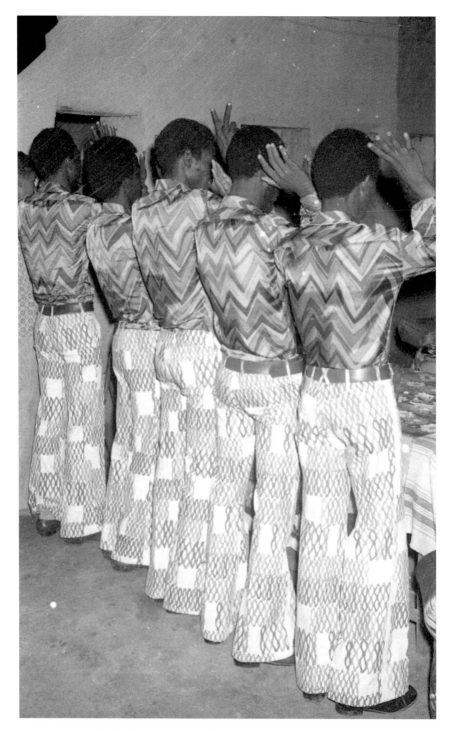

Figure 3.12. Malick Sidibé, *Very Good Friends in the Same Outfit, Night of June 3, 1972*, 1972. © Malick Sidibé, courtesy MAGNIN-A gallery, Paris.

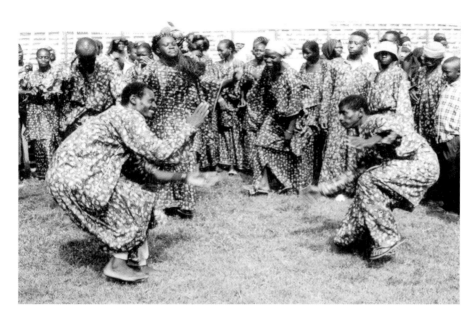

Figure 3.13. Ouassa Sangaré, *Untitled* (youth festival in Bamako), 2003. Collection of C. M. Keller. © Ouassa Sangaré.

Youth Week festivities, participants often wear "uniforms" to visually convey their solidarity (fig. 3.13). Rather than acts of "twinning," as Micheli has argued (2008, 2011), such duplication of dress is more broadly intended to visually highlight badenya connections and intimate relationships among couples, friends, and relatives, regardless of gender.[34] This perspective is underscored by a collection of Tijani Sitou's portraits that were posthumously assigned titles by his son Ibrahim and later published by Micheli (2008): *Circumcised Boys and Friend*, *Two Cousins and Close Friends*, *Two Sisters*, and *Two Friends* (fig. 3.14).

Thus, people utilize personal adornment—clothing, in particular—as a powerful means to publicly pronounce important aspects of their identity, including their values, morals, and intimate relationships. Outfits cut from the same cloth, often called "uniforms," are perceptible indicators of badenya relations.[35] The patterns they depict can denote similar themes. For example, according to Malick Sitou, cloth called *fan tan*, *den tan* ("ten eggs, ten children") worn by couples or women speaks to the familial (*denbaya*) concern of the individual sporting the textile and, in the case of couples, to the intimate relationship between two people (fig. 3.15). By wearing this cloth, which directly addresses the importance of propagation in marital life, a husband and wife express their love for each other as well as their hope to generate a large family (Malick Sitou 2004, 2006).

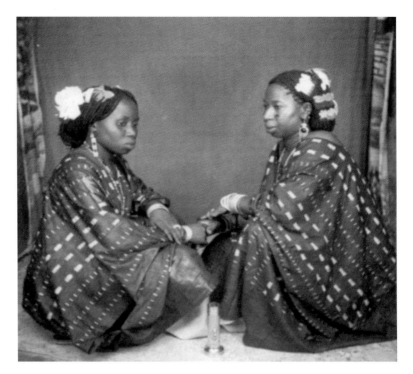

Figure 3.14. Tijani Sitou, *Two Friends Peul and Bozo*, 1981. Courtesy Tijani Sitou Estate © Tijani Sitou.

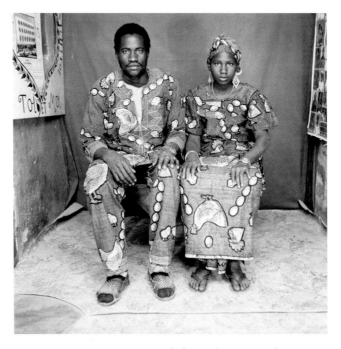

Figure 3.15. Tijani Sitou, *Untitled* (couple wearing *fan tan, den tan* cloth), c. 1970s–1980s. High-resolution digital scan of original 6 × 6 cm negative. Courtesy Tijani Sitou Estate © Tijani Sitou.

Interpreting Malian portrait photographs in terms of the intentional creation and preservation of fadenya identities and badenya relationships is not merely an academic exercise. Nor is it confined to Mande segments of the population. In this regard, Malick Sidibé stated, "Badenya and fadenya exist between countries, between people, between family members, everyone. . . . Badenya and fadenya come from polygamy, but . . . apply everywhere in the world. Our society has been living in that situation for a long time" (M. Sidibé 2004). Malian historian Adama Bâ Konaré makes a similar argument, "Malian culture is diverse and plural. Each ethnic group in Mali has its own cultural identity. But it is also true that there is a common denominator to all of these cultures, a denominator strengthened by a long history of cohabitation, conflict, and exchanges of all sorts—matrimonial, commercial, or simply that of neighbors. This history has forged what we call a veritable Malian identity of common characteristics and values that are internalized and shared" (A. B. Konaré 2000, 15).

Fadenya and badenya are part of this shared identity. The values these terms embody resonate with individuals in Mali of various ethnicities who are not only aware of these social dynamics but use them to formulate ideas about their own character and principles, to express those ideas to others, and to make sense of the world in which they live.[36] In fact, instances taken from contemporary Bamakois public life illustrate that the terms themselves can be visually employed to convey a person's moral beliefs and self-proclaimed identity. Donning a bold, hand-painted badenya inscription on his back, a young man in the streets of Bamako (plate 7) makes a conspicuous public statement that literally aligns him with badenya values while explicitly declaring their social significance. Furthermore, some business owners publicly display the term on their shop signs and incorporate it within the titles of their businesses (figs. 3.16a, 3.16b, 3.16c) to emphasize the importance of trust and honesty in commercial relations as well as the desire for unity among neighbors (M. Sidibé 2003, 2004; K. Sidibé 2004). Similar sentiments are publicly expressed in phrases like Ben ka di (agreement/coming together is "good" or "sweet"), which is often painted on urban public transportation vehicles. If we recall the portraits by Keïta introduced earlier (figs. 3.1–3.2), people also make visual public statements about fadenya, although less blatantly.[37]

Thus far, I have argued that individuals and groups consciously perform and record fadenya characteristics and badenya relationships in portraiture. I have also highlighted some of the ways in which these concepts inform photographers' personal relationships and professional networks and more generally affect citizens' interpretations of and participation

Figures 3.16a, 3.16b, 3.16c. Façades featuring *Badenya* in the titles of a hair salon (2004), tailor's shop (2004), and photography studio (2012) in Bamako. Photos by author.

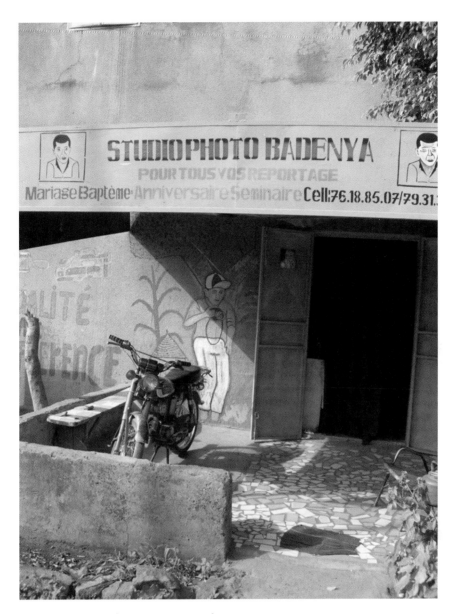

Figures 3.16a, 3.16b, 3.16c (*continued*)

in the global landscape. The discussion now moves to an analysis of the social position photographers have occupied within their communities, addressing the means they have developed to communicate, accentuate, and reinforce their clients' (fadenya) individuality and (badenya) relationships in visually effective ways. Of particular consideration are the strategies, tools, and practices photographers employed and invented to this end and how they were able to generate a demand for their unique creations in the commercial market.

Notes

1. Charles Bird and Martha Kendall refer to fadenya and badenya as a "social theory," a "Mande ideology," and a "philosophy of action" (Bird and Kendall 1980, 13–16). Cheick Oumar Mara, director of cultural patrimony at the Ministry of Culture in Mali, described badenya and fadenya as aspects of "Malinke and Bamana philosophy" (Mara 2004). Folklorist John Johnson has discussed the terms as part of a "Mande worldview" (Johnson 1999, 16). Similarly, Jan Jansen considers fadenya and badenya part of "Mande logic" (Jansen 1996b, 30). Often, colleagues and friends in Mali discussed these concepts in terms of Mande philosophy, ideology, or theory. In this analysis, they are considered principal aspects of Mande theories of social action.

2. On this topic, Malick Sidibé stated, "Fadenya often starts with the women in a family. . . . When there is strong jealousy among the mothers the [children] can join the battle" (M. Sidibé 2004). However, this does not imply that rivalry is the only dimension of interpersonal communication experienced among cowives. On the contrary, some cowives form deep, intimate friendships with one another. David Conrad cites the formative years of the Mande hero Fakoli's life to illustrate the "degrees of closeness [that can exist] between co-wives . . . and brothers and sisters" in Mande families (Conrad 2006, 90).

3. Youssouf Tata Cissé translated the title of this cloth as "the jealous dark eyes of my co-wife" (Y. T. Cissé 1997, 275). In consultation with Barbara Hoffman, Cherif Keïta, Valentin Vydrin, Soumana Kané, and Karim Traoré, I have slightly revised this English translation as well as the transliteration of the original Bamanankan.

4. Youssouf Tata Cissé referred to this cloth as *n'te siran n'sinamuso nyèn nyan* and translated it as "I'm not afraid of my co-wife's goggling eyes" (Y. T. Cissé 1997, 273). In consultation with Barbara Hoffman, Cherif Keïta, Valentin Vydrin, Soumana Kané, and Karim Traoré, I have made slight revisions to the transliteration and translation of this Bamanankan phrase.

5. For more on this topic, see Bird and Kendall (1980) and Jansen and Zobel (1996).

6. As Bird and Kendall argue, the tension that exists between these concepts "should not be understood as a polar opposition" but rather as a symbiotic relationship between individuals and social groups or as "the intersection of two axes: the axis of individuality, fadenya, and the axis of group affiliation, badenya" (Bird and Kendall 1980, 14).

7. Konaré has variously spelled her name Adama and Adame in her publications. I have consistently used Adama.

8. Most photographers whom I interviewed in Mali feel there is strong fadenya and badenya among members of the photography community (M. Sidibé 2004; Malick Sitou 2004; S. Sidibé 2004; Abdoulaye Kanté 2004; L. Traoré 2004). However, in accordance with Kanté, the majority complained that "fadenya is more frequent" (Abdoulaye Kanté 2004).

9. Elder has written about the competition among ambulant photographers, arguing that "competitiveness and individual capital accumulation characterize the strategies and organization of the street photographers' work" (Elder 1997, 162).

10. Over the course of my research, I have come to learn some particulars concerning the trade secrets of individual photographers. However, for obvious reasons, I am unable to disclose them here. For instance, while unveiling some of his unique darkroom strategies, Malick Sitou (2004) cautioned, "These are secrets. Everyone has their own way. It is very personal. Don't publish the specifics."

11. Baba Keïta, Seydou's son, similarly explained that he plans to train only his children in photography because, if he trains others, they will "leave and start another business" (B. Keïta 2010).

12. According to Malick Sitou, "The marketplace is a sacred, significant location where a lot of things happen. . . . People physically battle to provide for their family, and family members pray for them to succeed. There are a lot of lies, a lot of fights, a lot of tricks and games, cheating. . . . People say things are real when they are fake, and the scales are altered to make objects seem to weigh more than they actually do. [For this reason] a lot of sacrifices take place at the market" (Malick Sitou 2005; reiterated in 2008).

13. Malian musician Oumar Koïté performs a song about the negative behavior of those who remain abroad rather than return home to benefit their community (Malick Sitou 2008).

14. From 2004 to 2016, Malick Sidibé served as the president of honor for the organization, with Papa Kanté as active president (A. B. Cissé 2011).

15. For more on fraternal dynamics in Mali, see Jansen and Zobel (1996).

16. This is true among Mande communities outside Mali as well. For a recently published account on this, see Roth (2014).

17. In 2008, Africanist colleagues engaged in dialogue on the H-Africa listserv about whether it is more appropriate to use *Bamana* or *Bambara* when referring to this culture. In these conversations, there was mention of *Soninke* being used today instead of *Sarakolé*, as the latter is a derogative term. However, during the course of my research, individuals in Bamako with whom I spoke repeatedly referred to people of this group as Sarakolé. Thus, incorporating their accounts, I have maintained the term here.

18. Also known as "joking cousins" in English, according to Sekou Camara, the practice of senankunya dates "back from the collapse of the Ghana Empire in 1076." Camara also refers to "joking partners" among Mande communities as *lasiriw* (Camara, n.d., 3–4). Father Bailleul alternately spells the term *sènènkùnya* (Bailleul 2000a, 409), while David Conrad has used *senankuya* (Conrad 2006, 91).

19. Conrad explains that "joking relationships or senankuya are based on popular notions of what happened between ancestors, with perhaps only a vague awareness of what actually led to the customary jokes. For example, when people named Traoré and Condé are introduced to each other, one of them will almost invariably announce that the other is his 'slave'. This will be followed by humorous banter about whose ancestor enslaved the other, but the chances are that neither of the two can explain how the custom began" (Conrad 2006, 91).

20. However, in an interview with Lamunière, Malick Sidibé shared a less intimate example of togoma: "One woman showed up here [at Studio Malick] one time, and I heard her saying, 'Malick! Malick!' I turned around, but she wasn't talking to me—she was talking to her son. Not only did she know my

name [all the way from the countryside], but she had named her son after me!" (Lamunière 2001b, 56).

21. Less is known about the specifics of the Sakaly/Doumbia togoma relationship because both men are deceased.

22. Foltz does not use the term *badenya* but nevertheless makes a similar argument, stating that "the Sudanese [Malians] saw the [Mali Federation] as a modern expression of traditional African unity" (Foltz 1965, 131).

23. Among GNPPM's first members were Seydou Keïta, Malick Sidibé, Youssouf Traoré, Moumouni Koné, Abdourahmane Sakaly, Baru Koné, Samba Bâ, Bakary Doumbia, and Mamadou Cissé (M. Sidibé 2003).

24. However, Kanté admitted, "Fadenya [among photographers] is more frequent" (Abdoulaye Kanté 2004).

25. Meillassoux refers to these as "village," or "mutual aid," associations while Elder calls them "home-town" associations (Meillassoux 1968, 76 and 145; Elder 1997, 163).

26. Members of the association are those who continue to reside in Soloba and those who originated in Soloba but are now living in the environs of Bamako. As one of its most renowned, successful, and established members, Malick Sidibé served as the president of the association until 2009. By extension, until that time, most meetings convened in the courtyard of his home (M. Sidibé 2004; Bakary Sidibé 2006).

27. For more on these associations, see Meillassoux (1968) and Little (1957).

28. For information on these association groups, consult Hopkins (1971, 1972), McNaughton (1988), Ezra (1983, 2001), McGuire (1999), and Colleyn (2001).

29. Iyouba Samaké described a club called Baara Ton in Medina-Kura as a *ton*, in which case there does not seem to be a great conceptual distinction between *club* and *ton* in urban contexts. Samaké stated that grins "began with politicians, [whereas] the ton is traditional. It's been around a long time" (I. Samaké 2004).

30. This initiation society is also known as Ntomo among many Bamana communities. James McGuire defines Ntomo as "the bond that ties together a group of men who have been circumcised at the same time" yet argues that this "initiation brotherhood provides an arena for the rivalry with one's peers necessary for living up to or surpassing one's jamu [last name, patrilineage, father's reputation]" (McGuire 1999, 259–69). Much has been written about the sculptural art (masks) associated with Ntomo. See, e.g., Colleyn (2001).

31. Since 2002, I have witnessed many lively, even heated, discussions of fadenya and badenya among these groups that have informed this analysis.

32. The Hasselblad is among the most prestigious international photography awards in the world. In 2003, Sidibé became the first African photographer to receive the distinction (Knape, Diawara, and Magnin 2003, 107).

33. To protect their subjects' privacy, most photographers do not allow images depicting nudity, swimsuits, or undergarments to be made public. Therefore, these images are not featured here.

34. Twins (*flanniw* in Bamanankan) hold an ambivalent, uniquely powerful position in society; they are viewed as spiritually endowed with the ability to incite positive or negative affect in the lives of family members, neighbors, and the community at large. In Mali, as elsewhere in western Africa, mothers

often bring their twin children to the market, where they receive payment for their blessings, praise songs, and dancing. None of this particular social or spiritual capital is referenced or considered in the context of donning identical attire in portraiture. Therefore, it is misleading to discuss such imagery within this specific, narrow framework. Rather, as several photographers and their clients have explained, this practice is directly intended to convey more broadly the badenya connection and alliance among those pictured.

35. This practice may have originated with early school uniforms during the colonial era, particularly among women, as evident in Seydou Keïta's photographs (see fig. I.1).

36. This notion derives from my research experiences, which consist of numerous conversations and interviews with photographers, colleagues, and friends as well as discussions overheard in public spaces and the observation of the myriad ways the terms are visually utilized in public arenas in Bamako, Mopti, Sanga, and Ségu.

37. Public expressions of badenya far outnumber those of fadenya, likely due to the contended nature of the latter and the fact that, as Sitou stated, "People don't talk about fadenya easily. You only talk about fadenya with people you trust" (Malick Sitou 2004).

4

Visual Griots

Photographic Artistry and Invention

THROUGHOUT HISTORY, GRIOTS (ORAL HISTORIANS, musicians, and poets) have held an important social and political position among communities across much of West Africa, including present-day Mali.[1] They are admired and appreciated for their creativity, wit, and artistic acumen, and their expertise rests in part on their ability to embellish on the positive characteristics of their patrons (Conrad 2006, 78; Hoffman 2000). Through their verbal orchestrations, they often construct idealized identities for their patrons, popularize them in the public sphere, and preserve them over time in the form of reputation and historical account (Conrad 2006, 78–84). Since the twentieth century, griots have also aggrandized the reputations of photographers, as in the case of Nabi Doumbia, who relayed, "Even the griots used to sing: 'For a good photo, you must go to Pierre Garnier, where Mr. Nabi works. That way you'll be well photographed and you'll have an indelible memory.' . . . [As a result,] my name spread throughout Mali" (Nimis 1996, 25).[2] In the most ideal sense, griots are simultaneously guardians of personal and communal histories and coauthors of an individual's public persona and reputation.[3]

Professional photographer Malick Sidibé, along with many of his colleagues working in Mali during the twentieth and twenty-first centuries, likened the societal position and artistic profession of photographers to those of griots.[4] Like griots, these photographers function as artists as well as personal and social historians, retaining archives of images that document political, social, and personal changes and events (Njami and M. Sidibé 2002, 95; Mießgang 2002, 16; Elder 1997, 242). In this regard,

Malian photographer Amadou Baba Cissé explained, "A photographer is a reporter; [an] archivist. [Photographers] immortalize all that they see [in] photographs [which are] the past, present, and future. In the long run, a photographer is like a griot" (A. B. Cissé 2005). Conceptualizing the documentary dimension of the medium in terms of personal and familial histories, Malick Sidibé added, "I . . . like the idea of photography as a means of creating memories. . . . These images are physical memories that people can keep in their family archives, for the children, for the grandchildren, for the great-grandchildren. They are the very emblem of the self. The camera . . . proves one's existence, or at least part of one's existence. It leaves you with a permanent trace, something you can look at anytime you want, that you can send to friends and family" (Lamunière 2001b, 54). As he also stated, "Bear in mind that a photograph will outlive you. . . . It is the only medium that can win you a degree of immortality" (K. Sokkelund 2003, 9).

Alongside the photographer's role as social historian, the title "visual griot" describes their position as entertainer, performer, and personal relations expert. Nimis emphasized, "Photographers have to know how to attract clients and have to take care of their image to create a feeling of trust: they prospect a lot, and approach their clients in the hope of gaining their loyalty and becoming liked by the whole family. . . . Apart from technical ability, their primary quality is sociability. But it isn't easy and they need to be patient and subtle" (Nimis 1998c, 83). Elder described some of the strategies photographers have employed to ensure a "stable relationship" with their clientele: Those who work door-to-door make multiple visits when necessary and help their clients prepare for their photograph by supplying clothing and props and even bathing children. They also entertain "special requests" and remain flexible with payment schedules, offering credit and installment plans that may take weeks or months to be paid in full (Elder 1997, 208). Malick Sidibé explained, "You have to remember a good photographer is also a social animal. . . . Because the customers don't really see the camera, they see you, the artist—you become the product they're buying. It's like sugar cubes in coffee: you stir the sugar into the coffee and it dissolves and enhances the taste. . . . So a good photographer gets to know everyone" (Lamunière 2001b, 57).

Like the diplomatic sagacity of griots and skilled businessmen, most photographers, including Sidibé, stress the importance of sociability and pleasant demeanor in professional relations. Often they cite the need to make their customers feel comfortable and relaxed in the unfamiliar studio environment, as elucidated by Seydou Keïta: "To have your photo taken was an important event. . . . Often [the client] became serious, and I think they were also intimidated by the camera. It was a new sensation

for them. I always told them to relax more: 'OK, look over here, try to smile a little, not too much.' In the end they liked it" (Magnin and Keïta 2002, 68).[5] In a similar statement, Malick Sidibé opined, "A good photographer should act like a griot, flattering his customers to make them relax, stand straight and feel at ease in the studio" (K. Sokkelund 2003, 9). To this end, Sidibé would often interject humor into his working process akin to Ghanaian photographer Philip Kwame Apagya, who stated, "It is important to break the ice early on, to chat a bit, make a joke; I call that 'chilling out' the clients" (Wendl and Apagya 2002, 46).

Out of respect for their clientele and to safeguard their professional reputations, photographers in Bamako today are particularly careful when taking pictures inside nightclubs—as documenting discreet behavior in photographs may jeopardize its secrecy. For fear that damning information may be inadvertently recorded and an unintended viewer might identify it and take action, photographers take care only to photograph their clients, ensuring others are kept out of the background. They are similarly discerning when they dispense their images. For example, if a photographer were to photograph a couple at a bar, without knowing the particulars of the relationship, he would be sure to give the resulting image only to the client himself when delivering it at a later date. To avoid potential conflicts or grievances, he would not, say, leave it with someone at the man's household (a wife or child) if the patron was not present for the photographer's arrival (Elder 1997, 212, 237). These concerns highlight the precariousness of being photographed and the consequences of exposure. In these cases, the creation and distribution of photographs becomes a serious matter for photographers, who bear responsibility for these processes. Therefore, most professionals today recognize that as indisputable—and potentially damning—evidence, photographs must be carefully guarded.

Thus, trust is an important factor among photographers and their clients. As Wells has stated, "We need to trust, not the mechanical properties of the camera, but the personal integrity of the photographer" (Wells 2001, 77). In our increasingly visual conception of the world and our knowledge of it, photographs occupy a weighty yet ambiguous position. While they offer individuals creative license in the control of their own physical representation, they equally present the lack of it. In Africa, because most individuals have not had absolute control over the creation and dissemination of their portraits, some have refused to allow photographers to take their photo. Underpinning the significance of client-photographer trust, Nigerian photographer J. D. 'Okhai Ojeikere discussed his experience with such apprehension after requesting to photograph Elizabeth Akuyo Oyairo's coiffure on several occasions for his

hairstyle series. Oyairo repeatedly refused his offers, explaining, "Ojeik-
ere was a newspaper photographer, and I didn't know what he was going
to do with the photographs" (Magnin 2000, 128). Mustafa reported that
garment producers in Senegal are also "ambivalent about photography be-
cause itinerant photographers own the negatives, putting what we might
call intellectual property at stake. [As a result] some tailors do not allow
photographs of their work" (Mustafa 2002, 181). These well-founded
concerns have been bolstered somewhat by the recent publication of
vernacular portraiture in international art contexts. For example, previous
clients have arrived at Studio Malick to complain that images of themselves
or their relatives (which were originally private, personal commissions)
have been enlarged and publicly displayed in international art collections,
catalogs, and exhibitions without their consent (M. Sidibé 2004). Such
grievances have been particularly poignant when the photographs in
question reveal women—now mothers and grandmothers—topless or in
bikinis in their youth at picnics and parties during the 1960s and 1970s.
This brings to light issues of ownership, authorship, and the professional
responsibility photographers have toward their patrons, which, although
related to this discussion, are more fully addressed in chapter 7.

Drawing parallels among the social roles of griots and photographers
in Mali, practitioners and scholars alike have addressed the requisite
involvement (for related purposes) of both professionals at a variety of
public and personal events (M. Sidibé 2003; B. Koné 2004; Nimis 1998c,
82–83; Elder 1997, 78, 241–42; Conrad 2006, 80). Their shared presence
occurs at weddings, baptisms, musical performances, cultural festivals,
and other national events where each serves to validate the occasion,
highlighting the social status and reputation of the host while entertain-
ing and flattering the attendees.[6] As Sidibé relayed, "I received invitations
to family celebrations (weddings, baptisms) or to bare-earth dances, the
so-called 'bals poussière.' The photographer had to be there because this
added prestige to the occasion" (Magnin 1998, 76). The esteem that pho-
tographers bring to an event and its host derives from many levels: the
cost of their commission, the excitement and drama they contribute, and
their agency to preserve the moment for future commemoration—all of
which stem from their specialized knowledge and artistic aptitude.

Thus, as well as entertainers and historians, photographers are artists
and often define themselves as such (M. Sidibé 2003; Sogodogo 2004;
D. Cissé 2004; A. Lawal 2004; Awani 2004; Alioune Bâ 2004).[7] The
following remark by Sidibé illustrates this perspective: "I was an artist
starting from my first year in school. So you see it was kind of a natural
path from drawing to photography, because both offered me the op-
portunity to create images. . . . For me, setting up a photo shoot isn't so

different from drawing a scene: I decide what goes where, I decide how to pose the person in order to capture a certain physicality. That's what I do with cameras, with shadow and light" (Lamunière 2001b, 27, 53).[8] Generally speaking, therefore, professional practitioners in Mali (and to some degree their clientele) recognize artistry in photographic processes, which include several phases of production, from staging or framing a scene to postprinting techniques.[9]

In very simple terms, there are three or four fundamental steps—involving negative and positive processes—that determine the overall quality and success of an image. The first requires an in-depth practical understanding of the arrangement and balance of a composition; the relationships among lighting, distance, and film speed (ASA or DIN); and the camera's aperture or f-stop setting (essentially, the amount of light to which the film is exposed). The combination of these elements determines the balance, clarity, contrast, and three-dimensionality of the negative image.

As a result, a photographer must comprehend a number of formulaic equations to create a successful photograph, which renders photography as much science as it is art. For instance, the photographer must understand the technology of film: Higher film speeds require less light and can better accommodate fast-moving subjects due to shorter exposure times while lower speeds necessitate more light, a stationary subject and camera, and a longer duration of exposure. The former (400 ASA and higher) are not readily available in Mali (M. Sidibé 2003; Malick Sitou 2004).[10] Rather, 100 and 200 ASA black-and-white and 100 ASA color film are ubiquitous in local markets, which forces photographers to be quite creative and inventive in their work and explains why, as Malick Sitou says (2004), photographers there "use big flashes."

In addition to film speed, photographers must factor in the camera's distance from the subject in order to calculate and select the device's appropriate aperture or f-stop setting.[11] For example, according to Sitou, when working with a distance of three meters or less, an f-stop setting of 8 is typically used; 5.6 is employed for farther distances and for indoor use; and 11 is chosen "when the sun is overhead." For outdoor photographs, f-stop numbers are selected to suit the quality of sunlight during particular hours of the day. In Bamako, for example, Sitou suggests using 8 in the morning hours, 11 during midday, and 5.6 in the evening (Malick Sitou 2004).

Like their international colleagues, professional photographers in Mali make accommodations for particular lighting conditions during various times of the year, preferring to work when natural light is ideal, and know how to appropriately adjust the f-stop when it is not. According

to Sitou, during the cool season, when the sun is not as strong, the best time of day to take photographs is from 7:00 a.m. to 9:00 a.m. During this period, the light is soft and harmonious as opposed to dramatic and harsh. Alternatively, in the hot season, for Sitou, the ideal time to take pictures is earlier, between 6:15 a.m. and 7:30 a.m. (or 5:20 p.m. to 6:30 p.m.), using f-stop 8, because the sun is already too bright by 8:00 a.m. (Malick Sitou 2004). Of course, it is not typically possible for photographers to complete all their work within this brief time frame, as they must accommodate the schedules of their clientele. Thus, certain equations (noted in the previous paragraph) are used to improve lighting conditions that are less ideal. However, many photographers, such as Malick Sitou and Diango Cissé, create unsolicited photographs during these ideal hours for personal use or for their professional portfolios.

With equivalent observation, Sidibé discovered that it is best to use f-stop 8 while composing photographs in wedding contexts, where the bright flashes of multiple photographers' apparatuses and the lights of video cameras have an impact on the scene (M. Sidibé 2004). Furthermore, when working in color, some photographers find that adjustments must be made to suit the brand of film used. In Sitou's opinion, for instance, Konica does not require as much light as Kodak (which works best with a lot of light and bright colors), although it lacks the crispness of detail yielded by the latter (Malick Sitou 2004). In all cases, the technical expertise of photographers in Mali is impressive, particularly because none employ tools, such as the light meter, that have become mainstays among photographers in the West.

Within the studio, where photographers have more control over the compositional formulae (lighting, distance, film speed, and aperture), their unique solutions to common conditions are more apparent. First, many photographers have developed a system to regulate the standard distance they use to compose their portraits. For example, at Studio Malick, Sidibé had his tripod set at a distance of three meters to capture the most ideal portrait with the f-stop he uses (M. Sidibé 2003).[12] Second, photographers have been quite resourceful in installing self-engineered lighting systems within their studios, making use of available materials such as umbrellas, paint, fabric, plastic containers, scrap metal, and duct tape as well as inventing wiring systems that sync multiple lamps to a single remote switch. The resourceful engineering of available materials is prevalent in the darkroom lighting techniques of several photographers in Mali as well. Some paint standard white bulbs red while others place a red plastic bucket, tape, cellophane, or fabric over the light.

Each artist has also developed unique strategies to circumvent *kun fɛ kò*: an unplanned happening or unexpected surprise, an event often

resulting in an error not considered the fault of the photographer (M. Sidibé 2004; Malick Sitou 2004).[13] In the context of portraiture, this might include a person's movement (a blink or turn of the head), mechanical errors (film that does not advance properly or becomes stuck), electrical power outages, and so on. Practical attempts to manage these include supplying the studio with generators and, in the case of Tijani Sitou in Mopti, directing people—particularly children—not to blink (*kana i'nyɛ komi* in Bamanankan) or to "watch the bird [flash]" (*Wo eye* or *Ewo eye* in Yorùbá) before taking their picture (Malick Sitou 2006).[14] In 2004, with postmodern retrospection and a sense of humor, Malick Sidibé had plans to exhibit *kun fɛ kò* images from his archive in a future show he intended to curate titled *C'est pa ma faute* ("It Is Not My Fault"), which, unfortunately, never came to fruition.

After careful consideration of the aforementioned strategies and techniques, at this stage the photographer's image remains latent. At least two more processes must be completed to determine the outcome of the finished product: film development and printing. Both take place in the darkroom and require a specific set of skills as well as the capacity for creative innovation. As a result, most photographers agree that the true artistry of photographic processes takes place in the darkroom. In the words of Malick Sidibé, it is in this locale that "you become a real artist." He explained, "In the darkroom you [can] invent, create, ameliorate [and] beautify a photo with materials and techniques. . . . First you have to be selective in your materials: developer, fixative, paper and the lighting [the aperture setting of the enlarger]. . . . You must know how to measure light and find the equilibrium. Really . . . the darkroom [is where] a lot of things happen. . . . The darkroom is the birthplace of photos" (M. Sidibé 2004).

Arguably, the most important darkroom procedure is film development. The success of this process is largely determined by the previously delineated compositional elements and by one's familiarity with the chemicals (developer, stop bath, and fixative) and the ideal length of exposure for each. In Mali, there are three different methods photographers typically use to develop their black-and-white film: the lidded-cup system used by Malick Sidibé,[15] the dip-and-fall technique employed by Tijani Sitou,[16] and the suspension-box arrangement practiced by Adama Kouyaté.[17] Regardless of the particular method, the most important facet of this process is to keep the solution moving over the entirety of the film's surface to avoid unwanted specks, which are created when particles in the solution settle on the film.

Although the development process has become fairly standardized in Western contexts, local working conditions require that photographers in

Mali remain flexible, relying again on their creative ingenuity. Jean-Francis Werner has deftly explained, "The techniques of the darkroom are the triumph of empiricism, of inventiveness, of tinkering and manual skills. The ingenious practitioner [in Africa] works under radically different technical conditions, far from the norms recommended by all of the manuals. For example, the temperature of the various baths [developer, stop, fixative] is not controlled, neither [is] that of the darkroom, where chemical products and paper are stored" (Werner 1996, 100; see also Elder 1997, 85–86). In other words, the imported materials with which photographers must work have been designed to operate within specific climactic conditions (temperatures near seventy-two degrees Fahrenheit) that are difficult to attain in western Africa.[18] Thus, most photographers in Mali have had to invent ways to work around these challenges by developing and printing film during the late evening and early morning hours when temperatures fall, adding ice to their solutions, and shortening the time the film is exposed to the chemicals, as heat accelerates these processes (M. Sidibé 2004; S. Sidibé 2005; Elder 1997, 85). About these inventions, Malick Sitou (2004) stated, "These are secrets. Everyone has their own way. . . . However, there are three primary facts to consider: the lower the ASA, the longer the exposure; the more photos taken in daylight, the shorter the exposure; the newer the chemicals, the shorter the exposure. Don't pay attention to temperature."

If film development is most important, then producing the positive imprint of a negative image is the most artistic and creative of darkroom processes. It is during this phase that the photographer summons his greatest imagination, ingenuity, and expertise (S. Sidibé 2005). Here, with the use of an enlarger, he is able to manipulate the image: enlarge or diminish its size; crop it, reframe it, or alter the focus or balance of its composition; correct its flaws; and combine it with other imagery to create one-of-a-kind renditions (M. Sitou 2004). With regard to the last, some photographers have used double-exposure techniques to create images that combine portraiture with text for holiday wishes and greetings in several locally spoken languages (fig. 4.1), to create a double image of a single portrait (see fig. 2.40), or to combine two portraits within one image.[19] Malick Sidibé described his use of the technique to accomplish the last: "I took some photos of [a friend] and his wife. I made their portraits separately and then I joined them on the same paper" (M. Sidibé 2004). For these images, photographers print more than one negative (or the same negative more than once) on a single piece of paper in a two-step process. Typically, the first negative is exposed on one side of the paper, followed by the second negative, which is exposed adjacently.

Figure 4.1. Tijani Sitou, *Untitled* (double image holiday photograph of Adama Bamba, an apprentice of Tijani Sitou), 1989. © Tijani Sitou. Collection of C. M. Keller.

Photographers employ a host of other commonly shared and uniquely invented techniques to manipulate their images and correct flaws in their work. Like photographers who work with film around the globe, if an area of an image is too light, the photographer can utilize a "burning" technique, which exposes the particular area to light (the projected image from the enlarger) for an additional period of time. This is accomplished through the use of an opaque framing device (usually a piece of cardboard the size or larger of the paper being printed on) held between the paper and the projected image. It contains a small opening that when placed over the area in question exposes it to additional light, thereby rendering it darker in the final print. Alternatively, the "dodging" technique is used to correct areas of an image that are excessively dark or obscure. In this method, the photographer prevents the area from being exposed to the projected image by inserting a hand, finger, or specially designed tool (of various sizes) between the paper and the light, using small circular motions to ensure that visible demarcating lines do not result.

Imperfections can also be corrected directly on the negative with the use of a fine-point metal tool before printing or afterward by utilizing a retouching pencil or pen on the final print (Magnin 1997, 68; M. Sidibé 2003, 2004; Malick Sitou 2004). As Malick Sidibé stated,

We can retouch a negative . . . with a pen [or a pencil]. . . . White spots are due to the chemical being too strong or [if there is something on the negative] during the enlarging process the dot becomes more noticeable. We use the pen to darken them. I have done that a lot as there is a lot of dust here. I like it, but not too much. I base my prints on the tonality of my negatives. [In Mali] we don't use sharp metal objects to remove wrinkles, moles, etc., like they did in the West. (M. Sidibé 2003)

Likewise, Malick Sitou explained that at his father's studio in Mopti, they "usually buy the retouching pencil [with a hole that is filled with black charcoal] at a neighborhood bookstore. There are different grades: dark, light, etc. We use it to darken light spots on the prints. It is permanent. It doesn't come off" (Malick Sitou 2004).

Knowledge of the chemicals used in photographic processes is as critical for printing as it is for developing negatives in the darkroom.[20] In this space, where visual sensory perception is reduced, photographers identify the various solutions (developer, stop bath [usually water in Mali], and fixative) by smell and touch. Malick Sidibé explained, "The fixative has a strong smell . . . [and] is a bit dry, like water. [By contrast] the developer is slippery." However, photographers must rely on visual cues to gauge the age and effectiveness of each over time. Sidibé, for one, was able to identify "when the developer is getting old by the color. If it is the color of coffee, it is very old. Usually when it is light-coffee colored you can throw it away." However, he continued, "The fixative is something else. It is hard to know if the fixative is getting old, unless it stops working: If you put glossy paper in the fixative, and it is not working, the paper will no longer be glossy. Then you know that it is really old. [Typically] the fixative can print between four hundred and five hundred prints. It doesn't get old easily" (M. Sidibé 2004).

In addition, familiarity with photosensitive paper varieties is akin to, but more complex than, understanding film speeds.[21] In fact, for some photographers, the paper used is a trade secret; as a result, most do not regularly discuss the specifics of their paper selections with their colleagues. Before the advent of polycontrast paper, which was a fairly recent introduction in Mali in 2003, professionals learned which paper to use, and under what circumstances, from trial and error and by reading catalogues and print materials that accompanied Kodak, Ilford, Agfa, Lumière, and Adox products.[22] For example, Malick Sidibé would use paper grade 0 if a negative was dark or had a great deal of contrast, grade 4 if the image on the negative was "soft or weak," grade 3 if it was "hard or light," and grade 2 if it was "normal." He added, "Paper grade 1 is good for Africans and dark [skinned] people. When 1 has too much contrast, use 0. For lighter skin use 2" (M. Sidibé 2004). In the twenty-first

century, polycontrast paper and its affiliated filter system have rendered paper technology increasingly flexible and nuanced, offering a nearly infinitesimal variety of creative and corrective options.[23] Like its forerunners, polycontrast paper also comes in numbered grades as well as sheens such as glossy, pearl, or matte. However, the filters used with it allow photographers more breadth in terms of manipulating the contrast and brightness of an image. Sidibé stated that with polychrome paper he could "correct or adjust" certain aspects of a photograph more precisely by using one of the available filters (M. Sidibé 2004). It is worth noting here, however, that filters and polychrome paper must still be purchased outside the country—namely in Europe or the United States—as the only paper available in Malian markets is grade 2, glossy, in a variety of brands. A small box containing one hundred sheets of this paper costs about six thousand CFA (around twelve dollars), which is not a small fee given the average annual household income in Mali, in 2013, was estimated at six hundred dollars.[24] Those who can afford to obtain materials abroad pay even more, of course, underscoring their professional success, socioeconomic status, and ability to access the latest technologies. Therefore, through their own travels or those of their friends and relatives, a handful of photographers have been able to incorporate new photographic materials and methods within their work, which is thereby differentiated from that of their compatriots.

While championing the virtues of these new technologies, Sidibé simultaneously lamented some of the changes they bring that favor speed and efficiency over quality: "The world today is very fast, so they make products that are very fast. . . . The chemicals [and] the paper are made to work faster now. They call them 'Ultra Fast.' Even the Ilford box reads 'Ilford Speed.' [But] you need slow printing and good bathing for good photos. Then they will last for one to two hundred years without fading" (M. Sidibé 2004). Thus, imported materials reflect the cultural logics and value systems of the people who developed them, which are, in this regard, markedly distinct from those of photographers such as Sidibé in Mali.

Nevertheless, as previously stated, the majority of professional photographers in Mali believe most of the artistic processes for creating a great photograph take place in the darkroom, which they find more challenging than composing a photograph well. This is the primary reason that professional photographers in the country consider practitioners who have not learned darkroom processes "amateurs" rather than "artists." Sidibé confessed, "For me, they are not artists. They make only snapshots. After taking a photo, you should go into the darkroom to develop and print. There are things that you can do in the darkroom that you can't

do when you are taking a photo. . . . From the enlarger [one becomes an] artist" (M. Sidibé 2004).

Clearly Sidibé conceived of himself as an artist and had since childhood, when the French administration lauded his illustration skills and brought him to the capital as a teenager to study art and train in jewelry making at what is now the National Art Institute.[25] Thus, it is perplexing that Malian scholar Manthia Diawara should emphasize "that at the time that they were taking people's pictures in Bamako neither Malick Sidibé nor Seydou Keïta considered himself to be an artist" (Diawara 2003a, 10).[26] Although not all professional photographers in Mali believe they are artists,[27] many do. Moreover, a fair number were trained as artists before entering the photographic profession and conceptualize photography as an extension of their artistic engagement. In addition to Sidibé, these photographers include Diango Cissé, Youssouf Sogodogo, Harouna Racine Keïta, Alioune Bâ, Emmanuel Bakary Daou, Siriman Dembélé, Aboubakrine Diarra, Harandane Dicko, Dahirou Traoré, Abdoulaye Kanté, Adama Kanté, and others.[28]

Furthermore, it is noteworthy that while photographers such as Sidibé have considered themselves artists in terms of their social roles, they have not equated themselves to those engaged in the visual arts (such as blacksmiths, or *numuw* in Bamanankan). Rather, they identify their equivalent in the oral arts (griots, or jeliw).[29] This is largely due to the fact that there has not been a precedent for portraiture in local visual art traditions.[30] Given the genre's central import for photographers in Mali, it is unsurprising that Malick Sidibé and his colleagues have chosen to compare their role and work with that of oral artists whose central occupation has concerned the creation, idealization, and preservation of individual and communal portraits—the reputation, identity, and historical significance of personages in the region over time.

Thus, in addition to being artists, entertainers, and historians—most importantly, perhaps, as "visual griots"—professional photographers are creators and embellishers of individual and collective identities, preserving them on film to be reproduced and in some cases widely disseminated in the form of portraits, identification cards, postcards, posters, album covers, and other social media. Stressing this point, Sidibé stated, "A photographer must be like a griot. They must have the ability to make a flattering picture—to make things better than they are in actuality. [Photographers] make the individual more perfect. . . . They improve on reality to praise and respect the client" (M. Sidibé 2003).[31] In an interview with Karen Mohr Sokkelund, Sidibé made a similar statement: "[In the studio] I could model my picture any way I wanted, shading it like a drawing by adjusting an arm or correcting a lamp, creating a picture that

shows the customers the way that they wanted to be remembered. . . . A good photographer should act like a griot, flattering his customers. . . . Then you get the best out of them and the result is a picture that makes the customer very happy (K. Sokkelund 2009, 9).

Supporting Sidibé's position, Thomas Mießgang argued, "Just as [griots] sang the praises of princes and successful businessmen, photographers took the yearnings, dreams and desires for admiration of its socially segmented clientele and turned them into attractive [and desirable portraits]" (Mießgang 2002, 16). Likewise, Lamunière commented, "In Mali, sitters choose a photographer not just for his technical skills, but for his knowledge of fashion and style, his ability to interpret social values, and his inventiveness in helping the sitter create a particular identity" (Lamunière 2001b, 34). Diawara concurs, citing Keïta's work as an example:

> As a photographer, Seydou Keïta's role was to make his subjects look like they belonged to the bourgeoisie and middle class of Bamako, to make them feel modern and Bamakois. . . . Photographers in Bamako were no different that the barbers or tailors—they all beautified their clients or provided them with styles for the visual pleasure of people in Bamako. Their success depended on word of mouth, which contributed, as Pierre Bourdieu would put it, to increasing their symbolic capitals. They only became artists by first pleasing their customers, by providing them with the best hair styles, dresses, and photographs. (Diawara 2003a, 10)

For many photographers in Mali, it is the aspect of identity creation and embellishment that is most important in their work, and as such it is made central within the following analysis.[32] To best illustrate the role photographers have had in helping develop and augment the identities of their clients in photographs, this chapter turns its focus to the genre of portraiture. In so doing, it concentrates on the creative inventions and productions of world-renowned and locally famous artists, such as Seydou Keïta, Malick Sidibé, Tijani Sitou, and Adama Kouyaté, who have practiced in the cities of Bamako (Keïta and Sidibé), Mopti (Sitou), and Ségu (Kouyaté) during much of the twentieth century.

Photographers' Inventions

Since the 1930s, photography has provided Malians with a new medium and venue to express, invent, and preserve personal and collective identities. However, it remained largely under the control and mediation of professional photographers, who retained a monopoly over the trade until the 1980s, when amateur and color photography was enabled by the founding of large commercial laboratories.[33] Before that time, and

in some cases continuing today, professional photographers occupied a particularly significant, influential position within their communities, particularly in their role as visual griots.

Visual griot is a Western term. Malick Sidibé explained that he first considered it in 1992 when three journalists, an "American, Egyptian, and Frenchman," asked him if he thought of himself as a griot. After much reflection, he decided that he did, but for reasons different from those of the journalists. According to Sidibé, the unnamed reporters considered the photographer a griot because of the sociohistorical, or documentary, value of his work. This aspect pertains to Sidibé's conception of the term *visual griot* as well. However, he and his colleagues have considered themselves visual griots foremost because they have created idealized depictions of their patrons through their work both behind the camera and inside the darkroom (M. Sidibé 2005).

Like griots, in order to be successful, photographers must be able to identify and embellish the attributes of their clients, both physical and metaphorical, while minimizing their less desirable features, through the creative use of lighting and composed postures (Magnin 1997, 11; 1998, 39; M. Sidibé 2004). For example, one patron (fig. 4.2) was stylishly positioned by Tijani Sitou to conceal the fact that he is missing his left arm (Malick Sitou 2006).

Commenting on this aspect of his work, Seydou Keïta stated, "What really made a difference was that I always knew how to find the right position. I was never wrong. Their head slightly turned, a serious face, the position of the hands. . . . I was capable of making someone look really good. The photos were always very good. That's why I always say it's a real art" (Magnin 1997, 11). Keïta made a related statement elsewhere: "When you are a photographer, you always have to come up with ideas to please the customer. My experience taught me the positions that my customers liked best. You try to obtain the best pose, the most advantageous profile, because photography is an art, everything should be as close to perfection as possible. After all, the customer is only trying to look as good as possible" (Magnin and Keïta 2002, 68). He also stated, "I had to pose [my clients], to position them in the best possible way to try to add something to the figure, to embellish the person. That's why so many people would come to make appointments with me. You have to pose them. There are some people whose profiles aren't that attractive, but viewed from the front, it's very good. A good photographer is an artist" (Diakité 2002, 20). Likewise, Malick Sidibé argued, "[The photographer] decides what position will best compliment the person and the outfit they are wearing. The photographer must find the best pose for the person" (M. Sidibé 2005). Although complex agency is engaged in the

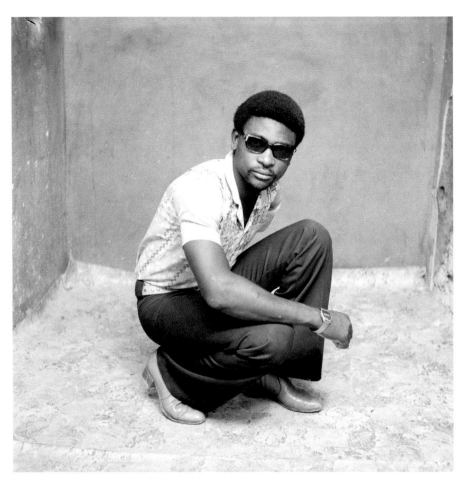

Figure 4.2. Tijani Sitou, *My Santiago* (named after the shoes; pose conceals missing left arm), c. 1980–84. High-resolution digital scan of original 6 × 6 cm negative. Courtesy Tijani Sitou Estate © Tijani Sitou.

photographic moment, in which clients may strike a pose of their own volition, most often the photographer positions his patrons and directs the composition (see Keller 2008, 597).[34]

For similar ends, although they do not necessarily select the material aids that appear in each portrait, photographers provide their patrons with props to facilitate the narrative quality of the image and to define the portrayed persons as worldly, modern, educated, pious, or a host of other desired qualities. Likewise, several urban photographers have utilized painted backdrops depicting idyllic city streets, villa interiors, manicured gardens, mosque settings, airplanes, hotel pools, and the like to further emphasize these characteristics in their portraits (Malick Sitou 2004; Elder 1997, 112; Nimis 2013).[35] Moreover, they regularly change these backdrops to keep them up-to-date, following the current trends

and meeting the immediate desires of their clientele (Malick Sitou 2004; Wendl and Apagya 2002, 45).

In portraiture, then, clients experiment with the visual communication of particular aspects of their real and idealized identities, values, trends, and relationships. Therefore, while creating a niche for themselves and their work in the increasingly competitive market, professional photographers have had to invent unique visual strategies that empower their images with particular meaning and facilitate the expression of their clients' aesthetic ideals and personal desires.[36] Through their formal orchestrations, photographers have been able to visually emphasize the fadenya aspects of the real or desired character of their patrons—their individuality, confidence, and strength—or their badenya relationships. Clients have wished to memorialize both aspects in portraiture. The compositional strategies photographers have employed most often concern the posture or pose clients assume in their portraits, the camera angle or vantage point from which the photographer composes the image in the lens, and the incorporation of backdrops and studio props.

For example, from 1948 to 1962, Keïta introduced unique and identifiable aspects in his portraits that have contributed to his success in both Mali and the global market.[37] Perhaps the most iconographic is his incorporation of printed textile backdrops in his portraits, which he likely learned from his mentor, Mountaga Dembélé (see Keller 2008, 616). Keïta, Sidibé, and others have continued this practice throughout their careers, aesthetically distinguishing their work from that of European photographers, particularly during the colonial period (Magnin 1997, 12; Lamunière 2001b, 23). In most colonial portraits, backdrops typically consist of plain cloth, bare architectural walls, rural settings, or painted interior or exterior scenes, often with Western-style architectural elements such as columns, arches, or staircases that suggest a location or narrative and add a decorative touch—a tradition locally continued into the present (see figs. 1.10 and 5.26). By contrast, the richly patterned backdrops in Keïta's and Sidibé's photographs, for example, add movement and energy to their images and emphasize the facial expression, posture, and personal style of their patrons, which appealed specifically to their Malian clientele. The use of patterned textiles as backdrops in Malian portraiture was likely an African invention developed locally in the early twentieth century. About this development, Lamunière argued that "it was the itinerant photographers traveling to rural areas outside colonial influence who were instrumental in developing a unique African style of portraiture [using] African textiles" (Lamunière 2001b, 19–20).

The visual effect and aesthetic appeal of this practice may have been influential for some European photographers in African cities as well.

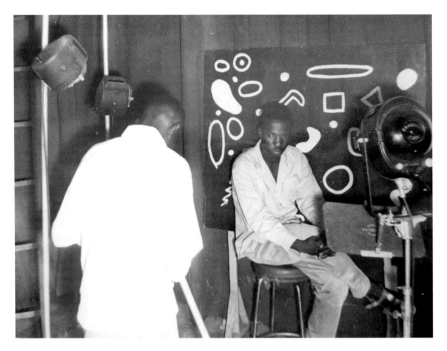

Figure 4.3. Gérard Guillat-Guignard, photo of Mamadou Berthé taking a portrait inside Photo Service featuring a geometrically painted backdrop, c. 1950s. Courtesy and © Gérard Guillat-Guignard.

This was true for Guillat-Guignard at Photo Service in Bamako during the 1950s. When Sidibé was hired by Guillat-Guignard to paint his studio, plain backdrops were used in the Frenchman's portraits (M. Sidibé 2003). However, a few years later, Guillat-Guignard introduced a painted panel he made (fig. 4.3) featuring abstract designs similar to modernist abstractions and contemporary *bogolan* "mud cloth" compositions created by Groupe Bogolan Kasobané in Ségu years later (Rovine 2001; Guillat-Guignard 2016). It remains unclear how often it was employed—or exactly by whom in every case—as it does not appear in portraits of Westerners or Africans displayed along the studio walls (see Keller 2008, 517, 640). Yet its presence highlights fluid and at times reciprocal exchange among European and African photographers in Bamako during the late colonial era. It also underscores the appeal patterned backdrops had in Mali at this time, particularly among African clientele.

With similar aesthetic goals, Adama Kouyaté created a special method of picturing infants by propping them up against the back of their mother (or some other object) concealed beneath a mass of printed cloth (fig. 4.4). In Kouyaté's own words, the strategy "makes them look like a grand person," both larger than life and the center of attention (A. Kouyaté 2004a). It also had a calming effect on the child, particularly when resting on their

Figure 4.4. Adama Kouyaté, *Untitled* (signature-style baby portrait), 1975. High-resolution digital scan of original 6 × 6 cm negative. Courtesy Adama Kouyaté and the Archive of Malian Photography (AMP). © Adama Kouyaté.

mother's back, ensuring a better photograph. As a result, both in Ségu and the international art market, Kouyaté's brand of infant portraits has become the photographer's famed specialty.

Another distinctive creation of Seydou Keïta is his "angled portrait," about which he stated, "I invented that myself as I went along. Since more and more people were starting to have their picture taken, I had to find a way to make the customers happy. That's something every photographer has to figure out for himself, and that's why I had so many clients. After all, I wasn't the only photographer in Bamako" (Magnin 1997, 11; Lamunière 2001b, 29, 46).[38] In Keïta's angled bust portraits, the client's upper body tilts slightly in one direction while the camera is gently turned in the other. The subject's face is positioned either frontally or in three-quarter view while his or her torso appears to lean toward the edge of the picture frame (fig. 4.5). The effect, which is often quite dramatic, draws special attention to the face, particularly the person's gaze, highlighting the client's distinct features and individuality and providing the emotive quality of strength and independence. Similar strategies were used in portraiture by Keïta's compatriots and West African colleagues around

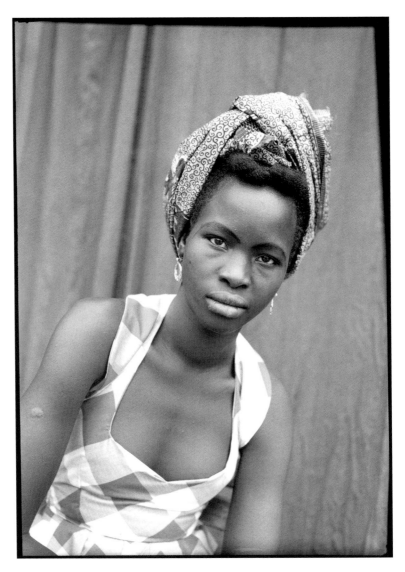

Figure 4.5. Seydou Keïta, *Untitled*, c. 1952–55. Gelatin silver print, 23 × 19 inches. Courtesy CAAC—The Pigozzi Collection. © Seydou Keïta/SKPEAC.

the same period (Mustafa 2002, 177).[39] Furthermore, photographs that capture images on display inside Photo Service during the 1950s suggest that Guillat-Guignard employed angled compositions within portraits of Western clients akin to the glamorous head shots of celebrities taken by the Harcourt studio in Paris during the 1930s and 1940s (see Keller 2008, 640). However, the often extreme dramatic slant, balanced composition, lighting, and technical strategies Keïta used to create his angled portraits appear unique to his work.[40]

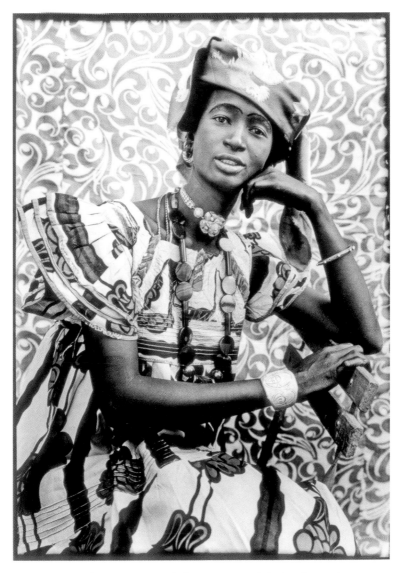

Figure 4.6. Seydou Keïta, *Untitled*, c. 1953–57. Gelatin silver print, 23 × 19 inches. Courtesy CAAC—The Pigozzi Collection. © Seydou Keïta/SKPEAC.

In portraits by professional African photographers in Mali, clients often assume relaxed postures to illustrate a sense of confidence and autonomy. In those taken by Keïta, Sidibé, and Sitou, for example, the viewer's regard is often directed upward toward the subject in a respectful manner and the person's gaze is confident, at times direct, stressing his or her independence and power to act (plate 2, figs. 4.5 and 3.4). Keïta's subjects, in particular, recline backward into their chair (see fig. 2.4), informally lean on one arm resting on the back of their chair (fig. 4.6), or liberate themselves from the seat, instead placing one foot

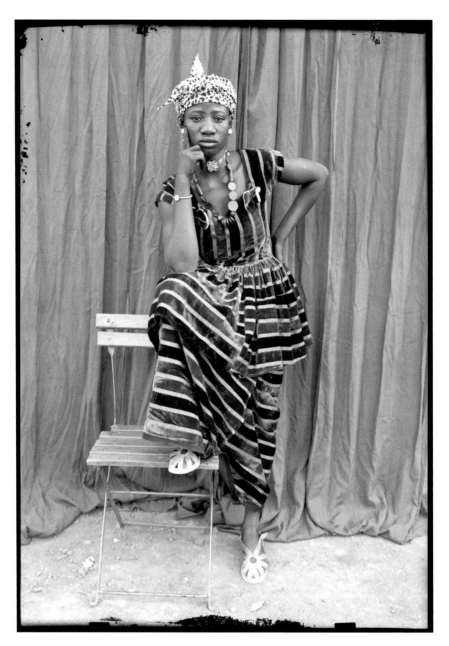

Figure 4.7. Seydou Keïta, *Untitled*, c. 1954–60. Gelatin silver print, 23 × 19 inches. Courtesy AAC—The Pigozzi Collection. © Seydou Keïta/SKPEAC.

on it (fig. 4.7). Similar trends are evident in the work of Sidibé, who often photographed patrons casually yet confidently seated backward in their chair, appearing stylish, rebellious, and in control (fig. 4.8; see also fig. 3.4).[41] As Lamunière observed, "Sidibé's subjects seem to throw their personalities at the camera to announce their individuality" (Lamunière 2001b, 31).

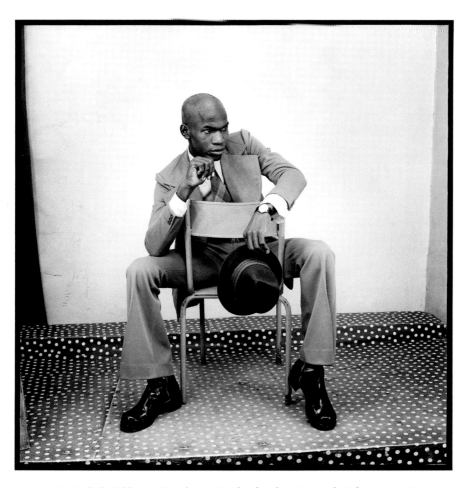

Figure 4.8. Malick Sidibé, *A Gentleman Tailor by the Name of Mabus*, 1972. ©
Malick Sidibé, courtesy MAGNIN-A gallery, Paris.

In contrast to portraiture created by some of his West African col-
leagues and compatriots (see fig. 2.5), which may deliberately appear
formal, serious, conservative, or restrained, Sidibé's images intentionally
convey a sense of gaiety and playfulness (see fig. 2.15).[42] On this topic,
his apprentice and adoptive son, Malick Sitou, admitted, "I think Malick
[Sidibé] asks people to laugh and smile more than my dad [Tijani Sitou]
did. [My dad's photos] are not as lively as Malick Sidibé's photos. Dad
didn't push [customers] to be as jovial and smiley as Malick does" (Malick
Sitou 2004). Sidibé himself explained, "Above all [in my photographs] I
have wanted to show laughter, joy [and] gaiety" (Magnin and M. Sidibé
2003, 77).[43]

Moreover, to reflect the energetic atmosphere of youths in Bamako,
Sidibé honed his ability to carefully frame dynamic compositions of

bodies in motion and cultivated this capacity among his apprentices (see fig. 2.27). About this practice, Sidibé stated,

> I was always attracted by movement. . . . I have always liked young people and felt good in their company. I don't like posed pictures; I've always felt the need to bring some life into my photos. Even in my studio photos, I was interested in movement, I was not happy when my subjects just sat there. I encouraged them to take a more casual pose so that their children and grandchildren would have a vivid memory of them and could form an idea of what they were like. That's what attracted me to young people and their parties as well. I really enjoyed watching them dance; the liveliness of their movements fascinated me. (Njami and M. Sidibé 2002, 94–95)

This talent is particularly evident in portraits of young people dancing at neighborhood parties, which simultaneously emphasize his patrons' abilities to participate in their often contumacious social world while highlighting their individuality and personal style. Discussing these images, Sidibé commented, "As a photographer I have been able to show this mad ambiance, this period so rich in revolutions that it threw our traditions into disarray. . . . When I saw them dancing . . . I had no need to look elsewhere. I revolved, I followed them like a hunter. I stepped to the right, to the left, following the movement" (Magnin and M. Sidibé 2003, 76–77).

In addition to this practice, Sidibé and his peers, such as Keïta and Sitou, experimented with low camera angles and dramatic lighting to visually articulate and underscore the fadenya sensibilities of patrons in their photographic compositions (M. Sidibé 2003). Both Sitou and Keïta have used low vantage points and pyramidal compositions to convey the commanding presence and status of elders (fig. 4.9; plate 2) and the individuality and strength of young kamalenbaw who are regularly posed in a variety of chic, dramatic postures (see figs. 2.41–2.43). The same tactics were utilized by a photographer employed at Studio Malick to convey the fadenya attitude of a young man in a photograph titled *On the Rocks of the Niger River* from 1971 (fig. 4.10). Through the use of an extremely low perspective, the contours of the man's body soar above the viewer, culminating in his confident gaze.

In his portrait of a boxer, Sidibé manipulated artificial light sources to create strong illumination and cast dramatic shadows behind his subject (see fig. 2.33). This strategy serves to highlight the boxer's aggressive posture and facial expression, thereby underscoring his fadenya qualities. Although Sidibé was not the only photographer to utilize such

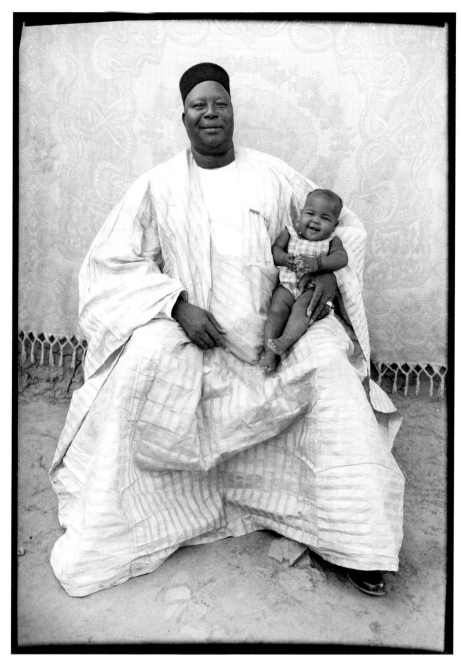

Figure 4.9. Seydou Keïta, *Untitled*, c. 1949. Gelatin silver print, 23 × 19 inches. Courtesy CAAC—The Pigozzi Collection. © Seydou Keïta/SKPEAC.

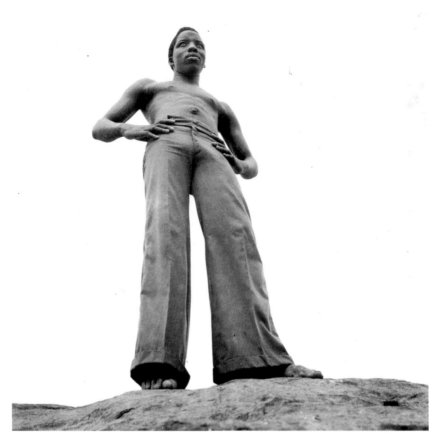

Figure 4.10. Studio Malick, *On the Rocks at the Shore of the Niger River*, 1971. © Malick Sidibé, courtesy MAGNIN-A gallery, Paris.

devices, he pushed these tropes further and developed a signature style of his own.

Professional photographers invented strategies to visually communicate badenya relationships as well, using posture and gesture to express these alliances in group portraits. For example, Sakaly's portrait of a couple from the early 1960s (fig. 4.11) expresses the badenya connection and relationship of the man and the woman through its triangular composition, intimate body language, and simplicity of design and texture. Photographers arrange the hands, arms, and faces of their clients to lead the viewer's eye through the composition, constructing visually solid and structurally unifying geometrical arrangements (figs. 4.11–4.12; see also figs. 3.9 and 3.11).

To more directly emphasize these partnerships, photographers employed narrative gestures in their compositions. In Sidibé's portraits, and in those of his friend and colleague Tijani Sitou, clients are at times

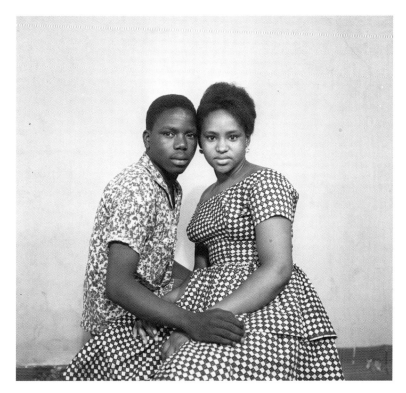

Figure 4.11. Abdourahmane Sakaly, *Untitled*, 1961. High-resolution digital scan of original 6 × 6 cm negative. Courtesy Abdourahmane Sakaly Estate and the Archive of Malian Photography (AMP). © Abdourahmane Sakaly.

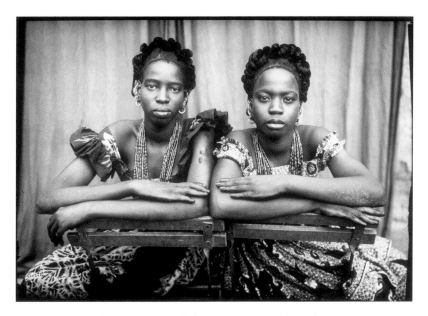

Figure 4.12. Seydou Keïta, *Untitled*, c. 1954–60. Gelatin silver print, 23 × 19 inches. Courtesy CAAC—The Pigozzi Collection. © Seydou Keïta/SKPEAC.

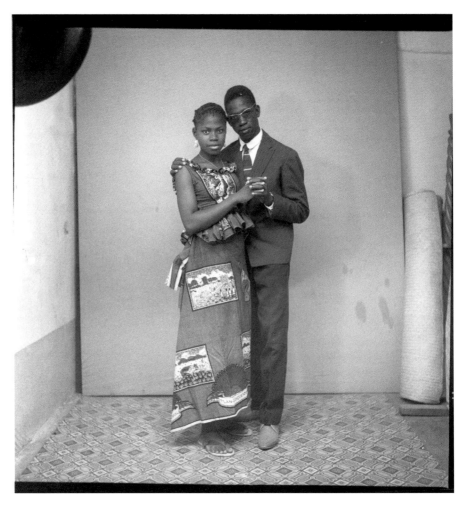

Figure 4.13. Malick Sidibé, *Untitled*, 1963. © Malick Sidibé, courtesy the Archive of Malian Photography (AMP) and MAGNIN-A gallery, Paris.

photographed in the process of holding or shaking hands to physically symbolize an existing partnership or alliance (fig. 4.13; see also fig. 3.14).[44] According to Sitou's son Malick, who is also a photographer, this pose depicts "real friendliness and badenya fraternity among people" (Malick Sitou 2004, 2006). As a result, Sitou posthumously titled a number of his father's portraits *Badenya Handshake* for exhibitions held at the Indiana University Art Museum in 2007 and the Residential College in the Arts and Humanities at Michigan State University in 2009 (fig. 4.14).

In related portraits, friends not only communicate and record their badenya relationship by shaking hands but—through the use of their left hands—express that one will be traveling soon and both want to ensure

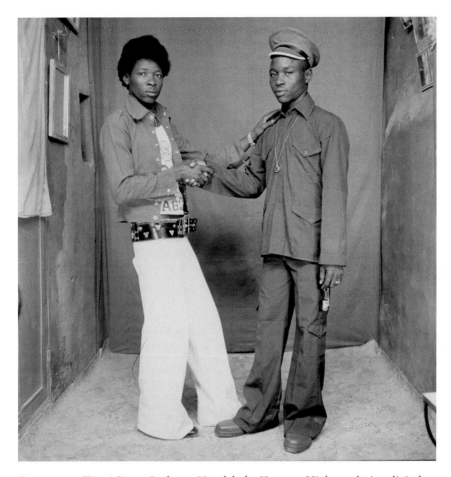

Figure 4.14. Tijani Sitou, *Badenya Handshake II*, 1975. High-resolution digital scan of original 6 × 6 cm negative. Courtesy Tijani Sitou Estate © Tijani Sitou.

they will see one another again (fig. 4.15). In Mali, according to Mande tradition, the right hand (*kinibolo* or "rice hand") is the social hand; it is the *only* acceptable one to be used for eating, greeting, or drinking. Alternately, the left hand (*nyumanbolo* or "good hand") is the private hand, which is reserved for personal hygiene. When taking leave of someone for an extended period of time, however, intimates purposefully shake left hands with the expectation the pair will be reunited and thus given the opportunity to "right" the social "wrong." This symbolic act illustrates their close relationship and desire to be physically reunited in the future. In this portrait, and ones similarly intended to convey badenya relationships by Tijani Sitou, Seydou Keïta, Malick Sidibé, Moumouni Koné, Bassirou Sanni, M'Barakou Touré, and Drissa Diakité, young women are positioned in what has been referred to as the "squatting pose" by Stephen Sprague (called *sònsoroli* in Bamanankan and *ìloósò* in Yorùbá; see also

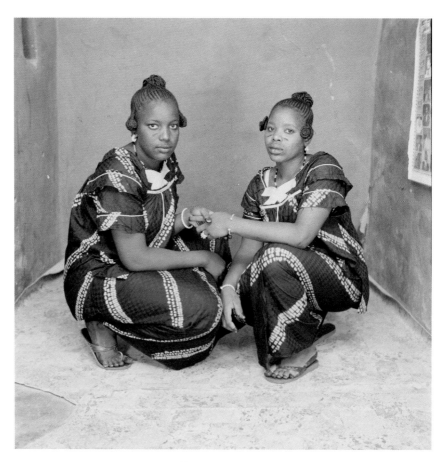

Figure 4.15. Tijani Sitou, *Farewell Friends*, 1983. High-resolution digital scan of original 6 × 6 cm negative. Courtesy Tijani Sitou Estate © Tijani Sitou.

fig. 3.14; Keller 2008, 597–99; Pigozzi and Magnin 2011, plate 11150).[45] Malick Sitou explained that the posture relates to one performed in rural areas when greeting a friend or relative with the desire not only to show humility and respect for that person but also to locate a position in which to speak more intimately (Malick Sitou 2004).[46] Thus, it is a posture understood as displaying esteem or honor as well as an intimate relationship with someone. During her research in Mali in the 1990s, Elder identified this as one of the three most common positions photographers work with in portraiture (Elder 1997, 117).

More generally, as Christraud Geary recognized, "sitters touching one another in group portraits allude to friendship and intimacy" (Geary 1999), thereby blatantly conveying their *badenya* connections.[47] As already seen, this includes holding or shaking hands and placing arms around shoulders (fig. 4.16; also see figs. I.1 and 3.11) as well as more culturally specific gestures. For instance, in photographs by Keïta and

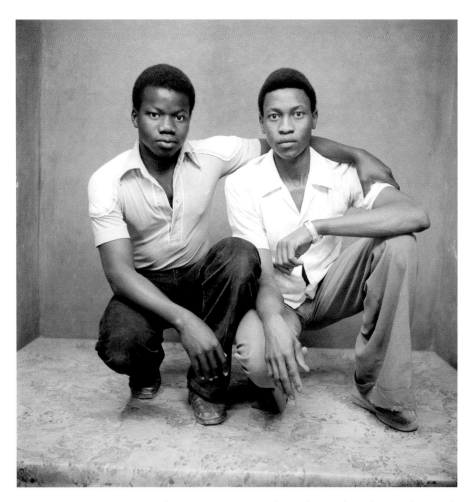

Figure 4.16. Tijani Sitou, *Badenya Pose*, 1980. High-resolution digital scan of original 6 × 6 cm negative. Courtesy Tijani Sitou Estate © Tijani Sitou.

Sitou (figs. 4.17 and 4.18), respectively, women have been positioned by the photographer, or posed of their own accord, with one hand on the breast of their intimate, be they relative or friend. This motion is a direct reference to badenya and is intentionally used to illustrate close, special relationships between individuals.

Sitou's portraits attest that fadenya and badenya are equally expressed in the portraits of foreign photographers in Mali. Born Yorùbá in Saki, Nigeria, he operated a studio in Mopti, four hundred miles north of Bamako, during the 1970s, 1980s, and 1990s. In his images of multiethnic clientele (namely Bozo, Fulani, Bamana, Yorùbá, Jokoramé, Dogon, and Songhai), expressions of fadenya and badenya are evident, and he intentionally constructed ways to visually emphasize them. Alongside his portraits of pairs assuming the *sònsoroli* and hand-shaking poses,

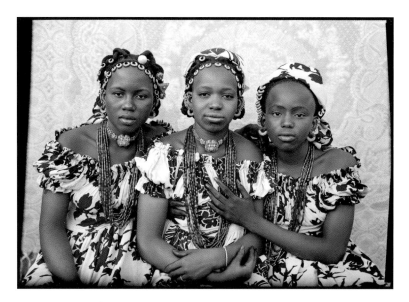

Figure 4.17. Seydou Keïta, c. 1948–54. Gelatin silver print, 23 × 19 inches. Courtesy CAAC—The Pigozzi Collection. © Seydou Keïta/SKPEAC.

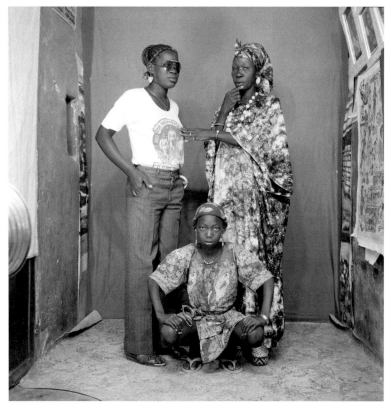

Figure 4.18. Tijani Sitou, *Untitled*, 1976–78. High-resolution digital scan of original 6 × 6 cm negative. Courtesy Tijani Sitou Estate © Tijani Sitou.

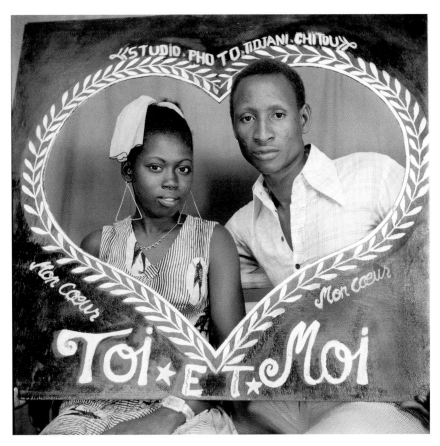

Figure 4.19. Tijani Sitou, *In Love*, 1977. High-resolution digital scan of original 6 × 6 cm negative. Courtesy Tijani Sitou Estate © Tijani Sitou.

he commissioned Malian artist Sidi Cissé to paint several heart-shaped frames with the words *Toi et Moi* ("You and Me") to convey intimate badenya relationships among couples, relatives, and friends (fig. 4.19).[48]

Sitou was first introduced to this practice by his mentor, Mahaman Awani, better known as "Juppau," in Gao (Malick Sitou 2004; Awani 2004). By 1974, Sitou's *Toi et Moi* frames had become popular among couples, women, and young men in Mali. Similar success was experienced by Abdourahmane Sakaly, Mamadou Cissé, and Azeem Lawal, who also used cut-out heart frames in their studios (see Keller 2008, 602–3). Elder attributes these devices to European origins, as they were once common in photographers' stands at fairgrounds and carnivals in Europe and the United States during the early to mid-twentieth century (Elder 1997, 114–15, 119).

In addition to inventing and appropriating compositional strategies, creative postures, and lighting techniques and incorporating African

textiles in their images, photographers made particular aesthetic choices in their portraits.[49] These techniques enabled them to create successful photographs while communicating significant cultural and personal ideals, such as those associated with fadenya and badenya. In order to deepen our understanding of the local significance of photography in Mali (particularly the genres of reportage and portraiture), the roles and inventions of photographers, and the relationship between aesthetics and societal values (largely conceptualized in terms of fadenya and badenya), this discussion now moves to an analytical overview of Mande aesthetics.

Notes

1. Eric Charry attributes the origin of the word *griot* to seventeenth-century French authors who derived the term *guiriot* from those used locally by West Africans. According to Charry, "By the late eighteenth century the spelling became standardized to 'griot,' which has since gained wide currency in francophone countries" (Charry 2000, 106–9). Although, as Conrad argued, "the Mande-specific term jeli . . . is preferred to the broadly used 'griot' . . . which describes bards of many cultures from the Senegambian coast to the Republic of Niger" (Conrad 2006, 78), the term *griot* is used in this discussion because it is employed most frequently by Malick Sidibé and his colleagues as an analogy to the social significance of professional photographers in Mali.

2. Popular musicians have also played this role in the twentieth and twenty-first centuries. For example, in 2009, renowned songstress Nahawa Doumbia sang Malick Sidibé's praises as he exited a nationally televised interview with Office de Radio et Télévision du Mali (ORTM) at Hotel l'Amitié in Bamako. (In this particular case, the Doumbia and Sidibé families share a special relationship that spans three generations [A. B. Cissé 2009]).

3. Mine is a highly abbreviated description of the multifaceted social roles of the griot. It is intended to launch the discussion of professional Malian photographers as visual griots in this chapter and by no means seeks to summarize the scope of the artistic, social, and historical significance of the oral historian in Mali.

4. As professional experts working in a relatively recent, urban-centered medium, photographers occupy a social position that falls outside the conventional social system of stratified labor, trade, or caste groups. As such, they are quite free to publicly define their social role and status and align themselves with established social identities according to their own conceptions. In this vein, Sidibé describes his social and professional role as that of a "visual griot" (M. Sidibé 2003, 2005). This notion is shared by fellow Malian professional photographers Amadou Baba Cissé, Emmanuel Bakary Daou, Sidiki Sidibé, and Omar Niang (Elder 1997, 242).

5. Similar coaching practices are evident at Studio Malick in a short film created by Susan Vogel, Samuel Sidibé, and Catherine de Clippel titled *Malick Sidibé: Portrait of the Artist as a Portraitist* (2006).

6. There is one remarkable exception to the often shared public presence of griots and photographers in Mali: the funeral, which typically includes griots but not photographers. Reasons for this are provided in chap. 6.

7. Doro Sy claims that photographer Diop in neighboring Senegal similarly held "special status as an artist among his friends and neighbors," suggesting that photographers in West Africa have been considered artists in modern local as well as global contexts (Chapuis [1998] 1999, 58).

8. While Sidibé's perspective may have been informed by his entrée into the international art market during the 1990s, in his youth Sidibé had already been recognized for his artistry by the French administration. As a result, he was brought to the capital to study art more formally at what is now the National Art Institute, where his work was exhibited in the 1950s. Most of his professors were French, and by this time he was quite familiar with the European concept of art and considered himself an artist (as did influential others).

9. This view has been informed by the following interviews: M. Sidibé (2005); Sogodogo (2004); Awani (2004); A. Lawal (2004); H. R. Keïta (2004); S. Sidibé (2003); A. Kouyaté (2004); Alioune Bâ (2004); Malick Sitou (2004); Magnin (1997, 11); Lamunière (2001b, 27, 51); and many others.

10. I characterize these products as "not readily available" because, although Lebanese markets in Bamako such as La Formi sell 400 ASA film, the price is prohibitively expensive for most photographers in Mali. Thus, most professionals use 100 ASA, 125 ASA, and 200 ASA, which they can purchase inexpensively at outdoor markets and in small boutiques, such as Dogon Electroniques, which is where Studio Malick personnel purchase their film (M. Sidibé 2003).

11. For those unfamiliar with manual photographic formulae, Bruce Warren explains, "the aperture is a variable-size opening in the lens . . . like the iris. . . . It is adjusted with the aperture ring. The numbers on the ring are an indication of the size of the opening and are called f-stop numbers. A standard series of f-stop numbers has been established: 1.4, 2, 2.8, 4, 5.6, 8, 11, 16 [and] 22. Contrary to what you might expect, [because they represent fractions] larger f-stop numbers indicate smaller apertures, which admit less light. Setting the aperture at f/8 will give *less* exposure than setting it at f/4" (Warren 2003, 4).

12. I have been asked not to publish all the details concerning each photographer's methods in the interest of protecting their trade secrets, which is why I have not specified the f-stop Sidibé employs within his studio. In a 2003 interview, Sidibé made nearly the same information public, omitting the aperture setting (Magnin and M. Sidibé 2003, 80).

13. For more on *kun fɛ kò* in Malian performance contexts, see Strawn (2011).

14. According to Malick Sitou (2006), "Yorùbá say that the flash is a white bird that flies into the eyes of the customer. To encourage them to keep their eyes open, my father used to say, 'Watch the bird!'"

15. For this method, the full development process takes place within a lidded plastic, cylindrical cup that has the capacity to hold one to two rolls of 35-millimeter or one roll of medium-format film. In this process, the film is wound around an internal plastic core that holds it in place while allowing

space for the chemical solutions that will be added to come into contact with the entire surface of the film—both front and back. In timed, sequential fashion, the developer, stop bath, and fixative solutions are individually added to the cup, which is then sealed and agitated for the appropriate length of time and finally emptied, until the development process is complete and the film is removed, rinsed, and hung lengthwise to dry. This is the most common method used by several professional photographers in Mali (M. Sidibé 2004; S. Sidibé 2005; Malick Sitou 2004). Most photographers and photography students working in black and white in the West also utilize this system.

16. According to Malick Sitou, his father, Tijani, "never used the cup method" to develop film. Rather, he used a tray. Sitou explained this system:

> If you have new chemicals, take the film in a straight line and hold it at each end. Keep it vertical. Dip the bottom end in the chemical, then switch [to do it from the other side] and switch again. You count thirty-five seconds, so you switch thirty-five times [once per second], and be careful not to get the chemicals on the table. If the chemicals are gold [older], then try forty to forty-five seconds. From there, you put it in the water [stop bath]. Then you put it in the fixative. Malick Sidibé said that this method is good, but it is too fast. To develop slower is better. The cup is better. It takes five to six minutes. Malick Sidibé used to do it this way also but he doesn't any longer. (Malick Sitou 2004)

17. Adama Kouyaté does not like the cup method employed by Malick Sidibé. Instead, he prefers to use plastic boxes that contain metal racks with clips inside (to hold the film in place). Each box contains a different solution: developer, stop bath, and fixative. After the last box, he places his film in water and hangs it to dry (A. Kouyaté 2004).

18. Elder pointed out that "early photographers [in Mali] relied on products coming from France, the most important of which were the French 'Lumières' products" (Elder 1997, 86). This has remained true over the decades as most photographers have continued to use (largely due to availability) Ilford (France) and Kodak (United States and Germany) products.

19. Nimis argues that double-exposure printing was introduced throughout western Africa by Yorùbá photographers from Nigeria during the 1950s (Nimis 2005, 2013). In part due to *ere ibeji* (twins) photographs created among Yorùbá photographers in Nigeria (Sprague 1978), this practice informs part of Micheli's "twinning" argument (Micheli 2008, 2011). However, to be clear, the practice of creating double-exposure images is distinct from wearing identical attire or "uniforms" in Mali, although they may appear in the same contexts, in which case they are typically indications of badenya rather than of "twinning" or twins.

20. The function and order of these chemicals (developer, stop bath, and fixative) are the same in printing sequences as in developing processes. Most photographers in Mali, like those in Western contexts, use the same three-tray system. In this arrangement, each chemical is poured into its own tray (or bin), which are then placed side by side from developer to fixative. Individual preferences introduce some variance in the practice. For example, Malick Sidibé (and his son Karim) arranged the trays from right to left while Tijani Sitou (and his son Malick) worked from left to right (Malick Sitou 2004).

21. Photo papers vary according to size, sensitivity, speed, and contrast. The speed of a given paper is determined by its particular sensitivity to light. Warren explains, "Less sensitive papers, called slow papers, are used for contact printing [placing the negative directly on top of the paper to print]. More sensitive papers, called fast papers, are needed for enlarged images. . . . Paper speed is not calibrated as closely as film speed, so . . . variations [may exist] from box to box of the same type of paper." Alternatively, Warren adds, "Print contrast is the difference in tones between light and dark. Paper contrast is the physical response of a paper to differences in exposure [to light]. . . . Paper contrast is given as a number, the contrast grade, which may range from 0 to 5. Grade 0 produces the least contrast and grade 5 the most. The normal contrast grade is 2" (Warren 2003, 79–80).

22. Polycontrast papers, or variable-contrast papers, can create greater variety in contrast, which is controlled in half-grade steps through the use of filters called variable-contrast filters. The filters are sold in sets by a number of companies and typically range from numbers 00 to 5 (Warren 2003, 80).

23. Malick Sidibé, for example, owned a set of Ilford Multigrade filters that contained numbers 00, 1/2, 1, 1 1/2, 2, 2 1/2, 3, 3 1/2, 4, 4 1/2, and 5, ranging from the lightest in burgundy color (which creates the least amount of contrast) to the darkest (which creates the most amount of contrast). Those who are intimately familiar with his darkroom know the number he uses most frequently and where it is stored. Again, I was asked to keep this information private to protect Sidibé's intellectual property.

24. Consult Arsenault et al. (2013).

25. When Sidibé was enrolled (1953–55), the institution was known as the École des Artisans Soudanais, and noted artist Alpha Yaya Diarra was one of his professors (M. Sidibé 2003; A. Y. Diarra 2009).

26. I cannot comment on Keïta's particular position since he unfortunately passed away before I began my research in Mali, and I was never able to speak with him. However, the recollections of Senegalese photographer Boubacar Touré Mandémory suggest that, unlike Sidibé, Keïta did not consider himself an artist while working as a photographer from the 1940s to the 1970s (Matt and Mießgang 2002, 79).

27. In addition to Seydou Keïta, one example that stands out in particular is that of Mamadou "Papa" Kanté, who stressed in an interview that he could not say he was an artist. Rather, he preferred to describe himself as a "pharmacist" since he was trained in pharmaceuticals in the USSR, although he does not own a pharmacy and has not worked as a pharmacist for several decades (M. Kanté 2004).

28. In a few of these cases (Harouna Racine Keïta, Siriman Dembélé, and Emmanuel Bakary Daou), photographers formally studied photography or enrolled in art courses at an institution in Mali or Europe after they had begun practicing photography. However, most of these men were versed in some form of art before pursuing their careers in photography.

29. This point is made evident in the case of Malick Sidibé, who engaged a variety of artistic media over the course of his life (illustration, jewelry making, photography) yet aligned his profession with that of oral rather than visual artists. Sidibé explained, "I don't make comparisons [between photography and] other visual art traditions in Mali . . . because design is

all that they have in common" (M. Sidibé 2005). Similar comparisons with "praise singers" are drawn by professional photographers in the Gambia, as reported by Liam Buckley (Buckley 2013, 303–5).

30. Traditional visual arts in Mali, particularly those created in Mande communities, include wooden and metal sculpture, leatherworking, textile weaving and dying, jewelry smithing, architecture and architectural decoration, and painting. However, none of the sculptural or painted arts serve as portraiture per se, with the exception of small personal figures (*flanitokélé*) that act as hosts for the spirits of deceased twins. (See Imperato and Imperato 2008 and Peek 2011 for more on twins in western Africa.) Rather than compare artists on the basis of sensory (vision) or media bias, as is customary in the West, photographers like Sidibé in Mali have based their comparisons on the symbolic and practical functions of their work.

31. Olu Oguibe bolsters Sidibé's argument, referring to the photographer's studio as a "chamber of dreams . . . where the reinventions and transfigurations [of one's identity] were accomplished" (Oguibe 2002, 14).

32. This is also true among photographers elsewhere in West Africa, such as Philip Kwame Apagya (Wendl and Apagya 2002, 45).

33. According to Bourama Soumaoro, a former employee of Tokyo Color, the first of these photo laboratories to open in Bamako was Couleur-Banque in 1983, followed by Tokyo Color in 1987 (Soumaoro 2004). With the advent of color photography and the presence of commercial laboratories in Bamako, many studios closed their doors. For the hundreds who persevere today, it remains difficult to be financially successful. Studio photographers are in constant competition with ambulant photographers and other amateurs who are not required to pay governmental taxes, rent, or electrical bills and thus are able to undersell studio prices by large percentages (A. B. Cissé 2005; S. Sidibé 2005; H. R. Keïta 2004).

34. I observed this practice on numerous occasions and personally experienced it during photo shoots I solicited of myself with friends and colleagues in Bamako during 2003 and 2004.

35. Nimis argued that these hand-painted, greyscale scenic backdrops were introduced throughout western Africa by Yorùbá photographers since the 1950s, constituting part of what she describes as "Yorùbá-style photography" (Nimis 2005, 2013).

36. Western authors often assume that techniques utilized by African photographers in Mali derive largely from Western practices and pop-cultural products. To the contrary, Keïta argued that before the 1970s, photographers in Mali were not influenced by the work of Western photographers (Magnin 1997, 12; Magnin and Keïta 2002, 68). Given the flow of material culture among the United States, Europe, and West Africa since (and before) the colonial era, it is likely that photographers and clients in Bamako were at times inspired by Western cultural productions. However, this does not suggest that the photographic creations of African photographers in Mali are merely derivative. Rather, they are transcultural with specific local relevance.

37. Keïta worked as a professional photographer from 1939, when he began learning from French photographer Pierre Garnier and Malian photographer Mountaga Dembélé, until 1977, when he retired. However, he ceased working at his own practice in 1962 while employed at the Sûreté Nationale (police

headquarters) in downtown Bamako. By the time André Magnin, the first to research Keïta's archives, arrived in Bamako in 1992, the negatives predating 1948 had been lost (Magnin 1997, 7, 12).

38. The photographer made a similar comment the following year (Magnin and Keïta 2002, 67).

39. See, for example, a portrait by Mama Casset from neighboring Senegal (Saint-Léon 1994) and one by Keletigi Touré from Mali (Monreal and Oliva 1997).

40. In addition to such artistic inventions, Keïta, like many of his younger colleagues, created a rubber stamp that enabled him to impress his signature, "Photo Keïta Seydou," on the back of his prints. This, he says, increased the value of his images among his Malian clientele (see Chapoutot 2016; Magnin 1997, 3).

41. See also portraits by Félix Diallo (Nimis 2003, 36 and 74).

42. Due to the formal appearance of these images, some Western authors have assumed they merely represent a continuation of Victorian tropes. However, scholars such as Geary and Sprague argued that the popular frontally seated, hands-on-knees posture likely derives from traditional methods of honorably depicting seated adults during public occasions, as seen in ancient sculptural arts as well as nineteenth-century portrait photographs of leaders (Geary 1997, 404–9; Sprague 1978, 52–59, 108–9). Furthermore, as Buckley recognized in the Gambia and Abiodun observed among Yorùbá communities in Nigeria, these formal depictions strategically convey an individual's idealized character and composure. In the Gambia, informed by a desire to depict oneself as a serious, model citizen and an aesthetic distaste for the contorted facial configuration, individuals are generally not pictured while smiling (Buckley 2013). Moreover, Abiodun argues, Yorùbá individuals find it important to have all ten fingers captured in their portraits because this allows them to be socially read as mature, full adults—an interpretation that derives from Yorùbá spiritual beliefs (Abiodun 2013). Malick Sitou (2006) explained that the "formal pose with hands on legs" is called *ya mi tika-tika* ("take me with my fingers" in Yorùbá), which young people consider to be a pose for elders. However, smiling in portraiture seems to be acceptable, and even expected, in portraits of children in Nigeria and other West African countries, such as Senegal. For example, Nigerian scholar Oguibe recalls a studio photographer telling him to smile when he was a child (Oguibe 2002, 10). Similarly, Doro Sy remembers an intimate named Dioundious yelling, "Smile, smile!" while he was being photographed in a studio during his youth (Chapuis [1998] 1999, 65). Seydou Keïta in Mali also asked his clients to "try to smile a little bit [but] not too much" (Magnin 1997, 11).

43. Elsewhere, Sidibé has said, "I am mainly interested in capturing joyful moments, joy and pleasure" (Lamunière 2001b, 54). His preference for conviviality and his manner of directing patrons to smile in their portraits has been captured in a curt documentary film (Vogel, Sidibé, and de Clippel 2006).

44. A similar gesture is performed in portraits by Seydou Keïta (see Pigozzi and Magnin 2011, plates 07477 and 00094).

45. Although few scholars have discussed this genre, Sprague attributes it to Western traditions of pinup girl posters (Sprague 2003, 249). After viewing

thousands of negatives and interviewing numerous photographers and their patrons in Mali, however, it is more probable that the posture recalls one assumed in certain rural and market areas when greeting in an intimate manner.

46. In a later interview, Sitou stated, "Sònsoroli is a sign of humility, patience, and respect. It is used when greeting and eating. In Nigeria, the Ibariba, an ethnic group from the Kwara State near Oyo State, all greet this way at the market, also on the farm. This is true in Dogon areas of Mali also, in certain places. The Tamacheck and Fulani greet this way, too, even today" (Malick Sitou 2006). Todd Crosby, a former Peace Corps volunteer and nongovernmental worker in Mali, concurs with Sitou's interpretation. Reflecting on his experiences working and living in several rural areas of the country during the past decade, Crosby commented, "The crouching, or down-on-one-knee, posture that many people assume in portraits may relate to practices of honoring people and expressing humility. [For example,] when women serve a visitor water in the village, they go down on one knee or crouch like that. So do performers and masqueraders when soliciting donations from attendees and when greeting elite audience members" (Crosby 2004). My own experiences in Bamako further support this notion. For instance, my colleague and I were offered water by Baru Koné's wife on our arrival to their home. She crouched down as she did so to humbly welcome us. Additionally, on several occasions, I was counseled by a Yorùbá neighbor of Studio Malick (nearly daily, as he passed by) to go down on one knee every time I greet him out of respect for his position as an elder.

47. Elder also commented on the use of touching in portraiture to indicate intimacy, particularly among youth (Elder 1997, 117–18 and 206).

48. It remains unclear when these studio aids were first introduced in Mali. However, according to Tijani Sitou's son Malick, his father was the first photographer to utilize them in Mopti.

49. In Western vernacular, *aesthetics* is often considered synonymous with *beauty*. However, as several international scholars have noted, aesthetics can be better understood as part of cultural logic, along with language, art, social structure, and organization, incorporating socially communicable values, such as categories defining what is "scary," "funny," "homely," "beautiful," and so on. This topic is the central focus of the following chapter.

5

Portraiture and Mande Aesthetics

MANDE AESTHETICS EXIST IN A vast constellation of culturally in-
formed knowledge that operates within all aspects of human experience.
Consisting of multivalent phenomena, they cannot readily be divided or
organized into neat categories. Any attempt to do so is admittedly overly
simplistic and generalizing. However, not to do so would mean forgoing a
certain degree of understanding the ways in which Mande aesthetics func-
tion in social and personal worlds. Therefore, this analysis centers on two
pervasive aesthetic concepts: *jɛya*—"clarity"—and *dìbi*—"obscurity."
These complementary aspects are present in all social interactions in Mali
to varying degrees and inform the creations and perceptions of people
across all genres of social life, including the domain of portraiture.[1]

In the thoughts and impressions of Malian citizens, jɛya and dìbi are
not static, clearly divided, or wholly separate concepts. Rather, they are
interdependent, correlative ideas fundamentally linked to practical as
well as philosophical principles. Operating in concert, their combinations
or ratios fluctuate, which enables them to express an array of complex
ideas. The kind of ideas communicated largely depends on the contextual
variables of a given situation and the knowledge base of their interpreter.
But identifiable generalities exist that can be illuminated to bring some
insight into the intricate world of Mande aesthetics. In the discussion
that follows, the general principles of clarity (jɛya) and obscurity (dìbi)
are individually presented to explore their role in constituting specific
aesthetic categories, such as beauty, humor, and horror, that inform
photographic practice.[2] Furthermore, this investigation will reveal how

they are sensually articulated in visual performance arts, including portraiture, to communicate underlying moral, philosophical, and spiritual values associated with fadenya and badenya.

Since commissioned portraiture is typically designed to represent one's ideal self, this discussion begins with beauty and the visual and verbal criteria through which it is articulated. In Mali, as elsewhere in the world, beauty (cɛnyi or cenye) is generally embodied in the feminine.[3] Idealized feminine features include a long "pointed" nose, a small mouth, almond eyes, an elaborate coiffure, a light complexion, and teeth that are "white, intact, straight, and not too big" (M. Sidibé, K. Sidibé, and Malick Sitou 2004). In addition, according to Malian anthropologist Youssouf Tata Cissé, "The ideal woman is characterized by four sets of three things each: three round forms (a well rounded head, ample breasts and large rounded buttocks); three attachments (a visible neck, a finely delineated waist and slender arms); three black traits (abundant black hair, large black eyes and black lips and gums); and three white traits (the untainted white of the eye, white teeth and an inner purity)" (Elder 1997, 103).[4]

These commonly held aesthetic ideals are repeatedly expressed in visual art forms. Among the most exemplary of these is Yayoroba, one of the human puppet masquerade characters that performs in the kamalen ton (youth association) theatre. Yayoroba, the "beautiful woman," "has firm jutting breasts, rounded buttocks, and a slender waist." She also features an elegant neck; a long, thin nose; black lips; white teeth and eyes; an elaborate hairstyle; and a light complexion (see Arnoldi 1995, 174, pref. 4). Jinè-Faro, the "female water genie," exhibits many of the same idealized attributes, including prominent breasts, black lips, an aquiline nose, a long neck, and light skin. Several of these features are also represented in jirimooni and jonyeleni sculptures and in the female figures atop some Ntomo masks,[5] which display large protruding breasts, a small mouth, an elaborate hairstyle, an elegant neck, thin arms and waist, and prominent, rounded buttocks (see Colleyn 2001, 105, cat. 81).[6]

Emphasis on these traits is also important in portrait photographs, in which photographers use lighting and strategic positioning to highlight the attractive features of their female patrons while accentuating other attributes such as jewelry, hairstyles, and smooth skin. In seated or bust portraits, photographers such as Moumouni Koné, Adama Kouyaté, Abdourahmane Sakaly, and Mamadou Cissé (fig. 5.1) have arranged women to create the illusion of being round and voluptuous and thereby more attractive (Elder 1997, 103). Discussing this practice, Kouyaté stated, "There were clients who came, thin women who came and who said 'I want to be fat in the photograph.' I took the picture in such a way as to

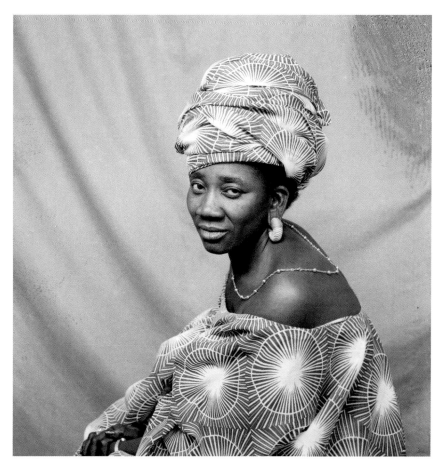

Figure 5.1. Mamadou Cissé, *Untitled*, 1960. High-resolution digital scan of original 6 × 6 cm negative. Courtesy Mamdou Cissé Estate and the Archive of Malian Photography (AMP). © Mamadou Cissé.

make them larger, and yet they were small and thin you see" (Elder 1997, 103). With similar impetus, Malick Sidibé intentionally composed his *Vues de dos* ("Back Views"; fig. 5.2), in ways that draw attention to the curvature and overall ampleness of his female models (M. Sidibé 2004).

Jɛya

On one level, the representation and identification of beauty is inextricably tied to the concept of jɛya, which can be defined as "whiteness, clarity, and cleanliness" (Bailleul 2000a, 179–82; M. Sidibé 2004; S. Sidibé 2004; Mara 2004). As an aspect of ideal beauty, jɛya is represented in the healthy white eyes and teeth of men and women and in the aesthetic appreciation of human skin. Smooth, luminescent, blemish-free

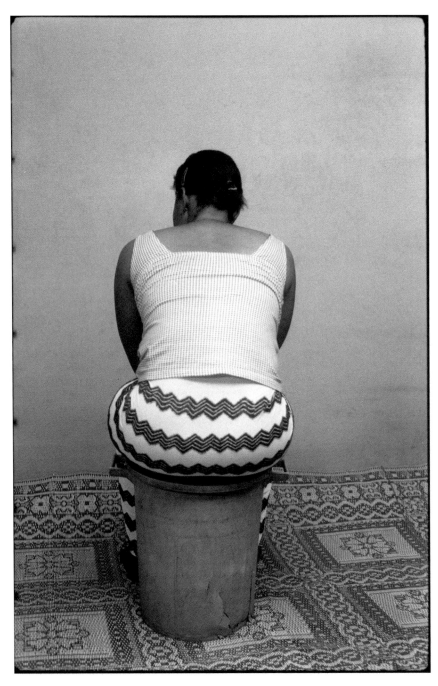

Figure 5.2. Malick Sidibé, *Vue de dos*, c. 2000s. © Malick Sidibé, courtesy the Archive of Malian Photography (AMP) and MAGNIN-A gallery, Paris.

skin is admired for both its appearance and its connotation of values such as healthfulness and youthfulness. As a result, in Mali, as in neighboring West African countries (Buckley 2013), fair complexions generally are favored over darker ones. Light skin is one of the essential attributes epitomizing ideal female beauty, as exemplified in Yayoroba. This aesthetic goal has driven many women to artificially lighten their skin—predominantly their face and hands—with commercial bleaching products.[7] Considered a luxury that most households cannot afford, an overwhelming majority of women who practice skin bleaching are members of the urban social elite.[8] These include popular female musicians, such as Oumou Sangaré, Nahawa Doumbia, and Babani Koné, and other women, regularly featured on Malian television (ORTM), who are active in political and cultural affairs.

Numerous socioeconomic and historical factors inform the appreciation of fair complexions and relative popularity of skin lightening in Mali. The most pronounced of these relates to lighter-skinned Fulani and Tuareg populations. For several centuries, both groups have remained among the wealthier classes and culture groups in the region. They have long been admired for their complexion as well as their personal displays of material wealth, including ornate jewelry, leather trappings, embroidered attire, elaborate coiffures, and henna-decorated skin.[9] By extension, traits that epitomize feminine beauty in Mali are embodied in the Fulani woman. This is evident in the puppet Mèrèn, which, according to Bamana communities in Ségu, represents a beautiful "Fulani maiden [who is] alluring but unobtainable as a wife" (Arnoldi 1995, 175). Likewise, for many years, a framed photograph of a local Fulani woman, renowned for her beauty, was featured on the wall of Tijani Sitou's studio in Mopti (Malick Sitou 2004). Expressing their admiration and desire, young male clients would often commission portraits of themselves taken with her image (fig. 5.3).

The values of whiteness and clarity associated with jɛya are also important for rendering individuals attractive in portrait photographs. This is particularly evident in the depiction of skin tone. When black-and-white studio photography was in vogue, clients often preferred artificial studio lighting to natural sunlight for its ability to lighten the appearance of one's complexion. They did so at their own expense since artificially lit photographs were more costly. About this practice, Keïta stated, "In the 1950s, my price was 300 francs for the natural light photos and 400 francs for the artificially-lit photos, because of the additional cost of the electricity. . . . Many people preferred the artificially-lit [photographs] . . . but I preferred natural light" (Magnin 1997, 11).[10] To amplify the skin's luminosity and lighten its appearance, some studios, such as that operated

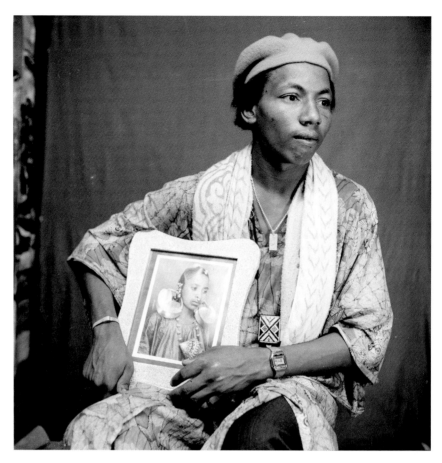

Figure 5.3. Tijani Sitou, *Untitled*, 1978. High-resolution digital scan of original 6 × 6 cm negative. Courtesy Tijani Sitou Estate © Tijani Sitou.

by Tijani Sitou, provided petroleum jelly and talcum powder for clients to use in their portraits (Malick Sitou 2004). Over the years, to render skin paler during the day as well as at night, many patrons requested the use of flash photography in portraits made outside studio walls (M. Sidibé 2004). Beyond beautification, artificial lighting and flash photography indicate the client's socioeconomic status due to their heightened cost.[11] Photographer Youssouf B. Touré explained, "We throw light on the event. . . . It's a way of showing people this guy (the client) has spared nothing on his wedding or on this event" (Nimis 1998c, 81–83).

The aesthetic consideration of individual complexions informs darkroom practices as well. Like their international peers, photographers in Mali print for skin tone[12]—the ideal of which, again, is smooth, uniform skin that tends toward the lighter side (fig. 5.1). As a result, harsh or high-contrast prints are avoided as undesirable.[13] To ensure that his prints have a soft, uniform quality with minimal contrast (see fig. 3.4),

for example, Sidibé innovated aesthetic strategies that require the use of secret products (M. Sidibé 2004).[14] With the advent of color laboratories in the 1980s, photographers have requested the reddening of their prints during development processes[15] because it makes skin appear lighter, softer, and smoother (plate 8).[16] Reddened portraits are particularly favored by female clients, who constitute the largest percentage of photographers' patronage (Ombotimbe 2004).

As such, jɛya principles inform the practice of photography as well as the aesthetic evaluation of photographs.[17] For example, a "good," or *net*, negative, one that is considered ideal, is sharply focused with clean, fine lines (M. Sidibé 2004).[18] Net negatives illustrate the technical skill of the photographer as they depend on several factors: correct aperture, distance, film and shutter speeds, and lighting. Expressing his preference for sharp images, Adama Kouyaté commented, "For me, a good picture is a bust. Two to three people, that is perfect. But when someone wants to be photographed with the entire family, if the picture turns out sharp it would make a nice picture, but often it lacks sharpness" (Elder 1997, 117).[19] Medium-format negatives, which most photographers working in black and white prefer to 35 millimeter, help in this regard because they decrease graininess in enlarged prints. This is particularly important today when exhibition and gallery prints are aggrandized to formats that reach fifty by sixty inches.

Unlike Western art gallery preferences for matte paper, photographers and clients in Mali typically prefer a glossy finish, which effectively maintains crisp, unbroken lines. For instance, Malick Sidibé once complained that matte paper is riddled with "pits" into which light falls, "breaking" the desired clean, fine lines of the image (M. Sidibé 2004). Likewise, most people in Mali prefer the brilliant shininess of glossy paper to the muted somberness of a matte finish, which explains why it is the only option available in Malian markets. Attesting to its deliberate articulation in photographs since the early twentieth century in Mali, Mountaga Dembélé explained, "I developed and printed all in the same night. Then, the following morning, when I went to the school [to teach], my wife did the glossing on a car windscreen" (Nimis 1998c, 49).

With related aesthetic concern, Sidibé discovered the "need to have a small white point in the pupil [of the subject], reflecting light." Otherwise, he said, "the person would look dead. It makes them look alive" (M. Sidibé 2004). Luminosity in eyes, skin, and teeth is considered ideal and symbolic of a person's *tère nyuman*, or "good character" (Elder 1997, 103).[20]

Jɛya also connotes significant, subtle notions that are conceptually related to, yet unique from, clarity and whiteness. These stem from the

root of the word, jɛ (or jè), which is defined as "white" and "clear," as well as "unity" and "alliance" (Bailleul 2000a, 179–80).[21] In terms of this understanding, jɛya is appreciated in the bodily structure of individuals and expressed through the proportion, harmony, balance, and symmetry of certain features, especially those of the face. Symmetry is often an important aesthetic ideal in hairdressing and scarification patterns as well.

Similarly, jɛya is represented in the structural perspicuity of artistic constructions, which is visually expressed in the balanced, symmetrical features of women in sculpture, such as Yayoroba, Jinè-Faro, jonyeleniw, jirimooniw, and female figures surmounting Ntomo masks (see Keller 2008, 607–8). Structural balance is also evident in the abstracted, clearly articulated features and scarification patterns of Ntomo masks and CiWara headdresses (see fig. 2.47). Likewise, McNaughton notes that youth association masks are praised for being "beautifully proportioned" (McNaughton 1988, 163). Formal harmony and balance, however, are not always symmetrical, as illustrated in *bogolanfini* textiles and some CiWara and Sogoninkun headdresses, which are generally considered attractive (see Colleyn 2001, 72, 233).

Rather, photographs regularly depict structure and balanced asymmetry. Balance in the layout or composition of portraits is often expressed through the arrangement of figures in groups and the calculated posture of individuals. This is true in the S-shaped composition created by Sidibé (fig. 5.4) and in the L configuration regularly used by Keïta (plate 1; fig. 5.29). To provide a sense of balance and organization in group portraits, Keïta, Sidibé, and Sitou have arranged their clients in the shape of a V as well as other geometric compositions (see figs. 2.15, 3.2, 4.14, and 4.18).[22] Although Sitou positioned a man wearing a grand boubou nearly in the center of his photograph, the large portable radio on the right adds a layer of interest without disturbing the balance of this otherwise symmetrical portrait (plate 2). Balanced asymmetry is also evident in a portrait of a man taken at a house party by Sidibé's assistant, Sidiki (fig. 5.5).[23] The curve of the man's body energizes and complements the linear division of the room while neither focal point—the man's head nor the record in his hands—is directly centered within the photograph. Malick Sidibé used this approach to particular dramatic effect through the interplay of light and shadow in his portrait of a boxer (see fig. 2.33).

Additional strategies were employed by photographers to avoid exact centrality and symmetry in portraiture. These include Keïta's angled bust portraits (see figs. 2.10 and 4.5), which intentionally frame clients with their head just off-center, and Sakaly's portrait of a couple in which

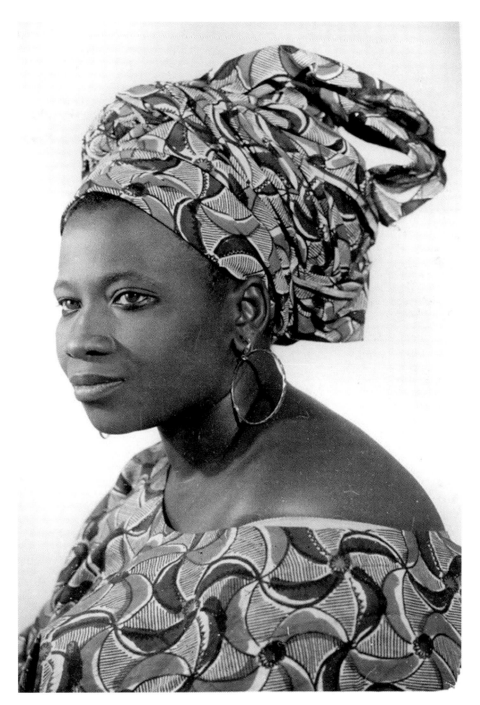

Figure 5.4. Malick Sidibé, *Untitled*, 1960s–1980s. Reprinted by Malick Sidibé for author, Bamako, 2004. © Malick Sidibé.

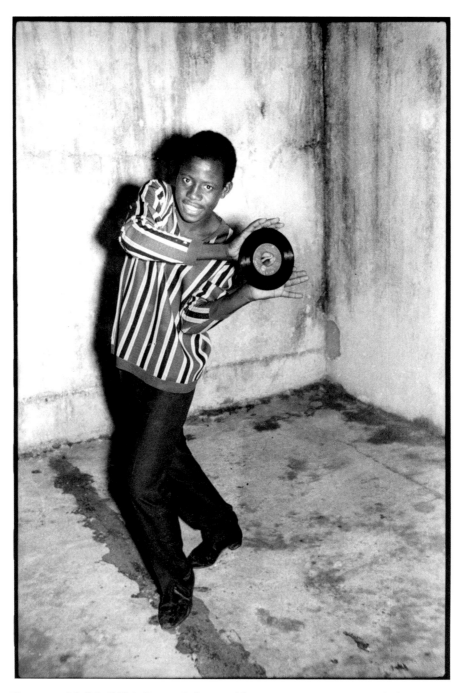

Figure 5.5. Malick Sidibé, *Drissa Balo's Wedding Reception*, 1967. © Malick Sidibé, courtesy MAGNIN-A gallery, Paris.

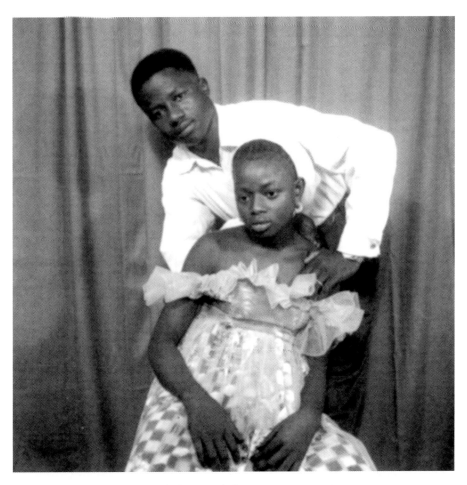

Figure 5.6. Abdourahmane Sakaly, *Untitled*, c. 1950s–1960s. Courtesy Abdourahmane Sakaly Estate and the Archive of Malian Photography (AMP). © Abdourahmane Sakaly.

each person leans in opposing directions to create various angles that add visual dynamism to the balanced composition (fig. 5.6). A similar tactic was used by one of Sidibé's assistants in a "party" picture that depicts two men posed in a dynamic composition replete with multiple angles (fig. 5.7). The use of angles to create an energetic, asymmetrically composed, balanced portrait is evident in Studio Malick's "freeze-frame" images of dancers (see fig. 2.27). According to McNaughton, "Mande sculptors depend heavily upon the controlled collisions of prominent angles, curves and planes . . . to give prominence to heads" (McNaughton 1988, 105). Photographers create angular compositions for similar ends, as the head—the most identifiable feature of a person—is the most important aspect of a portrait.

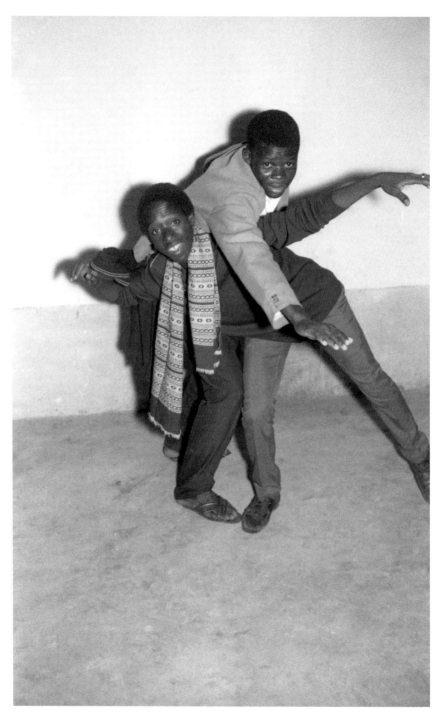

Figure 5.7. Malick Sidibé, *The Makessous*, 1969. © Malick Sidibé, courtesy MAGNIN-A gallery, Paris.

Jεya and Badenya

The aesthetic ideals affiliated with jεya (whiteness, clarity, cleanliness, structure, and balance) are conceptually linked to the moral values associated with badenya (unity, harmony, cooperation, and honesty). For example, in her research among *jeliw*, or griots, in Mali, Hoffman relates, "Speech that can be characterized as clear (*kuma jè*) is the conveyor of truth" (Hoffman 1995, 39; 2000, 83, 93). Similarly, in his studies of Mande blacksmiths, McNaughton has found that *kuma jε* is synonymous with *kumakolo*, "the bone of speech, true speech, speech that is without ornament and goes concisely to the heart of the matter" (McNaughton 1988, 109). Moreover, clarity is also used to describe the expected composure, character, and speech of nobles, or *hòròn*, in Bamanankan (Hoffman 1995, 38). In this way, it represents an ideal that symbolizes emotional restraint, trustworthiness, and fairness. More broadly, it is commonly used to describe the honorable intentions, integrity, and appropriate behavior of people in general. For example, when blacksmith Sédu Traoré compared the "good work of smiths—as doctors, diviners and amulet makers—to the bad work of charlatan . . . Muslim marabouts who seek personal gain by claiming to help people," he did so in terms of "clarity," stating, *An ka sira jεya de!*, "Our path is clear." *Mori ka sira jεya tè*, "The marabout's path is not clear" (McNaughton 1988, 110). Likewise, according to Imperato, during Modibo Keïta's Cultural Revolution in 1967, the president was praised on Radio Mali and in *L'Essor* as *Le guide éclaire*, meaning "The Clear Guide" in French (Imperato 1977b, 60), which directly relates to the use of jεya in descriptions of one's character as transparent and righteous. Clarity as a virtue was similarly expressed during my own research experience in which Malian friends and colleagues complimented my project by stating, *i ka sira jεlen don*, meaning "your path is clear" (M. Sidibé 2004; Malick Sitou 2004). Moreover, when shaking left hands (or "good hands," nyumanbolow) with a confident who is soon departing (see fig. 4.15), one must step out of the shade and into the sunlight to render the gesture clear and true (Grosz-Ngaté 2013). This aesthetic value is visually articulated in one's resting posture, as well, whether in casual contexts or when formally posed before the camera. Almost as habit, individuals of diverse genders, generations, and cultural backgrounds in Mali commonly place their right hand over their left wrist or cross their right leg over their left, privileging clarity and righteousness (Malick Sitou 2009, 2019).

Another aspect of jεya, whiteness, signifies inner purity or goodness, trustworthiness, and honesty (Elder 1997, 103). Malians generally view interior and exterior states as inherently connected. Attractive physical

traits convey one's positive, badenya-oriented character. Such demeanor, and the physical features that articulate it, indicate a person's tère nyuman. This equation enables people to draw "a direct relationship [for example] between physical beauty and a woman's moral worth" (Arnoldi 1995, 174). This is evident in the beautiful woman of "exemplary character," Yayoroba, through her idealized aesthetic attributes and moral behavior. Arnoldi explains, "Her appearances . . . always highlight these qualities, as she begins her performance by modestly bowing first to the elders, then to the lead singers, and finally to the assembled audience. . . . Yayoroba's characterization as a *muso nyuman* [good woman] is clearly communicated through both her sculptural form and her dance and is further reinforced in her signature song" (Arnoldi 1995, 174). McNaughton's account of youth association dances is similar, and he argues that they "were praised as beautiful in the deep sense that acknowledges character as well as appearance" (McNaughton 1988, 163). Thus, aesthetic ideals affiliated with jeya are conceptually linked to moral values associated with goodness.

Formally represented through clarity, balance, and whiteness, jeya in art signifies purity, harmony, and forthrightness—values associated with badenya (Hoffman 1995, 39). In sculpture, for instance, jeya and badenya are mutually expressed in the depiction of prominent, symmetrical breasts and enlarged, open palms (Arnoldi 1995, 174). Referencing *sinjiya*, and by extension badenya, breasts highlight the importance of communal support and socially nurturing behavior while magnified, open palms metaphorically suggest clarity, honesty, and cooperation, underscoring values related to badenya (McNaughton 1988, 123). Badenya and jeya are also expressed, as Arnoldi demonstrated, through the form and behavior of puppet and masquerade characters, including Yayoroba. On entering the arena, these costumed performers bow to seated elders and community leaders, openly signifying humility, integrity, social etiquette, and respect for social hierarchies (Arnoldi 1995, 174).[24]

To represent badenya relationships and related ideals in portraiture, professional photographers visually articulate jeya through their compositional arrangements, poses, and lighting techniques. In these photographs, generally uniform lighting is employed, as opposed to dramatic lighting, which, for example, Sidibé has used to emphasize fadenya in portraits of boxers (see fig. 2.33). Sidibé described this very soft (*a sumani*) and uniform lighting as "good lighting" (*a yelen ka nyi*) as well as *lumière ambiante* (M. Sidibé 2004).

Photographers also use posture and gesture to express badenya alliances in group portraits. To visually emphasize intimate relationships (badenya) and provide a sense of unity and balance in these images,

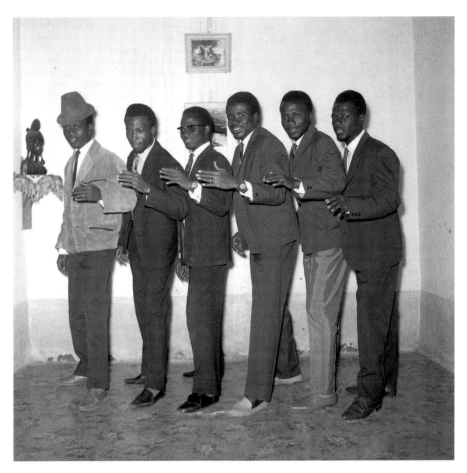

Figure 5.8. Malick Sidibé, *The Barbus Group*, 1969. © Malick Sidibé, courtesy MAGNIN-A gallery, Paris.

photographers arrange clients in structurally stable configurations based on the circle, the triangle, the rectangle, the diamond, and the pyramid (figs. 5.8 and 5.9; see also figs. 3.9, 3.11, and 4.12). Photographers also render these values visual by maintaining balance in the social hierarchy of those depicted (see fig. 2.1). As Elder noted, when pictured with younger relatives, respected elders are typically centrally seated with children and grandchildren featured beside, behind, or encircling them (Elder 1997, 116).

In aesthetic appreciation, jɛya does not function alone. While structure and clarity render an object readable, organized, and balanced, embellishment adds interest, motion, and what McNaughton calls "spice."[25] In Bamanankan two terms are commonly used to describe visual embellishment: *nyègen*, "pattern and adornment," and *màsiri*, "decoration"

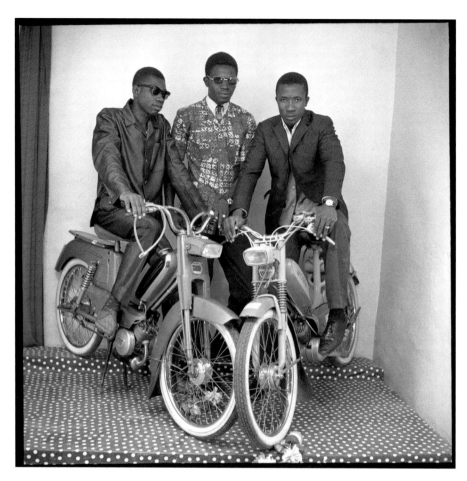

Figure 5.9. Malick Sidibé, *Three Friends with Mopeds in the Studio*, 1975. © Malick Sidibé, courtesy MAGNIN-A gallery, Paris.

(Bailleul 2000a, 304, 368; McNaughton 1988, 143–44). They apply to personal adornments, such as jewelry, hairstyles, scarification, and henna, that embellish the previously discussed structural attributes of human form and are regularly emphasized in portraiture through meticulous compositional arrangements and lighting (plates 1 and 9; figs. 5.10 and 5.11). They can also refer to the juxtaposition of design and color in clothing and textile patterns as well as to the decorative aspects of sculpture and architecture. Inherently, then, structure and embellishment represent complementary aspects of a visual dynamic in which ideally some sort of balance is maintained. In other words, nyègen (pattern and adornment) and màsiri (decoration) contribute vitality and motion to prevent the boredom and stasis of structure alone. Alternately, jɛya provides order and stability to restrain embellishment from becoming overwhelming, chaotic, and, by extension, meaningless.

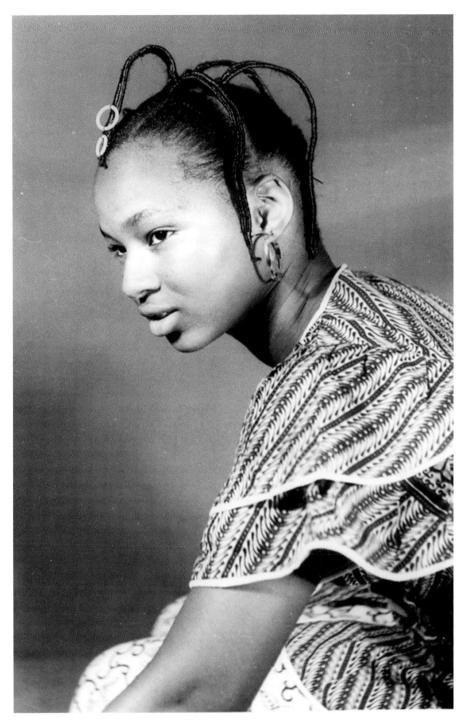

Figure 5.10. Papa Kanté, *Untitled*, 1970s–1980s. Reprinted for Papa Kanté for author, Bamako, 2004. Courtesy the Papa Kanté Estate. © Papa Kanté.

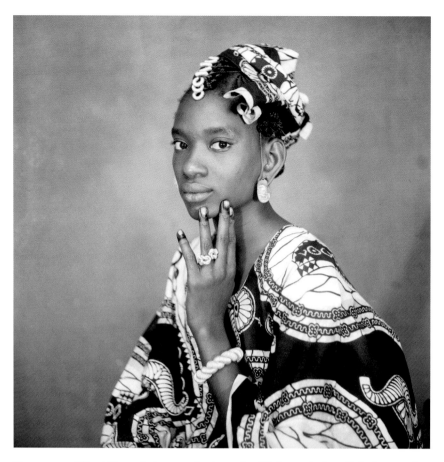

Figure 5.11. Tijani Sitou, *Jokorame Lady*, 1980. High-resolution digital scan of original 6 × 6 cm negative. Courtesy Tijani Sitou Estate ©Tijani Sitou.

In terms of these separate formal qualities in the aesthetic appraisal of artworks in Mali, Brink divides "goodness" (*nyì*) from "tastiness" (*di*): "An art form's 'goodness' refers to its basic ordering characteristics [structure], those qualities which give form an identifiable and appropriate shape in time and space, whereas an art form's 'tastiness' summarizes qualities which emerge to challenge, develop, embellish, improvise or change this given shape." Thus, for an artwork to be considered "good," *a ka nyì*, and "tasty," *a ka di*, requires an "interplay between [the] two dimensions of form": structure and embellishment (Brink 2001, 238). The same principles apply to photography.

In tandem with jɛya, embellishment (nyègen and màsiri) is prevalent in portrait photographs in a variety of ways. Most predominantly, it is constituted in backdrops, flooring, studio props, and clients' attire. For several decades, particularly in Bamako, patterned, nonfigurative backdrops (nyègen) have been employed in photographers' studios as

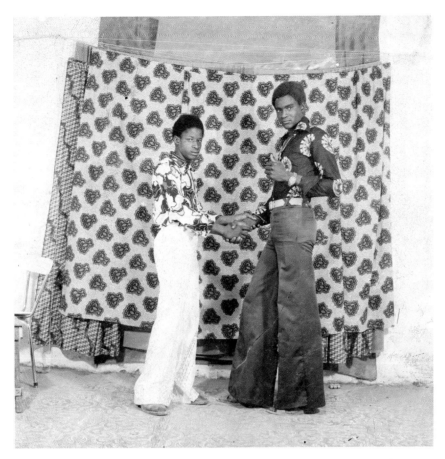

Figure 5.12. Mamadou Cissé, *Untitled*, c. 1960s–1970s. Courtesy Mamadou Cissé Estate. © Mamadou Cissé.

decoration (màsiri). One of the first Malian photographers to incorporate decorative cloth in portraits was Mountaga Dembélé. Not long afterward, his apprentice and colleague, Seydou Keïta, featured ornate cloth in the background of his portraits (plate 1; see also fig. 5.29, including delicate floral patterns as well as more dramatic arabesques, checkers, and paisleys or "leaves" (Magnin 1997, 12).[26] Mamadou Cissé also had numerous printed and woven textile backdrops in his studio (fig. 5.12). In Timbuktu, Hamidou Maïga incorporated a checkered blanket, patterned cloth, and a woven mat within some of his portraits (fig. 5.13). Félix Diallo in Kita employed a decorative cloth and a checkered blanket in the background of his images (see Nimis 2003). For many years Sidibé has used two versions of striped cloth as studio backdrops, coupled with polka-dot patterned, checkered, floral, or variously designed linoleum flooring (fig. 5.14).

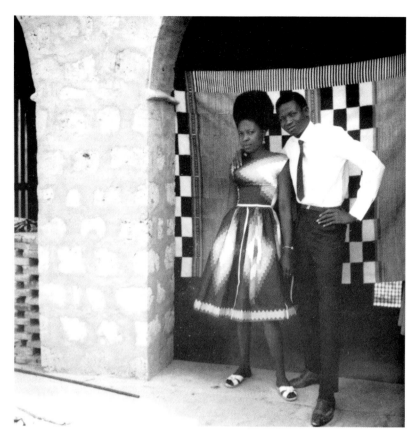

Figure 5.13. Hamidou Maïga, *Untitled*, c. 1950s–1960s. Courtesy and © Hamidou Maïga.

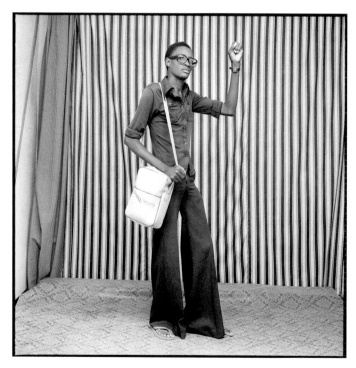

Figure 5.14. Malick Sidibé, *Young Man in Bellbottoms with His Bag and Watch*, 1977. © Malick Sidibé, courtesy MAGNIN-A gallery, Paris.

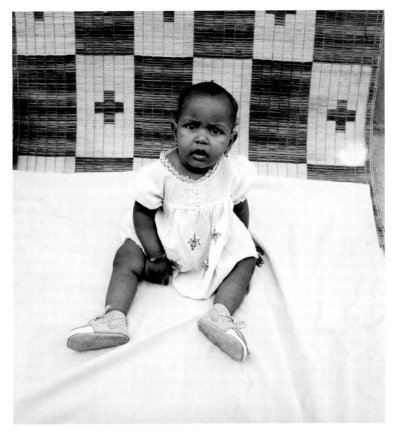

Figure 5.15. Tijani Sitou, *Untitled*, 1978. High-resolution digital scan of original 6 × 6 cm negative. Courtesy Tijani Sitou Estate © Tijani Sitou.

Each of these decorative additions contributes energy and movement to the photographs in a manner that painted scenes, for example, cannot. This aspect of Sidibé's images is so important that during his son's wedding celebration, a patterned cloth (plate 6)—normally featured in the studio—was hung along one of the walls in the courtyard of his compound to be used as a background for composed portraits (M. Sidibé 2004). As such, the cloth serves three functions: it helps create a formal atmosphere in the outdoor setting (much as backdrops did in the courtyard studios of first-generation photographers), it adds energy and vitality and embellishes the photograph to increase its appeal, and it acts as a trademark or signature indicating Sidibé's involvement with and/or authorship of an image.[27] In a similar fashion, Drissa Diakité regularly used a blue-and-white floral patterned backdrop to energize and adorn his studio portraits for this purpose (plate 8). In some cases, such as Sidibé's *Vues de dos* portraits and those by Mamadou Cissé and Tijani Sitou, woven fiber mats are used to embellish the background (fig. 5.15). Sometimes, even the texture of

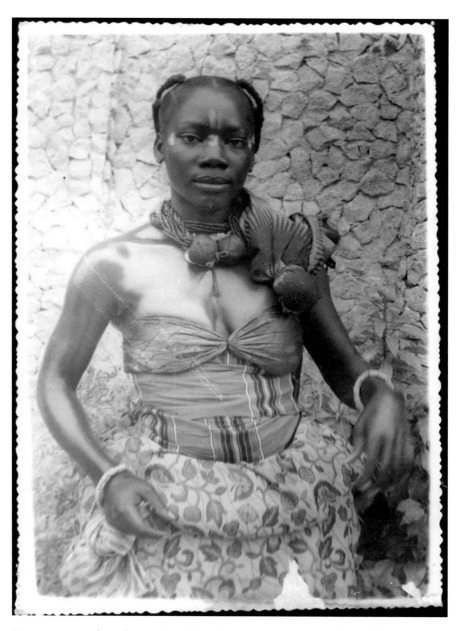

Figures 5.16a and 5.16b. Amadou Baba Cissé, portraits taken in Grand Bissam, Ivory Coast (*above*: *40 days after birth ceremony*, 1999) and Gao (*facing*: 2000). Collection of C. M. Keller. Courtesy and © Amadou Baba Cissé.

outdoor walls provides a convenient decorative element (figs. 5.16a and 5.16b). Today, with the advent of color photography, nearly every studio offers a solid red backdrop to add visual intensity in portraits. In addition, Mamadou Konaté created an "atmospheric" effect in one of his backdrops by using white paint on blue fabric to energize and embellish his studio portraits, rendering them more attractive (figs. 5.17a and 5.17b).

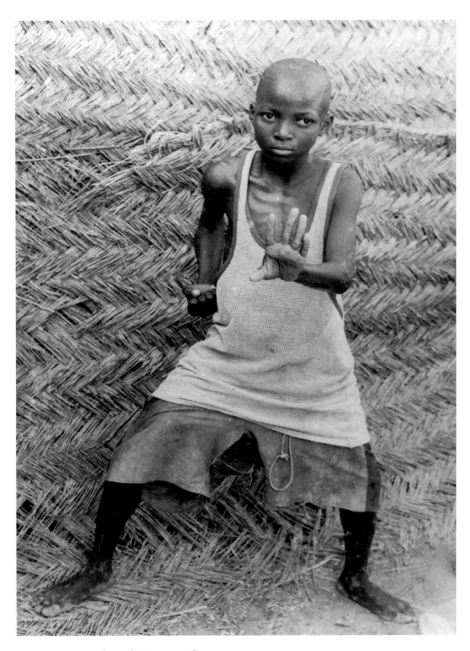

Figures 5.16a and 5.16b (*continued*)

Each photographer's studio often has several backdrop options available at any given time, which they have amassed through the years while creating new styles and themes to keep their business relevant. Those depicting interior scenes and exterior landscapes can "set the stage" of an image while serving as màsiri (decoration). For example, in Bamako during the 1970s, Sidibé utilized a painted backdrop (see

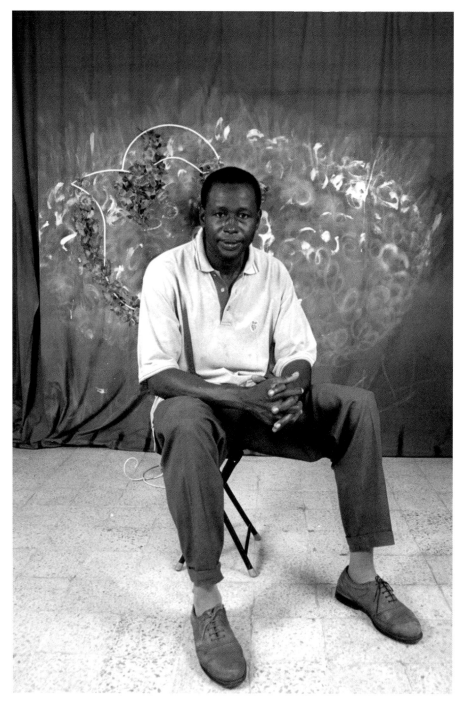

Figures 5.17a and 5.17b. Mamadou Konaté, self-portrait (*above*) and client portrait (*facing*) with blue backdrop Konaté painted, c. 1990s. To view the image in color, see Keller (2008, 621, fig. 573). Reprinted by Mamadou Konaté for author, Bamako, 2004. Courtesy and © Mamadou Konaté.

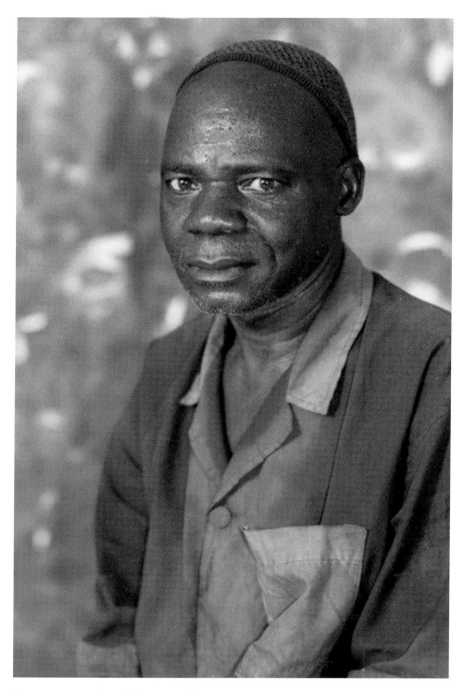

Figures 5.17a and 5.17b (*continued*)

fig. 2.28) that featured a domestic courtyard and manicured lawn (M. Sidibé 2004). In Gao at this time, Azeem Lawal used a wrought-iron gate in league with a painted backdrop that featured a window with matching iron dressings, a simple column, and ornate linoleum flooring to decorate his portraits. From the 1970s to the 1990s in Mopti, Tijani Sitou furnished his studio in Mopti with several scenic backdrops painted by Sidi Cissé (see figs. 2.31, 2.32, 2.41, and 2.45), including one featuring airplanes and another depicting an electrified city street (Malick Sitou 2004).[28] Similarly, in Ségu in 2004, an enormous painted airplane was featured on the wall of Studio Askia Mohamed, and in Mopti the same year, Sitou's studio boasted a colorfully painted background of a hotel pool (plate 10).

At times these backdrops serve a narrative function, creating an atmosphere that symbolizes the material aspirations and aesthetic values of the clients. In such cases, they relate to those used in neighboring countries, such as Ghana, in studios like that of Philip Kwame Apagya, where clients could stand next to a painted airplane, refrigerator, or television as if it were real and interactive (see CAACART.com, n.d.). Or, as Malick Sidibé said of his interior scene, such backdrops were used "to create the impression of being in a house" (M. Sidibé 2005), akin to those taken by the photographer and his assistants during domestic dance parties (fig. 5.18).

In similar fashion, several photographers have used backdrops depicting a mosque façade, both as decoration and as a means for clients to express their moral and spiritual values and religious goals (see figs. 2.48 and 2.49). Many of these photographs emulate portraits Malians brought back from their pilgrimage to Mecca—or hajj—as souvenirs and proof of their newly gained, coveted status as "El-Hajj." Whether in commercial-poster or painted form, these backdrops remain popular, particularly during Muslim holidays such as Ramadan and Tabaski. For the most part, however, atmospheric background scenes serve decorative purposes and have little to do with the pose or action performed before them (see fig. 3.5, for example).

Backdrops of painted, poster-print, or wallpaper landscapes continue to provide popular decoration in the studios of numerous photographers in Mali. In Bamako, Gao, Timbuktu, Kita, Ségu, and Mopti, for example, these include idyllic Malian country scenes that often feature rivers and lakes adorned with palm trees. Some illustrate regional landscapes, such as palm-lined ocean views with sea gulls overhead (fig. 5.19). Other versions feature "exotic" nature scenes that typically depict Western gardens or countrysides. Each of these, of course, is designed to suit the needs of the clientele. Hamidou Maïga explained that the manicured garden backdrop would be used for portraits intended for relatives and friends

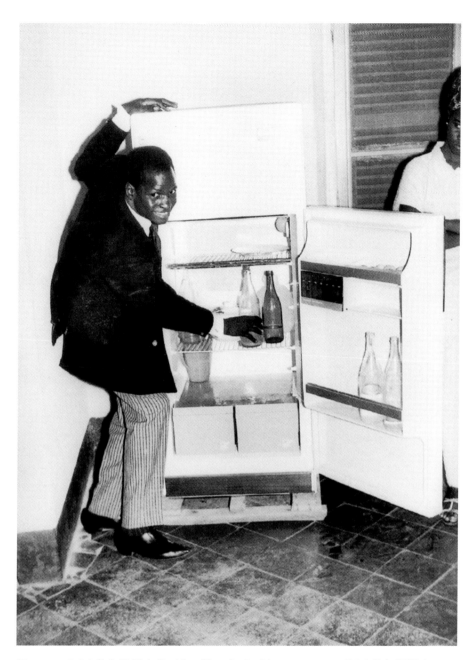

Figure 5.18. Malick Sidibé, *By Myself at the Refrigerator*, 1968. © Malick Sidibé, courtesy MAGNIN-A gallery, Paris.

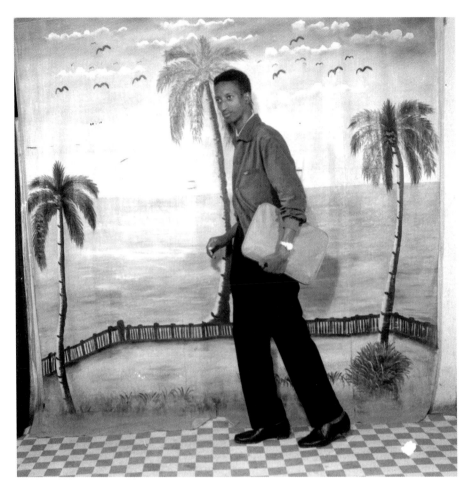

Figure 5.19. Abdourahmane Sakaly, *Untitled*, 1958. High-resolution digital scan of original 6 × 6 cm negative. Courtesy Abdourahmane Sakaly Estate and the Archive of Malian Photography (AMP). © Abdourahmane Sakaly.

in rural areas or other places in Africa. It would not, for instance, be sent to intimates residing in Europe or the United States because "they would not find them interesting, as they can access them easily" (photographer H. Maïga 2004). For those individuals, simple, locally inspired backdrops would be used along with island beach scenes. Outside studio walls, gardens located in front of studios, restaurants, hotels, and national monuments are often used as decorative backdrops in a similar manner. This is particularly the case for bridal (*konyomuso*) portraits, about which Elder states, "Among the most striking features of these [newer] studios are the gardens that have been planted in front of them. The purpose is specific enough—to have a picturesque setting in which the client can be photographed" (Elder 1997, 130). Elder goes on to argue that this

specific aesthetic preference is likely informed by socioeconomic factors, much like the practice of skin lightening, explaining that "gardens are expensive, especially since they require watering. In a semi-arid country like Mali only the rich Malian upper class . . . and foreigners can afford to spend water on a garden. It seems that it is not only the aesthetic value of the garden setting which is appreciated by the Malians but also the wealth for which it stand[s]" (Elder 1997, 130).

Along with backdrops, material aids and studio props are regularly incorporated in portraiture as decorative narrative devices. One common and ornamental choice is silk or paper flowers, usually held in the hand or placed in a vase on a table or the floor. Due to sentimental associations, flowers are often featured in portraits of women, children, and couples. Other popular props include radios, telephones, records, cameras, musical instruments, and, of course, clothing and accessories. For more playful portraits, some studios have supplied customers with additional accoutrements such as soccer balls, toy guns, and cowboy hats (see fig. 2.31). Party decorations, including balloons and streamers, beach balls, and large white wicker chairs, are some recent examples (figs. 5.20a and 5.20b). At times, as explained in the previous chapter, painted cardboard or wooden cutouts have been employed as decorative as well as narrative framing devices (see fig. 4.19).

In some instances, portraits were embellished after they had been taken. For example, in the 1960s at Studio Malick in Bamako, illustrated images created by Malick and Sidiki Sidibé were used as photographic frames (see fig. 5.21). To create these composite images, single portraits were placed behind the illustrated frame or cut and placed within the opening—to provide a three-dimensional effect—and photographed once more. This style of portraiture was commonly commissioned during the holidays, such as the beginning of a new year. Other studios, like Sitou's in Mopti, introduced festive slogans and decorative designs alongside portraits by printing two negatives at once (see fig. 4.1). To create these portraits in a variety of local languages, Sitou etched phrases and designs backward onto the emulsion side of a plainly developed negative. In the darkroom, he placed the etched negative in the enlarger and printed it on one-half of a sheet of photographic paper, the other side of which had been recently exposed to a portrait negative. During the 1970s and 1980s, Sitou had several of these etched negatives available for his multiethnic clientele, with most featuring popular phrases in French, Bamanankan, Fulfulde, Hausa, and Yorùbá. Examples include *Barika de Salla*, which means "Happy Holiday," or "*Bonne fête*," in Hausa, and *Oyu Larí Iwa Ko Papo*, which is Yorùbá for "We see the face, but the behavior is not

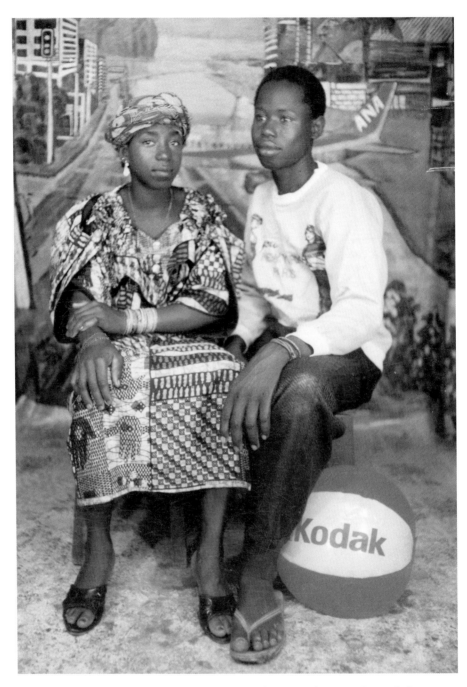

Figures 5.20a and 5.20b. Tijani Sitou, *Bozo Couple*, 1994 (*above*), and *Untitled*, c. 1990s (*facing*). Courtesy Tijani Sitou Estate © Tijani Sitou.

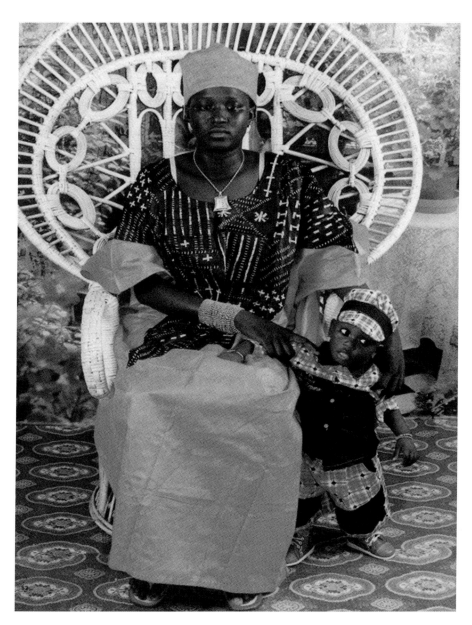

Figures 5.20a and 5.20b (*continued*)

Figure 5.21. Sidiki Sidibé (Studio Malick), *Untitled* (cutout decorated portrait), 1965. Collection of C. M. Keller. Courtesy Sidiki Sidibé.

alike," meaning "people befriend each other because they are different," everyone is unique (Malick Sitou 2006).

Dìbi

In the realm of daily life interactions, a discussion of Mande notions of beauty, and by extension attractiveness, must admit a certain level of dìbi. To be specific, dìbi does not signify obscurity alone. Rather, it is a complex concept associated with darkness, obscurity, ambiguity, and mystery, which are significantly intertwined with secrecy, or *gundo* (Bailleul 2000a, 99; M. Sidibé 2004; Malick Sitou 2004; Bakary Sidibé 2004). Due to these qualities, dìbi has been discussed by Mande scholars as part of an "anti-aesthetic" (McNaughton 1988, 143). However, that specific interpretation does not always apply to the myriad ways dìbi functions aesthetically. Malians conceive of dìbi as a necessary yet ambiguous aesthetic component, able to appeal or repel. As such, it does not inherently reflect an anti-ideal or antiaesthetic, although, in the extreme sense, it can be used to that effect. In general, dìbi inspires human curiosity, intrigue, interest, and even excitement as it heightens the mystery of a given situation, person, or object. Positive aesthetic appreciation of dìbi is most pronounced in the daily behavior and interactions of people.

In matters of personal adornment, mannerisms, and even speech, dìbi is a key aesthetic component. It informs, for example, the general aesthetic preference for loose-fitting, fluid garments, particularly for women. This attire includes (but is not limited to) the blousy gown known throughout western Africa as a boubou and the *complet*, an outfit that consists of a wrap-around skirt, or *pagne*, and a large, loose, often billowy blouse (plate 6). The predilection for this clothing became apparent to me after several encounters with Malick Sidibé and other men at his studio. They regularly complimented me for wearing skirts and dresses as opposed to pants and expressed their preference when I wore flowing garments rather than fitted ones. More than once, Sidibé explained that such clothing was appreciated, and in fact preferred, due to the element of ambiguity and mystery (dìbi) it entails (M. Sidibé 2004).[29] Opposed to slacks, especially jeans, which often fit snugly (revealing certain formal details, such as curves, lines, and volumes), flowing garments leave more to the imagination. They merely provide a glimpse or indication of what lies beneath. Dìbi is also admired in menswear (see fig. 4.9; plate 2). In addition to being comfortable and practical, the voluminous grand boubou elicits an air of majesty—literally rendering a man larger than life (Hardin 1993, 140, 209). It suggests an element of mystery as well due in part to the amulets one knows are hidden beneath its surface. The attire of hunters and blacksmiths, which includes baggy pants and large amulet-laden shirts, also incorporates dìbi (figs. 5.22a and 5.22b). In such cases, dìbi's aesthetic effect is associated with an increased level of spiritual power, which will be addressed in the subsequent chapter.

A woman's gait is often appreciated for being fluid or rolling, sensuous, and at times indirectly suggestive. Arnoldi's account addresses this aspect of feminine mannerisms, relating that Yayoroba "dances around the arena, slowly swaying her hips to the right and left" (Arnoldi 1995, 174). Hoffman similarly reports that griot women "display their sensuality in dance" (Hoffman 2000, 246). In related nuanced behavior that may be perceived as sexually suggestive or enticing, young women often stop in the road to adjust or retie their pagne. This act often intentionally attracts the attention of men, hinting at the revealing of something that remains concealed. Sitou explained that young women use the mirrors of parked cars to playfully entice the imagination and attention of nearby men (Malick Sitou 2004). As women walk down the street or through the market, they sometimes move in a way that creates a sensuous rhythm with their *baya* (waist beads worn under clothing). That inconspicuous yet identifiable sound is considered extremely appealing to members of the opposite sex.

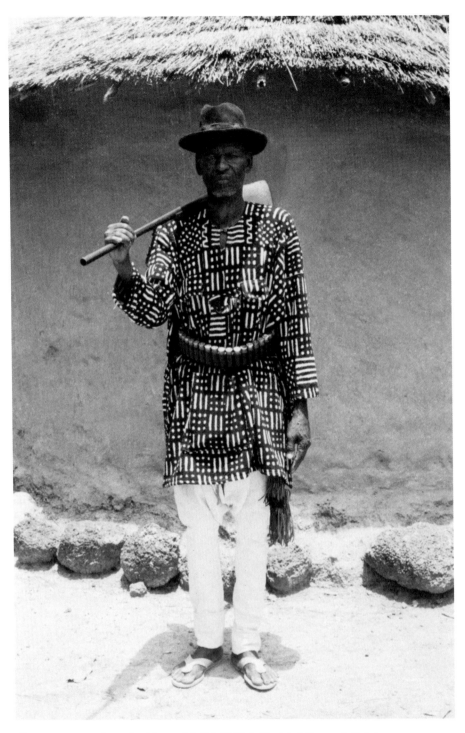

Figures 5.22a and 5.22b. *Above*: Malick Sidibé, *Untitled* (hunter), Soloba, c. 1960s–1980s. © Malick Sidibé, courtesy MAGNIN-A gallery, Paris. *Facing*: Diango Cissé, *Portrait of a Hunter*, c. 1970s–1980s. Postcard edited by Graphique Industries, printed in Mali. Collection of C. M. Keller. Courtesy and © Diango Cissé.

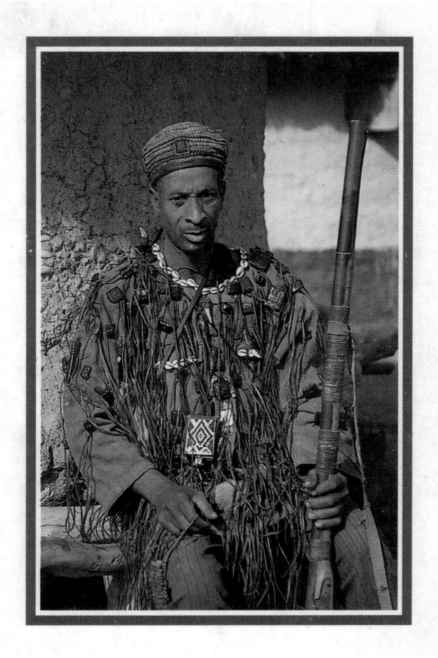

Figures 5.22a and 5.22b (*continued*)

In the aesthetic appreciation of social behavior, dìbi often relates to the important value of restraint.[30] In this facet dìbi is a significant aspect of social etiquette. For example, when speaking to an elder, rather than making eye contact, as taught in the West, women and young people are expected to avert their eyes to the side, occasionally glancing toward the face of the person but never into the eye for prolonged intervals, as a sign of respect.[31] During my stay in Mali, I was personally counseled by numerous friends and mentors not to look someone directly in the eye (M. Sidibé and Malick Sitou 2004).[32] The expectation of such conduct was particularly pronounced during my interviews and discussions with elder photographers.

Ambiguity is also greatly appreciated and valued in speech (*kuma*) in the form of proverbs (*zanaw*) and fables (*nsiirinw*) as well as in casual conversation (*baro*).[33] For example, Hoffman has stated, "Like an object viewed in the shadows, the language of proverbs (*zanaw*) is often obscured and difficult to make out" (Hoffman 2000, 123). Likewise, as McNaughton has noted, "innuendo and indirect references often populate people's speech" (McNaughton 1988, 64). Malians have a deep respect for the art of configuring language in an appropriate, indirect, and inventive manner. I was continually confronted with this lesson while conducting interviews. Inevitably, at times I would pose a question too directly, lacking finesse and unwittingly rude besides. In such cases, my assistants would wisely rephrase my inquiry or elaborate on it (to correct my error). Doing so kept interviews open and appropriate and made interviewees feel more comfortable to respond. Another example illustrating a preference for ambiguity in speech is *karisa*. This special term in Bamanankan is used to maintain an air of ambiguity when referring to someone in their presence without them knowing.[34] Karisa is also used to reference oneself in the third person because Malians find it egocentric to use one's own name in that manner (Malick Sitou 2006). More broadly, indirect language is an important aspect of teasing, joking around (*tulon ke*), and making fun.

Humor

Humor is an important part of daily life in Mali in both culturally formulated and personally inventive ways. It is exemplified in senankunya, "joking cousin," relationships and the common bean joke (*i be so dun*, "you eat beans").[35] One of the most enjoyable aspects of living in Mali is this inclination toward humor, which is displayed by people of all ages.[36] Often it involves making fun of things that have power in a playful, socially accepted manner or is embodied in the things that lack it. This is

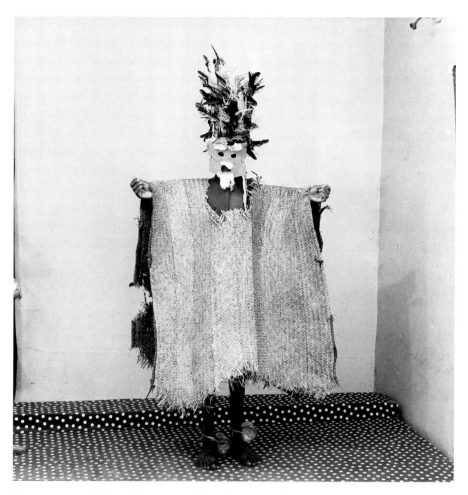

Figure 5.23. Malick Sidibé, *Man with a Plait, End of Lent 1983, Commonly Called Yokoro*, 1983. © Malick Sidibé, courtesy MAGNIN-A gallery, Paris.

true in the case of Yokoro, a children's comedic acrobatic performance whose character has been recorded in several photographers' studio archives (figs. 5.23 and 5.24; also see fig. I.4).

The exact origin of Yokoro is unclear, but it seems to have been practiced prior to colonialism in Mali (Abdoulaye Kanté 2004; D. Traoré and L. Traoré 2004; Brehima Sidibé 2005; Malick Sitou 2006; Moussa Sitou 2006).[37] Although Yokoro is believed to have originated within Bamana culture, it has been practiced as far back as people can remember in every rural and urban community, by all cultural groups, in all languages throughout Mali. In cities such as Bamako and Mopti, performances take place every night during Ramadan, the Muslim month of fasting and alms giving. Each night, after the last evening prayer (around 7:30 p.m.) until after midnight, groups of neighborhood children perform

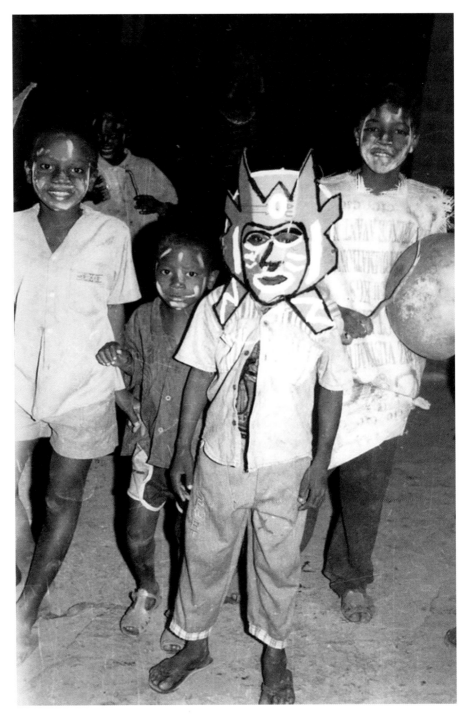

Figure 5.24. Adama Kanté (Studio Photo Kanté), *Yokoro*, 2000. Reprinted by Adama Kanté for author, Bamako, 2004. Courtesy Adama and Abdoulaye Kanté © Adama Kanté.

Yokoro. Dressed in ragged clothing, with painted faces and bodies, and pounding makeshift drums (sticks and metal bowls and calabashes), they travel from house to house collecting small gifts. Within each group, only one individual assumes the role of Yokoro, the lame, fat, incompetent clown. This character often wears a mask and/or headdress made of found objects such as feathers, cardboard, paint, and cloth and clothing made of old, dirty rags or tattered fiber mats and burlap sacks. Accompanied by amateur percussionists and singers, Yokoro typically performs with a consort whose name and costume varies from region to region. In Bamako, this character goes by the name of Cekorobani (Little Old Man) or Dondoli and is identifiable by an exaggerated, pregnant belly while in Mopti he goes by the name Dodo and, due to Fulani influence in the area, displays a large set of cattle horns. Yokoro's entourage is intended to embody the opposite of jɛya. The youths are purposefully dirty (nògòlen), smelly (a kasa man di), loud (mankanma), obnoxious, out of control, and threatening—all in a playful manner (Abdoulaye Kanté 2004; A. B. Cissé 2004; Malick Sitou 2006). Both girls and boys perform Yokoro, but they do so separately. The boys' performance includes acrobatics and is more rambunctious than that of the girls. Adhering to some rules of social decorum, the performance commences at each new location by greeting the household, Aw ni su. I ni su n'bamuso. I ni su n'fake ("Good evening. Good evening mother. Good evening father"), followed shortly by the Yokoro song, which is repeated at least twice and sung in several local languages. A popular version in Bamanankan consists of the following:

> YOKORO: Aw ma yokoro ye wa? ("Haven't you seen Yokoro?")
> THE REST OF THE GROUP: Yokoro!
> YOKORO: Aw ma yokoro yelen to ye wa? ("Haven't you seen Yokoro climbing up?")
> THE GROUP: Yokoro!
> YOKORO: Aw ma yokoro jigi to ye wa? ("Haven't you seen Yokoro getting down?")
> THE GROUP REPEATS: Yokoro![38]

Both of Yokoro's last statements refer to the acrobatic performance, in which the performers jump, somersault, tumble, and wreak havoc by kicking pots and pans and other household objects sitting about in the courtyard. In this way, Yokoro is "defined in terms of representing the inverse of Bamana ideal morality [badenya], and exploiting it by means of conventional strategies common to Bamana theater, such as comedy, farce, satire, and the blending of exaggeration and juxtaposition that these strategies imply" (Brink 2001, 240).[39]

Although entertaining, the objective of the performance is to annoy the adults into bribing the group to go away. The obnoxious intrusion of loud singing, noisy banging, acrobatics, and thrashing about the place ends when the matron or matrons of the home offer uncooked millet, rice, beans, or small coins (10–25 francs). The group's earnings will either be shared the same evening or the collected grains will be sold to market vendors the following day for a small sum and the funds then evenly distributed. The production is made in jest, and the adults as well as the children enjoy the performances, finding them humorous and entertaining. Of course, if too many Yokoro groups have visited a household and its inhabitants do not wish to give offerings to a group, they can be chased away and their performance refused for the night.

While in the streets en route to new destinations, the groups confront one another. Often the "stronger" group attacks the "weaker" one to steal their earnings (Malick Sitou 2006). The girls' groups are regularly attacked by the boys, and younger boys are besieged by older ones. (Although the performance is the domain of uncircumcised children, or *bilakorow*, teenagers often continue to participate until the age of sixteen or seventeen.)[40] Yokoro troops also compete throughout the neighborhood, trying to get to more houses faster than the others. In cities, they visit businesses as well, which accounts for the number of Yokoro portraits in studio archives. After they perform at photographers' studios, the proprietor often takes their photograph as a memento of the occasion (figs. 5.23 and 5.24; see also fig. I.4).[41]

Dìbi is an important constituent of Yokoro activities. The characters are dirty, smelly, and wild. They don masks, paint, and costumes and perform in the obscurity of night. Furthermore, the relationship among the different groups is ambiguous. It is both threatening (provoking fights and aggressively trying to overpower the other to steal their earnings) and playful (a game of hide and chase). It is amusing and exciting for the children who participate, but it is also an opportunity for them to reinforce and challenge, in a socially sanctioned way, gender as well as generational relationships and related power dynamics. In costumes that sometimes feature beards, canes, and overgrown bellies, at times worn by characters named Little Old Man, the youth are able to poke fun at elders and perpetuate joking relationships they share with their grandparents. By thrashing about family compounds, they also act out against the respectful composure expected from daughters and sons. This is reminiscent of *koteba*, *kamalen ton Sògò bo*, and *kotè-tulon ton* theatrical performances, which, framed within the context of play, grant customarily improper, amoral behavior unique social immunity (Meillassoux 1964; Arnoldi 1994, 1995; Brink 1978, 1980; M. Sidibé 2005).[42]

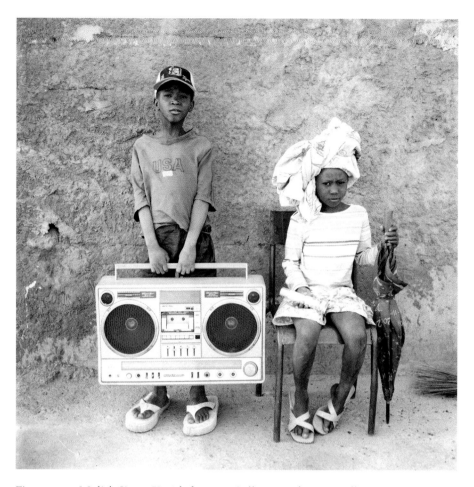

Figure 5.25. Malick Sitou, *Untitled*, 2004. Collection of C. M. Keller. Courtesy and ©
Malick Sitou.

Humor is depicted in photographs in a variety of similar ways, usu-
ally involving people wearing clothing in a strange manner, donning a
costume, or behaving in a dramatic, unusual, and unexpected way. For
example, at Tijani Sitou's studio in Mopti, a grotesque mask was one of
the props available for clients to use in their portraits, which Ibrahim
Sitou explained was used to be "funny and entertaining" (I. Sitou 2004).
Similarly, his brother Malick staged photos of kids juxtaposed with over-
sized items such as a huge radio, adult shoes and clothing, and a umbrella
and positioned them in exaggerated poses mimicking elders to humorous
effect (figs. 5.25 and 5.26). Often they appear in an unkempt fashion to
be funny in an endearing way, as exemplified in photos Sitou took of
Malick Sidibé's son Siné with his zipper open (fig. 5.27). Like Yokoro, hu-
mor in each of these cases is conveyed through the use of juxtapositions,

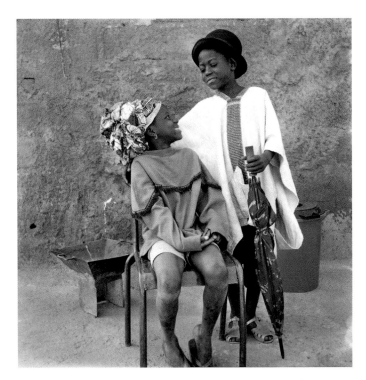

Figure 5.26. Malick Sitou, *Untitled*, 2004. Collection of C. M. Keller. Courtesy and © Malick Sitou.

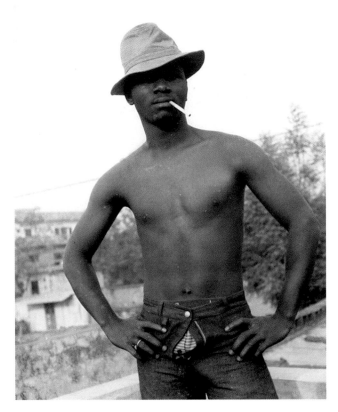

Figure 5.27. Malick Sitou, untitled portrait of Siné Sidibé, Malick Sidibé's son, 2004. Collection of C. M. Keller. Courtesy and © Malick Sitou.

exaggerations, and representations of the "inverse of Bamana ideal morality": badenya (Brink 2001, 240).

Likewise, in August 2001, Malick Sidibé hosted a neighborhood costume party at his home in Daoudabugu and had his son Fousseini capture the humorous event on film. The Bamakois dressed in exaggerated costumes of villagers, mainly the Wasulu Fulani of Sidibé's hometown of Soloba (figs. 5.28a and 5.28b). Women parroted Fulani jewelry and painted their lips black, mimicking the Fulani practice of lip dying, while men wore broken Fulani straw hats and mismatched shoes and attire (O. Sidibé 2004).[43] Humor in mimicry and stereotypes has also been expressed in other Malian art forms, including kamalen ton puppets. Arnoldi described the behavior and exaggerated aspects of a Western researcher depicted in the puppet of a European woman "who either smoked a cigarette or wrote with a pen into a notebook, the consummate ethnographer" (Arnoldi 1995, 75).

Dìbi and Fadenya

As jɛya signifies ideals associated with badenya, dìbi relates to values affiliated with fadenya. Worded another way, mystery, ambiguity, and obscurity are connected to notions of individual agency, ability, will, strength, personal agenda, power, and independence. For example, if someone is serving selfish interests, trying to get ahead, acquiring more money or power, and going about it in ways that are hidden, potentially dangerous, or amoral, it is said, *a ka sira dìbilen don*, "his/her path is unclear, obscure, ambiguous" (M. Sidibé 2004; Bakary Sidibé 2004; Malick Sitou 2004; B. Sidibé 2003). In a similar vein, in one interview dìbi was used to describe the behavior of former president Modibo Keïta, whose "big mistake was dìbi—lack of clarity. [A leader] should communicate with people so that they aren't confused and angry" (I. Samaké 2005).

In a more constructive light, dìbi is often used to protect one's own interests, identity, and personal knowledge. Malians consider it imperative and wise, for example, to "always keep some information to oneself" (Malick Sitou 2004). This philosophy is expressed in the following proverbs:

Kuma bee mana foli kama ("Not all words are to be spoken").
Yeko ye foko ban ("What you've seen brought an end to what you should say").[44]

Ma tɛ fini bee ja tile koro ("Not all clothes are to be dried under the sun").[45]

For example, as aforementioned, some knowledge is commonly withheld among mentors and apprentices in the field of photography. Protected

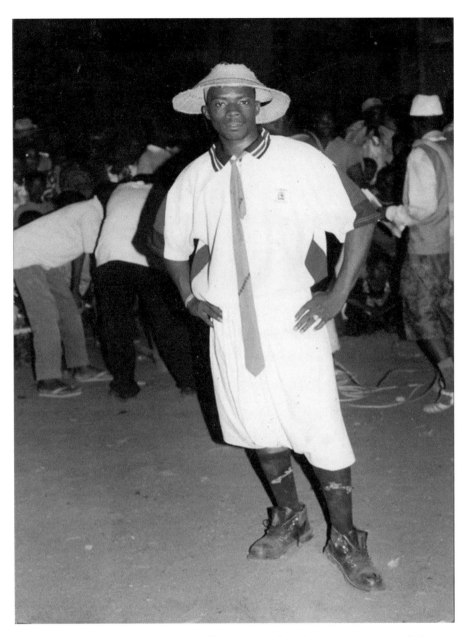

Figures 5.28a and 5.28b. Fousseini Sidibé, photos taken during a party at Malick Sidibé's home in Daoudabugu, 2000. Reprinted by Fousseini Sidibé for author, Bamako, 2004. Courtesy and © Fousseini Sidibé.

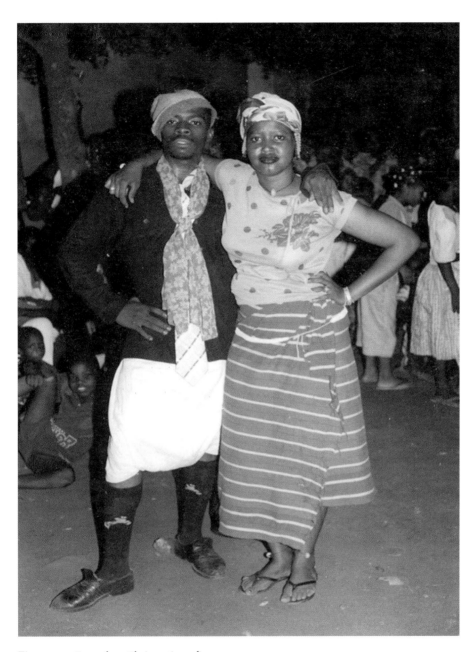

Figures 5.28a and 5.28b (*continued*)

information is often that which has been acquired through personal experience and experimentation. Preserving a professional niche typically requires guarding that knowledge rather than sharing it with others, even one's students or teachers. This practice illustrates the use of dìbi to protect intellectual property and trade secrets in an attempt to ensure future success in business.

In the previous chapter, I argued that photographers invent and employ compositional and technical strategies (such as camera angles, dramatic lighting, and diagonal postures) to communicate and emphasize fadenya in portraits. They also incorporate dìbi as a strategy to visually emphasize the unique power of individuals (fadenya) and heighten their visual and psychological intrigue in portraiture. In photographs, insofar as it serves to muddle jɛya, or clarity, dìbi can include decorative aspects such as nyègen, "pattern and adornment," and màsiri, "decoration," as well as other design elements that interfere with or withhold information from the viewer.

Like fadenya and badenya, the aesthetic principles of jɛya and dìbi operate in and express tension—that is, the conceptual, physical, and visual tension between clarity and obscurity, stability and motion, structure and embellishment. Thus, to be aesthetically appreciated, a photograph must be clearly readable yet incorporate a sufficient amount of obscurity in terms of patterning as well as other decorative and formal strategies to give it life, motion, and energy, enhancing its visual and psychological interest for the observer.[46] In turn, bold designs and patterns should not disrupt the formal clarity of the image. For example, the feature of greatest importance in a portrait—the face—and the structural balance that renders the entire composition organized and legible should not be jeopardized by dìbi. However, dìbi can be used to *emphasize* these aspects. Ideally, then, the formal and decorative elements of a portrait complement one another while existing in a discriminate yet unified whole. A successful combination attains the aesthetic goals expressed as *nyì*, "goodness," realized in the phrase *a ka nyì*, "it is good," or *a ce ka nyì*, "it is attractive, good, perfect," and *di*, "tastiness," in statements such as *a ka di*, "it is good/tasty."[47] These ideals are also represented in the phrase *a be n'nye mine*, "it grabs my eye" (Mara 2004).

The level of visual tension created between jɛya and dìbi varies. Thus, photographers are able to use different degrees of structural and decorative elements within their portraits to suit and express the desires and needs of their clients. In general, a greater level of dìbi, and thus an increased level of visual intensity in terms of energy, motion, and ambiguity, heightens the expression of fadenya in an image. Conversely, more restrained or conservative use of dìbi, with greater emphasis on formal

clarity, or jɛya, stresses stability and uniformity in the portrait. This renders a calmer image that is less confrontational to the viewer, thereby reducing the impact or communication of fadenya.

Therefore, to emphasize the sense of elegance and sophistication sought by zazous patrons who admired the debonair style of French symbolist poets, such as Stéphane Mallarmé, Keïta muted the decorative aspects of their portraits and orchestrated meticulous, clearly readable compositions. Emphasizing his clients' sense of refinement and grace, Keïta utilized a delicately patterned floral backdrop and accentuated it with a carefully poised flower in the foreground (plate 4). In a similar image, the decorative aspects and use of diagonal composition have been refined and even contained by the balanced jɛya composition, the woman's graceful posture and downward glance, and the incorporation of subtle rather than stark contrasts (see fig. 2.16). Together, they communicate a desired aesthetic style and the idealized aspects of a person's character, providing a cultivated quality and sense of charm and sophistication. As a result, the overall agenda and visual impact of these portraits lack some of the intensity found in other images by Keïta.

To express a heightened level of fadenya strength and individuality, Keïta and Sidibé used backdrops featuring bold, high-contrast designs that help create a sense of vitality and dynamism in their portraits (M. Sidibé 2004). The organic, curvilinear, floral-inspired patterns used by Keïta and the black-and-white vertically striped motif employed by Sidibé elevate the visual energy and impact of their images (M. Sidibé 2005). In addition, they serve to push the subject—particularly his or her face—toward the foreground, confronting the viewer in a more direct fashion (plate 1).

Such portraits express greater visual intensity, and a heightened level of dìbi, when the highly decorative backdrops are juxtaposed against black-and-white polka-dotted or checkered floors, patterned blankets, and the elaborately printed attire of their clients (fig. 5.29; see also figs. 2.4 and 4.6). In these portraits, the amalgamated patterns of the clothing, backdrop, and flooring obscure the three-dimensional form of the body and flatten the picture plane. This serves to frame the patron's face and hands—aspects of portraiture that emphasize the individuality and distinctiveness of a person—which stand apart as clearly readable. As a result, they become focal points of attention. Lauri Firstenberg noticed this effect in Keïta's images: "The dialectic between the sitters' attire and the patterned backdrops of the photographs perform an illusory camouflage of the body . . . the clothing of the sitters meshes with the background, thus calling attention to their physiognomy" (Firstenberg 2001, 176).

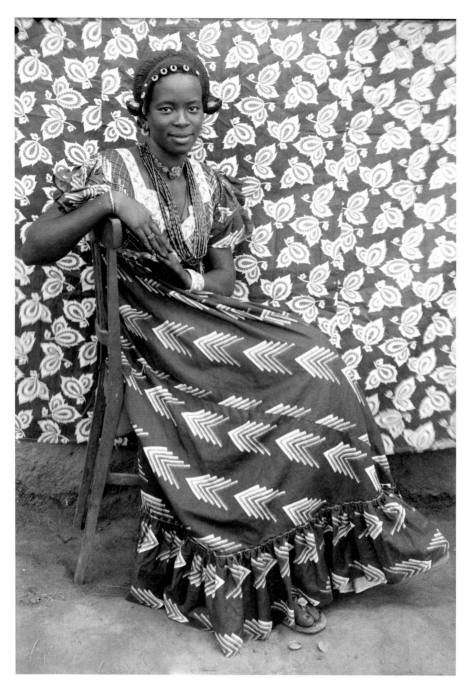

Figure 5.29. Seydou Keïta, *Untitled*, c. 1955–59. Gelatin silver print, 23 × 19 inches. Courtesy CAAC—The Pigozzi Collection. © Seydou Keïta/SKPEAC.

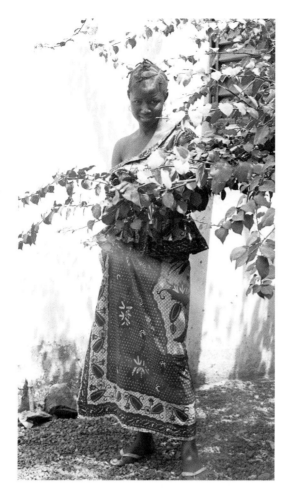

Figures 5.30a and 5.30b. Abdourahmane Sakaly,
untitled outdoor print, 1961. High-resolution
digital scan of original 6 × 6 cm negative.
Courtesy Abdourahmane Sakaly Estate and the
Archive of Malian Photography (AMP).
© Abdourahmane Sakaly.

For instance, in a portrait by Keïta (plate 1), a woman's direct gaze
and confident posture are emphasized by the striking contrast of her pat-
terned dress and headscarf and the energized background and therefore
confront the viewer with aesthetic immediacy and strength. These im-
ages illustrate how dìbi, in the form of pattern (nyègen) and decoration
(màsiri), has been employed by portrait photographers to visually express
their clients' fadenya qualities and ideals of personal fortitude, individual-
ity, and independence.

In portraits taken outside the studio, often foliage is used to partially
obscure depicted persons (figs. 5.30a and 5.30b). In a technique common
since the 1960s, individuals have regularly positioned themselves or been

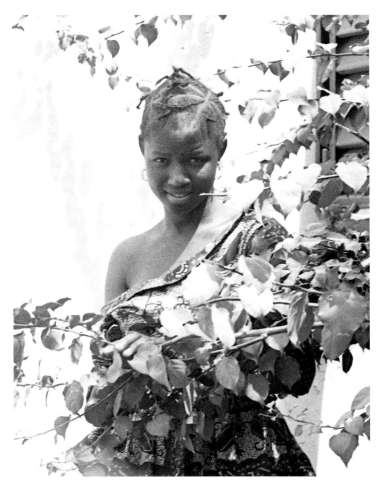

Figures 5.30a and 5.30b (*continued*)

positioned by photographers, such as Abdourahmane Sakaly, Malick Sidibé, and Tijani Sitou, behind palm leaves, vines, and bushes (part of landscaped gardens), rather than in front of them in a common backdrop fashion (Malick Sitou 2004). These decorative obstructions create an elevated sense of mystery and ambiguity (dìbi) that renders intriguing portraits (see Keller 2008, 629–31). This practice is also seen in Mamadou Konaté's contemporary studio in Bamako in which palm fronds serve as decoration that obscures the dress of the depicted, placing emphasis on the client's facial features and expression (plate 11).

The play between clarity and obscurity is also used humorously in photographs. This is the case, for example, in images in which partygoers position themselves in window frames or room corners as if emerging out of them toward the spectator (figs. 5.31a and 5.31b). Sunglasses,

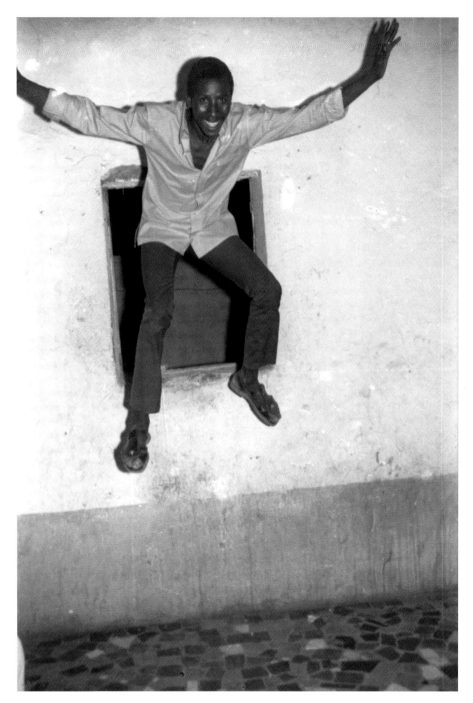

Figures 5.31a and 5.31b. Malick Sidibé, *I Come from the Sky, The Young Nice Guys, April 20, 1968* (*above*) and *Babenco, Boy from Medina-Kura, 1968* (*next page*), 1968. © Malick Sidibé, courtesy MAGNIN-A gallery, Paris.

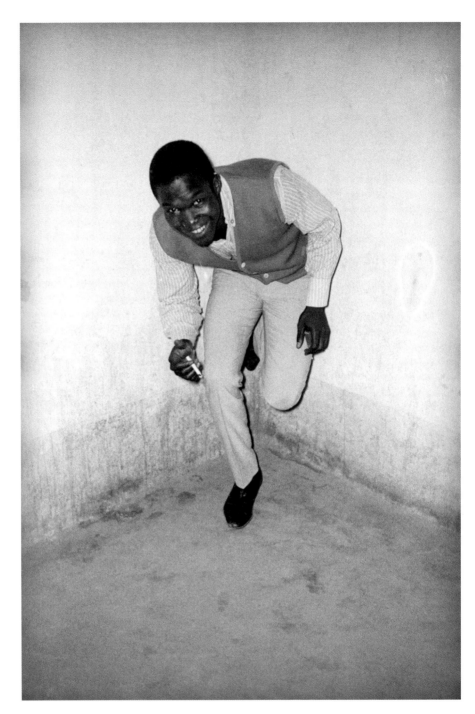

Figures 5.31a and 5.31b (*continued*)

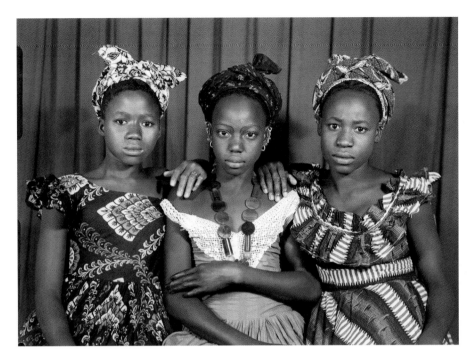

Figure 5.32. Seydou Keïta, *Untitled*, 1954–60. Gelatin silver print, 23 × 19 inches. Courtesy CAAC—The Pigozzi Collection. © Seydou Keïta/SKPEAC.

by concealing a person's eyes and by extension their expression, also add an element of mystery and ambiguity to portraits (see fig. 2.42). In these images, individuals wish to be seen as "cool," stylish, young, and independent—and often as playful and amusing or serious and strong.

Of course, the separation of these two ideals (jɛya and dìbi) cannot be so clearly defined in terms of representing either badenya or fadenya in portraiture. For example, a photograph by Keïta (fig. 5.32) depicts three friends who at once express their close badenya relationship as well as their own fadenya individuality. Symmetrically posed in a compact rectangular format, with hands resting on the central figure's shoulders, structural clarity is used to convey the badenya relationship among them. Either deliberately or coincidentally, they are further visually unified by the intercepting upright and inverted V formations. The first of these is created through the visual connection of white seen in the head wraps worn by the two flanking figures and the dress of the centrally positioned female. The second consists of the dark-colored cloth of the head wrap worn by the figure in the center and the dresses donned by her companions to either side. The patterned cloth, coupled with the pleated curtain in the background and the up-close rendering, emphasizes the faces of each girl, highlighting her individuality. Furthermore, the central figure

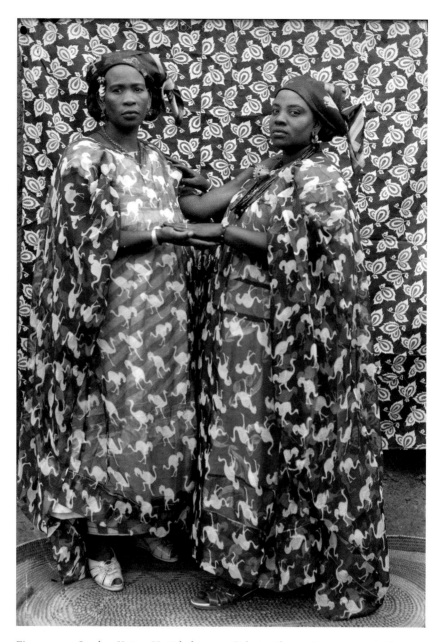

Figure 5.33. Seydou Keïta, *Untitled*, 1959. Gelatin silver print, 23 × 19 inches. Courtesy CAAC—The Pigozzi Collection. © Seydou Keïta/SKPEAC.

receives greater attention due to her location and the triangle in which she is framed (formed by her arms, their hands, and her face).

In Keïta's portrait of two women (fig. 5.33), dìbi simultaneously emphasizes their badenya relationship (melding their bodies into one) as well as their individual fadenya identities (obscuring all but their faces—the most identifiable, individual physiological feature).[48] Badenya is further

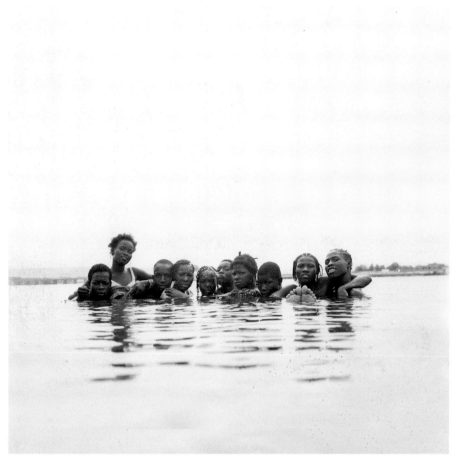

Figure 5.34. Studio Malick, *During the Great Heat*, 1976. © Malick Sidibé, courtesy MAGNIN-A gallery, Paris.

emphasized in this image by the women's intimate position and the fact they are holding hands. Water serves a similar purpose in a group portrait by Sidibé's assistant Amadou Fané (fig. 5.34).[49] Amassed together with their bodies hidden, attention is drawn at once to their solidarity and their unique facial features and expressions. Similarly, although the intimate and unified composition of a Tuareg couple by Keïta conveys their nurturing bond, the woman expresses her confidence and individuality by looking directly into the camera lens (fig. 5.35).

Another image created by photographers employed at Keïta's studio blatantly expresses fadenya individuality through a number of structural and decorative elements (fig. 5.36). The most striking of these is perhaps the use of an extremely low vantage point, which distorts the figure of the man and emphasizes his strong pose, face, and hands. As a result,

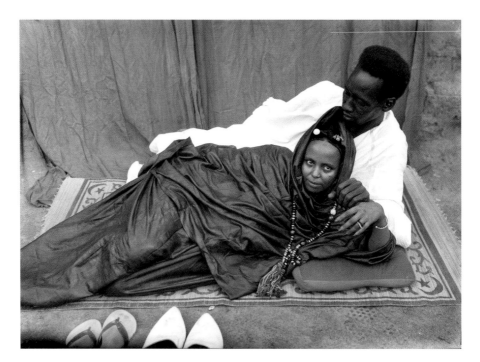

Figure 5.35. Seydou Keïta, *Untitled*, 1952–55. Gelatin silver print, 23 × 19 inches. Courtesy CAAC—The Pigozzi Collection. © Seydou Keïta/SKPEAC.

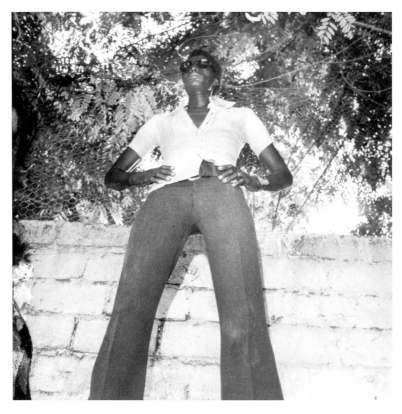

Figure 5.36. Studio Keïta Seydou (taken by Keïta's assistant), *Untitled*, c. 1970s. Gelatin silver print, 23 × 19 inches. Courtesy CAAC—The Pigozzi Collection. © Seydou Keïta/SKPEAC.

the focus becomes his gaze, which is obstructed by his sunglasses, adding a sense of mystery and ambiguity to the otherwise direct triangular composition. All of this is augmented by the play of light and shade and the visual energy in the trees behind the subject as well as the coincidental contrasts created between his light shirt, his dark pants, and the brightly lit wall. Compared with a similarly orchestrated portrait by one of Sidibé's assistants (see fig. 4.10), the effect of dìbi here becomes readily apparent.

There are numerous instances such as these that illustrate how jɛya and dìbi in photographs convey either fadenya or badenya aspects of one's identity or a combination. In many cases, the effect results from the photographer's strategic use of compositional and embellishment techniques (M. Sidibé 2004; Malick Sitou 2004; S. Sidibé 2005). However, at times these ideas are expressed through the contrived attire or pose of the clients themselves or via the coincidental juxtapositions of decorative elements and/or serendipitous combinations of these.

Horror

Beyond beauty and humor exists an emotive aesthetic category of that which is scary, horrific, repulsive, and dangerous. In Mali, elements that incarnate horror generally incorporate dìbi in the extreme. For example, McNaughton has argued that kòmòkun—helmet masks of the kòmò association (figs. 5.37a and 5.38b)—and their performances are "intentionally horrifying" and obscure. Moreover, according to blacksmith Sédu Traoré, "The kòmò mask is meant to look like an animal. But it is not an animal; it is a secret" (McNaughton 1988, 145). With an enormous mouth, jutting jaws, jagged extensions, fire-spitting abilities, and an amulet-laden raffia costume, kòmò symbolism is "aggressive" and engages the "capacity for violence." The masquerader's appearance, combined with eerie sounds made during their nocturnal performances in the wilderness and their known capacity to kill, renders the ability of kòmò to frighten unparalleled among Malian arts.[50] McNaughton opines that an accomplished dancer could manipulate a kòmò mask "to raise the neck hairs of even the most stoic observer" and describes the context within which these art forms operate:

> Kòmò masks . . . are potent images, carved of wood and covered with many different animal and vegetable materials that help them function as instruments of divination and destroyers of criminals and sorcerers. They are worn by high-ranking officials of the kòmò association, often the leaders, kòmòtigiw, and always men who have spent many years developing the power needed to dance within such creations and harness

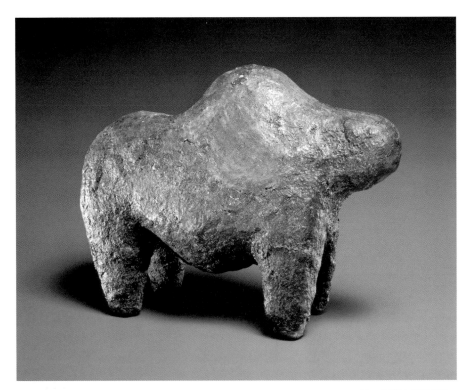

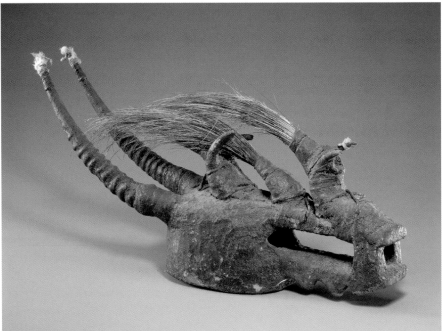

Figures 5.37a and 5.37b. Bamana sculptures, Mali. *Top*: Boli, wood, bark, roots, incrustation; 15 × 6 1/2 × 20 1/4 inches; 70.48. *Bottom*: Komokun, wood, resin, feathers, quills, fibers, animal hair; 13 3/4 × 5 1/4 × 27 inches; 72.111. Courtesy Eskenazi Museum of Art, Indiana University.

energies believed to be embedded in them. . . . Both kòmò leaders and lay members refer to these added animal elements as decoration (masiri), and they classify the large mouths and carved teeth in the same way. (McNaughton 1988, 129–45)

Due to their visual and conceptual power, which is embodied in dìbi, kòmò masks remain frightening for many Malians outside performance contexts—in museum settings, for example. McNaughton explains, "When one faces [a kòmòkun on display] . . . and imagines it charging toward spectators at a kòmò dance, the mask becomes electrifying, with huge mouth, horns, quills and feathers combining to create a tight, compact composition that radiates energy and animality" (McNaughton 1988, 139). Due to their vast, composite power, kòmò masks are imbued with a conceptual quality akin to "dangerous radioactivity" (McNaughton 1988, 138). Underscoring this reality, McNaughton once shared an anecdotal story about a Malian friend who refused to enter the Indiana University Art Museum's gallery of non-Western art because of the potentially hazardous kòmòkun exhibited within. Rather than take his chances being exposed to its radiating power, he chose to keep his distance as a person who had not been initiated into kòmò (McNaughton 2000). Similarly, Bamakois accounts of kòmò are often emphatically negative and laced with fear, with a common statement being *kòmò be mogow faga; kòmò manyi de!*, "kòmò kills people; kòmò is bad!" (B. Sow 2004).

Dìbi and Power

McNaughton recognizes dìbi as the visual articulation of power in the appearance, media, and surface texture of large amulets (*sèbènw*), in power sculptures known as *boliw* (fig. 5.37a), and in the performances of kòmò masks:[51]

> Kòmò masks . . . bear a special relationship to *dibi*. They . . . depict "obscurity fighting obscurity," *dibi kèlè dibi* [and] are designed to be unclear. . . . Like the smiths who make them, the masks used in kòmò project a strong air of inaccessibility. The coatings and other elements added to their surfaces, their ambiguous visual references, and the frightening aspect produced by the parts and the whole make them intimidating works of art. . . . These masks symbolize and assemble power. . . . [Similarly, the] ambiguous earthen constructions called boli . . . represent [what] is not readily identifiable, and, more to the point, their full symbolic significance is not visually accessible. (McNaughton 1988, 130–44, 196)

Like kòmò masks, boliw consist of a wooden armature around which are placed vegetal and animal materials laden with spiritual power. Over

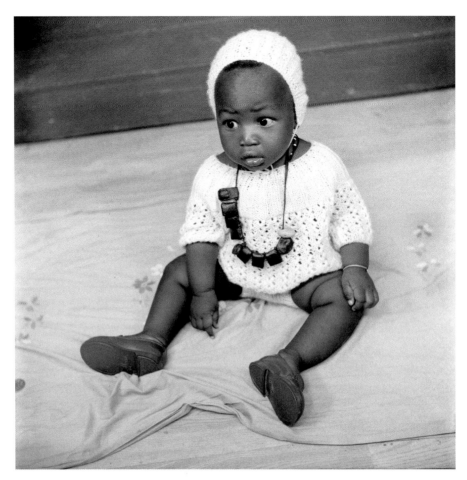

Figure 5.38. Tijani Sitou, *My Amulets*, 1977. High-resolution digital scan of original 6 × 6 cm negative. Courtesy Tijani Sitou Estate © Tijani Sitou.

time, these objects are repeatedly doused with matter that augments their potency, which is expressed in the unseen core of the object and in the thick, blackened, obscure appearance of the surface patina. Thus, power is visually and conceptually expressed in these sculptures through metaphorical associations and physical manifestations of dìbi.

In less dramatic fashion, smaller-scale amulets (sèbènw), in the form of jewelry, simultaneously embody ambiguous, obscure power (fig. 5.38). Rings, bracelets, and necklaces of nearly every metal, as well as of knotted leather, fiber, and beads, may appear simple on the surface but encase potent medicines or "recipes of action" (McNaughton 2000). Thus, hidden under clothing or in plain view, the power they communicate and contain is on the level of dìbi—ambiguous, obscure, mysterious, and secret.

Likewise, according to Hoffman, dìbi is an important constituent of accomplished griot speech (Hoffman 2000, 82–83). Ambiguous speech,

or verbal constructions laden with dìbi, attests to a griot's skill, experience, and wisdom as an accomplished orator. Hoffman explains, "Griot language (*jelikan*) derives [its] power from a simple syntactic structure whose meaning is made obscure. . . . Like the Komo mask [the] power of the griot's words, power that moves, that enables . . . is articulated in obscurity" (Hoffman 1995, 38, 41; 2000, 82–83).

Dìbi in jelikan also serves an amuletic function, couching direct agendas or claims within multiple layers of possible interpretation. As such, the power and position of the griot in public performances is both protected and reinforced by the latent aspect of a certain degree of inaccessibility in his or her words (Conrad 1995, 14).

Alongside jelikan, Hoffman discusses *dibikan*, "the language of dìbi," which is the powerful language of divination: "The obscurity of dibikan is the power to transmit messages from an unseen world. The articulation of dibikan, unlike that of jelikan, takes place at night, in private. . . . The diviner speaks in a series of conjoined nouns and noun-phrases. . . . The syntax of dibikan is impenetrable to the non-initiate and requires translation. It is obscured by the power of ambiguous form and meaning" (Hoffman 2000, 82–83; 1995, 41).

Ultimately, then, to be concerned with dìbi is to be engaged with some form of power, whether social, personal, or occult. The power of dìbi in part is the faculty to suggest the existence of something more than what appears to be, to visually or aurally express a significant level of inaccessibility to the spectator, and to elevate the aesthetic value and psychological intrigue of an artistic creation.

Dìbi in Malick Sidibé's *Vues de dos*

I have argued that photographers and clients utilize compositional strategies to incorporate dìbi within their images. Through his own invention, Malick Sidibé expanded this practice, pushing the aesthetic element of dìbi in portraiture further in his *Vues de dos* series (M. Sidibé 2004). Some of these were published for the first time in the 2003 Hasselblad catalog (fig. 5.39 and plate 12; see also Knape, Diawara, and Magnin 2003). Sidibé began experimenting with *Vues de dos* portraits in the 1960s, inspired by the bold, confident manner male actors in French and American films of the period regularly used to exit a scene—with their jacket flung over one shoulder, for example (fig. 5.40).

The first clients he posed in these early *Vues de dos* were young kamalenbaw who wished to convey a stylish, contemporary, independent attitude in their portraits, although some young women during the 1960s and 1970s also appreciated this pose (see fig. 2.15). Later, at the

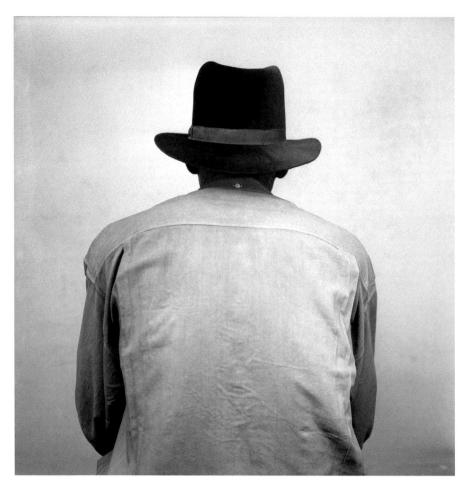

Figure 5.39. Malick Sidibé, *Lacina Sanogo, the Friend of Mody Seen from Behind* (*Vues de dos* series), 2002. © Malick Sidibé, courtesy MAGNIN-A gallery, Paris.

turn of the new millennium, he began creating *Vues de dos* images as a series intended for Western audiences. For these photographs, he solicited friends, neighbors, and family members as models. He choreographed the entirety of each image, selecting and arranging the attire, pose, backdrop, flooring, and, in some cases, props. He began working with young male models, gradually shifting his focus to women (fig. 5.2; plate 12).

Incorporating and representing dìbi in a more direct fashion, these photographs most blatantly express the important element of fadenya in individual portraits. The portraits withhold a certain amount of expected information, and the viewer is drawn toward the individual, scrutinizing the whole of the composition. Thus, the intended visual and psychological effect of these images is one of mystery and intrigue (M. Sidibé 2004). This strategy further empowers the photographer and the depicted

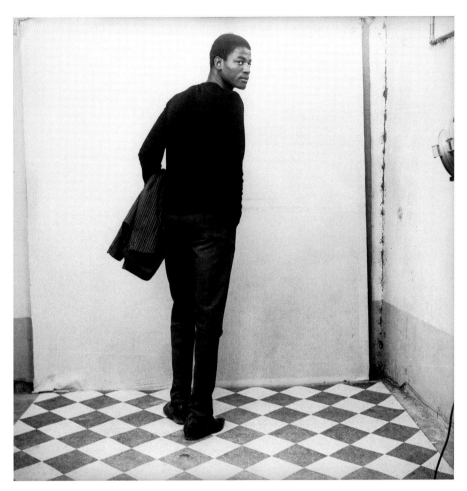

Figure 5.40. Malick Sidibé, *Untitled* (early *Vue de dos*), c. 1960s. © Malick Sidibé, courtesy MAGNIN-A gallery, Paris.

person, placing them in a position of knowledge, awareness, and accessibility the viewers lack. In this way, these images take an inward turn, retracting power from the viewers and rendering them somewhat impotent as outsiders.[52]

This is the most extreme example of the strategic incorporation of dìbi and fadenya in Malian photography. It is also visually, socially, and personally the most antithetical to portraits of Africans made by Western photographers, which, as Elder has argued, move from the "outside in, sweeping across the field of vision and then retreating back to a position of power" (Elder 1997, 60). In Sidibé's *Vues de dos* images, the opposite is true. The positions of power, knowledge, and accessibility have been removed from the intended audience and repositioned with the photographer and the individual on display (fig. 5.39; plate 12). Intentionally

created by Sidibé for international audiences, these images illustrate that not only do Malians have the agency to creatively depict themselves, but they have the power to deny Western audiences clear or easy access into their world (M. Sidibé 2004).[53] In these portraits, Sidibé visually states that these individuals are worthy of attention and respect, illustrating that he and his clients have the capacity to invent themselves, to introduce new styles and modes of photography, and to participate in global artistic and philosophical dialogue as equal agents.

Transcultural Aesthetics

The *Vues de dos* series is unique from the artworks, photographs, and contexts previously discussed in this chapter. It describes a situation in which local aesthetics have been successfully used to convey values, ideas, and emotions to audiences at home *and* abroad. In this case, Mande aesthetic concepts (dìbi and jɛya) have been applied by Sidibé within portraiture to express related sociocultural ideals associated with fadenya. These images have been intentionally created for a foreign, international audience. Yet the ideas they convey are readily communicated to—and create the desired effect in—Western viewers. The visual expression of clarity and ambiguity in these images has been (at least partially) interpreted and understood across cultural boundaries. For Edmund Leach, this is an example of "intercultural recognition underlying the transcultural appreciation of formal references to the human condition" (Van Damme 1996, 320). This level of appreciation—by Westerners of the *Vues de dos* portraits, for example—points to the intrigue associated with ambiguity and obscurity in human thought and experience (Ottenberg 1971, 15). It is also suggestive of the ability of formal clarity to render an object readable. As Wilfried Van Damme argued, "Visual clarity can and should be related to the contribution [it] makes to conceptual clarity, meaning the communicative function these cultural forms are expected to fulfill" (Van Damme 1996, 96). Because tensions between these two elements operate in most forms of human creation and communication, they can be perceived and understood on a "pan-human" or "supra-cultural" level (Van Damme 1996, 91).

Like Sidibé's *Vues de dos* images, Malian portrait photographs continue to be appreciated outside Mali, suggesting a degree of shared aesthetic values and experiences. One determinant of this reception, for example, is the fact that clarity and embellishment are "pluriculturally adhered to principles of form ... [or] ... cross-culturally applied aesthetic principles." According to Gestalt psychology, "Human beings search for order and regularity [clarity]." However, as Van Damme argued, in

artworks an excess of order or structure is boring, stiff, and disengaging. His view aligns with that of Irenäus Eibl-Eibesfeldt, who states, "When it is too easy for the observer to discover order, the object lacks aesthetic effectiveness." To resist this, embellishment or complexity is added to provide motion, energy, and interest. Too much complexity, however, brings chaos, rendering an art form indecipherable and therefore meaningless. To avoid this, structure renders embellishment manageable, intelligible, and inviting. Thus, in these aesthetic interpretations, like those of Malians, "both order and complexity are involved in generating a pleasurable visual experience" (Van Damme 1996, 61, 73, 91–98).

Recognizing these seemingly global commonalities, a number of scholars have considered "universalism in aesthetics" (Ndaw 1975; Maquet 1986; Blocker 1994; Van Damme 1996). According to similar criteria, many authors stress the aesthetic significance of clarity in multiple societies throughout the world. For example, in most cultures, as in Mali, clarity is "regarded as the sum of several other criteria such as symmetry, balance, discernibility, even smoothness and relative brightness" (Van Damme 1996, 103). This is true in the West as well as in various parts of Africa. In his comparative analysis, Van Damme identified clarity as an aesthetic standard in visual arts of several culture groups in Africa, including Bamana and Yorùbá (82, 103).[54] Shared cultural implications exist, for instance, among the terms used for "clarity" by Yorùbá in Nigeria (*ifarahon*), Mende in Sierra Leone (*ma ja-salin*), and Mande in Mali (*jɛya*).[55] In fact, Stephen Sprague discussed the importance of ifarahon in Yorùbá portrait photographs in relation to ideals of balance, symmetry, definition of form and line, and "visibility"; it is similar, but not identical, to jɛya in Malian portraits (Sprague 2003, 246, 250). Furthermore, additional terms in Yorùbá relate to badenya (such as *Omoya*, meaning "mother-child" and "shared breast milk") and fadenya (such as *Orogun*, which means "rival" as well as "cowife," and *Omobaba*, which is "father-child" or "spoiled child"). This helps explain, and perhaps facilitates, the transition from Yorùbá to Mande logic in the photographs of Tijani Sitou in Mopti. As Sitou's son Malick stated, "Everywhere in West Africa there is fadenya and badenya. There are even Hausa and Fulfulde words for fadenya and badenya. It is everywhere in the world; not just in Mali" (Malick Sitou 2004).

Scholars have also hypothesized that brilliance, as an esteemed aesthetic effect, operates cross-culturally (Van Damme 1996, 88). Although true, this value is not universal. As noted, Western art galleries and photographers in Mali do not share an aesthetic preference for brilliance in the finish of photographic paper.[56] Thus, while aesthetic concepts may operate similarly within multiple societies, considering them "universal"

aesthetic standards is neither entirely appropriate nor accurate. Rather, these so-called "pan-human values . . . take culture-specific forms" and significances (Van Damme 1996, 64). By the same token, however, acknowledging these shared aesthetic values helps explain the power visual culture has in global as well as local contexts. It illustrates, on an aesthetic level, at least, how objects such as photographs are able at once to facilitate, complicate, and confuse communication across cultural lines.

Notes

1. Previous scholars have discussed clarity as an ideal and obscurity as an anti-ideal within Mande aesthetics (Arnoldi 1995; McNaughton 1988; Brink 1980, 1981, 1982, 2001). Moreover, they have stressed the presence of one or the other in particular contexts, but never the interaction or tension that exists between them in most contexts. In this analysis, I argue that both clarity and obscurity contain positive and negative properties and that a relative balance between them represents an ideal in most instances.

2. Certainly a variety of diverse emotive categories exist in Mali. However, this analysis is restricted to considerations of beauty, humor, and horror (the power of obscurity) to keep it manageable and focused on aesthetic categories related to photography.

3. In Mali, television programs and beauty pageants emphasize the relation between cɛnyi (or cenye) and womanhood. On Saturday mornings on Malian television (ORTM) there is an hour-long program, I ni Sogoma ("Good Morning"), that includes a ten-minute segment titled Saramaya, a Bamanankan term for "beauty appraisal" or "beauty specialist" (literally referring to sara, "charm"). Each week this program focuses on cɛnyi in terms of personal adornment for women (Malick Sitou 2006).

4. Additional traits render a person attractive to members of the opposite sex, often indicating the person is a "good lover." The most prominent of these is a gap between the two front teeth. Physical characteristics can also indicate a good marital match. Even today, considerations for a prospective bride include high-arched feet. Each of these idealized features are aspects of a person's tère—"character"—as expressed through behavior and attitude and symbolically manifested in physical traits. In Mali, a person's tère is directly related to his or her dakan, "destiny." Both are considered to have been determined at birth and are important constituents of an individual's unique identity. A person's tère as well as dakan can be either good or bad. The traits listed here are some that indicate good tère (tère nyuman), rendering a woman attractive. According to this understanding, attractive traits hold deep significance in the lives of people beyond beauty, suggesting far-reaching effects for a successful future (M. Sidibé and Sitou 2004; Y. Doumbia 2004; Bakary Sidibé 2004; and Malick Sitou 2006).

5. Jonyeleni—or "beautiful woman of the Jo"—figures are owned and operated by the Jo secret initiation society. According to Salia Malé, "They are the materialization of the soul of the female entity at the origin of the

initiation practices which organize the society and maintain social order. . . . They are part of the exposition of *Jo* values" (Malé 2001, 143, 154).

6. Malick Sitou underlined the importance of a woman's large posterior, citing a song by Alou Sangaré called "The Big Butt Woman Disappointed Us" (Malick Sitou 2004). Similarly, in February 2008, the "Bobaraba" ("Big Butt") song and dance was popular in neighboring Ivory Coast and featured in numerous professional and home videos posted on YouTube. John James discussed this craze in an article for the BBC (James 2008).

7. In Bamako, nearly every neighborhood boutique that caters to women offers bleaching products. Likewise, many *cabines telefoniques* (public phone booths) sell bleaching creams and nail polish.

8. The practice remains controversial for much of the urban population, and many of the older generations, mainly men, disapprove. However, it is not yet disdained to the degree it has been in The Gambia, where a "Skin Bleaching (Prohibition)" act was passed by the government in 1995 (Buckley 2013).

9. This relates to Marxist arguments of scholars such as Peter Newcomer who stress the "socio-economic production of aesthetic values." Newcomer similarly analyzes the aesthetic preference for suntanned skin in "white Western culture" (Van Damme 1996, 122–23).

10. Most photographers prefer soft, natural lighting to its artificial counterpart. Although artificial lighting renders skin lighter (particularly that of the face), much to the appreciation of photographers' clientele, it is also harsher, making it more difficult to create the appearance of smoothness and uniformity. However, Félix Diallo, a Malian photographer working in Kita, found naturally lit photographs more difficult. Because the sun's angle changes throughout the day, the film speed and aperture must change accordingly. With artificial light, film speed and aperture settings often remain the same, as electrical lighting is more consistent (Nimis 2003, 8).

11. As Elder argued, flash photography also "marks the occasion," informing clients that a picture has been taken and giving photographers greater credibility among their clientele (Elder 1997, 219).

12. It is nearly universal to print for skin tone in portraiture. In this practice, the contrasts of light and dark in the image are chosen according to the tonal preferences and three-dimensionality of the skin's appearance. Adjustments are made by experimenting with the aperture opening on the enlarger, length of exposure, filter number, and number of paper used. In Mali, lighter, lower-contrast prints are called *a jera*, literally "it lightened or whitened," and high-contrast or overexposed prints are called *a finan*, "it darkened or blackened" (Mara 2004). In a related aesthetic issue, photographers often complain that taking portraits of dark- and light-skinned people together is the most difficult because often the lighting that flatters pale skin renders dark skin "too dark." Inversely, the ideal lighting for darker skin is usually too harsh for paler skin (M. Sidibé 2004).

13. Photographers usually appreciate contrast more than their patrons (M. Sidibé 2005). In this regard, their aesthetic preferences are commonly in line with those taught in photography courses in the West. However, in general, less contrast is preferred by all. Note: All images in the *Malick Sidibé* 2003

Hasselblad catalog (Knape, Diawara, and Magnin 2003) appear in higher contrast than considered ideal by Malian aesthetic standards.

14. This is a trade secret, the specifics of which are not to be publicized.

15. Elder and Nimis also attest to this practice (Elder 1997, 227; Nimis 1998c, 116). Reddening color photographs is not unique to Mali. It is practiced in neighboring countries as well, such as The Gambia (Buckley 2013).

16. Most color photographers prefer "natural" to "red" developing, yet they request the service in order to please their clientele, to remain competitive, and to be successful (M. Sidibé 2004).

17. I asked several photographers in Mali to comment on the appearance of photographs (their own, mine, or those of other photographers), identifying the ones they like best and why and critiquing the ones they found less successful. Beyond stating *a ka nyi*, "it is good," or *a ka di ne ye*, "I like it," analyzing particular aspects of images was not something most people seemed comfortable doing. Their responses were often vague, lacking specificity, and cautious or deliberately restrained. Abiodun commented on this phenomenon in Nigeria when he stated that "overt criticism is not a feature of Yorùbá culture" (Van Damme 1996, 184). In Mali, McNaughton noted, it is "neither kind nor wise to criticize someone else's work in the presence of others" (McNaughton 1988, 38, 106–7). This emphasizes the use of both ambiguous speech and restraint in Mali, mainly as a protective strategy. In my experience, the same is true in discussions of one's own work. Most photographers, such as Malick Sidibé, were reluctant to point out which of their photographs they preferred. When he did share some of his favorites (and least favorites) with me, Sidibé explained that making such information public was not prudent because it might affect how his works are appreciated, both at home and in the international art market, influencing which ones might be commissioned, purchased, or exhibited in the future. In respect of this, such information will remain private. However, in general, photographers prefer black-and-white photographs to color, partially because they preserve better, particularly in the climate of West Africa. Photographers generally prefer photos that are well-focused, with harmonious or *ambiante* lighting, free from black or white marks (scratched negatives, dust, or other imperfections on the negative or print itself), with balanced (not necessarily symmetrical) compositions. Portraits that flatter clients are deemed the most successful. Those featuring young children, beautiful women, and scenes from rural life were commonly appreciated, with the most enjoyment arising from images considered humorous (M. Sidibé 2004; Malick Sitou 2004).

18. In this case, photographers use the French term *net* to designate a "good" negative. *Net* is defined as "clear, sharp, definite, neat and clean" (Cousin et al. 2000, 285).

19. Many photographers voiced this complaint, finding large group portraits among the most challenging. It is more difficult to create a clear sense of balance, to pose each person well, and to keep everyone in sharp focus—all important aesthetic considerations that determine the success of a portrait.

20. Father Bailleul defines *tère* as "luck," probably because it is tied to one's destiny, or dakan, although it is typically described as "character" (Bailleul 2000a, 451).

21. Arnoldi defines *jɛ* as "unity" (within a village) and connects it with badenya (Arnoldi 1995, 159).

22. The V configuration was common in Victorian era portraiture as well. It is unclear whether its use by Malian photographers stems from training with French photographers or if it was created and used by Malian photographers independently as a logical means to create interesting, balanced three-person compositions.

23. To date, it is not entirely clear who took this picture. However, it was likely created by Sidibé's first assistant, Sidiki, who perpetuated many of his mentor's photographic techniques (M. Sidibé 2004; S. Sidibé 2004).

24. In March 2004, I attended a puppet and masquerade performance in Markala in which Yayoroba bowed to political and social leaders as well as those who funded the event (such as the director of the French Cultural Center) before commencing the performance.

25. McNaughton appropriately uses the term *spice* in his discussions of embellishment in Mande arts.

26. I use quotation marks here to indicate that Keïta refers to the paisley backdrop as "leaves" in this interview. Keïta began using his fringed bedspread, later changing his backdrops every two to three years, which has helped him and more recent scholars date his archives (see Chapoutot 2016).

27. Often backdrops are a means to identify the work of different photographers—as a form of propriety and advertisement. In addition to clients, most photographers are familiar with the studio interiors and styles of their competitors and thus are able to recognize each other's work.

28. Nimis argues that Yorùbá photographers from Nigeria and Ghana introduced these greyscale painted scenic backdrops throughout western Africa in the 1950s (Nimis 2005, 2013).

29. Certainly the quality of the fabric and its coloration, patterns, and design are all considerations that factor into aesthetic assessments. Comfort and practicality are also important factors for the appreciation of this style of dress. However, the emphasis here is on the important aspect of dìbi and its function as an element that heightens aesthetic appeal.

30. Due to its conservative nature, jɛya (in league with badenya) is often considered to be related to restraint. However, dìbi is an important aspect of this value as well. Several Mande scholars previously discussed the important aesthetic aspect of restraint both in terms of jɛya and dìbi. For further explanation see McNaughton (1988, 2001), Hardin (1993), and Arnoldi (1995).

31. This gesture also relates to issues of social and spiritual inequities of power, which are addressed in the following chapter. As such, it is a protective strategy. Women may also employ this practice as a flirtation tactic to entice the interest of young male suitors.

32. Over the past few years, Brehima Sidibé, Oudya Sidibé, Bakary Sidibé, and Heather Maxwell have individually also made me aware of this social etiquette.

33. This is evident in the proverbs cited throughout this text. It is also an important aspect of moral lessons or fables (*nsiirin*).

34. According to Malick Sitou (2006), there is a term in the Yorùbá language, *lagbaya*, that serves a similar purpose.

35. The bean joke refers to the gastrointestinal effects of eating beans.

36. Nearly everyone I encountered in Mali, young or old, male or female, had a jovial sense of humor and expressed it quite freely. In addition, among grandparents and grandchildren there exists a special joking relationship that, like senankunya, is intended to reinforce badenya in a playful manner. It helps keep a sense of unity and intimacy between disparate generations and social positions of power and inequality.

37. For example, Brehima Sidibé stated, "I cannot say when Yokoro began, but I am certain that my parents, grandparents, and great-great grandparents practiced Yokoro in their youth; and we have always sung the same song and worn the same masks but, perhaps, for different reasons" (Brehima Sidibé 2005).

38. All these phrases are sung at least twice. In Mopti, the songs are sung in the Fulani language, Fulfulde, blended with Bamanankan. For example, Yokoro begins with *Aw ni su, ina na kirdo, baba na kirdo*, "Good evening, good evening mother, good evening father." Mopti performances add another character that is not represented in Bamako. This character, called Dodo, carries a large set of cattle horns. He accompanies Yokoro and pretends to fight and stab him with the horns in a manner similar to that of a matador in a bull ring. Dodo likely originated among Fulani groups as they are the predominant cattle herders in the region and one of the prominent culture groups in Mopti (Malick Sitou 2006).

39. In this quotation, Brink describes the moral and social implications of the strategic use of humor in the "kote-tlon play" in Mali, although his description applies to Yokoro performances as well.

40. According to Malick Sitou (2006), young people "hate [the] word" *bilakoro* because it implies that "you are nothing, you know nothing, and that you have not done anything yet." It is used to designate uncircumcised children—those who have yet to be indoctrinated into the ways of adulthood. However, Sitou stated that it implies "someone who has not reached the age of twenty-one: seven, times three, which has spiritual significance."

41. Fatoumata Diabaté recently featured Yokoro images in her photographic series titled *L'Homme en animal* (Diabaté, n.d.).

42. For information on kamalen ton and kotè-tulon ton in Mali, see Brink (1980, 2001) and Arnoldi (1995).

43. Although beauty in Mali is generally epitomized in the Fulani woman, by exaggerating these aspects in imitation the ideal can be trumped and its related power usurped. This practice illustrates the complex relationships between city-dwelling youths and their rural relatives—a dynamic replete with honor, duty, obligation, envy, and estrangement.

44. This proverb relates to the English adage "seeing is believing" but implies that one has knowledge not shared with others (Malick Sitou 2006).

45. Clothing, here, is symbolic for identity. It contains one's secrets, dirt, sweat, and tears. To expose all these under the sky is a metaphor for revealing everything about oneself. Therefore, this proverb imparts the following wisdom: Do not expose everything about yourself. Keep some things hidden, secret (Malick Sitou 2006).

46. In contrast to other art forms, like sculpture, in which embellishment is not intended to obscure formal clarity, to some degree in photography it is.

For example, McNaughton notes, "Patterns . . . do not obscure the sculpted form beneath. Rather, they enhance it, augment it" (McNaughton 1988, 108). In photographs, structure and embellishment, stability and motion, and clarity and obscurity ideally strike some sort of balance, with neither aspect entirely consuming the other. The tension or ratio between them perhaps varies to a greater extent in photographs than in other visual arts, inherent in the play between two- and three-dimensionality, as the following discussion shows.

47. These expressions are commonly used in Mali to compliment someone on their appearance as well as to evaluate and appreciate artworks and photographs (Arnoldi 1995, 157; M. Sidibé 2003, 2005). Kris Hardin gives a similar account in her analysis of the "aesthetics of action" among Kono, a Mande culture group in Sierra Leone (Hardin 1993, 179–80).

48. Malick Sidibé explained that these women were well-known and influential in their neighborhood (M. Sidibé 2003).

49. The authorship of picnic portraits taken along the Niger River during the 1970s by a reportage photographer at Studio Malick is presently contested. Both Sidiki Sidibé and Amadou Fané have claimed to have produced these images for Malick Sidibé. Since the dates align with those during which Fané was employed at the studio, I have attributed this photograph to him.

50. Kòmò performances feature dramatic, often "ominous or eerie" drumming made by very large *jembe* or smaller friction drums (Charry 2000, 7, 207, 213). Kòmòkun performers "use kazoo-like voice disguisers and are often accompanied by bards who translate the sounds they make into songs that are laden with power" (McNaughton 2001, 176).

51. Kòmòkun (masks used in the kòmò association) and boli sculptures are spiritually and materially charged power objects that serve as agents of positive or negative action on behalf of the individuals and groups who own and manipulate them. They are created to ensure the success of their owners and to underscore their authoritative capacities, knowledge, and power. Part of their potency derives from their visual ambiguity, which is articulated in their amorphous, amalgamated shapes and encrusted layers of composite materials and in their inaccessibility to most citizens or members of an association.

52. To these ends, Sidibé's employment of dìbi in his *Vue de dos* series functions similarly to Édouard Glissant's notion of obscurity and "the right to opacity" as a strategy for self-empowerment and inaccessibility among members of the African diaspora (Glissant 1997; Glissant, Diawara, and Winks 2011). Unfortunately, I did not become familiar with Glissant's work until after I had written this book, when I was preparing to sit on a panel to discuss Manthia Diawara's film *An Opera of the World* (2017) during the filmmaker's visit to Michigan State University in October 2018.

53. Malick Sidibé did not consider his images to be particularly political. However, he did believe in the creativity and distinctiveness of his work and was continually introducing fresh ideas to the global art community.

54. Van Damme noted the "importance of clarity as an aesthetic standard" among the Diola, Senufo, Baule, Akan, Okpella, Igbo, Tiv, Chokwe, Batammaliba, and Idoma (Van Damme 1996, 82). In fact, several Africanist

scholars have discussed the aesthetic and formal principles of clarity, balance, and harmony in art works (J. Fernandez 1971; R. Thompson 1971, 1973; Vogel 1980; McNaughton 1988; Murphy 1990; Arnoldi 1995).

55. Citing McNaughton, Van Damme discusses clarity in Mande arts in terms of *jayan* rather than jɛya (Van Damme 1996, 82).

56. This is evident in Japanese aesthetic preferences for the patinated surfaces of metallic objects as opposed to the shiny, brilliant ones that tend to be appreciated among Western cultures (Okakura 1997).

6

Ja and the Metaphysical Dimensions of Photography

IN MALI, PHOTOGRAPHS OPERATE WITHIN two interconnected realms of power: secular and metaphysical (McNaughton 1982, 494). Therefore, these spheres are not considered wholly separate within this analysis. However, to address the myriad capacities photography has served in the personal, social, and political lives of individuals in Mali since the late nineteenth century, much of this discussion has centered on the secular power of the medium. In this chapter, which explores the transcendental dimensions of photographic agency, local practices of photography are understood in the context of mutually affecting belief systems—Islam and the principle of energy and consequence known as *nyama*—that inform the Bamanankan term for the medium: *ja*.

Photography and Islam

Popular discussions of Islam and material culture often assume the prohibition of figurative, particularly anthropomorphic, imagery. However, although most Islamic art is nonfigurative, the relationship between the religion and figuration is quite nuanced. While the Qur'an definitively bans idols, it does not explicitly forbid all forms of figurative representation (Rosen 2008, 94). Rather, for many Muslims, this interdiction derives from predominant interpretations of the hadiths, a collection of the Prophet Muhammad's teachings recorded and compiled by his followers from the seventh to ninth centuries (Zepp 2000, 141; von Silvers 2000, 23). Yet the hadiths actually reveal Muhammad's own ambiguous

relationship to figuration and, by extension, portraiture. As anthropologist Laurence Rosen observed, for example, one text records the prophet's destruction of all pictures in the Ka'ba save for one depicting Mary and infant Jesus; another notes his appreciation of a youthful portrait depicting his future wife, Aisha. Regarding this equivocacy, Rosen comments, "Indeed, representations of the Prophet himself are to be found from the first two centuries following his death, and though there appears to have been some discouragement of human pictorial representation, even at this early date there were no rules specifically barring portraiture" (Rosen 2008, 94–95).

Even with such initial ambiguity, the majority of Muslims today find the undesirable repercussions of depicting the human form rendered clear in the hadiths, which constitutes the basis on which the practice is considered morally forbidden. The passage most recounted during my research in Mali highlights the moment in which Muhammad finds Aisha in the process of making a pillow featuring zoomorphic imagery and inquires, "Don't you know that angels refuse to enter a house in which there is a picture? On the Last Day makers of pictures will be punished, for God will say to them, 'Give life to that which you have created'" (M. Sidibé 2003; Zepp 2000, 141).[1] Inherent in this statement is the concept that those who make visual representations of sentient beings are in heretical competition with God—the sole creator of all living things.

Conceptually, this condemnation includes portrait photographs. Therefore, during spiritually significant periods, such as the month of Ramadan, some Malians hide, cover with cloth, or turn around portraits regularly on display in their homes. They do so to encourage angels, the messengers of God, to enter and report back that they are good and pious Muslims (M. Sidibé 2003; A. B. Cissé 2003; Malick Sitou 2004).[2] However, most contemporary Bamakois do not consider themselves heretics or idolaters for creating, preserving, and exhibiting portrait photographs in albums and frames in their living spaces. Nevertheless, in spite of the relative popularity of photographic portraiture in the country, most photographers have been challenged on the figurative basis of their profession at some point in their career. In an interview with Magnin, Malick Sidibé explained, "When I was young I made drawings and people told me that religion forbade this. People reproached me. The same thing happened when I started taking photographs" (Knape 2003, 79).

In fact, when it comes to photographic practice in Muslim worlds, there is a good deal of individual and cultural variance. In Mali, when questioned about the broadly assumed Islamic prohibition of human imagery, photographers are quick to defend their profession, pointing out that identification portraits are required for passports in every Muslim

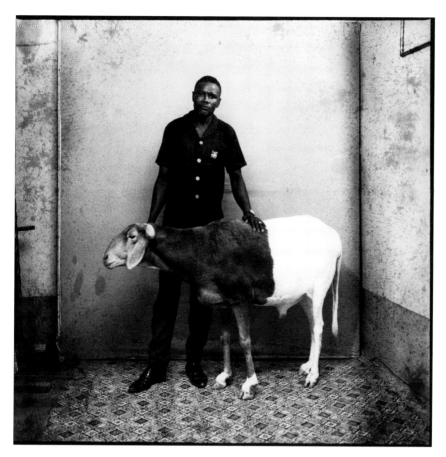

Figure 6.1. Malick Sidibé, *Touré with a Sheep*, 1962. © Malick Sidibé, courtesy MAGNIN-A gallery, Paris.

country, including their own. Such photographs, they argue, are a prerequisite for individuals who wish to complete the hajj, the all-but-mandatory Muslim pilgrimage to Mecca, thereby rendering them spiritually sanctioned images. Due to this modern reality, many Muslim clerics, imams, marabouts, and other spiritual leaders have decreed that photographs that only capture the bust of a person (for identification purposes) are permissible while depictions of the entire human body are not.[3]

However, due to complex human perceptions and proclivities, this rule is not unanimously upheld. Rather, for several decades, the busiest occasions for portrait commissions in Malian urban centers have been the Muslim holidays of Tabaski and Ramadan. Photographers' archives in Bamako, Ségu, and Mopti are replete with images of people depicted with their sheep in celebration of Tabaski (fig. 6.1; also see fig. I.5) and dressed in their finest attire on the festive final day of Ramadan. With similar force, frequent commissions for portraits illustrating Muslim piety

have led photographers to feature mosque-inspired backdrops and prayer costumes in their studios (see figs. 2.48 and 2.49). In Mopti, for example, Tijani Sitou made a white cloak, Saudi *igal* headband, and his own prayer beads available for clients who wished to pose in the act of worship (plate 5). Often they did so to document their aspirations to complete the hajj (Malick Sitou 2006). Illustrating photography's intimate relationship with Islam in Mali, Nimis describes individuals who have their picture taken while praying inside mosques, where such activity is "authorized" (Nimis 1998c, 85).[4] In each of these instances, photography functions in the service of religious faith, allowing Muslims to visually preserve and perpetuate that vital aspect of their identity.

Illustrating nuanced relations among figuration, photography, and Islamic practice around the world, recent scholarship problematizes claims about the aniconic position of Muslims (Behrend 2002a, 2002b, 2003, 2013; Brielmaier 2003; Damandan 2004; Flood 2002; Luizard 2012; Roberts and Roberts 1998, 2003, 2008; Rosen 2008; Strassler 2010; Gruber 2019). These accounts describe specific ways figurative imagery, particularly portraiture, has been engaged, appropriated, and produced—even while being contested and at times resisted—in the historical and contemporary Muslim contexts of eastern and western Africa, Indonesia, and the Middle East. For example, Rosen reports that contemporary Muslim Arabs generally accept "individual pictures, though not of the Prophet or God," and despite "the Saudi ban on cell phones with built-in cameras, [photographs] are now very common in the Arab world" (Rosen 2008, 96–99). Behrend explains that Muslims along the East African coast have overcome early resistance and incorporated photographic portraiture into various life domains yet, through cutting and collage, have developed ways to render figuration more abstract and thereby challenge visibility in their portraits (Behrend 2013). Finally, Damandan argues that studio portraiture has continued to be practiced in Iran, even withstanding the late 1970s, when several studios were burned down and photographs of unveiled women were prohibited (Damandan 2004, 8, 43, 261).

Historically, portrait photography, including common examples of full-length portraiture, has been practiced in many Muslim countries since the nineteenth century. Across the globe today, several Muslim activists—even those who are restrictive in their beliefs—employ photography to popularize their cause and are able to reach audiences through the media of television, video, and film. Likewise, large-scale commemorative portraits of Muslim leaders have regularly been held aloft in processions and demonstrations in the Middle East, Africa, parts of Asia, and the United States. Ousmane Charif Madani Haïdara, a popular preacher, head of the Ansar Dine movement, and well-known imam of the Bankoni

mosque in Bamako, has been adamantly outspoken for some years against the creation of figurative imagery in Mali (Malick Sitou 2005; M. Sidibé 2006; Grosz-Ngaté 2008).[5] Although he has referenced photographs within his damning speeches, he regularly employs photographic portraiture to popularize his public image and religious teachings. In addition, as previously mentioned, many of his followers in Mali, Burkina Faso, and the Ivory Coast don cloth decorated with his portrait to proclaim their faith and perpetuate his message (Malick Sitou 2005). In related practice, according to Nimis, professional photographer Mamadou Cissé created a portrait of Muslim leader "El Hadj Sidy Modibo Kâne, The Religious Chief of Dilly," to be dispersed among faithful followers in Mali during the colonial era (Nimis 1996, 41). Additionally, as a religious memento, Mountaga Dembélé kept a portrait of Muslim spiritual leader Cheikh Hamallah long after his deportation to Algeria in 1941.[6]

The persistence of portraiture in Mali and other international Muslim contexts thus illustrates the volatility of the popularly accepted Islamic prohibition against human imagery. Although some photographers, such as Mamadou Wellé Diallo, have been conflicted about their profession (Nimis 1998c, 84), the majority of practitioners in Mali, who are predominantly Muslim in faith (with the exception of Emmanuel Bakary Daou, who is Christian), are not concerned about the spiritual implications of their work. For his part, Malick Sidibé stated, "This is the path that God has marked out for me. Perhaps tomorrow he will put me to the test and insist that I give souls and life to all these faces. Perhaps he will make this possible for me" (Knape 2003, 79; M. Sidibé 2003).

The generally relaxed view of photography and portraiture in Mali, in spite of arguable Islamic dogma, may also result from the marrying of spiritual beliefs. Although the country's population is reportedly 90 percent Muslim, most Malians practice a spiritual faith and philosophical perspective that incorporates animist and Muslim principles.[7] Alongside the tenets of Islam, many Malians appreciate another omnipotent force, known as nyama in Bamanankan, that informs the production and function of photographic images in the nation.

Photography and Nyama

Nyama is a complex concept that has been defined in several varied yet related ways. The most comprehensive of these is the summary provided by McNaughton:

> At sorcery's base lies a phenomenon that generates its own fair share of ambivalence and disquiet among the Mande. It is perceived as the world's basic energy, the energy that animates the universe. It is the

force the Mande call nyama, which I refer to as special energy or occult power, and which most Westerners would consider supernatural. The Mande, in contrast, are inclined to see it as both natural and mystical, and as a source of moral reciprocity.

The missionary Father Henry said that nyama was hard to define; he called it force, power, and energy and then described it as a kind of fluid possessed by every living being (Henry 1910: 27–28). Monteil called it a fluid common to all of nature (Monteil 1924: 121). The Malian scholar Youssouf Cissé followed the colonial administrator Maurice Delafosse in saying that it meant life or endowed with life, spirit or endowed with animated spirit. Cissé added that it was the emanation of the soul, a kind of flux or flow that executes the soul's will (Cissé 1964: 192–193).[8] Labouret described it in much the same way, adding, by way of illustration, that it was the power behind human thought and will, and the force that causes rain or a lack of it (Labouret 1934: 120). Dominique Zahan described it as a force that exists in all beings and inorganic matter, and is comparable to a vibration (Zahan 1963: 133).

The Mande believe that in concentrations, especially when they are massive and uncontrolled, this force is potentially dangerous, even deadly. People can learn to control it through sorcery, however, and thereby harness it to help them carry out their activities. Thus the linguist Charles Bird describes its essence most appropriately when he calls it the energy of action (Bird 1974: vii). Nyama is the necessary power source behind every movement, every task. It is a prerequisite to all action and it is emitted as a by-product of every act. . . . Nyama then is like electricity unconstrained by insulated wires but rather set neatly into a vast matrix of deeply interfaced social and natural laws. But it is more than energy. When the Mande tell folk stories, recount legends, or explain things to researchers, it becomes clear that they view nyama as a rationale for their most fundamental behavior patterns and as an explanation for the organization of their world. (McNaughton 1988, 15–16)

Although, at its origin, nyama is conceived as pervasive energy that "animates the universe," it is also understood as "consequence." For example, Youssouf Tata Cissé described nyama as an "avenging force" (Y. T. Cissé 1973, 160–61) while Madina Ly-Tall, Seydou Camara, and Bouna Diouara called it "a vengeful force that hits blasphemers" (Jabaté et al. 1987, 9). In these interpretations, nyama is thought to be a *negative* consequence, such as the undesirable repercussions of breaking a taboo or deliberately disobeying the rules of nature.[9] Addressing this conception of nyama, McNaughton continues:

This energy also provides a system of cause and effect that binds a society to its mores and exists as a barrier to catch all but the most daring, the most enterprising of its citizens. Much of the scholarly literature describes it as an awesome force to be feared and forever guarded against, and the word vengeance is frequently used to relate its effects. Monteil

calls it a force that involves vengeance and Father Henry says it is the envoy, the messenger of hatred and vengeance, a form of justice that travels wherever the will sends it (Monteil 1924: 121; Henry 1910: 28). We may add to this a statement by Germaine Dieterlen, the disciple of Marcel Griaule, that when a person dies, the energy is released from the body into an extremely active form, which has the capacity to attack the person responsible for the death (Dieterlen 1951: 63). Henri Labouret says the nyama of a deceased person provides the power for that person, even though dead, to attack his enemies (Labouret 1934: 120). Youssouf Cissé states that nyama is good or bad according to the nature or state of the soul at the moment when it produces the energy (Cissé 1964: 193). He goes on to suggest that the most certain means of holding the nyama of others at bay is never to indulge in wrongful acts and always prove oneself full of goodness, kindness, humility, passiveness, patience and submission (Cissé 1964: 200).[10] (McNaughton, 1988, 17)

Clearly, nyama is a significant constituent in the worldview of Malians. As a vital force, it is intimately connected to the notion of the soul (*ni*), the immaterial energy that animates the body, which is tied to *miiri* (thought) and *taasi* (reflection), constituting a person's character (tère).[11] Conceived in terms of a network of material and immaterial phenomenological experience, nyama is a basic part of complex Mande understandings of personhood, or *màá*, and, by extension, *màaya*, humanity (Bailleul 2000a, 219, 293).[12] As a consequence, it is engaged in a "system of cause and effect" that ties society to its ethical standards (McNaughton 1988, 17). Thus, it is a foundational aspect of Mande cultural logic and is directly implicated in the social theory of action and morality elucidated through fadenya and badenya.

Nyama also comprises the basic principle of the affective power of art in Mali, including previously discussed boliw, kòmòkun, and jelikan. For instance, boliw (see fig. 5.37a) derive their power from nyama (an inherent force in all organic matter) through the materials amassed within their interiors and on their surfaces. Compiling botanicals and earthen matter as well as human and animal byproducts, these objects both represent and embody the collective nyama by which they are empowered. At once the physical and metaphysical manifestation of nyama, their force is augmented by the faculty and knowledge of those who own and control them, namely the secret associations created to manage nyama and direct it toward socially productive ends. Due to the perilous nature of their task, they are headed by persons called *somaw* with acute knowledge of the "less visible world."[13] Many blacksmiths, hunters, diviners, and leaders of secret associations are somaw, persons with expertise engaging esoteric powers. These individuals head the kòmò association and are responsible for the creation, care, and manipulation of kòmòkunw—great helmet

masks that function as theatrical, mobile boliw (see fig. 5.37b). Generally speaking, it is this power that exists in and can be expressed through ambiguity and obscurity. Dìbi makes nyama evident and aesthetically increases its mystery and potency.

Nyama activated, manipulated, and wielded by individuals with particular intent is called *daliluw*. McNaughton calls these "recipes for action" (McNaughton 2000).[14] Daliluw may take the form of herbal medicines or other spiritually charged materials. Or they may be more ephemeral, such as spoken words or gestures that are designed to act—benevolently or maliciously—on the world around them.[15] In this vein, amulets are a particular form of dalilu commissioned from jewelers, leather workers, blacksmiths, and diviners to protect their owners from harm.[16] In Mali, infants are equipped with these protective devices at birth to safeguard them from harmful daliluw and other malevolent forces, such as envy and jealousy, which are characterized by Muslims as the Evil Eye (see fig. 5.38). Because of these threats, people of all ages, genders, classes, and professions possess amulets. Often they carry them directly on their person in the form of metal or leather-bound jewelry or in small leather pouches held in wallets, purses, pockets, or other hidden locales. Special hats called Bamada (see fig. 3.9), "crocodile mouth," also function as amulets to "neutralize" malevolent sorcery (McNaughton 1988, 126; Y. Cissé 1973, 162). Most dramatically, hunter's shirts are externally laden with amulets bearing animal teeth, claws, fur, and botanical medicines to protect and aid the wearer during festive ceremonies and to proclaim one's efficacy in the bush (see fig. 5.22). Amulets are also present in homes. These larger examples are called *basiw* and are commonly located in the entryways and ceiling rafters of architectural structures or buried in the surrounding area. In the past and in rural areas today, they also function as carved wooden door locks (McNaughton 1988, 28). To protect owners from traffic accidents, most automobiles contain amulets, which often hang from the rearview mirror or are stored within the glove compartment. Later in this chapter, photographs will be shown to function as part of daliluw recipes.

Nyama, daliluw, and amulets (sèbènw) have their counterparts or parallels in Islam, which may help explain the marrying of spiritual beliefs in Mali. An historical account cited by Tièmòkò Keïta (Seydou Keïta's uncle) illustrates some similarities: "According to the writings of the Arab marabout Sidi Mahamane, Bamako was destined to become a large city inhabited by many races and [lineages] on both banks of the river. The early citizens set out to fulfill the prophecy that 'every new settler, whatever their origin, their religion or trade, will feel at home.' In order to bring about this prophecy, they buried [an amulet] prepared by the Arab marabout near the first mosque" (Magnin 1997, 15).

Marabouts are believed by many to possess powers akin to those of somaw and invoke an essential force or energy known as *baraka* (McNaughton 1988, 51; Roberts and Roberts 2002, 54–56, and 2008, 7). In Arabic, the sacred term *baraka* means "blessing" and refers to the enabling power of God's grace (Becker 2011, 125; Gibb 1999, 93–94, 101; Rasmussen 2004; Ryan 2000, 220; Hanretta 2008, 497; Von Denffer 1976).[17] Like nyama, baraka is conceived as energy that animates the interior of a "blessed" person and facilitates the efficacy of their will and physical actions. Malick Sitou (2006) explains that with baraka "you are blessed in your flesh and bones. *Baraka b'i la* [Baraka embodies you]. It protects you and allows you to be successful in everything that you do." Muslim holy figures, such as prophets and saints, are closest to God and endowed with greater concentrations of baraka (Rasmussen 2004, 333; Ryan 2000, 220; Von Denffer 1976, 169).

Marabouts (and their clients) are able to access baraka through specialized formulas (like daliluw) drawn from their extensive knowledge of Arabic, the Qur'an, and the ninety-nine names of Allah, as well as the immaterial presence of deceased saints (Miner 1953, 86–87). The names of Allah are found throughout the Qur'an and the hadiths and include titles such as The Lord of Mercy, The Giver, The Ever Relenting, The Most Merciful, The All Hearing, and The All Knowing (Haleem 2004, 3, 7, 15). In Mali, through the repetitious reading or utterance of these names, baraka can be invoked for protective and causative ends.[18] These and other passages from Qur'anic texts may also be spoken into one's palms (often accompanied by saliva) and rubbed onto the face, under the arms, or under the feet or else written and encased in large and small amulets for similar purposes (Malick Sitou 2006). In the account provided by Tièmòkò Keïta, an amulet was created and later buried to ensure the fulfillment of a prophecy. Others are intended to equip individuals against malevolent sorcery, evil *jinn* (devils or spirits), the Evil Eye, and their repercussions, including hardship, illness, and death (Miner 1953, 86–88).[19] Still others are designed to positively influence affairs of the heart or business. Thus, baraka, like nyama, is an omnipotent force that empowers and can be accessed via daliluw, of which amulets are an important part.[20] It is worth noting here that in Bamanankan the term for amulet, *sèbèn*, literally translates as "writing," which may derive from the fact that many of the leather-bound versions encase Qur'anic scripture (McNaughton 1988, 58, 62).[21]

Among Mourides (Sufi Muslims in neighboring Senegal), the indexical properties of photographs render them spiritually potent. In these contexts, photographs of saints such as Cheikh Amadou Bamba and other local Muslim leaders maintain the presence and essence of the depicted,

rather than function merely as their visual representations (Roberts and Roberts 2002, 2003, 2008; Mustafa 2002, 191). Given their heightened measure of baraka, and their ability to transmit it to others, those who possess and physically engage with images of Muslim saints and holy men are believed to benefit from God's blessings and protection. This is also true of illustrated portraits, which are often based on photographic originals. Mourides live in Malian cities as well. In Bamako, painted images of Bamba—based on an iconic photograph of the saint taken in 1913 while under house arrest by French colonials—decorate the exterior walls of Senegalese businesses and home interiors, rendering his essence and baraka present (fig. 6.2). Like Mourides, Tijanis (Sufi Muslims) in Mali believe that saints emanate baraka (Hanretta 2008 497; Ryan 2000, 220; Triaud 2010, 831). Moreover, they hold that baraka may be transferred through physical contact with saints and other holy figures via locations, such as tombs, or objects, such as portraits (Rasmussen 2004, 333; Von Denffer 1976, 169). For example, after the passing of Cheikh Sékou Sallah—an ascetic healer from Macina considered a saint by many in the region of Mopti—people flocked to Tijani Sitou's studio to purchase reprints of Sallah's portraits (taken during the 1980s) as a means to access baraka. For similar purposes, Mountaga Dembélé kept a portrait of Cheikh Hamallah over many decades, and today, Haidara's followers carry small pictures of him on their person for inspiration, protection, and spiritual endowment (Malick Sitou 2005, 2015).

Understanding nyama and baraka allows one to interpret the metaphysical significance of images that document the boliw of Malian presidents Modibo Keïta and Moussa Traoré. In Malian contexts, all leaders, including presidents, are believed to have spiritual as well as political power in terms of nyama, daliluw, boliw, and sèbènw. Indeed, it is felt that their ability to manipulate nyama has enabled them to acquire and retain political power. In fact, it is considered a prerequisite for such persons as it empowers them to overcome challenges and antagonistic forces, solve problems, and realize their aspirations (McNaughton 1988, 13). In other words, it facilitates their fadenya pursuits. About this reality, Malick Sidibé's cousin, Brehima, stated, "[Every political leader] is a soma or has their own soma. It is known that Sumangurun Kanté was a great sorcerer, that Samori [Touré] was a dreadful marabout (with his daliluw taken from the Qur'an), and that Modibo Keïta [had daliluw empowered by nyama]" (Brehima Sidibé 2006).[22] Several popular epics, such as that of Sunjata, emphasize that all leaders are to some degree powerful somaw with access to heightened levels of nyama (and, later, baraka).[23] Throughout the legend, two main protagonists, the hero, Sunjata Keïta, and his adversary, the powerful sorcerer king Sumangurun

Figure 6.2. Wall painting of Sheikh Amadou Bamba. Photo by author, Bamako, 2011.

Kanté, procure the power to rule and maintain it through their arcane knowledge and control of nyama and daliluw. Speaking to this very point, McNaughton surmises, "Sumanganguru's true power was his sorcery, and so he is said to have owned great numbers of potent occult devices" (McNaughton 1995b, 49).

For Malians, Modibo Keïta was an extremely powerful soma. According to Iyouba Samaké, "He had jinnw power, daliluw power, soma power, and [sèbèn]" (I. Samaké 2005). Because of this license, enacted

through the boliw buried around the perimeters of his palace, it is thought that Keïta could never have been captured in his presidential palace atop Kuluba. Rather, it is commonly held that he would have been able to escape on the "magic carpet" he possessed inside and that any such attempt to overthrow him would have failed (I. Samaké and Sidibé 2005; Bakary Sidibé 2006). Nevertheless, on November 19, 1968, Keïta was strategically captured in the outskirts of Kulikoro on his return to the capital from Mopti (Imperato 1977b, 61).[24] After his arrest, the military unearthed and confiscated his powerful boliw (fig. 6.3), a process recorded by photographers working for ANIM, including Moumouni Koné. Purportedly, in the days that followed, those images appeared on the front page of *L'Essor*, Mali's daily newspaper (N. Samaké and Coulibaly 2004; O. Keïta 2004).[25] Images of the boliw in the possession of the military (many of them likely powerful somaw in their own right) attest to the end of Keïta's regime, the demise of his political (and spiritual) power, and its transfer to the coup d'état leaders.[26]

The same treatment was afforded Moussa Traoré, Keïta's successor and the leader of the military coup that abruptly terminated the Keïta's eight-year regime. Years later, in league with grievant women and students, the young nation's military led another successful coup d'état that ended Traoré's twenty-three-year dictatorship. When his boli, known today as "Moussa's Egg," was uncovered and removed from the palatial grounds by the army in 1991, once again ANIM photographers were present to document the moment on film (fig. 6.4). The surviving photograph serves as visual proof of the military's usurpation of Traoré's power and implies his subsequent spiritual and political impotence.

In each case, to stifle Keïta's and Traoré's power and prevent its future return, the boliw were later destroyed by the military. In light of such iconoclasm, photographs that record members of the military in possession of these power objects function as authoritative proof that the political and spiritual power of these leaders has been defeated and new leadership has taken control. With equal force, they attest to the significance of nyama and soma power in Mali as practical, effective means to control a nation and its people. Until his recent passing, in fact, as one's power is always in motion and can be recharged over time, many Bamakois still regarded Traoré as a potent soma whose present political party, MPR, functions as an acronym for Moussa Peut Revenir ("Moussa May Return").[27]

Thus, metaphysical power is pervasive in Mali and touches all aspects of life, including photographic practice. In fact, the term for photograph in Bamanankan, *ja*, connotes transcendental as well as material significance and is intimately tied to nyama. Ja incorporates a wide variety of forms having to do with the duplication of imagery or representation,

Figure 6.3. Moumouni Koné (AMAP), Modibo Keïta's boli (in the possession of the military after the coup d'état), 1968–69. Reprinted by Nouhoum Samaké for author, Bamako, 2004. Courtesy Nouhoum Samaké and Koné Family.

Figure 6.4. AMAP, photo of a man holding "Moussa's Egg" (Moussa Traoré's boli) in the palace gardens of Kuluba, 1991. Reprinted by Nouhoum Samaké for author, Bamako, 2004.

including "shadow," "reflected-image" (on the surface of water, glass, or a mirror), and "photograph" (Y. Cissé 1973, 150–51; Y. T. Cissé 1995; M. Sidibé 2006; Malick Sitou 2005; A. Fernandez 1995–96, 47).[28] In general, as in the case of photographs, it concerns the "double" or image of a thing resulting from or created by light. It includes those created from all objects and entities, not merely human beings.[29] Thus, the image or shadow of *anything* is called ja.[30] However, in terms of portraiture, ja is conceptually and spiritually related to a person's soul, ni (representing its double), and by extension his or her character, tère (Y. Cissé 1973, 132).[31] Anthropologist James Brink finds that

> ja is usually translated as "double" but it summarizes more generally what we would render in English as "identity."[32] . . . The word ja is often used by Bamana to designate the person's shadow and mirror reflection, and in a more general sense to refer to the material form and action of the body as it is monitored by the interior self and by exterior others, notably other persons. The ja of the person is said to mediate between the interior world of the person's soul (ni) and the exterior world of the social group. As such, the person's ja reflects his motivations, intelligence and character (tere), and, thereby, functions as a synthesis or portrait of the essential features of the individual's idiosyncratic and social identity, his personhood. (Brink 2001, 239)

Essentially, then, ja is the double of a person's soul—equally immaterial yet visually manifested in shadows, reflections, and images. It is believed that people can be physically or spiritually reached, affected, or captured through their shadow or image (ja), as it is the soul's counterpart.[33] This notion is expressed in the story of Malado, which Malick Sidibé recounted to illustrate the powerful metaphysical implications of ja as a means by which people can be effectively "touched":

> Malado was a very beautiful and, therefore, famous woman in the Wasulu region of Mali [near the southwestern border with Guinea]. Every day, she went to fetch water from the nearby well. . . . As she dipped her bucket into the well to collect water, her image was cast on its surface. In this way, the crocodile that inhabited the well saw her, and eventually fell in love with her. One day, he "tapped" her image (he was able to touch her spirit through her image and command her to follow him into the water). She followed him and disappeared. After her disappearance, the people of her village consulted a diviner. Through him they learned about the crocodile and how he had captured her. A hunter was sent to look for Malado and to kill the crocodile. After the crocodile was slain, his belly was opened and inside was Malado's body. (M. Sidibé 2004)[34]

Similar illustrations of the power of ja were expressed to me by his cousin Brehima Sidibé, who shared one of his grandmother's proverbs, "*N'i*

tara baa la, i kan'i sigi ji dala, barisa bama b'a sigi ja kan," translated as, "After swimming, don't sit or dry off next to the water; crocodiles will get you if they lie on your ja" (Brehima Sidibé 2006).[35] Notably, this proverb and the story of Malado highlight the importance of the crocodile in Mande mythos: Occupying land and water, it imparts scientific knowledge and metaphysical understanding to sages and somaw (Y. Cissé 1973, 162).[36] Regarding ja, Sidibé continued, "People who are in the secret of harmful crocodiles [somaw] can reach and hit other people through their ja. Some very famous *donsow* [hunters] get animals and kill them through their ja [via their footprints or tracks]" (Brehima Sidibé 2006). Similarly, Imperato explained, "Each person has ni, the soul, and dya, the spirit double of the ni . . . [which] is especially vulnerable to the mischief of sorcerers and other malevolent personalities" (Imperato 1975, 52).

The ability to be accessed through one's shadow or image has been a fundamental concern about being photographed. In fact, some people believe that "to photograph someone is . . . to rob them of their [ja]" (Y. T. Cissé 1995), which is explicit in the Bamanankan expression *ja taa*. Colloquially, it means "to take a picture," but its literal translation is "to take [one's] ja." It is this belief that Seydou Keïta encountered in rural areas, about which he remarked, "Out in the country, as soon as I took out my camera, everyone ran or turned away. It was believed to be very dangerous to have your photo taken because your soul was taken away, and you could die. Even in the city, some older people believed the same thing" (Magnin 1997, 11). Nearly every professional photographer in Mali has been met with this apprehension.[37] For example, due to wariness in rural areas regarding photography's power, Malian photographers Youssouf Touré and Kaly Diawara had to resort to trickery to obtain photographs of reticent elders for the latter's children or grandchildren. Diawara once concealed himself on a rooftop to take a picture of an unwitting man (Nimis 1998c, 83). Similar concerns are expressed in neighboring communities as well. Nigerian photographer Ojeikere commented on this phenomenon in his monograph: "It wasn't always easy to photograph in the villages. . . . They thought that life would be taken from their bodies or their souls would be stolen." He exemplified this with a more personal anecdote: "I remember that my father-in-law, even though he was quite old, always delayed having his photograph taken. One day he said, 'You can come and take my photograph, but don't think that I am going to die.' Six months later he was dead. The fear that the camera would take life out of the body lasted a long time" (Magnin 2000, 54).

Although this suspicion is particularly pronounced in rural areas, it is also expressed in cities among some youth as well as elders.[38] For instance, during my stay in Mali, I took several photographs of one of

Malick Sidibé's daughter's closest friends, Dumbe Diallo. Due to her belief in ja, she deliberately avoided looking into the camera lens in every picture (plates 13a and 13b). Cissé elucidates this behavior by explaining that because the eyes are engaging and thought to be the vehicle through which the ja exits the body (at death), some Malians look away from the camera lens to protect themselves (Y. Cissé 1973, 175). Nimis noticed related behavior in the photographs of Malians taken by French colonials in the late nineteenth and early twentieth centuries. In particular, she cited a portrait depicting a group of Tirailleurs Sénégalais during one of Gallieni's missions in which several men look away from the camera lens in other directions while a few of them close their eyes (Nimis 1996, 7).[39] I observed similar avoidance and apparent apprehension in several of the photographs I viewed in the Centre des Archives d'Outre-Mer (CAOM) archives in Aix-en-Provence. For example, in photograph AOF 2-644, taken in the region of Mopti during the 1940s or 1950s, three women turn their eyes downward or keep them closed.[40] Certainly direct sunlight may have caused individuals to divert their gaze in such outdoor contexts. Yet belief in the power of ja is also a probable cause. For example, the notion that one could be harmed, disabled, or destroyed by photographing one's ja is blatantly expressed in the declaration of an elder Malinké man during the colonial era, who stated, "If the French should manage to overcome l'Almâmy Samoury Toûré, it is because by photographing him they have 'robbed' and taken with them his *dyaa*" (Y. T. Cissé 1995).[41] Because of this power, Cissé has referred to the photographer as a "soul-eating sorcerer" and *subaga*, or "witch" (Y. T. Cissé 1995).[42]

These individuals are not alone. Many Westerners have shared similar anxieties about the power of photography since its inception. According to French photographer Nadar, in the nineteenth century, Balzac experienced a "vague dread" of being photographed (Sontag [1973] 1977, 158). In the early twentieth century, some Americans felt unnerved or controlled by the camera, referring to it in the plural as "deadly weapons" and "deadly little boxes" (Mensel 1991, 29). Alongside this dread was a sense that the medium operated in an incorporeal plane and could interface with the spiritual world. For over a century in the West, this notion provided photography with an "aura of magic" (Marien 2002, 61, 75; Benjamin 2002, 512). According to Marien, in the nineteenth century, it was believed that the "medium could reach beneath the surface and penetrate the minds of sitters" (Marien 2002, 75). Of this notion, Mensel has written, "Even so rational a man as Thomas Edison, Jr. made serious scientific efforts to photograph human thought and the human soul" (Mensel 1991, 30). It was also thought that photography could "thwart villains and make a straight path for love" (Marien 2002, 75). In the

same era, the medium merged with hypnotism and mesmerism, with some practitioners claiming that characteristics could be passed from portrait photographs to hypnotized persons through sympathetic magic (Mensel 1991, 30). Some photographers even employed "tokens of the dead," such as a hat or scarf, to summon the departed and photograph his or her apparition. Such images were called "spirit photographs," which some later considered to be authenticated by the advent of X-ray technology (Marien 2002, 75, 197, 218). Today, there are photographers in the United States who purport to photograph a person's aura—the internal energy that emanates beyond the physical body.[43] Therefore, while Western accounts have often mischaracterized Africans as "primitive" for their metaphysical conceptions and mistrust of the medium, many contemporaries in Europe and North America have held related beliefs and reservations.[44]

In Mali, photographs as ja are imbued with nyama and baraka to varying degrees dependent on the particular context and beliefs of the perceiving individual. As noted prior, because photographs capture the essence of a person, portraits of Muslim holy figures are able to transmit baraka. Additionally, since people can be reached through their ja, some individuals bring portraits to marabouts and somaw to be used in dalilu recipes (Brehima Sidibé 2006; Malick Sitou 2005, 2006). Most often, portraits of oneself that have been immaterially enhanced by a specialist are given to members of the opposite sex as love charms. In other instances, photographs have been used in hypnotism or mesmerism.[45] Photographers explained that portrait photographs are similarly incorporated within metaphysical practice in Senegal, where the images can be wrapped with red, white, or black string to achieve arcane immaterial ends (Malick Sitou 2005, 2006). Elsewhere in Africa, photographs are also engaged to heal or harm. According to Behrend,

> along the Kenyan coast . . . [traditional healers] use photographs to diagnose as well as to identify persons who are attacking or harming their clients. In love magic, photographs are widely "worked on" to bring back a beloved who has run away or fallen in love with another person. In the 1950s, when photography spread through the villages of western Kenya, many people feared that their likenesses would be used by witches or sorcerers to kill them. As a means to counter this threat, the practice of holding or posing with a bible while being photographed evolved as a protective device. (Behrend and Wendl 1997, 411; see also Behrend 2003, 134–35)

In Mali, because ja can render the depicted vulnerable in the hands of others, control over one's image is important. It is prudent to be protective of one's own portrait, just as one takes caution with nail clippings, hair, and other personal byproducts that are loaded with one's nyama, which

could be used malevolently by others in the form of a daliluw or *kòròte* (Malick Sitou 2005). That is why, according to Brehima Sidibé, "people take care of their ja . . . [and] give their photographs only to people they trust and love" (Brehima Sidibé 2006).

Just as Islamic scripture, herbal medicines, and accessories serve amuletic purposes, so can photographs. During the time of the two world wars, for example, soldiers in the Tirailleurs Sénégalais often carried photographic portraits inside their uniform for protection.[46] Portraits of powerful spiritual leaders such as Haidara, Hamallah, Sallah, and Bamba are maintained by followers in part for their amuletic properties. Thus, as shadows or images (ja) of the depicted spiritual figure, photographs hold within them some of their potent essence (nyama) and blessings from God (baraka), which can protect the possessors from harm and enable them to accomplish certain goals.

Throughout western Africa, it is known that some people do not cast a shadow (Malick Sitou 2005). Therefore, they equally cannot be captured in photographs. In Mali, these people are often somaw who have daliluw or sèbènw that protect them from the process of being photographed—an act that might render them vulnerable, as has been previously shown. Photographers do not readily discuss this aspect of their work, but I have yet to meet a professional practitioner who has not encountered this phenomenon.[47] In fact, at the opening of the *African Art Now* exhibition in Houston (2005), several African photographers, including Malick Sidibé and Malick Sitou, held a conversation on the very topic. During the discussion, Nigerian photographer Ojeikere shared a personal anecdote about trying to photograph a man whose head would never appear on film. He said that he first took the man's picture during a wedding in Nigeria. Later, when he developed the film, Ojeikere was surprised to find that in the images he had taken of the man that day, his body was well-focused but his head was blurry and unidentifiable. Puzzled, Ojeikere located the man and solicited his photograph. Ojeikere took several shots of him, confident that he had technically executed the photographs perfectly. When he developed the film in the darkroom, he again discovered that the man's head was never clearly depicted. It was as if he lacked a head or was some sort of ghost. Ojeikere determined that the man was what Mande refer to as a soma who had some form of dalilu making it impossible to photograph his likeness.[48]

In a related dimension of photography, I have been told that "all [professional] photographers" in Mali and West Africa "know a particular protective technique and perform it when they themselves are having their picture taken" (Malick Sitou 2005). It is a discreet act that goes undetected by all but the rare few who have been indoctrinated

into its secrets. It is an ephemeral dalilu used to deflect negative energy that might be directed toward the depicted photographer, protecting him from possible future harm. Since it is not known where the image might end up or how it might be used, the action is considered a necessary precautionary measure, protecting the individual from manipulation by others and its undesirable consequences. It is a coveted and initiated secret known only by some military men (who are often hunters and in some cases photographers) and professional photographers. However, ordinary citizens suspect that such spiritually charged, initiated knowledge exists. For example, Brehima Sidibé wisely stated, "Knowing all of the [metaphysical] practices related to their work, photographers may have their own crocodile way of protection [dalilu or sèbèn]. I know I am not in their secret" (Brehima Sidibé 2006). The following quote from McNaughton explains its arcane status: "For the Mande, dalilu knowledge is deep, and, by definition, secret. . . . Things known universally . . . are accessible to all with a modicum of personal effort. Deep things are harder earned, and secrecy serves as a vehicle to protect their value, and protect society at least to some extent from their misuse" (McNaughton 1982, 500). As a researcher and novice apprentice in Mali over the past eighteen years, my awareness of the technique's metaphysical effect (dalilu) extended only to the knowledge that such practice exists.[49] However, its specifics were finally shared with me in 2020. For all of the reasons put forth, I swore to guard this secret and not to disclose my source.

The combined beliefs of Islam, nyama, and ja are important forces behind the lack of postmortem or funerary photographs in Mali, which are common in neighboring countries such as Ghana, Nigeria, and Benin.[50] Among the populations of these nations, which include Akan and Yorùbá, funerals are a grand affair in which photographs are an important part of the commemorative process. As a Yorùbá man, Malick Sitou (2006) provided his account of these events: "They keep the body for a long time. They sing, wear . . . the same type of cloth . . . and . . . have a big celebration. They beat drums, slaughter cows, and spend a lot of money. They even make calendars with photos of when the person was alive [to commemorate them] and hand them out [to guests attending the funeral]."[51] These communities are largely Christian—a faith that informs their practice of postmortem photography and commemorative portraiture. Both genres are an important part of the wake, viewing, and celebratory festivities surrounding funerals. Such images often include deathbed portraits, which may have been inspired by nineteenth- and twentieth-century colonial practices, as these photographs were common in the funerary rites and family albums of Victorian-era Europeans

and Americans, whose populations were also predominantly Christian (Marien 2002, 135; Wells 2001, 135).[52]

By contrast, in Muslim communities such as those in Mali, burial customs are much more austere; photographs and cameras generally are absent.[53] In accordance with the tenets of Islam, the deceased is buried promptly, usually within twenty-four hours, in a simple grave often without a coffin (Malick Sitou 2006; Zepp 2000, 102–3; Braun, Pietsch, and Blanchette 2000, 206). The body is wrapped in a series of seamless white cloths and positioned so that the face, and sometimes the entire body, is directed toward Mecca. Placing flowers and candles on the grave is not customary, and mourners do not usually express their grief publicly by donning black attire (Braun, Pietsch, and Blanchette 2000, 206). To ensure that the soul "rests in peace," those present do not moan or cry aloud. Rather, they "talk softly . . . and act calmly out of respect. [They] do not want to disturb the soul" (Malick Sitou 2006; also Zepp 2000, 102; Braun, Pietsch, and Blanchette 2000, 206). For this reason, in Mali, one "never bring[s] a camera to photograph death, except to record accidents for the police and insurance companies." According to Malick Sitou (2006), "[Even] Yorùbá in Mali do not do it. My dad never took photographs of the dead in Mali—not even for Yorùbá, and he is Yorùbá." Supporting the claim that photographers in Mali do not take postmortem photographs, Elder has found that "two types of images are never taken by photographers in [Ségu], namely pornographic images . . . and photos of deceased people during funerals" (Elder 1997, 235).

In addition to Islamic thought and practice, belief in nyama and its relationship with ja is a determining factor behind the lack of postmortem photography in Mali. Nyama is both animating energy and an avenging force that is present in all things and is linked to ni (soul) in humans. For Dieterlen and Labouret, in particular, the nyama of a deceased person is the active energy released at death that enables them to attack their enemies (Dieterlen 1951, 3; Labouret 1934, 120). This notion relates to the dimension of ja that Cissé terms sŭ ja, the "image of the dead" (Y. T. Cissé 1995; Y. Cissé 1973, 151).[54] Sŭ ja is the double of the soul (ni), or the nyama, released at death (saya), that can take the form of a ghostly apparition or embody people, animals, and objects such as photographs. Cissé explains that the soul (ni) remains in communication with its double (ja) at death. Ni leaves the person through the nostrils and mouth during their last exhale. Sŭ ja exits the body via the pupils. Ideally, each returns to their designated resting place: ni to the realm of ancestors and ja to that of the water goddess Faro. However, if disturbed, they can wander about in the atmosphere, inhabiting various locales and affecting or haunting people, especially family members. As a result, one does not wish to

disturb or "capture" these forces (Y. Cissé 1973, 151, 174–78). Therefore, people find it risky and imprudent to photograph the dead. According to Sitou, "Taking pictures of them . . . can be dangerous. The soul leaving the body could be captured in the photograph. If you keep the picture in your home, [their soul] could haunt you in your sleep, for example. So to prevent that from happening, we don't take pictures of the dead" (Malick Sitou 2006). This situation is specific to photographs, particularly to those taken after or around the time of death, as similar concerns do not arise in terms of a deceased person's personal possessions, which are divided and kept among family members. Malick Sitou (2006) explained, "People are not worried about [the deceased's] soul haunting them through the things that they owned."

The world over, photography has been readily assimilated into the preexisting beliefs and social practices of communities and their arts. This was true among the Victorians, for example, about whom Jay Ruby wrote, "The idea of photographing the dead came from [a] tradition of portraying the dead, which is as old and widespread as the idea of portraiture itself" (Ruby 1995, 47). In light of this, it is interesting that postmortem photographs do not exist in Mali given the tradition of depicting deceased twins in portraiture called *flanitokélé*, much like the Yorùbá practice of *ere ibeji* (Imperato 1975; Imperato and Imperato 2008, 2011; McNaughton 1988, 101). In Nigeria, prior to the advent of photography, figures called *ere ibeji* that represented a deceased twin were carved from wood and kept on personal and family altars. Later, as Sprague demonstrated, photographs have been used to represent the lost twin (Sprague 1978, 2003).[55] Yorùbá persons also create postmortem photographs to commemorate deceased relatives and place them on altars for similar purposes (Abiodun 2013).[56] However, unique from this practice, postmortem portraits are not created in Mali—even among Yorùbá populations—suggesting that they do not suit the spiritual beliefs (Islam, nyama, ja), social customs, aesthetic traditions, and needs of Malians.

In discussions of photography in Mali, nyama and other metaphysical aspects of photographs are not readily disclosed. Yet their transcendental capacities remain significant for photographers and their clients. After several months spent working with photographers at their studios, accompanying them to reportage venues, and spending time at their homes, I gradually began to learn about the importance of this dimension of the medium.[57] Due to its indexical nature as ja, photographic portraiture is imbued with spiritual as well as corporeal power. As a result, the immaterial dimension of photographs continues to render its subjects vulnerable, perhaps even in contexts outside Mali. Therefore, important ethical considerations are raised as these objects move through time and space,

experiencing new ownership and authorship among foreign agents in the twentieth and twenty-first centuries.[58]

Notes

1. Nimis mentions similar circumstances in her research and cites photographer-explorer Pierre Trémaux (1818–95), who, writing about his experiences in Egypt in the 1850s, stated, "The law of Mohammed condemns the reproduction of animate beings as being an impious infringement of God's rights. He alone can give life to the beings he created. He who photographed people will, on the Day of Judgement, give them a soul. It is therefore sacrilege to photograph" (Nimis 1998c, 84).

2. For more on the significance of angels in Islam, see Zepp (2000), 67.

3. An imam is the head of a mosque and typically leads the congregation in prayer. A marabout is a Muslim holy man, well versed in the Qur'an, who provides council and services such as divination, healing, and the prescription of amuletic devices.

4. Malick Sitou (2006) corroborates Nimis's interpretation. However, he cites "journalists [who] take reportage pictures of group prayers inside mosques, most often when there is a political figure visiting or during the 'id al-Fitr at the end of Ramadan . . . like in Saudi Arabia during mass prayer."

5. Haïdara's Ansar Dine should not be confused with the more recent militant movement in Mali led by Iyad Ag Ghaly under the same name.

6. Hamallah was an important Muslim leader of the Tijaniyya Sufi brotherhood, or tariqa, in Mali during the colonial era (Hanretta 2008, 478, 485). The photograph Dembélé retained was taken of Hamallah before his arrest in Bamako (in June 1941) and subsequent deportation to Algeria and later France (in July 1942), where he was finally entombed in 1943 (Nimis 1996, 41; A. O. Konaré and A. B. Konaré 1981, 127–28).

7. US Department of State, Bureau of African Affairs (2006). The majority of Muslims in Mali are Sunni. Some belong to Sufi brotherhoods (tariqas), such as Tijaniyya, Qadiriyya, and Muridiyya (Mourides). Particularly in urban centers and the northern regions of the country today, a small but growing population of Muslims are Shi'a and others are Islamic reformists, commonly referred to as Wahhabi (Levtzion and Fisher 1987).

8. In line with Cissé's interpretation, Bakary Sidibé has described nyama as "spiritual energy created by human feelings" (Bakary Sidibé 2005). For others, nyama is "the spirit of an ancestor . . . genie . . . animal or . . . thing" (Jabaté et al. 1987, 9).

9. Bakary Sidibé described nyama as "the negative consequence of a forbidden act" (Bakary Sidibé 2005). For Sidiki Sidibé, nyama is "taboo, forbidden, consequence" (S. Sidibé 2005). Iyouba Samaké explained that nyama addresses "things [that] are forbidden to do, sacred things, consequences" (I. Samaké 2005). Finally, Malick Sitou (2006) holds that nyama "is consequence; revenge."

10. Cissé describes nyama as an avenging force and suggests that belief in the powers of nyama is fundamental to the Mande moral and social universe, which includes fadenya and badenya (Y. Cissé 1973, 160–61).

11. Tère is the external, visual indicator of a person's soul (ni), which resonates with and is embodied in nyama (Y. Cissé 1973, 149).

12. Several scholars have uniquely, and similarly, described the relationship among nyama, ni, miiri, taasi, dakan, màá, and ja (among others) as interconnected elements operating within the natural universe. All see them originating with the creator god as part of an intricate, complex system of biology, mathematics, psychology, philosophy, spirituality, and morality expressed in (and interpreted through) a series of 266 symbols related to kòmò (Y. Cissé 1973; Amadou Bâ 1973; Dieterlen 1955; A. Fernandez 1995–96). More on Bamana conceptions of human inner and outer life and their connection to nyama can be found in Zahan (1960).

13. McNaughton describes somaw as "particularly powerful and frequently aggressive sorcerers" (McNaughton 1988, 49). Father Bailleul translates the term as "1.) benevolent or malevolent sorcerer, 2.) herbal medical doctor or one who casts evil spells (who knows a lot of secret things: remedies, poisons . . .)" (Bailleul 2000a, 429).

14. Likewise, Bird and Kendall describe daliluw as "the means or powers required to perform an act" (Bird and Kendall 1980, 16).

15. McNaughton has spoken of *kilisi*, secret speech, as an example of transient daliluw, "a spoken formula that generates and directs energy" (McNaughton 1982, 498).

16. Malevolent sorcery often includes bad daliluw (*daliluw jugu*) such as *kòròte* (poison), which at times have been known to kill people (McNaughton 1982, 490). According to Bakary Sidibé, amuletic power "is designed to fight nyama. It is nyama fighting nyama for the will of particular [competing] agents" (Bakary Sidibé 2005).

17. Von Denffer and Gibb argue for pre-Islamic origins of baraka (Gibb 1999; Von Denffer 1976).

18. The number of repetitions is specified by a marabout according to each individual case and can vary immensely, ranging from as few as three to more than one hundred (Malick Sitou 2006).

19. McNaughton describes jinnw as "creatures of tremendous power, said to live invisibly in the bush . . . capable of materializing at will in all sorts of sizes and shapes." He goes on to say, "Frequently, people with the expertise to manipulate nyama seek alliances with [jinnw] serving them, sacrificing to them, and receiving from them special powers and abilities" (McNaughton 2001, 4). These entities are also mentioned in the Qur'an, which may constitute the origin of the term in Bamanankan (Zepp 2000, 12).

20. As formulae, or recipes for action, baraka- and nyama-based amulets fall under the category of daliluw. They are spiritually charged means to material and immaterial ends.

21. This genre of amulet likely predates colonialism in the region. Large examples are evident in the French colonial photographs of Malians in the CAOM archives under ICO, 30FI/10 and in the national archives at Kuluba. Furthermore, McNaughton cites the account of Jobson, a European who mentions Mande use of such amulets in the Gambia River region in 1620 (McNaughton 1988, 62).

22. Bakary Sidibé echoed Brehima's account, stating, "No matter the profession, success is due to spiritual power [nyama, daliluw, baraka]. Nothing is natural" (Bakary Sidibé 2005).

23. Several texts have been published on the epic of Sunjata, illustrating flexibility and variance in narrative accounts: Niane ([1965] 2006); Bird, Koita, and Soumaouro (1974); Johnson (1986); and Austen (1999).

24. In the preceding days, President Keïta toured the country, stopping at Timbuktu and Mopti, where he attended the city's eighth economic conference. He was taken into military police custody during the coup d'état on November 19, 1968 (*L'Essor* 1968b). According to Imperato, "Keita was returning to Kulikoro from Mopti on the *General Soumaré* river steamer. He was arrested on the outskirts of Kulikoro as he drove by car to Bamako" (Imperato 1977b, 61).

25. Head of the photography department at AMAP in 2003–4, Nouhoum Samaké assured me these photographs were illustrated on the front page of *L'Essor* sometime in late 1968 or early 1969 (N. Samaké 2004). Supporting his claim, in 2005, Iyouba Samaké and Bakary Sidibé illustrated their knowledge of the military's destruction of Keïta's boliw, suggesting that this information was made public. However, I have yet to find documentary evidence corroborating these accounts. In fact, these images were not likely published in the national newspaper at the time out of respect and fear of possible future repercussions from Keïta on both spiritual and social levels. Whether made public or merely kept private in governmental archives (where they are currently housed in the photographic collections of AMAP), these images attest to the power of photographic authority and its affecting capacity to incite strong reactions (either positive or negative) in large audiences.

26. It is commonly known that men in the police and military are often hunters empowered by several daliluw, sèbènw, and perhaps boliw.

27. Traoré died in Bamako on September 15, 2020. Officially, MPR is the acronym for Mouvement Patriotique pour le Renouveau (du Mali).

28. In this sense, ja is akin to terminology used elsewhere in Africa to denote photography. According to Warren d'Azavedo, among the Gola, *ne fòno* translates as "something imitated or portrayed . . . a photograph, a drawing, a sculpture, a shadow or a reflection in the water" (D'Azavedo 1997, 201). Likewise, Axel-Ivar Berglund states that *isithunzi* in the Zulu language means "reflexive self, double, or image, and is often given as 'shadow'" (Berglund 1976, 85).

29. Malick Sitou (2005) holds that ja is the reflection, shadow, or image of any natural entity. Brehima Sidibé (2006) contends that it is "my visual other . . . being my shadow, my image in the mirror, water, photographs. This is also true of animals and plants." Ana Fernandez also reports that "animals . . . have a ni and a ja" (A. Fernandez 1995–96, 47).

30. Malick Sitou (2005) described ja as "the reflection or shadow of anything, living or not living. Ja is so powerful that it can be anything."

31. Youssouf Tata Cissé has published the most comprehensive explanation of ja to date. He divides the category into five components: 1) *dyaa yèrè-yèrè*, "true" reflected and reversed image; 2) *dyaa naloman*, "stupid" image or shadow, one that parrots the movements of the originating source; 3) *dyaa*

ni kekun, "small, intelligent" image, the miniature believed to be hidden in the interior of a person; 4) *sukon dyaa*, "dream" image; and 5) *shu dyaa*, "image of the dead," the "shadow" or apparition of a ghost (Y. T. Cissé 1995). This text includes a revised and shortened version of his earlier work on ja, which did not include *sukon dyaa* (Y. Cissé 1973, 150–51). Of the five listed here, the first (*dyaa yèrè-yèrè*) and the last (*shu dyaa*) most directly relate to photography.

32. On this point, Brehima Sidibé stated, "Isn't watching a mirror or your own photograph the best way to be with yourself emotionally?" (Brehima Sidibé 2006).

33. Ja is the ni's double and, due to this connection, what happens to one affects the other (Y. Cissé 1973, 150–51, 174–78; Y. T. Cissé 1995). According to Malick Sitou (2006), "Anything that has a shadow can be reached in a soma way. *Ja bògò* means to 'hit the ja.' Thus, if someone or something hits or reaches your ja, it hits or reaches you."

34. According to Malick Sidibé and Malick Sitou, this is a true story. It is not a myth. A month after I left Mali, in November 2004, Sidibé told the story to some television journalists from Amsterdam. Over a period of a week, they made a film of Sidibé's daily life, asking people at his studio (such as Malick Sitou) to play certain roles. During the filming, Sidibé told the story of Malado to impress upon them the spiritual significance of ja as it relates to photography. Afterward, the journalists filmed a dramatic reenactment of the Wasulu tale and asked the lady who lives across the street from Studio Malick, Sitan Coulibaly, to play the role of Malado. They paid everyone involved, and it took about twenty minutes to shoot. Sidibé was promised a copy of the video. As of this writing, the family has yet to receive one. No one with whom I have spoken has viewed the reenactment, nor are they aware of its showing elsewhere. I heard the Malado story recounted a second time from Sitou in January 2005 and again in July 2006 during a telephone conversation. Bakary Sidibé also referred to the Wasulu story in an email in October 2006.

35. Popular logic holds that people have not only seen such nature spirits (or jinnw) in the "bush" but are sometimes abducted by them (McNaughton 1988, 11). Malick Sitou (2006) believes the crocodile in the Malado story could be a jinn or the soul of a deceased person possessing the crocodile, but it certainly was no ordinary animal.

36. Bama is also the totemic animal for many families, particularly those of blacksmiths, and thus it is a key figure in kòmò. Its protection is invoked in Bamada hats, the name and history of Bamana culture, and Mali's capital city, Bamako.

37. Written and oral accounts concerning this issue have been shared by the following photographers: Seydou Keïta, Malick Sidibé, Félix Diallo, Adama Kouyaté, Amadou Baba Cissé, Django Cissé, Tijani Sitou, Harouna Racine Keïta, Youssouf Touré, and others. Some of these can be accessed in Nimis (1998c, 11–12, 83; see also 1996, 24, 30).

38. Nimis also admits this point, stating, "Even though photography is now available to all sections of the population, via obligatory passport photos, apprehension and prejudice still remain" (Nimis 1998c, 81).

39. Nimis cites this as photograph 33 of the series We 14. Of course, this behavior may be guided by other factors, such as direct sunlight in the eyes. Thus, one must use caution when interpreting historical images, which do not allow dialogue with the photographer or the pictured subjects. Nevertheless, concern for their ja may have provided impetus for the individuals in these images to look away from the lens given current photographic practices and spiritual beliefs in Mali.

40. AOF 2-644 is housed in the ICO 30FI series. Several images in which people appear to avoid the camera with their eyes are located in the CAOM archives catalogued under ICO, 30FI/10, and ICO, 30FI/17. Again, it is possible that direct sunlight, a requisite element in plein air photography of that period, is the cause of such avoidance. Accounts from colonial photographers elsewhere in Africa during the 1920s, however, suggest that similar actions were performed for spiritually protective ends (Schildkrout 1991, 74). Yet Zoë Strother's recent argument justly posits suspicion of such accounts as prejudiced assumptions of the exoticized African "other," uninformed by contextual information from the photographed subjects themselves (Strother 2013). Therefore, all contemporary readings of historical photographs are admittedly largely speculative.

41. Samori Touré was a fierce opponent of the French presence in present-day Mali and led the Malinké in battle against them during the nineteenth century.

42. The title of Cissé's eight-page essay prefacing a collection of Seydou Keïta's portraits reads, for example, "The Photographer: 'Man-Eating Sorcerer'" (Y. T. Cissé 1995).

43. I first became aware of this practice through Betty Jo Irvine, the former renowned art librarian at Indiana University, who has had multiple versions of "aura" portraits taken of herself by a photographer just outside Bloomington, Indiana.

44. Western treatment of Africans' reservations about photography, which are rational concerns in their social environments and worldview (as already introduced), has tended to be patronizing, using terms such as *primitive*, and overwhelmingly dismisses their concerns as naive "fears" and superstitions. Two quotes from Susan Sontag's much-cited work *On Photography* provide examples: "As everyone knows, primitive people fear the camera will rob them of some part of their being" and "Many people are anxious when they are about to be photographed: not because they fear, as primitives do, being violated but because they fear the camera's disapproval." Yet her own description of photography in "modern society" and its particular authority is not far removed from an understanding of ja. Sontag has described the medium as a "trace, something directly stenciled off the real, like a footprint or a death mask," and has argued that "a photograph is never less than the registering of an emanation (light waves reflected by objects)—a material vestige of its subject in a way that no painting can be" (Sontag [1973] 1977, 85, 154, 158). Speaking critically of these Western tropes, Timothy Burke cites "the native who fears that the camera will capture his soul" and "the native who fails to recognize himself in the mirror" as "iconic tales that recur again and again in the Western Imaginary" (Burke 2002, 43). While the first

of these statements speaks to real situations in certain African communities, it need not be interpreted with primitive or naive connotations but rather should be understood as part of a deep philosophical, scientific, metaphysical knowledge system. The second reveals naivete in the Western imagination about Africans, which is the point made by Burke and, later, Strother (Strother 2013).

45. This informant wishes to remain anonymous.

46. An abundant number of amulets, in variant media, were commissioned in Mali during World War II, for example, when Malians and other Tirailleurs Sénégalais were conscripted to fight for the French government in Europe (McNaughton 1988, 63; Malick Sitou 2005).

47. Although he did not go into detail, Amadou Baba Cissé spoke of his experience with the "mystical powers of photographs in Bankass," east of Bandiagara toward Burkina Faso (A. B. Cissé 2005). Furthermore, in an experience much like Ojeikere's, Adama Kouyaté was once unable to take a man's portrait after numerous attempts (Malick Sitou 2005).

48. This story was recounted by Malick Sitou on January 29, 2005, during a conversation at the *African Art Now* opening in Houston and retold during a phone conversation on October 21, 2006.

49. McNaughton similarly discussed his experience with secrecy as a blacksmith's apprentice in Mali (McNaughton 1993, 7). Such restrictions are intended to protect the novice from exposure to powerful elements of which they are not yet knowledgeable and to which they would be extremely vulnerable, while simultaneously safeguarding the community.

50. Although the professional photographer portrayed in Abderrahmane Sissako's film *Bamako* (who champions death as a welcome release from imperialism in Mali) stresses that his primary commissions are to videotape funerals in and around Bamako today, in my experience, postmortem and funerary photography (including video) are rarely, if ever, practiced in the country. Anthropologist Kassim Koné (2009) shared a recent anecdote in which video was taken during a relative's funeral but admitted it was a very unusual act that was only performed so that he, in the United States, could be privy to the proceedings, ensuring the proper treatment was afforded the esteemed individual.

51. In the same discussion, Sitou made it clear that Hausa populations in Nigeria and Ghana, which are Muslim, do not take pictures of the dead or hold elaborate funerals (Malick Sitou 2006).

52. According to several American scholars, including Jay Ruby, Western conceptions of death have changed over time due to the advent of the death industry in the nineteenth century. However, Ruby also purports that postmortem and deathbed photos remained fairly common toward the turn of the twenty-first century as an increasingly privatized and individualized enterprise (Ruby 1995, 1, 60, 77, 161, 164, 180).

53. Although Sidibé agreed that cameras are not typically present during funerals in Mali, he admitted having taken photos of people during the funeral of his uncle, Jigiba, in Soloba in 1974. However, he did not take postmortem photos of the deceased (M. Sidibé 2004). Moreover, during my stay in Mali from October 2003 to November 2004, I attended several funerals yet never witnessed the presence of a camera.

54. Sǔ, in Bamanankan, means "death." *Sǔ ja* has also been described by Cissé as the "double of death." In this category, Cissé includes ghosts, ancestor spirits, and "super human forces" (Y. T. Cissé 1995; Y. Cissé 1973, 151).

55. In this case, the photographs were not taken of a deceased person after death. Rather, they were created from photos of the surviving twin or the deceased twin when still alive. Nevertheless, these images are intended to attract, honor, and appease the deceased's soul so the deceased will bless the family rather than cause them harm.

56. Abiodun, himself Yorùbá, has argued that postmortem commemorative sculpture called àkó (created for at least the past five hundred years) has so influenced the practice and appearances of photographic portraiture among Yorùbá in Nigeria that it should be considered "àkó-graphy" rather than photography (Abiodun 2013).

57. Nevertheless, at present, a great deal in this arena remains unknown to me as I was unable to work closely with diviners, somaw, marabouts, or imams during my previous research. Therefore, I intend to pursue this research in future projects.

58. With permissions from photographers, their agents, and archival proprietors, but not from every depicted subject (which does not seem possible), this historical account, too, is subject to criticism, particularly with regard to metaphysical considerations of commissioned portraiture in Mali. For this I take full responsibility and apologize in advance should any individual feel slighted or harmed by the publication of particular image(s) in this book. It has been written to advance scholarship and raise international awareness about photographic practices in Mali during the twentieth and twenty-first centuries. It is neither my wish nor intent to have a negative impact on anyone involved in this history.

7

Contemporary Practice and International Market (1990s–Present)

IN THE 1990S, PORTRAITURE COMMISSIONED in western Africa during the late nineteenth to mid-twentieth centuries was recontextualized in international art and pop-cultural contexts. This transition led to the development of a global canon of West African photography, which created a professional renaissance among its prominently featured photographers and ushered in a new era of photographic possibilities and constraints in Mali.

Contemporary Photography in Mali

The first Malian photographer to enjoy international acclaim was Seydou Keïta. In 1993, his photographs were featured by Françoise Huguier, Bernard Descamps, and Rojer Aubry of Afrique en Création[1] at the *Rencontres d'Arles*[2]—marking the first time Keïta received attribution for his work overseas. Inspired by the success of the festival, which was attended by then Malian minister of culture Hamidou Maïga, a new biennial of African photography was created in Mali's capital the following year. Organized by Huguier, Aubry, and Maïga, the *Rencontres de la Photographie Africaine*[3] designated Bamako the center of international photography on the continent (H. Maïga 2004). From the onset, its facilitators envisioned the event as a nexus in which photographers from various African countries could be introduced, exchange ideas, debate theoretical issues, exhibit work, and gain local as well as international attention (H. Maïga 2004; Njami 2001, 87).[4]

Along with the festival, *Rencontres* creators sought to develop a museum of photography in the capital: the African House of Photography (MAP), which would operate as a conservatory, archive, exhibition space, library, and school (Viky 2003, 2; Moussa Konaté 2004). In the past fifteen years, MAP has begun to amass an archive of photographic materials to represent the medium's history in Mali (acquiring Mountaga Dembélé's enlarger in 2004 and a collection of low-resolution images and metadata from the Archive of Malian Photography [n.d.] in 2018, for example) and has undertaken small digitization projects (Moussa Konaté 2004, 2009; H. Maïga 2004; D. Dembélé 2009). While MAP's full vision is yet to be realized, its potential functions and benefits continue to be discussed during each *Rencontres*, particularly among members of the photographers' union SYNAPROMIM (D. Dembélé 2009; A. B. Cissé 2009). Furthermore, over the past two decades, MAP has enjoyed support from the National Assembly, and, combined with the *Rencontres* office, its Bamako headquarters were established in ACI 2000, where it is under the direction of Tidiane Sangaré, who replaced Moussa Konaté in April 2018 (Moussa Konaté 2004, 2009; A. B. Cissé 2005, 2009; T. Sangaré 2019).

The *Rencontres* was designed to boost tourism and, by extension, the national economy; celebrate Mali's contributions to international contemporary art; and heighten local perceptions of photographic portraiture as a globally relevant art form and source of national patrimony. Its first iteration featured photographs by Seydou Keïta, Malick Sidibé, Alioune Bâ, Harouna Racine Keïta, and Diango Cissé (M. Sidibé 2003; Viky 2003, 2; Lortie 2007, 113).[5] Smaller overseas exhibitions of work by Keïta and Sidibé quickly followed. Early examples include the Cartier Foundation for Contemporary Art (1994), agnès b.'s Galerie du Jour (1994), and FNAC (1995) in Paris, the Guggenheim in New York City (1996), and the Smithsonian Institution's National Museum of African Art in Washington, DC (1996). Shortly thereafter, André Magnin published two monographs, *Seydou Keïta* (1997) and *Malick Sidibé* (1998). Together, these projects helped Keïta and Sidibé gain international fame and provided them a new source of income a decade after the decline of the golden age of black-and-white photography in Mali (M. Sidibé 2004; H. Maïga 2004). As Sidibé stated, "We were already known in Bamako but in the 1990s our work gradually became known internationally as well" (Njami and M. Sidibé 2002, 94).

Perhaps the most rewarding aspect of the *Rencontres* for photographers in Africa, such as Jean Depara, Philippe Koudejina, Samuel Fosso, Dorris Haron Kasco, and Zwelethu Mthethwa, has been the fostering of dialogue and research among them. For example, Kasco

commented, "Through [the *Rencontres*] I came into contact for the first time with photographers of the older generation, people like Seydou Keïta and Malick Sidibé. The physical presence and the pictorial invention of these artists from Mali fascinated me so much that I started investigating whether such precursors had existed in my own country, the Ivory Coast, as a result of this search, I discovered Cornelius A. Augustt, who today is quite known beyond Africa" (Matt and Mießgang 2002, 57).

Coupled with the global success of Keïta and Sidibé, which ultimately shaped the international art world's aesthetic expectations of twentieth-century photography in Mali, the festival has presented new opportunities for established and up-and-coming photographers in the nation to more formally engage in local and international art markets. Among those who have benefited are fourth- and fifth-generation "fine art" photographers, including women. For example, the 2005 *Rencontres* featured work by ten Malian photographers: Emmanuel Bakary Daou, Fatoumata Diabaté, Aboubakrine Diarra, Harandane Dicko, Mamadou Konaté, Ouassa Pangassy Sangaré, Malick Sidibé, Youssouf Sogodogo, Amadou Sow, and Kasadu de Sikasso. Of these, three young artists—Diabaté (who is female), Diarra, and Dicko—received the first prize supported by Afrique en Création de Cultures France. The subsequent biennial in 2007 featured work by four younger generation photographers from Mali: Adama Bamba, Mamadou Camara, Emmanuel Bakary Daou, and Harandane Dicko. Camara received the Elan prize while Bamba and Dicko won the first prize from la Fondation Blanchere, which consisted of 1,500 Euros along with the promise of a solo exhibition and residency in France.

Like earlier colonial projects, such as the House of Sudanese Artisans in Bamako, the biennial has been largely driven by French organizers and institutions that cater to Western audiences (H. Maïga 2004).[6] This bias has been evident in the preparation and selection processes, which take place in France.[7] It has also informed the time of year the *Rencontres* is held—sometime between October and January, when the climate reaches its coolest temperatures—even though this has meant it transpired during Ramadan, when people in Mali are much less active during the day (Njami 2003). According to Simon Njami, cofounder of Revue Noire, this Western bent kept him from assuming a central position in the biennial until he became its director during the third *Rencontres*.[8] Maintaining its French headquarters, from 2001 to 2007 the festival adhered to his vision, which centered on recent photography produced by international artists from Africa and beyond, including photographers from Europe and the Americas (Njami 2003).[9] As a

Figure 7.1. Harandane Dicko, *Untitled*, c. 1990s. Photo of original print by author with permission from Harandane Dicko, Bamako, 2004. Courtesy and © Harandane Dicko.

result, it succeeded in drawing key members of the international art market to Bamako during the week-long opening ceremonies. Without investing in local photographic practices and aesthetic tastes, however, the festival has largely failed to gain the popular interest of Malian citizens despite extensive advertisement via ORTM, *L'Essor*, Radio Mali, and the biennial's own newsletter.

By and large, local populations do not relate to "art" photography, such as that created by Harandane Dicko (fig. 7.1), Emmanuel Bakary Daou (plate 14), Alioune Bâ (fig. 7.2), and Mamadou Konaté (plate 15), which the festival has championed alongside commercial portraiture created by early studio photographers in western Africa. Nevertheless, due to its conspicuous position and the networking/career opportunities it presents, several Malian photographers continue to participate in the *Rencontres*, although most are forthright with a variety of complaints. General criticisms cite its Western inclination, lack of sustained engagement with Bamakois and Malian communities (revenue is present for a brief period and vanishes without substantial local benefit until the cycle is repeated two years later), and failure to produce local resources (adequate exhibition spaces, archives, supplies, and educational facilities).[10] Moreover, many participants have found it largely disorganized. All these factors contribute to an apparent disinterest in local ideas and concerns.

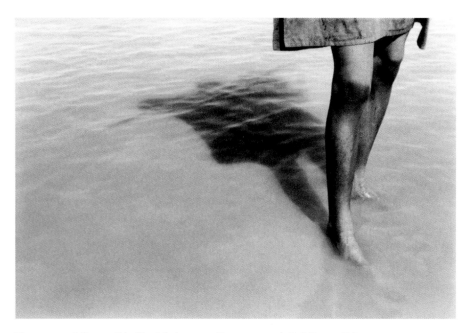

Figure 7.2. Alioune Bâ, *Untitled*, 1997. Courtesy and © Alioune Bâ.

In 2002, Senegalese artist Bouna Medoune Seye corroborated many of these critiques:

> All of these biennials, which were created in Africa—what was the outcome for the artists themselves? Next to nothing. And in most cases, they are also very poorly organized. If the artists dash off to the biennials in Dakar or Bamako and buzz about with their invitation cards from one idiotic reception at a gallery to the next, then it doesn't do anything for anybody. At best the organisers themselves stand to gain: France doles out some cash, the European Union pays for it, but only those people are promoted who had been favoured from the very outset. (Matt and Mießgang 2002, 87)

Due to these issues, many photographers remain only peripherally involved, and others have disengaged or refrained from attending entirely. However, in 2011, under the directorship of Michket Krifa and Laura Serani,[11] the ninth *Rencontres* made greater attempts to engage local photographers and audiences. They developed a more robust website that featured photo blogs and reportage photography by Harandane Dicko and curated an outdoor public exhibition of large weatherproof prints displayed in the gardens surrounding the National Museum free of charge. Despite these improvements, the selection processes still ghettoize many local photographers whose works do not conform to Western aesthetic tastes and styles of photography. Of this situation, Sidibé remarked, "I

am constantly telling young photographers that we must not stop capturing our own reality. . . . Young Africans need to look into themselves [rather than to the Western art market and biennials] for their pictures" (Matt and Mießgang 2002, 95–96; M. Sidibé 2004). Beyond these challenges, the festival has been impeded by political instabilities following the March 2012 military coup d'etat in Bamako.[12] Amid security concerns, the *Rencontres* was not held in 2013, and international attendance for the biennial's tenth anniversary (under the artistic direction of Bisi Silva) in 2015 was comparatively low.

In 2017, the festival increased its commitment to the advancement of young photographers in Mali. While none of the eleventh biennial's standard prizes were awarded to local photographers, a new accolade was created to support a student from the national Conservatory of Multimedia Arts and Crafts in Bamako through a two-year residency at Le Fresnoy in Tourcoing, France. Moïse Togo received this scholarship, which was created in honor of Bakary Diallo, a former student of each institution who passed away in 2014 (Biennial Foundation 2017).

Alongside the *Rencontres*, developments have been made in Bamako to promote contemporary photographic practice in Mali. In addition to the schools and workshops identified toward the end of chapter 2, these include the work of the Promo-Femme school and the Association Naye-Naye Mali. From 1996 until 2009, Promo-Femme functioned as the first and only institution in the country dedicated to audiovisual training for young women. Financed by the national government and the Canadian Agency for International Development, during its tenure nearly two hundred young women were trained in photography, including black-and-white darkroom processes and video. According to the center in 2006, twelve of its graduates were employed at ORTM, twenty worked at communication agencies in Bamako, one produced news-reporting photography for AMAP, thirty operated private reportage businesses that specialize in video commissions, and five opened their own studios (Promo-Femme 2006). Today, another woman, Sokona Diabaté, serves as photographer and archivist at the National Museum (Vroegindewey 2013). Since the development of the institution, therefore, women have been able to lead successful careers in photography, primarily in the nation's capital. During its nascent years, the school participated in the second (1996) and third (1998) *Rencontres* as well as an exhibition hosted by the French Cultural Center in January 1997. In 2002, it undertook a large project documenting colonial buildings in Bamako, which was exhibited at the Bamako Museum. Thus, for over a decade, Promo-Femme helped women enter the professional market for photography in Mali, which for generations had remained the purview of men. Today, this work

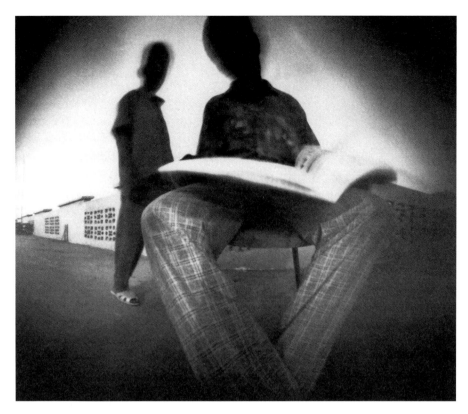

Figure 7.3. Issa Sidibé, *The Scorpion and the Toad*, Mopti, c. 1996–2000. © Issa Sidibé. Courtesy Sidiki Sidibé.

is undertaken by the CFP and the Conservatory of Multimedia Arts and Crafts in Bamako. Both institutions provide advanced training for young men and women.

The Association Naye-Naye Mali is composed of photographers, visual artists, and educators. It was created after Oscura workshops held in Mali in 1996 and a photography seminar organized at the French Cultural Center[13] in 1997 (M. Sidibé 2004; Towns 2001, 2008). The association, whose name means "light" in the Dogon language, promotes pinhole photography (locally called *Photo-Wonin* in Bamanankan and *Sténopé* in French). This method employs locally viable, inexpensive technology to yield experimental imagery that holds particular appeal for young people (fig. 7.3). As part of its educational outreach, the association has organized several workshops, conferences, and exhibitions on pinhole photography in Bamako. One, entitled *L'exposition "Photo-Wonin" sur la jeunesse malienne de 1960 à nos jours* ("'Pinhole Camera' Exhibition on Malian Youth from 1960 to the Present"), was held in the capital at the African Tower monument in 2003 (M. Sidibé 2004). In 2004, its members included Malick Sidibé, Amadou Chab Touré, Moussa Konaté, Harouna

Racine Keïta, Youssouf Sogodogo, Alioune Bâ, Mamadou "Papa" Kanté, Boubacar Konaté, Amadou Gaba, and Amadou Baba Cissé. Their work has helped reinvigorate photography among youth in Mali, offering new opportunities for their individual creative expression and participation in the international art world.[14]

To support these and other local projects, a few important galleries have been created in the capital over the past two decades to promote the work of contemporary artists. Often specializing in photography created in Mali during the twentieth and twenty-first centuries, these include Galerie Chab (opened in the capital by Chab Touré in 2000 and relocated to Ségu by 2009), La Médina (formerly Galerie Médina, headed by Igo Lassana Diarra and opened in 2011 during the *Rencontre*s festival), and Quartiers d'Orange (active since 2008). While many photographers, across the generations, have engaged with these spaces, their impact on local markets has been moderate. However, their events attract larger populations of local youth than those sponsored by the *Rencontres*.

To exercise more control over the presentation of their work, photographers in Mali since 1996 have formed artists' collectives, such as Djabuguso and the Association of Women Photographers in Mali, and have curated their own exhibitions known as *OFF* during the *Rencontres* festival (Vroegindewey 2013; Amkoullel 2014). To develop greater local interest, these presentations utilize popular locales, like restaurant Bla Bla in Hippodrome, as well as photographic projections and displays along neighborhood walls and city streets (A. B. Cissé 2004).

Additional venues have helped foster a local art scene and promote the work of Malian photographers in Bamako—both during and beyond the *Rencontres*. These include national institutions, such as the National Museum, the Bamako Museum, the Cultural Palace, the Modibo Keïta Memorial, and the National Art Institute as well as the cultural institutions of foreign governments (the French Embassy and French Cultural Center [now the Institute Français], the United States Embassy, and the Canadian Embassy). Private organizations, like the (now defunct) Seydou Keïta Foundation and the Center for Photographic Training (CFP, formerly Helvetas), have also advanced these goals.

To facilitate local exhibitions, large-scale printing has become possible during the past decade in Bamako at the CFP, which is headed by Youssouf Sogodogo, and to a lesser degree at MAP. In his work preparing images for display in the aforementioned venues, Moussa Doumbia has undertaken most of the matting and framing projects for resident professionals and affiliated institutions (Vroegindewey 2013). During the 2009 *Rencontres*, for example, the work of several Malian photographers was featured in an exhibition titled *Regards sur le Joliba* ("Focus

on the Niger River") at the Bamako Museum. It featured photographs by Alioune Bâ, Amadou Baba Cissé, Emmanuel Bakary Daou, Diby Dembélé, Oumar Konaté, Yacouba Dembélé, Sokona Diabaté, Alima Diop, Amadou Keïta, Harouna Racine Keïta, Richard Koné, and Amadou Sow. Audiences in these locales primarily consist of expatriate Westerners and some elite Bamakois. Therefore, although these spaces have contributed to local awareness and increasing appreciation for these photographers' images, a viable market in Mali has been slow to develop.

In the twenty-first century, new commercial opportunities are available to young and established photographers in the arenas of international freelance journalism[15] and local advertising (Vroegindewey 2013). Although publicity photographs in the past were commissioned by numerous professionals, including politicians, religious figures, and tailors, today they are also needed by fashion designers, popular musicians, and cinematographers. For example, in the last twenty years, Malick Sidibé (as well as photographer Sanaba N'Diaye) collaborated with renowned filmmakers such as Souleyman Cissé and Abderrahmane Sissako and musicians like Oumou Sangaré, Tiken Jah Fakoly, and Amkoullel (M. Sidibé 2004; M. Sidibé, D. Sidibé, and S. Sidibé 2009; N'Diaye 2005; Amkoullel 2014).

Recently, digital processing has become increasingly viable via the introduction of digital laboratories in the capital since 2008 that serve commercial as well as lay photographers.[16] Predating this, governmental institutions such as AMAP, successful young professionals like Seydou Keïta's son Baba Keïta, and more established studios like that operated by Amadou Fané, which can afford the requisite investment in computer equipment, software, and the infrastructure to support them, were able to transition over to digital production (N. Samaké 2004; B. Keïta 2010; Fané 2004). Today, however, due to financial constraints and the fact that digital cameras are currently unable to be locally repaired, such enterprises remain relatively few. Therefore, presented with greater opportunities overseas, facilitated by the *Rencontres* (whose prizes often include fellowships and solo exhibitions abroad), promising young photographers often set their sights beyond Bamako.

While these practitioners have been better able to engage the global art market since the development of the *Rencontres* and the international popularization of Keïta and Sidibé, the careers of the first three generations of photographers have also been affected. For those whose works have entered the international canon (namely Seydou Keïta, Malick Sidibé, Abdourahmane Sakaly, Hamadou Bocoum, and Adama Kouyaté), careers that fell stagnant in the 1980s and early 1990s have been revitalized on the global stage. Through their involvement in the international

art community, Sidibé, Keïta, and their colleagues have been able to travel around the globe, exchanging experiences, ideas, and practices while enjoying foreign commissions and accolades. Sidibé described the personal rewards he received from these opportunities as follows:

> I did some work in a studio in Munich. . . . I did the same thing in Geneva; I took some really lovely pictures there: young people, old people. I also took pictures in Nantes. And just the other day, I got a phone call asking if I could go to Amsterdam to shoot some portraits. It used to be that there were always twenty or thirty people around my studio in Bamako, waiting to have their portraits taken; today, it's not like that anymore. So when I get the chance to go other places and take photos, I'm happy. It keeps me young. (Lamunière 2001b, 58)

Locally, however, these photographers' contemporary commissions have largely been reduced to four primary categories. These include reprints of negatives held in studio archives for patrons who wish to refurbish old, decaying photographs. Since the late 1990s, for example, nearly half the orders placed at Studio Malick have been solicitations for reprinted negatives. In December 2003, Amourou Traoré traveled from France (where he currently resides) to have Sidibé reprint a negative that was made in 1963, when he accompanied his family to the studio as a child (M. Sidibé and Amourou Traoré 2003). Testament to Sidibé's archival system (organized by year, month, event, and, often, clients' names), the photographer was able to reproduce the prints within two days. The following month, when I arrived at the studio, Sidibé showed me a photo from 1967 brought in the day before by a woman who ordered a reprint because the original had become creased and torn over the years. Thanks to the stamp and date imprinted on the back of the image, Sidibé was able to locate the original negative in his studio's archives and print a pristine version for her (M. Sidibé 2004).[17]

Other primary commissions derive from Western tourists who travel to these studios to have their likenesses made by renowned photographers whose services are relatively affordable. Over the past twenty years, for instance, the archives of Adama Kouyaté, Hamadou Bocoum, Tijani Sitou, and Malick Sidibé have added portraits of many tourists and resident expatriates from Europe and North America (fig. 7.4). Since the late 1990s, Studio Malick has enjoyed a regular influx of Western patrons, who make up the majority of its twenty-first-century clientele. Until Sidibé's passing in 2016, journalists, dealers, critics, collectors, artists, scholars, filmmakers, stylists, tourists, and diplomats almost weekly frequented the studio to have their portrait taken with Sidibé's iconic backdrops and checkered flooring, buy original works or reprints, frame photographs for exhibition overseas, or interview the photographer. Posthumously, this practice has

octobre - 2010 Malick Sidibé

Figure 7.4. Malick Sidibé, portrait of Ryan Vroegindewey at Studio Malick, 2010. Digital copy of original print. © Malick Sidibé. Courtesy Ryan Vroegindewey.

continued, although at a slower pace. Among other instances, in 2017 I witnessed a large delegation of US Embassy staff, including the ambassador and the public affairs officer, organize a photo shoot at Studio Malick with Sidibé's son Karim.

Additionally, alongside reportage photography, video recordings of important personal and social events are a large percentage of popular commissions in urban areas of Mali since the 1990s. In this vein, photographers' apprentices and younger generation studio proprietors

have success offering video (VHS and DVD) and still photo (CD-ROM) montages, using a variety of software programs, primarily documenting weddings and baptisms.

Finally, another principal market for studio photographers is identification portraiture, which is a mandatory feature of passports, drivers' licenses, military and professional cards, and research permits. Nearly every official document requires a national stamp and ID photo, including school applications and exams, job applications, bank transactions, the collection of retirement pensions, and the declaration or importation of goods (Elder 1997, 171, 209). Originally identification photographs were the province of professional photographers. Later they became the domain of street as well as studio photographers. Today, state photographers and the police are beginning to take control of the trade as the process for visas and passports is becoming increasingly digitized (A. B. Cissé 2005).

In this regard, as previous chapters have shown, the vision of the nation and of nation building in Mali has been predominantly under governmental control (N. Samaké 2004). In the twenty-first century, these sociopolitical domains remain the prerogative of governmentally approved photographers and those employed at AMAP. Still, professional identification cards do not always grant photographers permission to record national events and political appearances. While photographers such as Malick Sidibé were able to freely photograph those occasions in the past, in more recent years, they have been increasingly censored. As one photographer stated, "It is hard for photographers to make reportage photos anymore. It is not allowed . . . even with a badge."[18] The same individual explained that on Jacques Chirac's arrival at the airport in Mali in 2003, all the local photographers were forced to place their cameras on the ground. In this manner, they were blocked from recording the moment on film. Again, during an appearance in 2005, President Amadou Toumani Touré forbade photographers from taking his picture. When one individual defiantly did so anyway, ATT destroyed his camera.[19] That same year, a group of professional photographers were prohibited from documenting the biennial in Ségu.[20] As one stated, "We were not allowed to enter the area. . . . The photographs we took were taken outside biennial events. . . . I wrote a letter to the Ministry of Culture about why photographers can't take pictures [at public, national events] but they haven't responded." Another photographer sees such censorship as a financial blow to professionals who already face numerous market challenges in the form of digital photography, itinerant photographers (who pay neither taxes nor overhead expenses), and lay photographers.

Throughout history, photographic practice in Mali has always felt administrative pressure and has been subjected to its surveillance and

control. As noted previously, Seydou Keïta was forced to stop working at his commercial studio while employed by the government. Similarly, in the 1970s, both Ousmane Keïta and Moumouni Koné were required to forgo their employment at ANIM because they owned their own studios (M. Coulibaly 2004; O. Keïta 2004). The minister of information at the time, Youssouf Traoré, deemed it a conflict of interest to simultaneously engage in private and governmental photographic enterprises. Therefore, during his tenure, photographers working for the state were not allowed to operate their own commercial businesses.[21] According to AMAP photographer Nouhoum Samaké, the same policy was in place in the twenty-first century. He explained, "When you work for the government, you can't open a studio" (N. Samaké 2004). As aforementioned, some photographers not employed by the state have also endured its scrutiny and censorship.

Governmental restrictions on photography, in terms of accessing and documenting state leaders and official events, are common in countries worldwide. Administrations regularly condone only preapproved, documented photographers who work for accredited news-reporting agencies. However, censorship and the control of visual information concerning the nation seem more pronounced in Mali. More so than in the United States, for example, where photographs of the White House are not prohibited to the many tourists and citizens who visit the capital annually while those of the presidential palace at Kuluba in Bamako are strictly forbidden.[22] The government's will to control and censor such imagery speaks to the power of photographs and their ambiguous nature. They can warp, to a positive or negative effect, the depicted subject and its connotation. Equally, they can expose or mask covert behavior. Thus, issues of trust and agenda are at the forefront of the medium's subjectivity and its (false) aura of truth, authority, and authenticity. Because of this pervasive power, Malian news-reporting and visual media agencies such as CNPC, ORTM, AMAP, and the national publication *L'Essor* are under governmental control.[23] As with most nations, there is not a great deal of private enterprise in Mali's visual news media. Although "there are more than fifty newspapers and journals" in Mali today, according to Nouhoum Samaké, all of them obtained their photographic illustrations from AMAP as of 2004 (N. Samaké 2004). However, the internet is increasingly becoming a viable option for middle- and upper-class urbanites to more freely access visual information about the global world in which they live.[24]

From Mali to International Contexts

In 1996, Clare Bell, Okwui Enwezor, Octavio Zaya, and Olu Oguibe opined, "Whenever marginal peoples come into a historical or

ethnographic space that has been defined by the Western imagination, 'entering the modern world', their distinct history quickly vanishes" (Bell, Enwezor, Zaya, and Oguibe 1996, 29). This has largely been the case for African photography. Yet despite its absence in most historical anthologies, photography has been present in Africa for nearly two centuries and has been practiced by African photographers in Mali since the 1930s. As such, its images have documented and preserved fluctuating political, social, and cultural trends in the country through the eras of colonialism, independence, socialism, military dictatorship, and democracy. Like elsewhere in the world, its citizens have used the medium to explore and memorialize important aspects of their identities and relationships, including their accomplishments, values, and aspirations. As in other nations, local political, religious, and pop-cultural figures have used photographic imagery for advertisement, legitimization, and popularization. Thus, photography has served as a powerful communicative tool, and its practitioners, who have enjoyed a long-term monopoly, have occupied a critical social position as visual historians, entertainers, and artists.

Created by and for Africans in Mali, photographic images represent distinct histories that have been informed by specific, locally derived, ideological perspectives and aesthetic values. Within these original contexts, portraits and identification photos convey particular ideas about the character and social relationships of unique, named individuals,[25] with the former often created to share with intimates and to serve as keepsakes in albums, frames, and other private locales. In terms of their purpose, audience, and largely authorship, they stand in contrast to images of Africans popularized by Western media since the colonial era,[26] which have tended to present people as remote, anonymous cultural "types" often challenged by disease, poverty, malnutrition, and war.[27] Recapitulated in Western contexts, however, much of the original import (name, local significance, and function) of African portraiture is erased, raising a number of significant issues, including questions of authorship and ownership.[28]

Guided by Magnin and Pigozzi—who have functioned as primary agents for Keïta and Sidibé since 1993 and later other African photographers, such as J. D. 'Okhai Ojeikere and Philip Kwame Apagya[29]—an aesthetic preference for large-scale, uncropped images has developed overseas with regard to West African portrait photographs. Reframed in art contexts, these once privately commissioned portraits are now regularly accompanied by titles, even that of *Untitled*, although it is not always clear by whom. According to Sidibé, it was Magnin who advised him to title his photographs for the 1995 FNAC exhibition, arguing that it helps "better organize them for clients who would like to purchase the

images, and for writers who wish to discuss the works." Sidibé continued, "I named them after something that inspired me to take the photo and what the clients were preoccupied with in their portrait. . . . The clients did not participate in this" (M. Sidibé 2003). Illustrating their iconic and market-driven power, such commercial strategies have been replicated in more recent introductions of West African portraiture. For example, to align Tijani Sitou's images with those currently dominating the market, his son insisted that his father's prints appear uncropped and posthumously titled for an exhibition at Indiana University in 2007.

Since the early exhibition of Keïta's and Sidibé's portraits, these images are also often greatly enlarged. At the New York Gagosian gallery in 1997, for example, some of Keïta's work was featured at forty-two by sixty inches (Rips 2006, 1, 32–33). Initially, these alterations were not critically considered. Rather, the practice produced a memorable experience for Keïta, who explained, "You can't imagine what it was like for me the first time I saw prints of my negatives printed large-scale, no spots, clean, and perfect. I knew then that my work was really, really good" (Lamunière 2001b, 47).

Typically, enlargements are made overseas, removing the photographer from a major segment of the (re)creative process: printing. As discussed in chapter 4, professionals in Mali consider printing the most significant reflection of their artistry. Overseas printing was practiced when Keïta and Sidibé were still alive and has become posthumously requisite since their passing in 2001 and 2016, respectively. To reprint negatives from the archives of Keïta and Sidibé, Pigozzi and Magnin have regularly commissioned Philippe Salaun and Payram at PICTO in Paris.[30] Informed by Western aesthetic standards, their prints exhibit greater contrast than those of Keïta and Sidibé, which were printed according to local perceptions of ideal skin tone. Photographer and professional printer Charles Griffen recognized this issue in reproductions of Keïta's portraits at the Gagosian gallery in 1997 and was "immediately disturbed by . . . the extent of the contrast between the blacks and whites," opining that "too often, printers are influenced by the preference wealthy collectors have for highly graphic images" (Rips 2006, 1).[31] Western reproductions also regularly transform the surface quality of the photographs through the utilization of matte paper while photographers in Mali prefer a glossy finish. Sidibé complained about this practice, arguing that matte paper is riddled with "pits" that break the clean, fine lines of his images (M. Sidibé 2004). Due to such formal changes, these images no longer reflect the tastes and artistic practices of the photographers and patrons they represent. Rather, they have become new commodities that serve distinct aesthetic functions for foreign audiences. In an effort to separate himself

from some of these contested practices, in 2004 Jack Shainman exhibited Sidibé's photographs in their original, smaller formats (see Keller 2008, 552). (Re)printed by Sidibé and his apprentices in Bamako and presented in glass frames (popular during the 1970s) painted by Cheickna Touré, these images were arranged in geometrical configurations along the walls of Shainman's New York gallery (M. Sidibé 2004; Simard 2006).

Beyond aesthetic transformations, as one of the first to write about photography in Mali, and the work of Keïta and Sidibé in particular, Magnin's accounts have helped established market niches for the photographers' work abroad while distorting the historical realities of their careers in Bamako. After the publication of Magnin's monographs on Keïta (1997) and Sidibé (1998), Keïta has been continually described as *the* exemplary Malian portraitist since the 1940s, which the photographer himself perpetuated in numerous interviews. Bolstering this perspective, the *Rencontres* biennial named its grand prize, which initially was dedicated to portraiture, after Seydou Keïta (Vine 2004, 71). Most extremely, Pigozzi has erroneously promoted Keïta as the "Father of African Photography,"[32] although Africans and those of African descent operated professional photography studios along the coast as early as the 1850s, and many were quite renowned in their day. Magnin was also the first person to present Keïta as *the* official state photographer in Mali from 1962 to 1977 (Magnin 1997, 8). In fact, several professionals, including Malim Coulibaly, had occupied this role since 1959 at the Information Commissionership, which became the National Information Agency of Mali (ANIM) in 1961. Rather, Keïta worked for the National Security taking mug shots of prisoners at police headquarters downtown (A. Sangaré 2005; B. Keïta 2010).

Alternately, Sidibé has been known predominantly as *the* reportage or "party" photographer of the nation's youth during the 1960s and 1970s. Acknowledging these constructions, Sidibé has stated, "Magnin . . . didn't show all of my work. It was more or less just party pictures. . . . Listen . . . Seydou has a collection of portraits, and so they prefer to show my candid work. . . . I see how it works" (Lamunière 2001b, 55–56). In fact, most, if not all, of these published images were created by Sidibé's assistants, Sidiki Sidibé (1961–70), Amadou Fané (1968–74), and Shaka Sidibé (1974–80), and therefore do not reflect his personal artistic expression. Rather, during this era, Sidibé was creatively engaged in his studio. This highlights a significant and neglected aspect of the international market for West African photography: the publication and exhibition, without recognition, of apprentice work remnant in the archives of professional studios. By the time Sidibé opened Studio Malick, he had been married for two years, had his first child, and had hired his first apprentice, his

cousin Sidiki Sidibé, who was twenty years old (M. Sidibé 2003; S. Sidibé 2003). According to both photographers, during this time, Sidiki carried out the studio's reportage commissions at dance parties every Saturday night and took pictures of youths gathered at the beach in the Sotuba area of Bamako on Sundays, as he was "well-known and preferred by young people" (M. Sidibé 2003; S. Sidibé 2003). Before his apprentice left to get married and open Studio Sidiki in 1970, Sidibé hired his second apprentice, nineteen-year-old Amadou Fané, in 1968 (M. Sidibé 2003; Fané 2004). Until 1974, when he left to start his own business and Shaka Sidibé took his place, Fané assumed the studio's reportage commissions and today claims to have authored *all* the beach photos housed in the studio archives from that period (Fané 2004).[33] Given this history, it is not surprising that Sidibé championed studio portraiture over reportage imagery (M. Sidibé 2004), as the former reveals his true artistry.

In related fashion, photographs taken between 1962 and 1977 and since credited to Seydou Keïta were certainly the work of his assistants, Abdoulaye, Mouris, Lacina, and "Gomez" Keïta, as the photographer was employed at the police station during this era and had turned his studio practice over to younger apprentices (B. Keïta 2010). Similar situations pertain to other prominent photographers working in Mali and elsewhere in western Africa since the 1950s. By drawing attention to this reality, I do not wish to tarnish the careers or reputations of these men. On the contrary, their authorship is customarily sanctioned in Mali, where professional proprietors are the rightful owners of the negatives produced by their studio "workshops." Rather, I address this point to highlight the significant role apprentices have occupied, arguing that they, too, deserve international recognition in these histories as those responsible for cultivating youthful clientele and composing the now iconic images in situ.

Via interviews and documentary videos, such as *Dolce Vita Africana* (Spender 2008), Sidibé perpetuated his international celebrity as *the* party photographer of Bamako's youth during the 1960s and 1970s, although his active engagement in these practices actually occurred during the 1950s while he was employed at Photo Service (before opening Studio Malick in 1962).[34] Similarly, Keïta and authors paraphrasing interviews with the photographer repeatedly suggest he was the official state photographer in Bamako during the same decades (Magnin 1997, 13; French 1997; Keedler 1997; Loke 2001; Lamunière 2001b, 48; Plesse 2016). Thus, the reframing of Keïta's and Sidibé's careers for global audiences in the late twentieth and early twenty-first centuries results from collaborative efforts and complex negotiations. Protecting their vested interests through interview accounts, the furnishing of titles, and the granting of

permissions, Keïta and Sidibé participated in the reimagining of their oeuvres and the social roles they occupied within their communities.

Authorship and Ownership

The repetitious publication and display of these photographs and their embellished histories has helped construct and reinforce an artistic canon and master narrative that complicates their authorship. Through the aforementioned processes, the original negatives have been transformed into new creations, and, by extension, the coauthorship of the photographer and the initial clients has been destabilized to some degree. Through archival and reframing processes, the names of pictured subjects—who are primarily responsible for the original creation of these images—have been obscured, as was once the name of Seydou Keïta. Overshadowing them, in these recent contexts, are new clients and mediators—the curator, collector, critic, printer, and dealer—who, condoned by the collaboration of prominent professional photographers, serve as authoritative agents manipulating and framing the photographs in new ways, as Elizabeth Bigham has effectively argued with regard to Keïta's portraits (Bigham 1999).

Positing Keïta as *the* studio photographer and Sidibé as *the* reportage photographer leaves little room in the international market for the work of their locally celebrated peers: Moumouni Koné (a popular studio and press photographer from 1947 to the 1960s in Bamako-Kura), Mamadou Cissé (who opened a studio in Mopti in 1948 and, from the 1950s to the 1980s, worked as a state photographer throughout the region), Abdourahmane Sakaly (a famous Senegalese-born photographer who operated Studio Sakaly in Bamako from 1956–88), Adama Kouyaté (the most celebrated photographer in Ségu since 1946), Hassan and Hussein Traoré and Hamadou Bocoum (who were well-known in Mopti from the 1950s to the 1980s), and, also in Mopti, Tijani Sitou (a Yorùbá man from Nigeria who operated a successful professional studio enterprise from 1971 to 1999). It also excludes many contemporary photographers whose work resides outside this canon, which at once ghettoizes young practitioners and anachronistically characterizes "contemporary" photography in Mali according to black-and-white film practices of the 1950s through 1970s.

In addition to issues of authorship, the publication of these images in Western contexts raises questions of ownership and privacy rights for the depicted.[35] As previously stated, in Mali, the professional proprietor is the rightful owner of the negatives created in their establishments, which are considered to be their intellectual and creative property, while the commissioner owns the rights to the printed images. This system is somewhat

complicated by reprinting and exhibiting processes in global contexts. Like people the world over, many Malians have been wary of the use of their photographic depictions in unauthorized contexts. Although Sidibé argued that most clients are honored to find their images reproduced in catalogues and exhibitions, he admitted others have suffered humiliation and vehemently criticize the practice. On this topic, he shared an anecdote about a woman who arrived at Studio Malick outraged by having witnessed her mother's large-scale portrait (which featured her clad in a bikini) on exhibition in a Parisian gallery (M. Sidibé 2003).[36] Add to this the belief in ja, and the seriousness with which most individuals protect their photographic images in Mali, and the issues of ownership and right to privacy become real ethical concerns.[37] To avoid such harm, images that depict clients posed topless or in their undergarments are no longer reproduced from Sidibé's archive—even after Sidibé's death (Ménoret 2016). Other photographers, like Moussa Diarra in Buguni, refuse to publicly release their archives entirely, preferring to safeguard the privacy of their clientele (M. Diarra 2004).

Yet photographers are not the only way locally commissioned portraiture moves into international contexts. Recently, Magnin, among others, purchased original prints from frame maker Cheickna Touré in Bamako (Byrd 2016). Several of these were featured in an exhibition and accompanying catalog of Seydou Keïta's work at the Grand Palais in Paris in 2016 (Chapoutot 2016). These transactions complicate local definitions of ownership since clients—typically those pictured in the images—are considered the rightful owners of their prints. However, because most of the prints in Touré's collection were acquired due to lack of payment or were never collected by his patrons, claims of their ownership may be contested and remain unclear.

Concerns over privacy and ownership partially informed projects Sidibé undertook in the late 1990s and early 2000s, including international photo shoots for *Paper* (1998), *Pennyblack* (2008), and the *New York Times Magazine* (2009) and his recent *Vues de dos* series. These images feature paid models who pose for global audiences and thereby circumvent privacy rights and questions of ownership. Such projects also allowed Sidibé to address the ethical challenge of ja—as evident in his recent back views, which arguably afford greater protection to his subjects by concealing their visage—while engaging in public outreach. In terms of that outreach, Sidibé took advantage of recent fashion commissions to provide young women, who do not typically hold paying jobs, with a temporary source of income (M. Sidibé, D. Sidibé, and S. Sidibé 2009). These opportunities enabled him to perpetuate community service projects he began during the past decade working with

neighborhood women on a series of *Vues de dos* photographs (plate 12; see also fig. 5.2). About this philanthropic practice, Sidibé stated, "The first woman I asked to model for a *Vues de dos* was Fatim . . . [and] I gave her some money afterward. Another [woman] I chose because she is an orphan, and I wanted to help her. . . . It is a way to help women obtain some money" (M. Sidibé 2004). In these contexts, his black-and-white film technology also granted him a certain degree of control over the production and exhibition of his images. As with local commissions, Sidibé retained all the negatives from the fashion shoots. A portion of those created for the *New York Times Magazine* were printed in twenty-four-by-thirty-centimeter format by Youssouf Sogodogo at the CFP in Bamako to be published in the April 5, 2009, issue (M. Sidibé, D. Sidibé, and S. Sidibé 2009; Keller 2013a). Later that year, the body of negatives was printed a second time for an exhibition Sidibé held at the National Museum in Bamako during the eighth *Rencontres* (Krifa and Serani 2009b, 190–95).

Nevertheless, while the monetary value and market demand for these images continue to grow, the prerogative photographers and heirs maintain over their negative archives remains uncertain. This point was illustrated in 2005 by the highly publicized lawsuit concerning the ownership of 921 negatives Keïta once entrusted to Magnin and Pigozzi in the 1990s, which has since been settled in favor of Pigozzi (Spiegler 2005; Rips 2006). On April 9, 2008, Pigozzi procured exclusive global rights over Keïta's oeuvre under the appellation IPM (International Photo Marketing), which no longer exists and has been replaced by SKPEAC, or Seydou Keïta Photography Estate Advisor Corporation (Whitelaw 2016; Tribunal de Grand Instance de Paris 2008).[38]

The ownership of Sidibé's archive is also in question. Shortly after his passing, the Sidibé family received an offer to sell the copyright of his images for the duration of twenty years to Magnin, who has effectively served as Sidibé's global agent for the past two decades and is in possession of Studio Malick's most iconic negatives in Paris. The family hired a lawyer and solicited advice from trusted colleagues, scholars, and friends. While a definitive decision has not been made, the family has not signed the contract as of January 2020.

More vulnerable, perhaps, are the archives kept by descendants of locally renowned photographers who have yet to experience global celebrity. Inspired by the revitalized success of Keïta and Sidibé, these individuals aspire to similar recognition for their forefathers and similar personal financial gains yet lack requisite international visibility, mobility, and legal acumen to be protected from exploitation by unscrupulous members of the global art market.

Over the course of my research, a number of professional photographers and their families have cited instances in which negatives from their archives had been wrongly removed from their possession or retained abroad. In many cases, the images later appeared in exhibitions, catalogues, and websites, and their unauthorized reproductions were sold for profit without compensation or permission. For the most part, those implicated are Western dealers, collectors, curators, and scholars. However, in some contexts the accused are Malian—particularly those who hold prominent positions in national and international art markets.[39]

The most insidious example is that of a businessman who began "borrowing" negatives from studio archives in Mopti alongside a doctoral student in December 1994 for "a restoration project [of] old African portrait[s]."[40] By 2002, under this premise, he had "borrowed," and brought back to Copenhagen, Denmark, at least two hundred negatives from photographers and their relatives in Mali, including those of Abdourahmane Sakaly, Mamadou Cissé, Tijani Sitou, and Hassan and Hussein Traoré. After several unauthorized exhibitions and numerous reproductions sold, the aforementioned families have made claims against the dealer, demanding the return of their property. Nevertheless, he has refused to repatriate the negatives. When I inquired about these allegations during *Rencontres* opening events in November 2005, he admitted he has no intention to return the negatives, stating, "After all, I have to eat too." Despite his arrest in Bamako days later on charges of theft by the Cissé family, he maintains this position (O. Cissé 2005).[41] On his release on bail shortly thereafter, he fled to Europe, where he has since presented three unauthorized exhibitions and featured the contested images on Facebook. Moreover, he continues to offer reproductions for sale on his website without repercussion (Keller 2014, 46).[42] Although the original website claimed that part of the proceeds are paid to the families of the photographers, the Sakaly, Sitou, Cissé, and Traoré families attest otherwise and intend to reclaim their archives, pending necessary funds and legal representation.

In Mopti during 2006, a doctoral candidate borrowed negatives from Tijani Sitou's son Ibrahim with the promise of an invitation to Lyon, France, to collaborate on an exhibition of his father's work. In 2007, the scholar curated two exhibitions featuring Sitou's work in France (in Lyon and Honfleur). However, Ibrahim was never invited to participate. In fact, he only learned of these events after several of the images were published on the cover of the Spring 2008 issue of *African Arts* and the family was notified (Keller 2014, 46). After a series of incensed email and phone correspondences later that year to which I was privy, the negatives were finally reclaimed in 2010 along with meager reparations (Malick Sitou

2010). Nevertheless, the accused has continued to feature the photographer's work in unauthorized venues, such as a 2012 exhibition in Lyon titled *Gémellités, Images d'Afrique de l'Ouest* and his online blogs.[43]

Like the clandestine pillaging of Jenne-Jeno terracottas (McNaughton 1995a) and the iconoclast destruction of ancient monuments in Timbuktu (Nossiter 2012; Kottoor 2013), the pilfering of negatives is detrimental to Mali's cultural heritage and the legacy of its professional image makers. The physical integrity of these collections is in serious jeopardy as they are vulnerable to mistreatment, theft, and exploitation as well as harsh climactic conditions and poor storage facilities. This reality was already recognized by the organizers of the first *Rencontres*, who stated in their brochure, "It is clear that safeguarding old photography collections constitutes an important goal of the program. African photographic patrimony, surely important, is not [properly] catalogued; the collections that have already been identified are poorly conserved and suffer from disappearance as the recent examples of Senegalese [photographer] Mama Casset and Malian [photographer] Seydou Keïta have shown."[44]

As a result, their repatriation, retention, and preservation remain primary concerns for photographers and legal custodians of these private archives in Mali who recently have begun engaging conservation and digital archival projects as possible solutions and sources of empowerment within the global art market. The largest of these have been supported by the National Museum,[45] MAP,[46] the British Library Endangered Archives Programme,[47] and the National Endowment for the Humanities Division of Preservation and Access.[48] The last two examples are part of the Archive of Malian Photography (n.d.), which I direct in Mali along with managers Youssouf Sakaly (son of Abdourahmane Sakaly), in Bamako, and Catherine Foley, at Matrix (n.d.). Composed of conservators, photographers, and students, this project has cleaned, preserved, digitized, and cataloged over one hundred thousand images from five archival collections in Mali to safeguard original materials from further damage and theft. The project also promotes their global accessibility to research and education in the form of low-resolution digital collections housed at MAP in Bamako and presented in a dual-language database online (Archive of Malian Photography, n.d.).[49]

International Influence

In the last twenty years, photographic portraiture from West Africa has captured the imagination of international audiences. These images have appeared in numerous exhibitions on nearly every continent and have been featured in a large corpus of catalogs, monographs, fashion

Figures 7.5a and 7.5b. Malick Sidibé's images in other popular international media. *Above*: agnés b., Paris, gray T-shirt, 2009. *Facing*: Orchestra Baobab, *Pirates Choice* CD cover, World Circuit, Dakar, 2001. © Malick Sidibé, courtesy Malick Sidibé and MAGNIN-A gallery, Paris.

magazines, and news journals, attracting copious attention in the realms of art and popular culture. Perhaps none have been more publicly revered and emulated than the black-and-white works of Malian photographers Malick Sidibé and Seydou Keïta. Admired for the artistry and graphic quality of their images, which showcase their subjects' flair for fashion, both photographers have been commissioned to shoot fashion spreads for some of the world's top designers and stylists, and their photographs have been referenced on textiles and compact disc jackets (figs. 7.5a and 7.5b) as well as in video and film.[50]

French anthropologist Jean-Loup Amselle was one of the first people to critically examine this. On one hand, these images challenge

Figures 7.5a and 7.5b (*continued*)

depictions in Western media that concentrate on perceived cultural difference and deficits in Africa, including war, disease, corruption, and poverty. On the other hand are the multidirectional, fluid processes of transculturation (Ortiz 1947, 97): While youths in Mali appropriated Western fashion to express their modern, cosmopolitan sensibilities and membership within global youth movements, elements of African fashion were being reinterpreted by European and American urbanites in a manner that reinforces the idea of a timeless, alien continent.[51] The latter practice has been justly criticized by scholars as primitivist due to the exoticizing treatment of "Africa *as* fashion" (Rovine 2009, 135) often through what Amselle called the recycling of African "kitsch" (Amselle 2005, 53). This practice was brought to the fore by Wendy Grossman in a 2009 exhibition that featured photographs Man Ray published in *Harper's Bazaar* in 1937. In these images, models don beaded hats from central Africa coupled with ivory bracelets, recontextualizing African objects as exotica and, by extension, symbols of high fashion (Grossman 2009, 144).

Amselle critiqued the position of West African portraiture in Western art contexts as an example of "neo-primitivism" akin to the exoticization and recycling of African "kitsch" by fashion designers throughout the twentieth century (Amselle 2005). For him, the current popularity of portraits taken in Bamako from the 1950s to the 1980s results from Western nostalgia for the fashions and popular culture of those eras—part of what Amselle refers to as Western discarded "trash" (Amselle 2005, 52)—that have been renewed by their use in African contexts. Conflating contemporary trends with urban African pasts, an anachronistic Africa is created as fuel for Western, and now global, imaginations. On this point, referencing the magnified, uncropped reproductions of Sidibé's archive that have been developed for the scrutinizing pleasure of the foreign eye, Amselle reproachingly argued, "It is no longer in the jungles of the Amazon or New Guinea but in the jungles of African . . . cities . . . [where] one can find the primordial Eden" (Amselle 2005, 87).

Arguably, this exoticism is more pronounced in the formalist treatment of Sidibé's Yokoro images overseas (plate 16; see also figs. I.4, 5.23, and 5.24). Despite the numerous interviews Sidibé conducted over nearly two decades, no explanations or inquiries of these images have been published. Rather, in every case, the visual composition is given primacy. Until now, Yokoro has not been discussed in extant literature on art, performance, and cultural practices in Mali, rendering its contextual depth allusive. All that exists are Father Bailleul's definition of *Yogoro* as a "boys' game of disguise" and the Hasselblad catalog's awkward description, "Man with a Plait: End of Lent 1983, commonly called Yokoro, 1983," which erroneously implies a connection with Christian practice and springtime activities (Bailleul 2000a, 493; Knape, Diawara, and Magnin 2003, 102). How, then, do foreign audiences interpret these esoteric images, which feature costumed children within the studio context, bearing an obscure title?

Providing some indication in her article "Malick Sidibé Bamako Fantastique," Bronwyn Law-Viljoen described Sidibé's 1970 Yokoro image as "a delightful portrait of two young boys in strange getup" (Law-Viljoen 2007, 48). Featured without explanation or background information, their "strangeness" is emphasized. Conveying a sense of masquerade, circus performance, or surreal child's play and depicting barefoot children who don tattered clothes, painted skin, and feathers, this image perpetuates popular Western notions of an impoverished exotic African continent. Moreover, Yokoro's alterity is elevated to the uncanny in these images via the depiction of a rigidly posed masked character with tin cans strapped to his ankles (see fig. 5.23) and painted skeletal bodies encircling a pyramidal tent-like costume among a dizzying array of patterns (plate 16). Such bizarre imagery is reminiscent of Alex Van Gelder's carnivalesque selection of commissioned photographs by Sidibé's contemporaries in the

Republic of Benin, which features "astonishing images of . . . ju-ju men, voodoo . . . priestesses . . . and, most startlingly, the dead and dying"[52] alongside photographs of accused criminals, the disfigured, and children in masquerade costumes (Van Gelder 2005).

The formalist presentation of Yokoro images thus exemplifies Amselle's claim that the Western appropriation of Sidibé's commissioned portraits is an example of neoprimitivism. More than portraits featuring cosmopolitan fashions, however, decontextualized representations of Yokoro performers, like Van Gelder's collection, reinforce primitivist notions of a timeless alien continent and, by extension, exoticize Sidibé's images among foreign audiences.

Offering a compelling critique, Amselle's neoprimitivist arguments remain largely formalist, essentializing, and speculative with regard to portrait photographs in Mali, based on assumed hegemonic power dynamics. In fact, photographs taken by Keïta, Sidibé, and their associates since the 1950s illustrate dynamic processes of transculturation, facilitated by the agency of multiple actors. As negotiated displays, they are products of cultural imagination and hybrid exchange, conflating Western appropriations of aesthetic and material culture from Africa with Malian articulations of cosmopolitan fashions and popular culture from Europe and the United States. Thus, they represent an aesthetic that is at once fresh and familiar, local and global. By embellishing meticulously framed performances and urban symbolism with juxtaposed patterns and visual obscurity, Sidibé and Keïta have introduced a new style of imagery—a new visual aesthetic. Their photographs, which variously function as art, portraiture, advertisement, and popular culture, do not simply parrot Western trends or recycle Western "trash" but, as the creations of significant modern and contemporary artists, introduce new ways of viewing that have been publicly revered and emulated across the globe.

As Mande scholar James Brink has noted, contrary to formalist practice, "it is generally recognized nowadays that . . . art objects . . . cannot be fully comprehended outside their cultural context. We can appreciate them as works of art, we can be moved by them, but we cannot really understand them" (Brink 2001, 237). Therefore, comprehending Keïta and Sidibé's images, the cultural context in which they were created, and the role of the photographers and their studios in their production requires looking beyond the surface of their images.

Without understanding the context in which Keïta's and Sidibé's photographs originated, one cannot substantially appreciate their artistry or the significance of the studio as a nexus for collaborative creative expression where, in the case of Yokoro, fashion shoots, and *Vues de dos* images, pictured subjects are not always patrons. By contrast, familiarity with

local cultural practices renders the visual content of these photographers' images comprehensible, inspirational, and perhaps even relatable to overseas audiences. By addressing local social theories, ideological perspectives, aesthetic values, and photographic strategies, this account has been able to highlight relationships among unique forms of artistic production and cultural practice in Mali and the role of professional studios in theses intersections largely due to the performative social character of the space and the documentary nature of the photographic medium.

Thus, as both art and archive, professional photographers' oeuvres facilitate studies of ephemeral cultural practices and, by extension, transcultural fluencies among rural, urban, contemporary, and traditional contexts. Their archives illustrate the integration of photography with long-standing cultural, aesthetic, and artistic practices in the country. Bridging compartmentalized knowledge in the field of African art history, they record important life transitions, such as initiation into adulthood via Jo or Ntomo, and enable the visual communication of important concepts and communal ideals. These include fadenya individuality and badenya camaraderie and mutual support, which are not only engaged among Bamana communities in rural villages but also are transcultural and perpetuated in contemporary urban life by multiethnic populations.

The recontextualization of these archives in global art contexts has brought Keïta and Sidibé international celebrity and a prestigious position in the canon of world photography. However, while distorting the historical realities of their careers, it has also dramatically altered the appearance, function, and meaning of their images. With an emphasis on form, the decontextualized presentation of their oeuvres in popular exhibitions, publications, and websites suggests the reformulation of "exotic African kitsch" in the twenty-first century. Arguably, more primitivizing are the economic and social inequities and the assumed remoteness of West African photographers that have allowed their images to be reframed as the work of "unknown" creators and their archives to be exploited by international scholars, collectors, curators, and dealers. This reality underscores the importance of emic studies and scholarly field research as means to complicate Western-centric, formalist biases in the international presentation of photography from Africa and to promote African perspectives, patrimony, and cross-cultural understanding.

Notes

1. Aubry was director of the French Cultural Center in Bamako from 1982 to 1985 and director of l'Association Atout Centre, which was appropriated by

Afrique en Création and later absorbed by the Association Français d'Action Artistique (AFAA). Aubry was one of the early organizers and promoters of the Bamako *Rencontres* until 2000 (Mercier 2006, 15, 28, 110).

2. The *Rencontres d'Arles* is an important international photography biennial founded by French photographer Lucien Clergue in 1970.

3. Today, the biennial is commonly referred to as *Rencontres de Bamako* in publicity materials and media reports.

4. During the first *Rencontres*, the artistic director was Françoise Huguier, the French director was Rojer Aubry, and the Malian director of art and culture was Hamidou Maïga; the person in charge of press was Dominique Joquer (H. Maïga 2004).

5. The first two *Rencontres* featured a small, locally produced brochure (twenty pages for the first and twenty-eight for the second). The third was substantially larger (sixty-nine pages) and was published by Actes Sud (Lortie 2007, 115). Since the fourth festival, the biennial has published substantial hard- and softcover catalogs in Paris with Éditions Éric Koehler (Njami 2003a, 2003b) until the ninth edition, which was published by Actes Sud.

6. According to the French Ministry of Foreign Affairs and International Development (2015), for example, the Institute Français is the "driving force behind the Bamako Encounters photography biennial." The name of the House of Sudanese Artisans has changed several times throughout its history. It was the School of Sudanese Artisans from 1933–48, the House of Sudanese Artisans from 1948–64, and the National Art Institute from 1964 onward.

7. Moussa Konaté, former Malian director of the *Rencontres* and the Maison Africaine de la Photographie in Bamako, provided the following criticism: "All monies come from Europe. Everything for the *Rencontres*, all major decisions are made in France. [The biennial] needs to be more local. The art is collected, chosen, the themes are created, etc. in France" (Moussa Konaté 2004).

8. In 2003, Njami relayed that he "was on the committee that was supposed to get Malian writers, photographers, and other scholars involved in the [first biennial] so that it wouldn't be another case of colonialist behavior. But, instead, the workers were all French." By the third *Rencontres*, Njami was able to direct the festival in what he thought would be "the most interesting, helpful, and forward-thinking manner" (Njami 2003, 2001, 87).

9. During this period, Njami generated the biennial's theme and "network[ed] the idea out to other people through associates in various institutions and countries." With regard to his selection processes, Njami explained that people sometimes "send me things that are interesting." If he finds the photos inspiring, he includes them (Njami 2003).

10. According to Konaté, the biennial suffers from infrastructure, funding, and technical problems. For example, he said, a central venue, "the Palais de la Culture . . . is a problem because it is very hot. We need better locales for purposes of conservation, presentation, and attendance" (Moussa Konaté 2004).

11. Both the 2009 and 2011 *Rencontres de Bamako* were under the artistic directorship of Krifa and Serani.

12. For information about this history and related current events, consult Lecocq (2010), Wehrey and Boukhars (2013), Harmon (2014), and Pézard and Shurkin (2015).

13. In March 2010, the French Cultural Center in Bamako became the Institute Français.

14. See Association Oscura (2001).

15. For example, Sanaba N'Diaye (who studied photography and began working for newspapers in the United States) takes pictures for Reuters Agency and Agence France Press (N'Diaye 2005). Such freelance journalism is a career option for more young photographers in Mali in the twenty-first century.

16. See, e.g., Photo Vesta at 153–54 Rue Dakar in Bamako-Kura.

17. Other times, Sidibé would reprint negatives within his archives without solicitation. In recent years, when reminded of individuals he had photographed (by recognizing their relative in the street or encountering a negative of them in the process of reviewing his archive for one reason or another), he would create prints from the old negatives and give them to the individual's spouse, family member, or close friend as a token of generosity.

18. This photographer will remain anonymous for protection.

19. The photographer continued, "ATT broke my camera. I have no camera now. Photographers cannot take pictures of ATT anymore . . . due to security reasons, except for AMAP." His identity is withheld for his protection.

20. The identity of these photographers will remain anonymous for their protection.

21. However, Elder reports that ANIM-owned studios were opened to the public after-hours as private studio practices (Elder 1997, 89). It is unclear if this was subversive or condoned.

22. For example, I was not allowed to photograph the façade of the National Archives at Kuluba due to its location in front of the palace. In so doing, I might have inadvertently depicted the palace and its activities (or the act might have suggested that was my primary intention). I was told by the local guards, as well as the archivists and my colleague Brehima Sidibé, that if I did so my camera would be confiscated and the film inside would be destroyed.

23. Created in 1977, CNPC is the national film and cinematographic agency of Mali and ORTM is the national television network (A. O. Konaré and A. B. Konaré 1981, 207). Nimis has argued that *L'Essor* was the only daily newspaper in Mali until 1991 (Nimis 1998c, 62). In fact, the history is more complex. *L'Essor* began as a daily newspaper on October 17, 1949, with a print run of one hundred copies each day, and was affiliated with the Union Soudanais party (A. O. Konaré and A. B. Konaré 1981, 140). By 1950, three hundred copies were printed daily; and later that decade, *Verité* (PSP) and *L'Essor* (US-RDA) became competing daily newspapers (Centre des Archives d'Outre-Mer, 14MIOM/2283, 15G/5b, and 14MIOM/2275, 15G/24). From 1953 to 1958, *Soudan Matin* was published every day, and by 1958, *L'Union*, a daily newspaper affiliated with Parti du Groupement Soudanais and written by Fily Dabo Sissoko, was also published (*L'Union* 1958a; A. O. Konaré and A. B. Konaré 1981, 147). When the US-RDA took control after independence under Modibo Keïta, *L'Essor* became the sole national daily newspaper. It remains the premier newspaper for most Malians today.

24. In the late 1990s, small internet cafés started popping up in neighborhoods throughout Bamako. In the early 2000s, a French-owned communications company, Ikatel, become a growing virtual monopoly in the city (hampering Malitel and putting smaller Malian-owned companies such as Data Tech out of business). More recently, Orange, another French company, has taken over, becoming all but a monopoly, and has rapidly developed cell phone and Wi-Fi technology throughout the nation. For those who can afford it, the internet is presently accessible in every moderately urban town in the country via privately owned commercial cyber cafés.

25. Photographers' archives typically preserve original negatives in envelopes that feature the name of the client and date of the commission. In Malick Sidibé's collection, for example, original prints are attached to folders. Written below them is information that identifies the client's last name, the name of the host of an event (if it was a reportage context), and the date. Similarly, Tijani Sitou's filing system recorded the name of the patron and the date of the exposure. Thus, whether or not a photographer was familiar with the portrayed, their names were recorded as part of good business practices. Today these records enable us to know—by name, at least—most of the depicted.

26. The need to challenge such stereotyped depictions and assumptions (which are prevalent in Western culture at times regardless of skin color) is made evident in the following quote by Ghanaian photographer Philip Kwame Apagya: "Questions by black American journalists in Bamako really shocked me. I did not fit into their image of African although my picture of Africa is one that my African clients completely identify with. Our people are interested in modern, new things and in the future—that is the driving force and object of their ambitions, and I try to adapt myself to this" (Wendl and Apagya 2002, 46).

27. These colonial images have been discussed in chaps. 1 and 6. In addition to *National Geographic* imagery, examples of this exoticizing genre that persist today include the work of Carol Beckwith and Angela Fisher (Fisher 1984, Beckwith and Fisher 1999, Fisher and Beckwith 2004), Françoise Huguier (1996), and De Clippel and Colleyn (2007) as well as most online and print news media. For thought-provoking analyses on this topic, refer to Lutz and Collins (1993), Landau and Kaspin (2002), and Keim (1999).

28. Sidibé's archive presents a few exceptions as he incorporated the names of his subjects within some of his titles, particularly in the recent catalog edited by Incardona, Serani, and Zannier (2011).

29. In 2010, Magnin became an independent art curator and dealer and created his own company, A-Magnin, which currently represents Malick Sidibé. The Pigozzi Collection (CAAC) and SKPEAC presently own the rights to Keïta's archive.

30. See Seydou Keïta Photography (n.d.).

31. According to Michael Rips, although Griffen has never seen an original Keïta print, when he was later asked to reproduce Keïta's negatives, he chose rather to "give more emphasis to the ground between the blacks and the whites" than is customary in prints produced in Mali for local patrons (Rips 2006, 1).

32. See Seydou Keïta Photography (n.d.).

33. Fané's account contradicts Sidibé's performance in the 2008 documentary *Dolce Vita Africana*, which, corroborated by a few former clientele, suggests Sidibé's presence in those contexts was critical (Spender 2008). What is conflated in the video account is the reportage work Sidibé carried out while employed at Photo Service during the 1950s (as a young member of Triana—not the Las Vegas club) before opening Studio Malick in 1962, which was purportedly destroyed and therefore has never been published, with the internationally celebrated (published) party photographs created by Sidibé's apprentices during the 1960s and 1970s for Studio Malick.

34. Most of these images were destroyed by Gérard Guillat-Guignard (who set fire to his archives) when he left Mali for Nouméa in 1958 and by other Photo Service proprietors during regular purges of the establishment's negative holdings (M. Sidibé 2003; Guillat-Guignard 2016).

35. This issue of subjects' rights to privacy remains an unresolved ethical challenge faced by anyone who reproduces historically commissioned portraiture in public contexts today, including this author. Consult the final note chap. 6 for my comments on this topic.

36. The photograph in question was taken by a photographer working for Studio Malick in the early 1970s. During our conversations, Sidibé did not disclose the year, location, or title of the exhibition, and he did not identify the specific photograph.

37. Articles 125–27 in the Malian Constitution of 2013 address one's legal right to privacy, including in the context of photographic imagery. However, according to my research, there are not yet laws to support such constitutional rights or formal means by which to uphold them (Tounkara 2019; Malick Sitou 2019; Sakaly 2019).

38. See Seydou Keïta Photography (n.d.).

39. Conflicted by the need to expose unethical practices on behalf of the families whose archives have been stolen or exploited and concerned about the possible ramifications this information might have for the accused, I have decided to omit the names of the accused within the text of this book. However, I cite specific interviews in the notes and bibliography to indicate that I have corresponded with these individuals, and their comments attest that the claims against them are not merely accusations.

40. S. Sokkelund and Elder (1996, 3); S. Sokkelund, n.d.

41. Personal communication with said businessman about his contested engagement with the negatives and photographers' families in question, November 2005, Bamako.

42. See S. Sokkelund, n.d.

43. See Micheli (2012; n.d., "Doubles portraits"; and n.d., "My Blogs").

44. Ministère de la Culture et de la Communication République du Mali and Fondation Afrique en Créations (1994), my translation from French into English.

45. This project digitized five hundred negatives from the archives of Soungalo Malé, Abdourahmane Sakaly, and Malick Sidibé. Prints from this collection were exhibited at the National Museum during the 2011 *Rencontres*.

46. A small collection of Abdourahmane Sakaly's archives were digitized and exhibited at MAP in 2011.

47. From 2011 to 2014, this project (part of the Archive of Malian Photography, n.d.) cleaned, preserved, catalogued, and digitized twenty-eight thousand negatives from the earliest archival collections of Mamadou Cissé and Abdourahmane Sakaly.

48. During 2014–16, circa one hundred thousand negatives from the archives of Adama Kouyaté, Abdourahmane Sakaly, Malick Sidibé, and Tijani Sitou were cleaned, preserved, digitized, and catalogued by this project, which is part of the Archive of Malian Photography (n.d.).

49. See also British Library (2015).

50. See, e.g., the numerous fashion shoots that Keïta and Sidibé have undertaken for *Elle* (Malick Sidibé and Laurent 2003), *Harper's Bazaar* (MacSweeny 1996; Als 1997), *Double, nouveau feminine* (Lamunière 2001b, 38), *Paper* (Dosunmu and Sidibé 1999), *Pennyblack* (2008; Malick, Dia, and Siné Sidibé 2009), the *New York Times Magazine* (Malick Sidibé and Kokkino 2009b), and other magazines (Wendl and Apagya 2002, 48), as well as the projects they have influenced: Arakas and Elgort (2005); Nnandi (2012); Keller (2013a); Hype Williams's 1998 hip hop film *Belly* (Henry 2001, 2); and Janet Jackson's 1997 video "Got 'Til It's Gone."

51. See, e.g., Yves Saint Laurent's "Bambara Dress" of 1967 (Bergé 2008, 111).

52. See the inside front dust jacket of Van Gelder's *Life and Afterlife in Benin* (2005).

Bibliography

Abiodun, Rowland. 2013. "Àkó-graphy: Òwò Portraits." In *Portraiture and Photography in Africa*, edited by John Peffer and Elisabeth Cameron, 341–62. Bloomington: Indiana University Press.

"Africa News: Mali Pardons Former Dictator Moussa Traore, Wife." 2002. *Namibian*, May 30, 2002. http://www.namibian.com.na/2002/may/africa /0262BE4A68.html. Page no longer available.

Agence Malienne de Presse et de Publicité et la Photographie (AMAP). 2002. "Agence Malienne de Presse et de Publicité 1992 à 2002." Unpublished article, Bamako, Mali.

"AGNÈS B. Runway/Ready-to-Wear/Spring 2009." 2008. *Elle*, October 3, 2008. https://www.elle.com/runway/spring-2009-rtw/g17987 /agnes-b-237809/.

Als, Hilton. 1997. "Sunday Best: Malian Photographer Seydou Keita's Portraits of Local Citizens Are Both Intimate and Grand." *Harper's Bazaar*, May 1997, 72.

Amkoullel. 2014. Personal correspondence, May 16, Lansing, Michigan, and email communication, May 22.

Amselle, Jean-Loup. 1998. *Mestizo Logics: Anthropology of Identity in Africa and Elsewhere*. Stanford, CA: Stanford University Press.

———. 2005. *L'art de la friche: Essai sur l'art africain contemporain*. Paris: Flammarion.

Anderson, Benedict. (1983) 2006. *Imagined Communities: Reflections on the Origin and Spread of Nationalism*. London: Verso.

Anderson, Martha, and Lisa Aronson, eds. 2017. *African Photographer J. A. Green: Reimagining the Indigenous and the Colonial*. Bloomington: Indiana University Press.

Anginot, Dominique. 1995. *Seydou Keïta Studio Work, 1949–1970*. Paris: Lux Modernis.

Appadurai, Arjun. 1996. *Modernity at Large*. Minneapolis: University of Minnesota Press.

Arakas, Irini, and Arthur Elgort. 2005. "Bring It on Home." *Vogue*, January 2005, 138–45.

Archives Nationales du Mali. "Registre des Photos disponibles aux Archives Nationales du Mali, Section Archéologic Koulouba, Contrifan du Soudan (1951–1955)."

———. *Repertoire de Dossiers de Personnes, Fonds Recent Serie 1C 1918–1960 (1989)*, 1C5.17, Gizycki Georges, operateur de la photographie (1928–31).

———. *Repertoire Fonds Anciens 1855–1954*. Book 1, *1855-1917*, ID-33 and IG-188.

———. *Repertoire Fonds Recents 1855–1954*. Book 2, *1918–1960*, ID-2, ID-19, ID 33-3, ID-49, ID-62, ID-70, ID-71, ID-243, 2D-138, IG-221, 7-D-90/2, J-9.

———. "Repertoire Photos—IFAN."

Archive of Malian Photography. n.d. Michigan State University. Accessed November 5, 2020. https://amp.matrix.msu.edu.

Aren, Jean-Pierre. 2001. "Un sac posé sur le quai: Gérard Guillat-Guignard, 'G.G.G. la Pellicule' dans le métier de la photo, raconte ses souvenirs de boulingue. Du Pacifique à Afrique en passant par l'Indochine." *Sud Ouest*, January 12, 2001, H.

Arens, William, and Ivan Karp, eds. 1991. *Creativity of Power: Cosmology and Action in African Societies*. Washington, DC: Smithsonian Institution.

Arnoldi, Mary Jo. 1994. "Political History and Social Commentary in Malian Sogobò Theater." *Africa Today* 41, no. 2 (2nd Quarter): 39–49.

———. 1995. *Playing with Time: Art and Performance in Central Mali*. Bloomington: Indiana University Press.

———. 2001. "The Sogow: Imagining a Moral Universe through Sogo bò Masquerades." In *Bamana: The Art of Existence in Mali*, edited by Jean-Paul Colleyn, 77–93. New York: Museum for African Art.

Arsenault, Catherine, Pierre Fournier, Aline Philibert, Koman Sissoko, Aliou Coulibaly, Caroline Tourigny, Mamadou Traoré, and Alexandre Dumont. 2013. "Emergency Obstetric Care in Mali: Catastrophic Spending and Its Impoverishing Effects on Households." *Bulletin of the World Health Organization*, January 17, 2013. http://www.who.int/bulletin/volumes/91/3/12-108969/en/.

Association Oscura. 2001. *Mali Photos: Sténopés d'Afrique*. Paris: Snoeck-Ducaju and Zoon.

Association Seydou Keïta. 2005. "Press Release." Unpublished document, distributed by the association during the fifth *Rencontres* in Bamako, Mali, November 2005.

Atlas du Patrimoine. 1997. *(1895–1930) Cartes Postales d'Afrique de l'Ouest* [West African postcards]. CD-ROM. Paris: Memory of the World, Association Images et Mémoires, and Mémoire Direct.

Au-Senegal.com. n.d. "Cartes postales et cartes anciennes." Accessed November 5, 2020. http://www.au-senegal.com/-Cartes-postales-anciennes-.html?lang=fr.

Austen, Ralph A. 1999. *In Search of Sunjata: The Mande Oral Epic as History, Literature, and Performance*. Bloomington: Indiana University Press.

Awani, Mahaman. 2004. Interview by author, August 30, Gao, Mali. Tape recording.

b., agnès. 2009a. "Agnès b." Black Rainbow Extraordinaire. http://www
.bkrw.com/whoswho/agnes-b.html. Page no longer available.

Bâ, Alioune. 2004. Interviews by author, January 6 and 24, Bamako, Mali.
Tape recording.

Bâ, Amadou Hampaté. 1973. "La Notion de Personne en Afrique Noire."
In *La Notion de Personne en Afrique Noire*, edited by Germaine
Dieterlen, 181–92. Paris: Éditions du Centre National de la Recherche
Scientifique.

Baby, Abdoulaye. 2004. Interview by author, September 16, Bamako, Mali.
Tape recording.

Bailleul, Père Charles. 2000a. *Dictionnaire: Bamabara-Français*. Bamako,
Mali: Donniya.

———. 2000b. *Dictionnaire: Français-Bambara*. Bamako, Mali: Donniya.

Banta, Melissa, and Curtis M. Hinsley, eds. 1986. *From Site to Sight:
Anthropology, Photography, and the Power of Imagery*. Cambridge, MA:
Peabody Museum Press.

Barakela. 1954. No. 129 (May): 11.

Barthes, Roland. 1981. *Camera Lucida: Reflections on Photography*. New
York: Hill and Wang.

Barry, Harouna. 2003. *Les Charmes Discrets de Bamako*. Bamako, Mali:
Djéné Color.

Batchen, Geoffery. 1999. *Burning with Desire: The Conception of
Photography*. Cambridge, MA: MIT Press.

———. 2015. Email communication, March 6.

Becchetti-Laure, Marie-Françoise. 1990. "Apercu de la Jeune Peinture a
Bamako, Republique du Mali 1960–1990 Formation—Creation—
Diffusion." Master's thesis, Universite de Provence, Aix-Marseille I,
Centre d'Aix, Département d'Histoire de l'Art et d'Archéologie.

Becker, Cynthia. 2011. "Hunters, Sufis, Soldiers, and Minstrels: The Diaspora
Aesthetics of the Moroccan Gnawa." *RES: Anthropology and Aesthetics*
59/60 (Spring/Autumn): 124–44.

Beckwith, Carol, and Angela Fisher. 1999. *African Ceremonies*. New York:
Harry N. Abrams.

Behrend, Heike. 2002a. "'I Am Like a Movie Star in My Street': Photographic
Self-Creation in Postcolonial Kenya." In *Postcolonial Subjectivities in
Africa*, edited by Richard Werbner, 44–62. London: Zed Books.

———. 2002b. "Images of an African Modernity: The Likoni Ferry
Photographers of Mombasa, Kenya." In *African Modernities: Entangled
Meanings in Current Debate*, edited by Jan-Georg Deutsch, Peter Probst,
and Heike Schmidt, 85–106. Oxford: James Currey.

———. 2003. "Photo Magic: Photographs in Practices of Healing and
Harming in East Africa." *Journal of Religion in Africa* 33, no. 2 (May):
129–45.

———. 2013. *Contesting Visibility: Photographic Practices on the East
African Coast*. Bielefeld, Germany: transcript Verlag.

Behrend, Heike, and Tobias Wendl. 1997. "Photography." In *Encyclopedia
of Africa South of the Sahara*, vol. 3, edited by John Middleton, 409–15.
New York: Simon and Schuster Macmillan.

Bell, Claire, Okwui Enwezor, Octavio Zaya, and Olu Oguibe, eds. 1996. *In/Sight: African Photographers, 1940 to the Present*. New York: Solomon R. Guggenheim Museum.

Benjamin, Walter. 1999. *Walter Benjamin: Selected Writings*. Vol. 2, *1927–1934*. Edited by Michael W. Jennings, Howard Eiland, and Gary Smith. Cambridge: Belknap Press of Harvard University Press.

Bennett, Valerie Plave. 1975. "Military Government in Mali." *Journal of Modern African Studies* 13, no. 2 (June): 249–66.

Bergé, Pierre. 2008. *Yves Saint Laurent Style*. New York: Abrams.

Berglund, Axel-Ivar. 1976. *Zulu Thought Patterns and Symbolism*. Uppsala: Swedish Mission Institute.

Biennial Foundation. 2017. "11th Rencontres De Bamako—African Biennale of Photography Announces Prize Winners." Biennial Foundation, December 5, 2017. http://www.biennialfoundation.org/2017/12/11th-rencontres-de-bamako-african-biennale-photography-announces-prize-winners/.

Bigham, Elizabeth. 1999. "Issues of Authorship in the Portrait Photographs of Seydou Keïta." *African Arts* 32 (Spring): 56–67, 94–96.

Bignat, Jean. 2004. Interview by author, June 23, Mopti, Mali. Transcript.

Bingen, R. James. 2000. "Overview—The Malian Path to Democracy." In *Democracy and Development in Mali*, edited by R. James Bingen, David Robinson, and John M. Staatz, 245–50. East Lansing: Michigan State University Press.

Bingen, R. James, David Robinson, and John M. Staatz, eds. 2000. *Democracy and Development in Mali*. East Lansing: Michigan State University Press.

Bird, Charles S., Mamadou Koita, and Bourama Soumaouro. 1974. *The Songs of Seydou Camara*. Bloomington: African Studies Center, Indiana University.

Bird, Charles S., and Martha B. Kendall. 1980. "The Mande Hero: Text and Context." In *Explorations in African Systems of Thought*, edited by Ivan Karp and Charles S. Bird, 13–26. Bloomington: Indiana University Press.

Bird, Charles S., and Kalilou Tera. 1995. "Etymologies of *Nyamakala*." In *Status and Identity in West Africa: Nyamakalaw of Mande*, edited by David C. Conrad and Barbara Frank, 27–35. Bloomington: Indiana University Press.

Blanchard, Pascal, Stéphane Blanchoin, Nicolas Bancel, Gilles Boëtsch, and Hubert Gerbeau, eds. 1995. *L'Autre et Nous: "Scènes et Types."* Paris: Syros.

Bleneau, Daniel, and Gerard la Cognata. 1972. "Evolution de la Population de Bamako." *Etudes Maliennes* 3 (September): 26–42.

Blocker, H. Gene. 1994. *The Aesthetics of Primitive Art*. Lanham: University Press of America.

Bocoum, Ali. 2004. Interview by author, July 24, Mopti, Mali. Transcript.

Bocquier, Philippe, and Tiéman Diarra, eds. 1999. *Population et Société au Mali*. Paris: L'Harmattan.

Bolton, Richard, ed. 1989. *The Contest of Meaning: Critical Histories of Photography*. Cambridge, MA: MIT Press.

Bonetti, Maria Francesca, and Guido Schlinkert, eds. 2004. *Samuel Fosso*. Milan: 5 Continents.

Bourdieu, Pierre. (1965) 1990. *Photography: A Middle-Brow Art*. Stanford, CA: Stanford University Press.

———. (1984) 2002. *Distinction: A Social Critique of the Judgement of Taste*. Cambridge: Harvard University Press.

Bouttiaux, Anne-Maries. 2003. *L'Afrique par elle-même: Un siècle de photographie africaine*. Paris: Revue Noire.

Boyer, Allison. 1992. "Mali: An Exemplary Transition." *Africa Report* 37, no. 4 (July–August): 40–42.

Brasseur, Paule. 1964. *Bibliographie Générale du Mali*. Dakar, Senegal: IFAN.

Braun, Katherine L., James H. Pietsch, and Patricia L. Blanchette, eds. 2000. *Cultural Issues in End-of-Life Decision Making*. Thousand Oaks: Sage.

Brenner, Louis. 2010. "A Living Library: Amadou Hampâté Bâ and the Oral Transmission of Islamic Religious Knowledge." *Islamic Africa* 1, no. 2 (Winter): 167–215.

Brielmaier, Isolde Anna. 2003. "'Picture Taking' and the Production of Urban Identities on the Kenyan Coast, 1940–1980." PhD diss., Columbia University.

Brink, James T. 1978. "Communicating Ideology in Bamana Rural Theater Performance." *Research in African Literatures* 9 (Winter): 382–94.

———.1980. "Organizing Satirical Comedy in Kote-tlon: Drama as a Communication Strategy among the Bamana of Mali." PhD diss., Indiana University.

———. 1981. "Dialectics of Aesthetic Form in Bamana Art." Unpublished paper presented at the University of Wisconsin, Milwaukee, October 16, 1981.

———. 1982. "Speech, Play and Blasphemy: Managing Power and Shame in Bamana Theater." *Anthropological Linguistics* 24, no. 4 (Winter): 423–31.

———. 2001. "Dialectics of Aesthetic Form in Bamana Art." In *Bamana: The Art of Existence in Mali*, edited by Jean-Paul Colleyn, 237–41. New York: Museum for African Art.

British Broadcasting Corporation (BBC). n.d. "Bamako, Mali." http://www.bbc.co.uk/weather/world/city_guides/city.shtml?H=TT000380. Page no longer available.

British Library. 2015. "Archive of Malian Photography." *Endangered Archives* (blog). December 3, 2015. http://britishlibrary.typepad.co.uk/endangeredarchives/2015/12/archive-of-malian-photography-.html.

Brooks, George E. 1989. "Ecological Perspectives on Mande Population Movements." *History in Africa* 16:23–40.

Buckley, Liam. 2003. "Studio Photography and the Aesthetics of Postcolonialism in the Gambia, West Africa." PhD diss., University of Virginia.

———. 2013. "Portrait Photography in a Postcolonial Age: How Beauty Tells the Truth." In *Portraiture and Photography in Africa*, edited by John Peffer and Elisabeth L. Cameron, 287–314. Bloomington: Indiana University Press.

Bulletin de l'Afrique Noire. 1967. Vol. 488, no. 11 (December 13): 9845.

———. 1973. Vol. 754, no. 17 (October 24): 14778.

Bulman, Stephen P. D. 1996. "The Image of the Young Hero in the Printed Corpus of the Sunjata Epic." In *The Younger Brother in Mande: Kinship and Politics in West Africa*, edited by Jan Jansen and Clemens Zobel, 75–96. Leiden, Netherlands: Research School CNWS.

Burke, Timothy. 2002. "Our Mosquitoes Are Not So Big: Images and Modernity in Zimbabwe." In *Images and Empires: Visuality in Colonial and Postcolonial Africa*, edited by Paul S. Landau and Deborah D. Kaspin, 41–55. Berkeley: University of California Press.

Burton, Melanie. 2004. "Voice: Signs of the Times." *J Select* 31, no. 4 (April/May): 20–24, 23.

Byrd, Antawan. 2015. Personal communication, February 26.

———. 2016. Personal communications, April 29, May 1, and May 30.

CAACART.com. n.d. "Contemporary African Art Collection." Jean Pigozzi Collection. Accessed November 5, 2020. http://www.caacart.com.

Calmel, Captain. 1896. *Chemin de Fer Senegal-Niger*. Paris: Berher-Levrault and Co. In Archives Nationales du Mali, *Repertoire Fonds Recents 1855–1954*. Book 2, *1918–1960*, ID-71.

Camara, Sekou. n.d. "The 'Sanankunya' in Mali." Unpublished manuscript, Bamako, Mali.

Camhi, Leslie. 2002. "Darkness Visible." *Village Voice*, March 26, 2002, 61.

———. 2006. "Royal Portraits." *Village Voice*, February 22–28, 2006, 69.

Carrascosa, Marta. 2004. Interview by author, February 18, Bamako, Mali. Tape recording.

Cassell, Philip, ed. 1993. *The Giddens Reader*. Stanford: Stanford University Press.

Castro, Alexis. 2004. "Evaluation des Rencontres de la Photographie Africaine de Bamako: Rapport realize à la demande de la Direction des 'Rencontres de la Photographie Africaine.'" Unpublished report, May 2004.

Centre des Archives d'Outre-Mer. FM, DFC, XXXIX, MEMOIRES/194, dossier 117; 14 MIOM/2283, 15G/5b; 14 MIOM/2275, 15G/24; ICO, 30FI/10; ICO, 30FI/12; CO, 30FI/14; ICO, 30FI/17.

Centre Edmond Fortier. n.d. Accessed November 5, 2020. https://www.edmondfortier.nl/edmond-fortier-eng.html.

Cerf, Richard. 2001. *Mamadou Konaté: Les nouvelles parures de quotidian*. Bamako, Mali: Galerie Chab.

Chapoutot, Anne, ed. 2016. *Seydou Keïta*. Venice: Graphicom.

Chapuis, Frédérique. (1998) 1999. "The Pioneers of St. Louis." In *Anthology of African and Indian Ocean Photography*, edited by Revue Noire, 48–67. Paris: Revue Noire.

Charry, Eric. 2000. *Mande Music: Traditional and Modern Music of the Maninka and Mandinka of Western Africa*. Chicago: University of Chicago Press.

Cissé, Amadou Baba. 2003. Interview by author, December 10, Bamako, Mali. Tape recording.

———. 2004. Interviews by author, August 3 and 31 and October 5, Bamako, Mali. Tape recordings and transcripts.

———. 2005. Interview by author, November 22, Bamako, Mali. Transcript.

———. 2009. Interview by author, July 29, Bamako, Mali. Transcript.

———. 2011. Interview by author, November 19, Bamako, Mali. Transcript.

Cissé, Diango. 2004. Interview by author, July 21, Bamako, Mali. Tape recording.

Cissé, Oumar. 2004. Interview by author, February 5, Bamako, Mali. Tape recording.

———. 2005. Interview by author, November 21, Bamako, Mali. Transcript.

———. 2011. Personal communication, November 20, Bamako, Mali.

Cissé, Youssouf. 1964. "Notes sur les sociétés des chasseurs Malinké." *Journal de la Société des Africanistes* 34, no. 2.

———. 1973. "Signes Graphiques, Représentations, Concepts et Tests Relatifs a la Personne Chez les Malinke et les Bambara du Mali." In *La Notion de Personne en Afrique Noire*, edited by Germaine Dieterlen, 131–79. Paris: Éditions du Centre National de la Recherche Scientifique.

Cissé, Youssouf Tata. 1995. *Seydou Keita*. Paris: Centre National de la Photographie, Photo Poche 63.

———. 1997. "A Short History of Bamako and of the Family of the Famous Photographer Seydou Keïta." In *Seydou Keïta*, edited by André Magnin, 282–86. Zurich: Scalo.

Clark, Andrew F. 2000. "From Military Dictatorship to Democracy: The Democritization Process in Mali." In *Democracy and Development in Mali*, edited by R. James Bingen, David Robinson, and John M. Staatz, 251–64. East Lansing: Michigan State University Press.

Clauzel, Jean, ed. 1989. *Jean Clauzel—Administrateur de la France d'Outre-Mer*. Paris: Jeanne Laffitte and A. Barthellemy.

———. 2003. *La France d'outre-mer (1930–1960): Témoiggnages d'administrateurs et de magistrates*. Paris: Karthala.

Coe, Brian, and Paul Gates, eds. 1977. *The Snapshot Photograph: The Rise of Popular Photography 1888–1939*. London: Ash and Grant.

Cohen, William B. 1971. "The French Colonial Service in French West Africa." In *Papers on the Manding*, edited by Carleton T. Hodge, 183–204. Bloomington: Indiana University Press.

Colleyn, Jean-Paul, ed. 2001. *Bamana: The Art of Existence in Mali*. New York: Museum for African Art.

Colleyn, Jean-Paul, and Manthia Diawara. 2001. *Mali Kow: Un Monde Fait de Tous Les Mondes*. Montpellier, France: Indigène.

Comite, Gilbert. 1970. "Mali: Quinze Mois après la chute de president Keita." *Revue Française d'études politiques Africains* (February): 16–24, 17.

Conrad, David C. 1995. "*Nyamakalaya*: Contradiction and Ambiguity in Mande Society." In *Status and Identity in West Africa: Nyamakalaw of Mande*, edited by David C. Conrad and Barbara Frank, 1–23. Bloomington: Indiana University Press.

———. 1999. *Epic Ancestors of the Sunjata Era: Oral Tradition from the Maninka of Guinea*. Madison: University of Wisconsin–Madison.

———. 2006. "Oral Traditions and Perceptions of History from the Manding Peoples of West Africa." In *Themes in West Africa's History*, edited by Emmanuel Kwaku Akyeampong, 73–96. Athens: Ohio University Press.

Conrad, David C., and Barbara Frank, eds. 1995. *Status and Identity in West Africa: Nyamakalaw of Mande*. Bloomington: Indiana University Press.

Coulibaly, Daudi. 2004. Interview by author, February 6, Bamako, Mali. Tape recording.

Coulibaly, Malim. 2004. Interviews by author, September 28 and 30, Bamako, Mali. Tape recordings.

Coulon, Gilles, and Marie-Laure de Noray. 1999. *Avoir 20 ans à Bamako.* Paris: Alternatives.

Cousin, Pierre-Henri, Lorna Sinclair, Lesley A. Robertson, Jean-François Allain, and Catherine E. Love. 2000. *French Concise Dictionary.* New York: HarperCollins.

Couturier, Elisabeth. 2001. "L'Afrique zazou et yé-yé." *Match* 2738 (November 15): 22.

Crooks, Julie. 2015. "Alphonso Lisk-Carew: Imagining Sierra Leone through His Lens." *African Arts* 48, no. 3 (Autumn): 18–27.

Crosby, Todd. 2004. Interview by author, June 14, Bamako, Mali. Transcript.

Damandan, Parisa. 2004. *Portrait Photographs from Isfahan: Faces in Transition 1920–1950.* London: Saqi.

Daou, Emmanuel Bakary. 2004. Interview by author, July 28, Bamako, Mali. Tape recording.

Daou, Thomas. 2004. Interview by author, September 10, Bamako, Mali. Transcript.

D'Aprecourt, Flamerville. 1940. "Nos Grandes Interviews Coloniales au Musée d'Ethnographie du Trocadéro avec M. Georges-Henri Rivière." *La Cronique Coloniale*, 349–53.

Davenport, Kim, André Magnin, Thomas McEvilley, Alison de Lima Greene, and Alvia Wardlaw, eds. 2000. *Clubs of Bamako.* Exhibition brochure. Houston, TX: Rice University Art Gallery.

David, Philippe. 1977. "De Fernand à Berthe ou le Temps des Cartes Postales (1903–1904)." *Notes Africaines* 153: 11–12.

———. 1978. "La Carte Postale Sénégalaise de 1900 à 1960 Production, Édition et Significantion: un Bilan Provisoire." *Notes Africaines* 157 (January): 3–12.

———. 1988. *Collection Génerale Fortier.* Paris: Fostier.

———. 1993. *Alex A. Acolaste 1880–1975: Hommage à l'un des premiers photographes togolais.* Lomé, Togo: Haho Goethe Institut.

———. 1999. "Photographer-Publishers in Togo." In *Anthology of African and Indian Ocean Photography*, edited by Revue Noire, 42–47. Paris: Revue Noire. Originally published in French in 1998.

D'Azavedo, Warren. L. 1997. "Sources of Gola Artistry." In *Aesthetics*, edited by Susan Feagin and Patrick Maynard, 197–206. Oxford: Oxford University Press.

de Benoist, Joseph-Rojer. 1998. *Le Mali.* Paris: L'Harmattan.

De Clippel, Catherine, and Jean-Paul Colleyn. 2007. *Secrets: Fétiches d'Afrique.* Paris: Éditions de la Martinière.

De Noray, Marie-Laure. 1999. *Avoir 20 ans à Bamako.* Paris: Alternatives.

Deberre, Jean-Christoph. 1996. *Cornélius Yao Augustt Azaglo: Photographies, Côte d'Ivoire, 1950–75.* Paris: Revue Noire.

Dembélé, Diby. 2009. Interview by author, July 13, Bamako, Mali. Transcript.

Dembélé, Siriman. 2004. Interview by author, February 23, Bamako, Mali. Tape recording.

Denaës, Freddy, and Gaël Teicher, eds. 2011. *Malick Sidibé: Au Village*. Montreuil, France: Éditions de l'Oeil.

Denver Art Museum. 2013. "Common Threads: Portraits by August Sander and Seydou Keïta." May 19–October 27, 2013. *Summer 2013 Map and Guide*. http://www.denverartmuseum.org/exhibitions /common-threads-portraits-august-sander-seydou-keita.

Denyer, Susan. 1978. *African Traditional Architecture*. New York: Africana.

Derrick, Jonathan. 1977. "The Great West African Drought, 1972–1974." *African Affaires* 76, no. 305 (October): 537–86.

Deutsch, Jan-Georg, Peter Probst, and Heike Schmidt, eds. 2002. *African Modernities: Entangled Meanings in Current Debate*. Oxford: James Currey.

Diabaté, Fatoumata. n.d. "L'homme en animal." Accessed November 5, 2020. http://zarbophoto.free.fr/FatouSite/homanimal/index.html.

Diakhaté, Lydie. 2002. "The Last Interview: Seydou Keïta 1921–2001." *Nka, Journal of Contemporary African Art* 16 (Fall/Winter): 17–23, cover.

Diakité, Drissa. 2004. Interviews by author, October 4, 9, and 17, Bamako, Mali. Tape recordings and transcripts.

Diallo, Aïda Mady. 2003. *Aïda Mady Diallo: Romancière*. Paris: Éditions de l'Oeil.

Diarra, Aboubakrine. 2003. "Rôle du audio-visuel dans la collecte, la conservation et la diffusion du patrimoine musical au Mali: Et cas du Musée National du Mali." Master's thesis, Institut Nationale des Arts de Bamako.

———. 2004. Interview by author, January 15. Tape recording.

Diarra, Alpha Yaya. 2009. Interview by author, July 26, Bamako. Transcript.

Diarra, Moussa. 2004. Interviews by author, January 7 and October 15, Bamako and Buguni, Mali. Transcripts and tape recordings.

Diarrah, Cheick Oumar. 1986. *Le Mali de Modibo Keita*. Paris: L'Harmattan.

———. 1991. *Vers la Troisième République du Mali*. Paris: L'Harmattan.

Diawara, Manthia. 1998. "Talk of the Town." *Artforum* (February): 64–71.

———. 1999. "Talk of the Town: Seydou Keïta." In *Reading the Contemporary: African Art from Theory to the Marketplace*, edited by Olu Oguibe and Okwui Enwezor, 236–42. Cambridge, MA: MIT Press.

———. 2003a. "The 1960s in Bamako: Malick Sidibé and James Brown." In *Everything But the Burden: What White People Are Taking from Black Culture*, edited by Greg Tate, 164–90. New York: Broadway Books.

———. 2003b. "The Sixties in Bamako: Malick Sidibé and James Brown." In *Malick Sidibé—Photographs*, 8–22. Göteborg, Sweden: Hasselblad Center.

Dicko, Harandane. 2004. Interview by author, October 17, Bamako, Mali. Tape recording.

Dieterlen, Germaine. 1951. *Essai sur la religion Bambara*. Paris: Presses Universitaires de France.

———. 1955. "Mythe et Organisation Sociale au Soudan Français." *Journal de la Société des Africanistes* 27, no. 1: 39–76.

———. 1957. "The Mande Creation Myth." *Africa* 27: 124–37.

———, ed. 1973. *La Notion de Personne en Afrique Noire*. Paris: Éditions du Centre National de la Recherche Scientifique.

Dosunmui, Andrew, and Malick Sidibé. 1999. "African Holiday." *Paper* (July): 64–77, 124.

Doumbia, Ibrahim. 2005. Interview by author, November 14, Bamako, Mali. Transcript.

Doumbia, Youssouf. 2004. Interviews by author, February 23–26 and March 3, Bamako, Mali. Tape recordings.

Doumbia, Youssouf, and Bakary Sidibé. 2004. Interviews by author, February 26 and March 3, Bamako, Mali. Tape recordings.

Duclos, France. 1992. "La Place de l'Afrique dans les Collections Photographiques de la Bibliothèque de la Société de Géographie." In *Les Transports en Afrique XIX–XXe Siècle*, edited by Helene d'Almeida-Topor, Chantal Chanson-Jabeur, and Monique Lakroum, 11–17. Paris: L'Harmattan.

Duignan, Peter, and Robert H. Jackson, eds. 1986. *Politics and Government in African States 1960–1985*. Stanford, CA: Hoover Institution Press.

Echenberg, Myron. 1991. *Colonial Conscripts: The Tirailleurs Sénégalais in French West Africa, 1857–1960*. Portsmouth, NH: Heinemann.

Eibl-Eibesfelt, Iranäus. 1988. "The Biological Foundation of Aesthetics." In *Beauty and the Brain*, edited by Ingo Rentscheler, Barbara Herzberger, and David Epstein, 29–68. Boston: Birkhäuser Verlag.

Eicher, Joanne B., and Barbara Sumberg. 1995. "World Fashion, Ethnic, and National Dress." In *Dress and Ethnicity: Change Across Space and Time*, edited by Joanne B. Eicher, 295–306. Oxford: Berg, 1995.

Elder, Tanya. 1997. "Capturing Change: The Practice of Malian Photography 1930s–1990s." PhD diss., Institute of Tema Research, Linköping University.

Englebert, Victor. 1974. "Drought Threatens the Tuareg World." *National Geographic* 145, no. 4 (April): 544–71.

Enwezor, Okwui, ed. 2010. *Contemporary African Photography from the Walther Collection: Events of the Self: Portraiture and Social Identity*. Göttingen, Germany: Steidl.

Enwezor, Okwui, and Octavio Zaya. 1996. "Colonial Imaginary, Tropes of Disruption: History, Culture, and Representation in the Works of African Photographers." In *In/Sight: African Photographers, 1940 to the Present*, edited by Okwui Enwezor, Olu Oguibe, Octavio Zaya, and Clare Bell, 17–47. New York: Solomon R. Guggenheim Museum.

EuropeOutremer. 1978. Vol. 55, no. 586 (November): 12, 20, 36–48.

Evans, Chloe. 2015. "Portrait Photography in Senegal: Using Local Case Studies from Saint Louis and Podor, 1839–1970." *African Arts* 48, no. 3 (Autumn): 28–37.

Ezra, Kate. 1983. "Figural Sculpture of the Bamana of Mali." PhD diss., Northwestern University.

———. 2001. "The Initiation as Rite of Passage: Art of the *Jo* Society." In *Bamana: The Art of Existence in Mali*, edited by Jean-Paul Colleyn, 131–41. New York: Museum for African Art.

Fabienne, Pompey. 1993. "Arles 93 XXIV^eme Festival Rencontres de la Photographie les Images de Seydou Keita la Memoire de Bamako." *Le Monde*, July 1, 1993, 3.

Fané, Amadou. 2004. Interview by author, October 27, Bamako, Mali. Tape recording.

Feagin, Susan, and Patrick Maynard, eds. *Aesthetics*. Oxford: Oxford University Press, 1997.

Fernandez, Ana M. 1995–96. "Practiques Magico-Rituelles Chez les Bambara (Mali)." Master's thesis, Institute Catholique de Paris, Institute d'Etudes Economiques et Sociales.

Fernandez, James W. 1971. "Principles of Opposition and Vitality in Fang Aesthetics." In *Art and Aesthetics in Primitive Societies*, edited by Carol F. Jopling, 356–73. New York: E. P. Dutton.

Firstenberg, Lauri. 2000. "Negotiating the Taxonomy. Contemporary African Art: Production, Exhibition, Commodification." *Art Journal* (Fall): 108–10.

———. 2001. "Postcoloniality, Performance, and Photographic Portraiture." In *The Short Century: Independence and Liberation Movements in Africa 1945–1994*, edited by Okwui Enwezor, 175–79. Munich: Prestel.

Firth, Raymond. "Art and Anthropology." In *Anthropology, Art and Aesthetics*, edited by Jeremy Coote and Anthony Shelton, 15–39. Oxford: Clarendon, 1992.

Fisher, Angela. 1984. *Africa Adorned*. New York: Abrams.

Fisher, Angela, and Carol Beckwith. 2004. *Faces of Africa: Thirty Years of Photography*. Washington, DC: National Geographic.

Flam, Jack. 1992. "Africa Explores: 20th Century African Art, Exhibition Review." *African Arts* 25 (April): 88–90.

Flood, Finbarr Barry. 2002. "Between Cult and Culture: Bamiyan, Islamic Iconoclasm, and the Museum." *Art Bulletin* 84, no. 4 (December): 641–59.

Foltz, William J. 1965. *From French West Africa to the Mali Federation*. New Haven, CT: Yale University Press.

France Eurafrique. 1971. Vol. 23, no. 228 (August–September): 7–9.

———. 1972. Vol. 24, no. 232 (February): 17–18.

Frank, Barbara E. 1998. *Mande Potters and Leather-Workers: Art and Heritage in West Africa*. Washington, DC: Smithsonian Institution Press.

French, Howard W. 1997. "Bamako Journal: Here, An Artist's Fame and Fortune Can Be Fatal." *New York Times*, September 11, 1997, A4.

French Ministry of Foreign Affairs and International Development. 2015. "The Institut Français and the Alliance Française, Promoting French Culture Overseas." Accessed November 5, 2020. http://www.diplomatie .gouv.fr/en/french-foreign-policy/cultural-diplomacy/france-s-overseas -cultural-and-cooperation-network/article/the-work-of-the-institut -francais.

Galerie Chab, ed. 2001. *Portrait(s) Bamako-Coura Rue 369 Photographies*. Bamako, Mali: Donniya.

———. n.d. *Photographies du Mali*. Bamako, Mali: Galerie Chab.

Gallieni, Le Commandant. 1885. *Voyage au Soudan Français (Haut-Niger et Pays de Ségou) 1879–1881*. Paris: Librairie Hachette et Cie.

Gardarin, Denis. 2006. Interview by author, July 7, Sean Kelly Gallery, New York. Transcript.

Gardi, Bernard. 1994. "Djenné at the Turn of the Century: Postcards from the Museum für Völkerkunde Basel (Photo Essay)." *African Arts* 27, no. 2 (April): 70–75, 95–96.

Garnier, Jules. 1942a. "A propos des noms de plantes en Bambara." *Notes Africaines* 13 (January): 13–14.

———. 1942b. "Aliments Crus." *Notes Africaines* 13 (January): 18–19.

———. 1944. "Javanais ouest-Africain Pays bambara." *Notes Africaines* 24 (October): 10.

———. 1948. "Périodicité des crues du Niger." *Notes Africaines* 38 (April): 29–20.

———. 1954a. "Le Bambara le Plus pur Est-il lui de Segou?" *Notes Africaines* 63 (July): 89.

———. 1954b. "Quelques measures de luminosité à Bamako." *Notes Africaines* 61 (January): 2–4.

Gasser, Martin. 1992. "Histories of Photography 1839–1939." *History of Photography* 16, no. 1 (Spring): 50–60.

Gattegno, Agnès, and Bertrand Desprez. 2005. "Bamako: L'art africain en capitale/Bamako: City of Artists." *Magazine Air France* 103 (November): 96–114.

Gaudio, Attilio. 1998. *Le Mali*. Paris: Karthala.

Gbadegesin, Olubukola. 2014. "'Photographer Unknown': Neils Walwin Holm and the (Ir)retrievable Lives of African Photographers." *History of Photography* 38, no. 1 (February): 21–39.

Geary, Christraud. 1991. "Old Pictures, New Approaches: Researching Historical Photographs." *African Arts* 24 (October): 36–39, 98.

———. 1996. *Seydou Keita, Photographer: Portraits from Bamako, Mali (March 27–July 28, 1996)*. Washington, DC: National Museum of African Art, Smithsonian Institution.

———. 1997. "Photography." In *Encyclopedia of Africa South of the Sahara*, vol. 3, edited by John Middleton, 404–9. New York: Simon and Schuster Macmillan.

———. 2002. *In and Out of Focus: Images of Central Africa, 1885–1960*. Washington, DC: National Museum of Art, Smithsonian Institution, Philip Wilson Publishers.

———. 2017. "Early Photographers in Coastal Nigeria and the Afterlife of Their Images, 1860–1930." In *African Photographer J. A. Green: Reimagining the Indigenous and the Colonial*, edited by Martha G. Anderson and Lisa Aronson, 37–81. Bloomington: Indiana University Press.

Getty Museum. 2008. "August Sander: People of the Twentieth Century." May 6–September 14, 2008. http://www.getty.edu/art/exhibitions/sander/.

Gibb, Camilla C. T. 1999. "Baraka without Borders: Integrating Communities in the City of Saints." *Journal of Religion in Africa* 29, no. 1 (February): 88–108.

Giddens, Anthony. 1984. *The Constitution of Society*. Berkeley: University of California Press.

———. (1979) 1990. *Central Problems in Social Theory: Action, Structure and Contradiction in Social Analysis*. Berkeley: University of California Press.

Gioni, Massimiliano. 2002. "New York Cut Up: Faces and Names." *Flash Art* 34, no. 222 (January–February): 62–63.

Glissant, Édouard. 1997. *Poetics of Relation*. Translated by Betsy Wing. Ann Arbor: University of Michigan Press.

Glissant, Édouard, Manthia Diawara, and Christopher Winks. 2011. "Édouard Glissant in Conversation with Manthia Diawara." *Nka: Journal of Contemporary African Art* 28:4–19.

Golia, Maria. 2009. *Photography and Egypt*. London: Reaktion Books.

Gologo, Mamadou El Béchir. 2004. Interview by author, October 13, Bamako, Mali. Tape recording, transcript, and curriculum vitae.

Gore, Charles. 2013. "Neils Walwin Holm: Radicalising the Image in Lagos Colony, West Africa." *History of Photography* 37, no. 3 (August): 283–300.

———. 2015. "First Word: African Photography." *African Arts* 48, no. 3 (Autumn): 1–5.

Gorer, Geoffrey. 1970. "Taxation and Labor Practices in French West Africa in 1930's." In *Colonial Africa*, edited by Wilfred Cartey, 101–7. New York: Random House.

Grandidier, G., and E. Joucla, eds. 1937. *Bibliographie Générale des Colonies Françaises*. Paris: Société d'Éditions Géographiques, Maritimes et Coloniales.

"The Great Diplomatic Dates of Mali." 1996. *L'Independent*, no. 49 (January 18): 3.

Griffith, R. 1970. "Malinke Chief Samori Toure Delayed French Occupation in French West Africa 1882–1898." In *Colonial Africa*, edited by Wilfred Cartey, 15–21. New York: Random House.

Grossman, Wendy A. 2009. *Man Ray, African Art, and the Modernist Lens*. Washington, DC: International Arts and Artists.

Grosz-Ngaté, Maria Louise. 1986. "Bambara Men and Women and the Reproduction of Social Life in Sana Province, Mali." PhD diss, Michigan State University.

———. 2000. "Labor Migration, Gender, and Social Transformation in Rural Mali." In *Democracy and Development in Mali*, edited by R. James Bingen, David Robinson, and John M. Staatz, 87–101. East Lansing: Michigan State University Press.

———. 2008. Personal communication, July 18.

———. 2013. Personal communication, October 11.

Gruber, Christiane. 2019. *The Praiseworthy One: The Prophet Muhammad in Islamic Texts and Images*. Bloomington: Indiana University Press.

Guerrin, Michel. 2001. "Seydou Keita 'Le' Photographe Africain." *Le Monde*, November 25, 2001.

Guerrin, Michel, and Emmanuel de Roux. 2003. "Guerre de droits autour du maître malien Seydou Keïta." *Le Monde*, October 26–27, 2003, 21.

Guez, Nicole. 1996. *L'Art Africain Contemporain*. Paris: Association Afrique en Créations.

Gugler, Josef, and William G. Flanagan. 1978. *Urbanization and Social Change in West Africa*. Cambridge: Cambridge University Press.

Guillat-Guignard, Gérard. 2003. Unpublished letter addressed to Malick Sidibé, December 5.

———. 2016. Personal correspondences, June 27–October 24.

———. 2018. Personal correspondences, August 13–October 22.

Guissé, Amadou Malick. 2010. *Bamako des origins à 1940*. Bamako, Mali: Imprim'Vert.

Hale, Thomas A. 1998. *Griots and Griottes*. Bloomington: Indiana University Press.

Haleem, M.A.S. Abdel, trans. 2004. *The Qur'an*. New York: Oxford University Press.

Hallen, Barry. 2002. *The Good, the Bad, and the Beautiful: Discourse about Values in Yoruba Culture*. Bloomington: Indiana University Press.

Hamès, Constant. "Cheikh Hamallah ou Qu'est-ce qu'une confrérie islamique (Tarîqa)?" *Archives de sciences sociales des religions* 55, no. 1 (January–March 1983): 67–83.

Haney, Erin. 2010. *Photography and Africa*. London: Reaktion Books.

———. 2014. "Going to Sea: Photographic Publics of the Free and Newly Freed." *Visual Anthropology* 27: 362–78.

Hanretta, Sean. 2008. "Gender and Agency in the History of a West African Sufi Community: The Followers of Yacouba Sylla." *Comparative Studies in Society and History* 50, no. 2 (April): 478–508.

Hardin, Kris L. 1993. *The Aesthetics of Action: Continuity and Change in a West African Town*. Washington, DC: Smithsonian Institution Press.

Harmon, Stephen Albert. 2014. *Terror and Insurgency in the Sahara-Sahel Region: Corruption, Contraband, Jihad and the Mali War of 2012–13*. Farnham, UK: Ashgate.

Hastreiter, Kim. 2007. "Bravo, Malick Sidibe!" *Paper Magazine*, May 31, 2007. http://www.papermag.com/blogs/2007/05/bravo_malick_sidibe .php. Page no longer available.

Hazard, John N. 1969. "Marxian Socialism in Africa: The Case of Mali." *Comparative Politics* 2, no. 1 (October): 1–15.

Henry, Joseph. 1910. *L'âme d'un peuple africain: Les Bambara, leur vie psychique, éthique, sociale, religieuse*. Münster, Germany: Aschendorff.

Henry, Tanu T. 2001. "Picturing Africa: A Talk with Malian Photographer Malick Sidibé." Africana.com, December 8, 2001. http://www.africana .com/DailyArticles/index_20011218.htm. Page no longer available.

Hersant, Guy. 2004a. Interview by author, September 20, Bamako, Mali. Transcript.

———. 2004b. *Photographes ambulants: Togo—Bénin—Nigeria—Mali— Ghana*. Nyons, France: Filigranes and Africultures.

———. 2005. *Malick Sidibé*. Paris: Filigranes and Africultures.

———. 2007. Personal communication, April 23.

Hickling, Patricia. 2014. "Bonnevide: Photographie des Colonies: Early Studio Photography in Senegal." *Visual Anthropology* 27: 339–61.

Hight, Eleanor M., and Gary D. Sampson, eds. 2002. *Colonialist Photography: Imag(in)ing Race and Place*. New York: Routledge.

Hirsch, Robert. 2000. *Seizing the Light: A History of Photography*. Boston: McGraw-Hill Higher Education.

Hodge, Carleton T., ed. 1971. *Papers on the Manding*. Bloomington: Indiana University Press.

Hoffman, Barbara G. 1995. "Power, Structure, and Mande *Jeliw*." In *Status and Identity in West Africa: Nyamakalaw of Mande*, edited by David C. Conrad and Barbara Frank, 36–45. Bloomington: Indiana University Press.

———. 2000. *Griots at War: Conflict, Conciliation, and Caste in Mande*. Bloomington: Indiana University Press.

Hopkins, Nicholas S. 1971. "Mandinka Social Organization." In *Papers on the Manding*, edited by Carleton T. Hodge, 99–128. Bloomington: Indiana University Press.

———. 1972. *Popular Government in an African Town: Kita, Mali*. Chicago: University of Chicago Press.

Houis, M. 1959. "Le Groupe Linguistique Mandé." *Notes Africaines* 82 (April): 38–41.

Huguier, Françoise. 1996. *Secrètes*. Arles, France: Actes Sud.

———. n.d. "Seydou Keïta: Studio Work, An Interview with Seydou Keïta." Accessed February 29, 2016. http://www.zonezero.com/exposiciones /fotografos/keita/default.html.

Humphreys, Marcatan, and Habaye ag Mohamed. 2003. *Senegal and Mali*. January 2003. http://www.columbia.edu/~mh2245/papers1/sen_mali.pdf.

IMDb.com. n.d. "Bruce Lee." Accessed November 5, 2020. http://imdb.com /name/nm0000045.

Imperato, Pascal James. 1975. "Bamana and Maninka Twin Figures." *African Arts* 8, no. 4 (Summer): 52–60, 83–84.

———. 1977a. *African Folk Medicine: Practices and Beliefs of the Bambara and Other Peoples*. Baltimore, MD: York.

———. 1977b. *Historical Dictionary of Mali*. Metuchen, NJ: Scarecrow.

———. 1980. "Bambara and Malinke Ton Masquerades." *African Arts* 13, no. 4 (August): 47–55, 82–88.

———. 1983. *Baffoons, Queens, and Wooden Horsemen: The Dyo and Gouan Societies of the Bambara of Mali*. New York: Kilima House.

———. 1989. *Mali: A Search for Direction*. Boulder, CO: Westview.

———. 1991. "Mali: Downfall of a Dictator." *Africa Report* 36, no. 4 (July–August): 24–27.

———. 1994. "The Depiction of Beautiful Women in Malian Youth Association Masquerades." *African Arts* 27, no. 1 (January): 58–65, 95.

———. 2008. *Historical Dictionary of Mali*. Lanham, MD: Scarecrow.

Imperato, Pascal James, and Gavin H. Imperato. 2008. "Twins, Hermaphrodites, and an Androgynous Albino Deity: Twins and Sculpted Twin Figures among the Bamana and Maninka of Mali." *African Arts* 41, no. 1 (Spring): 40–49.

———. 2011. "Twins and Double Beings among the Bamana and Maninka of Mali." In *Twins in African and Diaspora Cultures: Double Trouble, Twice Blessed*, edited by Philip M. Peek, 39–60. Bloomington: Indiana University Press.

Incardona, Laura, and Laura Serani. 2010. *Malick Sidibé: La vie en rose*. Milan, Italy: Silvana Editoriale.

Incardona, Laura, Laura Serani, and Sabrina Zannier. 2011. *Malick Sidibé: The Portrait of Mali*. Milan, Italy: Sinetica.

Industries et Travaux d'Outremer. 1969. Vol. 17, no. 182 (January): 43–44.

Institut National des Arts. 1981. Unpublished manuscript; copy in author's possession.

International Center of Photography. n.d. Accessed February 20, 2010. http://www.icp.org/site/c.dnJGKJNsFqG/b.3945787. Page no longer available.

Jabaté, Kanku Madi, Madina Ly-Tall, Seydou Camara, Bouna Diouara. 1987. *L'histoire Mande d'après Jeli Kanku Madi Jabate de Kéla.* Paris: Association SCOA pour la recherche scientifique en Afrique noire.

Jackson, Michael, and Ivan Karp, eds. 1990. *Personhood and Agency: The Experience of the Self and Other in African Cultures.* Washington, DC: Smithsonian Institution.

James, John. 2008. "Ivory Coast's 'Big Bottom' Craze." BBC News, February 18, 2008. http://news.bbc.co.uk/go/pr/fr/-/2/hi/africa/7233565.stm.

Jansen, Jan. 1996a. "Kinship as Political Discourse: The Representation of Harmony and Change in Mande." In *The Younger Brother in Mande: Kinship and Politics in West Africa,* edited by Jan Jansen and Clemens Zobel, 1–7. Leiden, Netherlands: Research School CNWS.

———. 1996b. "The Younger Brother and the Stranger in Mande Status Discourse." In *The Younger Brother in Mande: Kinship and Politics in West Africa,* edited by Jan Jansen and Clemens Zobel, 8–34. Leiden, Netherlands: Research School CNWS.

———. 2001. *Épopée, Histoire, Société: Le Cas de Soundjata, Mali et Guinée.* Paris: Karthala.

Jansen, Jan, and Clemens Zobel, eds. 1996. *The Younger Brother in Mande: Kinship and Politics in West Africa.* Leiden, Netherlands: Research School CNWS.

Johnson, John William. 1986. *The Epic of Sun-Jara: A West African Tradition.* Bloomington: Indiana University Press.

———. 1999. "The Dichotomy of Power and Authority in Mande Society and in the Epic of Sunjata." In *In Search of Sunjata: The Mande Oral Epic as History, Literature, and Performance,* edited by Ralph A. Austen, 9–23. Bloomington; Indiana University Press.

Journal Officiel du Soudan Français. 1944. No. 979 (October 15): 70.

Juittey, Ousmane. 2004. Interview by author, September 25, Ségu, Mali. Tape recording.

Kanté, Abdoulaye. 2004. Interview by author, October 7, Bamako, Mali. Tape recording.

Kanté, Adama. 2004. Interview by author, October 7, Bamako, Mali. Tape recording.

Kanté, Mamadou. 2004. Interview by author, September 1, Bamako, Mali. Tape recording.

Kapuściński, Ryszard. 2002. "The Shadow of the Sun." In *Flash Afrique! Photography from West Africa,* edited by Gerald Matt and Thomas Mießgang, 41–43. Göttingen, Germany: Steidl.

Karp, Ivan. 1986. "Agency and Social Theory: A Review of Anthony Giddens." *American Ethnologist* 13 (February): 131–37.

———. 1997. "Person, Notions of." In *Encyclopedia of Africa South of the Sahara,* edited by John Middleton, 392–96. London: Simon and Schuster.

Karp, Ivan, and Charles S. Bird, eds. 1980. *Explorations in African Systems of Thought.* Bloomington: Indiana University Press.

Kasco, Dorris Haron. 2002. "The City in the Mirror." In *Flash Afrique! Photography from West Africa*, edited by Gerald Matt and Thomas Mießgang, 56–65. Göttingen, Germany: Steidl.

Keedler, Jayne. 1997. "Gifts from Africa: Seydou Keïta's Work Comes into Focus." *New Mass Media*, Spring 1997. http://www.newmassmedia.com /IS97spring/keita.html. Page no longer available.

Keeley, Robert V. 1991. "Robert V. Keeley, Political Officer, Bamako (1961–1963)." Interview by Thomas Stern. Association for Diplomatic Studies and Training, Mali Country Reader. https://www.adst.org/Readers/Mali /pdf. Page no longer available.

Keim, Curtis. 1999. *Mistaking Africa: Curiosities and Inventions of the American Mind*. Nashville: Westview Press.

Keïta, Baba. 2010. Interview with author, August 5, Bamako, Mali. Transcript.

Keïta, Cheick Chérif. 1996. "A Praise Song for the Father: Family Identity in Salif Keïta's Music." In *The Younger Brother in Mande: Kinship and Politics in West Africa*, edited by Jan Jansen and Clemens Zobel, 97–104. Leiden: Research School CNWS.

Keïta, Harouna Racine. 2004. Interviews by author, February 18 and 19, Bamako, Mali. Tape recordings.

Keïta, Kadar. 2004a. Interviews by author, February 23, March 2, and March 4, Bamako, Mali. Tape recordings.

Keïta, Kadar, and Alioune Bâ. 2004. Interview by author, September 30, Bamako, Mali. Transcript.

Keïta, Koni. 2004. Interview by author, October 12, Bamako, Mali. Transcript.

Keïta, Ousmane. 2004. Interview by author, September 29, Bamako, Mali. Tape recording.

Keïta, Seydou. 2011. Interview with André Magnin. In Pigozzi and Magnin, *Seydou Keïta Photographs: Bamako, Mali 1948–1963*, unpaginated. Göttingen, Germany: Steidldangin.

Keller, Candace M. 2007. *Mopti à la Mode: Portrait Photographs by Tijani Sitou*. Exhibition brochure. Bloomington: Indiana University Art Museum.

———. 2008. "Visual Griots: Social, Political, and Cultural Histories in Mali through the Photographer's Lens." PhD diss., Indiana University.

———. 2012. "Gologo, Mamadou El Béchir." In *Dictionary of African Biography*, edited by Henry Louis Gates Jr. and Emmanuel Akyeampong, 481–83. New York: Oxford University Press.

———. 2013a. "Transculturated Displays: International Fashion and West African Portraiture." In *African Dress Encounters: Fashion, Agency, Performance*, edited by Karen Tranberg Hansen and Soyini Madison, 276–301. London: Bloomsbury Academic (Berg).

———. 2013b. "Visual Griots: Identity, Aesthetics, and the Social Roles of Portrait Photographers in Mali." In *Portraiture and Photography in Africa*, edited by John Peffer and Elisabeth Cameron, 363–405. Bloomington: Indiana University Press.

———. 2014. "Framed and Hidden Histories: West African Photography from Local to Global Contexts." *African Arts* 47, no. 4 (Winter): 36–47.

———. 2015. "La photographie de studio au Mali / Studio Photography in Mali." In *Rencontres de Bamako*, edited by Bisi Silva and Antawan Byrd, 374–85. Berlin: Kehrer.

Keller, Candace M., and Malick Sitou. 2007. "Studio Photo: The Photographic Studio of El Hadj Tijani Sitou in Mopti." Unpublished video recording.

Kelly, Sean. 2006. Interview by author, July 7, Sean Kelly Gallery, New York. Transcript.

Kinsella, Eileen. 2005. "Where the Good Buys Are." *ARTnews* 104, no. 10 (November): 154–61.

Knape, Gunilla, Manthia Diawara, and André Magnin. 2003. *Malick Sidibé—Photographs*. Göteborg, Sweden: Hasselblad Center.

Konaré, Adama Bâ. 2000. "Perspectives on History and Culture: The Case of Mali." In *Democracy and Development in Mali*, edited by R. James Bingen, David Robinson, and John M. Staatz, 15–22. East Lansing: Michigan State University Press.

Konaré, Alpha Oumar, and Adama Bâ Konaré. 1981. *Grandes Dates du Mali*. Bamako, Mali: Imprimeries du Mali.

———. 1997. *Mali Donbaw*. Bamako, Mali: Jamana.

Konaté, Mamadou. 2004. Interview by author, September 29, Bamako, Mali. Transcript.

Konaté, Moussa. 2004. Interviews by author, March 10 and 20 and September 21, Bamako, Mali. Transcripts and tape recordings.

———. 2009. Interview by author, July 28, Bamako, Mali. Transcript.

———. 2017. Interview by author, May 11, Bamako, Mali. Transcript.

Koné, Baru. 2004. Interviews by author, February 24 and March 2 and 5, Bamako, Mali. Tape recordings.

Koné, Kassim Gausu. 1995a. *Bamanankan Danyegafe*. West Newbury, MA: Mother Tongue.

———. 1995b. *Mande Zana ni Ntalen Wa no ko: Bamanankan ni Angilekan na* [More than a thousand Mande proverbs in Bambara and English]. West Newbury, MA: Mother Tongue.

———. 2009. Personal communication, June 22, Bamako, Mali. Transcript.

Koné, Moumouni. 2004. Interview by author, January 19, Bamako, Mali. Tape recording.

Kottoor, Naveena. 2013. "How Timbuktu's Manuscripts Were Smuggled to Safety." *BBC News Magazine*, June 3, 2013. https://www.bbc.com/news/magazine-22704960.

Kouoh, Koyo. 2002. "Frozen Mobility: A Photographer in Dialogue with His Environment." In *Flash Afrique! Photography from West Africa*, edited by Gerald Matt and Thomas Mießgang, 37–40. Göttingen, Germany: Steidl.

Kouyaté, Adama. 2004a. Interview by author, September 26, Bamako, Mali. Tape recording.

———. 2004b. Interview by author, October 2, Ségu, Mali. Tape recording.

Kouyaté, Boya Dembélé, and the Dembélé family. 2004. Interview by author, January 17, Bamako, Mali. Tape recording.

Krifa, Michket. 2011. *For a Sustainable World: Rencontres de Bamako, African Photography Biennial*. 9th ed. Arles, France: Actes Sud.

Krifa, Michket, and Laura Serani. 2009a. *Frontiers, Rencontres de Bamako 9: Biennale Africaine de la Photographie, 7 Novembre–7 Decembre.* Unpublished program.

———. 2009b. *Frontiers, Rencontres de Bamako 9: Biennale Africaine de la Photographie.* Arles, France: Actes Sud.

Labouret, Henri. 1934. *Les Manding et leur langue.* Paris: Larose.

Lake, René. 1993. "Mali: Pluralism in Radio Broadcasting." In *Radio Pluralism in West Africa*, edited by Panos Institute and West African Union of Journalists, 56–90. Paris: L'Harmattan.

Lamunière, Michelle. 2001a. "Ready to Wear: A Conversation with Malick Sidibé." *Transition* 10, no. 4:132–60.

———. 2001b. *You Look Beautiful Like That: The Portrait Photographs of Seydou Keïta and Malick Sidibé.* New Haven, CT: Yale University Press.

Landau, Paul S. 2002a. "An Amazing Distance: Pictures and People in Africa." In *Images and Empires: Visuality in Colonial and Postcolonial Africa*, edited by Paul S. Landau and Deborah D. Kaspin, 1–40. Berkeley: University of California Press.

———. 2002b. "Empires of the Visual: Photography and Colonial Administration in Africa." In *Images and Empires: Visuality in Colonial and Postcolonial Africa*, edited by Paul S. Landau and Deborah D. Kaspin, 141–47. Berkeley: University of California Press.

Landau, Paul S., and Deborah D. Kaspin, eds. 2002. *Images and Empires: Visuality in Colonial and Postcolonial Africa.* Berkeley: University of California Press.

Law-Viljoen, Bronwyn. 2007. "Malick Sidibé Bamako Fantastique." *Art South Africa* 5, no. 3 (Autumn): 42–49.

Lawal, Azeem Oladejo. 2004. Interview by author, August 30, Gao, Mali. Tape recording.

Lawal, Babatunde. 1974. "Some Aspects of Yoruba Aesthetics." *British Journal of Aesthetics* 14: 239–49.

Lecocq, Baz. 2010. *Disputed Desert: Decolonisation, Competing Nationalisms and Tuareg Rebellions in Northern Mali.* Leiden, Netherlands: Brill.

L'Économiste Soudanais. 1935a. Vol. 22 (July 21).

———. 1935b. (October 20).

———. 1935c. Vol. 43 (December 15): cover, 1.

———. 1938. Vol. 11, no. 134 (September 1): 1 (advertisement).

———. 1939. Vol. 15, no. 138 (January): 1.

Lee, Victor T. 1986. "Cameroon, Togo, and the States of Formerly French West Africa." In *Politics and Government in African States 1960–1985*, edited by Peter Duignan and Robert H. Jackson, 78–119. London: Croom Helm.

Le Guern, Philippe. 2003. "La photographie d'exploration, une prouesse." In *Explorateurs photographes: Territoires inconnus 1850–1930*, edited by Antoine Lefébure, 21–27. Paris: La Découverte.

Lefébure, Antoine, ed. 2003. *Explorateurs photographes: Territoires inconnus 1850–1930.* Paris: La Découverte.

Leichtman, Mara A. 2009. "Revolution, Modernity and (Trans)National Shi'i Islam: Rethinking Religious Conversion in Senegal." *Journal of Religion in Africa* 39, no. 3: 19–351.

Le Nouëne, Patrick, ed. 2003. *Malick Sidibé: Photographies de la vie bamakoise de 1960 aujourd'hui*. Angers, France: Musée Pincé.

L'Essor. 1951. No. 461 (Wednesday, May 7): 1–2.

———. 1952a. No. 742 (Monday, April 21): 1–2.

———. 1952b. No. 747 (Saturday, April 26): 1–2.

———. 1952c. No. 750 (Friday, May 2): 1–4.

———. 1952d. No. 782 (Friday, June 13): 1–2.

———. 1952e. No. 783 (Saturday, June 14): 1–2.

———. 1953. No. 979 (Friday, February 13): 1–2.

———. 1955a. No. 1795 (Friday, August 19): 1–2.

———. 1955b. No. 1859 (Friday, November 4): 1–2.

———. 1958. No. 2958 (Monday, December 22): 1–2.

———. 1968a. (Tuesday, November 19).

———. 1968b. (Friday, November 22).

———. 1969. (September).

———. 1977. No. 7585. (Tuesday, April 19).

———. 1978. (Wednesday, March 8).

———. 1978. (Tuesday, November 28).

———. 1979a. No. 7890 (Friday, February 9).

———. 1979b. No. 8012 (Saturday, March 3).

———. 1979c. No. 8149. (Wednesday, July 18).

L'Etat de Droit. n.d. "Mali: Key Events." http://www.etat.sciencespobordeaux.fr/ _anglais/chronologie/mali.html. Page no longer available.

Levtzion, Nehemia, and Humphrey J. Fisher, eds. 1987. *Rural and Urban Islam in West Africa*. Boulder, CO: Lynne Reinner.

Levtzion, Nehemia, and Randall L. Pouwels, eds. 2000. *The History of Islam in Africa*. Athens: Ohio University Press.

Lewis, Paula Gilbert. 1976. *The Aesthetics of Stéphane Mallarmé in Relation to His Public*. Plainsboro, NJ: Associated University Press.

L'Institute National des Arts. 1981. Unpublished paper.

Little, Kenneth. 1957. "The Role of Voluntary Associations in West African Urbanization." *American Anthropologist* 59, no. 4 (August): 579–96.

Lloyd, Rosemary. 1984. *Mallarmé Poésies*. London: Grant and Cutler.

———. 1999. *Mallarmé: The Poet and His Circle*. Ithaca, NY: Cornell University Press.

Loke, Margarett. 1997. "Inside Photography." *New York Times*, July 11, 1997, 21.

———. 2001. "Seydou Keïta Dies; Photographed Common Man of Mali." *New York Times*, September 8, 2001, D9.

Lortie, Marie. 2007. "Colonial History, Curatorial Practice and Cross-Cultural Conflict at the Bamako Biennial of African Photography." MA thesis, School for Studies in Art and Culture, Department of Art History, Carleton University.

Lothrop, Jr., Eaton S. 1978. "The Brownie Camera." *History of Photography* 2, no. 1 (January): 1–10.

Loughran, Kristyne. 2009. "The Idea of Africa in European High Fashion: Global Dialogues." *Fashion Theory* 13, no. 2 (June): 243–72.

Luizard, Pierre-Jean. 2012. "Saint and Holy Portraits in Shia-Sunni Mausoleums and Saint Veneration." In *Portraits and Faces of Saints and*

Holy Figures in Saint Veneration, edited by Pedram Khosronejad, 4–21. London: Sean Kingston Publishing.

L'Union. 1958a. (Wednesday, October 15): 1–4.

———. 1958b. No. 34 (Saturday, November 29): 1–4.

———. 1958c. No. 59 (Wednesday, December 24): 1–4.

———. 1959a. No. 116 (Saturday, March 28): 1–2.

———. 1959b. No. 119 (Monday, March 31): 1–2.

Lutz, Catherine A., and Jane L. Collins, eds. 1993. *Reading National Geographic*. Chicago: University of Chicago Press.

Lydon, Ghislaine. 2000. "Women in Francophone West Africa in the 1930s: Unraveling a Neglected Report." In *Democracy and Development in Mali*, edited by R. James Bingen, David Robinson, and John M. Staatz, 61–86. East Lansing: Michigan State University Press.

Mack, John. 1991. "Documenting the Cultures of Southern Zaire: The Photographs of the Torday Expeditions 1900–1909." *African Arts* 24, no. 4 (October): 60–69, 100.

MacSweeny, Eve. 1998. "Sunday Best." *Harper's Bazaar*, May 1998, 172–79.

Mage, Abdon-Eugène. 1868. *Voyage dans le Soudan Occidental (Sénégambie-Niger) 1863–1866*. Paris: Librairie Hachette et Cie.

Magnin, André. 1995. "Seydou Keita." *African Arts* 28, no. 4 (Autumn): 90–95.

———. 1997. *Seydou Keita*. Zurich: Scalo.

———. 1998. *Malick Sidibe*. Zurich: Scalo.

———. 2000. *J.D.'Okhai Ojeikere Photographs*. Zurich: Scalo.

———. 2004. Interview by author, May 27, Paris. Transcript.

———. 2005. *African Art Now: Masterpieces from the Jean Pigozzi Collection*. London and New York: Merrell.

Magnin, André, and Hervé Chandès. 1994. *Seydou Keïta*. Exhibition catalog. Paris: Fondation Cartier pour l'Art Contemporain.

Magnin, André, and Seydou Keïta. 2002. "Seydou's Story." In *Flash Afrique! Photography from West Africa*, edited by Gerald Matt and Thomas Mießgang, 66–69. Göttingen, Germany: Steidl.

Magnin, André, and Malick Sidibé. 2003. "In My Life, as in Photography, I Have Told the Truth and I Have Given My All." In *Malick Sidibé—Photographs*, edited by Gunilla Knape, 75–81. Göttingen, Germany: Steidl.

Maïga, Hamidou (professional photographer). 2004. Interview by author, January 27, Bamako, Mali. Tape recording.

Maïga, Hamidou (former minister of culture). 1993. Video recording (footage of the outdoor evening projection of Seydou Keïta's images during the Rencontres in Arles, France). Gifted to author in 2004.

———. 2004. Interview by author, September 14, Bamako, Mali. Tape recording.

Maïga, Jafa. 2004. Interview by author, September 25, Ségu, Mali. Tape recording.

Malé, Salia. 2001. "The *Jo* and the *Gwan*." In *Bamana: The Art of Existence in Mali*, edited by Jean-Paul Colleyn, 142–65. New York: Museum for African Art.

"Mali: Photographes." 1995. *Revue Noire* 17 (July–August): 20–24.

Manaud, Jean-Luc, and Martine Ravache. 2002. *Racine Keïta*. Paris: Éditions de l'Oeil.

Mandémory, Boubacar Touré. 2002. "I Do Not Like the Cinema." In *Flash Afrique! Photography from West Africa*, edited by Gerald Matt and Thomas Mießgang, 78–80. Göttingen, Germany: Steidl.

Mann, Gregory. 2000. "The Tirailleur Elsewhere: Military Veterans in Colonial and Post-Colonial Mali, 1918–1968." PhD diss., Northwestern University.

Maquet, Jacques. 1986. *The Aesthetic Experience: An Anthropologist Looks at the Visual Arts*. New Haven: Yale University Press.

Mara, Cheick Oumar. 2004. Interview by author, September 17, Bamako, Mali. Transcript.

Marchés Tropicaux et Méditerranéen. 1966. (January 22): 333–439.

———. 1969a. No. 25, 1215 (February 22): 415.

———. 1969b. No. 25, 1217 (March 8): 558.

Marien, Mary Werner. 2002. *Photography: A Cultural History*. New York: Harry N. Abrams.

Marion, Sara L. 1997. "Syncretic Topographies: The Portraits of Seydou Keïta." MA thesis, University of New Mexico.

Marshall, Peter. 2001. "Seydou Keïta—African Photographer. Part 4: His Pictures." About.com, December 13, 2001. http://www.photography .about.com. Page no longer available.

Martin, Jean-Hubert. 1989. *Magiciens de la Terre*. Paris: Editions du Centre Pompidou.

Matrix. n.d. Center for Humanities and Social Sciences, Michigan State University. Accessed November 5, 2020. https://matrix.msu.edu/.

Matt, Gerald, and Thomas Mießgang, eds. 2002. *Flash Afrique! Photography from West Africa*. Göttingen, Germany: Steidl.

McGuire, James R. 1999. "Butchering Heroism? Sunjata and the Negotiation of Postcolonial Mande Identity in Diabaté's *Le Boucher de Kouta*." In *In Search of Sunjata: The Mande Oral Epic as History, Literature, and Performance*, edited by Ralph A. Austen, 253–73. Bloomington: Indiana University Press.

McNaughton, Patrick R. 1982. "Language, Art, Secrecy and Power: The Semantics of Dalilu." *Anthropological Linguistics* 24 (Winter): 487–505.

———. 1988. *The Mande Blacksmiths: Knowledge, Power, and Art in West Africa*. Bloomington: Indiana University Press.

———. 1992. "From Mande Komo to Jukun Akuma: Approaching the Difficult Question of History." *African Arts* 25, no. 2 (April): 76–85, 99–100.

———. 1993. "In the Field: Mande Blacksmiths." In *Art in Small-Scale Societies: Contemporary Readings*, edited by Richard L. Anderson, 3–8. Englewood Cliffs: Prentice-Hall.

———. 1995a. "Malian Antiquities and Contemporary Desire." *African Arts* 28, no. 4 (Autumn): 23–27.

———. 1995b. "The Semantics of *Jugu*: Blacksmiths, Lore, and 'Who's Bad' in Mande." In *Status and Identity in West Africa: Nyamakalaw of Mande*, edited by David C. Conrad and Barbara E. Frank, 46–57. Bloomington: Indiana University Press.

————. 2000. "Art of the Western Sudan." Lecture, Bloomington, Indiana University, March 21.

————. 2001. "The Power Associations Kòmò." In *Bamana: The Art of Existence in Mali*, edited by Jean-Paul Colleyn, 175–83. New York: Museum for African Art.

————. 2008. *A Bird Dance near Saturday City: Sidi Ballo and the Art of West African Masquerade*. Bloomington: Indiana University Press.

Meillassoux, Claude. 1964. "The 'Koteba' of Bamako." *Presence Africaine* 24, no. 52 (Fall): 28–62.

————. 1968. *Urbanization of an African Community: Voluntary Associations in Bamako*. Seattle: University of Washington Press.

Memmi, Albert. (1965) 1991. *The Colonizer and the Colonized*. Boston: Beacon.

Méniaud, Jacques. 1931. *Les Pionniers du Soudan avant, avec, et après Archinard 1879–1894*. Paris: Société des Publications Moderns.

Ménoret, Albane. 2016. Personal communication, May 19.

Mensah, Alexander. 2001. "La galerie Chab à Bamako: Une nouvelle antenne pour la mouvance photo, Entretien avec Chab Touré." *Africultures* 39 (June): 20–29.

Mensah, Ayoko. 1998. "Photographes Maliens en Gros Plan: Malick Sidibe, Racine Keïta, Django Cisse, Seydou Keïta, Alioune Bâ." *Balafon* 142: 36–45.

Mensel, Robert E. 1991. "'Kodakers Lying in Wait': Amateur Photography and the Right for Privacy in New York, 1885–1915." *American Quarterly* 43, no. 1 (March): 24–45.

Merleau-Ponty, Maurice. 1963. *The Structure of Behavior*. Translated by Alden L. Fisher. Boston: Beacon.

Mercer, Kobena. 2005. *Cosmopolitan Modernisms*. Cambridge, MA: MIT Press.

Mercier, Jeanne. 2006. "Les Rencontres Africaines de la Photographie, Bamako 2005." Master's thesis, École des hautes études en sciences sociales.

Mesplé, Louis. 1996a. "Bamako, Capitale de la Photographie Africaine." In *2èmes Rencontres de la Photographie Africaine, Bamako—Mali, 9–15 Décembre 1996*. Bamako, Mali: Ministère de la Culture et de la Communication République du Mali and Fondation Afrique en Créations.

————. 1996b. "Bamako, Capitale de la Photographie Africaine." *Cimaise* 43, no. 244 (November–December): 5–28.

Metropolitan Museum. 2004. *August Sander: People of the Twentieth Century, A Photographic Portrait of Germany*. May 25–September 19, 2004. Online exhibition abstract. http://www.metmuseum.org/special/se _event.asp?OccurrenceId={DC021885-C838-4448-A135-E335A09B BB78}. Page no longer available.

Meurillon, Georges. n.d. "Seydou Keita: Un photographe de studio à la mode." *Bulletin Images et Mémoires 6*. http://www.sedet.jussieu.fr/sites /Afrilab/documents/Icono/Articles/SeydouKeita.html. Page no longer available.

Micheli, C. Angelo. 2008. "Doubles and Twins: A New Approach to Contemporary Studio Photography in West Africa." *African Arts* 41, no. 1 (Spring): 66–85.

————. 2010. Personal communication, November 7 and November 11.

————. 2011. "Double Portraits: Images of Twinness in West African Studio Photography." In *Twins in African and Diaspora Cultures: Double Trouble, Twice Blessed*, edited by Philip M. Peek, 137–62. Bloomington: Indiana University Press.

————. 2012. "Portraits photographiques d'Afrique de l'Ouest." June 26, 2012. http://studio-portraits-afrique.blogspot.com.

————. n.d. "Doubles portraits photographiques d'Afrique de l'Ouest." Accessed November 5, 2020. http://doubles-portraits-afrique.blogspot.com.

————. n.d. "My Blogs." Accessed November 5, 2020. https://www.blogger.com/profile/05864222525450310694.

Michetti-Prod'Hom, Chantal. 2003. Mali: *Photographies et textiles contemporains*. Lausanne: Musée de design et d'arts appliqués contemporains.

Mießgang, Thomas. 2002. "Directors, Flaneurs, Bricoleurs: Studio Photographers in West Africa." In *Flash Afrique! Photography from West Africa*, edited by Gerald Matt and Thomas Mießgang, 16–23. Göttingen, Germany: Steidl.

Miller, Kristin. 2004. "The Way It Was: Mali, 1963." *Condé Nast Traveler*, December 2004, 130.

Miner, Miner. 1953. *The Primitive City of Timbuctoo*. Princeton, NJ: Princeton University Press.

Ministère de la Culture et de la Communication République du Mali and Fondation Afrique en Créations. 1994. "1er *Rencontres de la Photographie Africaine*, Bamako—Mali, 5–11 Décembre 1994." Catalog.

————. 1996. "2èmes *Rencontres de la Photographie Africaine*, Bamako—Mali, 9–15 Décembre." Catalog.

Monreal, Lluís, and Lydia Oliva. 1997. *Retrats de l'anima: Fotografia africana*. Barcelona, Spain: Fundació "la Caixa."

Monteil, Charles. 1924. *Les Bambara du Ségou et du Kaarta*. Paris: Larose.

Monteil, Vincent. 1968. "Photographies de Marabouts de Djenné (Mali) prises par Charles Monteil en 1900." *Notes Africaines* 117 (January): 29–32.

Monti, Nicolas. 1987. *Africa Then: Photographs 1840–1918*. New York: Alfred A. Knopf.

Moore, Allison. 2008. "Shifting Identities: Contemporary Photography in Mali." PhD diss., City University of New York.

Murphy, William P. 1990. "Creating the Appearance of Consensus in Mende Political Discourse." *American Anthropologist* 92 (March): 24–41.

Mustafa, Haditha Nura. 2002. "Portraits of Modernity: Fashioning Selves in Dakarois Popular Photography." In *Images and Empires: Visuality in Colonial and Postcolonial Africa*, edited by Paul S. Landau and Deborah D. Kaspin, 172–92. Berkeley: University of California Press.

Nampa-Reuters. 2002. "Africa News: Mali Pardons Former Dictator Moussa Traore, Wife." *Namibian*, May 30, 2002. http://www.namibian.com.na/2002/ may/africa/0262BE4A68.html. Page no longer available.

National Geographic. 1973. *National Geographic* 144, no. 3 (September): cover.

Ndaw, Alassane. 1975. "Conscience et communication. Esthétique négro-africaine." *Ethiopiques* 3:80–88.

N'Diaye, Samba. 2005. Interview by author, November 17, Bamako, Mali, transcript.

Newhall, Beaumont. 1982. *The History of Photography: From 1839 to the Present*. New York: Museum of Modern Art.

Niane, D. T. (1965) 2006. *Sundiata: An Epic of Old Mali*. Essex, UK: Pearson Education.

Nimis, Érika. 1996. "Etre photographe à Bamako: Evolution et réalités d'un métier issu de la 'modernité' (1935–1995)." Master's thesis, Université de Paris 1.

———. 1997. "Félix, le premier photographe de Kita." *Tapama* 2 (December): 56–58.

———. 1998a. "Bamako, Entre Deux Rencontres." *Africultures* 8 (May): 48–53.

———. 1998b. "L'Age d'Or Noir et Blanc au Mali." In *Anthologie de la Photographie et de l'Ocean Indien*, edited by Pascal Martin Saint Léon and N'Goné Fall, 104–17. Paris: Revue Noire.

———. 1998c. *Photographes de Bamako de 1935 à nos jours*. Paris: Revue Noire.

———. 2003. *Félix Diallo Photographe de Kita*. Toulouse, France: Galerie Toguna.

———. 2005. *Photographes d'Afrique de l'Ouest: L'expérience yoruba*. Paris: Karthala.

———. 2013. "Yoruba Studio Photographers in Francophone West Africa." In *Portraiture and Photography in Africa*, edited by John Peffer and Elisabeth Cameron, 103–40. Bloomington: Indiana University Press.

Njami, Simon. (1998) 1999. "The Writer, the Griot and the Photographer." In *Anthology of African and Indian Ocean Photography*, edited by Revue Noire, 20–23. Paris: Revue Noire.

———. 2001. "Bamako: Une ville, un continent." *Paris Photo* 16 (September/October): 86–95.

———. 2003a. Interview by author, December 2, Bamako, Mali. Tape recording.

———. 2003b. *V^es Rencontres de la Photographie Africaine Bamako 2003: Rites sacrés/Rites profanes*. Paris: Éric Koehler.

———, ed. 2005. *VI^es Rencontres Africaines de la Photographie Bamako 2005: Un autre monde*. Paris: Éric Koehler.

Njami, Simon, and Charlotte Boudon, eds. 2001. *Mémoires Intimes d'Un Nouveau Millénaire: IV^es Rencontres de la photographie africaine Bamako 2001*. Paris: Éric Koehler.

Njami, Simon, and Lucy Durán. 2005. *Africa Remix: Contemporary Art of a Continent*. New York: DAP.

Njami, Simon, and Malick Sidibé. 2002. "The Movement of Life." In *Flash Afrique! Photography from West Africa*, edited by Gerald Matt and Thomas Mießgang, 94–96. Göttingen, Germany: Steidl.

Nnandi, Chioma. 2012. "Photographer Malick Sidibé's Influence on Fashion—and His New Solo Exhibit." *Vogue*, April 13, 2012. https://www.vogue.com/article/photographer-malick-sidibs-influence-on -fashionand-his-new-solo-exhibit.

Nossiter, Adam. 2012. "Mali Islamists Exert Control, Attacking Door to a Mosque." *New York Times*, July 2, 2012. https://www.nytimes.com/2012/07/03/world/africa/mali-islamists-exert-control-with-attacks-on-mosques.html.

Oguibe, Olu. 1993. "Africa Explores: 20th Century African Art, Exhibition Review." *African Arts* 26 (January): 16–22.

———. 2002. "The Photographic Experience: Toward an Understanding of Photography in Africa." In *Flash Afrique! Photography from West Africa*, edited by Gerald Matt and Thomas Mießgang, 9–15. Göttingen, Germany: Steidl.

Okakura, Kakuzo. 1997. "Many Aesthetics." In *Aesthetics*, edited by Susan Feagin and Patrick Maynard, 56–61. Oxford: Oxford University Press.

Ollier, Brigitte. 2001. "Malick Sidibé: Portrait Nature." *Liberation*, November 8, 2001. https://next.liberation.fr/images/2001/11/08/malick-sidibe-portrait-nature_383196.

Ombotimbe, Hamadou. 2004. Interview by author, February 7, Bamako, Mali. Tape recording.

Ortiz, Fernando. 1947. *Cuban Counterpoint: Tobacco and Sugar*. New York: Alfred A. Knopf.

Ortner, Sherry B. 1984. "Theory in Anthropology since the Sixties." *Comparative Studies in Society and History* 26 (January): 126–66.

Osterweis, Max. 2009. Interview with author, September. Phone conversation.

Ottenberg, Simon. 1971. *Anthropology and African Aesthetics*. Legon: Ghana Universities Press.

Ouédraogo, Jean-Bernard. 1996. "La figuration photographique des identities sociale: valeurs et apparences au Burkina Faso." *Cahiers d'Etude Africain* 141–42, no. 1–2:25–50.

———. 2002. *Arts Photographique en Afrique: Technique et esthétique dans la photographie de studio au Burkina Faso*. Paris: L'Harmattan.

Pabanel, Jean-Pierre. 1984. *Les Coups d'État Militaires en Afrique Noire*. Paris: L'Harmattan.

Pakenham, Thomas. 1991. *The Scramble for Africa: White Man's Conquest of the Dark Continent from 1876 to 1912*. New York: Avon Books.

Paoletti, Giulia. 2015. "Un Nouveau Besoin: Photography and Portraiture in Senegal (1860–1960)." PhD diss., Columbia University.

Paster, James E. 1992. "Advertising Immortality by Kodak." *History of Photography* 16, no. 2 (Summer): 135–39.

Peek, Philip M. 2011. *Twins in African and Diaspora Cultures: Double Trouble, Twice Blessed*. Bloomington: Indiana University Press.

Peffer, John, and Elisabeth L. Cameron, eds. 2013. *Portraiture and Photography in Africa*. Bloomington: Indiana University Press.

Pellizzi, Francesco. 1993. "Africa Explores: 20th Century African Art, Exhibition Review." *African Arts* 26 (January): 22–29.

Pézard, Stephanie, and Michael Robert Shurkin, eds. 2015. *Achieving Peace in Northern Mali: Past Agreements, Local Conflicts, and the Prospects of a Durable Settlement*. Santa Monica, CA: RAND Corporation.

Phillips, Tom. 1999. *Africa: The Art of a Continent*. Munich: Prestel.

Pigozzi, Jean, and André Magnin. 2011. *Seydou Keïta Photographs: Bamako, Mali 1948–1963*. Göttingen, Germany: Steidldangin.

Pinney, Christopher. 1997. *Camera Indica: The Social Life of Indian Photographs*. Chicago: University of Chicago Press.

———. 2008. *The Coming of Photography in India*. London: British Library.

Pinney, Christopher, and Nicolas Peterson. 2003. *Photography's Other Histories*. Durham, NC: Duke University Press.

Pivin, Jean Loup. 1994–95. "Une nouvelle photographie, l'ombre et le noir." *Revue Noire* 15 (December–January): 42–60.

Pivin, Jean Loup, and Pascal Martin Saint Leon, eds. "African Photographers Photographes Noirs." 1991. *Revue Noire*, no. 3 (December).

Plesse, Richelle Harrison. 2016. "Discovering the 'Father of African Photography' and Nobuyoshi Araki's Exotic Art." France 24, May 5, 2016. http://www.france24.com/en/20160505-culture-photography-seydou-keita-fabrice-monteiro-nobuyoshi-araki.

"Political Persecutions in Mali under the 1st, 2nd and 3rd Republics." 1996. *Tempete*, no. 35, November 5, 1996.

Poole, Deborah. 2003. "Notes from the Surface of the Image: Photography, Postcolonialism, and Vernacular Modernism." In *Photography's Other Histories*, edited by Christopher Pinney and Nicolas Peterson, 173–202. Durham, NC: Duke University Press.

Popenoe, Rebecca. 2004. *Feeding Desire: Fatness, Beauty, and Sexuality among Saharan People*. London: Routledge.

Potoski, Antonin. 1998. *BKO-RAK, Photographes de Bamako: Amadou Traoré, Mamadou Konaté, Youssouf Sogodogo, les élèves du prytanée de Kati; et de Marrakech: Hicham Benoboud*. Paris: Revue Noire.

———. 1999. *Alioune Bâ Photographies 1986–1997*. Bamako, Mali: Le Figuier.

Potoski, Antonin, and Amadou Chab Touré. 2000. *Youssouf Sogodogo photographies: Les cahiers de Gao, Les tresses du Mali, La ferme de mon frère*. Paris: Éditions de l'Oeil.

"Première Rencontres de la Photographie Africaine, Bamako." 1994. *Le Démocrate Malien* 2, no. 81 (December 20): 3–6.

Prochaska, David. 1991. "Fantasia of the *Photothèque*: French Postcard Views of Colonial Senegal." *African Arts* 24, no. 4 (October): 40–47, 98.

Promo-Femme. 2006. "Notes techniques sure le centre promo-femme." Unpublished paper, shared with author by Allison Moore, October 13, 2006.

Rasmussen, Susan J. 2004. "Reflections on Witchcraft, Danger, and Modernity among the Tuareg." *Africa: Journal of the International African Institute* 74, no. 3:315–40.

Rawson, David. 2000. "Dimensions of Decentralization in Mali." In *Democracy and Development in Mali*, edited by R. James Bingen, David Robinson, and John M. Staatz, 265–88. East Lansing: Michigan State University Press.

Rips, Michael. 2006. "The Ghosts of Seydou Keïta." *New York Times*, January 22, 2006, 1, 32–33.

Roberts, Allen F. 2010. "Recolonization of an African Visual Economy." *African Arts* 43, no. 1 (Spring): 1–8.

Roberts, Allen F., and Mary Nooter Roberts. 1998. "L'aura d'Amadou Bamba: Photographie et fabulation dans le Sénégal urbain." *Anthropologie et societes* 22, no. 1: 15–40.

———. 2002. "A Saint in the City: Sufi Arts of Urban Senegal." *African Arts* 53, no. 4 (Winter): 52–73, 93.

———. 2003. *A Saint in the City: Sufi Arts of Urban Senegal*. Los Angeles: Regents of the University of California.

———. 2008. "Flickering Images, Floating Signifiers: Optical Innovation and Visual Piety in Senegal." *Material Religion* 4 (March): 4–31.

Robinson, Kenneth. 1958. "French Africa and the French Union." *Africa Today*, 311–31.

RolleiClub. n.d. "All Rollei TLR by Year." http://www.rolleiclub.com/cameras /tlr/info/allTLR1.shtml. Page no longer available.

Rosen, Laurence. 2008. *Varieties of Muslim Experience: Encounters with Arab Political and Cultural Life*. Chicago: University of Chicago Press.

Roth, Claudia. 2014. "The Strength of *Badenya* Ties: Siblings and Social Security in Old Age—The Case of Urban Burkina Faso." *American Ethnologist* 41, no. 3 (August): 547–63.

Rovine, Victoria. 2001. *Bogolan: Shaping Culture through Cloth in Contemporary Mali*. Washington, DC: Smithsonian Institution.

———. 2009. "Viewing Africa through Fashion." *Fashion Theory* 13, no. 2 (June): 133–40.

Ruby, Jay. 1995. *Secure the Shadow: Death and Photography in America*. Cambridge: MIT Press.

Ryan, Patrick J. 2000. "The Mystical Theology of Tijani Sufism and Its Social Significance in West Africa." *Journal of Religion in Africa* 30, no. 2 (May): 208–24.

Saint-Cyr, Agnès de Gouvion. 1999. "Africa of Gods, Africa of People." In *Anthology of African and Indian Ocean Photography*, edited by Pascal Martin Saint Léon and N'Goné Fall, 16–19. Paris: Revue Noire.

Saint-Léon, Pascal Martin. 1994. *Mama Casset: Les précurseurs de la photographie au Sénégal, 1950*. Paris: Éditions Revue Noire.

Saint Léon, Pascal Martin, and N'Goné Fall, eds. 1998. *Anthologie de la Photographie Africaine et de l'Océan Indien*. Paris: Revue Noire.

Sakaly, Youssouf. 2010. Personal communication, October 28.

———. 2016. Personal communication, May 16.

———. 2019. Personal communication, June 7.

Samaké, Iyouba. 2004. Interviews by author, January 14, June 14, and September 23, Bamako, Mali. Transcripts and tape recordings.

———. 2005. Interviews by author, November 22 and 23, Bamako, Mali. Transcript.

Samaké, Iyouba, and Bakary Sidibé. 2005. Interview by author, November 23, Bamako, Mali. Transcript.

Samaké, Nouhoum. 2004. Interviews by author, February 25 and September 28 and 29, Bamako, Mali. Tape recordings and transcripts.

Samaké, Nouhoum, and Malim Coulibaly. 2004. Interview by author, September 30, Bamako. Transcript.

Sangaré, Anatol. 2005. Personal communication, November 22, Bamako, Mali.

Sangaré, Karim. 2004. Interview by author, July 14, Bamako, Mali. Transcript.

Sangaré, Ouassa. 2004. Interview by author, October 26, Bamako, Mali. Transcript.

Sangaré, Tidiane. 2019. Personal communication, June 11, Bamako, Mali, and East Lansing, MI.

Schildkrout, Enid. 1991. "The Spectacle of Africa through the Lens of Herbert Lang: Belgian Congo Photographs 1909–1915." *African Arts* 24, no. 4 (October): 70–85, 100.

Schneider, Jürg. 2014. "Demand and Supply: Francis W. Joaque, an Early African Photographer in an Emerging Market." *Visual Anthropology* 27: 316–38.

Schwartz, Jay. 2002. "Secret Cinema and International House Co-Present FRENCH POP Mini-Fest." http://slick.org/pipermail/tikievents /2002-July/000078.html. Page no longer available.

Schwartz, Joan M., and James R. Ryan, eds. 2003. *Picturing Place: Photography and the Geographical Imagination.* New York: I. B. Tauris.

Sekula, Allan. 1986. "The Body and the Archive." *October* 39 (Winter): 3–64.

Sembéné, Ousmane. 1988. *Le Camp de Thiaroye.* 152 min. Dakar, Senegal: Doomireew Films.

Serani, Laura, and Laura Icardona. 2010. *Malick Sidibé: La vie en rose.* Milan, Italy: Silvana Editoriale.

Seydou Keïta Photography. n.d. Accessed November 5, 2020. http://www .seydoukeitaphotographer.com/.

Shoemaker, Heida. 2013. Email communication, November 7.

Sidibé, Bakary. 2004. Interviews by author, September 4 and 9, Bamako, Mali. Transcript.

———. 2005. Interview by author, November 13, Bamako, Mali. Transcript.

———. 2006. Email communications, October 19 and 20.

Sidibé, Brehima. 2003. Personal correspondence, November 3, Bamako.

———. 2005. Email communications, June 15 and August 5.

———. 2006. Email communications, September 9, 21, and 22, and telephone communication, October 24.

Sidibé, Fousseini. 2004. Interviews by author, July 20 and September 2, Bamako, Mali. Tape recording.

Sidibé, Issa. 2004. Interview by author, January 17, Bamako, Mali. Tape recording.

Sidibé, Karim. 2004. Interviews by author, February 12 and 18 and July 7 and 8, Bamako, Mali. Tape recording.

Sidibé, Malick. 2003. Interviews by author, November 7, 20, 26, 27, 28, and 29 and December 1, 3, 5, 7, 8, 11, 16, 17, and 22, Bamako, Mali. Tape recordings.

———. 2004. Personal communications and interviews by author, January 5, 6, 7, and 22; February 17 and 18; June 7; July 7, 8, 14, and 29; August 2 and 27; and September 6 and 9, Bamako, Mali. Transcripts and tape recordings.

———. 2005. Interview by author, November 21, Bamako, Mali. Transcript.

Sidibé, Malick, and Andreas Kokkino. 2009a. "The Backstory: Malick Sidibe." The Moment Blogs, *New York Times*, April 3, 2009. http:// themoment.blogs.nytimes.com/author/andreas-kokkino/. Page no longer available.

———. 2009b. "Prints and the Revolution: From Milan to Mali, a Riot of Checks, Stripes, Patterns, and Polka Dots." *New York Times Magazine*, April 5, 2009, 40–47.

Sidibé, Malick, and Caroline Laurent. 2003. "Malick Sidibé, l'oeil African." *Elle*, March 24, 2003, 214–16.

Sidibé, Malick, and Youssouf Saker. 2003. Interview by author, December 8, Bamako, Mali. Transcript.

Sidibé, Malick, Dia Sidibé, and Siné Sidibé. 2009. Interview by author, November 19, Bamako, Mali. Transcript.

Sidibé, Malick, and Karim Sidibé. 2004. Interview by author, July 29 and August 7, Bamako, Mali. Tape recordings.

Sidibé, Malick, Karim Sidibé, and Malick Sitou. 2004. Interview by author, July 8, Bamako, Mali. Tape recording.

Sidibé, Malick, and Malick Sitou. 2004. Interview by author, August 27, Bamako, Mali. Transcript.

Sidibé, Malick, and Amourou Traoré. 2003. Interview by author, December 8. Transcript.

Sidibé, Oudya. 2004. Interview by author, September 19, Bamako, Mali. Transcript.

———. 2005. Interview by author, November 20, Bamako, Mali. Transcript.

Sidibé, Sidiki. 2003. Interviews by author, November 7 and December 11 and 15, Bamako, Mali. Tape recording.

———. 2004. Interview by author, July 15, Bamako, Mali. Tape recording.

———. 2005. Interview by author, November 17, Bamako, Mali. Transcript.

Simard, Claude. 2006. Interview by author, July 7, Jack Shainman Gallery, New York. Transcript.

Simmel, Georg. 1955. *Conflict*. Translated by Kurt H. Wolff. Glencoe, IL: Free Press.

Sissako, Abderrahmane. 2006. *Bamako*. 115 min. Mali, France, and the United States: Archipel 33, Arte France Cinéma, Chinguitty Films, Louverture Films, Mali Images, and New Yorker Films.

Sitou, Dramane. 2004. Interview by author, June 24, Bamako, Mali. Transcript.

Sitou, Ibrahim. 2004. Interview by author, February 28, Mopti, Mali. Tape recording.

Sitou, Malick. 2004. Interviews by author, February 17, 28, and 29; June 23, 24, 27, and 29; August 27; September 1 and 2; and October 2, Bamako and Ségu, Mali. Tape recordings and transcripts.

———. 2005. Personal communications, January 29, Houston, and October 15, San Diego.

———. 2006. Interviews by author and telephone communications, March 13, June 4, and July 29, San Diego. Transcript, September 11, Bloomington. Personal communications, October 21 and 25, November 13, and December 11, San Diego.

———. 2008. Telephone communications, March 8 and April 19, San Diego.

———. 2009. Telephone communication, April 16, Lansing, Michigan.

———. 2010. Telephone communication, September 26, Lansing, Michigan.

———. 2015. Telephone communications, August 8 and September 20, East Lansing, Michigan.

———. 2018. Personal communication, October 18.

———. 2019. Personal communication, May 27.

Sitou, Malick, and Ali Bocoum. 2004. Interview by author, June 24, Mopti, Mali. Transcript.

Sitou, Malick, Candace Keller, and Ryan Claytor. n.d. Accessed April 5, 2009. http://www.tijanisitou.com. Page no longer accessible.

Sitou, Malick, and Amidou Sidibé. 2008. Telephone communication, May 14, San Diego.

Sitou, Malick, and Ibrahim Sitou. 2004. Interview by author, June 23, Mopti, Mali. Transcript.

Sitou, Malick, and Dada Traoré. 2004. Interview by author, October 15, Buguni, Mali. Transcript.

Sitou, Moussa. 2006. Telephone communication, October 24, San Diego.

Sitou, Sarata, and Moussa Sitou. 2004. Interview by author, February 29, Mopti, Mali. Tape recording.

Snyder, Francis G. 1969. "The Keita Decade: An Era Ends in Mali." *Africa Report* 14 (March–April): 16–22.

Sogodogo, Youssouf. 2004. Interviews by author, January 14 and 23 and February 20, Bamako, Mali. Tape recordings.

Sokkelund, Karen Mohr. 2003. "Malick Sidibé: Photographs with a Touch of Humour." *Katalog: Journal of Photography and Video* 16, no. 2: 2–11.

Sokkelund, Svend Erik. n.d. "The Sokkelund African Collection." Accessed September 15, 2014. http://www.african_collection.dk/english/samlingen .htm. Page no longer available; a revised version of the website is available as "Sokkelund's African Collection." Accessed November 12, 2020. http://www.africancollection.dk/.

Sokkelund, Svend Erik, and Tanya Elder. 1996. *Hamadou Bocoum.* Copenhagen: Fotografisk Center.

Sontag, Susan. (1973) 1977. *On Photography.* New York: Picador USA.

Soulillou, Jacques. 1991. "Art Exhibition or Collectors' Cabinet? Africa Explores: 20th Century African Art." *Revue Noire* (September): 54.

Soumaoro, Bourama. 2004. Interview by author, March 10, Bamako, Mali. Tape recording.

Sow, Amadou. 2002. "La Photo en tant que Témoin de l'Histoire." Master's thesis, Institute Nationale des Arts de Bamako.

Sow, Bouba. 2004. Interview by author, March 10, Bamako, Mali. Transcript.

Spender, Cosima. 2008. *Dolce Vita Africana.* Videocassette, 59 min. London: BBC4.

Spiegler, Marc. 2005. "Negative Charges." *Art + Auction* (February): 94–101.

Sprague, Stephen F. 1978. "Yoruba Photography: How the Yoruba See Themselves." *African Arts* 12, no. 1 (November): 52–59, 108–9.

———. 2003. "Yoruba Photography: How the Yoruba See Themselves." In *Photography's Other Histories*, edited by Christopher Pinney and Nicholas Peterson, 240–60. Durham, NC: Duke University Press.

Squiers, Carol. 1996. "Seeing Africa through African Eyes." *New York Times,* May 1996, 30.

Stamm, Andrea L., Dawn E. Bastian, and Robert A. Myers. 1998. *Mali.* Oxford: Clio.

Steward, Sue. 2003. "The Magic of Malick." *Observer Magazine*, March 2, 2003, 40–46.

Storr, Robert. 1997. "Bamako—Full Dress Parade: Seydou Keïta." *Parkett* 49: 25–29.

Strassler, Karen. 2010. *Refracted Visions: Popular Photography and National Modernity in Java.* Durham, NC: Duke University Press.

Strawn, Cullen. 2011. "Kunfe ko: Experiencing Uncertainty in Malian Wasulu Hunters' Music Performance and Hunting." PhD diss., Indiana University.

Strother, Zoë. 2013. "'A Photograph Steals the Soul': The History of an Idea." In *Portraiture and Photography in Africa*, edited by John Peffer and Elisabeth L. Cameron, 177–212. Bloomington: Indiana University Press.

Tagg, John. 1993. *The Burden of Representation: Essays on Photographies and Histories.* Minneapolis: University of Minnesota Press.

Takeda, Noriko. 2000. *A Flowering Word: The Modernist Expression in Stéphane Mallarmé, T.S. Eliot, and Yosano Akiko.* New York: Peter Lang.

Thompson, J. Malcom. 1990. "Colonial Policy and the Family Life of Black Troops in French West Africa, 1817–1904." *International Journal of African Historical Studies* 23, no. 3: 423–53.

Thompson, Robert Farris. 1971. "Aesthetics in Traditional Africa." In *Art and Aesthetics in Primitive Societies: A Critical Anthology*, edited by Carol F. Jopling, 374–-81. New York: E. P. Dutton.

———. 1973. "Yoruba Artistic Criticism." In *The Traditional Artist in African Societies*, edited by Warren d'Azavedo, 19–61. Bloomington: Indiana University Press.

Thuillier, Michel. 2007. Personal communication, August 7.

Thurber, Jon. 2001. "Seydou Keïta; Self-Taught Photographer Known throughout Africa for Thousands of Portraits." *Los Angeles Times*, November 30, 2001, B12.

Tounkara, Cheick Oumar. 2019. "Memo sur le droit a l'image" and personal communication, May 16.

Touré, Amadou Chab. 2000. *Hamidou Maïga: Photographie les "Tomboctiens."* Bamako, Mali: Galerie Chab.

———. 2003. *Contours: V^{èmes} Rencontres de la photographie africaine de Bamako.* Bamako, Mali: Helvetas, AMAP, World Press Photo, Panapress, Electrosonic, Peintor, RFI.

———. 2004. Interviews by author, January 14, February 25, and October 7, Bamako, Mali. Tape recordings and transcripts.

Touré, Cheickna. 2009. Interview by author, July 4, Bamako, Mali. Transcript.

"Tourism in Mali." 1970. *Africa* 9, no. 52, 49–76.

Towns, Elisabeth. 2001. "Les ateliers sténopé d'Oscura au Mali." *Africultures* 39 (June): 30–36.

———. 2008. "The Oscura Pinhole Photography Workshops in Mali." Africultures. http://www.africultures.com/anglais/articles_anglais /39oscura.htm. Page no longer available.

Traoré, Alioune. 1983. *Cheikh Hamahoullah: Homme de Foi et Résistant.* Paris: Maisonneuve et Larose.

Traoré, Alitiny. 2004. Interviews by author, September 1 and 10, Bamako, Mali. Tape recording.

Traoré, Amadou Seydou. 1996. *Defense et Illustration de l'Action de L'Union Soudanaise RDA 1946–1968.* Bamako, Mali: Éditions "La Ruche à livres."

Traoré, Baba. 2004. Interview by author, October 27, Bamako, Mali. Tape recording.

Traoré, Dada, and Ladji Traoré. 2004. Interview by author, September 24, Bamako, Mali. Transcript.

Traoré, Dahirou. 2004. Interviews by author, September 1, 2, 6, and 20, Bamako, Mali. Transcripts and tape recordings.

Traoré, Dominique. Archives Nationals du Mali (Kuluba). *Repertoire Fonds Recents 1918–1960 (book 2)*, ID 33-3, 11-14.

Traoré, Fanta. 2004. Interview by author, February 13, Bamako, Mali. Tape recording.

Traoré, Issa Baba. 1974. "La Mission Gallieni au Soudan." *Etudes Maliennes* 9 (March): 1–7.

Traoré, Lito. 2004. Interview by author, September 1, Bamako, Mali. Tape recording.

Traoré, Rokia. 2004. Interview by author, September 10, Bamako, Mali. Transcript.

Traoré, Soloman. 2004. Interview by author, September 25, Ségu, Mali. Tape recording.

Traoré, Youssouf. 2004. Interview by author, October 20, Bamako, Mali. Tape recording.

Triaud, Jean-Louis. 2010. "La Tidjaniya, une confrérie musulmane transnationale." *Politique étrangère* 75, no. 4 (Winter): 831–42.

Tribunal de Grande Instance de Paris. 2008. Court Case # RG: 04/11897. April 9. Transcription courtesy Érika Nimis.

"Un malien aux états-unis: Le Smithsonian accueille M. Seydou Keita à l'Institut Smithsonian." 1996. *AMAWAL*, April 15 (no. 62), 5.

US Department of State, Bureau of African Affairs. 2006. "Background Note: Mali." http://www.state.gov/r/ei/bgn/2828.htm. Page no longer available.

Uwechue, Ralph, ed. 1996. *Makers of Modern Africa: Profiles in History.* London: Africa Books.

Van Damme, Wilfried. 1987. *A Comparative Analysis Concerning Beauty and Ugliness in Sub-Saharan Africa.* Ghent, Belgium: University of Ghent.

———. 1996. *Beauty in Context: Towards an Anthropological Approach to Aesthetics.* Leiden, Netherlands: Brill.

Van Gelder, Alex, ed. 2005. *Life and Afterlife in Benin.* New York: Phaidon.

Vassalo, Aude. 2003. "Eugène Lenfant et le fleuve Niger." In *Explorateurs Photographes: Territoires inconnus 1850–1930*, edited by Antoine Lefébure, 118–23. Paris: La Découverte.

Verité. 1958. Vol. 734 (January 25).

Viditz-Ward, Vera. 1985. "Alphonso Lisk-Carew: Creole Photographer." *African Arts* 19, no. 1 (November): 46–51, 88.

———. 1987. "Photography in Sierra Leone, 1850–1918." *Africa* 57, no. 4: 510–18.

———. (1998) 1999. "Studio Photography in Freetown." In *Anthology of African and Indian Ocean Photography*, edited by Revue Noire, 34–41. Paris: Revue Noire.

Viky. 2003. "Communiqé du conseil des ministres." *L'Essor* 15092 (November 27): 1–3.

Villien-Rossi, Marie-Louise. 1963. "Bamako, capitale du Mali." *Les Cahiers d'Outre-Mer Revue de Geographie* 64 (October–December): 379–93.

Vine, Richard. 2003. "Seydou Keïta Legacy Disputed." *Art in America* (December): 29–31.

———. 2004. "Report from Mali: The Luminous Continent." *Art in America* (October): 69–73.

Visser, Hripsimé. 2000. "Malick Sidibé." *Bulletin Stedelijk Museum Amsterdam*, 8–15.

Vogel, Susan Mullin. 1980. "Beauty in the Eyes of the Baule: Aesthetics and Cultural Values." Working Papers in the Traditional Arts 6. Philadelphia: Institute for the Study of Human Issues.

———. 1991. *Africa Explores: 20th Century African Art*. New York: Center for African Art.

———. 2006. "Poor Housekeeping." Paper delivered during the Rebele Conference on Portrait Photography in African Worlds at the University of California, Santa Cruz, February 3–4.

Vogel, Susan, Samuel Sidibé, and Catherine de Clippel. 2006. "Malick Sidibé: Portrait of the Artist as a Portraitist." Videorecording (DVD), 8 mins. Brooklyn, NY: First Run/Icarus Films.

Von Denffer, Dietrich. 1976. "Baraka as Basic Concept of Muslim Popular Belief." *Islamic Studies* 15, no. 3 (Autumn): 167–86.

von Silvers, Peter. 2000. "Egypt and North Africa." In *The History of Islam in Africa*, edited by Nehemia Levtzion and Randall L. Pouwels, 21–36. Athens: Ohio University Press.

Vroegindewey, Ryan. 2013. Personal correspondences, November 15 and 16, East Lansing, Michigan.

Warren, Bruce. 2003. *Photography: The Concise Guide*. Clifton Park, NY: Thomson Delmar Learning.

Wehrey, Frederic, and Anouar Boukhars, eds. 2013. *Perilous Desert: Insecurity in the Sahara*. Washington, DC: Carnegie Endowment for International Peace.

Wells, Liz, ed. 2001. *Photography: A Critical Introduction*. London: Routledge.

Wendl, Tobias. 2001. "Entangled Traditions: Photography and the History of Media in Southern Ghana." *RES: Anthropology and Aesthetics* 39 (Spring): 78–101.

Wendl, Tobias, and Philip Kwame Apagya. 2002. "Photography as a Window to the World." In *Flash Afrique! Photography from West Africa*, edited by Gerald Matt and Thomas Mießgang, 44–55. Göttingen, Germany: Steidl.

Wendl, Tobias, and Heike Behrend, eds. 1998. *Snap Me One! Studiofotografen in Afrika*. Munich, Germany: Prestel.

Wendl, Tobias, and Nancy DuPlessis. 1998. *Future Remembrance: Photography and Visual Imagery in Ghana*. Videocassette, 55 min. Watertown, MA: Documentary Educational Services.

Werner, Jean-François. 1993. "La photographie de famille en Afrique de l'Ouest Une méthode d'approache ethnographique." *Xoana* 1: 43–57.

Whitelaw, Elisabeth. 2016. Personal communication, June 21, East Lansing, Michigan.

Wikipedia. 2020. "Moussa Traoré." June 29, 2020. http://en.wikipedia.org /wiki/Moussa_Traore.

Wildi, Ernst. 1987. *Medium Format Photography*. Boston: Focal Press.

Wolpin, Miles D. 1980. "Legitimizing State Capitalism: Malian Militarism in 3rd World Perspectives." *Journal of Modern African Studies* 18, no. 2 (June): 281–93, 289.

Zahan, Dominique. 1960. *Sociétés d'initiation bambara*. Paris: La Haye Mouton et Cie.

———. 1963. *La dialectique du verbe, chez les Bambara*. Paris: Mouton.

Zepp, Ira G. 2000. *A Muslim Primer: Beginner's Guide to Islam*. Fayetteville: University of Arkansas Press.

Zinsou, Marie-Cécile. 2009. *Malick Sidibe*. Contonou, Benin: Fondation Zinsou.

Zobel, Clemens. 1996. "The Noble Griot—The Construction of Mande *Jeliw*-Identities and Political Leadership as Interplay of Alternative Values." In *The Younger Brother in Mande: Kinship and Politics in West Africa*, edited by Jan Jansen and Clemens Zobel, 35–47. Leiden, Netherlands: Research School CNWS.

Index

48n14, 51n31, 58n84, 116;
immigrant populations in, 24,
141; location of, *5f*; as major city,
81–82; as metaphor for fadenya, 185;
postcard photographs of, 47n5; radio
in, *33f*, 103; schools in, 50nn27–28;
social turbulence in, 142
Bamako Museum, 367
Bamanankan, 9, 14
Bamba, Adama, 362; photograph of,
228f
Bamba, Cheikh Amadou, image of,
339, 340, *341f*, 349
Bangoura, Robert, 34, 102, 162n23
baraka, 339–40, 348–49, 354n17,
355n22
Barthes, Roland, 1, 86, 87, 164n39
beauty: and dìbi, 290; ideal feminine
traits in, 260–61; in the ideal
Malian woman, 260, 324n3; link to
moral worth, 272; and luminosity,
265
Behrend, Heike, 334, 348
Bell, Clare, 371–72
Bemba, Adama, 153
Berthé, Mamadou, 75, 79, 162n24;
photograph of, *236f*
Bertillon, Alphonse, 117
bicycles, 25, *27f*, 40, 65
Bigham, Elizabeth, 377
Bignat, Jean, 135
Bird, Charles, 180, 183, 197, 216n1,
216n6, 336, 354n14
Black African Youth Festival, 104
black-and-white photography:
artistry of, 159; continued
fashionability of, 135; cultural
context for peak of, 8; decline and
end of, 151–59; durability of, 87;
golden age of, 44, 60; preference
for, 326n17. *See also* portrait
photography
Bocoum, Ali, 153
Bocoum, Hamadou, 61, 75, 100, 158,
369, 377
boliw, *316f*, 317–18, 337–38, 340,
342, *343f*, 355nn25–26
boom boxes, 138–39, 160n9,
188, *394f*

Borgnis-Desbordes, Gustave, 19–20,
22, 48n14
boxing and boxers, 88, *89f*, 113, *114f*,
135, 164n39, 272
Brazzaville conference, 44
Brink, James, 144, 276, 345, 385
British Library Endangered Archives
Programme, 381, 390n47
Buckley, Liam, 257n42
Burke, Timothy, 357n44

Camara, Abdoulaye "Blocus,"
163n34, 200
Camara, Abdoul Karim, 150–51,
174n127
Camara, Mamadou, 362
Camara, Salif, 34, 80
Camara, Sekou, 217n18
Camara, Seydou, 336
cameras: 35-millimeter cameras, 131;
Kodak Brownie, 58n82, 161n20;
medium format cameras, 131;
Polaroid cameras, 143; repair of,
103, 155; twin lens reflex (TLR)
cameras, 77, 161n20; view cameras,
35, *36f*, 39, 77; Zenit camera, 121,
172n108
Center for African Art (now the New
Africa Center), 156
Center for Photographic Training
(CFP, formerly Helvetas). *See*
Helvetas
Charry, Eric, 252n1
cigarettes and cigarette smoking,
50n24, 93, *94f*, 95, *96f*, 122,
170n86, 173n113, 189, 191
cinema in Mali: censorship of,
51n33, 54n58; cowboy films, 91,
93f, *112f*, 135; detective and spy
films, 91, 93, *94f*; fashion driven
by, 108; international attention to,
145; karate films, 135, 173n111;
popularity of, 88; theaters in
Bamako, 30, 51n31, 60, 91, 160n5,
165n44
Cissé, Amadou Baba: and
Association Naye-Naye, 366–67;
on cost of electricity, 174n129;
on photographer as reporter,

Military Committee of National Liberation (CMLN), 127, 128, 129, 144, 145

military dictatorship. *See* Keïta, Modibo; Traoré, Moussa

modernities: cosmopolitanism, 65; imagery of, 65; and luxury items, 28–29f, 33f, 65; and new modes of transportation, 25, 27–29f, 65; photography in imaging of, 6–7, 32, 179; smoking and, 95; symbols of, 28–29f, 33f; telephones, 138. *See also* power and prestige; style and fashion; urbanization in Mali; youth culture

modernization: in Bamako, 41, 54n57; and French civilizing mission, 6, 20, 40, 47n7; of rural economy, 116; urban work opportunities, 30

Modibo Keïta Memorial, 367

Monteil, 336–37

monuments and architecture, 115

Moukarzel, Rahael, 39

Moutet, Marius, 41

Mthethwa, Zwelethu, 361

mug shot photography, 117, 119, 144, 160n21, 168n76, 169n78

music, popular, 108, 114, 139, 165n46, 166n53, 189; photographic images on, 383f

Muslim populations, 57n78

Mustafa, Haditha Nura, 223

National Art Institute, 131, 153, 159, 161n18, 367. *See also* House of Sudanese Artisans

National Center of Cinematographic Production (CNPC), 119, 145, 147, 372, 388n23

National Cinematographic Agency, 143

National Committee of the Defense of the Revolution (CNDR), 127–28

National Endowment for the Humanities Division of Preservation and Access, 381, 390n48

National Group of Professional Photographers of Mali

(GNPPM), 154, 155, 198, 203, 217n14, 218n23

National Information Agency of Mali (ANIM, today AMAP): documentation of leader's boliw captured, 342; extra income opportunities at, 163n34; as the official press agency, 168n69; photographers at, 114, 119, 375; and post-coup availability of supplies, 129; and private studios of employees, 131; support for, 121; training at, 81; transformation into AMAP, 143

nationalism and independence: in the 1960s, 105–7, 167n65; activism of the 1940s, 43, 55nn61–62; political activism of the 1950s, 60, 61, 63–64; steps toward, 102–3; undercurrents of, 42

National Museum: archivist at, 175n132, 365; construction of, 145, 173n119; digital archiving at, 381, 390n45; evolution of, 167n65; exhibitions at, 364, 367; workshops at, 158

National Security, 117–19, 168n75. *See also* Keïta, Seydou

National Youth Week, 75, 115, 131, 168nn70–71, 211, 211f

N'Diaye, Sanaba, 388n15

New Museum (New York City), 156–57

Niang, Omar, 252n4

Nimis, Érika: on backdrops, 166n56, 256n35, 327n28; on controls over film, 42; on double exposure printing, 254n19; on earliest portrait photography in Bamako, 31; on ja and photography, 356n38; on looking away from the camera, 347, 357n39; on photographs and Islam, 353n1; on photography and memory, 86; on reddening, 326n15; and religious portraiture, 334, 335; on Sakaly, 162n26, 201; on sociability of photographers, 221; on Yorùbá photographers, 166n57

Njami, Simon, 362, 387n8–9

professional studios: clientele of, 139; competition with amateurs, 256n33; and construction of identity, 256n31; demise of, 151, 174n129, 175n133; establishment of, 22; of fourth-generation photographers, 153–54; gardens in front of, 286–87; for governmental employees, 131; growth of, 45; identification photographs in business of, 116; indoor and outdoor venues, 37, 81, 110, 163n32; planning for surprises, 225–26; props and backdrops in, 327n27; and skin lightening strategies, 263–65; urbanization and practices of, 6; use of props and backdrops, 69, 147–48, 148–49f. *See also* apprenticeships; authorship and ownership; clientele; props and backdrops

Promo-Femme school, 365–66

props and backdrops: in colonial photography, *38f*, 235, *300f*; decorative narrative props in, *112f*, *251f*, *288–89f*; to depict modernity in, 138–39; as embellishments, 279, 280–81, 284–87, 327n28; to facilitate narrative quality of image, 234–35; fadenya in, 305; gardens as backdrops, 307–8, *307–8f*, *400f*; heart-shaped frames, 251, *251f*; landscape backdrops, 284, 286, *286f*; in marketing, *38f*, 100, *101f*, 327n27; religious themes, *148–49f*, 334, *396f* (plate 5); and self-identity, 188; use of grey painted backdrops, 166n56; use of patterned backdrops, 166n55, 235–36, 256n35; use of props to depict modernity in, 100, 138–39, *138f*; of women by third generation photographers, 135, 138. *See also* identity, construction of; power and prestige; religion depicted in portraiture; style and fashion; youth culture

protest demonstrations, 120, 169n81

al-Qaddafi, Muammar, 147
Quartiers d'Orange, 367

Radioduffusion-Télévision du Mali (ORTM), 147, 198, 324n3
Radio Kayira, 151
radios: under colonialism, 42, 97; as important commodities, 70; as luxury possessions, 65; in portraits, *33f*, 103, 188, 266, 299, *299f*, *394f*
Radio Soudan (later Radio Mali), 103, 123, 159n1, 167n63, 198
Ray, Man, 383
RDA. *See* African Democratic Rally (RDA)
record players, 97
Regards sur le Joliba exhibition, 367–68
religion depicted in portraiture, 70, 72, 284, 334; photographs, *13f*, *148–49f*, *189f*, *333f*
Rencontres African Photography biennial: attempts to engage local photographers and audiences, 364–65; Bamako as site for, 105; criticisms of, 363–64, 387nn7–8, 387n10; Cultural Palace as venue for, 144; cultural projects affiliated with, 147, 198; and dialogue among photographers, 361–62; directors for, 360, 387n1, 387n4, 387n11; driving force for, 387n6; first, in 1994, 158; grand prize from, 198, 375; National Museum and, 145; and political instabilities, 365; publications for, 387n3; purpose of, 361; and safeguards for old photography, 381; selection process for, 387n9; Western audience bias for, 362
Rencontres d'Arles, 360, 387n2
reportage photography: under the Active Revolution, 125, *126f*; ANIM's work in, 81; censorship of, 371–72; and Islam, 353n4; most popular photographer in, 102; Sakaly and, 162n26; social preference for, 108, 110; technology advances for, 77; by third-generation photographers, 131, *132f*; and tourism, 143
research in Mali: approach and methods used in, 11–13; resources consulted and interviewees, 13–14; support for, 11
Rosen, Laurence, 332, 334

CANDACE M. KELLER is Associate Professor of African Art and Visual Culture in the Department of Art, Art History, and Design at Michigan State University. She also directs the Archive of Malian Photography (http://amp.matrix.msu.edu) and is Associate Director of Matrix—the Center for Digital Humanities and Social Sciences at Michigan State University.